AMERICAN

WOMEN

SCULPTORS

AMERICAN

WOMEN

SCULPTORS

A

History

of Women

Working

in

Three

Dimensions

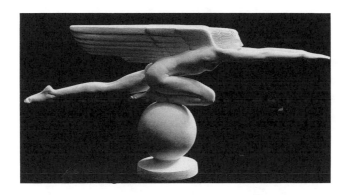

CHARLOTTE STREIFER RUBINSTEIN

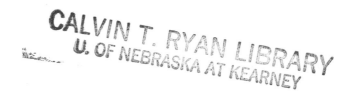
G.K. HALL & CO.
BOSTON

First published 1990
by G.K. Hall & Co.
70 Lincoln Street
Boston, Massachusetts 02111

10 9 8 7 6 5 4 3 2

Book design by Barbara Anderson.

Library of Congress Cataloging-in-Publication Data

Rubinstein, Charlotte Streifer.
 American women sculptors: a history of women working in three
dimensions / Charlotte Streifer Rubinstein.
 p. cm.
 Includes bibliographical references.
 ISBN 0-8161-8732-0
 1. Women sculptors—United States—Biography.
 2. Sculpture, American. I. Title.
NB236.R8 1990
730′.82—dc20 89-26846
 CIP

The paper used in this publication meets the minimum requirements of American
National Standard for Information Sciences—Permanence of Paper for Printed
Library Materials. ANSI Z39.48-1984
MANUFACTURED IN THE UNITED STATES OF AMERICA ⊗™

CONTENTS

ACKNOWLEDGMENTS

This survey could not have been completed without the generous help of many scholars, collectors, gallery owners, librarians, curators, registrars, artists, and other individuals—many more than I can possibly acknowledge here. To all of them I express my deepest gratitude.

I particularly wish to thank the staff at G.K. Hall & Co.—above all India Koopman for her patient and sensitive editing and her fortitude while enduring endless changes and revisions; John Amburg, managing editor of the publications department, and Michael Sims, executive editor; Cecile Watters, copy editor; and Barbara Anderson, book designer, whose fine layout and design survived last-minute pleas for "just one more picture." Thanks also to Meghan Robinson Wander for her interest in the book proposal.

Generous with help and information were Janis Conner, Joel Rosenkranz, and Douglas Berman, all experts in the field of American sculpture; Garth Clark, authority on American ceramics; Elsa Honig Fine, editor and publisher of the *Woman's Art Journal*; Chris Petteys, author of the monumental *Dictionary of Women Artists,* who generously opened her extensive archives to me at the outset; and Anita Duquette of the Whitney Museum of American Art.

I also want to thank Abigail Booth Gerdts, National Academy of Design; Theadora Morgan, National Sculpture Society; Harry Rand, George Gurney, Rachel Allen, Lois Fink, and Margaret Harman, National Museum of American Art; Barbara Wolanin, curator for the Architect of the Capitol; Douglas K. Hyland, Birmingham Museum of Art; Robert F. Brown and Joyce Tyler, New England Area Archives of American Art; Cynthia Ott and Judith Throm, Archives of American Art, Washington, D.C.; Sue Ann Kendall, Archives of American Art, Detroit, Michigan; Bill Barrett, Sculptors Guild; Gurdon Turbox, Jr., and Robin Salmon, Brookgreen Gardens, South Carolina; Eunice Glosson and Wendy Reaves, National Portrait Gallery; Samuel Hough, curator of the Gorham Company archives at the John Hay Library, Brown University; Peter Johnson of the Rockefeller Foundation; Barbara Martin and Susan Anable of the National Trust for Historic Preservation; Jerry Kearns, Prints and Photographs Division, Library of Congress; Jonathan Heller, Still Pictures Division, National Archives; Marian Grif-

fiths, Sculpture Center, New York; Father Nathan Cochran, St. Vincent Archabbey, Latrobe, Pennsylvania; art historian Kathryn Greenthal; Blossom Kirschenbaum, professor, Johns Hopkins University; Christine Boyanoski, Art Gallery of Toronto; Emily Cutrer, University of Texas, Austin; Louise Todd Ambler, Fogg Art Museum; Martha Hoppin, Springfield Museum of Art; John Stringer, Center for Interamerican Relations; Marilyn Richardson, Museum of Afro-American History, Boston; Flora Miller Biddle, Whitney Museum of American Art; Myles Libhart, United States Department of the Interior, Indian Arts and Crafts Board, Washington, D.C.; Arnold T. Schwab, professor emeritus, California State University, Long Beach, who generously shared his references on Clio Hinton Bracken; Deirdre L. Bibby, New York Public Library Schomburg Center for Research in Black Culture; Frances M. Naumann, art historian, Parsons School of Design; Dextra Frankel, gallery director at California State University, Fullerton; Jaune Quick-to-See Smith, distinguished painter and spokesperson for contemporary Native American artists; Betty Bryson Burroughs, sculptor and former curator of education at the Rhode Island School of Design; Dolly Sherwood, biographer of Harriet Hosmer; Kathryn D. Oestreich, who shared material about Julia Bracken Wendt; Jeanne Hingston, who offered information about Una Hanbury; artist Tee Corinne, who generously shared her files on Ruth Cravath; and Roslye B. Ultan, who shared her master's thesis on Bessie Potter Vonnoh.

Also art historians Biruta Erdmann, East Carolina University; Saul Zalesh and Calvin Hennig; Lewis Rabbage, Louise Noun, and Jeanne Madeleine Weimann (author of *The Fair Women*); R. W. Smith, New Haven dealer in rare books; Deborah Park, Ann Dasburg, and Mrs. Seabury C. Mastic; Alice Ryerson; Sidney Haskins; L.

Neal Smith, professor emeritus; Dr. Harvey Slatin; Christine Knopf, registrar at the Philbrook Art Institute; Ronald Kuchta, director of the Everson Museum; Adolpho Nodal, director of cultural affairs for the city of Los Angeles; Frederic Sharf, who generously shared his research files on Louisa Lander; Laura Mason, Sheldon Swope Art Gallery, Terre Haute, Indiana; and Virginia Watson-Jones, author of *Contemporary American Women Sculptors*.

I also owe special thanks to Nelda Stone and Marianna Hoff, reference librarians at the Laguna Beach Public Library, who obtained rare books for me from all over the country and answered queries at all hours of day and night, and to Roger Barry, librarian in charge of the Special Collections at the University of California, Irvine. Among other librarians who were so helpful are Lois Noonan of the Bixby Library, Vermont; William Lang, head art reference librarian at the Philadelphia Free Library; Janice H. Chadbourne, curator of fine arts, Boston Public Library; Cynthia Weiss, Kendall Young Library, Webster City, Iowa; Leta Hendricks, Illinois Room, Galesburg Public Library; Susan Dehler, Special Collections, Vigo County Library, Terre Haute, Indiana; Melissa Kaufmann-Buhler, Mount Pleasant Public Library, Pleasantville, New York; Carolyn Davis, George Arents Research Library, Syracuse University; Melanie Wisner, Houghton Library, Harvard University; reference librarians at the James Duncan Phillips Library of Essex Institute, at the Rhode Island School of Design, and at the Pennsylvania Academy of the Fine Arts; curators and archivists at the Colorado, Nevada, Nebraska, Chicago, Pennsylvania, Massachusetts, Rhode Island, Denver, Oregon, and California historical societies; and Karen Schultz, curator of collections at the Santa Barbara Historical Society.

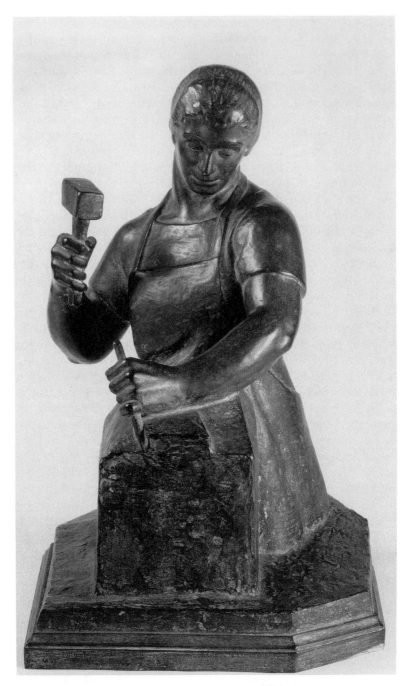

Marion Sanford, CORNELIA CHAPIN AT WORK (1942), bronze.
George Walter Vincent Smith Art Museum, Springfield, Mass.

INTRODUCTION

[Every] city of importance . . . claims a woman sculptor while in all parts of the country are evidences of their handiwork. No longer is there discrimination as to the character of the work they can do. Into all contracts they enter as man's equal, often to emerge as his superiors
—Elizabeth Lonergan, *Harper's Bazaar,* 1911

This book grew directly out of my first book, *American Women Artists from Early Indian Times to the Present* (G.K. Hall/Avon Books, 1982). While compiling the earlier volume, a survey of American women painters, sculptors, and graphic artists, I was astonished by the extraordinary amount and quality of the sculpture. Since the midnineteenth century women have been creating works that stand in parks, plazas, and public buildings all over the United States. They have carried out not only garden sculptures, fountains, small bronzes, and portrait busts but also large-scale equestrian monuments and war memorials. In the U.S. Capitol alone there are a dozen life-sized statues of leaders by American women. Elsewhere in Washington, D.C., are Vinnie Ream's *Farragut,* Gertrude Vanderbilt Whitney's *Titanic Memorial,* and, one of the most moving of all American war memorials, Maya Lin's *National Vietnam Veterans Memorial Wall.* It became obvious to me that another volume was necessary to do full justice to the subject.

During research trips for *American Women Sculptors* I continued to come across monuments in unlikely places. Driving into Oshkosh, Wisconsin, to examine the work of Helen Mears, I saw Theo Kitson's Spanish American war memorial, *The Hiker,* standing on a flowery mound near the main intersection. Later I learned that bronze casts of this figure are in dozens of other American cities and that Kitson had designed fifty other public sculptures. Driving down a country road in southern Iowa to visit Nellie Walker's bronze *Chief Keokuk,* I was delighted to see a picture of Walker's statue on highway markers—it is a mascot for the region. In Lincoln, Nebraska, I walked up the broad steps of the state capitol and entered a vast ceramic and marble mosaic interior designed by Hildreth Meière in the 1920s. Here was the foremother of the pattern and decoration movement of the

1970s. Stirred by this magnificent interior, I decided to touch on such works in my book.

Women sculptors have participated in every important art movement of their day. They were neoclassicists who carried out marble sculptures in Rome in the middle of the nineteenth century; they studied in Paris and modeled Rodinesque statues to be cast in bronze at the turn of the century; they were in the ash can school and among the handful of modernists who brought cubism and abstract sculpture to the United States; they were prominent exponents of direct carving in the 1920s and 1930s. They were also among the leaders of the Harlem Renaissance of black artists, and during the depression they carried out commissions for the Federal Art Project. After World War II they were abstract expressionists, minimalists, welders in steel, shapers of neon light. The work of American women sculptors cannot, however, simply be subsumed under the categories and movements established by patriarchal art history, nor can it be reduced to any formula or stereotype defining "women's art." Women sculptors have been innovators who contributed their own points of view, influenced by the complex circumstances of their lives—class, race, gender, social outlook, and specific personal history.

Despite a continuous history of achievement, recognition has been sporadic at best. Public applause for the work of women sculptors peaked in the second decade of the twentieth century, at the time that the suffrage movement was also reaching a crescendo. Article after article lauded their work and declared them to be the equals of men. Women sculptors won major commissions and completed large projects for world's fairs. "Today the shackles are being cast off," wrote Ada Rainey in a 1917 issue of *Century Magazine.* "A joyous exuberance is the dominating quality . . . the outcome of woman's mental emancipation is expressed in figures dancing with joy

in new found freedom . . . women are competing on an equal footing with men in the arts and winning the laurels." At that time and in the 1930s, the proportion of women sculptors in major exhibitions was as high as 25 percent (in fact, 46 out of 157 sculptors in the 1915 San Francisco Panama–Pacific Exhibition were women—nearly 30 percent).

But in the postwar period, as American abstract art became world ascendant and American male artists assumed the roles of titans, the proportion of women selected for major exhibitions declined. The image of woman as homemaker was being promoted in American society, and the art world, too, seemed as much as ever to be a man's world. In 1969 only 6 percent of those selected for the Whitney Biennial were women. Close to none were in such major surveys as New York Painting and Sculpture 1940–1970 at the Metropolitan Museum of Art or Sculpture of the Sixties and Art and Technology, both at the Los Angeles County Museum of Art. After a century of rising expectations, women artists had taken a temporary step backward.

It was the feminist movement of the 1970s that finally gave a new impetus to women artists. Once again newspapers are carrying articles such as the one in the Sunday *New York Times,* 8 November 1987, headlined "Women Are Reshaping the Field of Public Art." The 1989 book accompanying the important exhibition Making Their Mark emphasizes that women have entered the mainstream and are among the major innovators of new forms and visions. Yet even now, when women sculptors are so prominent, the public is unaware of their long record of accomplishment. How many of the thousands who pass *Bethesda Fountain* in Central Park know that it was created by a woman? Constant vigilance is the price of equality; it is time to put the whole history of American women sculptors together in all its richness and variety.

The principal purpose of this book has been to unearth a buried history. In this light, it touches on three-dimensional forms that are not ordinarily included in a book on sculpture. As the boundaries between art and craft disappear, the whole field is being redefined. Feminist critics object to the hierarchies of "high art" and "low craft" that were used to denigrate so much of women's work. I have therefore included highlights of ceramics, woven forms, and other design fields in which women have played an enormous role. Because women have also been major pioneers in performance art, a genre encompassing painting, sculpture, and theater, I felt it was important to note their contribution.

I also wanted to point out instances in which women brought their own perspectives to the work. They have sometimes created images of themselves that are quite different from the erotic nudes, sweet domestic groups, or, conversely, evil vampires invented by their male colleagues. One would have to look long and hard in American art surveys to find a woman's face resembling Anne Whitney's *Le Modèle.* In ironic contrast to the "artist's model," which the name of the work would lead us to expect, Whitney's bronze head is brutally honest in its portrayal of the ravages of toil and age on an old woman's face. Marion Sanford shows her colleague, Cornelia Chapin, vigorously attacking a stone with hammer and chisel—an active image of a creative woman. Helen Mears's *Frances Willard* is an intellectual standing at the podium about to deliver a speech, and Theo Kitson's statue of the Civil War nurse, *Mother Bickerdyke,* shows a middle-aged woman with muscular arms engaged in a professional task.

Another interesting example is Alice Cooper's *Sacajawea* in Washington Park, Portland, Oregon. When the 1905 Lewis and Clark Exposition was being planned for that city, a group of civic-minded women noted that no recognition was being given to the heroic Native American who led the explorers through the difficult western terrain. The women commissioned Alice Cooper to create a bronze statue of her and organized a committee to raise funds for it from the northwestern states. Suffrage leader Susan B. Anthony spoke at the gala unveiling in 1905. The history of this commission, which portrays Sacajawea as a heroic figure, demonstrates the link between the political consciousness of women in the early twentieth century and the upsurge of work by women sculptors at the time. Indeed, the history of American women sculptors

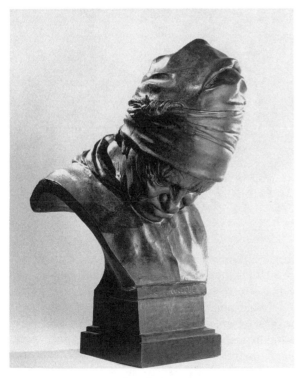

Anne Whitney, LE MODÈLE (1875), bronze, height 46.8 cm. Gift of Maria Weston Chapman. Courtesy, Museum of Fine Arts, Boston.

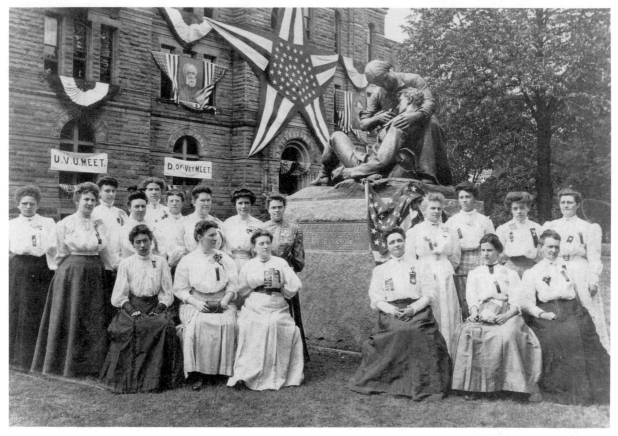

Daughters of Civil War Veterans (Illinois Chapter of Ladies of G.A.R.) with MOTHER BICKERDYKE (1906) by Theo Kitson. In front of Knox County Courthouse, Galesburg, Ill. Courtesy Galesburg Public Library. Photo: Charles Osgood.

is also a history of women helping other women, as patrons, mentors, teachers, and friends.

Included here are excellent women sculptors from many backgrounds, including Native Americans, African Americans, Asian Americans, and Hispanic Americans. Although they have been working in our country since early times, they rarely appear in surveys of American art. Meta Fuller's *Ethiopia Awakening,* a sculpture presaging the Harlem Renaissance, is as innovative in its way as the work of John Flannagan or

Robert Laurent. It addresses issues and concerns that the mainstream art establishment still refuses to recognize and incorporate.

It has sometimes been difficult to decide where to place certain artists chronologically. Women sculptors tend to be remarkably long-lived; their work extends over many decades and sometimes contributes to more than one movement. Most of the artists included in the chapter on the Gilded Age, for example, continued as important traditional sculptors of the early twen-

tieth century. Eugenie Gershoy, Concetta Scaravaglione, and Minna Harkavy, prominent in the 1930s, could have been discussed as members of the avant-garde of the 1920s because they were already breaking new ground at that time. Marion Walton, included as part of the direct carving movement of the 1930s, became a well-known abstract artist in the following two decades and was among the small group of women listed in Michel Seuphor's 1959 survey of international modern art, *The Sculpture of This Century.*

My greatest problem in writing this book, however, has been the impossibility of including all of the excellent women sculptors who have worked in the United States since the turn of the century. In his 1924 revised edition of *The History of American Sculpture,* Lorado Taft noted that there were already more than one hundred women sculptors working in New York City alone. Today, of course, extraordinarily talented aritsts are working all over the country. I hope others will continue to expand our knowledge of the many gifted women working in three dimensions in our time.[1]

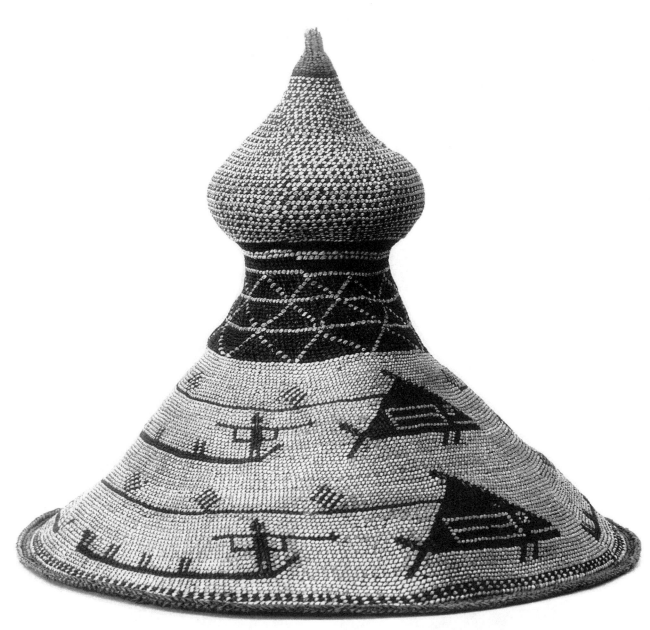

BASKETRY HAT, West Coast, late 18th century, whaling scene embroidered with bear grass on twined cedar bark and spruce. Collected by Lewis and Clark. Peabody Museum, Harvard University. Photo: F. P. Orchard © 1976.

The Three-Dimensional Art of the Early Native Americans

Such mastery does not spring up overnight out of nothing. Behind it is, not centuries, but thousands of years of development . . . within the limitations of applied design and utilitarian control of form—discipline, rhythm, color, vigor, suitability, mastery of technique.
—John Sloan[1]

Native Americans were creating three-dimensional forms for thousands of years before the arrival of the first European explorer in the Western Hemisphere. Yet most books on American sculpture begin with the colonial period, relegating all this magnificent art to a kind of anthropological ghetto. Whereas carving in wood and stone was traditionally assigned to men, clay was "the flesh of the female supernatural," associated with female goddesses who from the dawn of time, had taught women to make ceramics. Sometimes they took the forms of animals or figures. Women also fashioned three-dimensional forms out of reeds, grasses, corn husks, shells, leather, and many other materials.

Among the ancient Indians, there was no concept of "sculpture" as opposed to "crafts" or "useful objects." All art was for use, and all crafts were done as artistically as possible. The masks, effigy pottery, and other objects, whether by man or woman, were used in religious or funeral ceremonies, as containers, or for some other function.

The beautiful decorations on these daily objects were often images connected with survival. For example, motifs of clouds, lightning, and water serpents made a kind of perpetual prayer for rain on the side of a pot; a deer with an x-ray view of a line going to his heart was an expression of hope for success in the hunt; a sun disc brought strength and blessings from a deity. This feeling of the sacred imbues the objects with a special aura.

The bold forms and rich earth colors of the Indian woman's creations have exerted a continuing influence on American art, from the abstract and art deco movements of the 1920s, through the surrealists and abstract expressionists of the 1940s, to the art of today. This influence can be seen, for example, in Claire Zeisler's *Fragment for the Future* (1973–76), a sculpture made of tanned buckskin appliqued with beads and stones.

Claire Zeisler, FRAGMENT FOR THE FUTURE (1973–76), white buckskin and natural chamois with appliqued stones, fossils, and beads, 24″ × 42″. Collection of the artist. Courtesy Rhona Hoffman Gallery, Chicago. Photo: Dean J. Jacobson.

HOPI HOUSE BUILDER, detail of Edward S. Curtis photo, c. 1906. Library of Congress.

POSITION OF THE
AMERICAN INDIAN WOMAN

The stereotypic image of the downtrodden Indian woman has come to us from the biased writings of white male travelers and explorers of early times. Working hard at their tasks from dawn to dark, Indian women took pride in making magnificent robes and other artifacts, products that often determined the wealth of their families. They had their own quilling societies and other women's groups in which they earned distinction for their work among their peers, just as the men did in their warrior societies.

Although the status of women varied widely in the many different social systems that made up early Native American culture, in general they played an important role in the economy. In some hunting and gathering tribes, women collected 80 percent of the food and made many of the objects used for daily living out of rushes and reeds. In certain groups they were farmers, and among the Plains Indians they produced a large proportion of the community's artifacts out of leather. They also played a role in architecture—making the tepees, plastering the walls of pueblos (the men did the wood framing), and building earth lodges and bark- or reed-covered shelters.

Because Iroquois women held high positions in their society and were the farmers who traditionally owned the land, it was fitting that they made the corn husk masks worn by men of the Husk Face Society in planting and harvest ceremonies. With this simple material they still create a variety of striking spirit images.

CORN HUSK CEREMONIAL MASK, IROQUOIS. Catalog no. 391199, Department of Anthropology, Smithsonian Institution.

BASKETS

"She is weaving herself into the world."
—Navajo Woman

Perhaps the oldest three-dimensional forms created on the American continent are baskets. They were used for every conceivable purpose—cradles, hats, huge storage containers, even cooking pots—beginning with the early hunting and gathering stage because they were portable and could be made out of materials found along the route. Breakable ceramics, requiring more

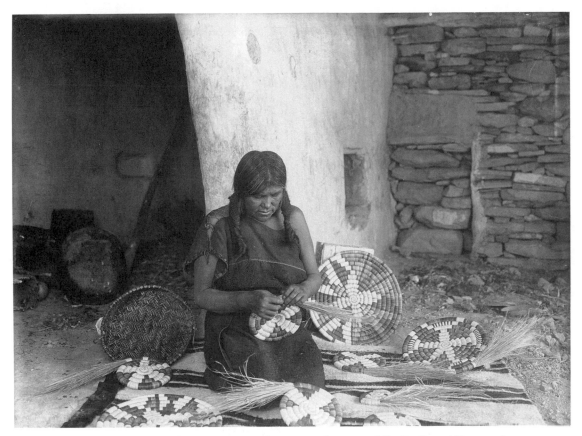

HOPI WOMAN COILING PLAQUE, A. C. Vroman photo, 1901. Courtesy of the Southwest Museum, Los Angeles, Calif., catalog no. P5453.

permanent locations, were introduced later, during the agricultural era, when tribes were more settled on the land.

Large burden baskets were sometimes strapped to the head with headbands decorated with bells and other materials to make the wearer more attractive. Indeed, it was often said that a woman looked most beautiful when she was carrying a burden basket—in other words she was appreciated for being hard-working and industrious.

As in the case of Greek vases, many characteristic forms and designs developed out of different functions. Only a few examples are presented here as paradigms of this great variety.

Hopi Baskets Among the Hopis of Arizona, a bride still coils a sacred wedding plaque for the groom. A kind of "passport to life," it is kept for a lifetime and is buried with him. The bride and her female relatives also present plaques laden with ground corn to the future mother-in-law, symbolizing, no doubt, the economic contribution that the bride will make as a grinder of corn and in other ways. Trays have always been used in the basket dances performed each fall by the Hopi women's societies. Hopi wicker trays made on the Third Mesa are noted for the dazzling optical effects produced by their low-relief sculptural surfaces.

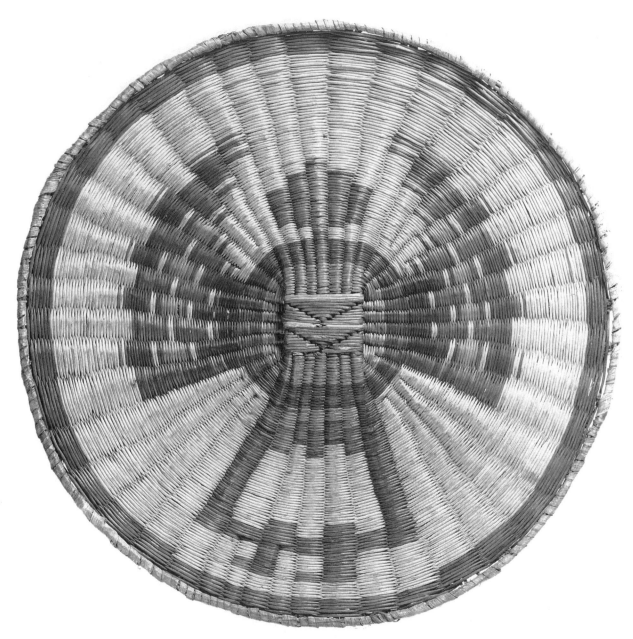

WICKER BASKETRY, HOPI, kachina motif. Catalog no. 213546, Department of Anthropology, Smithsonian Institution.

California Baskets California Indian women are among the greatest basket makers in the world. Edward Curtis's photographs show these artists literally living in a world of grass—gathering tules, sitting in reed-covered houses, paddling in reed boats. Among the Hupas of northern California, women were especially proud of their hats. Each tried to create a unique design; indeed, the entire costume of the Hupa woman, still worn at festivals, is an integration of woven forms, incorporating grasses, shells, and other materials.

The tiny gift baskets of the California Pomos, covered with exquisite arrangements of colored bird feathers and ornaments of pendant shells or beads, sometimes took an entire year to make. When the bride's mother presented one to the groom on her daughter's wedding day, he filled it with treats and passed it around to guests, but after that it was kept in the home as a treasured object to be admired, not used. Unfortunately for us, countless numbers of these exquisite baskets were made to be burned in funeral pyres as memorials to the dead.

Washo Baskets Indian women of the Great Basin carried basketry to a high pitch of virtuosity, twining and coiling reeds and grasses as tightly as sixty stitches to the inch. In modern times, after centuries of anonymous production, some of these women finally received recognition in their own names when white traders began to sell their work to collectors.

Most famous of these turn-of-the-century women artists is **Dat So La Lee** (Mrs. Louisa Keyser, 1835–50?–1925), a Nevada-Tahoe Washo, whose poignant story encapsulates the encounter between the white settler and the Native American. There were at that time many Washo women who created fine, tightly woven baskets, but because of special circumstances Dat So La Lee became known as "The Queen of the Basket Makers."

SUN BASKET, POMO. Catalog no. 131108, Department of Anthropology, Smithsonian Institution.

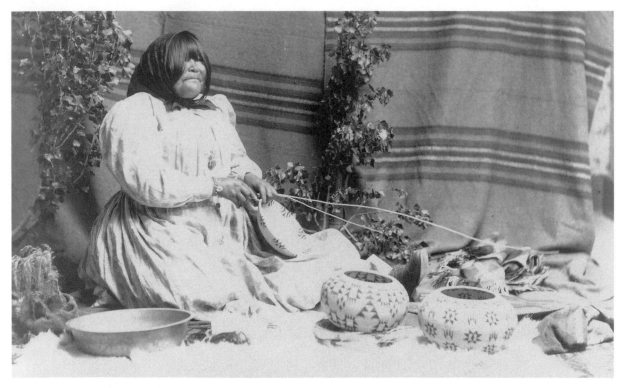

DAT SO LA LEE. A. L. Smith photo, Carson City, Nevada. Library of Congress.

Known as "Dabuda" when she was growing up near Lake Tahoe, Dat So La Lee was taught by the Washo women to gather willows and to coil and twine them into finely crafted forms. In this hunting and gathering group, almost all useful objects were so made—babies swung in basketry cradles while their mothers cooked meals by dropping red hot stones into liquid in tightly woven cooking baskets.

One day, while standing on a hill, Dabuda saw the first white men enter her valley. One of them frightened her with his rearing horse but gave her a gift of brass buttons that she treasured all her life. Soon the white settlers were enclosing the land, and polluting the fishing streams with mining wastes from the gold rush. Dabuda's peo-

ple were driven into beggary or menial labor. Dat So La Lee (as she was later called) washed clothes for the miners and worked as a servant.

Many years later, when she was about sixty years old, she walked into Carson City and showed four basketry whiskey flasks to Abe Cohn, the proprietor of an emporium, who had been a child when Dat So La Lee worked for his family. Recognizing her talent, he offered her and her husband maintenance, medical care, and a small house next to his own in return for her entire output.

Cohn promoted her into a media star. The artist, who had never been taught to read or write, signed her receipts with a hand print. In 1919, when the Cohns took her on a train to demon-

strate basketry at the St. Louis Exposition, Dat So La Lee became bored or frightened and disappeared at the Kansas City depot. The worried couple finally found her attempting to walk home to her ancestral valley. After they persuaded her to continue on, she became a great hit at the fair.

Dat So La Lee gave her baskets fanciful names, translated with poetic license by her impresario, Abe Cohn, who recorded and numbered her works in his journals (now in the Nevada State Historical Society). A typical flowery title, *With the Aid of Medicine Men's Magic Arrowpoints Abundance of Game Was Slain,* is expressed by abstract motifs of diamond and arrow shapes, symbolizing the antelope drives of the medicine men. One of her last baskets, *All Are Dead or Dying,* made when she was in her eighties, reflects her feeling about the passing of her friends and relatives.

Cohn encouraged Dat So La Lee to make the fine spherical small-mouthed baskets called *degikups* that brought good prices, but she also wove dolls, utilitarian objects, and sacred ceremonial baskets. *The Talisman* (Nevada State Museum, Carson City), shaped like a burden basket, was used to receive ritual offerings in a ceremony whose purpose was to destroy the demon We-Law-in-Nack, who lured women in various guises and then killed them. This large basket, strengthened at the bottom with white elder branches, is decorated with stalks of ripe grain, charmed arrows, and triangles symbolizing five generations.

Because Abe Cohn kept records of Dat So La Lee's baskets, it was possible for Marvin Cohodas to study the development of her designs as they went through various aesthetic periods. She had a "classic" phase, in which motifs were repeated in scattered units, giving a sense that they could go on and on indefinitely, as in a modern systemic painting. Later, she arranged the motifs in vertical bands that emphasized the closed curving form of the basket.[2]

Cohodas has also studied the influence of the white trader and the white collector on Indian basketry, seen both in ethnic designs and the adaptations of white women's embroidery patterns of birds, flowers, and other representational forms.

CERAMICS

Their woemen make earthen vessells . . . so large and fine, that our potters with wheles can make noe better.
—Thomas Harriot, 1590[3]

Mississippi Valley Ceramics When French, English, and Spanish explorers entered Florida, Virginia, Louisiana, and other parts of the East and Southeast, they found women everywhere making remarkable ceramics. In 1753, Dumont de Montigny described the Indian women of Louisiana: "They form rolls, six or seven feet long . . . they take hold of one of these rolls by the end, and fixing there with the thumb of the left hand the centre of the vessel they turn the roll with astonishing quickness around this centre, describing a spiral line. . . . In this manner they make all sorts of earthen vessels, plates, dishes, bowls and jars, some of which hold from forty to fifty pints."[4] The wonderful forms of this pottery were then decorated with rhythmic spiral designs—incised, carved, stamped, or painted, sometimes over a negative resist of beeswax.

The explorers in Louisiana stumbled on the last vestiges of an ancient, highly developed civilization—the Temple Mound, or Mississippian culture, in which all-powerful rulers conducted ceremonials from palaces located atop great mounds. In this society, women of a certain lineage could become the White Woman, a queen

whose harem of lower-class husbands and slaves did her bidding. Splendid effigy pottery, fashioned in the form of birds, frogs, animals, and figures, and buried with the dead, dates from the Mississippian period (1200–1700) immediately preceding the arrival of the explorers. Since women were creating pottery when the explorers arrived, scholars conjecture that these clay sculptural forms were probably made by them, although we cannot know with certainty. In a clay figure in the Denver Art Museum, the swelling forms of the body and arms and the sensitively modeled head have been beautifully adapted to the functional requirements of a water vessel.

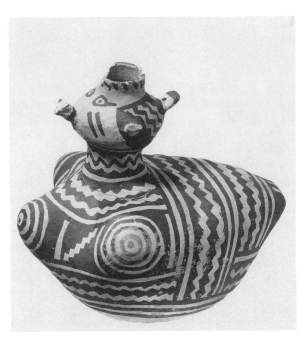

ANASAZI POTTERY VESSEL (c. 1000–1400). Catalog no. 281546. Field Museum of Natural History (Neg. # A98896), Chicago.

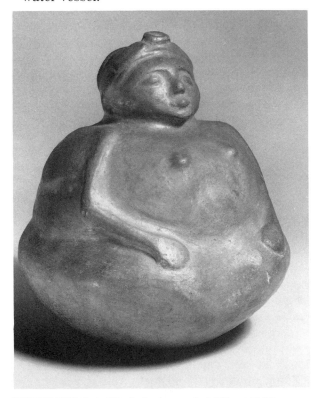

EFFIGY POT, Late Mississippian period, Missouri (?), early 15th century (?), clay, ground shell, height 23 cm. Denver Art Museum. 1956.32.

Southwest Ceramics In the Southwest, around A.D. 1000 the Anasazi people, who lived in remarkable adobe and stone apartment complexes, began to make pottery by pressing clay into their baskets. They then developed the coiled form of pottery, at first copying the geometric designs from their baskets onto the clay forms. Their vessels, decorated with black on white abstract geometric designs, were sometimes made in the shape of animals and figures.

When Spaniards came up from Mexico and entered the Rio Grande valley, they found a flourishing pottery tradition. The continuity of Rio Grande pottery making was interrupted when the Indians fled the white men or were wiped out through warfare or smallpox epidemics. In later years, however, new settlements grew up, and the Native Americans developed a rich variety of

ZUNI WATER CARRIERS. Edward S. Curtis photo, 1903.
National Anthropological Archives, Smithsonian
Institution. Original photo in the Library of Congress.

TRIANGULAR POTTERY CANTEEN, ZUNI. Catalog no.
39913, Department of Anthropology, Smithsonian
Institution.

forms and motifs. Women within each tribe vied
with one another to produce the largest, thin-
nest-walled pottery, which they used to carry
water long distances in the dry climate. They
decorated the pieces in characteristic patterns
that are associated with their village or group.

At the turn of the century, Edward Curtis pho-
tographed a Mohave woman working on an ef-
figy bowl in the form of a figure. Today, some
women continue to fashion owls, birds, and other
clay forms in traditional ways, while others are
creating contemporary sculptures and exhibiting
in mainstream galleries.[5]

LEATHER AND OTHER MATERIALS

From the time of early contact with the Indi-
ans, white settlers found Indian women drying
and tanning leather, and creating splendid ob-
jects out of the material—cradles, moccasins,
quivers, packing cases. Because of their great
love of children, they lavished much care and
artistry on cradles. A beaded cradleboard in the
Denver Art Museum is a fine example of coop-
erative division of labor between men and
women. Men (assigned by gender to do all work
in wood) fashioned the backboard, while women
made and decorated the casing, whose form and
design are as fine as a minimalist sculpture.

Women bit designs into birchbark and made
containers out of it; and they sheathed the leg-
endary birchbark canoe after the men had con-
structed the frame. Porcupine quills, shells,

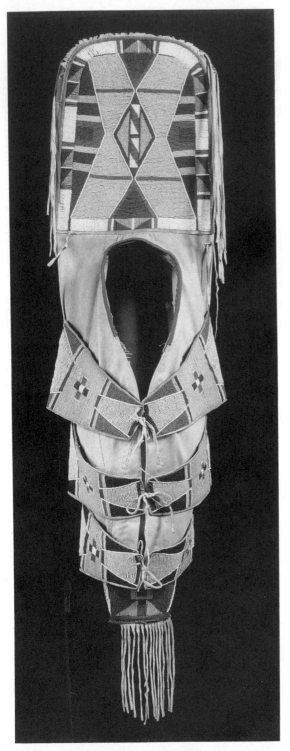

feathers, and many other materials were used ingeniously in three-dimensional forms.

NINETEENTH-CENTURY DECLINE

Forced off their ancestral lands, decimated by warfare and by diseases introduced by the white man, and herded into miserable reservation territories, the American Indians and their art were at a low ebb at the end of the nineteenth century.

One of the first painters to portray the misused Indian in America was the Baroness Hyde de Neuville, who traveled in the East around 1807 with her husband, a French royalist fleeing Napoleon's regime. The baroness's unromanticized sketch of a Seneca mother shows her perched awkwardly on the edge of a white man's chair, instead of sitting comfortably in the traditional manner on the ground with legs tucked under.

It was official U.S. government policy in the late nineteenth century to destroy native customs and forcibly integrate the Indian into white society. But Native Americans clung to their traditions, and in the early twentieth century they began to create a renaissance (see chapter 6). Later Yeffe Kimball and Otellie Loloma (chapters 8 and 9) and others began to widen the scope of Native American art.

CRADLE, CROW (1890), leather, wood, canvas, beads, 84 cm × 30 cm. Denver Art Museum. 1938.52.

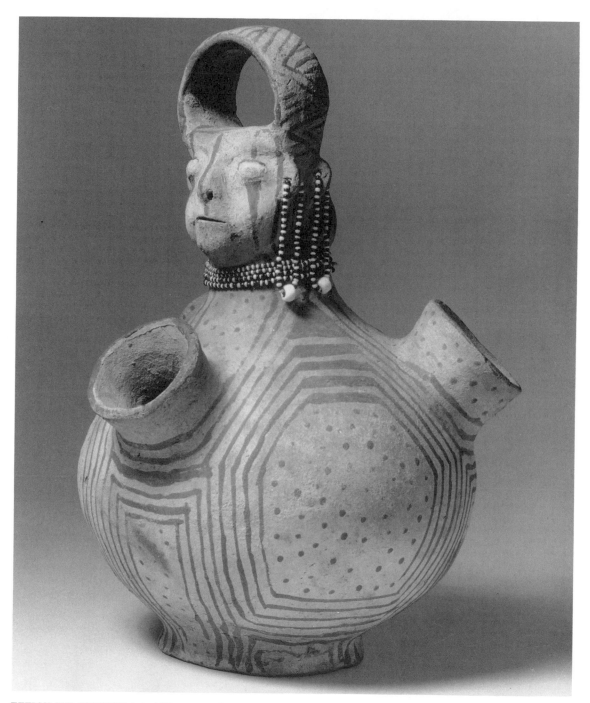

EFFIGY JAR, MOHAVE, late 19th century, buff clay, red and yellow paint, beads, height 28 cm. Denver Art Museum, photo by Otto Nelson. 1938.463.

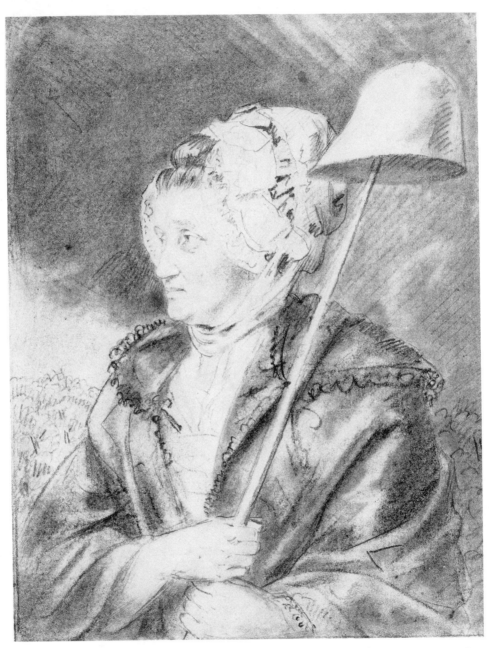

John Downman, A.R.A., PATIENCE WRIGHT (1777), drawing. Courtesy Trustees of the British Museum. An inscription below the picture reads: "Liberty I am, and liberty is Wright, and slavery do disdain, with all my might."

Patience Wright: Founding Mother of American Sculpture

When European women first disembarked on the shores of North America and faced the overwhelming task of survival, the last thing on their minds was making sculpture. After clearing the wilderness, they worked side by side with their husbands in a rough division of labor in which men did the farming, hunting, and construction of buildings, and women, while bearing and raising many children, tended the home garden plot, milked cows, churned butter, raised chickens, preserved meat, spun yarn, wove fabric, made clothing, and cared for the sick and old. Their first "art works" were bed rugs and quilts to keep out the cold.

As cities grew—in a still-fluid society with a shortage of labor—enterprising single, widowed, and sometimes married women held a surprising variety of jobs, such as tavern keeper, postmistress, printer, pharmacist, midwife. Only later, when men instituted medical licensing, were women, who were not admitted to professional schools, gradually shut out of the field of medicine.

While serving as "Adam's rib"—the necessary and useful helpmate—women received only rudimentary educations and were prevented from playing a role in political life. They could not vote, become members of governing bodies, or, with the exception of Quakers, hold office in the church.

Among the various religious sects, Quakers were perhaps the most egalitarian. They allowed women to become preachers; both sexes were encouraged to speak out at prayer meetings; and Quaker girls, on the whole, were given more education than those in other groups. Quaker women had before them the inspiring example of Mary Dyer, a Quaker preacher, banished three times for heresy from the Massachusetts Bay Colony, who still avowed her beliefs at the time of her hanging on Boston Common. (The twentieth-century sculptor, Sylvia Shaw Judson, created a splendid monument to Mary Dyer that sits

BRIDE'S QUILT (L. C. B. 1861), cotton, all white, stuffed work and trapunto (signed initials and dated in stuffed work), New York State. Collection of American Hurrah Antiques, N.Y.C.

alongside of the Massachusetts State House in Boston, facing the scene of her martyrdom.)

It is not altogether surprising, therefore, to find that on the eve of the American Revolution, one of America's first sculptors was a Quaker woman, Patience Wright. Touring the colonies with her waxworks show, she was the embodiment of the active, energetic colonial woman. Wax was readily available to women and did not require special tools or training to use. Even before Wright's time, around 1731, the Englishwoman Martha Gazley, living in New York City, had advertised that she was available to teach ladies how to make such "curious works [as] Artificial Fruit and Flowers and other Wax-Work." In Europe, Mrs. Salmon's waxworks show was a successful business in London, and Mme. Tussaud's was a popular exhibition in Paris. But Wright elevated the medium to a higher level.

In the colonies at that time sculptors consisted only of a few tombstone carvers and craftsmen like the Skillin brothers of Boston, who carved wooden ships' figureheads and ornaments for furniture. Marbles and bronzes, what there were of them, were imported from Europe. Patience Wright, with almost no training, astonished Americans with her natural gift for portraiture.

THE EARLY YEARS

See Wright's fair hands the livelier fire controul,
In waxen forms she breathes impassion'd soul . . .
Grief, rage and fear beneath her fingers start,
Roll the wild eye and pour the bursting heart.
—Joel Barlow[1]

Patience Wright (1725–86), considered by many to be America's first professional sculptor, was so highly regarded in her day that after her death the encomium above was included in an epic poem dedicated to the new nation.

In some ways, many American women even now have not caught up with her. Freely associating with men of power, demanding a role in the artistic, social, and political structure, an expert at publicity and self-promotion who refused to be confined to the narrow niche assigned her sex in the eighteenth century, she made her way by sheer force of personality as well as exceptional talent. It is perhaps not surprising that "the eccentric Mrs. Wright," as she was often referred to by her contemporaries, was once called a "crazy-pated genius."[2]

Charles Coleman Sellers published his biography of Wright in the bicentennial year of 1976 because she embodied the American myth so well. Uneducated, a self-taught artist, she nevertheless regarded herself as the equal of the titled, the wealthy, and the cultivated. A patriot during the revolution, she was living in London in close proximity to the king, but tried, at considerable risk, to serve as a spy and activist for her country.

Born in Oyster Bay, Long Island, the fifth daughter of a prosperous Quaker farmer, John Lovell, and his wife, Patience, she moved to Bordentown, New Jersey, with them when she was four. Lovell raised ten daughters and one son in accordance with the rather extreme religious principles of an obscure theologian, Thomas Tryon. A vegetarian who was opposed to the taking of animal life (the Lovells wore wooden shoes rather than leather), he insisted that the girls go veiled to protect them from defilement and that they dress in white clothing from head to toe as a symbol of "temperance and innocency."

According to Patience, it was in response to this color-drained and sensually repressed early experience that she and her sisters rebelled by secretly engaging in bouts of colorful painting, using natural pigments such as berry juice.[3]

And despite her community's biblical injunction against "graven images," Patience began to model small figures from bread dough and local clay at an early age.

Her family, however, was not devoid of links with the art world. One of her Oyster Bay cousins, Robert Feke, became an outstanding colonial portrait painter and may have been her escort when, in 1745 at the age of twenty, she "became a little disobedient" and ran away from her strict family to Philadelphia in order to see the dazzling works of art she had heard existed in that city. It was there that she tasted meat and perhaps other pleasures for the first time.

Wright's Philadelphia escapade is obscure. How, for example, did a lone girl support herself in a big city? At any rate, by 1748, she was back home in "straitened circumstances" and, acceding to custom and necessity, married Joseph Wright, "a substantial Quaker, who had nothing but Age and Money to recommend himself to her Favour." They settled down in a house in Bordentown which is still standing: "This Connection, however, enabled her to buy such materials as she wanted and to pursue the Bent of her Genius; and while the old Gentleman produced her four living Children, she modelled him an hundred in Clay, but not one to his *Gout* [taste]."[4] Mr. Wright evidently disapproved of his wife's messy habit of modeling.

Patience bore a son, Joseph, and three daughters. Her once prosperous husband was working as a cooper and living in Philadelphia when he died in 1769, leaving behind a peculiar will. He left his small estate to the children but willed her the house in Bordentown on condition that she raise and educate them.

THE WAXWORKS EXHIBITION

Now a forty-four-year-old widow with children to raise, Wright decided to use her lifelong hobby as a means of support. She and her widowed sister, Rachel Wells, who was already modeling portraits in wax, set up a waxworks show and were soon touring the colonies with it, traveling to Boston, Charleston, and other cities.

No ordinary exhibition, it was innovative for its time. Previously, shows such as Mrs. Salmon's in London had consisted of crude, manikinlike figures of notorious criminals or historical, religious, and allegorical figures, but Wright portrayed prominent living leaders—for example, Cadwallader Colden, lieutenant governor of New York, who was shown seated at his desk engaged in characteristic activities. People marveled at the realism of the tinted wax figures with real hair, glass eyes, and appropriate costume.

How did Patience arrive at such skill? Largely through native gifts. Her sister Rachel, with the same background, was evidently not as talented. John Adams later visited Rachel's waxworks exhibition in Philadelphia and wrote that "The Imitation of Life was too faint, and I seemed to be walking among a Group of Corps's."[5]

After moving to Queen Street in New York City, Wright returned from a business errand one day in 1771 to discover that her children had accidentally set fire to the house, destroying almost all her work. A month later the *New York Gazette* reported:

> Mrs. Wright with the assistance of her sister Mrs. Wells has been so assiduous in repairing the damage done to the waxwork ... that the Defect is not only supplied by new Pieces ... but they are executed with superior skill and judgment ... To both these extraordinary

geniuses may without impropriety be applied what Addison says of Kneller, a little varied:

By Heavn and Nature, Not a Master taught,
They give to Statues, Passion, Life and
Thought.[6]

The fire may have been the precipitating reason for Wright leaving her children temporarily behind and sailing to England in 1772, intent upon making a name for herself in the great center of art and power. Bearing a letter from Benjamin Franklin's sister, she visited the statesman at his rooms in Craven Street immediately after arriving in London. Franklin, astonished and delighted with the realistic wax head she showed him of his old friend Cadwallader Colden, consented to pose for a bust. He wrote to his sister: "I have this day received your kind letter by Mrs. Wright. She has shown me some of her work which appears extraordinary. I shall recommend her among my Friends if she chuses to work here."[7] Franklin's friend Henry Marchant also saw the bust of Colden and noted that Wright's work was vastly superior to that of her competitor, Mrs. Salmon, whose exhibition on several floors in Fleet Street had been for many years one of London's leading attractions.

The sculptor settled in the best part of town near Buckingham Palace, amidst the ateliers of such renowned artists as the American, Benjamin West, painter to the king and a Quaker, who soon became her friend. Lesley Parker writes: "She could not have made a more propitious move. In the metropolis of empire she felt at home and established herself immediately as a personality to be reckoned with. Tall, broad of beam, with sharp features and a sharp tongue, she brought to the precious society of the time an arresting candour and zealous hospitality. She took rooms in Chudleigh Court, Pall Mall, staking, with true pioneer insolence, everything on one throw."[8]

SUCCESS IN LONDON

Patience proceeded to amuse British society with the realism of her waxworks and with her nonstop monologues on politics, religion, life in the colonies, and other topics of the day. To the sophisticated nobility who began to crowd into her exhibition rooms she was a droll original who brought to their jaded world a fresh vision of an Arcadian land. Even the liberties she took—kissing the men on both cheeks in typical Quaker greeting or speaking to her "betters" as equals—were greeted with amusement as the symbols of a new order of being.

Horace Walpole described the show's astonishing realism; a spectator had actually mistaken a statue for the real thing: "Apropos of puppets, there is a Mrs. Wright arrived from America to make figures in wax of Lord Chatham, Lord Lyttleton, and Mrs. Macaulay. Lady Aylesbury literally spoke to a waxen figure of a housemaid in the room."[9]

Soon articles singing Wright's praises (probably initiated or written by her) and describing her as a "Promethean Modeller" began to appear in London periodicals, and a letter to the *Gentleman's Magazine* enumerated her works.[10] From these clippings it is possible to reconstruct a picture of the exhibition that Wright gradually orchestrated of notable British and American subjects; it became a kind of "agitprop" production, reflecting her social and political outlook.

In one corner, seated side by side, were her father with a long white beard and large white hat, her mother holding a book, and an Indian couple in native dress. This group often triggered long harangues to visitors about Wright's upbringing, her father's religious beliefs, her runaway rebellion, and egalitarian life in "dear America."

In addition to the portrait of Franklin, Wright

included several Britons sympathetic to the American cause, among them William Pitt, earl of Chatham, who opposed the Stamp Act; the brilliant liberal historian Lady Macaulay, another supporter of the colonies; Viscount Augustus Keppel, a British admiral opposed to the American war; and the Prince of Wales, who was hostile to his father and later became the patron of Wright's son-in-law, the painter John Hoppner. There were also assorted cranks and extremists with whom Wright later hatched bizarre plots. Thus her exhibition became more than a sensational sideshow—it was something of a propaganda statement.

Later she added the Old Testament figures Queen Esther, King Ahasuerus, and Mordecai. This tribute to the biblical heroine who used her influence to save her people by appealing to the king probably alluded to herself in relation to King George.

A loyal, if unconventional, mother, Wright sent for her children. Her daughters received visitors and sewed costumes. Elizabeth modeled in wax, and Phoebe posed at the Royal Academy, eventually attracting the attention of the young art student John Hoppner. Joseph, following in his mother's footsteps, enrolled as a student at the Royal Academy and eventually became a prominent American artist. Wright constantly used her influence with Benjamin West and others to promote his interests.

Firsthand accounts describe Wright's unorthodox working methods:

> With the head of wax upon her lap, she would mould the most accurate likenesses, by the mere force of a retentive recollection of the traits and lines of the countenance; ... manipulating the wax with her thumb and finger. Whilest thus engaged, her strong mind poured forth an uninterrupted torrent of wild thought, and anecdotes and reminiscences of men and events.... The vigor and originality of her conversation corresponded with her manners and appearance. She would utter language in her incessant volubility, as if unconscious to whom directed, that would put her hearers to the blush.... The King and Queen often visited her rooms. They would induce her to work upon their heads, regardless of their presence.[11]

Soon she was striding in and out of Buckingham House, modeling portraits of the king and queen and addressing them as "George" and "Charlotte." The appearance of the royal busts in her exhibition gave it the ultimate cachet.

Unidentified artist, PATIENCE WRIGHT, etching, 12.6 cm × 9.3 cm. Illustration in *London Magazine*, 1775. National Portrait Gallery, Smithsonian Institution.

SUPPORT FOR THE REVOLUTION

Wright's reputation as one of the "lions of London" was soon threatened, however. War was imminent; each month brought some new clash between the colonists and England or a tyrannous act by the king. An ardent patriot, Wright used the waxworks as a rendezvous for plotters, a place where military information could be wormed out of visitors and sent in hastily scribbled letters to Franklin, Adams, and others or stuffed into wax heads and sent across the sea to her sister Rachel. After the Boston Tea Party she sent information to Lord Chatham that helped him support the American cause in Parliament.

The value of most of this amateur spying is dubious, but Wright was certainly effective in her efforts to help a number of endangered Americans. After visiting young Ebenezer Platt who languished in chains in Newgate Prison, Wright petitioned for his release. (Her daughter Elizabeth married Platt, and they ran a waxworks show of their own in the United States until their unfortunate early deaths.) Wright even offered to supply the imprisoned Englishman William Dodd with a wax figure to help him escape, but the timid clergyman refused and went to the gallows instead.

Wright hatched a grandiose scheme with herself at the center in which her friend Benjamin Franklin, whose international stature was great, would come from France (where he was negotiating trade agreements), land at Dover, and march triumphantly on London, cheered by multitudes along the way. He would bloodlessly topple the throne, exile the king, and unite England and America in one democratic harmonious whole. Thus fratricidal war would be averted. Wright plotted with a group of odd characters to raise an army in support of this coup and bombarded Franklin in Paris with letters embroidered with ink blots from a rapidly scratching quill. In a portentous biblical tone she wrote: "Majr Labilear has seven hundred men who have not bow'd down to Baall [the king], and I have nere five hundred in my Congregation.... We are tiptoe to come to you and we Expect in July to see you Come in the name of the Lord of host and gidion.... My Inthuzasm encreases Everyday.... you will be Very shortly Calld upon by the People."[12]

These biographical details are not as peripheral to Wright's artistic career as they may at first appear, because they shed a great deal of light on the personality of a woman who, at a time when her sex had few legal rights, longed to play a powerful role in the world. Of course, this grand scheme did not work out, and Wright, after a period of furious activity, was sadly deflated.

Although she was tolerated for a while by the Crown, Wright soon overstepped the bounds. According to several accounts, she stamped into the palace after the battles of Lexington and Concord and berated the king for his oppressive policies. At a public gathering she announced that the Americans could never be defeated. Meanwhile, her son, Joseph, as brash as his mother, caused a scandal by submitting to the Royal Academy exhibition a painting that showed his mother modeling a bust of King Charles I (beheaded in Cromwell's revolution), while looking up knowingly at King George and Queen Charlotte.

The laudatory articles in the newspapers stopped abruptly; her movements were closely watched and her correspondence intercepted. Wright's political stance affected the lives of her children as well. When John Hoppner, reportedly the illegitimate son of the king, married Phoebe,

the daughter of the notorious Mrs. Wright, his court pension was immediately suspended, leaving the young painter penniless at the start of his career. Patience had to support the young couple for a while. The political climate was becoming so warm that Wright wrote to Franklin in Paris:

I have moved from Pall mall with the full Perpose of mind to settel my afair and get Ready for my Return to america. . . . I shall take France in my way and call at Parris where I hope to have the Pleaser of seeing my old american Friends—and take off some of your cappatal Bustos in wax. England will very soon be no longer a pattron for artists. The Ingeneous must flye to the Land of Pease & Liberty. . . . I beg the favr of you to Recommend my Performans.

<div align="right">Yr. old Friend
P. Wright[13]</div>

Apparently Franklin took a dim view of her cloak-and-dagger operations because he tried to discourage her from coming, but when she arrived, he introduced her, with customary generosity, to the duchess of Chartres and other important people.

At her hotel in Paris, Wright became good friends with a young American merchant, Elkanah Watson, who vividly described their first meeting:

Giving orders from the balcony . . . to my English servant, I was assailed by a powerful female voice, crying out from an upper story, "Who are you? An American I hope!" . . . In two minutes she came blustering downstairs with the familiarity of an old acquaintance. We soon were on the most excellent terms. I discovered that she was in the habit of daily intercourse with Franklin, and was visited by all the respectable Americans in Paris. . . . The wild flights of her powerful mind stamped originality on all her acts and language. She was a tall and athletic figure; and walked with a firm, bold step, and erect as an Indian. Her complexion was somewhat sallow; her cheek-bones high: her face furrowed; and her olive eyes keen, piercing and expressive. Her sharp glance was appalling; it had almost the wildness of a maniac's.[14]

Watson described one of those wildly improbable episodes that characterized Wright's career. Returning home one night from Passy where she had been modeling a bust of Franklin, the artist, who spoke no French, was stopped by guards at the city border who

searched for contraband goods. . . . She resisted the attempt to examine her bundle and broke out in a rage. . . . the bundle was opened, and to the astonishment of the officials they [saw what appeared to be] the head of a dead man. . . . Believing . . . that she was an escaped maniac who had committed murder and was . . . concealing the head of her victim . . . they were determined to convey her to the police station when she made them comprehend her entreaties to be taken to the Hotel. . . . Hearing in the passage a great uproar, and Mrs. Wright's voice pitched upon a higher key than usual, I rushed out, and found her in a terrible rage, her fine eyes flashing. . . . An explanation ensued. All except Mrs. W. were highly amused at the singularity and absurdity of the affair.[15]

After the American victory, Wright returned to London and lived quietly with her daughter and son-in-law, who was by now a distinguished portrait painter. The market for her busts had diminished; small, inexpensive wax profile reliefs were the fad.

POSTREVOLUTIONARY PLANS

Not content to rest in her children's shadow, the artist saw a great future for herself in America, a new nation in need of icons, and wrote to George Washington that she hoped to make a wax portrait of him, based on her son Joseph's study. Washington replied that it would be "an honor done me and if your inclination to return to this country should overcome other considerations, you will no doubt, meet a welcome reception from your numerous friends; among whom, I should be proud to see a person so universally celebrated; and on whom Nature has bestowed such rare and uncommon gifts."[16] Using this letter as a reference, she now began to drum up business with Thomas Jefferson, ambassador to France:

> Honoured sir:
> I had the pleasure to hear that my son Joseph Wright had painted the best likeness of our HERO Washington, of any painter in America; and my friends are anxious that I should make a likeness, a bust in wax, to be placed in the statehouse, or some new public building that may be erected by congress. . . . I most sincerely wish not only to make the likeness of Washington, but of those *five* gentlemen, who assisted at the signing the treaty of peace, that put an end to so bloody and dreadful a war. The more public the honours bestowed on such men by their country, the better . . . and I will, if it is thought proper to pay my expense of travelling to Paris, come myself and model the likeness of Mr. Jefferson; and at the same time see the picture, and if possible by this painting make a likeness of the General. I wish to consult with you how best we may honour our country, by holding up the likeness of her eminent men, either in painting or wax-work. . . . *A statue in marble is already ordered, and an artist gone to Philadelphia to begin the work* . . . Houdon.[17] [my italics]

This letter reveals that Wright was aware of the Frenchman Houdon's commission for a marble sculpture of Washington and had ambitious dreams of doing public sculpture herself.

Meanwhile, back in Bordentown, Rachel Wells, who had already managed to acquire a plot of land for a wax museum, trumped up a scheme to get her sister some kind of compensation from the new government. Pretending to be an anonymous retired congressman, she wrote to Benjamin Franklin a thinly disguised letter whose combined bravura and illiteracy are reminiscent of her sister's:

> it has bein often Asked me . . . if aney thing has been don for Mrs. Wright. Mr. Pain [Tom Paine also came from Bordentown] has bin Considred why not Mrs. Wright. Mr. Hancock & others of our oldest members allways alowd that her inteligence was the best. We Recevd them by the hand of her sister wells who found them in ye wax heads . . . By her last latters she Cant be Content to have her bons Laid in London. . . . We that was first in Congress Remember well her faithfull Atention to us in that Perilous hour . . . Now my desire is that Congress would give her a Lott of ground. . . . I Must bag That you will Excuse my Naim.[18]

While laying plans for a grand finale to her career, Wright kept in touch with John Adams, now the American ambassador in London. Adams's wife, Abigail, visited the celebrated Mrs. Wright and was appalled by her overly familiar manners (she kissed all the men) and slatternly clothes ("she is the very queen of sluts"), but she too succumbed to the witchcraft of Wright's art:

"There was an old clergyman sitting reading a paper in the middle of the room; and though I was prepared to see strong representations of real life, I was effectually deceived in this figure for ten minutes, and was finally told that it was only wax."[19]

Wright afterward haunted the embassy, supplying John Adams with inside tips about trade with Ireland and other tidbits. It was on returning from such a visit in 1786 that she fell and subsequently died of the injuries at age sixty-one.

A legend in the United States and England, Wright received obituaries that claimed her for both lands. The *New York Daily Advertiser* wrote on 16 May: "America has lost in ... the celebrated Mrs. Wright ... a warm and sincere friend, as well as one of her first ornaments to the arts.... Those brave fellows who during the late war were fortunate enough to escape from the arms of tyranny and take sanctuary under her roof, will join us in lamenting her loss."

PATIENCE WRIGHT'S LEGACY

Wright's flamboyant personality threatens to overshadow her art, yet according to contemporary accounts the realism of her figures was extraordinary. Few of the perishable waxes remain. The sculptor sent many pieces to her sister Rachel, which were later bought by an exhibitor, Daniel Bowen. He showed them with his own work until a fire destroyed them. Only an authenticated full-length figure of William Pitt, Lord Chatham, in Westminster Abbey's Islip Chapel remains to give a substantial idea of her style and working methods.

Pitt was a hero to Wright. The strongly modeled eagle head, with its prominent nose, wry expression, and alert-looking glass eyes, is a spirited characterization of the statesman who

Patience Wright, WILLIAM PITT, EARL OF CHATHAM (1775), wax and wood, lifesize (5'11"). Undercroft Museum, Westminster Abbey, London. By courtesy of the Dean and Chapter of Westminster.

recognized that the king was leading England toward a disastrous confrontation. He stands five feet eleven inches tall, somewhat stooped from age and illness, in wig and fur-trimmed red robe, delivering an oration to Parliament from a scroll in his right hand.

When the statue was cleaned in 1935, the keeper of the muniments of the Abbey found the realism "striking and convincing"—even the hands were "veined and tinted by coloured underslips ... with hairs [painted] on the surface."[20] The wax head is attached to a wooden trunk with cardboard and glue-filled papier-mâché strips, and the forearms are also cardboard and glue. The figure is supported at the back by an iron that screws into the wooden trunk. Similar methods may have been used for her other figures. It must be borne in mind that women in that period were not permitted to study anatomy, which limited their ability to model the human body.

Patience Wright, ADMIRAL HOWE (c. 1770), wax, 2½″ × 1¾″. Collection of the Newark Museum. Gift of Jay B. Tomlinson, 1965. Photo: Armen.

A number of small wax portrait medallions and profile reliefs were formerly attributed to Wright, but, according to Sellers, firsthand descriptions and sources tell only of busts and clothed figures in the round. The Newark Museum somewhat dubiously attributes a small profile relief of *Admiral Howe* to her because it bears the signature "Wright, F." on the back. Wax profile reliefs of *Thomas Hutchinson* (Philadelphia Museum of Art), *Benjamin Franklin* (Metropolitan Museum of Art), *Bishop James Johnson* (Bates Collection, England), and *Mrs. Francis Hopkinson* (Gilder House, Bordentown, New Jersey) are also attributed to her without decisive proof. It is widely believed that the Wedgwood profile medallion of Franklin is derived from Wright's wax portrait, but the Wedgwood Museum in England has not located any documentation. On the other hand, the wax profiles of George Washington at the New York and Maryland Historical societies are now attributed to the artist's son, Joseph Wright.

Aside from these, there is a small sketch of a man found in Wright's correspondence with Thomas Jefferson; it is the only drawing known to be by her hand. The artist has suggested the volume and stance of the figure with a few strokes of the pen.

If it seems that we have dwelt too long on an artist with only two remaining works that are certainly by her hand (out of fifty-five mentioned in the literature), it is because the legendary Wright embodies so vividly the unfulfilled dreams and wasted talent of American women artists. Here, at the dawn of the nation, was a gifted woman who, if society had been organized differently, might have peopled our public buildings with admirable portraits in marble and bronze. Instead a Frenchman, Houdon, had to be brought to our shores for this purpose. The dreams of Patience Wright had to be fought for and slowly won over the next two centuries. Indeed, the struggle continues today.

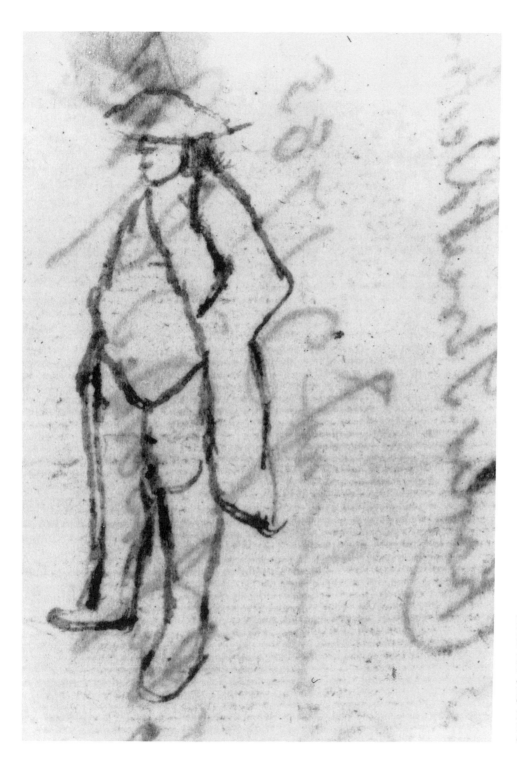

Patience Wright, DRAWING OF AN UNKNOWN MAN, pen and ink, in a letter to Thomas Jefferson, 15 December 1785. Thomas Jefferson Papers, Manuscript Division, Library of Congress.

•3•

Pioneering
American Women Sculptors:
1800–1875

Immediately after the Revolution there was little money or demand for sculpture. Self-trained artisans carved tombstones, ships' figureheads, and furniture and made wrought-iron weather vanes. A few wood and stone carvers, such as William Rush and John Frazee began to develop a true native sculpture tradition, but on the whole, for sophisticated marble sculpture and portraits of great leaders, Europeans were still imported to do the work.

As the country became wealthier and more urbane, American male sculptors, such as Horatio Greenough, Hiram Powers, and Thomas Crawford, began, around 1825, to go abroad to Florence and Rome to study amidst the great classical monuments and take advantage of the excellent, inexpensive Carrara marble and the skilled marble cutters, trained to carve from the artist's plaster model.

In the United States there was a great vogue for neoclassicism in architecture, furniture, and sculpture. Americans, harking back to the early democracies of Greece and Rome, saw in classical forms "the symbol of an ideal way of life re-born."[1] They designed their homes and public buildings to look like Roman or Greek temples and commissioned portraits of their leaders swathed in marble togas. It became important to study with foreign neoclassicists like Albert Bertel Thorvaldsen in Rome. "Expression and emotion were minimized as the artists aimed at a perfection of human form—modeling emphasized smooth planes and soft generalized transitions."[2] The public was interested in literary content—statues told stories taken from ancient mythology or romantic poetry and fiction, which embodied uplifting themes of morality, piety, and civic virtue.

In this period a few women amateurs—Caroline Wilson, Frances Lupton, Joanna Quiner—struggled against existing social mores and tried, with little success, to become serious sculptors. But by mid-century something unprecedented in the history of art was taking place. A group of women sculptors followed their brother artists abroad, to live and work around the Spanish Steps. Henry James called them "that strange sisterhood who at one time settled upon the seven hills in a white marmorean flock."[3]

The pied piper who led this troop was Charlotte Cushman, an internationally renowned actress and feminist from Boston who had traveled much abroad and was planning to move to Rome. Aware that leading American male sculptors were studying there, she urged her protégée, Harriet Hosmer, to join her and take advantage of the same opportunities. In a few years, a coterie of female sculptors had followed.

As may be imagined, their brother sculptors viewed their activities with suspicion and alarm. John Rogers, then a young sculpture student in Rome wrote home to his family: "Charlotte Cushman is here—but she is one of those kind of Cyclops that I am afraid of and I didn't pursue the acquaintance very far. She and Miss Hosmer and

Miss Stebbins, another female sculptress smoke cigars together and are quite intimate."[4]

William Wetmore Story, leader of the colony of American expatriate sculptors in Rome, ultimately became Hosmer's good friend and champion, but he was at first appalled by her behavior: "Hatty . . . would have the Romans know that a Yankee girl can do anything she pleases, walk alone, ride her horse alone, and laugh at their rules. . . . Miss Hosmer is . . . too independent by half, and is mixed up with a set whom I do not like."[5]

One of these women—Louisa Lander—was ruined by gossip, and Vinnie Ream and Harriet Hosmer were both accused of plagiarism. But Hosmer, Ream, Anne Whitney, Edmonia Lewis, Margaret Foley, and Emma Stebbins slowly won distinction and the acceptance of their contemporaries.

The achievements of the "white marmorean flock" can be properly appreciated only after examining the difficulties that women faced in obtaining an education. If their family had the means, they were tutored privately or given stilted drawing lessons at ladies' seminaries. For a number of years the Pennsylvania Academy permitted women to look at the collection of nude classical plaster casts only at fixed hours on "Ladies' Days."

To draw from the nude or study anatomy was at first regarded as unthinkable; it would ruin a woman's reputation. Harriet Hosmer had to go all the way to St. Louis to get instruction in anatomy because she was barred from the medical school in Boston, and it was 1877 before women were allowed to draw from the male nude at the Pennsylvania Academy.

European academies were also largely closed to women until the last quarter of the century, except for one extraordinary woman who was not yet an American—the German Elisabet Ney, who strong-armed her way into the Munich and Berlin academies. And in Rome, sculptor Thomas Crawford was shocked by the anatomical studies he saw in Hosmer's studio. He urged his wife to "cut her dead."

Although this was a very repressive period in many ways, it was also a time of tremendous growth for the women's movement. The first woman's college opened at Mt. Holyoke, and the first woman's suffrage convention was held at Seneca Falls, New York. Mill girls joined unions and participated in some of America's earliest strikes. Historians have shown how women's passion for justice led them to become antislavery speakers and organizers, to play a huge role in the Civil War, and ultimately to organize on their own behalf. There is no doubt that these social forces provided a liberating atmosphere for women sculptors.

EARLY WOMEN SCULPTORS

Around 1800 our native sculptors consisted largely of self-trained wood-carvers. A typical folk artisan of the day was **(Mrs.) Rachel Atkins (active 1802–4?)**, a Philadelphia frame-carver. During those two years the itinerant craftswoman made several trips to Alexandria and Norfolk, Virginia, where she set up shop and advertised "carving, gilding, and varnishing of picture frames and looking glasses . . . in a superb stile."[6] In 1804, "business not answering," Atkins advertised for sale "about 14,000 feet of Irish Northern Pine Boards," and presumably left for more profitable locations.

Before 1850, a few women struggled unsuccessfully to become sculptors, but the obstacles they faced prevented them from accomplishing much. This was the period of the "cult of true womanhood," when preachers and ladies' magazines warned that a woman, especially a married woman, who attempted serious intellectual labor would bring chaos into the social order,

warp the development of her children, overtax her small brain and delicate constitution, and go mad or develop "brain fever."

Mrs. Frances Platt Townsend Lupton (?–?) created portrait busts with sufficient distinction to be elected to the rank of "Artist of the Academy" at the National Academy of Design in 1827, the year after its founding. One of six women so honored, and the only sculptor, she continued as an Associate (or honorary) Member between 1829 and 1832.

The daughter of Dr. Platt Townsend, she married at a young age Lancaster Lupton, "a gentleman of high professional and literary attainments," in New York City on March 27, 1803. Lupton modeled many clay busts of her friends and presented a bust of *Governor Throop* to the National Academy and another to the city of New York in 1829. At that time the City Council ordered the bust placed in City Hall, but both versions are presently unlocated.[7]

Lupton also exhibited miniatures and paintings at the academy between 1828 and 1831, and a bust of James Madison (unlocated) in 1828. Ellet described her as a distinguished amateur who was accomplished in many fields: "There was hardly a branch of delicate workmanship in which she did not excel, and her literary attainments were varied and extensive. She was an excellent French scholar, and a proficient in Latin, Italian, and Spanish, besides having mastered the Hebrew sufficiently to read the Old Testament with ease. In English literature she was thoroughly versed, and was an advanced student in botany and natural history." After her husband's death, Ellet continued, "she devoted herself to study, that she might be qualified to educate her young daughter, and, after the loss of this only child, pursued knowledge as a solace for her sorrows. Her talents and accomplish-

ments, her elevated virtues and charities, and her attractive social qualities drew around her a circle of warm and admiring friends. She lived a short time in Canada, and died at the house of a relative on Long Island."[8]

This is the typical picture of the "lady" of that era, whose "talents and accomplishments" had to be explained as a need to educate her child or as a solace for her sorrows. Still, one would like to know more about this obscure figure who managed to become the first woman sculptor in the National Academy and at such an early date.

Mary Ann Delafield Dubois (1813–1888) an amateur sculptor of busts, ideal figures, and cameos, was, in 1842, the second woman sculptor to be elected an Associate of the National Academy of Design. She was dropped from the rolls the following year, however. Although she showed considerable talent, "her physician interdicted her devotion to the arts."

Daughter of the cultivated New York banker John Delafield, Jr. (a founder of the New York Philharmonic), and his English wife, Mary Roberts Delafield, Ann was born in England when her American father was stationed there as a merchant, and came to New York City with her family when she was seven. She married New York businessman Cornelius Dubois in 1832 and already had two children when, around 1842, she accidentally discovered her aptitude.

Her father was having his bust modeled. When he asked for her opinion of it, she pointed out some defects which the sculptor corrected in her presence. According to a contemporary account, she enthusiastically exclaimed, "I could do that!," borrowed some clay, and with little effort created a good likeness of her husband.[9]

She decided to take lessons, but "frail health" soon caused her to discontinue them. With only instructions from her teacher "to keep her clay

moist until her work was completed," she continued to model likenesses of her son and daughter, a copy of *Cupid and Psyche,* and an original work called *Novice.* She also carved a marble head of the Madonna. This last ambitious effort, it seems, was "a laborious and exciting work which injured her health to such a degree that her physician interdicted her devotion to the arts."[10] In those days, it was generally believed that intellectual effort undermined a woman's health.

Retreating to the more modest field of cameo carving, Dubois produced more than thirty likenesses, each "requiring only an hour's sitting, after which they were completed." While traveling in Italy "she asked the first artist in cameos to give her lessons. When he saw some that she had cut, he told her that he could teach her nothing; she had only to study the antiques."[11] Among her ideal cameo subjects were *St. Agnes and her Lamb, Alcibiades, Guido's Angel, Raphael's Hope,* and *Apollo* (all unlocated). A cameo self-portrait is illustrated in John Ross Delafield's *Delafield, the Family History* (New York, 1945).

Dubois, however, was to suffer the fate that presumably awaited a married woman who tried to become a serious artist—even a cameo artist:

> While ascending the ladder to fame, her progress was arrested by ill health, and she now lives only to feel, as she says, how little she has done compared to what she might do could she devote herself to the art. Anxious to impart to others this great gift, and to stimulate her countrywomen to the development of any latent talent they may possess, she formed a class of young ladies, and most disinterestedly devoted a certain portion of her time to their instruction for several months.[12]

Some of the sources of her difficulties are revealed in the same account:

> Notwithstanding the care of a large family, the superintendence of the education of her daughters, and the sad drawback of ill health . . . she has always extended a helping hand and a smile of encouragement to young artists [such as] the sculptor of the "Shipwrecked Mother" [Edward Brackett] who alludes to her kindness in his short autobiography . . . while all who know her admire the artist for her talents, her unceasing energy, and philanthropic exertions. They behold in her the good wife, mother, and friend, and the elegant and accomplished woman presiding over the social circle. Her heart remains true to the gentlest influences of Nature, while her genius is ever responsive to immortal art.[13]

This need to quickly assure the reader that the married woman artist's primary devotion is to hearth and home is a constant refrain in the nineteenth century. Dubois, in the end, became known primarily as a founder and supporter of New York's Children's Hospital, not as the creator of what author Hannah Farnham Lee called "cameos very beautifully cut."

Dubois evidently was not able to submit a self-portrait to the National Academy of Design within a year of election, thereby failing to qualify for regular membership. She was dropped from the rolls, and after her, no woman sculptor was elected to the academy until the twentieth century.

Joanna Quiner (1796–1869)

And this is woman's work! this noble brow,
These "features cast in Nature's finest mould,"
Thy skill evoked from out the damp, dull clay
to gladden loving hearts as they behold.
—The Reverend Phebe Hanaford[14]

A poignant figure is Joanna Quiner, a self-taught portrait sculptor who exhibited at the Boston Athenaeum between 1846 and 1848. She aspired to be a sculptor but was forced by circumstances to remain a seamstress.

Quiner spent most of her early life working as a seamstress in her home town and in Salem. For a short time she also did upholstery work for the family of Boston's liberal abolitionist preacher, Theodore Parker, and developed a great admiration for him and his free-thinking views. In 1838 she took a position as assistant (probably a euphemism for housemaid) in the family of Seth Bass, librarian of the Boston Athenaeum, and it was there that she discovered, at the age of forty-two, her talent in sculpture.

The Bass family lived in an apartment in what was then the Athenaeum building. Since the sculptor Shobal Vail Clevenger was at that time working in a studio in the same building, Quiner had the opportunity of watching him at work and one day asked Clevenger to give her some clay. She made such a fine study of Seth Bass that Clevenger encouraged her to continue, and soon Quiner was earning praise from both patrons and critics.

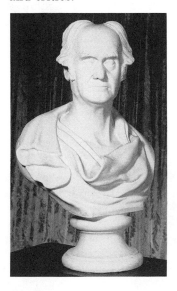

Joanna Quiner, BUST OF ROBERT RANTOUL (c. 1841), plaster, 73.8 cm × 50.2 cm × 31.2 cm. Boston Athenaeum. Gift of the artist.

Her most popular portrait was a bust of *Robert Rantoul* (c. 1841), a politician and social reformer from Beverly who was noted for his support of such causes as aid for the poor, temperance, and abolition of the death penalty. A plaster cast of this bust, presented to the Athenaeum by the artist in 1842, was exhibited there in 1846, 1847, and 1848.

She also did busts of *Fitch Poole* (editor of the *South Danvers Wizard*), poet *Alonzo Lewis, William H. Lovett, Albert Thorndike,* and artist *James Frothingham,* whose portrait of Quiner is at the Beverly Historical Society. The Beverly Society also has the sculptor's plaster busts of her father, Abraham Quiner, and her good friend, the well-known New England clergywoman and feminist Phebe A. Hanaford, author of *Daughters of America.*

Hanaford wrote a short vivid biographical sketch of Quiner, explaining why, despite her natural gifts, she did not progress in her art career: "She lacked the youth and beauty and wealth which might have assisted in bringing her before the public as an artist. She had always the cross of an unprepossessing person to bear, and her life was often an unequal struggle with poverty."[15]

The sculptor also, it seems, had strong—sometimes radical—opinions and an annoying habit of expressing them bluntly and honestly:

> Our acquaintance had been formed in the temperance societies, of which we were both members; and the hearty interest, which [she] always manifested in the good cause . . . won and kept for her my friendship, which grew stronger as I learned to look beneath the rather repelling outward appearance and blunt manners, and speech full of the "remorseless truth" . . . and saw the true, warm heart, the genuine nobility of character . . . which

constituted the woman, so little understood and appreciated . . .

Religiously, Miss Quiner was a radical, or free-religionist. . . . She revered the great iconoclast, Parker. . . . She never made any profession of religion, but was content to live purely and nobly. She trusted God . . . and was ever ready "to do good as she had opportunity."

The thoughtless and ignorant called her an infidel, when in truth her unfaltering faith could shame their own.[16]

Quiner's bust of *Robert Rantoul,* admired in its day, shows the same blunt and rugged honesty that Hanaford attributes to her personality.

In 1847 Quiner worked briefly for two dollars a week as a gallery attendant in the Athenaeum's Orpheus Room, but financial and health problems soon forced her to abandon sculpture and earn her living at the sewing machine in her later years. According to Hanaford: "She was industrious, but with all her industry . . . she could scarcely 'Keep the wolf from the door.' Had not kind and appreciating friends assisted her in a delicate way (for her pride forbade the request for help), she would have suffered for the necessaries of life, while yet she possessed more genius, in the way which made Michael Angelo famous, than any other woman of Essex County."[17]

Hanaford showed a keen perception of the social forces that help or hinder a woman artist. Even today, a pretty face and the right connections are very helpful—almost necessary—in getting ahead. Attractive, well-connected Harriet Hosmer, and Emma Stebbins, sister of one of the wealthiest men in New York City, were certainly not hindered by their backgrounds, and thus could accomplish much more. The feminist clergywoman ended the brief sketch of her friend with the hope that "the name of Joanna Quiner will not be forgotten among those women who believe in the use of all the powers which God has given . . . and if Harriet Hosmer and Emma Stebbins and Margaret Foley have done much more than she, still impartial justice will write her name with theirs, in the list of women brave to dare and strong to do."[18]

Caroline Davis Wilson (1810–90) of Cincinnati, an enthusiastic amateur, struggled to create marble sculpture while raising five children and making a home for her physician husband. Society's ambivalent attitude toward creative women (especially those who were married) in the mid-nineteenth century is illustrated in her life. On the one hand, she is a delicate creature whose mind may be endangered by too much enthusiasm for her art. On the other hand, if successful, she is an immoral schemer who threatens the male art establishment.

Caroline Davis, born near Cooperstown, New York, moved with her family to Cincinnati while still a child. She married Dr. Israel Wilson, "a most excellent person of Quaker family," in 1829, and raised a family. Her desire to create sculpture was reportedly aroused by a visit to a Cincinnati sculptor's studio. She began to work "with a feeling so intense that it could not be repressed. . . . she is a perfect child of nature, impulsive, but wonderfully perceptive, and there is so much freshness that all persons of mind are attracted to her."[19]

Her first attempt was a bust of her husband, but Dr. Wilson became alarmed when his wife began to "work with so much energy that sometimes she would faint away." He finally warned her: "If you are not more moderate, I will throw that thing out of the window."[20]

Despite her husband's remonstrations she finished the bust, carved it in stone, and placed it in her parlor. It was reportedly a remarkable

first effort. She then modeled a figure of her son: "He threw himself on the floor one morning, in an attitude at once striking and picturesque. To copy it required a perfectly correct eye, or a knowledge of anatomy; she courageously attempted it . . . and her success was triumphant. It is only a cast, and the cast does not do justice to the finish of her work, but she has not been able to procure a block of marble for the copy." The account then mentions other works in progress, concluding with the usual refrain about woman's role:

> She has a family of children, and is a devoted mother. We think *stone* will have but little chance with these beings of flesh and blood, whose minds and hearts she is carefully *modelling*. Perhaps family cares may be the true secret why female sculptors are so rare; but we congratulate this lady, that she has the true perception of the beautiful, and feel quite sure that it will mitigate the suffering from delicate health, and scatter fragrant flowers and healing herbs in the sometimes rugged paths of duty.

But the enthusiastic Mrs. Wilson was still at work five years later. Elizabeth Ellet, writing in 1859, described her as grabbing a hunk of red clay and modeling an amazing likeness of Ralph Waldo Emerson when she found herself in a tourist party with him at Mammoth Caves in Kentucky.

Although there are references in the literature to several works by her, only a few have been located. A marble bust of the *Reverend Lyman A. Beecher* (1860, Cincinnati Art Museum) is inscribed "Mrs. Wilson, artiste" on the back. When Wilson's *Mary of Bethany* (marble, 1860) came up at auction in New York in 1986, it was estimated to go for around $800, but bidding brought the selling price to $7,100.

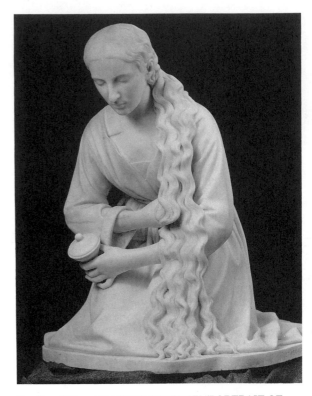

Caroline Wilson, MARY OF BETHANY (PORTRAIT OF THE ARTIST'S DAUGHTER) (1860), marble, 36¼″ × 28⅜″ × 30″. Courtesy H. V. Allison Galleries, New York. Photo: Helga Photo Studio.

The graceful, compact, kneeling figure holds a jar of ointment with which she is about to anoint Christ's feet, after which she will dry them with her long hair, shown rippling to the ground. According to the biblical account by John, when Judas remonstrated that the expensive oil should have been sold and the money given to the poor, Christ replied, "Let her alone; against the day of my burying hath she kept this." This statement is inscribed on the base. The work was formerly thought to portray Mary Magdalene, but Wilson, when presenting the sculpture to Lane Seminary in 1875, said that it represented Mary, sister of Lazarus. Wilson's daughter Genevieve served as

the model for the clay study, which was then carved in marble in Rome. This amount of expense and effort suggests that Wilson took her work seriously.

Indeed John Frankenstein, a Cincinnati sculptor, thought she took it too seriously. In his lampoon, *American Art: Its Awful Altitude, A Satire* (1864), he describes her as an ambitious harridan, a scheming "climber," hiding behind a coy and "artless" female façade. He even impugns her morals:

> There's still another who deserves a niche;
> A busy woman, but a venomous ———,
> Her tongue has placed her far outside that
> pale,
> that female weakness, men will not assail.
> To reach the upper-ten how she will
> scheme—
> 'Tis hard to rise on medicated steam!
> If she at last a surly sufferance gains,
> Her cringing low a dubious place obtains.
> Her artful artlessness is wondrous skill,
> Her artless awfulness more wondrous still.
> Some think her character without a taint,
> While others know a sinner, not a saint.[21]

Frankenstein also satirizes many men in his poem, but in this segment he reflects attitudes toward a woman who attempts "to reach the upper-ten," especially if she is old and not too attractive:

> She now, since age has laid her on the shelf,
> In chastened Magdalens concerns herself,
> And brings to light, from marble, human
> shape,
> As skillfully as monkeys men can ape;
> Her body's changed to grossness and her
> mind,
> In correspondence does not lag behind.

Perhaps the social pressure had its effect.

When Wilson died at age eighty, obituaries mentioned nothing about her role as an artist.

Rosalie French Pelby (Mrs. W. Pelby) (1793–1857) exhibited wax tableaux of religious subjects in New York, Boston, and Philadelphia between 1846 and 1851.[22]

A catalog accompanying her tableau *The Last Supper* reads "Our saviour and his apostles are represented in statuary, the size of life, designed from Leonardo da Vinci's celebrated painting." And the title page of the catalog for *The Trial of Jesus,* exhibited in Boston in 1846, reads

> The Trial of Jesus
> Represented in
> Twenty-three Wax Figures,
> The size of life.
> Executed by Mrs. Pelby

> In presenting this interesting subject for exhibition, Mrs. Pelby wishes to state, that the design was copied from an engraving found at Vienna, buried in the earth, cut upon a stone.

The artist was luring customers by advertising that she had a new, arcane source of information about the life of the Saviour. The catalog also contains an impassioned (and anti-Semitic) account of the trial so that viewers might follow the story while looking at the exhibition.

It is difficult to tell from the catalog's crude woodcut whether Mrs. Pelby's wax figures, long since vanished, had any of the vital realism of those by her predecessor Patience Wright. But the costumes, props, and other details created an exotic and at the same time morally uplifting entertainment for the entire family.

(R. W. Smith, dealer in rare books, must be credited with locating the artist's full name in the Union Catalog, finding rare catalogs, and locating news items about the artist.)

Rosalie French Pelby, THE TRIAL OF JESUS, wood engraving. From the brochure *The Trial of Jesus, Represented in Twenty-Three Wax Figures, the Size of Life. Executed by Mrs. Pelby,* c. 1848. Photo courtesy Charlotte S. Rubinstein.

THE WHITE MARMOREAN FLOCK

At mid-century a group of nine women sculptors went to Rome to work among their male colleagues in the neighborhood of the Spanish Steps. They paved the way for those who followed and changed the position of women sculptors in the United States.

Harriet Goodhue Hosmer (1830–1908) became an internationally renowned neoclassical sculptor. The New England novelist Nathaniel Hawthorne and his wife, Sophia, visited her studio during their stay in Rome and were fascinated by the unconventional artist. A visit to her atelier was de rigueur for an American or British tourist traveling abroad:

> We found Miss Hosmer in a little upstairs room. She is a brisk, wide-awake figure . . . and she seems so frank, simple, straightforward, and downright. . . . She [wore] a sort of man's sack of purple broadcloth, into the side pockets of which her hands were thrust as she came forward to greet us. . . . She had on a male shirt, collar and cravat, with a brooch of Etruscan

gold; and on her curly head was a picturesque little cap of black velvet; and her face was as bright and funny, and as small of feature, as a child's. . . . There never was anything so jaunty as her movement and action; she was indeed very queer.[23]

Although Hawthorne could not help admiring her talent and her independent spirit, his comments reveal the sexist ambivalence of his time; he wonders in this same passage "what she is to do when she grows old; for the decorum of age will not be consistent with a costume that looks . . . excusable enough in a young woman." Her face, he noted, "looked in one aspect, youthful, and yet there was something worn in it too, as if it had faced a good deal of wind and weather, either morally or physically."

She *had* "faced wind and weather." A pioneer, Hosmer had to overcome ridicule, charges of plagiarism, and barriers to an art education. The strength and stubbornness that this required were shaped (as feminist scholars have observed in the histories of most successful women artists of early times) by an unusually supportive upbringing.

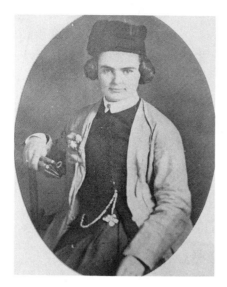

HARRIET GOODHUE HOSMER
(c. 1855). National Portrait Gallery,
Smithsonian Institution. Unidentified
photographer.

Harriet's father, a physician in Watertown, Massachusetts, had lost his wife and other children to the "white plague," tuberculosis. Desperate for his only remaining child to survive, he raised her in a permissive way and gave her "horse, dog, gun and boat," insisting "upon an out-doors life as indispensable to health."[24] She became an excellent horsewoman and an expert shot with her ivory and silver pistol.

The Hosmer home fronted on the Charles River, and from her private boathouse, Harriet paddled a silver-prowed gondola with red velvet curtains, exploring all the coves along the shores. She covered the walls of her room with the birds, bats, snakes, and toads she had stuffed, and "contrived at the same time to gratify and develop her own peculiar tastes.... she could often be found in a certain claypit, not ... far from the paternal residence, making early attempts at modeling horses, dogs, sheep, men and women."[25]

The high spirits and strong will developed by such a regime were sometimes manifested in wild pranks—behavior that seemed incorrigible to the decorous mothers of Watertown. She was, in fact, expelled from school three times, once unshackled two railroad cars "which her father had to pay dearly for," and played a practical joke on an elderly physician by placing a death notice for him in a Boston paper. His house was inundated with condolence cards.

At this point Dr. Hosmer decided to send his sixteen-year-old daughter to Mrs. Charles Sedgewick's school for girls in Lenox, Massachusetts, a place where his progressive approach could be continued by understanding teachers amidst a beautiful setting in the Berkshire hills. There Harriet was brought into early contact with such intellectual leaders as Emerson, Hawthorne, William Cullen Bryant, and Fanny Kemble, the strong-minded British actress living in the neighborhood, who, according to Ellet, encouraged the young girl to pursue her interest in sculpture. Cornelia Crow, her roommate and later her biographer, introduced Harriet to her father, the genial St. Louis businessman Wayman Crow, who played a crucial role in her career.

She needed his help soon enough. After three years of schooling, Hosmer returned home, built a studio on the family grounds, and began to study with the Boston sculptor Peter Stephenson, but soon realized that she needed training in anatomy. When no medical school in Boston would admit a woman to anatomy classes, she had to travel to St. Louis where Crow arranged for her to study with Dr. Joseph McDowell in 1850 at Missouri Medical College (now Washington University School of Medicine). Hosmer's careful anatomy drawings preserved at Radcliffe's Schlesinger Library demonstrate that the "incorrigible" tomboy had become an earnest and thorough student.[26]

After completing her studies, Hosmer took two adventurous boat trips on the Mississippi to New Orleans and to Minnesota. Along the way she was nearly trapped going down a mine shaft in a bucket, smoked a peace pipe with a Dakota Indian chief, and, near what is now Lansing, Iowa, raced some young men from the boat up the highest bluff along the river bank. When she won, they named the promontory Mount Hosmer in her honor (it still bears her name). Meanwhile the Crow family grew exceedingly nervous waiting for their young charge to come back.

After returning to Watertown, Hosmer worked herself into exhaustion wielding a four-and-a-half-pound lead mallet ten hours a day on her first major sculpture—a marble bust of *Hesper, the Evening Star* (1852, Watertown Public Library, Massachusetts). The young artist, already under the spell of classicism, was reading Pindar's Odes, but the direct inspiration for this work was Tennyson's poem *In Memoriam* ("have lost my wits over it," she said). She had memorized the lines

> Sad Hesper o'er the buried sun
> And ready, Thou, to die with him,
> Thou watchest all things ever dim
> And dimmer, and a glory done.

Author Lydia Maria Child described *Hesper* thus: "The face of a lovely maiden gently falling asleep to the sound of distant music. Her hair is gracefully intertwined with capsules of the poppy. A polished star gleams on her forehead, and under her breast lies the crescent moon. The hush of evening breathes from the serene countenance and the heavily drooping eyelids."[27] Hosmer was at that time making weekly pilgrimages to view the plaster casts of classical statues and Michelangelo's works at the Boston Athenaeum, and perhaps the symbols for sleep in Michelangelo's figure *Night* influenced her.

Around this time Hosmer met Charlotte Cushman, the famous Boston actress who had returned to her hometown for an engagement. Hosmer attended her performances nightly and visited the actress in her dressing room. The formidable Cushman, herself something of a maverick in life-style and mannish costume, was immediately attracted to the enthusiastic young fan with short, curly hair and jaunty boyish airs. The actress, about to take up residence in Rome, looked at the daguerreotype of *Hesper* and thought to herself that it would be a delight to play a shaping role in the development of this talented girl. Why should she not have the advantage of studying in Rome like the outstanding male sculptors of the day? Cushman persuaded Dr. Hosmer to allow his daughter to live and study there under her care.

Hosmer arrived in 1852, hoping to study with the Englishman John Gibson, sculptor of Queen Victoria and the leader of the neoclassicists in Rome. Although the teacher of British sculptors John and Mary Thornycroft, he usually avoided taking students, especially women. But when friends interceded on her behalf, something about her story and her daguerreotype of *Hesper* appealed to him. In a few days the courtly Englishman ushered Hosmer into his Via Fontanella studio, past a gallery of his work, across a garden of bright flowers, and up a staircase to a small workroom lighted by an arched window, which had once been occupied by the great Canova. Hosmer wrote home ecstatically that "inspiration may be drawn from its walls." Gibson, she said, "is my master, and I love him more every day. I work under his very eye, and nothing could be better for me.... He gives me engravings, books, casts, everything he thinks necessary for my studies, and in so kindly, so fatherly a manner, that I am convinced Heaven smiled most benignantly upon me when it sent me to him."[28]

Hosmer became the delight of Gibson's older years. The sculptor and the young apprentice could regularly be found breakfasting together at the Café Greco at dawn, Gibson reading his newspaper by the light of a candle he held in his hand. Absentminded and impractical, he grew to lean on his protégée. She said affectionately, "He is a god in the studio, but God help him outside of it." In turn, Gibson teasingly signed his notes to her "your slave."

He took great pride in her progress and sponsored her work in every way. As Hawthorne shrewdly noted, her proximity to Gibson's studio put her work before the "throngs of people who come to see Gibson's own; and these are just such people as an artist would most desire to come in contact with, and might never see in a lifetime, if left to himself."[29] Before long Hosmer's patrons included queens, princes, and other titled heads of European nations.

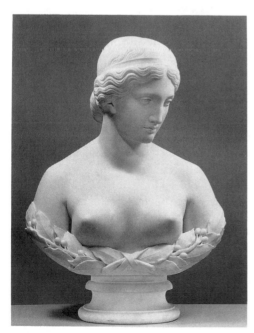

Harriet Goodhue Hosmer, DAPHNE (1854), marble, height 27½". Metropolitan Museum of Art, Morris K. Jesup Fund, 1973 (1973.133).

After copying antique statues, Hosmer completed her first major sculpture, a bust of *Daphne* "represented as sinking into laurel leaves" (marble, 1853, Washington University Gallery of Art, St. Louis; Metropolitan Museum of Art). Derivative of such works as Hiram Powers's *Proserpine* (1839), the bust shows a great advance over the relatively clumsy *Hesper*. The pure classical features, the long swinging line of the back of the head, culminating in the rich organic form of the bun, the elegantly chiseled laurel leaves forming a decorative border for the smooth marble, are all beautifully realized. The theme is also significant. Daphne, fleeing from Apollo's passionate pursuit, was saved by being turned into a laurel tree. In Victorian times Daphne was a symbol of purity and chastity, but for Hosmer, the myth may have had additional feminist implications.

Daphne was followed by a more original work, a bust of *Medusa* (1853, Detroit Institute of the Arts), shown brooding as she realizes that her beautiful locks of hair are being turned into snakes; henceforth all men who gaze upon her countenance will freeze to stone. Once again the artist strove for purity of line and form in the refined classical mode advocated by Gibson, and once again Hosmer dealt with a feminist theme—stoical suffering endured by woman in a male-dominated world. The sorrowing Medusa, the only one of the three Gorgons who is mortal, wears her snaky locks, the symbols of her oppression, proudly, as a kind of crown. The sinuous locks form a tiara, capped in the back by birds' wings, their curves echoed in intertwined snakes edging the bottom of the bust. Always the naturalist, Hosmer chloroformed a live snake in order to study its details and then set it free.

Gibson was enthusiastic. Declaring that his young student had portrayed the roundness of flesh in a way that he "had never seen ... sur-

passed and seldom equalled"[30] and that the Medusa would "do credit to many a sculptor in Rome," he wrote to Harriet's father: "Rauch of Berlin . . . came to my studio. . . . Your daughter was absent, but I showed him all she had done. . . . Rauch was much struck and expressed his opinion that she would become a clever sculptor. . . . So now you have the opinion of the greatest living sculptor concerning your daughter's merit."[31]

The head of Medusa is more than a neoclassical conceit. Unlike the grotesque gorgons of early Greek art or the coldly beautiful versions of Hellenistic times, Hosmer's *Medusa,* with its broad face, ripe mouth, shadowed brow, and warmly human expression, resembles Hosmer herself. One senses a strong identification with the mythic heroine at a time when the artist was becoming aware of her own situation in a chauvinistic society and was coming to terms with difficult choices in her life, such as her decision to avoid marriage. It was around this time that she wrote to Wayman Crow:

> You see, everybody is being married but myself. I am the only faithful worshipper of Celibacy, and her service becomes more fascinating the longer I remain in it. Even if so inclined, an artist has no business to marry. For a man, it may be well enough, but for a woman, on whom matrimonial duties and cares weigh more heavily, it is a moral wrong, I think, for she must either neglect her profession or her family, becoming neither a good wife and mother nor a good artist. My ambition is to become the latter, so I wage eternal feud with the consolidating knot.[32]

Like Medusa, whose frightening head turned male warriors to stone, Hosmer was also slowly realizing that her independence, energy, and power as an artist were threatening to many of the men around her. The community in Rome was, in fact, polarized between those who admired her pluck and talent and those who deplored her life-style. When a gentleman offered to escort her home one night, she, outspoken and witty, returned the favor by asking him if *he* needed an escort. She worked hard in her studio from six in the morning until mid-afternoon and then changed into riding clothes and spent several hours galloping across the Campagna with Charlotte Cushman or practicing jumps with the hunt society (sometimes taking spills).

Sculptors like Randolph Rogers and Thomas Crawford were appalled by her unfeminine demeanor. Crawford urged his socialite wife to cut her dead: "Miss Hosmer's want of modesty is enough to disgust a dog. She has had casts for the *entire* model made and exhibited them in a shocking indecent manner to all the young artists who called upon her. This is going it *rather strong.*"[33] Crawford's letters cluck about Hosmer's unladylike slang, her "impossible round straw hat," and so on. Still worse were those envious male artists who pretended to be her friend but spread rumors that Gibson was doing her work.

But others appreciated the young artist. William Wetmore Story, at first shocked by Hosmer's flamboyant behavior, wrote to his friend, the poet James Russell Lowell, that she was living with a "Harem (Scarem) of emancipated females,"[34] but before long she was included in his inner circle, took part in the entertainments at his home in the Palazzo Barberini, accompanied the Storys on vacation, and eventually took an apartment in the Palazzetto Barberini, in sight of their residence.

Hosmer was also part of a salon that met on Wednesday evenings to dine, listen to arias, and discuss life and art at the home of Adelaide Sar-

toris. In this group was the British painter Frederic Leighton (later head of the Royal Academy) and Robert and Elizabeth Barrett Browning, who became close friends. She and Robert exchanged punning doggerel and organized delightful outings. In a letter describing their picnics on the Campagna, Elizabeth wrote:

> Miss Hosmer . . . a great pet of mine and of Robert's . . . emancipates the eccentric life of a perfectly "emancipated female" from all shadow of blame by the purity of hers. She lives here all alone (at twenty-two), dines and breakfasts at the cafes precisely as a young man would; works from six o'clock in the morning till night, as a great artist must, and this with an absence of pretension, and simplicity of manners, which accord rather with the childish dimples in her rosy cheeks, than with her broad forehead and high aims.[35]

Hosmer, in turn, called the fragile Elizabeth "the most perfect human being I have ever known," and created a symbol for the extraordinary relationship between the poet and her devoted husband in a bronze cast of their joined hands (1853, Armstrong Browning Library, Baylor University, Texas).

This productive life was suddenly threatened when Hosmer's father wrote that he had suffered financial reverses and could no longer support her abroad. Deciding that her entire future as a sculptor depended on her continued training in Rome, she sold her horse and set about earning her own way. Wayman Crow tided her over this difficult period ("I owe all to you," she wrote) by advancing money and commissioning a work. The sculptor now felt sufficiently confident to create a full-length figure of *Oenone* (1855, marble, St. Louis Mercantile Library), the shepherdess-wife deserted by Paris for Helen of Troy—another portrayal of woman suffering from male oppression. Seated on the ground, half

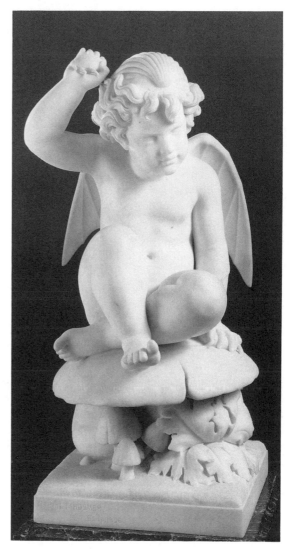

Harriet Goodhue Hosmer, PUCK (1856), marble, 30½″ × 16⅝″ × 19¾″. National Museum of American Art, Smithsonian Institution. Gift of Mrs. George Merrill.

draped, she gazes downward and pines for her lost love. Hosmer was never completely satisfied with the flowing contour and melancholy romanticism of *Oenone,* perhaps because it lacks subtlety in the definition of anatomical forms.

Cannily estimating the market, Hosmer now set about creating a sculpture with great popular appeal. She succeeded totally with her impish *Puck* (1856, National Museum of American Art and Wadsworth Atheneum, Hartford), her most popular work, which sold nearly fifty copies in marble at a thousand dollars each, establishing her as a self-supporting artist. The Prince of Wales bought one for his college rooms at Oxford, and other versions went to patrons as far apart as the United States, the West Indies, and Australia.

Bat-winged Puck, Shakespeare's "shrewd and knavish sprite," sits cross-legged on a toadstool: "This little forest elf is the very personification of boyish self-will and mischief ... scarcely aware of the pain he causes ... rollicking in the consciousness of his tiny might. . . . With his right hand he grasps a beetle, and seems about to throw it; with his left he presses unconsciously a lizard. . . . It is a laugh in marble."[36] When the crown princess of Germany saw it in the studio, she exclaimed, "Oh, Miss Hosmer, you have such a talent for toes!"

Often regarded as merely cute, *Puck* has an authentic breathing quality, embodying a side of the artist herself. The broad, childlike face framed with curls fringing out from beneath a shell-shaped cap resembles "Hatty," whose quips and pranks were Puckish, too. The beetles, toadstools, bat wings, and shell reflect Hosmer's naturalist interests, but also have symbolic meanings—the beetle, for example, shows that he is a creature of the night.

There is a curious sensuality about this work—even the toadstools and acanthus below the figure have an almost phallic quality. Thematically, Puck, who spreads pain and confusion in *A Midsummer Night's Dream* by causing people to fall in love, suggests a wry comment on the destructive power of heterosexual love. The eye is carried around from front to back in sweeping compact rhythms. Since it was customary to create such conceits in pairs, *Puck* was followed by *Will o' the Wisp* (Chrysler Museum, Norfolk, Virginia), whose flaming cap symbolizes the false phosphorescence of pedantic obscurantism ("St. Elmo's fire").

When an anonymous friend of Wayman Crow commissioned a sculpture for the St. Louis Mercantile Library, the artist created one of her finest works, the sleeping figure of *Beatrice Cenci* (1857). Forced to murder her monstrous incestuous father, Count Cenci, Beatrice is shown sleeping on her prison couch the night before her beheading. Hosmer used this melodramatic subject, the theme of a play by Shelley and a painting by Guido Reni, to again portray a woman stoically enduring an oppressive masculine world. The compact, but softly rounded figure, draped in rippling classicized folds, lies upon the hard sarcophagus-like bed. One arm hangs down holding a rosary and cross, symbols of Beatrice's faith and purity, despite her crime. Hosmer described the thought, labor, and refined corrections she put into this synthesis of romantic emotion and neoclassical form: "I ... gave her a vast quantity more hair ... sizable locks over the raised shoulder ... made a cushion of the upper stone (. . . a great improvement) ... and put on a slipper. . . . it was more in costume."[37]

When *Beatrice Cenci* was displayed at the 1857 Royal Academy exhibition in London, the occasion was a triumph for the artist. Eastlake, head of the Royal Academy, declared it "really a beautiful work of art, and for one of her age, quite wonderful."[38]

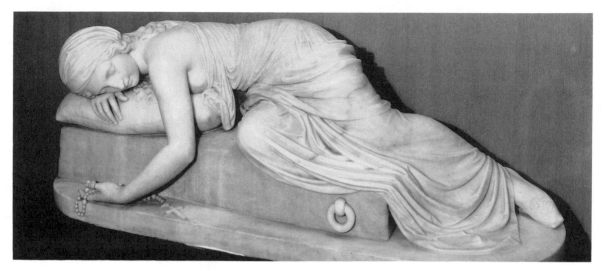

Harriet Goodhue Hosmer, BEATRICE CENCI (1857), marble. From the collection of the St. Louis Mercantile Library Association.

Hosmer next created a sculpture for the tomb of an English girl, Judith Falconnet (1857), in the church of S. Andrea delle Fratte near the Spanish Steps. At that time the only tomb sculpture by an American for a church in Rome (and even now one of very few tomb sculptures in Italy by a woman), the work achieves a powerful effect through its stark, unbroken horizontal lines.

The young girl lies in the sleep of death, in a modest dress on a simple Roman bed. No element of the supernatural—no gilded baroque angels or madonnas—detract from the effective simplicity. Art historian Barbara S. Groseclose points out that the transition between sleep and death is subtly conveyed by the modeling in the head, which moves from strong modeling in the chin, to the blurred form and lightly incised eyelids and hairline, conveying an effect of fading away.[39] The spectator's eye is led across the horizontal draped pleating of the dress to the only complication, the folds of a rippling sleeve from which a curving hand emerges, holding a rosary and cross, an understated symbol.

By this time commissions were crowding in ("I am busier than a hornet"). After seven years with Gibson, Hosmer felt secure enough to move into her own studio. She was commencing a seven-foot statue of Zenobia, the queen of Palmyra, and needed more space. She also needed to free herself from envious gossip that Gibson was doing her work.

Hawthorne visited Hosmer, hard at work on *Zenobia*: "We found the bright little woman hopping about in her premises with a birdlike sort of action. She has a lofty room with a sky-light window ... and there was a small orange tree in a pot, with the oranges growing on it, and two or three flower shrubs in bloom.... Zenobia stood in the centre ... as yet unfinished in the clay, but a very noble and remarkable statue indeed."[40]

The queen of Palmyra, a famed warrior, intellectual, and patron of the arts who was conquered and brought in chains to Rome, was just the kind of heroine who appealed to the sculptor. William Ware's widely read book *Zenobia* (1832) had popularized the theme in America; or perhaps the subject was suggested by Anna Jame-

son, a noted British author and art historian who spent many hours visiting galleries in Rome with the sculptor, advising her on details, and obtaining for her a copy of an ancient coin with the queen's head on it.

In Roman accounts Zenobia is described as fainting and failing as she walks in the triumphal procession in Rome, weighed down by jewels flashing in the sun and by gold chains so heavy they have to be supported by a slave. But Hosmer rejected this interpretation. She wanted to show an unshakable Zenobia. Hawthorne noted Hosmer's treatment of the chains as a kind of feminist symbol:

> She is supposed to be moving along as a captive in Aurelian's triumphal procession; and there is something in her air that conveys the idea of music, uproar, and a great throng, all about her, while she walks in the midst of it, self-sustained and kept in a sort of sanctity by her native pride. . . . she is decked with ornaments; but the chains of her captivity hang from wrist to wrist, and her deportment indicating soul so much above her misfortune, yet not insensible to the weight of it, makes those chains a richer decoration than all her other jewels . . .
>
> I know not whether there is some magic in the present imperfect finish of the statue, or in the material of clay, as being a better medium of expression than even marble; but certainly I have . . . never been more impressed by a piece of modern sculpture. . . . Zenobia's manacles serve as bracelets; a very ingenious and suggestive idea.[41]

In 1862 *Zenobia* (1859) was prominently displayed in the center of the London International Exposition in an octagonal temple lined with Pompeian red. Three of Gibson's tinted statues were in the other niches. Although the public ac-

claimed *Zenobia,* Hosmer was shocked when several British publications hinted that "Italian workmen" actually created her work. (She vowed to make them eat their words.)

But when the statue was subsequently shown in Boston, New York, and Chicago, it was highly praised in her native land. Thirty thousand viewers came to see it in Boston alone. The Civil War was on, and the poet Whittier declared: "In looking at it, I felt that the artist had been as truly serving her country, while working out her magnificent design abroad, as our soldiers in the field . . . in their departments."[42]

The *Atlantic Monthly,* December 1864, carried a rave review:

> A captive queen . . . who has proved her right to her throne by grand statesmanlike qualities . . . this is the group of ideas which Miss Hosmer wished to call up in our minds. Has she not done it? . . . a grand dignity in the attitude of the broad, powerful shoulders, and the firm column of the throat . . . pride and sorrow struggle in the knotted brow . . . contracted nostrils, and scornfully curled lip. . . . The ornaments . . . are kept well subordinated to the whole effect. . . . the heroic proportions of the figure lend much nobility.

The writer extols the didactic theme, so characteristic of the mid-nineteenth century:

> Such a work of art cannot but teach as well as delight us. . . . While the soft, sweeping lines and moulded loveliness of every part give pleasure to the eye, the grand endurance and determined fortitude—suggest only ennobling and elevating thoughts. . . . it is surrounded by the pure, high atmosphere of real art.[43]

Zenobia was particularly praised for its drapery and sometimes pointedly compared with the nudity of Hiram Powers's *Greek Slave.* While such criticism may reflect Victorian prudery, it also shows that Hosmer was treating the female figure in a way very different from that of her male colleagues—stressing the intellect, character, and strength of her heroine, instead of presenting a delectable victim whose eroticism is thinly disguised by allegorical or religious content.

Unfortunately the sole surviving example of *Zenobia* is the four-foot version at the Wadsworth Atheneum, although several eight-foot figures were bought by prominent patrons. A visitor to Hosmer's studio noted several "sizes and shapes" of Zenobia, but none like the one she had seen in Chicago. There was inevitably some variation in quality depending on the skill of the stonecutter.

Although *Zenobia* brought Hosmer's career to a peak in the United States, the slander against her in the British press continued to enrage her. In an 1863 issue of *The Queen,* an irresponsible journalist had written of "the meretricious charms of Zenobia ... said to be by Miss Hosmer but really executed by an Italian workman at Rome." This libel was repeated in other publications.

For years Hosmer had known that certain jealous male artists in Rome were spreading rumors about her, but she was aghast to find such accusations in print. Recognizing that not only her own career but the position of all creative women was at stake, Hosmer rallied support among her friends in the art world and decided to sue for libel. In a letter to the *Art Journal,* 1 January 1864, the artist showed, without naming names, that she knew who was originating the innuendos: "A woman artist who has been honored by frequent commissions is an object of peculiar odium. I am not particularly popular with any of my brethren; but I may yet feel myself called upon to make public the name of one in whom these reports first originated, and who, sheltered under an apparent personal friendship, has never lost an opportunity of defaming my artistic reputation."

In a private letter to Hiram Powers, Hosmer declared that her slanderer was the American sculptor Joseph Mozier, described by Thomas Crawford as one "who has completely burned out his heart with envy, jealousy and such charming passions."[44] Asking Powers for support, she vowed that she was ready to "plant a bomb" and urged that he remain quiet until "the gun is fired." The artist had been prone to use such military metaphors ever since the early days when she was taught to hunt and shoot by her father.

Defending her in the *Art Journal,* John Gibson pointed out that when Hosmer was his student, people said that *he* did her work. Now that she was in her own studio, detractors were claiming that her work was done by Italian assistants. William Wetmore Story attested that he had personally watched Hosmer at work on the statue. Although her assistant, Signor Nucchi, had put the irons and clay mass to scale from her sketch, she had modeled the work from her own original maquette in the same manner as all the other sculptors in Rome.[45] Hosmer never revealed Mozier's name publicly, but she forced the *Art Journal* and *The Queen* to print retractions.

The artist's energy was diverted to her self-defense for a long time. She published a poem satirizing the chauvinism of male artists, *The Doleful Ditty of the Roman Caffè Greco,* in the *New York Evening Post,* in the summer of 1864. She wrote "The Process of Sculpture" for the *Atlantic Monthly,* December 1864. Drawing a distinction between the creative artist who models

the work in clay and the craftsman who merely copies it in marble (thus freeing the artist for more creative work), she explained that all sculptors of her time worked this way, adding bitterly: "I am quite persuaded . . . that had Thorwaldsen and Vogelberg been women . . . we should long since have heard the great merit of their works attributed to the skill of their workmen."

In 1860, with the help of Wayman Crow, Hosmer received a Missouri state commission for a statue of Senator Thomas Hart Benton. Photographs show the sculptor at work in Zouave trousers ("not intending to break my neck upon the scaffolding by remaining in petticoats") on the ten-foot clay model. When the bronze sculpture, cast in Munich, was dedicated in Lafayette Park in 1868, St. Louis's schools and businesses were closed; thirty thousand people jammed the park; cannons were fired; and the senator's daughter, Jessica Benton Fremont, unveiled the statue and declared it to to be a splendid likeness. St. Louis's first public monument, it cost $36,000, a substantial sum in those days.

Benton stands draped in a togalike cloak, unrolling a scroll with a map on it. Pointing to the Pacific Ocean, he is speaking in favor of construction of the transcontinental railway. "There is the East, there is India," he thunders, as he tries to convince his audience that the wealth to be found in the American West is like the fabled riches of India. These words are inscribed on the pedestal.

The flowing profile of the sculpture works well, but the front view of *Thomas Hart Benton* seems a bit ungainly. To many, the classicized cloak was out of place on the rugged Missourian. Hosmer detested "ugly" modern clothes and attempted a kind of compromise, in which the cloak covers most of the costume—an approach used before in works like Francis Chantrey's *George Washington* (1826) and Christian Daniel Rauch's *Marshal Blücher* (1824). But times were changing; the Civil War had produced a new mood of realism in America, and neoclassical trappings were disappearing from sculpture. Hosmer's *Benton* is one of the last works in the United States in which a public figure is shown in classicized garb.

The death of Hosmer's father in 1862 left her with a modest independent income. By this time a successful artist with a crew of Italian marble carvers working for her, Hosmer occupied one of the most beautiful studios in Rome at 116 Via Margutta. Visitors stepped from the hot, dusty streets into an entrance filled with flowers and singing birds. In the center of the first room stood the *Fountain of the Siren,* a nude woman kneeling in a shell basin that splashed water onto putti and dolphins below (only a boy and dolphin from this fountain have been located).

From this time forward, many of Hosmer's sculptures were bought by a circle of titled Englishwomen who had become her close friends and patrons, among them Lady Marion Alford, who commissioned the *Fountain of the Siren,* and Lady Ashburton, who bought the *Waking Faun* and *Sleeping Faun* (1865, Forbes Collection, New York) of this period. They commissioned gates for an art gallery, chimney pieces (*The Death of the Dryads*), and other works that were never completed or are today unlocated. Hosmer spent increasing amounts of time vacationing at their magnificent English castles and estates. Elizabeth Barrett Browning was amused by Lady Marion Alford's adulation: "I thought there was the least touch of affectation. . . . [Lady Alford] knelt down before Hatty the other day and . . . placed on her finger the most splendid ring you can imagine, a ruby in the form of a heart surrounded and crowned with diamonds. Hatty is frankly delighted, and says so with all sorts of fantastical exaggerations."[46]

For a time the sculptor was infatuated by the

HARRIET
HOSMER AND
HER WORKMEN.
Rome. Photograph
in *Harriet
Hosmer, Letters
and Memories,* ed.
Cornelia Carr,
1912, p. 250.

beautiful but reactionary queen of Naples, who had defended her country in battle. A statue, now lost, showed the queen, her beautiful braids coiled in a kind of crown, in military cloak and boots, pointing to a pile of cannonballs at her feet. The Yankee rebel had become part of an international set that included kings of Bavaria, the empresses of Russia and Austria, and, of course, many intellectuals from different walks of life.

Hosmer's finest works were created in the decade after her arrival in Rome. After this her output became more sporadic; her style lost some of its purity of line and, in accord with the general trend in sculpture, became more fussy and mid-Victorian. She was involved in three frustrated attempts to complete a Lincoln Memorial. An elaborate proposal for the Freedman's Memorial, Washington, D.C., was touted in the 1868 London *Art Journal* as if it were a fait accompli, but the commission went to Thomas Ball. At the top, under a classical pergola, stands Lincoln in toga, holding the Emancipation Proclamation in one hand and a broken chain in the other. Relief panels on the base portray Lincoln's life, and below him on steps are figures representing the various roles of the black man in America.

Hosmer's last important project was a full-sized *Queen Isabella* for the 1893 World's Columbian Exposition. Because of internecine struggles between competing groups at the fair, the statue ended up in an insignificant spot in the Pampas Palace of the California pavilion. The facts are not altogether clear, but it appears that the California women's group encouraged Hosmer to send a second plaster copy of *Isabella* to the San Francisco Exposition the following year. After it was unveiled, the artist was lionized and delivered a series of lectures. An attempt was made to raise funds to put *Queen Isabella* into permanent materials, but this never came about and it disappeared, probably destroyed in the 1906 earthquake. A photograph at Radcliffe's Schlesinger Library shows a large, impressive sculpture of the queen, in full-skirted historical costume, at the moment she presents Columbus with the means to make his voyage—another feminist statement about a heroic woman.

Hosmer stopped producing in her last years. Neoclassicism was passé and she hated the new realism. In a San Francisco lecture she called that city's public sculptures "bronze photographs." She spent some of her later years in scientific tinkering, inventing an imitation marble

Harriet Goodhue Hosmer, proposed design for the FREEDMAN'S MEMORIAL. Illustration in the London *Art Journal*, 1868, 1–1, p. 8. From the Collection of the Getty Center for the History of Art and the Humanities.

that could be cast like plaster and patenting plans for a perpetual motion machine. Disenchanted with the changes in Rome after it became the capitol of Italy in 1870, she finally returned to Watertown in 1900 where she died of pneumonia in 1908.

Hosmer's personality was so striking that it tends to deflect attention from her work. In the years preceding and just after the Civil War, she produced a body of work that deserves greater recognition in American art history texts than it has received. *Medusa, Beatrice Cenci, Judith Falconnet,* and *Zenobia* are outstanding neoclassical sculptures of the mid-nineteenth century and were recognized as such in her day. Indeed, Hosmer was so famous in her time that when Theodore Dreiser, in his novel *The Financier,* wanted to create a fictional image of what a nineteenth-century tycoon's art collection might hold, he included "statues by Powers, Hos-

mer, and Thorwaldsen."[47] These works enrich American art with a thematic content that is notably absent from our biased textbooks—they stress the dignity, strength, and intellect of women.

While still smarting from the pain of the *Zenobia* controversy, Hosmer visited the United States and heard Phebe Hanaford, one of America's first clergywomen, preach in Nantucket. Afterward she wrote a letter to Hanaford that is a strong declaration of women's rights:

I honor every woman who has strength enough to step out of the beaten path when she feels that her walk lies in another; strength enough to stand up and be laughed at if necessary. That is a bitter pill we must all swallow at the beginning; but I regard those pills as tonics quite essential to one's mental salvation. . . . But in a few years it will not be thought strange that

women should be preachers and sculptors, and everyone who comes after us will have to bear fewer and fewer blows. Therefore I say, I honor all those who step boldly forward, and, in spite of ridicule and criticism, pave a broader way for the women of the next generation.[48]

Driven by a passion for social justice which informed all her work, **Anne Whitney (1821–1915)** abandoned the conventional marble neoclassicism of mid-nineteenth-century American sculpture for naturalistic bronzes that carry the messages of abolitionism, equality, and feminism. Whitney had her own experience with sexist discrimination. In 1875, when she had been a practicing sculptor for eighteen years, her anonymous entry for a memorial sculpture of the abolitionist Clark Sumner won a national competition, but when the judges discovered the winner was a woman, she was denied the commission and fobbed off instead with a $500 prize (which all three top contenders received). Whitney was enraged. For the rest of her life she refused to enter competitions. "Bury your grievance," she wrote of it. "It will take more than a Boston Arts Committee to quench me."[49] She was determined to do something about it no matter how long it took.

Whitney emerged as a productive sculptor at a time when very few women had entered the field. As is so often the case with nineteenth-century women artists, she came from a very supportive family. Liberal Unitarians, who had been long established in Watertown, Massachusetts, they believed in abolitionism and the equality of women. They were well-to-do people, in a position to give Whitney financial help, so that over a long career she never had to concern herself with money. But there was one thing they

couldn't do for her. As a practical matter, Anne could not be educated at Yale or Harvard. Instead she was tutored at home and spent a year at Mrs. Samuel Little's Select School for Young Ladies in Bucksport, Maine.

At the age of twelve she was outraged when a group of Protestant rioters burned a convent school and no one was punished for it. Later she expressed anguish over the passage of the Fugitive Slave Act.

According to scholar Elizabeth Roger Payne, she fell in love with a man whom she was unable to marry because of hereditary insanity in his family.[50] With no marriage prospects and no thorough education in any profession, what was she to do? Whitney and her sister often talked about the limited career choices available to women. In 1846 she opened a small school in Salem, Massachusetts, that lasted for two years.

While teaching school she turned to writing poetry and between 1847 and 1850 her verse appeared in *Harper's*, the *Atlantic Monthly*, and other magazines. In 1855 she had poetry in *Una*, a journal devoted to women's rights. By her middle twenties, Whitney, now well-known as a New England poet, was a friend of Ralph Waldo Emerson and the Unitarian leader Theodore Parker. By the time her collected poems appeared in 1859, she was a figure on the New England literary scene.

During these years, under the influence of one of America's first women doctors, Elizabeth Blackwell, she became an active feminist. Blackwell was raising money for the establishment of a women's hospital, and Whitney helped by giving poetry readings for the project. At Blackwell's she met an unusual radical circle that included Lucy Stone, a leader in the feminist movement, and Antoinette Brown, the first ordained woman minister in America. All these women were an inspiration to Whitney.

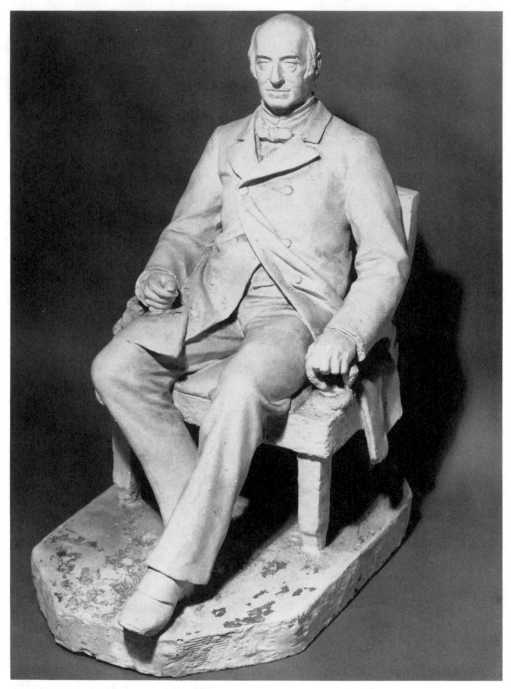

Anne Whitney, WILLIAM LLOYD GARRISON (1880), plaster, height 27½″. Garrison Family Papers, Sophia Smith Collection, Smith College. Photo: Herbert P. Voss, Wellesley, Mass.

Another possible source of inspiration was Whitney's Watertown neighbor, Harriet Hosmer, who although nine years her junior was already a successful sculptor. There is an attractive story that one day Whitney overturned a watering pot and began modeling with the wet sand. Another myth has her discovering her ability while sketching an overturned flower pot. However it happened, she was modeling seriously by 1855. Two years later, at the age of thirty-six, she decided to make sculpture her career. The family was, as ever, encouraging about this career change, and her brother built a studio-shack for her at their house.

For the first few years she did portrait busts of her parents, of her brother, James and of her lifelong friend and companion, Adeline Manning. Attracted by his acute satire of social conditions, she did a relief of the English poet Geoffrey Chaucer.

She wanted to go to Europe to study, but the Civil War kept her in the states from 1860 to 1866. In 1860 Whitney went to the Pennsylvania Academy of the Fine Arts but was too advanced for the classes there. Feeling the need of more knowledge of anatomy, she studied privately with a doctor in a Brooklyn hospital. Around this time she created her first important work, a charming, soft-cheeked, snub-nosed bust of little *Laura Brown* (marble, 1859, National Museum of American Art), daughter of her Brooklyn friends, the Browns.

Then, between 1862 and 1864 she was fortunate enough to study for two years in Boston with sculptor Wiliam Rimmer, one of the finest anatomy instructors in the country. Rimmer's students spent most of their time drawing bones and muscles, although as in all American art schools of this period, women did little drawing from the nude model. Nonetheless Whitney, while working with Rimmer, modeled what may be the first male nude by an American woman,

which she later reworked in Rome as *The Lotus Eater* (plaster, Newark Museum). Perhaps intended as a criticism of self-indulgent aestheticism, the languid standing figure seems to symbolize the attitude of those who drop out of life and withdraw into private fantasy.

During the Civil War years, Whitney also began to produce sculpture that reflected her social sympathies. In 1862 she completed her first life-sized sculpture, *Lady Godiva* (marble, private collection, Dallas, Texas), seen as in Tennyson's poem at the moment that she decides to ride naked and accept humiliation in order to lighten the tax burden of the oppressed. She is opening the eagle buckle of her belt, about to drop off her clothes. The border of the garment is inscribed with medallions containing a horse motif, referring to her famous horseback ride. The statue seems to be saying that women with courage can cast off shame and bring about social good.

Godiva has been described as "a sculpture perfectly suited to the typical Victorian parlor or vestibule. It is essentially a costume piece, with careful attention lavished on ruffles, patterns and pleats."[51] But in Whitney's day critics found it to be "full of purity and purpose," and a rich collector soon bought it. To many viewers today the broad sweeping lines of the strong, resolute figure seem to carry its original message.

In 1864 Whitney's concern over the issue of black freedom emerged in her statue *Africa,* in which a reclining black female figure is shown awakening from the long sleep of slavery. The woman shades her eyes from the blinding light of freedom. A contemporary critic felt that *Africa* "showed genius in its author," and another described it as Michelangelesque. There was some criticism, however, that the features were not sufficiently African, and Whitney attempted to change them after the work was exhibited at the National Academy of Design. The plaster model

was never cast or put into marble, and Whitney broke it up after her return from Europe. She later regretted the loss, and today it is even more keenly felt. Photographs show a strong image, with an almost art deco stylized quality of design.

Whitney made three trips to Europe between 1867 and 1876, staying about five years in all, principally in Rome, but also in Munich and Paris. One of the first fruits of her European sojourn was *Toussaint L'Ouverture* (unlocated), a sculpture of the black Haitian liberator. L'Ouverture is seen as a modern man stripped to the waist and in prison, where he was condemned to death by Napoleon. He points to a legend reading "Dieu se Charge" (God is taking charge of it).

Her finest work while she was in Rome was *Roma* (originally modeled in 1869, cast for Wellesley College in 1890), a bronze seated figure of an old beggar woman, symbolic of the city of Rome in its decay. In her right hand she holds two pennies; in her left, a license to beg. The *Apollo Belvedere, Laocoön,* and *Dying Gaul* are depicted in small medallions on the hem of her skirt—great works of the past now reduced to tawdry ornaments of the dying city. Whitney was undoubtedly showing sympathy for the struggle for national unification taking place in this period. This work, innovative in its naturalism, proved so offensive to the authorities that Whitney had to smuggle it out of Rome. Various versions of *Roma* were exhibited in Rome, London, at the Philadelphia Centennial, and at the 1893 Chicago World's Columbian Exposition.

Returning to America in 1871, Whitney opened a studio in Boston. Now a recognized sculptor, she won a commission in 1873 for a marble statue of Samuel Adams to be placed in the U.S. Capitol. Since the commission stipulated that the marble was to be cut in Italy from a plaster cast made in Boston, Whitney went to Florence in 1875 to select the marble and do the finish work on the statue in Thomas Ball's studio.

That summer, while waiting for the cutting to be done, she left for the little village of Écouen near Paris. An old woman in the village worked as a model for local artists and always fell asleep while she sat for them. Possibly Whitney saw in her a symbol of France as she had seen Rome in the beggarwoman *Roma;* possibly the woman, aged and exhausted as she was, was for her an ironic commentary on the usual sexist connotations of "the artist's model." In any event, *Le Modèle* (bronze, 1875, Museum of Fine Arts, Boston) is a powerful, unsparing bust of the old woman, her head fallen forward in sleep, a kerchief over her hair.

In this work, with its flickering modeling and broken highlights, Whitney was one of the first Americans to show the French influence that would soon sweep through American sculpture. As Kathryn Greenthal points out in *American Figurative Sculpture in the Museum of Fine Arts, Boston* (1986), Whitney's portrayal of a workworn peasant is highly innovative. It antedates the interest in labor themes by European sculptors such as Jules Dalou and Constantin Meunier. American sculptors of the ash can school introduced such themes even later, around 1905.

It was in that same year, 1875, that after submitting the winning model she was denied the commission to do a memorial for Charles Sumner because she was a woman. She had wanted that commission above all because Sumner had been an outstanding abolitionist senator. How it rankled! But she took back her model and congratulated Thomas Ball, the winner. The following year she sent the Sumner model along with *Roma* and *Le Modèle* to the United States art exhibition at the Philadelphia Centennial.

When her marble *Samuel Adams* was displayed at the Boston Athenaeum before being sent to Washington, it was so well received that

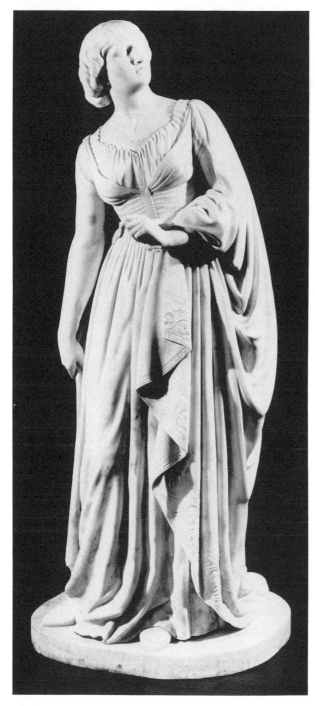

Anne Whitney, LADY GODIVA (1862), marble, height 67".
Collection of Alessandra Comini and Eleanor Tufts,
Dallas.

the people of Boston commissioned a bronze version to be placed in Adams Square in front of Faneuil Hall. Adams stands, arms folded in a posture of defiance, grasping a scroll in one hand.

In 1876 Whitney bought a four-story house at 92 Mt. Vernon Street in Louisburg Square. Here she lived and worked for the next eighteen years, and here in 1878 she executed a commission for a large statue of Harriet Martineau, the British feminist leader and enemy of slavery— a symbol of emancipated women everywhere. Given to Wellesley in 1886, it was destroyed in a fire at the college in 1914.

In her maturity, one success followed another. In 1878 when she was sixty-seven, she invited William Lloyd Garrison to sit for a portrait bust (plaster, National Museum of American Art). Garrison preferred this portrait to any other of him, including earlier ones by Jackson and Clevenger. He wrote to his daughter, "It is admirably executed.... I do not think a more accurate 'counterfeit presentment' of your father's features could possibly be made; and I am particularly pleased that it has been achieved by a woman."[52] Garrison's family so disliked Olin Warner's Garrison Memorial in Boston that they commissioned Whitney to make a statuette and had five bronze casts made, one for each household.

Art historian Wayne Craven describes the seated figure as "one of the finest specimens of her work. In it ... Whitney managed to overcome the problem of contemporary dress that had plagued sculptors for decades. The necessary details are present, but emphasis is successfully centered on the man himself, especially on his thoughtful expression." Art historian Milton Brown praised the "perceptive characterization" and described her later work as "straightforward naturalism, in the manner of Thomas Ball, though with a modest sincerity and sensitivity."[53]

A statue of *Leif Ericson* for Commonwealth

Avenue, Boston, and Milwaukee was funded by Scandinavian societies in America. This bronze costume piece, complete with chain mail and details of armor, is less compelling to modern eyes than her straightforward naturalistic portraits.

Four busts of women leaders, commissioned for the Woman's Building at the 1893 World's Columbian Exposition, include *Lucy Stone* (1892, Boston Public Library), *Frances Willard* (1892, Willard House, Evanston, Illinois), *Harriet Beecher Stowe* (1892, Stowe House, Hartford), and *Mary Livermore* (public library, Melrose, Massachusetts). Among numerous other portraits are those of Harvard president *James Walker,* Wellesley College president *Alice Freeman Palmer,* and *John Keats* (Keats House, Hampstead Heath, England).

Whitney continued to work for social causes. In the last decade of the century she became a leader in a modified socialist movement called Nationalism which aimed to nationalize basic industries. (The originator was Edward Bellamy, author of *Looking Backward,* a utopian fantasy that had great influence in the early twentieth century.) She and Adeline Manning produced pamphlets and distributed them on the streets of Boston. When the First Nationalist Club of Boston couldn't pay its debts, this elderly radical paid them. In 1882 Whitney bought a farm in Shelburne, New Hampshire, where she spent summers and became active in the cause of conservation; she also supported a school for freedmen in the South and a school for the blind.

In the spring semester of 1885 the sculptor taught modeling at Wellesley College, filling a temporary vacancy in the art department. Her correspondence—over three thousand letters—was given to Wellesley. The quantity, the topics covered, the scope, reflect a busy life of social involvement; the fact that the letters were preserved suggests that the artist recognized her importance and felt she ought to be remembered.

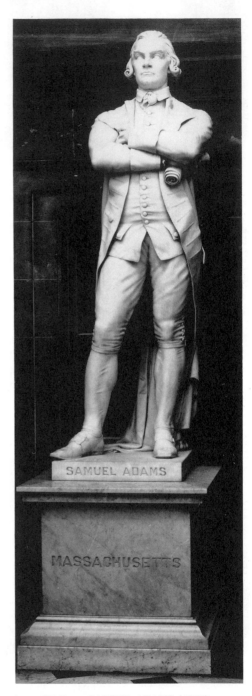

Anne Whitney, SAMUEL ADAMS (1875), marble, United States Capitol Art Collection. Courtesy Architect of the Capitol.

In 1893 Whitney sold the Beacon Hill house and moved into a penthouse duplex on top of the new Charlesgate Apartment Hotel. Here in a studio overlooking the Charles River she continued to do portraits of leading reformers of the day.

But the studio in the apartment was not big enough for a project she had had in mind for twenty-five years. For that she rented one outside of the city and in 1900 went back to work on the model for the Charles Sumner statue—the model she had salvaged in 1875 when she declared she would not be "quenched" by a Boston Art Committee. Now it was to be a full-sized statue—both righting the wrong done Sumner (a school friend of her brother's) when, a half century before, the abolitionist had been physically attacked on the Senate floor and settling Anne Whitney's score with Boston. In 1902 her bronze seated figure of Sumner was erected near Harvard Square in Cambridge.

A small woman of striking appearance, with a mane of short white hair, she was soft-spoken but witty and unsentimental in conversation. Young people and intellectuals gathered around her throughout her life. She died in her nineties after a productive career.

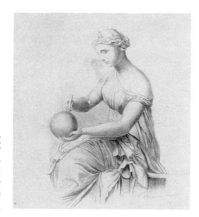

Edmonia Lewis, THE MUSE URANIA (1862), pencil on paper. Courtesy of the Oberlin College Archives.

(Mary) Edmonia Lewis (1844?–c. 1911), the first American sculptor of color to win an international reputation and deal with themes of racial oppression, was another member of the "white marmorean flock." She overcame all the obstacles that faced a woman of mixed African American and Native American heritage around the time of the Civil War.

Called "Wildfire" in her early years, she described her origins in an interview: "My mother was a wild Indian and was born in Albany, of copper color and with straight black hair. There she made and sold moccasins. My father, who was a Negro, and a gentleman's servant, saw her and married her. . . . Mother often left her home, and wandered with her people, whose habits she could not forget, and thus we, her children, were brought up in the same wild manner."[54]

Orphaned at five, Wildfire traveled with her mother's Chippewa tribe until she was about twelve. She fondly recalled her early life—swimming, fishing, and making baskets and moccasins which she sold in cities along the way. She once declared that her talent must have come from her mother, who was well known for her beautiful embroidery designs, "and the same thing is coming out in me in a more civilized form."[55]

Wildfire's older brother, Sunrise, a California gold miner, saw to it that she attended grade school near Albany, New York. According to her own account, she had a hard time settling down: "I was declared to be wild—they could do nothing with me. Often they said to me, 'Here is your book, the book of Nature, come and study it.'"[56]

Her brother nevertheless funded her journey by stagecoach to Ohio's Oberlin College, the first coeducational and interracial college in America, where, after changing her name to Mary Edmonia Lewis, she completed the high school

Edmonia Lewis,
OLD ARROW
MAKER (1872),
marble, 21½″ ×
13⅝″ × 13⅜″.
National Museum
of American Art,
Smithsonian
Institution. Gift of
Joseph Sinclair.

preparatory course (which offered drawing and watercolor lessons) and then took the college liberal arts program between 1860 and 1863.

Lewis, who later said that she always "liked to make the forms of things" began to make drawings "of people and things" at Oberlin. An 1862 pencil drawing, given as a wedding present to her schoolmate Clara Steele Norton, shows the muse Urania holding a stylus and a globe (probably a copy of an engraving). The subject— a female deity holding the globe in her hands— suggests that Edmonia and her friend shared feminist beliefs.

Lewis lived at the home of John Keep, a supporter of women's rights and abolitionism, and was well liked by her classmates. But a shocking episode showed how thin was the veneer that covered American racism, even in the liberal Oberlin community.

During a school holiday, when two of her closest chums were setting out on a sleighing expedition with gentlemen friends, Edmonia offered them a drink of hot mulled wine before the cold journey. On the way, both girls became violently ill with stomach cramps and did not recover for weeks. Their doctors immediately assumed that Edmonia had poisoned them. Repressed hatreds flared; the town was polarized. One day as Lewis was leaving the house she was seized by a gang of vigilantes, dragged to a nearby field, stripped of her clothing, and severely beaten. She had not yet recovered when she was arraigned in court on murder charges.

Lewis was defended by the brilliant black lawyer John Mercer Langston (later a congressman) who pointed out that there was no real evidence; no tests had been made at the time the girls fell ill. (It is generally believed today that Lewis put the aphrodisiac "Spanish Fly" in the drink as a prank.) When the case was dismissed, Edmonia, still unable to walk without crutches, was carried out of the courtroom in the arms of her cheering supporters.

Lewis later said that she was greatly tempted to return to her life as an Indian, but plucked up her courage and went to Boston, the center of liberal thought, in 1863, carrying a letter of introduction to the abolitionist leader William Lloyd Garrison. She evidently already hoped to become an artist: "I had heard a great deal about Boston and I thought if I went there I should perhaps find means to learn what I wanted to know. So we came here and my brother hired a little room in the Studio Building for me."[57] Garrison introduced her to the neoclassical sculptor Edward Brackett, who gave her a plaster foot to copy in clay and offered criticism and encouragement. She also asked Anne Whitney, who was in the same building on Tremont Street, to give her some lessons.

With very little instruction, the young sculptor modeled a medallion of the Civil War martyr, John Brown. She had won the support of the Boston abolitionists and social reformers, but they were somewhat taken aback by her ways.

They wanted her to fit the mold—to study more, take more time, polish her style. Abolitionist Lydia Maria Child wrote in a letter: "She does NOT take time; she is in too much of a hurry to get to a conspicuous place, without taking the necessary intermediate steps. I do not think this is so much 'self conceit' as it is an uneasy feeling of the necessity of making things to sell, in order to pay for her daily bread. Then you must remember that YOUTH . . . naturally thinks itself capable of doing anything."[58]

Lewis had seen the Civil War hero Col. Robert Gould Shaw—worshiped in Boston—on the day that he marched out of the city at the head of the first Massachusetts battalion of black soldiers, before his early death in battle. When she proposed to make a portrait bust of him, Lydia Maria Child was not encouraging, confiding in a letter to Shaw's mother that she was reluctant to have any "practice hands tried upon his likeness." Fortunately, Lewis pressed ahead despite these objections. Child was "very agreeably surprised" by the result. The bust was shown at the Soldier's Relief Fair of 1864, and approximately one hundred plaster copies were eventually sold, enabling her to buy a boat ticket to Rome, the international center of sculpture.[59]

Before leaving, Lewis went to Child's home to say good-bye, and saw there a book containing four photographs of Colonel Shaw. The young artist was hurt that Child had not loaned them to her while she was working on the portrait. She also saw that Child had sawed off the lower part of the chest on her bust of Shaw, because she thought it looked less awkward that way. Lewis exclaimed, "Why didn't you tell me of that before I finished it? . . . How much you have improved it!"[60] The marble version made for the Shaw family after she moved to Italy shows a noble head, with mustache and goatee, rising above bare shoulders (1867, on loan from the Museum of Afro-American History to the Boston Athenaeum).

One woman who believed in Lewis was Anna Quincy Waterston, daughter of a Harvard president, who raised the funds for the artist's first purchase of marble in Rome and wrote a poem, "Edmonia Lewis," published in the *National Anti-Slavery Standard,* 24 December 1864. Lewis's small marble portrait bust of her benefactor (1866) is in the National Museum of American Art.

When Lewis went to Rome in 1865, she was warmly greeted by Charlotte Cushman (who said "she has more to fight than all the others"), Hosmer, Stebbins, Story, and other abolitionist-minded intellectuals. Unlike her colleagues who hired Italian carvers, Lewis did all her own carving at first, and was even afraid to study with artists in the city because she feared accusations that others were doing her work. Only later did she farm out the carving to artisans. She deepened her skills by copying antique statues which she sold to tourists. The National Museum of American Art has her copy of a bust of *Young Octavian* (c. 1873) and a small version of Michelangelo's *Moses* (1875).

Soon after arriving in Rome, Lewis created two works inspired by the Emancipation Proclamation. Her first was *The Freed Woman and Her Child* (1866, unlocated), described as a kneeling woman wearing a slave's turban and chains and offering prayerful thanks to heaven upon learning that she is free. Her small son clings to her waist. The subject, Lewis said, was "a humble one, but my first thought was for my poor father's people, how I could do them good in my small way."[61]

This was followed by *Forever Free* (1867, Howard University, Washington, D.C.), a muscular freed slave, his foot on a ball and chain, triumphantly lifting an arm with a broken man-

acle. Beside him kneels a smaller Negro woman, her hands clasped in grateful prayer. This was an audacious undertaking; few of the American neoclassical sculptors attempted two-figure compositions even though they had skilled carvers to put their works into marble. Lewis had some difficulties with anatomy and proportions; the male figure seems too large for the female, and the well-modeled heads are large for the bodies. The expressive and emotional power of *Forever Free,* however, transcends its somewhat naive execution.

Lewis then turned to her Indian heritage in several works based on Longfellow's popular narrative poem *The Song of Hiawatha.* In *The Old Arrow Maker and His Daughter* (marble, 1872), Minnehaha is shown as Hiawatha first laid eyes on her—"plaiting mats of flags and rushes," next to her father, who wears an animal teeth necklace, furry breech cloth and moccasins, and holds an arrowhead. A slain deer lies at their feet. This idealized literary image contradicts the portrayal of Indians as brutal savages; it is a representation imbued with nostalgia for a bygone life-style. The flowing forms are plastically modeled, and there is a fine play of texture on the hair, fur, and other surfaces. A small bust of *Minnehaha* (1867) is at the Detroit Institute of the Arts, but *The Wooing of Hiawatha* and *The Marriage of Hiawatha* are unlocated.

Hoping to create a bust of Henry Wadsworth Longfellow, the sculptor waylaid the poet in the streets, trying to imprint his features on her mind. When he finally posed for her in Rome, she had already roughed out a likeness. Longfellow regarded her bust as one of the best likenesses of him (1869–71, Schlesinger Library, Radcliffe, Harvard University Collection).

Lewis's finest work is undoubtedly the life-sized *Hagar* (1875, National Museum of Ameri-

can Art). The Bible tells of Abraham's Egyptian maidservant who bore him a child and then was cast out by his jealous wife, Sarah, to wander in the wilderness. Lewis's *Hagar* looks up to heaven for help, her hands clasped in prayer. An empty urn lying on the ground perhaps symbolizes her thirst or her despair. *Hagar* is beautifully carved, with a fine play of texture—crinkly hair, smooth skin, pitted base. The rendering of drapery is very successful, and the entire figure is filled with rhythmic movement as it moves forward pleadingly.

The African *Hagar* powerfully symbolizes the alienation of black women in white society. Like Hagar, black women in America had been the sexual chattels of the slave owners, and their children had been resented by jealous wives. Lewis said that she was expressing her "strong sympathy for all women who have struggled and suffered."[62]

In 1873, the enterprising artist visited California. She told reporters, "Here they are more liberal, and as I want to dispose of some of my works, I thought it best to come West." At the San Francisco Art Association gallery she showed *Hiawatha's Wedding, Asleep, Awake, Love in a Trap* (a small Cupid caught in a trap), and a bust of *Lincoln.* She then exhibited the unsold works in San Jose. *Lincoln,* and the pairs of infants, *Asleep* (1871) and *Awake* (1872), were bought by a local collector and are now at the San Jose Public Library. Such conceits in pairs were a vogue of the day, also seen in Harriet Hosmer's pair, *Puck* and *Will o' the Wisp.*

At the 1876 Philadelphia Centennial Exposition, Lewis's figure of *Cleopatra,* shown in the throes of suicidal death after being bitten by an asp, was a succès de scandale. One critic wrote: "This was not a beautiful work, but it was very original and . . . striking. . . . The effects of death are represented with such skill as to be abso-

lutely repellent. Apart from all questions of taste, however, the striking qualities of the work are undeniable, and it could only have been produced by a sculptor of very genuine endowments."[63] Since Egypt was symbolic of Africa and the African people, it has been suggested that this image may have been a response to the disappointment of the Reconstruction period, with its aborted dreams of equality. (There was a virulent revival of racism after the Civil War.)

After being listed for sale at the Philadelphia Centennial, *Cleopatra* disappeared for a century, while scholars tried to imagine what it might look like. It resurfaced in the 1980s in a shopping mall storage room in Forest Park, Illinois. The sculpture's picaresque history typifies the neglect of the work of American women sculptors until recent times. *Cleopatra* had been bought by a Chicago gambler and horse fancier, who used it as a grave marker for Cleopatra, his favorite filly, and it remained on his Forest Park racetrack land which became a golf course and then a naval base. It was finally hauled off to a construction company dump in the 1970s when the post office erected a mail center on the site. Cleopatra lay half buried, damaged and covered with graffiti, until it caught the eye of fire chief Harold Adams during a routine inspection: "Believe me, I'm just a simple layman," said Adams, "but the minute I saw her, I knew that statue was something beautiful. She was like a big white ghost lying out there between all that heavy machinery and crying out to be saved."[64]

The Forest Park Historical Society adopted the sculpture, and Dr. Frank J. Orland, the society's president, in conjunction with Dr. Robert Ritner, an Egyptologist, found Lewis's name engraved on the base.[65]

At the height of her career, Lewis's studio was crowded with visitors and she received many commissions from prominent Americans and English royalty. The marquis of Bute reportedly bought a marble altarpiece of a Madonna and

Edmonia Lewis, HAGAR (1875), marble, 52⅝″ × 15¼″ × 17″. National Museum of American Art, Smithsonian Institution. Gift of Delta Sigma Theta Sorority, Inc.

Child with angels. Although charmed by Lewis's friendly manners and picturesque costume—a red fez atop wavy black hair—those around her could never quite see her outside of racial stereotypes. Despite her having been welcomed to Rome by Cushman, Hosmer, and others, she lived in a world filled with the contradictions that arose from her mixed heritage. Perhaps for this reason she, unlike her sister sculptors, entered the welcoming arms of the Catholic church and did a portrait of the Pope. She once said that to her, the Virgin Mary (like her statue of Hagar) represented noble, suffering womanhood.

As neoclassicism went out of style, Lewis received fewer commissions, her last major one being an *Adoration of the Magi* (1883, unlocated) for a Baltimore church. In 1887, the black political leader Frederick Douglass and his wife, on a visit to Rome, found her living in a pleasant room with a panoramic view on an upper floor at 4 Via XX Settembre. She took them on day trips around the city, and Douglass noted, "Here she lives and here she plies her fingers in her art as a sculptress. She seems very cheerful and happy and successful."[66]

Marilyn Richardson, who has done major research on Lewis, located her signature in the guest book for a reception at the U.S. embassy in Rome in 1909, but the actual date of her death is still unknown.[67]

Although Edmonia Lewis's work lacks the conventional polish of some of the other neoclassicists, its themes, expressiveness, and ethnic content have great interest and appeal today. Refusing to be stopped by either racism or the patronizing attitudes of well-wishers, she continued to work, becoming the first major black sculptor in America. For many years her work received little attention and was preserved only in Afro-American museums and black colleges, but today the National Museum of American Art displays it as part of the mainstream of American culture.

Other works are a figure of *Hygeia,* the goddess of health, on the tomb of a woman doctor and reformer, Dr. Hariot Kezia Hunt, in Mount Auburn Cemetery, Cambridge, Mass.; and portraits of Senator Charles Sumner; Ulysses S. Grant; William Lloyd Garrison; Wendell Phillips, president of the Anti-Slavery Society in America; Maria Weston Chapman, head of the Boston Female Anti-Slavery Society; and Charlotte Cushman.

(Maria) Louisa Lander (1826–1923)

> Tis time my friends, we cogitate,
> And make some desperate stand,
> Or else our sister artists here
> Will drive us from the land.
>
> It does seem hard that we at last
> Have rivals in the clay,
> When for so many happy years
> We had it all our way.

—Male sculptors complaining in *The Doleful Ditty of the Roman Caffe Greco,* by Harriet Hosmer[68]

Louisa Lander, a sculptor of American themes, went to Rome with high hopes. But a whispering campaign directed against her ruined her prospects. She spent her long last years as a recluse, living in Washington D.C., with her companion— her life-sized statue of *Virginia Dare.*

Born in Salem, Massachusetts, Lander's first glimpse of sculpture may have been the figureheads on the prows of her family's sailing ships. She was the daughter of ship captain Edward Lander and the great-granddaughter of Elias Hasket Derby, the wealthiest Salem merchant of his day.

When Louisa was seven, the Landers moved to her grandparents' charming mansion, Oak Hill, in Danvers, Massachusetts, where she grew up surrounded by some of the finest early wood

carving in New England. In addition to carved furniture, there were sculptures adorning the ends of the gable roof and a figure of *Plenty* with a cornucopia in front of the house—all by the Skillin brothers and Samuel McIntire, some of America's earliest professional wood sculptors. (Rooms from Oak Hill are reconstructed at the Boston Museum of Fine Arts.)

Louisa's mother and grandmother were talented amateurs, and a distant ancestor was the painter Benjamin West. In this artistic environment, Louisa, "a grave thoughtful child, serious and reserved at all times,"[69] began to model dolls' heads in wax that her mother found remarkable enough to preserve. Soon carving cameos and modeling portraits of her family, the intense girl, by the time she was in her teens, was obsessed with the desire to become a sculptor.

When Lander was eighteen, Thomas Crawford, the first American to live in Rome and create marble neoclassical sculpture, showed his statue *Orpheus* at the Boston Athenaeum and was hailed as an "American Canova." Perhaps Louisa decided at that time to study with him.

Oak Hill was sold after her mother's death, and the Landers moved back to a brick row house in Salem (today a part of the historic Salem Inn). By 1853 she was modeling portraits of notables in Washington, D.C. A bust of her father, described as "very lifelike" was reportedly acquired by the Boston Athenaeum (unlocated). She also attempted two ideal sculptures—a head of the water nymph *Galatea* (before 1855), and *Today,* a bust symbolizing the young American nation, draped in an American flag fastened at the breast and shoulders with stars, and crowned with a chaplet of morning glories.

Accompanied by her father, Lander sailed for Europe in October 1855, carrying an ambrotype of *Today.* She hoped, no doubt, to convince Thomas Crawford to take her on as a student, as

Harriet Hosmer had done with John Gibson.

Stopping en route in London, Lander became fascinated by records at the British Museum that told of the ill-fated Lost Colony in Virginia founded by Sir Walter Raleigh, and of Virginia Dare, the first child of English heritage born in America, who was believed to have been abducted and raised by Indians. She began to think about creating a statue of her.

In Rome, Lander had the honor of being accepted as a student by Crawford. In his twelve-room atelier amidst the Baths of Diocletian, he was working on commissions for the U.S. Capitol that incorporated such American motifs as Indians and pioneers. Perhaps this encouraged Lander to attempt American subjects such as Virginia Dare and Evangeline, the heroine of Longfellow's poem. But her training was short-lived—Crawford died of a brain tumor two years after her arrival.

Lander opened her own studio in Rome. On 21 August 1857, a letter in the *Philadelphia Enquirer* announced that she was working on a three foot statuette of Virginia Dare for a Salem patron, as well as

> an Evangeline ... two thirds the size of life.... The sad heroine of Longfellow's touching story is represented as having thrown herself by the side of a little stream, and, weary with wandering, fallen asleep. The position is graceful and easy, the little bundle fallen from her hand indicates the wanderer; the sorrowing, longing look expressed upon her fair features, even in sleep, is the very ideal of the faithful girl whose trusting love never faltered through all the long years of separation and suffering.... Those who desire to obtain a pleasing piece of statuary, and at the same time to encourage a youthful artist, should remember this embodiment of the fairest creation of our favorite poet.[70]

Author Elizabeth Ellet thought Lander had expressed Longfellow's lines perfectly:

> Fill'd was her heart with love, and the dawn of
> an opening
> heaven lighted her soul in sleep with the glory
> of regions celestial.

In 1858 when her fellow Salemite, Nathaniel Hawthorne, visited Rome, Lander immediately called on him at the Palazzo Larazani and invited him to sit for a bust. On 15 February, Hawthorne came for his first sitting. According to Hawthorne's son, Julian, Lander had a long, narrow, sallow face and sharp eyes, and usually displayed a grave and serious manner. Hawthorne, though, found her fascinating. She wore a picturesque studio costume, "a sort of pea-jacket buttoned across her breast, and a little foraging cap, just covering the top of her head." Startled by the bareness of the studio and the unconventional life that Lander was leading, he nevertheless was favorably disposed toward his fellow townswoman:

> Today has been very rainy. I went out in the forenoon and took a sitting at Miss Lander's studio, she having done me the honor to request me to sit for my bust. Her rooms are those formerly occupied by Canova; the one where she models being large, high, and dreary from the want of carpet, furniture, or anything but clay and plaster. A sculptor's studio has not the picturesque charm of a painter's. . . . Miss Lander . . . appears to have genuine talent, and spirit and independence enough to give it fair play. She is living here quite alone in delightful freedom, and has sculptured two or three things that may probably make her favorably known. "Virginia Dare" is certainly very beautiful.

> During the sitting, I talked a good deal with Miss Lander, being a little inclined to take a similar freedom with her moral likeness to that which she was taking with my physical one. There are very available points about her and her position; a young woman, living in almost perfect independence, thousands of miles from her New England home, going fearlessly about these mysterious streets, by night as well as by day, with no household ties, no rule or law but that within her; yet acting with quietness and simplicity, and keeping, after all, within a homely line of right.[71]

Lander was evidently somewhat insecure as an artist because she asked Hawthorne not to look at the bust after the sitting. ("Of course I obeyd; though I have a vague idea of a heavy-browed physiognomy, something like what I have seen in the glass.")

Hawthorne continued to muse about her life, so different from the confined existence of women at home. Indeed this encounter may have been the inspiration for the free-spirited women artists in his novel *The Marble Faun*: "Miss Lander has become strongly attached to Rome and says that when she dreams of home, it is merely of paying a short visit, and coming back before her trunk is unpacked. This is a strange fascination that Rome exercizes upon artists: I think it is the peculiar mode of life, and its freedom from the inthralments of society, more than the artistic advantages which Rome offers."[72]

Hawthorne posed frequently between February and April. The artist was a dinner guest at his home and went on outings with the Hawthornes, and he noted that she dropped in to chat one night "after all had gone to bed."[73] He listened to her views about sculptors; for example, she claimed that Joseph Mozier had plagiarized the composition of his group *The Prodigal Son*

Louisa Lander, BUST OF NATHANIEL
HAWTHORNE (1858), marble.
Concord Free Public Library.
Presented to the library by the
children of Hawthorne.

from a student work on display at the French
Academy. Interestingly, Miriam, the haunted
woman artist in *The Marble Faun*, jokes that all
the sculptors are "plagiarists."[74]

When the clay model was finished, Hawthorne
wrote exuberantly to his publisher Ticknor that
it was "Excellent . . . even Mrs. Hawthorne is de-
lighted with it." John Gibson and others had also
praised it. He urged his publishers to help Lan-
der secure commissions during her forthcoming
visit to America.[75]

Lander left the model to be put into marble by
her Italian carver and returned to America for
the summer. After modeling several busts, in-
cluding a posthumous one of *Governor Chris-
topher Gore* (based on John Trumbull's portrait)
for Harvard University, she returned to Rome in
November full of enthusiasm, with several casts
to be put into marble. But she found her situation
sadly changed. Hawthorne refused to admit her

when she and her sister repeatedly left calling
cards.

What was the "crime" that made her former
patron suddenly shut his door against her?
Sculptor John Rogers, Louisa's young cousin,
studying in Rome, gives some hints in a letter to
his father:

> I don't know the whole story but there have
> been stories in circulation affecting Louisa's
> moral character—some of her friends have
> turned the cold shoulder to her and cut her in
> the street, whilst a few have formed themselves
> into a committee to try and unravel the story.
> They have been at work for the last week but
> don't seem to clear it up yet. . . . It will make
> Rome a disagreeable place for her even if the
> committee are satisfied . . .
>
> She has the reputation of having lived on
> uncommonly good terms with some man here.
> She is very vain of her figure and a number of
> respectable people affirm that she has exposed
> herself as a model before them in a way that
> would astonish all modest yankees—I suppose
> there is not much doubt of that part of the story
> and it probably forms the foundation of all the
> rest. . . . If I had been in her place such a loss of
> reputation would have killed me I believe but
> she snaps her finger at all Rome and has not
> the least desire to leave.[76]

Rogers later visited Lander's studio and found
her struggling to survive:

> If I had a quarter of the pluck that our artistic
> cousin has I should be all right. . . . people don't
> come to [her] studio as they used to. . . . I don't
> think she has sold anything yet but her little
> Virginia Dare—she has made a figure of
> Evangeline and put it in marble which is not
> sold—a bust of Hawthorne which is very good
> but he does not notice her now and I don't know

whether he will take it or not. She is modeling a large Virginia Dare which she is having put into marble but it is not ordered and she has another little figure two or three feet high in marble and she is going to model an *Undine* on an uncertain order from Mary Warren. It is all money out of pocket.[77]

To add to her troubles, according to Hawthorne's son, Julian, a curious mishap had occurred to Lander's bust while she was in the United States. A presumptuous critic, "a cultured man," had visited her Rome studio during her absence and took it upon himself to instruct the marble carver to "correct" the lower part of the face.[78] As might be expected, this spoiled the likeness, and the Hawthornes were upset with the result when they looked at the completed bust.

In a complete turnabout, Hawthorne now wrote to his friend Fields, publisher of the *Atlantic Monthly,* that the bust was "not worth sixpence," but he felt obligated to pay for it—"she did her best." Adding that he had cut off all communication with her "for reasons unnecessary to mention," he asked Fields to make the payment for him.[79]

Was Louisa Lander, like Hester Prynne in Hawthorne's *Scarlet Letter,* branded with an "A" by the gossiping American art colony in Rome? If so, Hawthorne, in real life, failed to display the compassion and understanding he showed toward his fictional heroine. He was evidently embarrassed that he had had such a close association with a "fallen woman." Sophia Hawthorne, in editing her husband's notebooks after his death, obliterated all mention of her name, and not until 1980 was it included in an unexpurgated edition. It seems possible from this sequence of events that Hawthorne was thinking of Louisa Lander when he created the character Miriam, a woman artist haunted by guilt, in his novel *The Marble Faun.* And who were the "respectable people" who allowed the artist to pose for them and then used it in a vicious attack against her? Lander's career was damaged by the same kind of tongue-wagging that accused Vinnie Ream of using "women's wiles" to get the Lincoln commission and forced Harriet Hosmer to wage a libel suit. The men in Rome did not take easily to female competition, and no doubt their wives felt threatened by the free lives of these female pioneers.

Writing in 1859, author Elizabeth Ellet (probably unaware of the storm around Lander) listed a number of works by "the gifted young artist": "'Undine' . . . a drooping figure with an expression full of sadness, just rising from the fountain to visit earth for the last time. The base . . . is surrounded by shells forming water-jets; . . . She has also finished a "Ceres Mourning for Proserpine." The goddess is leaning upon a sheaf of wheat; her hands and head are dropping as if she were planning her daughter's escape."[80] Ellet also mentions an airy sylph looking at a butterfly and *Elizabeth, the Exile of Siberia,* a spirited, picturesque figure in short cloak, Prussian boots, and close-fitting cap.

After an 1859 trip with her sister to St. Petersburg, Russia (where she probably modeled the bust of Pickens, American minister to that city), Lander finally left Rome and returned to Salem. In 1860, *Evangeline* and the bust of *Hawthorne* were shown at Boston's Williams and Everetts Gallery and in a group show at New York's Dusseldorf Gallery. A reviewer in *Harper's Monthly Magazine* of May 1860 attacked the *Evangeline* as "a marble image of a puny girl lying asleep and expressionless among elaborately chiselled flowers" but praised the Hawthorne bust: "Although the execution seems to be somewhat crude and clumsy, there is certainly a vital like-

ness of the individual and of the character.... Hawthorne's head has a singular resemblance to that of Webster. It is the Websterian head refined, poetized, idealized" (pp. 345–46).

Back in Salem, Lander awaited the arrival of her chef d'oeuvre, the life-sized *Virginia Dare,* which had been put on a boat at Leghorn, Italy. Alas, the furies were now pursuing both Lander and her statue. The boat was wrecked off the coast of Spain. After a two-year delay the sculpture was fished out of the water and sent to America where Lander was forced to buy it back, at considerable expense, from the insurance underwriters and then laboriously repair the badly damaged work. By this time the Civil War had broken out, so she exhibited it in Salem for the benefit of wounded soldiers.

When *Virginia Dare* was shown with other works (*Galatea, Today, Maude Muller,* a bust of *Hon. F. Pickens and Lady* and other busts) in Room 7 at the Studio Building, Boston, it was touted as "The National Statue," indicating that Lander was very conscious of the American theme, and perhaps hoped it would be bought for a public building. But the ill-fated statue narrowly escaped destruction from a gallery fire, and after a prominent New York collector finally bought it (reportedly for $5,000), he died and his heirs refused to honor the purchase. *Virginia Dare* reverted to its owner.

The embittered artist moved to Washington, D.C., where she lived reclusively, spending each summer at Beach Bluff, Massachusetts. She made one last attempt to sell her statue to the organizers of the North Carolina pavilion at the 1893 Chicago World's Columbian Exposition, but the deal fell through for lack of funds. After this, Lander seems to have abandoned her career and faded into obscurity.

Patriotic North Carolina citizens, including the women's rights advocate Mrs. Cotten, finally vis-

Louisa Lander, VIRGINIA DARE (1860), marble. Elizabethan Gardens, Roanoke Island, N.C. Photo courtesy Dare County Tourist Bureau, Manteo, N.C.

ited her in Washington and persuaded her to give the statue to the state where Virginia Dare was born. The artist agreed, but it remained with her until her death. She reportedly regarded it as a kind of companion in her old age.

Even after Lander's death, the mishaps concerning the statue continued. It was stored in a government basement and then put on display in a government office where it was desecrated with lipstick and eyebrow pencil. It was moved about until at last it reached a perfect resting place. Today it stands peacefully in the Elizabethan Gardens on Roanoke Island, North Carolina, the site of the lost colony.

Virginia Dare is the only one of Lander's major ideal statues that has come to light. As in much nineteenth-century literary sculpture, viewers were expected to know the story when they looked at it.

Soon after the birth of Virginia in 1587, the governor of the Roanoke colony sailed for England to procure supplies, but on his return, the settlement had vanished. The infant and her mother were reportedly carried into captivity by the Indians. "After this, European features could be traced in the Indian lineaments."[81]

According to legend, Virginia Dare was raised as an Indian princess and that is how Lander portrayed her. The artist explained that she was creating a symbol of the new nation, born of the melding of British culture and the American wilderness:

> The Anglo-Indian princess stands on the sea beach, the waves rippling at her feet; her hair is bound with eagles' feathers; a fishing net of English manufacture, which unites the civil with the barbaric life, is carved to the nicest degree of accuracy, and hastily gathered up, hangs in graceful folds around her; a necklace and armlets of wampum beads are her sole

ornaments; and by her side stands her pet bird, one of the sea beach cranes (modelled from nature) fondly sheltering itself under the folds of the net.[82]

The statue displays "in her erect attitude and beautiful form, the fearless dignity and grace that such a life would impart. The head and face [exhibit] the thoughtfulness and spirituality that would naturally be derived from the dreamy recollections of her early life."[83]

Like Hiram Powers's *Greek Slave* and Erastus Palmer's *White Captive*, Lander's sculpture portrays noble white womanhood in the hands of "heathens." But whereas their versions show women as martyrs and delectable victims, Lander's heroine stands proud and strong, happy in her situation. Somewhat massive in its forms and partially draped, *Virginia Dare* has an aura different from her counterparts, whose Lolita-like prurience pulsates beneath the Christian symbolism. Clearly Lander was capitalizing on Powers's success with *The Greek Slave,* which was also put forward as a symbol of America: "The figure is of life size, five feet five and a half inches in height, and is somewhat larger than the Greek Slave of Powers, indicating Virginia's English origin, the type of English women being larger ordinarily than even our own."[84] Lander was very conscious of the "American" character of her subject: "This design . . . shows that we have in our own country, rich subjects of sculpture without resorting to the old heathen mythology for them."[85]

The pose owes a debt to the *Venus de Medici* in the Uffizi Gallery, except for the draped fishnet, whose arabesques sweep upward, echoed in the curves of hair, necklace, arm bracelet and base. Contrasting with the smooth body are textures of hair, bird feathers, and the intricately carved fishnet—a tour de force similar to that

found in Paul Akers's *Dead Pearl Diver* and Barbee's *Fisher Girl,* both of which were shown alongside her work at New York's Dusseldorf Gallery.

We can only conjecture about the artist's other literary sculptures. Mentioned in the 1872 Boston catalog is a six-foot *Pioneer Captive Mother and Daughter.* Whether this was ever completed is not known.

In Lander's *Hawthorne* bust (1859, marble, Concord Library; plaster, Essex Institute, Salem), the eyes and heavy brow convey the brooding intensity of the model. *Governor Christopher Gore* (described as weak in structure by art historian Wayne Craven) is in Harvard's Memorial Hall, and two cameos and a bust of Virginia Dare are at the Essex Institute. A Salem obituary mentions that Lander was also a painter who completed a portrait of tycoon J. P. Morgan.

Louisa Lander's career was cut short by sexism and slander. Vinnie Ream and Harriet Hosmer knew how to marshal allies against false accusations, but Lander was unable to deal with Victorian prudery. Her brother, Frederick Lander, who became a general, and was killed in action during the Civil War before he could see the full-sized version of *Virginia Dare,* had had high hopes for his sister's career. His poetic tribute to her patriotic art seems poignant in the light of later events:

Virginia Dare

Here view the grace that woman's hand
 can lend
to all ye love. Who, where eternal Rome
Bids artist souls to loftier themes ascend,
Could mould the tale of dear Virginia's home,
And love her native land beneath a foreign
 dome.[86]

Emma Stebbins (1815–82) was over forty when she began her career as a sculptor. She created one of New York's best-known monuments, *Angel of the Waters* in Central Park.

A New Yorker raised with all the advantages of wealth and gentle rearing, Emma was the daughter of Mary Largin and John L. Stebbins, president of the North River Bank. Her parents and her brother, Henry (head of the New York Stock Exchange), encouraged her talents.

At first an amateur who delighted her friends with portrait sketches and drawings made for charity bazaars, her talent soon attracted the attention of Henry Inman, a leading New York portrait painter. After studying oil painting at his studio, her work improved rapidly and before long she had lost interest in the customary social whirl of a young debutante, resolving instead "on an exclusive consecration of her talents to art, making it the sole business of her life."[87]

Among her early works was an illuminated volume of her poems, *A Book of Prayer.* Elected an associate of the National Academy of Design in 1843, she exhibited *A Portrait of a Lady* (1845) and crayon portraits (1855) and showed copies of oil paintings at the Pennsylvania Academy (1847).

In 1857, with her brother's backing, she left for further training in Rome. There, at the age of forty-two, she was inspired to try sculpture for the first time. John Gibson gave her criticism and advised her to study with Paul Akers, an American sculptor from Maine. Harriet Hosmer, Akers, and Stebbins became a friendly trio, meeting frequently for lunch.

Stebbins soon met Charlotte Cushman, whose Saturday night open house attracted many of the luminaries of the Anglo-American colony in Rome. According to biographer Joseph Leach, the actress was recovering from the breakup of a long-standing friendship with Matilda Hays.

Her protégée Harriet Hosmer had proved to be unpleasantly independent. She saw in Stebbins a woman whose career she would like to champion, and they immediately became close friends:

> The friendship that grew between them was a bond between two aggressive talents, creative minds and sensibilities that fully knew the scope of their powers. By the time they returned from an Easter excursion to Naples, Charlotte and Emma knew they would plan their lives together. They donned black bowler hats for their daily rides in the Borghese, for picnics of red wine and cheese under the pines. Often at night they went with other Americans to view the sculpture in the Vatican museum by flickering torchlight, a trick that made the antique carvings come luminously alive.[88]

Stebbins's earliest sculpture, a biblical statuette of *Joseph* as a young boy, showed a "most noble simplicity"[89] and was exhibited at the 1865 Dublin International Exhibition. A similar *Samuel* (1868, Chrysler Museum, Virginia) is depicted as a cherubic child with a drape covering his nudity. One of Stebbins's first commissions was a bust of *Charlotte Cushman* (1859–60) intended as a gift for E. P. Shepherd, the man who had first encouraged the actress when she was a young girl. It was donated by Shepherd's daughter to Boston's Handel and Haydn Society and at least three other copies were made.

August Heckscher, the coal-mining tycoon, ordered a pair of marble statuettes portraying *Industry* (1860) as a miner wearing a cap with a lamp on it and holding a pick over his shoulder, and *Commerce* (1860) as a sailor, symbolic of international trade. These graceful and innovative figurines, now at the Heckscher Museum, Huntington, New York, are among the first American neoclassical allegorical figures shown as modern subjects in modern dress.

Cushman promoted Stebbins's work. She wrote to publisher James Fields that the sculptor had made "a lovely little figure of the angel of youth ... and a colossal head of *Lucifer* ... which is full of power and ought to be ordered by somebody at home."[90] During an acting engagement in Boston, Cushman learned at a dinner party of a forthcoming commission for a statue of Horace Mann. Discovering that Mrs. Horace Mann was one of the jurors, she plied her with tickets to her plays and praised her friend's work at every opportunity.

Stebbins was, of course, ecstatic when she received the commission, but Cushman, looking at the contract, realized that there was no mention of payment. Concluding that this might be because Stebbins was a woman, the feminist energetically set about raising funds and was gratified when the full sum for the casting was raised, with money left over for the artist.

Stebbins's bronze of the great educator *Horace Mann*, sometimes called "the apostle of female education," stands before the State House in Boston, draped in a voluminous Roman cloak that covers his modern clothes. He holds a book in his left hand, and his right hand beckons all who pass to enter the life made possible through education. Harriet Hosmer was hurt when this plum went to the newcomer, Stebbins.

In 1860 Stebbins pleased the New York collector Marshall O. Roberts with a bas-relief showing *The Treaty of Henry Hudson with the Indians*. The following year he commissioned a life-sized marble *Columbus*, which was unveiled at Central Park and 102d Street in 1867. Upstaged when the later grandiose *Columbus* was installed at Columbus Circle, Stebbins's statue was put in storage for many years and then reinstalled near the Bowery, where it suffered greatly from vandalism. Finally in 1971,

Emma Stebbins, CHRISTOPHER COLUMBUS
(1867), marble. Brooklyn Civic Center.
Collection of the City of New York.
Photo: © Shoshana Rothaizer, 1987.

perhaps because of the growing appreciation of
women's work at that time, it was resurrected on
a new pedestal in front of the courthouse at the
Brooklyn Civic Center.

Stebbins's best known commission, her *Angel
of the Waters* for Bethesda Fountain in Central
Park, was installed in 1871. No doubt the pres-
ence of her brother, Henry Stebbins, on the Cen-
tral Park Commission did not hurt her chances
in the competition, and the family may have as-
sisted her with the expense of casting it in
bronze in Munich. This splendid monument, re-
cently restored, has always been a focal point in
the life of the city, a place where people congre-
gate and relax under the soothing gaze of the
flying angel, near the cool sprays from the
fountain. According to the Bible, the angel
miraculously infused Bethesda Pool with healing
waters. Cherubs around the ornamented base
represent *Health, Temperance, Purity, and
Peace.*

Stebbins's devotion to Charlotte Cushman was
such that when her friend was battling an ulti-
mately fatal breast cancer, she followed her back
to America, put aside her own career, and did
everything in her power to make Cushman's last
years as happy as possible. The two women set-
tled in a villa in Newport, Rhode Island, from
where Cushman toured the country, making a
last sensational comeback in the theater. After
Cushman's death in 1876, Stebbins wrote a sen-
timental memoir, *Charlotte Cushman: Letters
and Memories.* She did little work after this and
died six years later in New York.

The mention above of the connections that
made it possible for Emma Stebbins to pursue a
successful career in no way minimizes the qual-
ity of her well-designed and executed sculpture.
On the contrary, insight into the forces and fac-
tors that made it possible for her to produce her
work illuminates the waste of other female tal-
ents through the centuries. Few women were

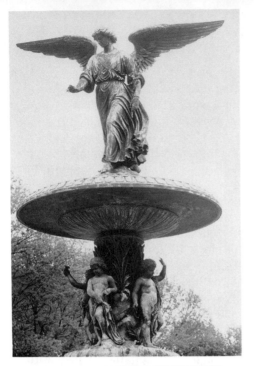

Emma Stebbins, ANGEL OF THE WATERS (unveiled 1873), bronze. Bethesda Foundation, Central Park, N.Y. Collection of the City of New York. Photo: © Shoshana Rothaizer, 1987.

lucky enough to have such support networks, and their contributions were lost to society.

Stebbins's notebooks in the Archives of American Art show *The Lotus Eater,* a beautiful youth crowned with leaves, holding a branch; studies for two allegorical groups intended for the gates of a reservoir (one is a seated Queen of the Sea grasping a trident, with two reclining male river gods at her feet holding cornucopias of running water); a winged angel *Sandalphon,* holding a garland of flowers; and an armored figure, *Satan Descending to Tempt Mankind.* In 1863 the Central Park Commission ordered four studies of *The Seasons,* intended for the steps descending from the mall in Central Park. A bust of her brother, John Wilson Stebbins, is at the New York Mercantile Society. She also drew a portrait of Harriet Hosmer.

Vinnie Ream (Hoxie) (1847–1914)

She knew nothing of the European storehouse of stereotyped remarks and salted drivel. Her own conversation was new; a breath of the independence of the great Republic swept through it. She was no fine lady, she was an *American girl,* who had not attained her rank by birth or through inherited riches, but had fought for it herself with a talent that had made its way to the surface without early training, through days and nights of industry, and a mixture of enthusiasm and determination.

—Georg Brandes[91]

In an encounter that seems straight out of Henry James, Georg Brandes, a Danish critic, met Vinnie Ream in Italy, where she was finishing her statue of Abraham Lincoln for the U.S. Capitol, and saw in her the embodiment of the new American woman and the mythic American West. For Ream was born in a log cabin to poor parents in the then tiny village of Madison, Wisconsin, on the edge of Indian territory, yet she became a prominent sculptor, the first woman to receive a public commission from the federal government. She accomplished this through a combination of talent, courage, and a shrewd instinct for making good use of her connections.

Her father was mapping the wilderness for the Office of the U.S. Surveyor General. In subsequent years the family moved frequently to sparsely settled locations in Kansas, Missouri, and Arkansas. Despite this hard life, Vinnie remembered a barefoot, carefree prairie childhood and loving parents who encouraged her talents.

She was still a small child when her father bought her a guitar and she taught herself to play it. She subsequently learned to play the piano and harp, composed music to her own lyrics, and played and sang at church and charity functions. (In later life, as a well-to-do Washington society matron, she played the harp at musicales in her home.)

Ream's talents began to flower when she was sent to the Academy, a division of Christian College in Columbia, Missouri, for students up to the age of twelve. It was here that teachers discovered her gifts for poetry, music, and art; in fact, one of her paintings was selected to hang on the wall of the college administration building.

At the Academy, Vinnie met James R. Rollins, a trustee of the college, who was so impressed with her talent that he urged her to study art. Rollins later became a congressman and played an important role in her life. This encounter was not solely an accident, however. Again and again, wherever she went, Vinnie showed the ability to elicit support from people in high places.

In Fort Smith, Arkansas, Vinnie's father, now suffering from rheumatism, went into the real estate business. Young Vinnie spent many hours in the family study, reading books and studying music and art. A vivacious teenager, she began to attract admirers, who clustered around her at family musicales. Two suitors of Cherokee Indian descent became lifelong friends. Cornelius Boudinot, attorney and Indian activist, later named the town of Vinita, Oklahoma, after her, and John Rollin Ridge, poet and journalist, dedicated many poems to her. Ream's respect for Native Americans remained with her and was reflected in her last sculpture, *Sequoya,* the Cherokee Indian leader, in the U.S. Capitol.

After the Civil War broke out, the family moved to Washington, D.C. Times were hard, and Vinnie, at the age of fifteen, went to work as a post office clerk. In order to make ends meet, the Reams took in a boarder, Senator Edmund G. Ross, whom they had known in Kansas. Ross also helped Vinnie's career.

On Pennsylvania Avenue, Ream ran into her Missouri mentor James Rollins, now a congress-man. One day he took her to visit sculptor Clark Mills's studio in the U.S. Capitol. The moment she saw Mills working, Ream blurted out with characteristic impulsiveness, "I can do that." Mills threw her some clay, which she took home and modeled into an Indian head medallion. The sculptor was so impressed he invited her to become his student-assistant.

While continuing with her post office job, Ream studied and worked for a year in Mills's studio, where such Washington notables as Representative Thaddeus Stevens and senators Nesmith, Yates, and Voorhees posed for her. Ream had seen Abraham Lincoln walking in the street in his shawl and stovepipe hat, and longed to model a portrait of him. When she expressed this ambition to Rollins, he and Senator Orville Browning approached Lincoln about it. Lincoln, however, hated to pose, regarding it as a waste of time. But when Vinnie's sponsors told him that she was "a poor girl from the West," he consented to give her half-hour sittings while he worked at his desk. Ream described these sessions:

> I was a mere slip of a child, weighing less than ninety pounds and the contrast between the raw boned man and me was great. I sat in my corner and begged Mr. Lincoln not to allow me to disturb him. He seemed to find a sort of companionship in being with me, although we talked but little. His favorite son Willie had just died and this had been the greatest personal loss in his life. I made him think of Willie and he often said so and as often wept. I remember him especially in two attitudes. The first was with his great form slouched down into a chair at his desk, his head bowed upon his chest, deeply thoughtful. I think he was with his generals upon the battlefields, appraising the

horrible sacrifices brought upon his people and the nation. The second was at the window watching for Willie, for he had always watched the boy play after school at that window. Sometimes great tears rolled down his cheeks. . . .

I think that history is correct in writing about Abraham Lincoln to describe him as a man of unfathomable sorrow. That was the lasting impression I always had of him. It was this that I put into my statue. . . . when he learned that I was poor he granted me the sittings for no other purpose than that I was a poor girl. Had I been the greatest sculptor in the world, I am sure that he would have refused at that time.[92]

Ream had completed her bust of Lincoln, and was reportedly pasting clippings into a scrapbook on the evening of 14 April 1865, when she learned that the president had been assassinated. The city was in turmoil, and Ream herself was for a time almost prostrate with grief.

When a competition was announced for a memorial to the martyred leader, several of Ream's friends in Congress urged her to submit a model. There was a great deal of resistance to the idea of an inexperienced eighteen-year-old attempting such an important project, but Ream managed to win supporters. Four months before the decision was made, they submitted a letter attesting to her ability, signed by President Andrew Johnson, Gen. Ulysses S. Grant, 31 senators, and 114 House members, including Rep. Thaddeus Stevens whose bust she had modeled.

After Ream received the commission there was a storm of protest. Senator Jacob Howard said that he would as soon expect a woman to write *The Iliad* or lead an army as to execute such a work: "I will go further, and say, having in view her sex, I shall expect a complete failure in the execution of her work."[93]

One of her most vicious critics was Mrs. Jane

Grey Swisshelm, an influential journalist who wanted Harriet Hosmer to get the commission: "Miss Ream . . . is a young girl of about twenty who had been studying her art for a few months, never made a statue, has some plaster busts on exhibition, including her own, minus clothing to the waist, has a pretty face, long dark curls and plenty of them. . . . [She] sees members at their lodgings or at the reception room at the Capitol . . . sits in the galleries in a conspicuous position and in her most bewitching dress, while those claims are being discussed on the floor, and nods and smiles as a member rises." Art historian Joan Lemp points out that the attacks were not only due to sexism; the New York-Boston establishment wanted to preserve its hegemony and objected to the encroachment of a midwesterner.[94]

But her friends in Congress defended her ability and her honor, and after a protracted debate the commission was confirmed. While she worked on the Lincoln model in a room in the Capitol, Ream found herself embroiled in politics. When her friends in Congress voted against impeachment of President Johnson, pro-impeachment forces accused her of using influence on his behalf and almost closed the studio. It took a major effort, led by Thaddeus Stevens, to reopen it and save the Lincoln model from destruction.

The usual accusations of plagiarism that have historically plagued women artists were leveled at Ream; it was rumored that Clark Mills had done the work. A journalist came to her defense in the *Midland Monthly* of August 1871, stating that he had watched Ream at work on the Lincoln statue and had seen many portrait busts by the artist. "Can it be possible," he wrote, "that Senator Sherman, Greeley and a dozen other celebrities did not know to whom they were sitting—a man or a woman?" Mills had to write a letter denying any part in the work.

After receiving $5,000 for her plaster model, Vinnie, accompanied by her parents (now totally dependent on her earnings), went to Italy to have the Lincoln put in marble. She took advantage of the opportunity to visit several cities on the way. In Paris the melodramatic artist Gustave Doré, who was so pressured by visitors that he was very particular about whom he admitted to his studio, invited her to sit up on the scaffold with him to observe his technique at close hand. Ream and Doré, with similar impulsive temperaments, hit it off. Doré confessed to a suicidal melancholy underneath his exuberant exterior, and as a parting gift the cynical artist quickly drew a sketch of a skeleton aiming a bow and arrow and wrote beneath it the title "love."[95]

Ream studied drawing with Léon Bonnat and visited Père Hyacinthe, the unorthodox cleric, at the convent of Passy on the outskirts of Paris. There she found him in a coarse gown, barefoot with shaven head, in an uncarpeted bare room. Although at first he was inclined to think that the rules of his Carmelite order would not permit him to sit for his bust, he agreed to do so the next day. Ream repeatedly broke down resistance and charmed the most hostile sitters.

In Munich she and her father visited the elderly painter Wilhelm Kaulbach. In the small crowded studio filled with cartoons of his mythological and historical murals, the artist, in shirtsleeves and wearing wig and cap, greeted her with a hearty "So this is my little colleague!" While Kaulbach and Ream's father (a Pennsylvania German) conversed animatedly in German, she modeled a medallion of the artist's head. Kaulbach gave her letters of introduction to artists in Rome.

Ream was warmly received in that city by sculptors Randolph Rogers, William Rinehart, Joseph Mozier, William Wetmore Story, Harriet Hosmer, and Emma Stebbins. She studied with the Italian Luigi Majoli, whom she regarded as the finest sculptor in Rome. Painter George Healy's studio was in the adjoining house, and he and Story were among her best friends and most judicious advisers about her work. Story, who employed twenty-five artisan assistants, selected the workman for her *Lincoln* and suggested slight alterations in the drapery on one arm. He then declared that he would stake his reputation on the statue, and Healy, who had painted a portrait of Lincoln, praised it highly.

Ream had an instinct for public relations. Said the Washington *Weekly Star,* "After she had secured a room and mounted her model in it, Miss Ream gave a reception and her studio was crowded for two or three days by the artist fraternity in Rome, and by the leading people there; and the admiration and sympathy of the people for the courageous young American artist was exhibited by the daily contribution of colorful flowers for the decoration of her studio."

Il Buonarroti, the art journal of Rome, generally severe in its judgments and condescending to American artists, praised Ream's *Lincoln:*

> A semi-colossal statue of Abraham Lincoln in plaster . . . by a young lady artist was on exhibition a few days ago in her studio at number 45 Via de San Basilia. . . . Miss Vinnie Ream . . . has most justly perceived how a monumental statue of President Lincoln should be represented so that . . . posterity might form a just idea of the man who . . . while . . . engaged in carrying on the greatest act of reparation to humanity, fell a victim to a blind fanaticism.
>
> Therefore, Lincoln is represented serious, calm, melancholy, standing erect, dressed in the costume of the times, yet rendered artistically . . . by the combination of the folds, naturally formed by the movement of the person, and enriched with the gracefully falling cloak which nearly covers the whole back part of the figure. He holds with his right hand a paper . . . on

Vinnie Ream, SAPPHO (c. 1870), marble, 66⅜" × 23⅞" × 21". National Museum of American Art, Smithsonian Institution. Gift of General Richard L. Hoxie.

whose folds can be read words referring to the abolition of slavery. He looks at the document and one can almost read his intention to consign to that solemn act his future fame and immortality.... A brilliant career in art attends Miss Vinnie Ream, who so young, has produced the great work we have described.[96]

While the workmen were putting the plaster Lincoln into marble, Ream was working on a life-sized figure of the Greek poet *Sappho* (marble, 1865–70, National Museum of American Art), and *Spirit of the Roman Carnival,* a seated girl holding a garland of flowers (Wisconsin State Historical Society)—both greatly admired by her colleagues. She had brought with her plaster models of two early works, *Miriam's Song of Triumph,* the Old Testament prophetess dancing in swirling drapery with a tambourine, and *The West,* a barefoot girl with a star on her head, in draperies "swept by the prairie winds." In her right hand is a surveyor's chain, and in her left a compass, indicating the work of laying out the western lands. At her feet a broken bow and arrow represents the vanquished Indians, and a sheaf of wheat symbolizes the coming of agriculture. This statue stands today in a circular alcove in the Wisconsin state capitol. She also obtained sittings from the melancholy *Franz Liszt* in Rome.

On the train from Carrara, where she had been selecting marble, Ream met the Danish litterateur, Georg Brandes and, in her usual uninhibited manner, struck up a conversation with him and continued the friendship in Rome. He left a vivid picture of the dynamic young artist at the height of her career:

> She was a true artist, and a true woman, and I have never, in any woman, encountered a will like hers. She was uninterruptedly busy. Although, now that the time of her departure was so near, a few boxes were steadily being

packed every day at her home, she received every day visits from between sixteen and twenty-five people, and she had so many letters that I often found three or four unopened ones among the visiting cards.... Every day she sat for a few hours to the clever American painter Healy, who ... called her abilities genius. Every day she worked at [Cardinal] Antonelli's bust. To obtain permission to execute it she had merely, dressed in her most beautiful white gown, asked for an audience of the dreaded cardinal, and had at once obtained permission [Antonelli never gave sittings]. Her intrepid manner had impressed the hated statesman of the political and ecclesiastical reaction.... But besides modeling the cardinal's bust, she put the finishing touches to two others, saw to her parents' household affairs and expenses, and found time every day to spend a few hours with me, either in a walk or wandering about the different picture-galleries.[97]

After a busy day she worked at her sculpture

with feverish eagerness ... and kept on, by candle-light, until three o'clock in the morning.... She was very ignorant of things outside her own field and the words *my work* were the only ones that she spoke with passion.

Rather small of stature, strong and healthy ... with white teeth and red cheeks, quick in everything ... at the same time she was unsuspecting and generous, and in spite of her restlessness and her ambitious industry, ingratiatingly coquettish towards anyone whose affection she wished to win.... it was amusing to watch the manner in which she dispatched the dutifully sighing Italians who scarcely crossed the threshold of her studio before they declared themselves. She ... dismissed them with a jest.

He later recalled this "Daisy Miller" of sculpture:

I am grateful to her, she has communicated to me a something good and simple that one cannot see too much and one scarcely ever sees at all.... she has shown me ... the spectacle of a human being ... without a trace of bitterness, an intellect whose work is not a labour.... There was a certain deep note about all that her heart uttered. She had a mind of many colours. And there was the very devil of a rush and Forward! March! about her, *always in a hurry.*[98]

Ream's personality was further revealed in the following entry:

Her opinion of me was that I was the most impolitic man that she had ever known ... made ... more enemies all the time. She herself won the affection of everyone she wished and made everyone ready to spring to do her bidding. She pointed out to me how political she had had to be over her art. When she had wished to become a sculptor, everyone in her native place had been shocked at the unfemininity of it, and people fabled behind her back about her depraved instincts. She ... let people talk as much as they liked, took no revenge on those who spread calumnies about her, showed the greatest kindness even towards the evil-disposed, and so, she said, had not an enemy. There was in her a marvellous commingling of determination to progress rapidly ... and of real good heartedness.[99]

Ream returned to Washington for the January 1871 unveiling of *Lincoln.* Wisconsin senator Matthew H. Carpenter expressed the general opinion when he said: "What Praxiteles might

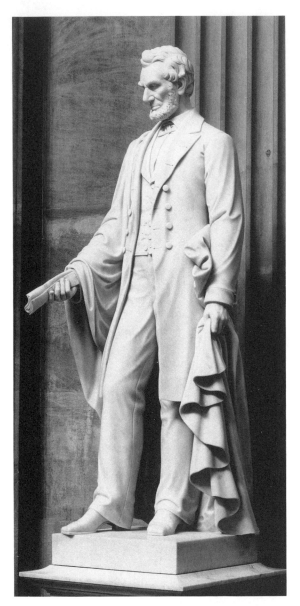

. Vinnie Ream, ABRAHAM LINCOLN (1871), marble, 6′11″. United States Capitol Art Collection. Courtesy Architect of the Capitol.

have thought of such a work, I neither know nor care; but I am able to say, in the presence of this vast and brilliant assembly (most of whom knew Lincoln well) that it is Abraham Lincoln all over."[100]

Ream wrote in her diary:

> The night when the Lincoln statue was unveiled in the Rotunda of the capitol was the supreme moment of my life . . . I had known and loved the man! . . . my country had loved him. . . . with shouts they had received his image in the marble.[101]

The statue has been criticized, especially by Lorado Taft who said it was "a monument to the gallantry of our statesman," but "reveals an absence of body within the garments." Yet even Taft admitted that the sculpture conveys with melancholy expressiveness the artist's reverence for Lincoln. As for the anatomy, Ream, in an address to a woman's group in Canada, described her working method: "For each statue I have given two years of study and work to the completion of the nude figure in every detail before putting on the drapery. In . . . the Lincoln statue . . . I sought and obtained the advice and criticism of the most competent experts in anatomy, and not until they pronounced the figure complete and correct in detail did I venture to clothe it. . . . It is easy with the flowing folds of old-time costumes; it is difficult with the modern costumes of men."[102]

In 1875, a few years after settling into her home on Pennsylvania Avenue in Washington, D.C., Ream won, in competition with such prominent sculptors as William Wetmore Story and J. Q. A. Ward, a $20,000 commission for a bronze statue of Admiral Farragut. The deciding vote was cast by Mrs. Farragut, who declared that Ream's simple, direct rendering "best recalled to her the form and features of her husband."

Ream worked on the *Farragut* at her studio and at the Washington Navy Yard. Emily Edson

Briggs of the *Philadelphia Times* described her arduous labors:

> Day after day ... year after year, with no emotion except to make her colossal work a success. The naval officers flocked about her to suggest and aid, but not without lifting their hats with something akin to awe. ...
>
> The writer recalls the face and figure of this girl-woman as she stood upon the scaffolding in the dingy barn-like structure. ... Not an article of luxury of any kind, met the eye. Dust, water, clay, plaster and old tarpaulin heaped in out-of-the-way corners on the floor. A coarse gray woolen skirt and over it fell the simple calico blouse below the knee; the Cinderella feet enclosed in school shoes rubbed at the toe. "The dust and plaster ruin my shoes," said Vinnie, when she saw the wife of a grand official surveying them. Down almost to the hem of the calico blouse, within a foot of the floor, rippled a cascade of dark hair, and such quantity rarely crowns the head of the loftiest woman. "I want to coil it up" says Vinnie, "for when I am tired it makes my head ache. I would cut it off, but pa won't let me!" So it was fastened back and a gray veil wound around her head with no more attempt at display than though she were a Carmelite nun.[103]

Vinnie Ream, ADMIRAL DAVID G. FARRAGUT (unveiled 1881), bronze. Farragut Square, Washington, D.C. Photo: Douglas Hunter.

The "Carmelite nun" in dusty shoes must have been appealing, however. An army engineer who came to watch her at work, Lt. Richard Hoxie, fell in love with her and proposed. According to the *Philadelphia Times,* she said at first, "'Wait until my statue is finished!' It was only after the intercession of Mrs. Farragut that the marriage took place before the work was done."[104]

After Ream married Lieutenant Hoxie in an elaborate society wedding, they moved to a house on Farragut Square in view of the spot where her monument, cast in bronze melted down from the propeller of Farragut's ship, was to be located. During the unveiling in 1881, a procession passed the White House, many speeches were made, and Vinnie Ream Hoxie's home was crowded with hundreds of guests who watched the ceremony from her windows.

Adm. David Farragut had led his faltering fleet to victory through mine-filled waters at Mobile Bay. The ten-foot figure of the Civil War naval hero stands with his left foot on a capstan, holding a spyglass between both hands. He looks out as if about to say "damn the torpedoes, full speed ahead!" On the four corners of the gray granite base are cannon mouths. *Farragut* is located on a line with the White House in a triangular park space amidst a crowded office district, where workers picnic on the grass at noon. It was probably even more effective when the buildings behind it were low; today it is somewhat dwarfed by high-rise office towers.

Unlike her sister sculptors in Rome, Vinnie Ream's career was affected by her marriage. The wife of a government official did not practice a profession; her husband built a studio in their home, but adjured her to work "for love, not money."

In 1883, Vinnie Hoxie bore a son, Richie. The boy was an invalid who died as a young man after spending much time in the hospital. According to a 1976 interview with Mrs. Robert Ream III (the wife of Vinnie Ream's nephew), Richie incurred a brain injury as a child when a gun that he and a friend were handling went off.[105]

This burden surely took its toll. Nevertheless, Mrs. Hoxie remained a well-known society leader, remembered for her generosity and warmth, who worked for charities and loved to give sculpture demonstrations for young people in art classes. Her house was filled with distinguished guests; she played the harp and sang at musicales in her home.

There is some evidence that she sporadically attempted to continue her career. Concerned about the placement of her work at the 1893 World's Columbian Exposition, she was disappointed when it was shown in the Woman's Building instead of in a state pavilion. Sculptor Moses Ezekiel reported in his memoirs that she was competing for a Richmond, Virginia, commission for a statue of Robert E. Lee. She had persuaded the members of the committee, but lost the commission because the governor didn't want a "Northern lady" to get the job.[106]

Like most army wives, Mrs. Hoxie moved many times with her husband as he advanced to the rank of general. In 1906, after a twenty-five-year hiatus, she returned to her career, receiving a commission for a statue of Iowa governor Samuel Kirkwood for the U.S. Capitol. She was heavy by this time and ill with a kidney ailment that flared up in the middle of the project. Her husband rigged up a boatswain's chair and pulley so that she could continue her work.

Shortly before her death she received another commission from the state of Oklahoma for a statue of the Cherokee leader, *Sequoya,* for the U.S. Capitol. This was particularly rewarding to the artist, who throughout her life had maintained ties with her midwestern Indian friends. According to her husband, she had begun a portrait of Sequoya many years before. Now a Native American posed for her. She had already completed the model when she was overcome by uremic poisoning and died in 1914 at the age of sixty-seven. Sculptor George Zolnay supervised the casting of her last work.

General Hoxie placed a bronze replica of his wife's sculpture *Sappho* over her grave at Arlington Cemetery, a fitting monument for a woman artist. The poised columnar figure of the great Greek poet holds a writing stylus in one hand and a scroll in the other. As art historian Eleanor Tufts has pointed out, the thoughtful expression on her face suggests that she is about to begin a new work of creation. Resting at her feet, the lyre awaits the future act of communicating her work to the public. The importance of the arms holding creative tools is emphasized compositionally by forming a prominent X shape located centrally on the figure. These diagonals are echoed in the flowing lines of the drapery. A confident image of woman as an active intellectual, Ream's sculpture makes an interesting comparison with Edward Bartholomew's earlier *Sappho,* who leans languidly, supporting herself on a column with one arm, while the other arm hangs limply holding the lyre and laurel wreath—a figure lost in a dream.

Vinnie Ream made her peace with life at every stage. One can only conjecture about the unspoken conflicts of an artist who loved her work so much that she said in a speech in 1909:

> Sculpture . . . is eminently a field for women; no one has ever questioned that the eyes are as true, the thoughts as noble, the touch as delicate as with men. . . . Often, perhaps, from a feeling of chivalry [men] have not desired that women should find occupations in which they could earn their own living, denying them independence that they might be obliged to lean upon men. I

have sometimes wished to be a man and have some loving, clinging soul leaning upon me— depending on me ... My work has never been labor, but an ecstatic delight to my soul. I have worked in my studio not envying kings in their splendor; my mind to me was my kingdom, and my work more than diamonds and rubies.[107]

Other works mentioned in the literature are busts of senators *Nesmith, Yates, Sherman* and *Voorhees, General Morehead, Parson Brownlow, General Custer, Thaddeus Stevens* and *Frank P. Blair,* all completed while she was studying with Clark Mills at the Capitol; a marble bust of *Lincoln* (for Cornell University); *The Morning Glory* (1865, a bust of a child); *America* (1866–68, an ideal bust); a bust of *Horace Greeley; Passion Flower* (a marble bust of a young woman) and a study of a *Hand* (both at the Wisconsin State Historical Society); and busts of generals *McClellan* and *Fremont, Reverend Spurgeon* (a London clergyman), *Albert Pike* (poet-journalist and longtime admirer, who wrote poems to her), *Ezra Cornell, Thomas Buchanan Read,* and an Indian girl (posed for by her brother's wife, who was half Chickasaw).

Margaret Foley (1827–77)

That broad browed delicate girl will carve at Rome
Faces in marble, classic as her own.
—Lucy Larcom[108]

Unlike her sister sculptors in the "white marmorean flock," Margaret Foley had to work her way up from poverty in her early years as a housemaid, a rural schoolteacher, and a factory worker. Self-taught, she began her career by carving cameos and later became distinguished for her large marble portrait medallions. A contemporary critic wrote: "She has worked her way bravely up to fame and success, winning pe-

culiar honors from Italian and British critics as well as her own countrymen.... Her portraits are true creations of art."[109]

Foley was born somewhere in northern Vermont or Canada. Her father, probably a hired hand, worked on farms around Vergennes, Vermont. In order to attend school there, the child had to earn her room and board with housework.

She taught herself to whittle and carve at an early age and soon attracted the attention of Philip Tucker, a member of the Vermont legislature. Neighborhood children used to bring "Grampa" Tucker rocks for his geological collection. Foley delighted him with stones she had carved into figures. He encouraged the budding sculptor, allowing her to spend hours in his personal library and study with his daughters, who became her friends. Later he continued to follow her career.

Foley became a schoolteacher in Vergennes and rewarded her better students with prizes in the form of figurines in wood or clay. In the 1840s, motivated by an idealized vision of what life was like in the textile mills, she left her country district to work for the Merrimack Corporation at Lowell, Massachusetts. Many New England girls had gone to work in the mills because they had heard that there were educational opportunities unavailable to them on the farms. They attended lectures and evening classes after work and put out their own magazine, the *Lowell Offering,* to which Foley contributed poems and articles.

The independent mill girls were pioneers in the labor movement and carried out some of the earliest strikes in America. By the time Foley came to Lowell, however, conditions had changed. The company was cutting wages, increasing the number of looms that each girl tended, and working them thirteen hours a day. No doubt disenchanted, Foley was reportedly already carving such skillful heads on the wooden

mill bobbins that her astonished factory foreman encouraged her to make art her career.

In 1848 she moved to Boston, where for several years she supported herself precariously by carving cameos. She wrote to her mentor Philip Tucker that she had turned down a teaching position because "my artist friends advised me to persevere in Cameo cutting.... my success was sudden and unexpected.... a likeness after Rev. John Pierpont established my reputation."[110] Dating from this period are twenty miniature plaster medallions of famous men, which she gave to Mr. Tucker and which are now in the Bixby Library at Vergennes.

Despite her "sudden success," Foley moved back to the Lowell district to teach at the nearby Westford academy (1853–54), but continued to carve and model in her spare time. A terra-cotta bust of *Dr. Gilman Kimball* (c. 1853) in the library of St. Joseph's Hospital in Lowell is an early attempt at a full-sized sculpture.

In 1860, Foley (with some help from Tucker) was able to go to Rome. There she rented a studio on the Via Margutta, the picturesque street that angles off from the foot of the Spanish Steps, in the same building where painter Elihu Vedder and sculptors Randolph Rogers and Florence Freeman worked.

The *Boston Evening Transcript* wrote glowingly in May 1865: "Among the American artists now in Rome no one is working harder than Miss Foley. She has sent several medallions to the great exhibition in Dublin. Her much admired head of Jeremiah the Prophet is ordered by an art-loving lady in New York. Wm. Aspinwall of N.Y. has given her a commission for her fine head of Bishop Whipple of Minnesota. She has sold her beautiful 'Albancee.'"[111] One of the splendid marble medallions of that year was the refined profile of *Jenny Lind* (1865, University of Chicago), the world-renowned Swedish soprano who was giving concerts on the Continent.

That summer, Foley returned to Boston, where, in a room in the Studio Building, she modeled portraits of such distinguished sitters as Henry Wadsworth Longfellow, Senator Charles Sumner, and Julia Ward Howe. After exhibiting work in New York's Derby Gallery she returned to Rome in the fall with numerous plaster models to carry out in marble. Henry Tuckerman, in his *Book of the Artists,* called her marble *Charles Sumner* (1866, Harvard University) "unsurpassable and beyond praise."

Some time earlier Foley had completed a bust of the fiery Boston Unitarian minister Theodore Parker who retired to Italy because of ill health and died in Florence in 1860. She did another in 1877. According to *Harper's Monthly Magazine* of June 1866: "he gave her frequent sittings while in Rome ... [his] face in its vigor is far more satisfactory than the *Socrates* of Mr [William Wetmore] Story.... His old congregation should order a colossal copy of this authentic bust for their assembly room." *Harper's* also praised her *Jeremiah*: "A well-known Boston clergyman ... exclaimed 'Ah, one of the old prophets has arisen from the dead! ... the majestic sorrow of that face.' ... Miss Margaret Foley has been forced to confine herself too closely to portrait medallions to allow the freest development of her genius. It is an epoch to her when she dare take a free breath and evoke from the marble a kingly head like that of the Prophet of Lamentation."

It was a neoclassicist cliché that art depicting classical and ideal subjects was on a higher level than portraits of real people. Artists like Harriet Hosmer, who were under less severe financial constraints, scorned portrait commissions.

The splendid profile medallion of the American nature poet *William Cullen Bryant* (1867, Mead Art Gallery, Amherst College) is an excel-

Margaret Foley, WILLIAM CULLEN BRYANT (1867), marble relief in medallion, 18¾″. Mead Art Museum, Amherst College. Unknown donor.

lent example of Foley's crisp, distinctly executed style, influenced no doubt by her years as a meticulous cameo carver. Eleanor Tufts, the principal scholar of Foley's oeuvre states: "Foley excels in her articulation of her sitter's features. In addition to the heaviness of Bryant's cheeks, the crow's feet under his eyes, and the grooves in his forehead, there is a vein that seems to pulsate over his temple. The hair is differentiated between the wavy locks that fold under at the neck ... and the short curlicues of his beard ... in fine contrast to the staccato lines of the bushy eyebrows."[112] Foley's strong feeling for pattern can also be seen in the richly textured lace cap of her medallion *Margaret Dawes Elliot* (Wellesley College Museum).

In 1868 an American couple visiting Foley in Rome noted how far she had progressed from the little housemaid in Vermont. An old servant with a lamp lighted them up a spiral stone staircase to the artist's comfortable apartment, where they looked at prints, glowing paintings, and books until Foley arrived. The servant prepared dinner and the three Americans chatted for hours afterward. The following day, in one of the sculptor's two studios, they saw many works in progress— medallions of a peasant girl from Capri and a Roman Jewess, and an unfinished head of Joshua: "she had thought ... long and seriously ... upon a noble representation for the Old Testament character ... and was hoping to present to the public ... something of the grand ideal which filled her own soul."[113]

In the early 1870s Foley developed a close friendship with the elderly British neo-Catholic authors Mary and William Howitt, admirers of the Nazarene painters, and began to spend summers with them in a picturesque old mansion at Dietenheim in the Austrian Tyrol. They found the place in ruins, but Foley, "a born carpenter and practical inventor, set to work ... and made

us all sorts of capital contrivances.... Thus ... we lacked nothing.... Dear Peggy [Foley's nickname] last night sat down to carve her Madonna ... and covered the table with heaps of chips and shavings, whilst Lizzie [Hudwen, an artist friend of Foley's] put a little life into us by singing some of her old songs."[114]

Harriet Hanson Robinson, a former sister mill worker turned author, visited Foley in 1874 and wrote that the sculptor resembled her own medallions: "A high, broad forehead gave her the stamp of intellectual power ... merry blue eyes, and a head as classic and a skin as white as her own beautiful marbles."[115] Robinson never saw the sculptor again because around this time Foley began to suffer from a neurological disease that intermittently interrupted her activities and eventually killed her.

The sculptor had arrived at the point where she was working on ambitious projects of the kind that she had always hoped to create. In 1876 she finished a life-sized head and shoulders of *Cleopatra* (National Museum of American Art), wearing a crown ornamented with a double asp. She was also completing an eight-foot fountain composed of acanthus leaves shading three life-sized figures of nude children seated on rocks. A Chicago collector had commissioned it in bronze, but he sustained losses in the Chicago fire and reneged on the order, so Foley decided to carry it out in marble for the Philadelphia Centennial Exposition. Persevering despite bouts of pain, she shipped the completed fountain to the exposition along with *Cleopatra, Jeremiah,* and several medallions for the Woman's Pavilion. The fountain was placed in Horticultural Hall, where it splashed as a centerpiece amidst the exotic horseshoe arches, begonias, and ferns.

After these tremendous exertions, Foley left Rome with the Howitts to recuperate in the Ty-

Margaret Foley, FOUNTAIN (c. 1874–76), marble. Horticulture Hall, Philadelphia Centennial Exposition, 1876. Photo: Free Library of Philadelphia Print and Picture Department. (This fountain is now in West Fairmount Park, Philadelphia.)

rol. When she became very ill, instead of returning to Rome they remained at a health resort in Merano until the artist's death in December 1877. Mary Howitt preserved the memory of her "gifted generous-hearted" friend in her autobiography.

Discussions of Foley's career reveal the biases of art history and the need for feminist scholarship. Because the sculptor died of a neurological illness (possibly a brain tumor), nineteenth-century scholars treated her history as a sob story, suggesting that her illness was the result of overwork and failure to sell her major opus, the fountain. Foley supposedly put all her strength and funds into this one large effort and wore herself out in the process.

But Tufts found that the sculptor was at the climax of her career when she died at the age of fifty. The productive artist would undoubtedly have recouped her fortunes by making portraits and continuing to do larger and more ambitious work, except for the accident of illness. Moreover, soon after Foley's death, her fountain was bought by George Whitney for Philadelphia's Fairmount Park, where today it still splashes amidst greenery in the Horticulture Building.

A self-taught artist with little training in anatomy, Foley restricted herself largely to the head, as so many women miniature painters did for the same reason. She was just beginning to treat the full figure. But within this narrow range, her work ranks with the best sculptors of her day. Because of their strong character and crisp, refined execution, Foley's portrait medallions look even better to us than some of the heavy-handed allegories of the neoclassical period. Nineteenth-century art historian Henry Tuckerman recognized the excellence of her work when he wrote that they showed "simple, absolute truth embodied in marble; not truth in outline and feature alone, but in expression and sentiment."

Other works mentioned in the literature include portrait medallions of *Mary and William Howitt, Henry Farnam, Mr. and Mrs. Samuel C. Hall, Granddaughter of Lucretia Mott* (1871, unlocated, photograph at Bixby Library), and an Italian matron (Watertown Library, Massachusetts); an oval *Head of a Roman Lady* wearing a shawl on her head (University of Vermont; Arts and Industries Building, Smithsonian, Washington, D.C.); the Magoun tombstone of *Mother and Child* (Mt. Auburn Cemetery, Cambridge, Massachusetts); *Young Trumpeter,* a version of a figure in her fountain (Bixby Library, Vergennes, Vermont); *Egeria*; and a photograph of *Boy with Kid* at Bixby Library.

Franzisca Bernadina Wilhelmina Elisabeth ("Elisabet") Ney (1833–1907), sculptor of "mad" King Ludwig II of Bavaria and other European leaders, immigrated to Texas and became one of the state's earliest and best-known sculptors. Her extraordinary story reads like sensational historical fiction, but although seven books and four plays have been written about her life, only now are scholars like biographer Emily Cutrer beginning to separate facts from the myth she created about herself.[116]

Born in Münster, Westphalia, Ney was the daughter of a proper German housewife, Anna Elisabeth Ney, and Adam Joachim Ney, a carver of tombstones and ecclesiastical statues who came from the Saar region of France. "Elisabet," as she later called herself, no doubt watched her father carve and listened to him boast about his illustrious distant ancestor, Napoleon's military leader, Marshal Ney. Later she declared that she came from "a race of revolutionaries."[117]

As a child, Ney's imagination was seized by her mother's tale of the fourteenth-century woman sculptor Sabina von Steinbach, who supposedly worked with her father on sculpture for Strasbourg Cathedral. At eighteen, already a rebel who rejected conventional female tasks and chose (like her father) to wear outré costumes of her own design, she announced to her parents that she intended to study in Berlin with Germany's leading sculptor, Christian Daniel Rauch. They were appalled. Not only was it unheard of for a woman in their circle to become a professional sculptor, but as good Catholics they feared that their daughter's religion and virtue would be compromised in Protestant Berlin.

According to her own account, Elisabet showed indomitable will, battling with her parents and finally embarking on a hunger strike. At this point Bishop Müller of Münster intervened, suggesting a compromise—Elisabet could begin by studying at the Royal Bavarian Academy of the Fine Arts in the Catholic city of Munich while living with friends of the family. If she showed sufficient talent and maturity she could go to Berlin in a year or two.

Ney thought her struggle was over, but in Munich the academy director refused to admit her; no woman had ever studied sculpture there. Ney had to mount a campaign of strategy and tactics for months before she was tentatively allowed to enroll in classes on probation. She was escorted to and from school by a protective academy official, although the authorities need not have worried about her virtue. According to Ney, the male students fell into an awed hush when the tall, red-haired girl entered the room. In March 1853, she was admitted as a full-time student in the sculpture program of Max Widnmann, a student of the neoclassicist Thorwaldsen.

While vacationing in Heidelberg at the home of the daughter of the radical philosopher Christian Kapp, Ney met a free-thinking medical student named Edmund Montgomery. Circumstantial evidence strongly suggests that he was the illegitimate son of a distinguished Scottish jurist, a painful position that may have caused him to question the values of society and scorn public opinion. In any event, at the age of thirteen he had already fought on the Frankfurt barricades in the unsuccessful revolution of 1848. Some of the fears of Elisabet's parents proved to be well founded—under his influence she soon lost her Catholic faith and developed very unconventional views.

The "two romantics"[118] shared their dreams; Elisabet wished to become a great sculptor, and Edmund, although preparing to be a physician, hoped to formulate a philosophical worldview compatible with the new scientific age. An ardent feminist, Ney seems to have resisted marriage—she vowed never to change her name—but the lovers pledged to join their lives in an unusual relationship; each would allow the other complete freedom to realize his or her goals, even enduring long separations if necessary. Theirs was to be an "ideal life" on a different plane from other people's.

In 1854, Ney realized her dream; she was admitted to the Berlin Academy and the atelier of the aging Christian Rauch. Although a neoclassicist, he insisted on being true to nature instead of relying entirely on classical models, and he demanded a thorough knowledge of carving and all the practical aspects of sculpture. Under his tutelage the artist developed a style of idealized realism, imbued with the spirit of German romanticism, and an interest in minutely re-

searched accuracy of detail. Her first professional commission was a classically draped *Saint Sebastian* for Münster Cathedral (destroyed), a gift to her first sponsor, Bishop Müller.

The tall, vivacious redhead, who once said that her motive for becoming a sculptor was to "meet the great and famous people of the world," soon cut a figure in the Berlin salon of biographer Karl Varnhagen von Ense. There she met Hans von Bülow and Franz Liszt; modeled medallions of Von Humboldt and Liszt's daughter, Cosima, who later left her husband and ran off with Richard Wagner; and made busts of Varnhagen and the German mythologist *Jacob Grimm* (1858, plaster, George Augusta University, Göttingen, Germany, and Ney Museum, Austin, Texas). Ney's head of the aged Grimm, his refined features framed by flowing hair, is one of the sculptor's finest works.

Ney's future seemed assured, but the realities of her position as a woman artist came home to her when her elderly mentors, Rauch, Varnhagen, Grimm, and Humboldt, all died between 1857 and 1859. Without the help of these influential men, the artist suddenly found herself in an empty studio at the Lagerhaus in Berlin, with no commissions.

Ney was in despair until her "best friend," Edmund Montgomery, suggested that she should capture media attention by convincing the philosopher Arthur Schopenhauer, at that time very much in the public eye, to sit for a portrait. Since Schopenhauer was a notorious woman-hater and had never permitted anyone to model a bust of him, such a commission would attract a great deal of publicity. She could break through the wall of indifference and at the same time teach the old misogynist a lesson about women's rights.

According to Ney's account, she went to Frankfurt unannounced and cornered Schopen-

hauer in his study. Taken aback by her confident air, intelligence, and beauty, the aging misanthrope consented to pose on condition that his portrait be shown in Berlin when the third edition of *The World as Will and Idea* came off the press. Delighted with the bust, he wrote enthusiastic letters about her to important people.

Ney's head of *Schopenhauer* (plaster, Ney Museum, Austin, Texas), with its wry, gaunt grin, has some of the iconoclastic quality of Houdon's portrait of Voltaire. The artist subtly hints at the vanity and malice of the philosopher in a bold image, relatively free of the surface detail that occasionally clutters her work.

Word of Ney's talent spread; she was invited to the court at Hannover to model a bust of the blind *King George V* (1859). Ney must have been ecstatic when the queen presented her with a diamond bracelet at an official ceremony and Friedrich Kaulbach painted a full-length portrait of her at work on the king's bust (Landesgalerie, Hannover). Under tousled clipped locks, the artist's eager face confronts the viewer. Ney wore short hair in defiance of custom because she believed that women should not be burdened with the care of long tresses.

In 1861 Ney secured commissions for life-sized plaster statues of four Westphalian heroes for the assembly room of the newly erected parliament building in her hometown, Münster (destroyed). Her work was praised in the Cologne newspaper: "this is the first time that the sculptress ever ventured a historical representation … she has given abundant proof that she is richly endowed with all the qualifications necessary for the excellent performance of such a difficult task, one so seldom discharged by feminine hands."[119]

Ney seems to have left a busy career to join Montgomery in London where he was now a successful physician. He had contracted tuberculosis, however, and they left for the island of Mad-

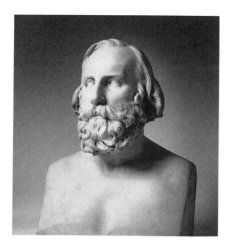

Elisabet Ney, GARIBALDI (1866),
marble bust, 21″ × 15″ × 8″.
Collection of the Modern Art Museum
of Fort Worth. Gift of Mrs. Varner Linn
Brown in memory of Tom Linn Brown.
Photo: David Wharton.

eira for his recuperation. They were married
there, but only on condition that she would keep
her own name, and their married state would re-
main, on the whole, a private matter.

Enchanted with the brilliant light of Madeira,
Ney built a vine-covered studio named For-
mosa (the Portuguese word for "beautiful") and
worked on a splendid bust of Montgomery (Ney
Museum, Austin) and an ideal group of two boy-
children, entitled *Sursum*. These two putti, gaz-
ing upward and carrying a torch and a key, sym-
bolize the cooperative search of humanity for
higher goals.

Among Montgomery's patients was Lord
Brownlow, the tubercular son of Harriet Hos-
mer's patron, Lady Marion Alford. No doubt hop-
ing to win an important patron, Ney modeled a
relief medallion of Lady Alford and a statuette of
Lord Brownlow, but records show that the sculp-
tor's only payment was a dress embroidered by
Alford (in contrast with the large sums paid to

Hosmer). Scholars conjecture that this was a hu-
miliating encounter—perhaps the reason Ney
left Madeira for Italy.

Ney was attracted to a kindred spirit, Gen.
Guiseppe Garibaldi, the guerrilla leader in the
cause of Italian unification, who, despite his
fame, chose to live like a simple peasant on the
tiny island of Caprera, off the coast of Italy. In a
charming fragmentary memoir dated 1865, Ney
described her encounter with Garibaldi.[120]

According to her account, she arrived at Ca-
prera without advance permission, and pro-
ceeded to ingratiate herself with the puzzled
general. The bearded hero, clad in red shirt, Cal-
abrese hat, and woolen poncho and walking with
a staff because of a foot injured in battle, was
just the kind of personality to arouse the artist's
admiration. Ney accompanied him around the
sunlit island and observed his graceful move-
ments as he worked in the garden and fed the
ducks. There in the fields, she took the measure-
ments of his head with calipers in order to rough
out the bust in clay.

When he began to pose, the general assumed
such a melancholy air that she broke off the ses-
sion after about ten minutes and asked him
about his moodiness. He replied, "It's true, when
I am not occupied with work, melancholy tor-
ments me," and began to unburden himself about
his hopes for Italy and his discouragement with
the king and the people. Ney felt a deep sympa-
thy for "a being, gifted with so sublime gifts, put
away from its proper place among mankind, be-
cause vanity and selfishness had achieved the
throne; the hours and days run off never to come
back again.... Then I told him that I burn with
scorn for those who condemn him to lead this life
... that seeing him thus on his island remind
[*sic*] me to the old chained Prometheus."[121]
Warming to a kindred spirit, the general gave
her longer sessions. The marble bust (1866, Fort
Worth Art Museum) shows the long head and

deep-set eyes of a maverick visionary.

Ney then took a studio in Rome for a year. Attracting little attention and no commissions, she used the time to study the great Italian monuments. That summer, in 1865, while vacationing with Edmund in a castle in the Tyrol, Ney worked on one of her few uncommissioned ideal pieces—a larger than life-sized statue of *Prometheus Bound*. The bearded reclining figure, hands manacled to the massive rock on which he lies, seems inspired both by Michelangelo's figure *Evening* in the Medici Chapel and by her experience with Garibaldi (the head resembles his). The mythological Titan who defied the gods and attempted to bring the light of knowledge to mankind, lying chained and tormented, is a potent symbol of Ney and Montgomery's lifelong struggle.

According to their servant, Cencie Simath, who claimed that she served as a go-between, Ney, while in the Tyrol, acted as a secret agent for Garibaldi, sending him reports on Austrian troop movements. Perhaps through Garibaldi's influence, Ney was summoned to Berlin to model a bust of Chancellor Otto von Bismarck, who was forging the unification of Germany and shared Garibaldi's opposition to Austria. The busts of *Garibaldi* and *Bismarck* (1867), both exhibited in the 1867 Paris International Exposition are interesting to compare. The Iron Chancellor with his cold assured gaze, bristly mustache and bullet head, contrasts with Garibaldi's long, intense face.

Ney next went to Bavaria, where the odd young king Ludwig II, patron of Richard Wagner, was erecting public buildings and attempting to create a renaissance of art and culture. There she worked on commissions for the new Munich Polytechnic Institute—*Iris* and *Mercury* for the exterior and busts of Ludwig and the German chemists Friedrich von Wöhler and Justus von Liebig for the interior. Ney was doing well, now; she lived in a splendid villa in Schwabing and rode about in an elaborate carriage.

It took months of maneuvering for Ney to win the confidence of the strange young Dream King and secure his consent for a portrait. In an improvised studio at the palace she worked on his full-length figure, clothed in the elaborate regalia of the Order of the Knights of St. Hubert. She sometimes read sections of Goethe's *Iphigenia* to him as she worked, to soothe his spirits. A draft of a letter to the reclusive monarch shows that she was trying to persuade him to trust and relate to people. This was the period when the tormented Ludwig was under enormous pressure from Bismarck to join in the Franco-Prussian War and make Bavaria part of a unified Germany under Prussian domination. The completed statue shows the lordly young monarch, hand on hip, in his embroidered garments, yet there is something odd and quirky about his childlike head and demeanor.

Mysteriously, at the apex of success, with her completed statue of Ludwig still not put into marble, Ney closed the villa, left her work there and in the palace studio, and with Edmund and their housekeeper, Cencie, quietly booked passage on a boat to the United States. Ney was always evasive about her reason for leaving, and authors have conjectured that she was a spy for Bismarck who found herself in danger because she had become sympathetic to the young king's plight. An aura of cloak-and-dagger mystery still surrounds this period of their lives.

Although there may be a kernel of truth in these conjectures, Ney's biographer Emily Cutrer finds no hard evidence to support these stories. Instead she has shown that Ney, disgusted with the world of royalty and sculpture, was copying out sections of Jean-Jacques Rousseau's *Emile*. At thirty-nine she was pregnant, and perhaps

dreamed of a utopian environment amidst nature, free from the corrupting influences of civilization, in which to raise her child.

In 1871, Ney and Montgomery, hoping to found a utopian colony, bought land and built a "log castle" on the outskirts of Thomasville, Georgia, near their friends, Baron and Baroness von Stralendorff. In the "land of liberty" she and Edmund hoped to live the ideal life, free of conventional social customs.

After the birth of their son Arthur, however, they were ostracized because Elisabet insisted on being called "Miss Ney," hitched wagon rides into town with blacks, and managed the farm herself in a top hat, white trousers, Prince Albert jacket, and boots. The gossiping townsfolk believed that the two foreigners were promoting a devilish cult of free love and radicalism. Their painful isolation, plus the heat and malaria of Georgia, caused the couple to move, in 1873, after the birth of their second son, Lorne, to Liendo Plantation, in Hempstead, Texas, not far from Houston.

Texas had long appealed to Germans, who had settled there in considerable numbers, attracted by the climate and cheap land. Putting aside her sculpture career, Ney now devoted herself to raising a son who would carry out her dreams (her first child had died of diphtheria). Riding over the plantation on horseback in breeches, leggings, and huge straw hat, Ney hoped to develop a great estate on which her son would be a young lord (*edelmensch*)—not an aristocrat in the old sense, but one of the spirit. With no insight into child rearing, she kept Lorne isolated from other children, had him tutored at home, and dressed him in Greek togas and other fanciful costumes that were ridiculed by the neighborhood children. Many of the ignorant neighbors in "six-shooter junction," as Hempstead was dubbed at the time, regarded Ney as a witch with a bastard child.

Not surprisingly, Lorne developed an unstable personality and a hatred of his mother. His rebellious behavior forced his parents to send him to various private schools, but to no avail. Meanwhile, the hermit philosopher buried himself in his study during crop failures, hurricanes, and other disasters that drove the couple deeper and deeper into debt. Heartbroken over her son, Ney, after a twenty-year hiatus resumed her career, turning the plantation over to her husband. In her fifties she set out to become the leading sculptor of the Lone Star State.

Ney had a small circle of cultivated friends and had won the support of Governor Oran Roberts, a far-seeing man who understood the importance of bringing the arts to raw Texas. One of her first works was a portrait bust of him (1882, marble, Barker Texas History Center, University of Texas at Austin). Through his recommendation she received her first American commissions in 1892 for statues of *Sam Houston* and *Stephen Austin*, the founders of Texas, for the Texas pavilion at the 1893 Chicago World's Columbian Exposition.

The artist found old documents and pictures and interviewed descendants of the Texas heroes, in order to make the statues as accurate as possible. Houston, the robust military leader and first governor, is burly and tall, sword at his side, while Austin, a smaller, more graceful figure wearing the fringed leather pioneer costume, stands, rifle in hand, unrolling the map of Texas, ready to lead settlers into the region. The statue of Houston was at the Chicago fair, but Austin was not completed until later.

Deciding to build a studio in Austin, the state capital, in order to carry out these works, Ney, always the neoclassicist, designed it in the shape of a Greek temple. Years later, throwing convention to the winds as usual, she added a

Elisabet Ney, STEPHEN F. AUSTIN (1893), marble, 76½″. United States Capitol Art Collection. Courtesy Architect of the Capitol.

crenellated Gothic tower to provide more living space—an eccentric but effective bit of eclecticism that predated postmodernism by nearly a century. She sold her villa in Schwabing. The descendants of Ludwig paid to have her full-length plaster portrait put into marble (now at Herrenchiemsee Castle, Bavaria), and during trips to Germany and Italy she located many early works, and shipped them to Austin.

Now an eccentric, colorful old lady, dressed in velvet cap and loose costumes (she was a self-conscious pioneer of dress reform), Ney lectured in German-accented English to women's clubs all over the state, invited legislators to "Gypsy teas" at her studio where they could see her work, and lobbied for a Texas Academy of Liberal Arts, offering to teach without salary.

As Cutrer points out, although in Europe Ney had been helped by powerful male figures, most of her efforts to secure commissions through important Texas men were unsuccessful. She was no longer young and beautiful, and they no doubt saw her as an aggressive, stout, outlandishly dressed middle-aged woman. It was through the intervention of the Daughters of the Republic of Texas and several civic-minded clubwomen who rallied to her support that she was able to put the statues of Houston and Austin in marble for the state capitol (unveiled in 1903) and the U.S. Capitol. She found champions in Ella Dancy Dibrell, wife of a Texas senator, who believed in Ney's genius, and in the journalist Bride Neill Taylor, who wrote the first biography of Ney.

Busts she created of prominent Americans include *Governor W. P. Hardeman* (1893), *Senator John H. Reagan* (1895), *Governor Francis R. Lubbock* (1895), *William Jennings Bryan* (1900), and a noble head of the Swedish philanthropist *Swante Palme* (1899, marble, Barker Texas History Center, Austin). A marble bust of *Benedette Tobin* (1892) at the Ney Museum, is a robust study of an American turn-of-the-century woman cultural and civic leader. An important late commission was the *Albert Sidney Johnston Memorial* (1902) to the Confederate leader of the Battle of Shiloh, a recumbent marble figure draped in the Confederate flag and lying beneath a wrought-iron canopy at the Texas State Cemetery in Austin.

The artist made trips to Germany and Seravezza, Italy, to carry out some of her commissions. The long-lost, damaged plaster figure of the heroic *Prometheus Bound* was located by someone in a locked state warehouse and shipped to Austin. In her last years she was repairing the shoulder, no doubt hoping to put the work into marble. Ney was becoming known again in Germany, but was devoted to Texas; her ambition was to become the state's leading

sculptor and to bring culture to the wilderness.

Ney struggled financially until the end of her life, but she was able to achieve two important goals—the publication of Dr. Montgomery's philosophical treatise on which he had been working all these years and the completion of a life-sized *Lady Macbeth* (1904, on loan to the National Museum of American Art), a powerful work that embodies the tormented, driving nature of Ney herself, an ambitious woman frustrated by the conventions of society in her efforts to reach high goals. The emotion in the noble head, the spiraling movement of the body and hands, and the fluid details of the drapery are all held in tension within a simple columnar form.

Ney experienced bitter disappointments in her later years. The Texas Academy of Liberal Arts to which she had devoted so much energy was never founded. She endured the humiliation of seeing major commissions in the state go to her male rivals. Today her Austin studio, saved by her husband and her champion, Ella Dibrell, is a state historic monument, the repository of more than fifty of her works (approximately a third of her output). It constitutes a gallery of some of the greatest figures of her age and a shrine to the personality and talent of one of America's pioneering women sculptors.

The marble busts of Ney and her husband in their youth have an aura of intense idealism. A traditional sculptor in the spirit of her teacher Christian Daniel Rauch, her portraits combine detailed realism and idealism. When her critics objected that her statue of Stephen Austin in the U.S. Capitol seemed much smaller and punier than Houston's and that both figures were overwhelmed by the over-life-sized works around them, Ney countered that the critics should complain to God, not her, since she had faithfully rendered the two figures as they actually were; she refused to bend an inch to glorify Austin as

an outsized hero.

Nevertheless it is undeniable that her work remained rooted in the old neoclassical tradition in which she was trained and did not develop or take on the lively baroque sweep of the new era of fluid bronze monuments. To the end of her life she regarded marble as the only proper medium. Lorado Taft, who visited her in Texas, characterized her in his *History of American Sculpture* as a competent sculptor who had failed to grow because of her isolation in a backwater. After reading this assessment of her work, Ney replied with characteristic independence—"What a twaddle he lets loose!"

Blanche Nevin (1841–1925) was hailed at the time of the Philadelphia Centennial as "one of the most promising lady sculptors" of her day. She even completed a major commission for the U.S. Capitol. But the obstacles she later encountered discouraged her from continuing a public career.

Born in Mercersburg, Pennsylvania, the daughter of Martha Jenkins and John Williamson Nevin, a theologian, Oriental scholar, and president of Franklin and Marshall College who took controversial stands on religious matters, Blanche shared his independence of mind and wide-ranging interests. An attractive girl who spoke several languages fluently, she was a painter, poet (some of her poems are at the Lancaster Historical Society, Pennsylvania), and musician. Her primary interest, however, was in sculpture.

Nevin studied at the Pennsylvania Academy and with Joseph Alexis Bailly, a French émigré who had fled France after the 1848 revolution and had become a prominent Philadelphia sculptor. In his studio she completed a highly praised marble sculpture of *Maud Muller* (1865), the heroine of John Greenleaf Whittier's poem.

The artist went to Italy, but unlike the rest of the "white marmorean flock," studied principally at the Royal Art Academy in Venice with Ferrari and spent time in Florence, Carrara, and Rome. Since her brother, the Reverend Robert Nevin, lived in Rome and had helped erect a church for American Protestants after the defeat of the temporal power of the pope, she probably had many contacts while abroad.

Returning around 1875, Nevin opened a studio in Philadelphia and completed a marble bust and at least two major works in time for the Philadelphia Centennial Exposition. An engraving in Frank Leslie's *Illustrated History of the Centennial Exposition* shows the public gawking at two life-sized statues, *Cinderella* and *Eve* (unlocated), that were the centerpieces of the art display in the Woman's Pavilion.

Eve, a standing nude, remorsefully buries her face in one arm. Garlands of flowers twine around her torso, covering the focal points of her nudity. This work shows the influence of her teacher, Bailly, who used flower garlands in such works as *Aurora* (Philadelphia Museum of Art). *Cinderella,* a reclining barefoot girl in a simple dress, leans on one arm gazing pensively down at what seems to be an invitation to a ball. In *Masterpieces of the Centennial International Exposition,* Edward Strahan praised *Cinderella* and included an engraving of it, one of the few illustrations of American sculpture:

> Cinderella sits with an air of discouragement among the ashes, in pose as if the Dying Gladiator had shrunk back into infancy and femininity. Dreams of the splendors and delights into which her luckier sisters have been admitted occupy her little head, while her own future seems as dry and cheerless as the faded embers.... The creator of this engaging figure ... is one of the most promising of the rising school of lady sculptors.... The lady is still

quite young, but several of her figures in marble have been successful, as witness her "Maud Muller" and a subject owned by Mrs. Stephens, the society queen.[122]

Cinderella and *Eve* are typical literary conceits of the period. From the rather insipid engravings they appear to be compact in form and harmonious in line, although it is impossible to determine the actual quality of the modeling. Nevin's sculpture must have impressed the critics, however, because soon after the exposition, in 1878, the U.S. government commissioned a full-length marble statue of Pennsylvania's Gen. John Peter Gabriel Muhlenberg for Statuary Hall in the Capitol. Vinnie Ream had already paved the way with her *Lincoln.*

What difficulties she encountered are not known, but for some reason twelve years elapsed before the work was finally installed in the Capitol in 1889. In 1879 she was in Italy, modeling her statue at Massa di Carrara, the marble center. She wrote to friends: "I'm still at Massa and likely to be for some time—my statue seems to develop need for an infinite amount of patient work. The more I do, the more I see to do, and while I work at one part another part gets roughened up.... I shall be much disappointed if I don't get ... to Rome this winter, but if I do it won't be until toward Spring.... However ... I am doing what I like in working over my statue. You should see how ugly my hands are between the cold and the modeling clay."[123] The length of time required for its completion suggests that Nevin ran into technical or bureaucratic problems.

The statue of Muhlenberg did not measure up to Nevin's early promise. A rather effeminate figure in colonial wig and garb, the statue was blasted by Lorado Taft in his *History of American Sculpture*: "It is hardly a kindness to refer to her insignificant 'General Muhlenberg' in the

national capitol."[124]

Nevin made one last major public effort at the time of the 1893 Chicago World's Columbian Exposition. When a competition was announced for sculpture to decorate the façade of the Woman's Building, she was one of about seventeen women who submitted models. Nevin's design for the pediment depicted the evolution of woman from ancient bondage to the more liberated era of the nineteenth century. Shortly before the jurying, Nevin told reporters that her model had been damaged en route to Chicago and did not properly demonstrate her ability to render detail. Still, it must have been a blow to the fifty-two-year-old artist when an unknown nineteen-year-old Californian, Alice Rideout, was judged the winner by Charles Atwood. Perhaps Rideout's theme appealed more to the judge because it was less feminist in content—it showed woman's capacity for self-sacrifice.

Nevin's *Maud Muller* was shown in the Hall of Honor of the Woman's Building. Nevertheless, the humiliation of losing the commission to a beginner may have caused her to abandon her public career. A woman of independent means, she now chose to live a pleasant, secluded life in her family's prerevolutionary mansion, Windsor Forges, set in a quiet valley in Churchtown, amidst Pennsylvania's Welsh Mountains. She traveled in Japan and China, collected art, entertained distinguished guests. Along with the American avant-garde at the turn of the century, she became interested in Oriental culture and made a large copy of the Buddha of Kamakura for the grounds of her home.

In 1910 when the architect of the Capitol requested a brief biography, she wrote that she now "practiced little in public work principally because of the strain of the business part of it but has done a good deal privately, some at her own place and made models, etc. . . . is a member of the Royal Arts of England, the Numismatic and Geographical Societies of New York." Nevin added a few telling lines: "I don't see what use all this is to anyone now—will that do? I do not care for notice."[125]

For the nearby town of Lancaster, Nevin modeled and cast a large lion for Reservoir Park and a fountain at Orange Street and Columbia Avenue. Around 1907, on a cruise to Bermuda, she met Woodrow Wilson and became friends with the entire Wilson family. The sculptor's nephew, Francis Sayre, met Wilson's daughter at her home, and Nevin attended their wedding at the White House. In 1910–11, shortly before Wilson ran for president, she modeled his bust, a plaster cast of which is at the Lancaster Historical Society. Newspaper reports describe busts of McKinley and Theodore Roosevelt on her mantelpiece.

Ella Ferris Pell (1846–1922) studied with William Rimmer at Cooper Union's Design School for Women, graduating in 1870. Around that time she created a sculpture of *Puck* that was compared favorably with the work of Hosmer, Stebbins, and others. In 1872 her *Cordelia with Lear* and other works were displayed in a tableaux that she staged at Bread Loaf Mountain, Vermont. Reference books also mention a heroic statue of *Andromeda*.

After studying in Paris she became a painter and illustrator, but was eventually buried in a pauper's grave. Resurrected in 1987, her painting *Salome* was a highlight of the first exhibition at the National Museum of Women in the Arts, and her career was discussed in the catalog *American Women Artists: 1830–1930*. Paintings and memorabilia are at the Pell Family Collection in Ticonderoga, New York, but thus far her sculpture is unlocated.

Horatia Augusta Latilla Freeman (1826–?), born in London of Italian and English parents, was not a sculptor when she married the American genre painter James Freeman in 1845 (some books say 1847). They lived in Rome, where Freeman began to do sculpture around 1857, a few years after Harriet Hosmer's arrival, soon earning a reputation for bas-reliefs, busts, ideal figurines, and decorative household objects such as clocks and vases—elaborate Victorian conceits, swarming with cherubs and heavily laden with moralizing symbolism.

In 1866 the *Art Journal* described Freeman's sculpture in the sentimental terms of the day, attributing the frequency of the child motif in her work to the artist's frustrated desire for children (the same was said of Mary Cassatt):

> Her genre is that of "putti," and as if to supply the want of that which has been denied to her, she throws all the tenderness of her woman nature into the pretty marble statuettes and heads which she creates. Who that has seen it will forget her *Sleeping Nelly,* an idea taken from that inimitable character in *The Old Curiosity Shop?* Poor deserted Nelly, deserted by all but Providence, lies extended on her rough mattress while guardian angels are watching at her pillow. Very similar in character are *The Princes Sleeping in the Tower* . . . all unconscious of the danger which menaces them.[126]

The Princes Sleeping in the Tower showed two sleeping children, a favorite theme of Victorian sculptors. As art historian Milton Brown puts it, "the maudlin sentiment aroused by plump and helpless babes carved in stone was one of the common emotional excesses of the period."[127] The most famous example is William Rinehart's *Sleeping Children.* Edmonia Lewis also made two pairs of cherubs, one asleep and one awake.

After a saccharine description of Freeman's sleeping babes, the *Art Journal* described a mélange of sculpture and decorative objects in Freeman's atelier at 68 Via Capo le Case.[128] *The Triumph of Bacchus* included four children holding up a young Bacchus, who clutches one by the hair and plants his foot on the ear of another—a "cunning symbol of the tyranny of wine." An elaborate clock was covered with putti symbolizing the hours—happy dancing ones and weary ones holding their heads in their hands. "Another, opposite, is weeping over a dead bird, thus symbolizing *Death;* and above, the Resurrection is suggested by one watching an insect in his hand. . . . This beautiful and thought-suggesting clock has been bought by Mr. Frederick Stevens of New York, and is to be cast in bronze."[129] What an enormous freight of symbolism was carried by this poor clock!

Other works included a chimneypiece bracketed by angels, whose fireplace opening was surrounded by mosaic and adorned with white marble pilasters; *The Angel Suonatore* playing a lyre; *The Angels of the Nativity* shown on a cloud (one plays a lute while the other two listen); a pouting, disconsolate *Cupid Bound.* A bronze vase by Freeman was on display in the art showrooms of the American bankers McQuay & Hooker at the foot of the Spanish Steps.

Freeman seems to have developed a market for her decorative work. *The Culprit Fay* was described as "the most ideal of her productions."[130] Perhaps scholars will unearth some of these interesting artifacts by an artist who freely crossed the boundaries between art and decoration in the nineteenth century.

Florence Freeman (1836–1883?), a young relative of James and Augusta Latilla Freeman, was born in Boston, studied sculpture with Richard S. Greenough, and in 1861 went to Italy with

the actress Charlotte Cushman. After a year of study with Hiram Powers in Florence, Freeman moved to Rome and opened a studio where she produced bas-reliefs, busts, figurines, and mantelpieces.

She was often compared with Hilda, the gentle heroine of Hawthorne's novel about women artists in Rome, *The Marble Faun*:

> Miss Freeman . . . is one of those delicate shrinking and artistic natures such as Hawthorne painted in his Hilda, that marvelous and truthful portrait of a type of character indigenous to New England; as lovely and as peculiarly its own as the delicate mayflower. In fact, "Hilda" is the soubriquet by which this young artist is known among her friends. Her works are full of poetic fancy, her bas-reliefs of the seven days of the week and of the hours are most lovely and original in conception. Her sketches of Dante in bas-relief are equally fine. Her designs for chimney-pieces are gems, and in less prosaic days than these, when people were not satisfied with the work of mechanics, but demanded artistic designs in the common household articles, they would have made her famous.[131]

Florence Freeman, SANDALPHON (c. 1864), marble bust, height 25½". Courtesy Longfellow National Historic Site, National Park Service.

Only one work, a marble bust of *Sandalphon, The Angel of Prayer,* is presently located (Emma Stebbins also did a sculpture of this subject). The lovely head is set into a carved wreath of flowers, because Sandalphon supposedly captured the sounds of prayers as they were wafted upward from earth and converted them into flowers that perfumed the heavens.

Longfellow owned this sculpture, now at Longfellow House, Cambridge, Massachusetts, as well as Freeman's ideal statue *Indian Musician* (unlocated), representing Chibiabos, a character from his poem *Hiawatha,* "who taught the birds to sing and the brooks to warble." The *Art-Journal* in March 1866 reported that Chibiabos was depicted with a flute in his left hand "the notes of which are suspended while he listens to the reeds."[132]

In 1871 the *Art Journal* reported that the sculptor exhibited several works in her Via Margutta studio, including the chimneypiece *Children and Yule Log and Fireside Spirits.* In the center relief, children bring in the Yule log, while on either side woodland elves pensively watch the blazing fire, thinking of their lost trees. This work won an honorable mention at the 1876 Philadelphia Centennial Exposition.

Freeman's *Thekla, or the Tangled Skein,* showed a sorrowful girl looking despondently at a tangled web of yarn which she has vainly tried to wind. It conveyed a moral about having the patience to untangle life's difficulties.

The fine portrait bust of Abraham Lincoln in the east lobby of the U.S. Senate gallery is by **Sarah Fisher Clampitt Ames (1817–1901).** Born in Lewes, Delaware, she studied art in Boston, was the first of the "flock" to go to Rome, and married the portrait painter Joseph Alexander Ames.

A woman who knew the leading artistic and literary people of her day, she was active in anti-

Sarah Fisher Ames, ABRAHAM LINCOLN (c. 1862), marble. United States Capitol Art Collection. Courtesy Architect of the Capitol.

Helen Reed, THE LOST PLEIAD (1878), unlocated. Photo: Library of Congress.

slavery circles, and served during the Civil War as a nurse. While in charge of the hospital in the U.S. Capitol, she came to know President Lincoln personally and worked on a bust of him around 1862, which went into a private collection. Ames had patented her Lincoln portrait in 1866. Congress purchased a marble replica for $2,000 in 1868, and another went to the Massachusetts State Capitol.

Lincoln and a plaster bust of *Ulysses S. Grant* were shown at the Woman's Building of the 1893 Chicago World's Columbian Exposition. She also did busts of *Anson Burlingame* and *Ross Winans,* and her portrait of Grant won an award at the Paris Exposition of 1900. She died in Washington, D.C.

Helen Reed (?–?) began her career in Boston by drawing portraits in crayon, and she later studied with sculptor Preston Powers in Florence, Italy. Her marble bas-reliefs, such as *The Lost Pleiad* (1878, unlocated), were exhibited at the Boston Art Club and in New York.

THE PHILADELPHIA CENTENNIAL EXPOSITION OF 1876

The Philadelphia Centennial Exposition, a turning point for cultural life in the United States, drew ten million people to see the work of artists and artisans of all nations. The sophisticated and opulent displays from Japan, France, and other countries transformed American taste. The public was also astonished by the unprecedented outpouring of work by women artists.

Among the women sculptors who exhibited alongside their male colleagues in Memorial Hall were Margaret Foley (*Jeremiah, Cleopatra,* and medallions of *Mary* and *William Howitt*), Edmonia Lewis (*Death of Cleopatra, Hiawatha's Marriage, Old Arrow Maker and His Daughter,* and terra-cotta busts of *Sumner, Longfellow,* and *John Brown*); Florence Freeman (*Children with Yule Log*); Vinnie Ream (*Spirit of the Carnival, The West, Miriam,* and busts of *Senator Morrill* and *A Child*); and Anne Whitney (*Roma, Le Modèle,* and a statuette of *Charles Sumner*).

The Centennial Exposition was also a turning point for women in that, quite unexpectedly, they had their own building. Under the leadership of Philadelphia civic leader Elizabeth Duane Gillespie, a national network of women's committees had raised a tremendous amount of money in support of the fair, with the understanding that there would be an exhibition of women's work in one of the main buildings. Informed by the male organizers at the last minute that there was no room left for a women's display, the women's committee, outraged and feeling betrayed, decided to erect a separate pavilion. The resulting exhibition aroused a great deal of interest and controversy.

As visitors entered, they were astonished to see a woman operating a six horsepower steam engine that ran six looms and a printing press. Also on display were patents, inventions, a hefty collection of books by "those damned scribbling women" who so annoyed Nathaniel Hawthorne, and an exhibition of prints, paintings, and sculpture. Blanche Nevin's life-sized plaster statues,

Caroline S. Brooks, THE AWAKENING OF IOLANTHE (A STUDY IN BUTTER), (1876). Photo: Library of Congress.

Cinderella and *Eve,* were centerpieces. Florence Freeman showed a marble bust, and Margaret Foley exhibited profile reliefs of *Joshua* and *Charles Sumner.*

A succès fou was Caroline Brooks's *Iolanthe*—a sculpture carved in butter and preserved in an ice-filled tin tub! The artist subsequently patented her method, claiming that plaster casts taken from butter produced a far more sensitive surface than conventional methods. People raved about *Iolanthe* (one writer went so far as to say it was the best sculpture at the fair). Brooks has been fair game for sarcastic wit about her "feminine" art ever since, but readers can now make their own judgment of the merits of her work from the illustration.

Furniture Carvers and China Painters One of the revelations at the Women's Pavilion was a separate display of over two hundred pieces of carved furniture, decorative objects, and ceramics by sixty-five women of Cincinnati, Ohio. This was the work of a group of energetic society women who had long been active in raising the cultural life of that city. They had started the first art gallery and art academy in Cincinnati

EXTERIOR VIEW OF THE WOMEN'S PAVILION, Philadelphia Centennial Exposition, 1876. Free Library of Philadelphia Print and Picture Department.

Maria Longworth Nichols, BASKET (1882), Rookwood pottery. Cincinnati Art Museum. Gift of Mrs. Roy D. Kercheval. Photo: Ron Forth.

and had studied wood carving and china painting with Benn Pitman, an émigré Englishman devoted to the ideals of John Ruskin, William Morris, and the arts and crafts movement. He believed that women were "born" decorators—in fact, his wife and daughter carved furniture and helped teach the classes.

After the Centennial, wood carving and china painting became a passion with the women of Cincinnati—they carved dadoes, mantels, furniture, and wooden bowls and worked on Pitman's home, today a historic landmark. More than a hundred women assisted the Pitmans and the Frys (another family of wood-carvers) on the most ambitious wood-carving project ever attempted in Cincinnati—the decoration of the grand organ in the Cincinnati Music Hall. The splendid Pitman bed carved by Adelaide Nourse Pitman (Benn Pitman's wife) and decorated with paintings by her sister, the noted painter Elizabeth Nourse, shows the exuberant heights that this movement later reached.

Since the mores of upper-class women prevented them from earning a living, these efforts remained for the most part a dilettante form of creativity, intended to raise the quality of life of the community; yet they had long-lasting consequences. Wood carving became an accepted part of the curriculum in art schools, and at the turn of the century several women sculptors, such as Janet Scudder and Adelaide Johnson, supported themselves as furniture carvers at the start of their careers. Some who began as dilettantes inevitably became more deeply interested in their craft and, in the next decades, became professional ceramists, silversmiths, and designers in many fields.

Cincinnati women not only displayed their work; they were in turn influenced by the exposition. Maria Longworth Nichols, a Cincinnati heiress who had studied wood carving and china painting, was so enthralled by Japanese art and the splendid French porcelain on display that she decided to open her own pottery, which eventually became the world-famous Rookwood Pottery. Mary Louise McLaughlin returned to Ohio determined to duplicate the technique of faience underglazing she had seen on French Haviland Limoges. These two women became founders of the art pottery movement that spread across the country in the next thirty years and brought American ceramics international recognition.

END AND BEGINNING OF AN ERA

All in all, the Philadelphia Centennial showed the world that a new chapter had opened in the history of women and women sculptors. The surge of confidence and optimism that women felt was undoubtedly accelerated by the growing suffrage and women's rights movement. Susan B. Anthony and her colleagues mounted a guerrilla action on opening day when, without warn-

ing, they seized the platform for a Declaration of the Rights of Women and showered leaflets upon the audience. At a meeting they sang a song by Francis Dana Gage expressing a belief in the future of women, and in their power to bring about a better world:

> Oppression and war will be heard of no more
> Nor the blood of a slave leave his print on our
> shore

> Conventions will then be a useless expense
> For we'll all go free-suffrage a hundred years
> hence.

> Then woman, man's partner, men's equal shall
> stand,
> While beauty and harmony govern the land,
> To think for oneself will be no offense,
> The world will be thinking a hundred years
> hence.

ART DEPARTMENT IN THE WOMEN'S PAVILION. Engraving in *Frank Leslie's Historical Register of the U.S. Centennial Exposition*, 1877. In foreground, visitors looking at CINDERELLA and EVE by Blance Nevins. Photo: Philadelphia City Archives.

MAHOGANY BEDSTEAD (c. 1883), designed by Benn Pitman, carved by Adelaide
Nourse Pitman, panels painted by Elizabeth Nourse, height 9′2″ × width 3′7″ ×
length 7′. Collection of Mrs. Casper Heeg Hamilton. Photo: David Allison
courtesy of the Metropolitan Museum of Art.

The Gilded Age: 1876–1905

The Gilded Age was the period in the history of America when talent met money to produce an explosion in the building of opulent mansions and public buildings, and in the creation and acquisition of artworks to fill them. The Vanderbilts built no less than seventeen large estates, including the Breakers in Newport, Rhode Island, and the Biltmore in Asheville, North Carolina. Like the Medicis and the Sforzas who patronized Michelangelo and Leonardo da Vinci, the new giants of capitalism—the Morgans, the Fricks, the Carnegies—became the patrons of such sculptors as Augustus Saint-Gaudens and Daniel Chester French.

America had entered a period of vast growth in industry, finance, and monopoly capitalism, accompanied by an expansionist foreign policy. To express this surge of growth and power, the government and captains of industry demanded an art that presented an idealized vision of the grandeur, pride, destiny, and dreams of American civilization. Artists and architects drew inspiration from the unified style of the fifteenth-century Italian Renaissance, infusing the older forms with a new American spirit. Indeed, this period has been called the American Renaissance because of the rush to fill the nation's cities with Italian Renaissance state capitols, city halls, museums such as the Metropolitan Museum of Art, and libraries like those of Boston and New York and to adorn them with public statuary. It should not surprise us that when the great French modernist architect Le Corbusier visited New York City in 1935 to admire its skyscrapers, he found himself admiring instead the Italian Renaissance: "In New York, then, I learned to appreciate the Italian Renaissance. It is so well done that you could believe it to be genuine."[1]

Mrs. Schuyler Van Rensselaer, an influential tastemaker and author, advocated the integration of all the arts—sculpture, architecture, landscaping, murals—as in the Renaissance. The great architectural firms, such as McKim, Mead and White, became the coordinators of these projects, and worked closely with the sculptors. This new vision of the City Beautiful and of the American dream was expressed in gigantic world's fairs, such as the 1893 World's Columbian Exposition in Chicago. There was, however, one respect in which the American Renaissance differed from the Italian—the surprising number of women sculptors, patrons, collectors, and arbiters of taste who participated in it.

WOMEN SCULPTORS IN THE GILDED AGE

Art, along with teaching, writing, and nursing, was among the few respectable occupations open to middle-class women. The suffrage movement was well under way and it was in keeping with the spirit of the times that "advanced" women entered such masculine fields as wood carving and large-scale public sculpture. The great need for monuments opened up unprecedented opportunities for them.

Women now received training at the Pennsylvania Academy, the National Academy of Design, the Art Institute of Chicago, the Cincinnati Art Academy, the newly opened Art Students League, and some excellent schools of design for women. It was, however, still considered de rigueur to go to Europe for the ultimate art education. Sculptors no longer studied in Rome or Florence, but in Paris, preferably at the great École des Beaux Arts. Instead of the restrained smooth white marble forms of neoclassicism they now sought a more lively naturalism, richly modeled surfaces, and sometimes a flamboyant neobaroque style expressed in bronze—a style promoted by the French masters Falguière, Mercié, and others. Toward the end of the century, art nouveau with its swirling lines was influential.

Women artists began to flock to Paris, but there they experienced discrimination. Although American male sculptors such as Augustus Saint-Gaudens and Frederic MacMonnies studied at the École des Beaux Arts, no women were allowed into that leading academy until the last years of the nineteenth century, and even then only because of a long campaign by the French Union of Women Painters and Sculptors. The less prestigious Julian and Colarossi academies opened segregated classes to women, where they could study with French academicians and work from the nude model, but at higher tuition rates and with less instruction than in the men's classes.

The most important method of getting professional training was to work as an assistant in the studio of a leading sculptor. American women did not secure entrée as assistants in the ateliers of the French masters until later, but a few were fortunate enough to be taken on as apprentices by leading American sculptors. Augustus Saint-Gaudens employed Helen Mears, Marie Lawrence (Tonetti), Annetta St. Gaudens, Frances Grimes, and Elsie Ward Hering. Daniel Chester French hired only one woman, Evelyn Longman, but she became a lifelong friend and colleague; Frederick MacMonnies employed Janet Scudder in his Paris atelier; and Lorado Taft hired a number of women assistants in his Chicago studio.

The Paris Salon It was regarded as a mark of achievement to have one's work accepted for exhibition at the Paris Salon, and a few American women sculptors exhibited there before the twentieth century. The earliest by many years was Elisabet Ney (chapter 3) who exhibited plaster busts in 1861, but she was not yet an American at that time. Theo Alice Ruggles Kitson was the first American woman sculptor to win an award, in 1889. Others who showed at the salon through 1900 included Katherine Swinburne (1878), Emma Elizabeth Phinney (1881), Helene Hill (1883), O. Winslaw Hall (1885), Adeline Gales (1885), Theo Alice Ruggles (Kitson) (1888, 1890), Katherine Cohen (1892), Edith Howland (1893), Zara M. Frisbane (1893), Jane N. Hammond (1893), Lucy Brownson Hinton (1898), and her daughter Clio Hinton Huneker (later Bracken, 1898), Claire Curtis Huxley (1897), Jane Nye (1897), Carol Brooks MacNeil (1900), and Anna M. Valentien (1900).[2]

The National Academy of Design and the National Sculpture Society In the Gilded Age it was important to be elected to the prestigious National Academy of Design. Two amateur sculptors, Cornelia Dubois and Frances Lupton, were admitted as Associate, or "honorary," members in 1828 and 1842. Neither was elected to permanent status, probably because they dropped their careers. After them no woman sculptor was admitted until 1906, when Bessie Potter Vonnoh became a member. Today the Academy has many women members.

The National Association of Women Artists, founded in 1889, became an important showcase for women artists, and continues its work today.

The National Sculpture Society was formed in 1893. Alice Theo Ruggles Kitson was the first woman admitted, in 1895, followed by Enid Yandell and Bessie Potter Vonnoh in 1899.

The Women Sculptors' Achievements Not surprisingly, some women sculptors reflected the values and the artistic styles of their age. In a period of extreme nationalism, they created patriotic monuments, war memorials, and allegorical sculptures expressing such abstract ideals as "Victory" and "Patriotism." In order to survive in a male-dominated environment, they accepted the values of their colleagues.

Theo Kitson, for example, created one of the most popular war monuments in America, *The Hiker,* a soldier with a gun, commemorating the Spanish-American War—a work so popular it was cast more than forty times and stands in cities as far apart as Oshkosh, Wisconsin, and Arlington, Virginia. Also reflecting the age are Nellie Walker's *Lincoln,* Enid Yandell's *Daniel Boone,* and Julia Wendt's *Art, Science and History*—the latter portrayed as idealized draped female figures in the lofty style of Daniel Chester French and Augustus Saint-Gaudens.

But there are some interesting comparisons to be made between the work of women and that of men at this time. Thematically, we find a group of realistic statues portraying female leaders and heroines, different from the abstract female symbols—the typical glorified "Columbias" and "Victorys" of the day. Helen Mears's figure in the U.S. Capitol of *Frances Willard,* educator and leader of the temperance movement, is not in swirling classical draperies but in everyday costume at the podium making a speech. Adelaide Johnson made uncompromisingly realistic busts of suffrage leaders. Theo Kitson created a vig-

orous figure of the maverick Civil War nurse Mother Bickerdyke giving water to a wounded soldier. She is shown as a middle-aged woman with muscular arms and rolled-up sleeves. It is not likely that we would have this layer of works portraying intellectual and active women without the input of women artists.

On the other hand, a group of small "feminine" works were also created by women. One of the most original artists of the period was Bessie Potter Vonnoh, whose small, impressionistic bronzes of women and children manifest a sincerity and sensitivity that continues to captivate students of American sculpture.

A number of sculptors started out with vigorous approaches but ended up doing lighthearted garden sculpture or cute figures of children because such subjects were felt to be more suited to women's talents. Although a few surmounted obstacles and carried out large heroic works, on the whole monumental commissions went to men. Caroline Peddle Ball created an admired "Victory" for a quadriga at the American exhibition in the 1900 Paris Exposition, but she too ended up doing small, cute studies of children which found a ready market.

Janet Scudder, who worked with Taft and MacMonnies, wanted to do large public commissions, but earned her bread and butter by making piping pans and garden fountains for the estates of the super-rich. After a while (especially after experiencing the horrors of World War I) she decided that she preferred garden sculpture to the pompous public effigies being erected in American cities: "I won't do it! I won't add to this obsession of male egotism that is ruining every city in the United States with rows of hideous statues of men-men-men-men-men each one uglier than the others.... Banish the thought that I should try to teach anyone anything.... My work was going to make people feel cheerful and gay, nothing more!"[3]

Garden sculpture, treated with contempt for a long time, is now being reexamined and reevaluated—recognized as a genre in which a considerable amount of inventiveness and creativity was given free rein. Several important exhibitions have focused on these works in recent years, bringing to light the important role that women played in their creation.

As might be expected, the independent careers of some women sculptors (like Vinnie Ream's, recounted in the last chapter) tapered off after the artists became wives and mothers. Several who married sculptors subordinated their careers to their husbands'—Annetta St. Gaudens, Elsie Ward Hering, and Marie Lawrence Tonetti. Augustus Saint-Gaudens noted that his women students often started out showing more promise than the men, but ended up producing much less. When he heard of the marriage of one of his favorite students, Marie Lawrence, to her less talented colleague François Tonetti, he reportedly burst into tears and said, "I suppose there'll be lots of festive children."[4]

THE 1893 CHICAGO WORLD'S COLUMBIAN EXPOSITION

The "White Rabbits" For the 1893 World's Columbian Exposition, America's leading architects and sculptors gathered in Chicago to design a magnificent neo-Renaissance "White City" that would reflect America's emergence as a leading power. Augustus Saint-Gaudens described it as the greatest gathering of talent since the fifteenth century. Daniel Chester French created a gigantic gilded theme statue of *The Republic,* and Frederic MacMonnies, a flamboyant *Barge of State,* reflected in a lagoon and propelled by scantily clad female rowers.

Just as the Philadelphia Centennial Exposition of 1876 had been an important showcase for women sculptors, so the 1893 Chicago fair presented them with many opportunities. One group

SCULPTURAL STUDIO IN HORTICULTURAL BUILDING (24 August 1892). Preparing for the Chicago World's Columbian Exposition, 1893. Courtesy Chicago Historical Society.

got the first boost to their careers by helping Lorado Taft scale up his large decorations for the Horticultural Building. Hard-pressed for help, he asked Daniel Burnham, chief architect of the fair, if he could hire some women. Burnham's famous reply was, "Hire anyone, even white rabbits if they'll do the work."[5] After that Taft's group of female assistants came to be nicknamed the "White Rabbits." Among them were Janet Scudder, Carol Brooks, Enid Yandell, Julia Bracken, and Bessie Potter Vonnoh, all of whom became well-known turn-of-the-century sculptors.

Taft, who taught at the Art Institute of Chicago, had a liberal policy about women artists. His own sister Zulime was a painter, and before this he had employed promising women students, such as Julia Bracken, as his teaching assistants and in his studio. Indeed, Frances Loring, who later became a noted Canadian sculptor, complained that he used their talent to create his work.

Several women also received independent commissions for various state pavilions, such as Yandell's *Daniel Boone* for her home state, Ken-

WOMAN'S BUILDING, Chicago World's Columbian Exposition, 1893. Photo: Library of Congress.

tucky, Wendt's *Illinois Greeting the Nations* for that state, Helen Mears's *Columbia* for Wisconsin, and Scudder's figure for Indiana. Augustus Saint-Gaudens recommended Mary Lawrence for one of the major theme statues, *Columbus*, at the entrance to the Administration Building. Women sculptors also displayed work alongside that of men in the U.S. art exhibition, and several worked on the Woman's Building.

The Woman's Building The Woman's Building, initiated by Susan B. Anthony, provided a showcase for women's accomplishments in many fields. In charge of the project was a Ladies Board of Managers, headed by Bertha Honoré Palmer, the capable wife of a leading Chicago tycoon.

Sophia Hayden, newly graduated from the Massachusetts Institute of Technology, won the architectural competition for the building, and carried out a graceful neo-Renaissance design with a roof-garden restaurant that became one of the most popular retreats from the hurly-burly of the fair.

A nineteen-year-old girl, Alice Rideout, was chosen in competition to design the figures for the pediment, and Enid Yandell created the model for the caryatids that held up the roof of the outdoor dining room. In the central Hall of Honor were Adelaide Johnson's portrait busts of suffrage leaders, Anne Whitney's fountain, Vinnie Ream's *The West* and other works, and sculpture by women from other countries.

Whitney, who now was engaged in a splendid career, was at first reluctant—she felt that by this time women's work should be shown along with the men's—but being a feminist, she finally succumbed to Mrs. Palmer's appeals. Vinnie Ream had also hoped to show her work elsewhere, and was disappointed when she was forced to put it in the Woman's Building. The question of whether women should exhibit separately has been debated continually since the beginning of the women's movement and still raises arguments today.

Yet, in retrospect, the Woman's Building of 1893 can be seen as a beacon for women. For the first time, they were able to show that they could

HALL OF HONOR, WOMAN'S BUILDING, Chicago World's Columbian Exposition, 1893. Sculpture grouping in center, around fountain by Anne Whitney. Souvenir Photo Company, 1893. Library of Congress.

create an integrated work of architecture, sculpture, and painting. The building became a center for meetings relating to the welfare of women around the world, and played a role in furthering the suffrage movement. Even now it is hard to find a major building designed by a woman and enriched by the work of women sculptors and muralists. Until such projects are commonplace, the Woman's Building remains an important milestone in the history of women artists.

Theo Alice Ruggles Kitson (1871–1932)

In the presence of this spirited and ably composed work one is almost compelled to qualify the somewhat sweeping assertion that no woman has as yet modelled the male figure to look like a man. Her talent is robust, and she attacks fearlessly the problems of monumental statuary.
—Lorado Taft[6]

Theo Kitson, sculptor of military monuments of "vigor and genuine craftsmanship,"[7] whose statue *The Hiker* became the symbol of the Spanish-American War, was the first American woman sculptor to receive an award in the Paris Salon and the first admitted to the National Sculpture Society.

Born in Brookline, Massachusetts, the daughter of Cyrus Washburn and Anna Holmes (Baker) Ruggles, Theo showed such extraordinary talent that when she was fifteen her mother tried to enroll her in the sculpture program at the Boston Museum School. Mrs. Ruggles was told that no art academy would accept such a young girl, but that perhaps Henry Hudson Kitson, an up-and-coming Boston sculptor, might be willing to give her private lessons.

When Mrs. Ruggles brought her daughter to Kitson's studio in 1886, Theo modeled an ear from the antique so perfectly that he was delighted to accept her as a student. The following year she won a prize for *Head of an Italian Girl* at the Mechanics Exhibition in Boston. Before long Henry Kitson was interested not only in her work but in "Little Tot" (his nickname for her)

as well. On 10 November 1889, an article in the *Boston Sunday Herald* entitled "A Boston Girl's Genius," announced her engagement and discussed the honors she had won abroad.

Accompanied by her mother, Ruggles had gone to Paris in 1887 and studied drawing with Adolphe Dagnan-Bouveret and Gustave Courtois, as well as sculpture in Kitson's Paris studio. She was only seventeen when her busts *Italian Girl* and *Shepherd Lad* were accepted in the 1888 Paris Salon. That fall, while studying painting with Daubigny at Auvers-sur-Oise, she commenced a sensitive life-sized nude figure of a boy seated on the river bank (*On the Banks of the Oise*, private collection). The plaster model won honorable mention at the Paris Universal Exposition of 1889, and the following year *Young Orpheus*, a boy seated on a tree stump, playing a horn for a rabbit, won an honorable mention at the Paris Salon. She was reportedly the first American woman sculptor to receive such an award (Elisabeth Gardner won a gold medal for painting earlier).

Theo wrote home to her fiancé (working on a commission in Boston) that she was frightfully nervous at the awards ceremony and that when she rose to go to the platform she heard gasps from the audience ("elle est si jeune!") and received a standing ovation.[8] These were extraordinary accomplishments for a teenaged girl; many well-established male sculptors could not even jury into these exhibitions.

In 1893, the year of her marriage, she was commissioned by the women of Michigan to create figures of a boy and girl holding tree branches "representing the Michigan woods" for the Chicago World's Columbian Exposition. In 1895 she was the first woman elected to the newly formed National Sculpture Society. Establishing residence in Quincy, Massachusetts, she subsequently created more than fifty public sculptures for sites around the country and collaborated on a number of other monuments with her husband. At the same time she raised three children.

An early commission, the bronze figure of *Esek Hopkins*, the first American commodore, stands in naval uniform on a tall stone pedestal in Hopkins Square Park, Providence, Rhode Island. He points ahead with one arm, holding a spyglass in his hand. In 1902 she created her first Civil War monument for Newburyport, Massachusetts—*The Volunteer*, a bronze figure of a young Union soldier trudging forward resolutely, shouldering a musket. A similar figure was commissioned for the Massachusetts State Monument in National Military Park, Vicksburg, Mississippi. Between 1904 and 1918 she created more than sixty busts and reliefs for Vicksburg.

Kitson's best-known work is a Spanish-American War memorial commissioned for the University of Minnesota in 1906. About fifty copies were later ordered for various locations across America, such as Oshkosh, Wisconsin; Savannah, Georgia; New Orleans, Louisiana; Portland, Maine; Providence, Rhode Island, Arlington National Cemetery, Virginia; and so on. It was ar-

Theo Alice Ruggles Kitson, THE HIKER (SPANISH AMERICAN WAR MEMORIAL) (1906), bronze, Oshkosh, Wis. Photo courtesy Oshkosh Public Museum.

guably the most popular war memorial in the country.

Nicknamed *The Hiker* because of the troops' long hikes in steaming jungles, the sculpture depicts an eight-foot soldier, handsome, muscular and—though standing at parade rest—ready for action, his rifle held horizontally between his hands. Dressed for tropical warfare in a broad-brimmed hat, his jaw firm but not jutting, he suggests high moral ideals rather than military might. Kitson's statue reflects the jingoistic American spirit at the turn of the century: "The romanticized treatment of the foot soldier suggests the popularity of 'this splendid little war,' the Spanish-American War of 1898–1902 in which the United States emerged as a world power and expanded its territories to include Puerto Rico, Guam, and the Philippine Islands."[9]

In 1906 Kitson also completed the bronze *Mother Bickerdyke Memorial,* commissioned by the state of Illinois for the grounds of the Knox County Courthouse in Galesburg. The famous Civil War nurse, who overrode bureaucratic regulations in order to help the wounded, is shown as a mature, unglamorized figure, kneeling on one knee, giving water to a wounded soldier whom she supports in the crook of an arm. Her muscular arms, workaday clothes, and active gesture present a different image of womanhood from the passive, elegant, or classicized female images of the period. On the plaque is General Sherman's statement "she outranks me."

During this period, when Henry Kitson was ill and depressed, and could not carry out his commission for the Framingham *Minute Man* (also known as *The Blacksmith*), Theo executed it from his design. She also collaborated with him on the *Patrick Collins Monument* (1908, Boston), which they both signed. This extraordinary partnership ended after Kitson left for New York to work on a commission. They remained separated after 1909, although they were never di-

Theo Alice Ruggles Kitson, MOTHER BICKERDYKE MEMORIAL (1906), bronze. Galesburg, Ill. Henry Hudson and Theo Alice Ruggles Kitson Papers, Archives of American Art, Smithsonian Institution.

vorced. (Two years after Theo Kitson's death he remarried.)

Theo Kitson continued an extraordinary career alone, moving to Sherborn, and around 1926 to Framingham. In 1927 she carried out a romantic seven-foot bronze figure of the Polish hero of the American Revolution, *Tadeusz Kosciuszko* (Boston Public Garden), commissioned by the Massachusetts Polish Society. The liberty-minded hero who came from Poland to help the American Revolution and then battled for freedom in his own land, is shown as a tall, slender, idealistic-looking figure whose tousled hair, flowing jabot, military epaulettes, sword, and boots give him an animated Byronic aura.

Around this time an interview with Kitson in her handsome stone villa atop a hill in Framingham described her as a down-to-earth, modest woman who, despite her impressive achievements, spoke of her work in a matter-of-fact way, with no attempt to project an image of genius. Some of her late works seem heavy-

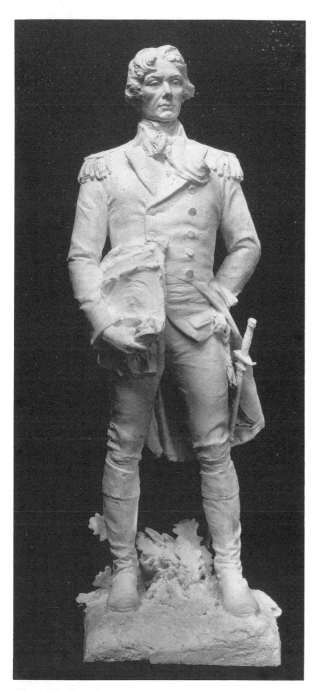

Theo Alice Ruggles Kitson, KOSCIUSZKO (1927), plaster, unlocated. Henry Hudson and Theo Alice Ruggles Kitson Papers, Archives of American Art, Smithsonian Institution. Bronze monument is in Boston Public Garden.

handed and formulaic (*The Wounded Color Sergeant,* Topsfield, Massachusetts, and the 1929 equestrian *Victory,* Hingham, Massachusetts).

Theo Kitson's vigorous military monuments shatter the stereotype of the woman sculptor as a fashioner of dainty devices. These were the kinds of commissions that came her way in that era. But a flowing, hooded, and winged female *Guardian Angel* with a gentle, melancholy expression, erected in several cemeteries, shows that she would have been equally adept with lyrical themes if the opportunity had presented itself.

Julia Bracken Wendt (1870–1942)

> To give the clay a primal speech
> of symbols, mystic, manifold
> Which down below all language reach
> A common concept, aeons old;
> And subtly through the veiled eyes,
> Like cowled confessors inner sight,
> To take the heart shrine by surprise
> And give its inner spirit light.
> —Landon Haynes[10]

Julia Bracken Wendt, one of the favorite protégées of Lorado Taft, was a successful Chicago sculptor by the age of twenty. After moving to California, she became the leading sculptor of Los Angeles.

Hers is the classic American legend of a poor girl who works her way up through pluck and talent. The twelfth of thirteen children of an Irish Catholic railroad man, Julia was born in Apple River and raised in Galena, Illinois. At the age of five she began to model small animals out of local red clay, working in a cave near her home. Haynes wrote that "she . . . served a long apprenticeship, lying all day long by the river bank, studying the forms and motions of water rats and toads; stealing out alone at night to the forest to watch the owls and bats."[11]

She was nine when her supportive mother died, and her sisters had little patience with a child who tracked clay mud into the house and whittled faces on the furniture arms. At thirteen she ran away from home.

Julia was fortunate enough to get a job as the domestic servant of a very generous woman, Alice B. Stahl, who immediately recognized her talent. By the age of sixteen, the self-taught artist was already beginning to earn money by modeling vases and other art objects and doing wood-carving jobs, such as a pulpit for the Evanston Congregational Church. Stahl took her to Chicago and paid to enroll her at the Art Institute.

Julia Bracken became Lorado Taft's star pupil. Between 1887 and 1892 he employed her both as his teaching assistant and in his studio. Bracken was still a student when she won recognition for the first of a set of bas-relief portraits—*The Modern Prophets,* images of Emerson, Tolstoi, Ruskin, Carlyle, William Morris, and the like. The Chicago School of Education reportedly electrotyped them and awarded them as prizes. When Taft went on an extended trip to Paris he turned over his studio to the young artist. A visiting architect saw her at work there and commissioned a frieze of nymphs and trees for the City Hall of Austin, Illinois (unlocated).

In 1893 Bracken was one of the White Rabbits who assisted Taft with sculpture for the Chicago fair and also carried out an independent commission, *Illinois Welcoming the Nations,* which the Illinois Women's Board subsequently had cast in bronze for the state capitol at Springfield. At the unveiling ceremony, Governor Altgeld profusely praised "woman's work" and its importance to the nation.

Bracken opened a studio on Wabash Avenue and was soon very busy. She completed *Monument to the 19th Illinois Volunteer Infantry* (1897), a bronze relief panel of a battle scene containing over twenty figures, for the Civil War monument at Missionary Ridge, Chattanooga, Tennessee, and was appointed a staff sculptor for the 1904 St. Louis Exposition (a rare honor for a woman), to which she contributed a heroic figure of *James Monroe* pointing to the junction of the Mississippi and Missouri rivers on a globe (reportedly sent to an eastern college campus).

Bracken was a progressive—a supporter of the arts and crafts movement, and one of the leaders of the Bohemia Guild which ran a school to train working people in craft trades (bookbinder Gertrude Stiles and printer Frederic W. Goudy were the other two leaders). The guild was connected with the utopian Industrial Art League, whose walls were adorned with Bracken's plaques of William Morris, Carlyle, and Ruskin. The Women's Trade Union League, a coalition of settlement house leaders, women unionists, feminists and socialists, hired Bracken to design their emblem. She also served as director of the Municipal Arts Club and was a leader in other Chicago groups.

The sculptor was far too busy supporting her elderly father and raising the orphaned children of a sister to think about marriage; in fact, she planned to devote herself entirely to her career. But one day she became intrigued with a "distinguished, pale bearded young painter," William Wendt, who worked across the hall from her, when she heard him playing the violin beautifully (she later discovered that the musician was Wendt's roommate, but by then the damage was done). William Wendt was characterized as a "shy, naive German," whereas Julia Wendt has been described as a lively Celtic type, with flashing dark eyes and lots of spirit. They remained "just friends" for thirteen years. In 1906, when Wendt moved to Los Angeles, they found that they were in love and he persuaded her to marry him and join him there. Like many a woman who has followed her husband, she had to start over

again in what was then a relatively raw, uncultured town. When they moved into the Sichel Street studio that had belonged to another well-known California artist couple, Marion and Elmer Wachtel, the sculptor built the necessary cabinets and shelves herself—indeed she continued to be described as a thoroughly trained craftswoman who constructed her own armatures and was familiar with tools.

At first Julia Wendt continued to travel periodically to Chicago to execute works like a *Memorial Tablet for Colonel Parker* (1907) for the Chicago University School of Education and an elegant Beaux Arts medal for the Chicago Society of Artists. But before long she was doing portraits of Angelenos (artists *Elmer Wachtel, Carl Oscar Borg,* and *Marion Holden Pope*) and modeling allegorical figures such as *The Sculptor and the Sphinx,* mortuary urns, Nymph and Pan fountains, and bronze fireplace mantels. A particularly beautiful baptismal font, *The Tree of Life,* shows the crucifixion with the cross metamorphosing on either side into ornamental trees.[12]

Julia Wendt's feminism surfaced in 1909 when she sent a blistering letter to the Art and Artists column of the *Los Angeles Times.* She was furious because the editor had written that women would use "any loophole" to get into a newly formed Los Angeles art organization:

> When artists—men or women—have some higher aim than "the sex question in art" (for it certainly has no place there) it will not be necessary for women to get in through loopholes. The fact is, the woman who succeeds in art must be too large to squeeze through "loopholes" for she must be large enough to overlook the littleness of would-be men, and she must succeed not with their brotherly help but in spite of them. This is not an age of chivalry. Nor does she want sentimentality. But she has

every reason to expect justice. There is plenty of work to be done in the field of art and room enough for all who have ability and are earnest workers.[13]

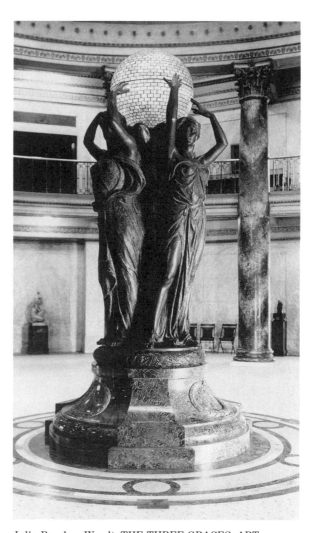

Julia Bracken Wendt, THE THREE GRACES: ART, SCIENCE, AND HISTORY (1914), bronze, height 11′. Courtesy Seaver Center for Western History Research, Natural History Museum of Los Angeles County. Photo: Julia Bracken Wendt.

Wendt then exposed the provincialism of the Angelenos by quoting from egalitarian statements at the national convention of the American Federation of Art. In 1911 she won the prize for the best poster design to be used by the Political Equality League. The poster featured a blow-up of her medallion of a seated female figure, *Justice,* holding a shield bearing the ancient symbol *Tomoye* (which signifies the equality of male and female) and the inscription "Intelligence Has No Gender."

Julia Wendt received the commission for the most important public sculpture in Los Angeles, a colossal bronze three-figure composition representing *Art, Science and History,* for the rotunda of the newly erected Los Angeles County Museum. At the 1914 dedication, conducted with great fanfare, Mrs. Henrietta Housh, who had founded the Fine Arts League and had pushed for the commission, spoke of the difficulties along the way:

> When I first began to say that we could get a beautiful group for the rotunda ... and that Mrs. Wendt certainly must have the commission, there were people who thought that something must be wrong with my head; but a few believed with me and rallied for the struggle. Even Mrs. Wendt had rather lost heart. She didn't think that the people out here would understand anything of this kind, this creative work. But I am of those who believe that the secret of all attainment is the setting of one's face in the right direction, then keeping straight on toward one's ideal until the realization comes.
>
> Then, too, this was a part of my suffrage work. I felt that this was an opportunity to furnish an illustration of living up to our principles; to see that something was done to show appreciation of the woman, here in our midst, who had the power to create a monumental and symbolic group.[14]

These remarks show that the going must have been hard and that Julia Wendt did not think too much of the cultural level of Los Angeles. Everett Maxwell, curator of art, pointed out that the statue was a milestone in the life of the community: "No statue that America possesses is more significant than the Wendt group. It has for the last three years occupied the center of the stage in the field of local art.... at last Los Angeles possesses one really good public statue."[15]

The more than life-sized green-bronze figures representing *History, Science and Art,* gracefully draped in classical robes, hold up a crystal electric light globe that sheds a soft light on the rotunda. The work fits in harmoniously with the architectural setting, a characteristic example of the American Renaissance style. Ironically, in the 1950s, when the Beaux Arts style was considered old-fashioned, the statue was hidden for years behind the mineral display. But recently, as taste has changed again, the entire rotunda has been refurbished and returned to its original harmonious form.

Wendt was also working on a peace fountain, the *Prince Edward Memorial,* intended for the campus of the University of Saskatchewan at Saskatoon, Canada. The maquette (which was reproduced in the *Los Angeles Times*) shows a winged draped female figure holding an olive branch, standing on a globe atop a tall pedestal. The four human races—Black, Asian, Indian, and Caucasian—are seated at the base. For some reason the large project was never carried out— perhaps because World War I broke out and Canada no longer wanted a peace monument.

Wendt continued to do Chicago commissions: a relief of *Marshall Field* for the Field Museum; a marble bust of *Dr. Sarah Hackett Stevenson,* and a presentation plaque for *William Merrit Chase* (1914). Locally she was working on a garden fountain for a Sierra Madre mansion, consisting of a seven-foot bronze figure, *The Comet,*

holding an electric lightolier, to stand in a lily pool. Behind the figure was a bronze relief of a landscape and dancing classical figures. Water gushed from bronze rocks on the panel into the basin below. "At night the round white globe of the Comet will be wonderfully reflected in the pool ... a scene from fairyland," wrote an art reviewer.[16]

The Wendts' joint exhibition at the Los Angeles County Museum in 1918 was called one of the "most significant exhibitions of the year." In 1924, the sculptor finished a major commission—a bronze half figure of *Lincoln* for Lincoln Park, Los Angeles.

Art critic Arthur Millier described the sculptor in 1931: "Mrs. Wendt's eyes constantly light up with gleams of humor and of fighting spirit as she recounts the past. She has the Celtic dislike of set rules and the Celtic love of symbolism and freedom."[17] Her studio, he said, was "a veritable museum of local history." It included many portraits of noted Angelenos such as *Charles Lummis* (Lummis House, Los Angeles), the defender and promoter of Native American and California culture, *Perry Widener, Frank Wiggins, Dean MacCormack, Charles Walton,* and *Judge William Rhodes Hervey* (the last three bronze busts are in the Masonic Temple, Los Angeles). She was working on a bust of *John Steven McGroarty* for Mission Playhouse, San Gabriel. "So lifelike is this author of the Mission Play that one recognizes him from the back before the fine features are even glimpsed." Wendt also carried out numerous medallions and sculptures such as the swirling art nouveau *Mermaids and Fish.*

In 1936 Julia Wendt closed her Sichel Street studio and moved out to Laguna Beach to join her husband. At the time of her death in 1942 she was working on a portrait of him.

Julia Wendt's career seems to have been the outgrowth of a remarkably balanced personality. Active in the community as well as in the studio,

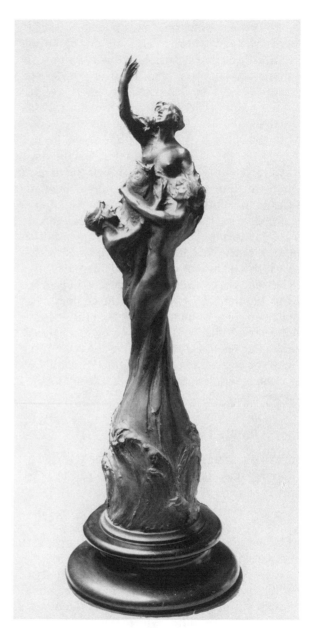

Julia Bracken Wendt, MERMAIDS AND FISH (n.d.), height 51″. Collection of Mr. and Mrs. Wilfrid H. Charlton. Photo: William C. Rubinstein.

she helped organize the California Arts Society, taught for seven years at Otis Art Institute (now the Otis-Parsons Institute), and was on the Municipal Arts Commission for three years. Her studio was always buzzing with students and artists dropping in for advice. Known for her generosity, both to humans and to animals (her studio was filled with stray dogs and injured birds and she even kept a pet spider in a drawer), the artist once said, "Life is much more important than art. The true artist ... does not make art his main business in life, for if he does he becomes narrow, one-sided, distorted, thrown out of all sympathy with the Divine realities. Holding that Art is life, he stultifies and makes barren the results of his endless labors."[18]

Her teacher, Lorado Taft, regarded her as one of the outstanding sculptors in the country. "Her work," he said, "abounds in ingenuity and a well-characterized style of her own, recognizable for its decorative grace."[19] She would probably have become even more prominent and better remembered today if she had remained in Chicago.

Bessie Potter Vonnoh (1872–1955)

What I wanted was to look for beauty in the everyday world, to catch the joy and swing of modern American life.
—Bessie Potter Vonnoh[20]

Bessie Potter Vonnoh's enchanting small bronzes portray mothers and children, or girls dancing, with an intimacy and authenticity of feeling very different from the grandiose public monuments of her male colleagues. Done in a subtle, impressionistic style, they capture the essentials of her subject. Vonnoh was the first woman sculptor to become a permanent member of the National Academy of Design, and her work is in museums in many countries. Yet her joyous, active life began with years of pain and invalidism. She later said that those long years "taught me a lesson in endurance":

When I was two years old my father was killed in a railroad accident. Shortly after this my invalidism set in.... The ailment was mysterious. One puzzled doctor after another diagnosed the case.... As a result I endured years of slow torture, sometimes encased in plaster casts, sometimes held by straps from the ceiling in an upright position, sometimes lying exhausted in a wheelchair.... [M]y inactivity stunted me so that to-day I am child-size, standing only about four feet eight inches from the floor.

At last, in my tenth year, the doctor then attending gave me up. I heard his death sentence: "I won't come again. Nothing can be done. Make her as comfortable as you can."

But instead of dying I began gradually to get well. Why, no one ever understood. I only know that when all treatments and fussing ceased I slowly began to mend.[21]

Janis Conner and Joel Rosenkranz, authors of *Rediscoveries in American Sculpture: Studio Works, 1893–1939*,[22] have made a study of Vonnoh's life, and they suspect that she was perhaps suffering from hysterical paralysis brought on by the shock of her father's death when she was two. They note the imagery of a strong, protective mother with small children and the absence of adult male figures in her art.

Shortly after her father's death, the family moved to Chicago. When Bessie Potter was able to go to school, the modeling class became her delight. "The touch of the clay and the joy of creating gave me a sense of deep contentment."

At fourteen, deciding to be a sculptor, she pinned magazine pictures of sculptors all over the walls of her improvised "studio" and began to get odd jobs, such as modeling the head of a political candidate for a campaign cane! When she was fifteen, she and her mother discovered the shop of an Italian plaster caster, who permanently altered her life by suggesting that she should study with Lorado Taft.[23]

Taft became a lifelong friend. In his class she found female role models; on the very first day he handed her a plaster eye from Michelangelo's *David* to copy and turned her over to his assistant, Julia Bracken. Potter was one of the White Rabbits assisting Taft for the Chicago fair. When she learned that she would receive five dollars a day and an eight-hundred-dollar commission (a considerable sum in those days) for an eight-foot figure representing *Art* for the Illinois building, she said, "my joy can hardly be imagined. What mattered it that I must ride to the Fair grounds every day in an unheated horse-car with straw spread on the floor? I mounted that bumpy car each morning as if it were a chariot."[24]

It was at the 1893 Chicago fair that she saw an exhibition of small spontaneous bronzes by Paul Troubetskoy, a Russian sculptor who worked in Italy, and decided to "do Troubet-szkoys" herself.

At twenty-two, Potter opened her own studio. Soon women were clamoring for her small, delicately colored plaster portrait-statuettes of them dressed in the "incongruities of the day." It was a hard struggle though; in order to make a living she was cranking out these "Potterines," as she called them, for twenty-five dollars apiece.

Doing statuettes of society women as they really looked was not as simple as one might think. There was "the serious problem of how to portray charmingly women in the atrocious fashions of the day—balloon sleeves, pinched waists, full skirts, funny little hats."

> An extreme example ... was a certain wealthy matron who wanted a portrait of Susan B. Anthony and herself together. This lady—Mrs. Blank—was enormously stout. And the dress she insisted on using would not come together in the back. It was terrible beyond words—white satin with balloon sleeves ... and great baskets of flowers embroidered at the hips.
>
> "Never mind," I consoled her as patient Miss Anthony looked on with quiet tolerance, a willing martyr because Mrs. Blank was helping to finance the "Cause." "No one will see that it is open." I seated Miss Anthony—a charming subject, gentle and feminine, almost beautiful; then I stood Mrs. Blank beside her, white gloves and all. We had hardly started when a caller dropped in, Mme. Lillian Nordica, a fashionable singer of the day. . . . Mrs. Blank's bosom began to heave and for a moment I thought she was going to run from the room. Instead, however, she kept turning, so the singer would not see her back. Nordica soon caught on, became highly amused, and tormented the poor lady by hovering near, until I was in despair for fear I should lose my order.[25]

Potter saved enough money for a trip to France with her mother, Taft, and his artist-sister Zulime. She was enormously impressed by a visit to Saint-Gaudens's New York studio; she met Rodin and may have been influenced by Jules Dalou, whose freely modeled study of a mother and child bears some resemblance to hers.

On her return, while turning out bread-and-but-

ter portraits, Potter created the *Young Mother* (1896), a handsome woman in modern dress seated in a chair, holding a swaddled infant. This tender, authentic work, which has a kind of grandeur-in-miniature, became famous and can be found in numerous museum collections.

Viewing herself as a vanguard artist, she was trying to show "beauty in the every-day world, to catch the joy and swing of modern . . '. life." This had been the battle cry of impressionist painters, but few had applied it to sculpture. The American impressionist painter Theodore Robinson recognized these qualities in her work and in 1894 bought one of the first plasters that Potter showed in New York: "Like all young things I was radical in art. . . . I was determined to prove that as perfect a likeness and as much beauty could be produced in statuettes twelve inches in height . . . as could be had in the life-size and colossal productions suitable for so few houses."[26]

Potter's Chicago studio became the gathering place for a club called "The Little Room"—a salon of artists, musicians, and writers, including the realist novelist Hamlin Garland (an early supporter of impressionism), poet-critic Harriet Monroe, and composer Edward McDowell. At the same time her work was becoming well known in New York. *The Young Mother, Girl Dancing* (1897), and *Girl Reading* were enthusiastically received in the 1898 exhibition of the National Sculpture Society.

After a trip to Italy, where for the first time she put some of her works into bronze and marble (before then she had been able to afford only plaster), Potter, with a major commission in hand for a heroic bust of Major-General Crawford for the Smith Memorial at Fairmount Park, Philadelphia, decided to take the big step and move to New York.

Robert Vonnoh, the American impressionist painter, had met Potter in Taft's studio when she was working on sculptures for the Chicago fair. After several years of friendship, Vonnoh was eager to marry her, but she persuaded him to wait until she was finished with the Crawford bust and another major commission—a gilded life-sized figure of actress *Maude Adams* (famous as Peter Pan) for the 1900 Paris International Exposition. In 1899, the day after she completed them, they were married.

In a rare harmony of taste and temperament, the Vonnohs shared a New York apartment-studio, critiqued each other's work, and exhibited together in Boston, Chicago, and many other cities. Later they spent a good deal of time entertaining lively, prominent people at their summer home near the art colony of Lyme, Connecticut.

Bessie Vonnoh was admitted to the National Sculpture Society in 1899, had a solo exhibition at the Brooklyn Museum in 1913, became a full academician of the National Academy of Design in 1921, was elected to the Institute of Arts and Letters, was commissioned to do a heroic bust of Vice President Sherman for the Senate Chamber, and, among many awards, won the National Academy's Watrous Gold Medal in 1921 for *Allegresse*, a three-figure group of dancers. The Art Institute of Chicago and the Corcoran Gallery of Art have large collections of her sculptures.

Vonnoh's work was often compared to Greek Tanagra figurines, although she had not seen any at the time she began to create her statuettes. After 1903, her subjects are increasingly shown in garments that vaguely suggest Greek tunics. Art historian May Brawley Hill has pointed out that Isadora Duncan and others were adopting such clothing at the time and that this

was part of the dress reform movement, intended to bring more freedom to American women.[27] Indeed Vonnoh had, at the turn of the century, been appalled at "the horrible dress of the day. It was amazing how intelligent women clung to it."[28]

The slender modern woman in flowing classicized garments is shown in *Girl with Garland, Beatrix, An Ideal, Daphne* (1911), *The Dance, The Scarf* (1911), *In Grecian Drapery* (1913, Fort Worth Art Museum), *Irene Castle, The Fan* (c. 1910, National Museum of Women in the Arts), *The Intruder* (1913, a small table fountain), *Cinderella,* and *Allegresse.*

Beginning in the 1920s Potter did larger public works—*Bird Fountain* (1920) for a bird sanctuary at Ormond Beach Park, Florida; a bird fountain with two children (1925, Theodore Roosevelt Memorial Bird Sanctuary, Oyster Bay, Long Island); and another fountain group of children, dedicated to the children's author Frances Hodgson Burnett (1937, Children's Garden, Central Park). On the whole these monuments seem more anecdotal and less fluid than her smaller figurines.

The Vonnohs were living in the south of France when Robert died in 1933. The sculptor returned to New York and thirteen years later married Dr. Edward Keyes, a noted urologist, who died nine months later. Her stepdaughters remember "Tante Bessie" (as they called her) as a pixielike woman of great charm, tiny and bent over, but cheerful and delightful.

It is not Bessie Potter Vonnoh's subject matter—the timeless, indeed banal themes of mothers and children or graceful girls dancing—that continues to preserve her reputation as one of America's distinguished sculptors. It is, rather, the plasticity of the compositions—the broad suggestion of the forms, eliminating details—

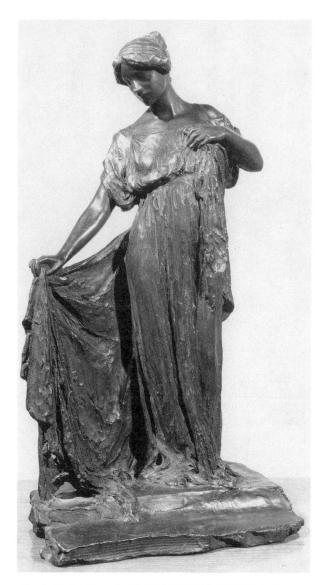

Bessie Potter Vonnoh, IN GRECIAN DRAPERY (1913), bronze, height 15″. Private collection. Courtesy Berry-Hill Galleries, New York. Photo: Thomas Feist.

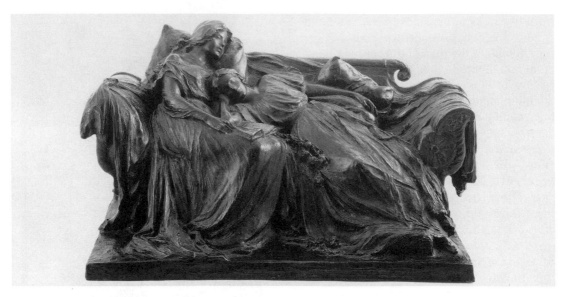

Bessie Potter Vonnoh, DAYDREAMS (modeled 1899, cast 1903), bronze, height 10½″. In the collection of the Corcoran Gallery of Art, museum purchase, 1910.

that gives a kind of generality to the subject, and the handling of the clay—the sensitive touch of tool and finger on the material. Her effective use of patinas can be seen in *Daydreams,* a sculpture of two young women dreaming on a couch (Corcoran Gallery of Art, Washington, D.C.), on which an area of burnished gold on one knee is a focal point amidst bluer tones around it.

Admittedly, Vonnoh presents a conventional view of passive dreaming girls or of the middle-class mother's role as protector and nurturer of children. Hers is a well-washed, well-dressed genre, unlike the powerful working-class mothers and children created a little later by Abastenia Eberle (see chapter 6). Yet she brings to the subject a dignity, a conviction, in short, an authenticity, that raises it to an icon of all who devote themselves to helping the next generation. Part of Vonnoh's sensibility certainly came

from her relationship with her own devoted mother.

In *Motherhood* (1903) the towering mother, holding an infant securely in one arm, stands like a strong wall behind two quirky little daughters. The flow of line moves diagonally across the mother's arm to her hand clasping one child's and then continues into the two girls' linked arms. The composition emphasizes the entwined relationships. The slightly disheveled long wrapper worn by the mother provides a monumental form and at the same time conveys a sense of everyday informality. Other statuettes on this theme are *Young Mother, Enthroned* (1904, a mother in a high-backed chair with children leaning on her), and *La Petite,* a seated mother holding an infant.

A contemporary critic said of Vonnoh's works in 1908, "While beautiful in sentiment, they are

primarily plastic in conception, and though small in size, large in significance." The realist novelist William Dean Howells wrote, "I think she has put new life into your old dry bones of an art. Her work, while it is as Greek as the Tanagra figurines, is . . . utterly and inalienably American . . . and perfectly modern. . . . it gets into sculpture the thing I am striving to get into fiction."[29]

Carol Brooks MacNeil (1871–1944), a sculptor of child life and small genre subjects, was one of a number of sculptors who worked to satisfy the market for small bronzes at the turn of the century. Her sculpture was described by her teacher, Lorado Taft, as abounding "in quaint fancies of rare charm."[30]

Born in Chicago, Brooks studied at the Art Institute, was one of the White Rabbits assisting Taft for the Chicago fair, and submitted a figure of *Charity* to the competition for sculpture on the Woman's Building.

Brooks then studied in Paris with Frederick MacMonnies and J. A. Injalbert. In 1895 she married Hermon Atkins MacNeil, sculptor of American Indians, and went with him to Rome where they worked for three years, supported by his Rinehart scholarships. At their studio in the Villa dell' Aurora, Carol MacNeil specialized in creating decorative, useful objects, such as tea kettles, ash trays, and chafing dishes. *Chafing Dish,* supported by three female figures representing herself and her two sisters, was cast in Rome.

In 1899 the MacNeils went to Paris, where she exhibited work at the Paris Salon, and won an honorable mention at the International Exposition of 1900. After returning to America, she won a bronze medal for a fountain at the 1904 St. Louis Exposition.

There is a droll, original quality about Carol MacNeil's work. *Water Baby,* a chubby tot par-

Carol Brooks MacNeil, CHAFING DISH (c. 1897), bronze and copper, 14½″ × 12″ × 12″. Private collection, New York. Photo: courtesy of Conner-Rosenkranz, New York. Photographer: Scott Bowron.

tially submerged in a wave which forms the base of the composition, and *Shy Girl* (Conner-Rosenkranz Collection, New York) capture the essence of children's gestures and moods, in loose, fluid modeling. The lively *Young Girl Dancing* (*Springsong* c. 1920), an adolescent holding up her skirt, shows surprisingly stylized forms, almost reminiscent of the work of Elie Nadelman.

A member of the National Sculpture Society, MacNeil made a specialty of children's busts. After she had two sons, domestic responsibilities at her home in College Point, Long Island, reduced

her productivity, while her husband continued to pursue a flourishing career as a sculptor of heroic monuments.

> Cited in the literature are *Giotta Giovane, Vasoviana, Cloudy Day, Foolish Virgin* (a seated marble nude with eyes cast down, purchased by Mrs. Cyrus McCormick of Chicago), *Farewell to the Fairies, First Lesson, Moth, Snowflakes, Two Larks, Mermaid,* and *Windy Day.* Some portraits are *Madame X, Constance, Betty, Father Maher, Father Brooks, Elizabeth Gibson, Brothers,* and *Thad Dean.* She also made vases, inkstands, and other objects.

Enid Yandell (1870–1934) was catapulted to prominence by her work on the 1893 World's Columbian Exposition. She received large-scale commissions at the turn of the century and became a symbol of the "new woman" to the press and public.

Born in Louisville, Kentucky, she was the oldest of four children of Dr. Lunsford Pitts Yandell, a distinguished southern Civil War surgeon, and Louise Elliston Yandell, from a well-known Nashville, Tennessee, family.

Elected Louisville's "Queen of the May" and an expert horsewoman, tennis player, and golfer, she was much sought after. But instead of choosing the life of a married southern belle, she chose a career as a professional sculptor. This was not an easy path in her case. Her grandparents had lost their fortune in the Civil War, and her physician father died penniless, leaving his widow with four children to raise. Enid's mother struggled to give them all a good education, but the artist had to support herself as soon as possible.

In this, she was fighting southern mores all the way. When her surgeon uncle, Dr. David Yandell, head of the American Medical Association, heard that she made money from her sculpture, he declared that she was "the first woman of the Yandell name who ever earned a dollar for herself . . . a disgrace to the family."

An outstanding student, she completed a degree in chemistry and art at Louisville's Hampton College and then entered the Cincinnati Art Academy, where she studied anatomy, drawing, and wood carving with Benn Pitman and modeling with Louis Rebisso. Completing the four-year program in two years, she won the first prize medal at graduation in 1889. Her neoclassical marble of *Hermes* with a lyre, modeled under Rebisso's supervision, was admired when it was exhibited at the Cincinnati Art Museum.

When word got out that sculpture would be needed for the 1893 Chicago World's Columbian Exposition, Yandell's friends petitioned the head of the Woman's Division, Mrs. Potter Palmer, whose family came from Louisville, to hire her. Palmer invited her to create the twenty-four caryatids that were to surround the roof garden of the Woman's Building.

Modeling the nine-foot figure was a challenge. Her first attempt collapsed; she had to learn to attach butterflies (criss-cross wooden supports) to the armature to hold up the large masses of clay. Eventually the artist was one of three women awarded the Gold Designer's Medal at the exposition. (Mrs. Palmer and architect Sophia Hayden were the others.)

Under a state contract, Yandell studied for three months with sculptor Lorado Taft, became one of the White Rabbits, and also assisted sculptor Philip Martiny with his flamboyant rococo sculptural decorations.

While working on the fair, Yandell shared an apartment in Jackson Park with colleagues Laura Hayes and Jean Loughborough. The

"bachelor girls" had such a heady time together they coauthored a semifictional account of their adventures, *Three Girls in a Flat,* dedicated to the exposition's "Board of Lady Managers—that noble body of women which is acting as advance guard to the great army of the unrecognized in its onward march towards liberty and equality."[31] The book's reviewers considered their life-style very daring, describing it as "the gay artist life of Bachelor Maids," but it hardly sounds like the bohemian woman artist of today: "It was not a very large suite of rooms—just seven ... but when the girls gathered round the snowy table, with its bunch of flowers ... the sideboard full of old fashioned silver ... it was the happiest feeling that they had known for many a day.... the neat little maid who had worked in the flat for the preceding occupants stayed with them."[32]

In the book, Yandell, nicknamed "The Duke" by her two friends because of her intrepid, imperious nature, is introduced as a promising young sculptor to President Ulysses Grant's widow at a reception at Bertha Palmer's crenellated Chicago castle. The president's wife narrows her eyes: "A sculptor! You cut marble? ... I met one before.... she was a great deal about the General, but I don't approve of women sculptors as a rule [she was referring to Vinnie Ream].... I don't approve of these women ... who paint and write ... in a soiled gown and are all cross and tired when the men come home and don't attend to the house and table."[33] Yandell engages her in a good-humored debate on women's right to work; but so great was the sexism of the period that she has to justify her career on the grounds that a poor brother might need support from his sisters in order to achieve his career goals.

The girls spend much time worrying about the propriety of going out alone in public with a man.

Altogether, the book is a fascinating social document, revealing the restrictions, conflicts, and aspirations of progressive middle-class women of the era.

Yandell's most important sculpture at the Chicago fair was the life-sized *Daniel Boone,* commissioned for the Kentucky pavilion by Louisville's Filson Society. The society asked for a Boone "moving along with his cautious step and watchful eye ... calm but never still." The sculptor captured the wary movement of the famed scout, looking ahead, rifle in both hands, one foot forward. She modeled the face from a portrait at the Filson Society and studied Boone's original fur cap, fringed leather shirt, flintlock rifle, powder horn, and hunting knife. Art historian Désirée Caldwell points out that the much admired *Daniel Boone* was part of a surge of patriotic

Enid Yandell, DANIEL BOONE (c. 1893), bronze, Cherokee Park, Louisville, Ky. Reprinted with permission from the *Courier-Journal.*

statues of great men, such as Daniel Chester French's *Minute Man* and deserves more attention than it has received. Its lively naturalism and rich surface detail differ from the cold, hard forms of the neoclassical era.

The subsequent history of this statue illuminates the financial struggle faced by a woman sculptor. Like all the work at the Chicago fair, Yandell's *Daniel Boone* was made of "staff," a temporary plaster-and-hemp material. For thirteen years Yandell shipped her plaster model to expositions, at considerable expense, hoping to find a patron. Finally, in 1906, C. C. Bickel, a Louisville manufacturer of Daniel Boone cigars commissioned it in bronze for Louisville's Cherokee Park. Around the same time, the Hogan family presented the sculptor's bronze and granite *Fountain of Pan* (1905) to the park.

Yandell dreamed of going to Paris. In order to earn money for the trip she worked in Karl Bitter's New York atelier, assisting him on the pediment for the Pennsylvania Railroad station in Philadelphia and on caryatids for the interior of the Astor family's New York mansion. By 1895 Yandell was in Paris studying with Frederic MacMonnies at the Vitti Academy and working in her own studio. There she completed what was reportedly the largest work thus far attempted by a woman—a forty-two-foot *Pallas Athena* (adapted from the Louvre's *Pallas de Velletri*) to stand before a replica of the Parthenon at the 1897 Tennessee Centennial Exposition in Nashville. (The work was destroyed.)

The evening before the three enormous segments of the statue were shipped, Yandell (although she was struggling with financial problems) hosted an "elegantly Bohemian" dinner on platforms erected in the hollow twelve foot stomach section. "We were a merry party, but we were also weird," she told Paris reporters. "Our voices sounded strangely within the statue and our faces glowed with the lamplight."[34] This episode evokes the fin-de-siècle mood of the period of Gustave Moreau. In the same exotic spirit, Yandell created a sculpture of a Hindu at prayer, *Allah Il Allah Indian* (1895, unlocated), that won a silver medal in Nashville.

In 1899, with her career in full flower, Yandell, along with Bessie Potter, was elected to the National Sculpture Society (Theo Kitson was the only other woman member) and won the commission for the *Carrie Brown Memorial Fountain* (1899–1900, Providence, Rhode Island).

Italian diplomat Paul Bajnotti wished to erect a fountain in memory of his wife, Carrie, daughter of the illustrious Brown family after whom Brown University is named. Yandell's model was selected from eighteen competing entries, all by male sculptors. Like many turn-of-the-century artists, Yandell was under the influence of Rodin. The struggling figures, flickering surfaces, and violent emotionalism of her composition are reminiscent of Rodin's *Gates of Hell,* on which he was then at work.

Thinking of the departed spirit of Carrie Brown, Yandell tried to express "the attempt of the immortal soul within us to free itself from the handicaps and entanglements of its earthly environment. It is the development of character, the triumphs of intellectuality and spirituality I have striven to express."[35]

A large female figure representing "the soul" dominates the group. Its wings and a mantle of "truth" flowing from its shoulders support the heavy basin above the heads of the figures. Smaller nude male figures representing gross earthly tendencies—"duty, passion, and avarice"—and a female figure representing "life" attempt to hold back the soul as she tries to release herself. Caldwell, who organized a Yandell

exhibition at the Rhode Island School of Design, notes a similarity between the *Carrie Brown* composition and Rodin's base for his *Vase of the Titans,* with its twining figures and flying draperies wrapped around a column that supports the vessel.[36]

When Yandell asked Rodin to critique the composition as she was working on it, he expressed some worry that it might be "heavy," and the completed fountain received mixed reviews. Lorado Taft pointed out that the attempt to relate figures of different sizes was somewhat "Confusing ... but certain features of the struggling group are very fine indeed. There is a back of a noble Amazon-like woman which would do honor to any of our sculptors."[37] Augustus Saint-Gaudens, in a letter to his protégée Helen Mears was more ruthless: "Miss Yandell, is doing an awful fountain for Providence. Thank God you are not going to get yourself down as an incompetent in bronze in the public streets."[38]

Nevertheless, the Providence community and American journalists in Paris were happy with the fountain. Richard Ladegast wrote in the *Outlook,* "the silhouette is ... interesting from all points of view.... the mass is full of color and movement."[39] Standing today in Kennedy Plaza, near the entrance to the Providence railroad station, the bronze group supporting a large basin on its head appears a bit ungainly, although the fountain spray from the rim of the thirty-foot lower granite basin mitigates this effect by veiling the figures in a soft mist.

Yandell's public monuments attracted commissions for garden fountains and reliefs for the homes of wealthy patrons. One of her most successful small works is the art nouveau *Kiss Tankard* (bronze,1895, Rhode Island School of Design), inspired by Goethe's poem, *Der Fischer.* The fisherboy kneels on the lid and peers over

the edge at a sinous mermaid gazing up at him, who forms the handle. When the lid is lifted, the head of the youth joins the mermaid's face in a kiss. Cast in bronze at Rudier's Paris foundry, it

Enid Yandell, KISS TANKARD (c. 1899), art nouveau lidded tankard, bronze, height 11½″. Museum of Art, Rhode Island School of Design, Providence. Gift of Miss Elizabeth Hazard.

was copied in silver by New York's Tiffany and Company, but unfortunately Tiffany's craftsman goofed and the fisherboy missed his love's lips, landing on her collarbone instead. This error was the subject of a ribald feature story, "When a Kiss Is Not a Kiss."[40] The tankard sold well nonetheless. Yandell completed a *Four Seasons Sundial* (1902, unlocated) with four allegorical figures in bas-relief around a slender supporting column; *The Water and the Flowers* (1911, bronze, Avco Corporation, Greenwich, Connecticut); *Satyr Fountain,* and *Lotus Flower Fountain* (bronze, c. 1910, J. B. Speed Art Museum, Louisville). Sometimes she designed garden pieces that could be converted to vases and table-top fountains in various sizes and materials as a source of further income. The sculptor must have been regarded as modern and progressive, because her *Five Senses* (1909, unlocated) was in the 1913 Armory Show.

Commuting between her New York and Paris studios, Yandell assisted George Grey Barnard on allegorical figures for the New Amsterdam Theater, New York. On the eve of World War I, one of her last public commissions was the seated bronze figure of *Chief Ninigret* (1914, Watch Hill, Westerly, Rhode Island), the Niantic Indian leader who prevented war with the Rhode Island settlers. The model was a Native American from Buffalo Bill's troupe, at that time performing in Paris. This work was the sculptor's farewell to the ebullient early phase of her career.

World War I broke over her head, changing her life: "After the war began, there was no art. There was nothing but agony and sorrow and a great striving to help."[41] Putting aside her career, the sculptor devoted herself to the Société des Orphelins de la Guerre. During a fund-raising trip to Chicago, she told horror tales of German atrocities, adding that she and her sister had taken eight orphans into their Paris studio. She served as an administrator of Appui aux Artistes, which provided meals for war-stricken French artists and their families; and in 1919, returning to the United States, she worked for the Red Cross at the debarkation center in Hoboken, New Jersey, setting up a filing system that helped locate American soldiers in France at the end of the war.

Yandell seems to have been affected psychologically by the war. Her work tapered off, except for some bas-relief portraits, such as the *Edwin Smith Memorial* (bronze, Edwin Smith Historical Museum, Westfield, Massachusetts).

In 1908 she had helped organize the Branstock School of Art in Edgartown on Martha's Vineyard, Massachusetts. Now she lived in Boston and taught during summers at her studio-home in Edgartown. One account states that the sculptor suffered a breakdown shortly before her death in 1934. Although a liberated woman who enjoyed her early career, she evidently didn't wish to encourage young women to attempt a life that she knew to be exceptionally difficult. She told a reporter in 1903, "Get married, girls. Success in other lines is hard won—too hard."[42]

Yandell's career dropped into obscurity until it was brought to light again by art historian Caldwell in a 1982 exhibition at the Rhode Island School of Design, whose catalog is the principal source of information about the artist.

Among at least seventy works completed by Yandell are busts of her mother (1893) and *Mme. Deckert de la Meillaie* (1905), and figurines of *Elsie Yandell Barber* (1895) and *Mrs. Edward Chapin* (1908), all at the J. B. Speed Museum, Louisville; busts of *General John B. Castleman* (1905, Free Public

Library, Louisville), *Henry Lewis* (1894, New Haven, Connecticut), and *Stephen Foster* (1906, State Capitol, Frankfort, Kentucky), and the *Major John W. Thomas Monument,* (1907–8, Nashville, Tennessee). Lost works include bronze busts of *Dr. William T. Bull* (1909) for the Columbia Medical School, New York, and *Emma Willard* (1899), destroyed by fire at the State Capitol Building, Albany, New York.

Nellie Verne Walker (1874–1973)

I've lived all my life on ladders. I'm only four-foot ten, but I've always been proud of my height. It is the same height as Queen Victoria's.
—Nellie Walker[43]

Nellie Verne Walker, another protégée of Lorado Taft, was a productive Beaux-Arts sculptor whose works enrich public buildings in several states. Born in Red Oak and raised in Moulton, Iowa, she was the daughter of Jane Lindsay and Everett Walker, a stonecutter. As a small child in a large family, she rebelled against household drudgery, preferring to hang around her father's workshop and watch him carve inscriptions on gravestones. At seventeen she begged him to allow her to try sculpture on a block lying in the yard. He was reluctant, but her mother said, "Let her have it, Ev. It can do no harm. It may even do a lot of good."[44]

Tacking an engraving of Lincoln over her work table, the young novice chiseled out a crude, but somehow vital bust in twenty-four days. This first effort was exhibited in the Iowa pavilion at the World's Columbian Exposition with the label "Work of an Iowa Girl."

The family was poor. Walker worked as a lawyer's secretary for six years, trying to earn tuition for art school. Finally, her employer loaned the aspiring artist two hundred dollars to study at the Art Institute of Chicago. Lorado Taft remembered the first day she came to class: "There walked into my studio one day a little girl not more than four-feet-eight inches in height, who told me she had come to Chicago to become a sculptor. She had her plans all worked out in her mind. It made no difference, she insisted, how hard she had to work to accomplish them."[45]

An outstanding student, she served as his secretary and then became his teaching assistant and gave lectures and sculpture demonstrations to community groups in his place when he was too busy. Taft was a missionary who liked to proselytize the public on the importance of sculpture.

Walker became a successful Chicago sculptor, living and working in the famous Midway Studio complex where Taft and other artists (Mabel Torrey among them) hired a common housekeeper to take care of household chores and make the meals. The artists ate together, enjoying the camaraderie of an extended artistic family. Walker had an active social life, but although five of her friends were married in her charming studio, she declared that she "never met a man who could compete with the interest I had in my work. . . . In this way I avoided marriage, the cookstove and a lot of other troubles."[46]

In 1902, while Walker was visiting in Colorado Springs, Winfield Scott Stratton, the "Midas of the Rockies" (a philanthropist who made a fortune in the gold rush), died suddenly. On short notice Walker was conscripted to make his death mask. Hastily improvising equipment in front of the grieving family, she did such a professional job that they commissioned her to do Stratton's bust and later a full-length figure to be placed in front of the Strattons' retirement home in Colo-

rado Springs. In 1905 she completed the Stratton grave monument in Evergreen Cemetery, Colorado Springs. Featured in *Art and Progress,* along with works by Augustus Saint-Gaudens and Daniel Chester French, as an outstanding cemetery monument, it was described as "Rodinesque ... using rough blocks of granite from which dimly emerg[e] spirit figures."[47]

In the following years Walker sculpted more than thirty-five public monuments, primarily in the Midwest and Colorado. In 1907 she completed a life-sized bronze statue of Iowa *Senator James Harlan* for Statuary Hall in the U.S. Capitol.

Her picturesque figure of *Chief Keokuk* (bronze, 1913, Rand Park, Keokuk, Iowa), commissioned by the Daughters of the American Revolution to mark the chief's burial place, stands in full regalia, looking out over the wide Mississippi, at the point where Iowa and Illinois meet. A kind of local symbol, the statue is reproduced on road signs marking the scenic trail throughout the region.

In 1923 Walker carved two horizontal stone relief panels on the front of the library of Iowa State University at Ames. As was her practice, the diminutive sculptor climbed a ladder to work directly on the Beaux Arts figure compositions symbolizing *Home Economics* and *Engineering,* two of the school's principal courses of study.

In 1937, at sixty-three, Walker created a thirty-two-foot-wide mixed media relief, showing young Abraham Lincoln and his family moving from Indiana to Illinois, on a monument located where the event took place, near the Wabash River in Vincennes. A full-length three-dimensional bronze figure of young Lincoln trudges alongside a shallow stone relief of his family, driving a covered wagon filled with fam-

ily goods, while an angel of destiny flies overhead and points the way to Springfield. This work of the 1930s shows some of the simplification of the art deco style.

Scholar Louise Noun has shown that despite these commissions Walker struggled during the Great Depression. She refused to work for the Chicago Federal Art Project ("that bunch") because, she said, it was dominated by modernists.

Walker worked for forty years in her Chicago studio, surrounded by full-sized models of her sculpture. In 1948, however, the building was sold to the University of Chicago for expansion and destroyed; it was traumatic to leave the place where she had spent her entire career. Impoverished, she moved to Colorado to live with her youngest sister, and there did some models for the Van Briggle Pottery. But her eyesight was failing and her artistic style was becoming passé. She was invited to spend her last years in the Stratton retirement home founded by Winfield Scott Stratton, the subject of her first commission. There she remained active into her late nineties.

Other works cited are: *Diggins Monuments* (1909, 1916, Cadillac, Michigan); the *Polish AmericanWar Memorial* (1927, Chicago); *Memorial to the Soldiers of 1812* (1929, Historical Building, Springfield, Illinois); panels on Woman's Building (1932, University of Michigan, Ann Arbor); *Suffrage Memorial Panel* (1934, State Capitol, Des Moines, Iowa); *St. Francis* (St. Francis Hospital, Colorado Springs); and the *Butterfield Monument* (Grand Rapids, Michigan). For Lorado Taft she helped design and modeled two art deco figures of *Moses* and *Socrates* that flank the entrance to the courthouse at Jackson, Mississippi. After Taft's death she carried out the figure of *Haym Solomon* for the

Nellie Verne Walker, LINCOLN CROSSING INTO ILLINOIS (1937), limestone and bronze, height 10′ × width 26′. Near Vincennes, Ind. Photo: Dennis J. Latta, Vincennes, Ind.

Chicago Monument that he was scheduled to execute (1937).

The green patined bronze figure *Forward* on the grounds of the state capitol in Madison, Wisconsin, was created for the World's Columbian Exposition by **Jean Pond Miner Coburn (1865–1967)**, another protégée of Lorado Taft. Born in Menasha, Jean Miner grew up in Madison, studied at the Art Institute of Chicago, and became Taft's assistant.

In 1893, as artist in residence in the Wisconsin pavilion of the World's Columbian Exposition, she created *Forward*. With arm thrust ahead and draped body moving forward in the spirit of Saint-Gaudens's angel of victory on the Sherman monument, the sculpture was a symbol of the suffrage movement, and was cast in bronze by the women of Wisconsin. A member of Taft's studio team, she created the figure to the right of center in his *Fountain of the Great Lakes.*

The sculptor married in 1896 and had a son. In her seventies she presented bas-reliefs, *Progress Is the Law of Life,* to the Women's Club of Wilamette and created art glass memorial windows for the First Congregational Church in Menasha. She finished a bust of her great-grandson in her nineties and was working on pastels up to the week she died at 101. Miner once said that "the secret for remaining young in spirit is the joy of being intellectually and creatively alive."[48]

AUGUSTUS SAINT-GAUDENS AND THE CORNISH ART COLONY

At the turn of the century, Augustus Saint-Gaudens towered over all other American sculptors. His noble, sensitive style, with its restrained grandeur, seemed to embody the highest aspirations of American society. He developed an original ap-

proach to bas-relief portraiture: he portrayed his subjects in their ordinary costumes, and included a chair or other appurtenance that told something of their daily lives or professions; yet at the same time he managed to convey the dignity of the human personality—something over and beyond the mere literal rendering. In his sensitively modeled bronze or marble tablets, he often included a quotation or legend identifying the subject in raised letters, exquisitely designed as part of the composition. His style influenced almost all artists of his generation, including, of course, the women sculptors who worked for him.

Saint-Gaudens played a significant role in the careers of several women. One of the principal ways to advance in the profession at that time was to serve as an assistant in a leading atelier for a period of years. Women seldom had this opportunity to learn the craft—the details of building armatures, casting, designing ornaments and lettering, transporting heavy sculptures to the site and other engineering problems, negotiating contracts, and not least, meeting the architects and people who commissioned public works. The mere fact of having worked in such a studio lent a cachet to a sculptor's reputation.

Out of twenty assistants who worked with Saint-Gaudens, five were women—an unusually high ratio. Some of them had been his students in the coeducational classes at the Art Students League, organized in 1875 along more progressive lines than the National Academy of Design. Frances Grimes came to his attention in the art colony at Cornish.

Saint-Gaudens's studio was in New York City, but in 1885 he began to spend part of the year at Cornish, in the New Hampshire countryside. Artists, musicians, and writers soon followed, turning Cornish into a magical artists' colony. Around 1900 Saint-Gaudens invited a group of assistants to join him year round at Aspet, his estate and studio. A spirit of camaraderie and intense idealistic effort developed, as this team of sculptors helped their ailing master complete the large number of commissions that inundated him.

Cornish was an extraordinarily poetic place. It was more than a place—it was a state of mind; one resident called it "life in the poetry of living."[49] The artists who went there were looking for a healthy outdoor environment where they could spend summers with their families and work undisturbed in a simple but aesthetic atmosphere. They had their own kind of snobbery. As one New York newspaper described it: "they have not made their homes in Cornish with the idea of converting it into a 'fashionable' summer resort, but rather to form there an aristocracy of brains and to keep out that element which displays its lack of gray matter by an expenditure of money in undesirable ways. Essentially the atmosphere of Cornish is one of culture and hard work."[50]

According to sculptor Frances Grimes, who became an integral part of the Cornish community, "They ... not only did not want interruptions, they did not want spectators, people who would ask to visit studios.... outsiders were feared ... as possibly bringing with them standards of luxury which might mar the simplicity of life necessary for their work and inevitable to their lack of money ... and I can still reproduce in my mind the tone of the word 'Philistine,' how often I heard it—a word rarely heard now."[51]

Artists and musicians gathered for picnics and musicales and created their own entertainments, which became more elaborate as time went on. With so much talent available, the costumes, music, and scenarios became extraordinary. Carrying the spirit of the American Renaissance into the countryside, they wrote and performed in

masques, reminiscent of those performed in ancient Florence at the time of the Medicis and peopled by gods and goddesses in Grecian draperies, fauns, and woodland sprites. An old photograph shows the classic profile of Frances Grimes costumed as Iris, a messenger of the gods, for a masque honoring the Saint-Gaudens's twentieth wedding anniversary.

The entire community was dominated by the "cult of beauty"; the exquisite gardens, the vistas, the houses, all carried faint echoes of Italy. This was part of the ambience, reflected so well in the antique feel of the sculpture produced there.

Of all the women who worked as Saint-Gaudens's assistants, the one who pursued the most developed career was Frances Grimes. Strongly influenced by the master's noble style, she completed some of his major unfinished work after his death and then went on to her own long distinguished career.

Frances Grimes (1869–1963) a sculptor of authority and refinement, created portrait busts and bas-reliefs reminiscent of Della Robbia in their quiet dignity. She was widely recognized and admired in the early twentieth century.

Born in Braceville, Ohio, to two doctors, Grimes was lucky to receive from her mother, a physician in that early era, total support in developing a precocious talent for carving and modeling. At Pratt Institute in Brooklyn, New York, her combination of native ability and industry attracted the attention of her teacher, Herbert Adams, who asked her to take charge of the slower students and took her on as an assistant in his own studio. Adams called her "the best marble cutter in America."[52]

Adams and his wife, Adeline, critic and author of *The Spirit of American Sculpture* (1923), brought her with them to the Cornish, New Hampshire, art colony in the summer of 1894. In subsequent years Grimes found the place to be an artist's "Midsummer Night's Dream" and described its special ambience in her unpublished "Reminiscences" (Special Collections, Dartmouth College).

Grimes's growing reputation aroused the interest of Saint-Gaudens. Already mortally ill and completing his life's work with a group of assistants, he persuaded Grimes to join him in 1900. From then until 1909, "Grimesy," as she was known in the studio, remained in Cornish year round.

In 1907, when Saint-Gaudens died, she stayed on to finish several commissions, including the eight standing *Caryatids* at the Albright-Knox Museum, which she modeled from Saint-Gaudens's sketch models. He had said that of all his assistants she was the one with the greatest sympathetic understanding of his intentions, so this task was a fitting one for her.

Even while working for Saint-Gaudens, however, she had not neglected her own artistic development. With the encouragement of painter Maxfield Parrish, who lived nearby, she began to do her own work, so that by the time of Saint-Gaudens's death she had completed several pieces and sitters were waiting for portraits. Grimes moved to New York, took a studio in Macdougal Alley in Greenwich Village, and there produced a body of work of growing maturity. In the spring of 1914 she traveled to France, Italy, and Greece.

Grimes's work shows the neo-Renaissance influence to be expected from this background. *Sleepy Hollow Panel* (1916), a ten-foot-wide bas-relief for Washington Irving High School in New York City, contains three seated, classically draped female figures. The center one is reading a passage from Washington Irving's *Legend of Sleepy Hollow*, inscribed in the panel: "There

was enchantment in the very air that blew from that haunted place, breathing an atmosphere of dreams and fancies." New York's Metropolitan Museum of Art owns *Singing Girls,* two large relief panels of adolescent nudes, intended for a fountain.

Grimes did numerous portraits. Her sensitive bas-relief of musician *Arthur Whiting* (1907, Music Division of the New York Public Library, Lincoln Center), done the year of Saint-Gaudens's death, shows the master's influence. Her busts of *Charlotte Cushman* and *Emma Willard* (New York University Hall of Fame), on the other hand, reflect in their rugged strength Grimes's support of women's suffrage. A similar strength is seen in the relief portrait of *Mrs. Sarah Elizabeth Parsons* and of *Dr. William Barnes* (1919, Decatur Memorial Hospital, Decatur, Illinois), shown in an informal relaxed pose, his strong, yet delicate surgeon's hand holding a smoldering cigarette, and in a bust of *Bishop Henry C. Potter* (marble, 1911, Grace Church, New York). Full-length garden figures like *Boy*

with Duck (Toledo Art Museum) and *Girl by a Pool* (Brookgreen Gardens, 1913) convey a quality of delicate fantasy.

During a long career, Grimes won numerous awards and honors. A fellow of the National Sculpture Society and a member of the National Academy of Design and the American Federation of Arts, she exhibited nine works at the 1915 San Francisco Panama Pacific Exposition, winning a silver medal.

Annetta Johnson St. Gaudens (1869–1943), described as quiet and modest, was one of a number of capable women artists who devoted much of their talent to others. One of the first women assistants hired by Augustus Saint-Gaudens, she later helped her sculptor husband, Louis St. Gaudens. After her husband's death she produced medallions, busts, public statuary, and garden sculpture in bronze, marble, and terra-cotta.

Born near Flint, Ohio, Annetta early showed an interest in sculpture: "On a farm in central

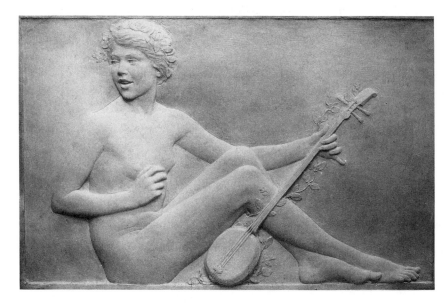

Frances Grimes, GIRL SINGING (1916), model(?) for one of a pair of marble reliefs at the Metropolitan Museum of Art, New York, 34″ × 45″. Photo: Peter A. Juley and Son Collection, National Museum of American Art, Smithsonian Institution (J0048579)

Frances Grimes, DR. WILLIAM BARNES (1919, unlocated). Photo: Peter A. Juley and Son Collection, National Museum of American Art, Smithsonian Institution (J0048576). Bronze cast, 3′5″ × 3′1″, is at Decatur Memorial Hospital, Decatur, Ill.

Ohio, far removed from cities and towns, I liked to draw and mold little horses, statuettes and then, finally, figures of people. . . . Perhaps it was because as a child I wanted to make up for my inferiority complex, for I had an older and younger sister both more beautiful and popular than myself."[53] Her farm parents evidently took her hobby seriously. They sent her to Columbus Art School in Ohio and then to the Art Students League in New York (1892–94) where she studied with John Twachtman and Augustus Saint-Gaudens, becoming "so interested in my work that many a time I would go without meals."[54]

Saint-Gaudens later said he recognized her talent immediately: "I readily picked out Miss Johnson as a student of the right feeling and with a firm foundation for sincere work."[55] The sculptor took her on as an assistant in 1894.

In Saint-Gaudens's New York studio, Annetta met another assistant, the sculptor's brother, Louis. They worked side by side for several years, married in 1898, and moved to Ohio to be near Annetta's family. Louis was talented, but an introspective person who never thought his work

was good enough—the opposite of his extroverted energetic brother. He spelled his name "St. Gaudens" because he thought the full "Saint-Gaudens" was too pretentious. Not a practical man, he had tried to manage his famous brother's business affairs in 1873–75 and had failed at it. In later years Augustus supervised *his* affairs, including his personal finances. Louis told his son, Paul, that all he had when he got married was "a borrowed valise, an extra collar, three socks and a banjo."[56]

After several years of doing small work in a small studio, Annetta and Louis eagerly accepted Augustus's invitation to rejoin him in Cornish. In 1900, with their newborn son, they became part of the artists' colony. Fascinated by the nearby Shaker community, Annetta, with her brother Lewis's help, disassembled and rebuilt a Shaker meetinghouse for their new home-studio on Dingleton Hill.

Annetta assisted Saint-Gaudens on various projects—for example, the boots and saddle on the figure of *General Logan* for Jackson Park, Chicago. After his death in 1907, Annetta became her husband's assistant; he refused to allow anyone but his wife to help him. She did the head of the huge figure of *Electricity* at Union Station, Washington, D.C., worked on figures for the U.S. Customs House in New York City, and after his death in 1913 scaled up his model and did the final carving on the colossal marble figure of *Painting* that stands opposite Daniel Chester French's *Sculpture* in front of the St. Louis Art Museum. Pictures show her hard at work with hammer and chisel.

After her husband's death Annetta St. Gaudens made numerous small terra-cotta portrait medallions (sometimes cast) that she modeled rapidly for people in Cornish. Seven small works were shown at the 1915 Pan Pacific Exposition in San Francisco, and she won a silver medal that same year at the San Diego exposition. In

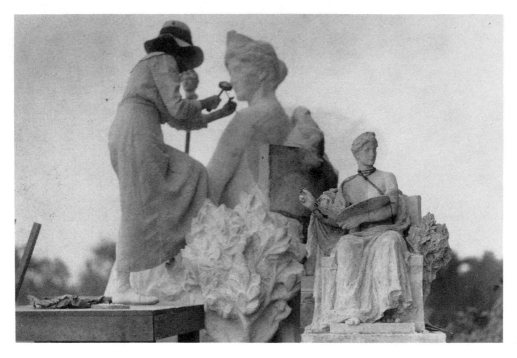

Annetta St. Gaudens at work on the marble figure of PAINTING, model by Louis St. Gaudens. Collection of the St. Louis Art Museum. Photo by A. E. Hutchings. Photo courtesy of the Saint-Gaudens National Historic Site, National Park Service, Cornish, N.H.

later years, Annetta and her son, Paul, a ceramist, operated a pottery in their Cornish studio. Among her terra-cotta works is a three-foot figure, *Mother Woman.*

Very much a part of the community, Annetta acted in several of the pageants with which the art colony entertained itself. She was "Love Bird" in *Sanctuary: A Bird Masque*— a production to raise funds for the Meriden Bird Sanctuary in Cornish. At that time bird sanctuaries were springing up all over the country; conservationists were attempting to pass legislation to prevent the slaughter of millions of birds for women's feathered hats, and the artist was an active supporter of the movement. Afterward she was commissioned to create a bronze bird bath for Meriden, ornamented with a frieze showing the pageant. All the actors, including President Woodrow Wilson's daughters, posed for her in costume. She made a mold of the bird bath so

that multiple terra-cotta copies could be sold. "This will bring it," she wrote, "within the reach of bird lovers."

A member of the Women's Christian Temperance Union and the Equal Suffrage League, St. Gaudens expressed her ideas in a large ceramic lunette, *Salvation* (c. 1919), that, according to one contemporary critic, expressed woman's reaction to war; instead of glorifying it, the lunette condemns Militarism and Alcoholism, represented as groups of figures. A militant but pacifist central figure of Christ dominates the composition. *Salvation* was displayed in Washington, D.C., at the headquarters of the Women's International League for Peace and Freedom.

The sculptor also executed a World War I memorial tablet, *Democracy* (bronze, 1920), showing a figure holding a torch in one hand and a cornucopia in the other; it still stands on the grounds of St. Aloysius's Church in Jersey City,

New Jersey. These larger works hint at what the artist might have accomplished if she had not given so much of her creative energy to others. In her last years, living in Pomona, California, she taught sculpture in the local high school.

A large collection of the artist's works and archival materials at the Saint-Gaudens National Historic Site in Cornish includes relief medallions of *Louis St. Gaudens* (pewter, c. 1899), *Paul St. Gaudens* (terra cotta, 1933), *Carlota Saint-Gaudens and Her Son Augustus* (1910), *Jane Addams, Lucy Allen, Nancy Moore Anibal, Dr. Starling Loring, Alfred Geller,* and *Harriet Griswold McCullough.* There are also bookends, candlesticks, ceramic bowls, and statuettes. A marble head of her brother *Lewis Johnson* (c. 1905–6) is at Agnes Scott College, Decatur, Georgia; a bronze medal of her infant son Paul (1900), at the Columbus Museum of Art.

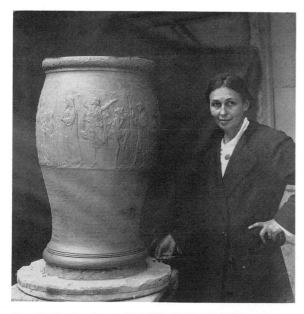

Annetta St. Gaudens with BIRD MASQUE URN, terra cotta. Commemorates the performance of *Bird Masque,* a play by Percy MacKaye for the Meriden Bird Club. Photo courtesy of the Saint-Gaudens National Historic Site, National Park Service, Cornish, N.H.

Mary Lawrence (Tonetti) (1868–1945), another protégée of Augustus Saint-Gaudens, modeled *Columbus,* a theme statue, for the 1893 World's Columbian Exposition. But her career was diminished by marriage and family obligations.

Born into an illustrious New York family, her ancestors included a mayor of New York City and the captain who died saying "Don't give up the ship." The family owned a New York brownstone on East Twenty-fifth Street and a summer place at Sneeden's Landing on the Hudson where Mary often entertained her sculptor friends.

At fourteen she was a tomboy, interested in "dogs, horses, stable boys, good food and art—mainly sculpture."[57] At twenty, when she became Saint-Gaudens's pupil at the Art Students League, he quickly spotted her talent. Others were captivated by her Junoesque beauty. Architect Charles McKim, whose wife had died, was in love with her. Saint-Gaudens and McKim often picnicked with her family at Sneeden's Landing.

Although she had no experience in doing a major work, Saint-Gaudens was so taken with her ability that he gave her the assignment of a major figure, *Christopher Columbus,* for the 1893 World's Columbian Exposition. Lawrence portrayed Columbus, haggard from his long voyage, at the moment of discovery on San Salvador Island, with a sword in his right hand and the flags of Aragon and Castile in his left. Pleased with the work, Saint-Gaudens made it clear to the public that Mary Lawrence "modelled and executed it and to her goes all the credit of the virility and breadth of treatment which it revealed."[58]

As was to be expected, there were men who resented the fact that the commission had been given to a woman. Frank Millet, director of decorations for the fair, seems to have been one. Lawrence was on hand to place *Columbus* on his pedestal in front of the Administration Building when the statue was delivered. When she

Mary Lawrence (Tonetti), CHRISTOPHER COLUMBUS (center figure), Administration Building, Chicago World's Columbian Exposition, 1893. Photo: National Archives.

stepped back to look at it, she heard Millet jeer, "Lost in admiration, eh?" He peremptorily ordered the work moved to the plaza of the railway station. Although Mary knew that McKim himself had designated the location in front of the Administration Building, she had to obey. But she appealed to McKim and *Columbus* was moved back where he belonged. Lawrence, who bitterly resented the affront, said later, "I could stamp on his face and grind it into the gravel till it bled."[59]

Did Mary Lawrence do the *Columbus* alone? Although Saint-Gaudens said she did, others have suggested that his brother, Louis, collaborated on it[60] or that Saint-Gaudens did.[61]

Lawrence subsequently went to Paris to study at the Académie Julien, and there became an assistant and friend of sculptor Frederic Mac-Monnies, in whose atelier she met another assistant, the French-Italian sculptor François Tonetti, whom she married in 1900.

Saint-Gaudens was unhappy at the news; in private he broke down and wept. He felt—and history bore him out—that she would waste a wonderful talent for a man whose abilities didn't match hers and would never do serious work again. He predicted, somewhat bitterly, "He is a regular picnic feller and she is a regular picnic girl. I suppose there'll be lots of festive children."[62] After her marriage Lawrence assisted her husband for a while and taught at the Art Students League after Saint-Gaudens left, but family needs soon took precedence over her career. Her estate on the Hudson became a gathering place for artists, and she became an active supporter of the arts in New York City.

At the age of nine, **Helen Farnsworth Mears (1871–1916)** won first prize for a clay head of Apollo at the Winnebago County Fair in Oshkosh, Wisconsin. The child had baked it in her mother's oven. At twenty-nine, she won a national competition for a statue of the temperance leader *Frances Willard* for the U.S. Capitol. At forty-five, acting out a real-life *La Bohème,* she died in poverty, probably of influenza and mal-

nutrition. Hers was the prototypical artistic tragedy—precocity, early recognition, and success followed by neglect, poverty, and early death.

The Mears family was devoted to the arts. Mears's mother, Elizabeth, author of poetry and plays under the pseudonym "Nellie Wildwood," was Wisconsin's first poet; her sister, Mary, wrote short stories and novels; and her father, who had studied surgery, taught Helen anatomy, fashioned tools for her, and set up a studio in the woodshed.

There Mears worked on a figure with an eagle that she called *Columbia*. Her mother invited members of the state legislature, who were selecting a statue for the 1893 Columbian Exposition, to see it. Rescued from the woodshed and rechristened *The Genius of Wisconsin*, it was her first commission (marble, Wisconsin State Capitol). To execute it she studied with Lorado Taft for six weeks at the Art Institute of Chicago, and then labored in a freezing shed on the exposition grounds, where she abandoned Taft's tools and methods for those of her father.

With help from a Milwaukee philanthropist, Alice Chapman, the Mears sisters went to New York so that Helen could study with Saint-Gaudens at the Art Students League. After two weeks he invited her to be his studio assistant.

With backing from Alice Chapman, the Mears sisters went to Europe where Helen studied with Paris sculptors, exhibited at the 1897 salon, and toured Italy. Saint-Gaudens invited her back to Paris to assist on a large equestrian statue of General Sherman. While working on it she modeled a bust (unlocated) and a bas-relief of *Saint-Gaudens*, shown with his Sherman statue in the background. Dissatisfied with the body, she later cut off the lower part, leaving only the head. The Saint-Gaudens family greatly admired this portrait.

Saint-Gaudens was just beginning to suffer from cancer, so his doctor, Henry Shiff, enlisted the help of the Mears sisters in diverting the sculptor, visiting historic spots, and enjoying Paris nightlife. In a way Helen played Rudolfo to the ailing Saint-Gaudens's Mimi.

Mears returned to the states in 1898, and the following year took a studio with her sister at 46 Washington Square, New York, where she won a commission from Illinois for a statue of *Frances Willard* for the U.S. Capitol. Willard, a professor, organizer of the World's Women's Christian Temperance Union, and president of the Women's National Council, was a famous orator. The artist chose to portray her at the podium, holding notes for a speech, at the moment when she gazes intently at the audience before beginning an address. Mears corresponded with Saint-Gaudens who advised her about details and encouraged her. When it was unveiled in 1905, he wrote, "It is as strong as a man's work, and in addition has a subtle, tangible quality exceedingly rare and spiritual."[63]

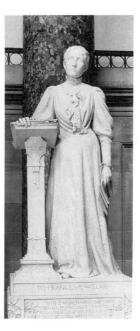

Helen Mears, FRANCES WILLARD (1905), marble, height 9′. United States Capitol Art Collection. Courtesy Architect of the Capitol.

In 1906, when composer *Edward MacDowell* was dying from a nervous disorder, Mears modeled a profile bas-relief of him seated in a chair with a shawl over his knees (bronze, Metropolitan Museum of Art), reminiscent of Saint-Gaudens's portrait of Robert Louis Stevenson. Mrs. MacDowell became interested in the Mears sisters and awarded them the first fellowships to the MacDowell Art Colony, established by the musician and his wife to provide creative people with a quiet retreat.

Dawn and Labor (1909, Oshkosh Public Museum; Norton Gallery, West Palm Beach) shows two idealized figures moving forward. Mary Mears posed for Dawn, who represents a "vision of the future," her scarf blowing behind her, while Labor turns to her for inspiration. The two sisters became ardent Christian Scientists around 1911, and this work, more than any other, captures their romantic, idealistic spirit, in a Saint-Gaudinesque style. She once wrote in her notebook: "To express the mystery of life in its deeper, more spiritual significance—the onward sweep of the human soul toward the light, is what I wish to depict."[64]

In 1910 Mears was recommended to design a figure to crown the dome of the Wisconsin state capitol—potentially the major commission of her career. After submitting several models, she was well along in her work on it before finding out that the matter was still under debate. The commission went to Daniel Chester French and she was fobbed off with a $1,500 payment—a blow to her pride and her reputation, and the beginning of the difficult period leading up to her death. Saint-Gaudens was dead, so she now had no one in high places to defend her. A small ideal head created around this time perhaps expresses Helen Mears's feelings; it depicts *Aphrodite,* the goddess of beauty, just arisen from the waves, looking out in wide-eyed alarm at the human world.

Caroline Peddle Ball, MARY LAWRENCE ELLIMAN MEMORIAL FOUNTAIN (1896), granite, 10′ × 4′. Located in Flushing Cemetery, Flushing, N.Y. Photo: © Shoshana Rothaizer 1987.

The sisters now entered a period of such poverty that they often had to choose between food and clay. The artist drove herself, despite the circumstances, to work on a *Fountain of Joy* and other projects embodying her idealistic visions. One of her last efforts—*End of the Day* (1914, Paine Art Center and Arboretum)—a roughly modeled study of a tired workingman in cap, gloves, and worn boots, slumped over his shovel as he returns home on the elevated train, shows the influence of the ash can school, suggesting that perhaps the artist was ready to move out in a fresh direction.

Mears died suddenly after a short bout of the flu at age forty-five. Mary, who had abandoned a journalistic career to devote herself to Helen, was left with one dollar and a dingy studio filled with half-finished wax and plaster works. She spent the rest of her life promoting her sister's reputation and raising funds to get the pieces cast. Memorial exhibitions were held at Gorham's, New York, the Milwaukee Art Institute (1917), and the Brooklyn Museum (1920).

Mears had worked for five years on *The Fountain of Life* (1899–1904), a thirteen-by-fourteen-foot wall fountain that she regarded as her chef d'oeuvre (it won a silver medal at the 1904 St. Louis Exposition). Saint-Gaudens described it as "a beautiful and touching thing—destined to live." Alas, that was not so. Mary Mears tried repeatedly to raise funds to put it in marble or bronze. In the 1930s the WPA was considering the matter, but the sister made such a fuss about the location of the fountain and the materials to be used that the project was dropped. The model moldered at the Milwaukee Art Institute, and in 1951 it crumbled in shipment to a patron who was going to have it cast.

Today Helen Mears is a cult figure in Wisconsin. A large collection of her work is at the Paine Art Center in Oshkosh.

The Paine Art Center and Arboretum collection includes *Madonna and Child* (plaster, 1896), *Morning Wind* (bronze, 1896), *Night Wind* (bronze, 1896), *Margaret Adams* (1906), *Elizabeth Mears* (a bronze profile bas-relief of the artist's mother), the second model for the *Capitol Dome Figure* (plaster, 1911), *Mary Mears* (1914), *Reclining Eve* (1914), and other works. Lawrence University in Appleton, Wisconsin, has *Luring Victory* (1909) and *Aphrodite* (1912). A bust of Dr. William Morton, discoverer of ether, is at the New York University Hall of Fame. A life-sized bronze seated figure of *Adin Randall* (1911–1915) is in Randall Park, Eau Claire, Wisconsin.

When **Caroline Peddle Ball (1869–1938)** and her friend Janet Scudder, as small children, submitted china painting, hammered brass, and other crafts to the Terre Haute, Indiana, county fair, every entry won a prize. This was the start of both careers.

Peddle's first art lessons were at Rose Polytechnic Institute in Terre Haute. She went on to the Pennsylvania Academy and studied with painter Kenyon Cox and Saint-Gaudens at the Art Students League. Saint-Gaudens recommended her for several commissions. While still at the league, she was engaged by the Tiffany Glass Company, for whom she modeled a bronze figure of *The Young Virgin* and a *Christ of the Sacred Heart* and reportedly designed the Tiffany exhibit for the 1893 World's Columbian Exposition.

Peddle was caught in one of those maddening episodes that punctuate the history of women artists. Bertha Palmer, director of the Woman's Building at the Chicago fair, hired Peddle to design a Queen Isabella coin for her group. Palmer was eager to have a woman artist do the work,

but an official at the U.S. Mint, preferring to have his own staff work on it, created so many annoying obstacles that Peddle, humiliated, quit the project.[65]

In 1894 she created a memorial fountain for Flushing, Long Island, in honor of Mary Lawrence Elliman, a philanthropist known for her support of the temperance movement. The eight-foot profile relief of a draped seated female figure with a pitcher, giving a bowl of water to a child—once located on a Flushing street—is now in Flushing Cemetery near the Elliman family plot.

Around this time she also did a relief of the British weaver *Anton Herkomer* at work on his loom. After a trip to Florence, Italy, in 1895, Peddle maintained a studio in Paris for three years. While there, she did the interior decoration for the Paris home of Appleton Curtis. Saint-Gaudens recommended her to design the figure of *America* for the quadriga on the United States Building at the 1900 Paris Exposition, for which she received an honorable mention. In a letter to Helen Mears, Saint-Gaudens wrote: "Miss Peddle's 'America' for Proctor's chariot, although somewhat amateurish in parts of its treatment is really large and fine in gesture and conception and quite personal and original."[66]

In 1902, Peddle married Bertrand E. Ball, moved to Westfield, New Jersey, and had a daughter. Although she had begun her career with ambitious commissions, on the whole, after her marriage, she devoted her energy to the creation of tiny winsome bronzes of children, with titles like *Bashful Boy* (Newark Museum), *Wading Boy, Lobster Boy,* and *The Student* (a small figure with books), that sold well. Many of these can be seen at the Sheldon Swope Art Gallery, Terre Haute. She also designed fanciful mantelpieces decorated with fauns and elves. Lorado Taft wrote, "Her exhibits are few, but are always of interest to the craftsman."[67]

Katherine M. Cohen, DAWN (1905), marble on yellow marble base, 17¼" × 11½" × 7½". Courtesy Artemis Gallery, North Salem, N.Y.

Other works are an SPCA fountain, Westfield, New Jersey; a memorial fountain, Auburn, New York; *Head of a Faun, Child at Play* (plaster plaque), and a bronze relief portrait of a child, Lenore Cox, holding a ball, at the Sheldon Swope Art Gallery; and a headstone for her nephew John Elliot Peddle, Highland Lawn Cemetery, Terre Haute. Other works mentioned in the literature are portraits of the actress *Nazimova* in the role of Hedda Gabler and *Madame Ivanowski*, wife of Paderewski's aide-de-camp.

Elsie Ward (Hering) (1872–1923), was yet another sculptor who, after a promising early career, subordinated it to her husband's.

Born on a farm in Fayette, Missouri, she came to Denver, Colorado, in 1887 with her family and studied art there with Ida M. Stair, Henry Read, and sculptor Preston Powers. After exhibiting locally, she went to study with Daniel Chester French and Augustus Saint-Gaudens at New York's Art Students League. There she won first prize for her statue *Youth*. During a year in Paris (1899) she modeled *Boy and Frog* (Brookgreen Gardens and Denver Botanic Gardens), a graceful garden sculpture of a nude boy teasing a frog with a stick. It won a bronze medal at the 1904 St. Louis Exposition.

She had just set up a studio in Denver in 1900 when Saint-Gaudens asked her to come to Cornish to join his team. He referred to her as "invaluable."[68] During the following years, she devoted herself to assisting him with the equestrian statue of General Sherman and the seated Lincoln in Chicago. After his death, she, along with Frances Grimes, helped finish some of his work. Ward composed and carried out the fine relief of angels behind the figure of Christ on the George F. Baker Memorial (Kensico Cemetery, New York), producing "an astonishingly beautiful and poetic result, filled with the spirit of his work."[69]

She did, however, work on a few of her own pieces. A large figure of *George Rogers Clark,* the explorer, for the 1904 St. Louis Exposition, was erected permanently in St. Louis, and a baptismal font of a child-angel holding a shell is at Saint George's Episcopal Church, New York.

In 1910 Elsie Ward married another Saint-Gaudens assistant, Henry Hering, and moved to New York where her husband became a successful sculptor. She spent the rest of her life as her husband's assistant.

Katherine M. Cohen (1859–1914) of Philadelphia was one of the few American Jewish sculptors before the twentieth century (Moses Ezekiel was another). Although many Jews were promi-

Elsie Ward Hering, BOY AND FROG (c. 1899), bronze, height 3'2". Photo courtesy of Brookgreen Gardens.

nent in other arts, such as literature and music, the biblical proscription against "graven images" tended historically to inhibit their participation in the field of figurative painting and sculpture until modern times.

Katherine's father, Henry Cohen, came to Philadelphia from London, and her mother, Matilda Samuel Cohen, from Liverpool. The artist was born in Philadelphia, attended the private Chestnut Street Seminary, and studied at the Philadelphia School of Design, at the Pennsylvania Academy of Fine Arts (1875) with Thomas Eakins, and the Art Students League with Saint-Gaudens.

Having decided to specialize in sculpture, Cohen went to Paris in 1887 and worked under the academicians Puech and Mercié, remaining in France and Italy for several years. In 1896 her life-sized statue *The Israelite,* was accepted by the Paris Salon. In Paris the artist was an honorary member of the American Art Association and enjoyed socializing with colleagues at Mrs. Whitelaw Reid's club for American women abroad, where, as she later described it, the impoverished young students could enjoy such rare amenities as a large library, a grand piano, a warm fire, and high tea.

Invited to lecture on "The Life of Artists" at the Woman's Building during the 1893 Chicago World's Columbian Exposition, Cohen made an ardent plea for philistine Americans to support native talent. Describing the intense idealism of American students in Paris, she said that they were not irresponsible bohemians, but, rather, "walked long distances to save expense, and lived by the light of one candle" in order to learn their craft: "When we arrive at the point that American art is better than anything we can get in Europe, then we shall stay home to study.... We can all of us help the quick realization of this, if we encourage our boys and girls to cultivate

their artistic tastes instead of scoffing at them as impractical.... It is time that the rich man should cease to look upon the artist as a 'poor devil' who can not earn a living."[70] Cohen urged Americans to buy American art and provide inexpensive studio space for artists.

In 1899, Cohen returned to Philadelphia, where she carried out a commission for a heroic-sized bust of *General Beaver* for a niche in the Smith Memorial at Fairmount Park. She was posthumously included in a 1916 exhibition of women sculptors at Philadelphia's Plastic Club.

> Books mention a small bronze *Bust of a Girl* (1898, private collection); *Abraham Lincoln, Dawn of Thought, Vision of Rabbi Ben Ezra,* ideal figures of *Romola* and *Priscilla,* busts of Judge *Mayer Sulzberger* and *Lucien Moss,* and watercolors with exotic titles like *An African Woman, Street in Cairo,* and *Moorish Mosque.*

Adelaide Johnson (1859–1955), sculptor of the suffrage leaders, dreamed of creating a museum dedicated to the women's movement.

Born Sarah Adeline into a farm family in Plymouth, Illinois, Johnson attended the St. Louis School of Design. In 1877, competing against professionals, she won first and second prizes for wood carving at the state exposition in St. Louis. Elated by this early recognition, Sarah took the more glamorous name of Adelaide and went to Chicago to study and work as a woodcarver and interior decorator.

While attending a performance at Chicago's Central Music Hall, Johnson fell down an elevator shaft and broke her hip. The fifteen-thousand-dollar injury award from this accident enabled her to study art in Europe.

Johnson studied painting in Dresden (1883) and then sculpture for eleven years with Giulio Monteverde in Rome, while going back and forth

to pursue her career in America. Although based in the United States, she maintained a studio in Rome for twenty-five years and had studios at different times in Carrara, London, New York, Chicago, and Washington.

A committed feminist, Johnson took up the mission of memorializing in sculpture the leaders of the suffrage movement. Beginning in 1886 she worked on a bust of *Susan B. Anthony* (marble, Metropolitan Museum of Art) at the suffrage leader's home in Rochester, New York, which was displayed at the 1887 Woman Suffrage Convention in Washington, D.C. A perfectionist, Johnson modeled two other versions in the next few years until she finally arrived at one that was not only an accurate likeness but also conveyed the strong, dignified spirit of the sitter. The sculptor, who believed in the occult, claimed that while she was in Italy having the bust put into marble, it shattered and then regrouped itself. On another occasion she woke from a dream and saw a message on the wall telling her to complete it at once.

Anthony urged Johnson to do busts of her colleagues *Elizabeth Cady Stanton* and *Lucretia Mott* (Smithsonian Museum of History, Washington, D.C.). In 1893 the three busts and one of the pioneer physician *Caroline Wilson* were grouped around Anne Whitney's central fountain in the Hall of Honor of the Woman's Building at the Chicago World's Columbian Exposition.

In 1896 Johnson married a kindred spirit, an English businessman, Alexander Frederick Jenkins, in a very unusual ceremony at her Washington studio. The minister was a woman; the "bridesmaids" were her busts of Anthony and Stanton; and Mr. Jenkins adopted his wife's last name, Johnson, as "the tribute love pays to genius."[71] In addition to their mutual belief in feminism, the couple shared an interest in vegetarianism and the occult. This relationship ended in

Adelaide Johnson, MEMORIAL TO THE PIONEERS OF THE WOMEN'S SUFFRAGE MOVEMENT (1921), marble. United States Capitol Art Collection. Courtesy of the Architect of the Capitol.

divorce twelve years later: "Their marriage was characterized by long separations in which Johnson felt that her husband had lost the spiritual consciousness they had shared."[72]

Johnson, who felt that feminism was "the mightiest thing in the evolution of humanity," had a vision of creating a museum dedicated to the history of the women's movement and made repeated efforts to obtain backing for such a project; but since no grants were forthcoming, she viewed her home-studio in Washington, D.C., with its collection of marble portraits, as such a center. For years she attempted to get the American Woman Suffrage Association to underwrite the expense of a monument honoring the suffrage movement for the U.S. Capitol, but after a falling out with Susan B. Anthony (who wanted it in the Library of Congress), she turned to the National Woman's party, a rival group, for support.

After women won the vote, this group did indeed lobby for and finance the monument, which shows busts of the three pioneer suffragists, Mott, Stanton, and Anthony, emerging from a rough-hewn, seven-ton block of white Carrara marble. At the unveiling in the Capitol on Johnson's birthday, 15 February 1921, Edna St. Vincent Millay read a sonnet written for the occasion. Still the only monument to the women's movement in Washington, the bust of Anthony appeared on a stamp commemorating the sixteenth anniversary of women's suffrage in 1936.

The artist, who always had financial problems, really began to suffer when her career went into eclipse in the 1930s. Too proud to sell her sculptures at the low prices offered and still dreaming of placing them in a feminist museum, she finally faced eviction from her Washington home in 1939. In order to focus attention on her plight, the flamboyant sculptor called in the press to watch as she mutilated a number of her works. This audacious act caused Congressman Sol Bloom to intervene and prevent her eviction.

In 1947 Johnson finally lost her home and moved in with friends on Capitol Hill. She remained a colorful figure, continuing to attract media attention by appearing on television quiz programs and speaking on behalf of women's rights. In her last years, in order to stay in the public eye, Johnson pretended to be twelve years older than she was, and celebrated every birthday from "100" to "108" amidst fanfare and newspaper publicity. She was actually 96 when she died.

Books mention busts of *Dr. Hiram W. Thomas* (Chicago Historical Society), *Mrs. O. H. P. Belmont, John Burroughs, Isabella Beecher Hooker, Gen. John A. and Mary Logan* (1887), *Dr. Newton Bateman, John W. Hutchinson, May Wright Sewall, Dr. Cora L. V. Richmond, Dr. Helen Densmore, Lillian Whiting, Ella Wheeler Wilcox, Dr. James L. Hughes, Harold L. Duncan,* and *William Tebb Esq. of London.*

Clio Hinton Huneker Bracken (1870–1925), creator of small statuettes, punch bowls, and other objects in a flowing art nouveau style, was a prime exponent of the arts and crafts movement. Mary A. Fanton wrote, "Mrs. Bracken is most decidedly one of the frontiersmen in the feeling new in America that all interior decoration should be good art. She proves the courage of her belief in her own house [and studio] where every mechanical detail is decoratively beautiful, from door handles to electric bulb holders."[73]

Born in Rhinebeck near the Hudson River, New York, Clio came from a free-thinking artistic family. Her father, Howard Hinton, was editor of *Home Journal,* and her mother, **Lucy Brownson Hinton (1834–1921)**—herself a sculptor who had studied with Launt Thompson and in Paris with Chapu and Carpeaux—was an early suffragist who loved to shock her staid New England relatives with her nonconformist views. Clio learned sculpture at her mother's knee and by 1888 was sharing a New York studio with her cousin, the sculptor Roland Hinton Perry.

In 1892 she married the avant-garde critic of the seven arts, James Gibbons Huneker. Living in a Carnegie Hall apartment, the couple led an exciting life amidst the New York music and theatrical scene, and Clio won praise for portraits of such noted musicians as *Ignace Paderewski* (bas-relief), conductor *Anton Seidl* (bust, 1891), pianist *Fanny Bloomfield-Zeisler,* and opera singer *Emma Eames Story* (bas-relief, c. 1895).

Around 1893 she studied with Saint-Gaudens at the Art Students League, receiving a good deal of publicity when she won a $10,000 prize

in a competition for a statue of General Fremont, which was reportedly to be erected in California.

Stresses developed in her marriage, and in 1895 Clio left her bohemian and hedonistic husband and took off for Paris with their two-year-old son to study with Frederick MacMonnies and Louis Oury. There she came under the influence of Rodin and was swept up in the art nouveau movement, modeling small nude figures that were "invariably symbolic of some thrilling emotion of life, some ecstasy of joy or sorrow."[74]

The artist and her mother both exhibited in the 1899 Paris Salon (Clio's entry was a head of a child). Huneker pursued her to Paris and tried in vain to get the artist to return to him. He later took his revenge by portraying her as the passionate, but basically conventional Mona in his notorious novel *Painted Veils.*

Returning to New York to divorce Huneker in 1899, she again shared a studio with her cousin Roland Hinton Perry in the Tenth Street studio building made famous by William Merritt Chase. It became a drop-in salon for artists and literati. There she modeled a bust of *Sarah Bernhardt* and other works.

In 1900 the artist married the wealthy lawyer William B. Bracken. The prejudice against divorced women was still so strong at that time that when the minister discovered she had been divorced he refused to have the wedding in his church.

Bracken's designs for punch bowls, door knobs, and other useful objects were acclaimed in *Craftsman* magazine in 1905 as prime examples of the flowing art nouveau style that related "the curves of a body with the curves of a flower, the sweep or droop of drapery with wind and wave."[75] Illustrations show a door handle formed as a flowing bronze figure; a bookend in the shape of a nude in swirling draperies; and a lotus-shaped ash tray. Bracken's chef d'oeuvre, a bronze punch bowl decorated with motifs from the *Rubaiyat of Omar Khayam,* was an extravaganza of female figures and roses sweeping up joyfully around the rim. Toward the bottom the figures and flowers begin to droop, and the base contains the gloomy figure of "Omar the Cynic, Omar the Melancholy." The article points out the symbolism—life is intoxicating, joyous, but at its base is sorrow. A great freight of meaning was

Clio Bracken, THE OMAR PUNCH BOWL (unlocated). Illustrated in *Craftsman,* July 1905. Photo: Library of Congress.

carried by this punch bowl, which was also scaled up and carved in marble as a fountain.

Bracken's statuettes express "the pagan joy of life" and pulse with sensual emotions, rendered in a loose impressionistic technique with melting surfaces and lightly suggested detail. Typical is a tiny dancing girl, "all her delicate gold draperies blowing close to the young body as if she were the spirit of a tropical gale, alluring yet destructive." Other works of this period are *The Roman Youth, The Kiss* (similar to Rodin's), *The Worship of Pan* (a slender nude girl kneeling imploringly before a bust of the god Pan), and a piece showing a nymph on the crest of a wave.

Bracken secured a commission to execute a large group for the new state capitol at Harrisburg, Pennsylvania (along with George Grey Barnard), but because of a political scandal about appropriations, she was unable to execute it.

Until her death the artist continued to model portraits of such prominent sitters as *Mrs. Ernest Seton-Thompson, General Pershing,* composer *Henry Hadley, Clarence Whitehill,* and others. Her small statuettes were sometimes enlarged for garden settings. *Chloe,* a draped marble figure holding a bunch of grapes, is in Brookgreen Gardens, South Carolina.

Edith Howland (1863–1949) was another of the few women to exhibit in the Paris Salon before 1900. She was born near Auburn, New York, to parents of Quaker descent. She attended Vassar College, studied modeling with Gustave Michel at the Académie Julien, and at the 1893 Paris Salon exhibited a bust of *Maud Muller,* also shown that year in the Woman's Building at the Chicago World's Columbian Exposition.

Howland then studied with Saint-Gaudens and Daniel Chester French at the Art Students League and, after traveling widely, took a studio

Edith Howland, BETWEEN YESTERDAY AND TOMORROW (1914), marble, height 6'4". Collection of Brookgreen Gardens. Photo courtesy of the National Sculpture Society. Photographer: Louis H. Dreyer.

in Neuilly, near Paris, where she modeled *Between Yesterday and Tomorrow* (marble, Brookgreen Gardens, South Carolina) shown at the 1913 salon. The statue represents three periods of life—a woman in her prime (the present), an old woman (the past), and a boy (the future). The subject was suggested by a Spanish Gypsy song:

> I move like a prisoner caught
> For behind me comes my shadow,
> And before me goes my thought.[76]

Howland also did garden figures, fountains, and small bronzes. She returned to New York City in 1917 and spent her last years in Catskill, New York.

Emma Marie Cadwalader-Guild (1843–1911) of Zanesville, Ohio, was one of those American artists who had to be recognized abroad before receiving any notice at home. Forgotten today, she did portraits of European royalty and one of President William McKinley in the Capitol.

Largely self-taught except for anatomy studies with William Rimmer in Boston, the sculptor, after going abroad, exhibited at the Munich Glaspalast from 1883, at the Royal Academy and Grosvenor Gallery in London (1885–98), and at the Paris Salon. She reportedly did busts of British prime minister Gladstone, Princess Christian of Schleswig-Holstein (second daughter of Queen Victoria), Princess Henry of Prussia, and the violinist Joseph Joachim (also a friend of Elisabet Ney).

George Frederick Watts, painter of huge pre-Raphaelite canvases, continued to run up and down ladders working on one of his enormous pictures while she modeled his bust for a Manchester museum. When it was finished, the artist reportedly said, pointing to his own work, "When I look at that bust I can understand how that man could have painted that picture."[77]

Cadwalader-Guild also exhibited a bronze figure of a standing black man entitled *Free* at the Paris Salon, Royal Academy of London, and in Munich, and *Endymion* (marble, c. 1905), a standing figure with a dreamy expression embodying the "eternal search for the ideal."[78]

Electron, a characteristic Beaux Arts attempt to deal with a modern theme through the use of allegory, shows the seated god Mercury leaning forward to touch an electric button. "He realizes that his dominance is gone.... Science has wrested from him his absolute power."[79] The German government reportedly bought *Electron* for the Post Museum in Berlin.

After seeing her work in Europe, Ambassador Henry White arranged for President William McKinley to give her sittings, but he was always too busy, so she worked from rather inadequate photographs. "It is by far the best that has ever been made," said Senator Mark Hanna who introduced a bill to have the United States buy the bust, now in the President's Room at the Capitol. Guild also did a bronze bust of Lincoln.

In her later years the artist had a studio in the Bryant Park Building, New York. Her works show a romantic, literary spirit.

DESIGN AND CRAFTS IN THE GILDED AGE

The arts and crafts movement that blossomed in the Gilded Age originated with English reformers such as John Ruskin and William Morris, who were appalled at the Industrial Revolution's degradation of workers and the environment. They urged a return to the handicraft traditions of the Middle Ages.

Women, now restlessly seeking to enter the labor force or find more significant roles within the home, played an important role in the move-

ment, carving furniture and creating ceramics, metalwork, and textiles. A feeling for color and ornament was perceived as being "natural" to women—related to their task of beautifying the home. Male leaders such as Walter Smith, state director of art education in Massachusetts, encouraged women to enter design fields, hoping that this domesticized outlet would contain their energies and cause them to flock "to the studios . . . [and leave] the ballot-box alone," and not "unsex themselves" by engaging in "men's affairs."[80]

This interest in the decorative arts inevitably developed into serious professionalism and became one of the major ways in which middle-class single or indigent women might earn a living without losing their social status. For example, Candace Wheeler, who was one of the leading textile and interior designers of the era and helped redecorate the White House, began as a volunteer charity worker, promoting textile crafts as a way of helping impoverished middle-class women support themselves. She ended up heading an all-female design company, Associated Artists, and becoming one of the major tastemakers of the era. Julia Munson and Patty Gay headed the team that developed Tiffany's first experiments in enameling, and other women designed stained glass and other objects. Indeed the men at Tiffany's company felt so threatened by the dominance of women in the lampshade department that they went on strike, demanding that men be hired instead. The crafts movement influenced sculptors. In the 1880s, the Japanese, Arabic, Indian, and Gothic motifs being introduced into the exotic interiors of the homes of the rich (reflecting America's new entry into the world of international commerce and power) were echoed in exotic works like Enid Yandell's *Hindoo Incense Burner*. Caroline Peddle Ball designed sculpture for Tiffany, and Ju-

lia Bracken Wendt declared in an interview that there was no difference between art and craft: "The world's idea of a sculptor is a man who models colossal statues for high granite pedestals. . . . the sculptor's real business in the world lies quite as much in the modeling of serviceable and beautiful door knobs and other articles of daily use."[81]

ARTS AND CRAFTS AND SOCIAL REFORM

Toward the end of the century, the opulent elegance of the aesthetic movement of the 1880s, with its Wildean "art for art's sake" orientation, began to be viewed as a form of self-indulgent ostentation for the wealthy classes. In a period of social reform and reaction against the unchecked growth of monopolies, a new mood of simplicity, practicality, and functionalism entered design fields.

Many artists, writers, and thinkers began to view the teaching and manufacture of arts and crafts as a way of educating and raising the standard of living of the proletarian immigrant masses and saving them from the misery of alienated factory labor. In 1889, Jane Addams and Ellen Gates Starr opened Hull House, a settlement house in Chicago where immigrants were taught to preserve their own ethnic crafts traditions, as well as learn new crafts. In Boston, women organized the Paul Revere Pottery to enlarge the perspectives of poor immigrant Italian and Jewish girls.

All over the country women took leadership roles in arts and crafts societies. Mary Ware Dennett, designer, feminist, and suffragist and a leading spirit in the Boston Arts and Crafts Society, urged the members to encourage production for beauty and use, not profit, and to help bring back conditions of creativity for workers.

As we have seen, Julia Bracken Wendt was an organizer of the Bohemia Guild, an offshoot of the Industrial Art League. Her bas-reliefs of the spiritual leaders of the arts and crafts movement, William Morris and John Ruskin, hung in the league meeting rooms and were used as illustrations in Owen Trigg's history of the arts and crafts movement.

The role of women in late nineteenth-century design is illuminated in two 1987 exhibition catalogs: *In Pursuit of Beauty: Americans and the Aesthetic Movement,* Metropolitan Museum of Art/ Rizzoli, 1987, and *The Art That Is Life: The Arts and Crafts Movement in America, 1875–1920,* Boston Museum, 1987.

CERAMICS

Two rival Cincinnati women, Maria Longworth Nichols and Mary Louise McLaughlin, played prominent roles in the rise of the great art potteries in the United States. **Mary Louise McLaughlin (1847–1939),** sister of Cincinnati's leading architect and one of the avid group of Cincinnati ladies who studied furniture carving with Benn Pitman at the Cincinnati Art Academy (see chapter 3), was introduced to china painting in that class. Enthused by the display of French Haviland faience at the Philadelphia Centennial Exposition, she set about discovering how to replicate its technique of slip underglaze decoration; then she founded the enthusiastic Cincinnati Pottery Club in 1879. "Cincinnati faience" soon attracted women from as far away as New York and Michigan, and they sought to study with the group. Thus the art pottery movement spread around the country.

McLaughlin was so successful that a male-owned Cincinnati company tried to patent her technique and bar her from using it. In 1899, the innovative artist began to experiment with glazes on porcelain and developed her Losanti-wares, elegant ovoid art nouveau forms. McLaughlin won a silver medal for overglaze decoration with metallic effects at the 1900 Paris Exposition Universelle and became one of the leading ceramists of her era. This extraordinary artist was also a painter, carver, and metal worker as well as a fine etcher who wrote books on ceramics and etching.

McLaughlin's rival, the imperious **Maria Longworth Nichols (1849–1932),** was born into a family of wealthy Cincinnati art patrons. While admiring Japanese pottery at the 1876 Philadelphia Centennial Exposition, she "first felt a desire to have a place of my own where things could be made." In 1880 she founded her own pottery and called it Rookwood after her father's estate.

Longworth money supported Rookwood for the first ten years of its existence, with Nichols setting the tone. After that she hired a manager who ran the pottery as a successful business. A feeling for Oriental elegance characterized much of Rookwood pottery. Nichols pioneered many innovations in glazes and techniques, finally reaching international fame by winning a coveted gold medal in 1900 at the Paris Exposition Universelle in competition with Europe's greatest potteries. Rookwood put American ceramics on the world map for the first time. A group of Nichols's "Orientalized" bronze sculptures is in the Cincinnati Museum of Art.

Other Rookwood decorators were **Clara Chapman Newton, Sara Saxe,** and **Laura Anne Fry** (who invented the technique of using a throat atomizer to spray slips on greenware). In 1883, **Susan Goodrich Frackelton** established the Frackelton China and Decorating Works in Milwaukee, Wisconsin, which produced about two thousand pieces a week. She pi-

oneered the use of salt-glazed decorative stoneware, formed the National League of Mineral Painters, and developed the Frackelton Dry Colours (golds and bronzes) which received international medals. Her book *Tried by Fire* (1895) was the bible of china painters.

Mary Sheerer, graduate of the Cincinnati Art Academy, was the first teacher of china painting at Newcomb Pottery, established in 1895 at Newcomb College for Women in New Orleans. Other Newcomb decorators were **Sadie Irvine, Mazie T. Ryan, Frances Simpson,** and **Henrietta Bailey.** Newcomb Pottery has its own distinctive New Orleans feel, using motifs drawn from the local flora and fauna. **Mary Chase Perry** founded the Pewabic Potteries of Detroit which

created a style of tile decoration used in churches, public buildings, and homes.

Whole books have been written about **Adelaide Alsop Robineau (1865–1929)**, whose porcelain was declared "the best ... in the world" at the Turin Exposition. She won innumerable prizes, edited the magazine *Keramic Studio* until her death, was on the faculty at Syracuse University, and received a memorial exhibition of her work at the Metropolitan Museum of Art. **Anna Valentien**, a student of Rodin and one of the few women to exhibit at the Paris Salon before 1900, produced some of the fine figure-ornamented Valentien pottery in a studio that she and her husband ran in San Diego.

Mary Louise McLaughlin, VASES. Cincinnati Art Museum. Gifts of the Porcelain League of Cincinnati (#s 1914.4 and 1914.5). Gifts of Theodore A. Langstroth (#s 1970.582 and 1970.583). Photo: Ron Forth.

• 5 •

Fauns and Fountains— Traditional Women Sculptors: 1905–1929

Evelyn Beatrice Longman, FOUNTAIN OF CERES, for the Court of Four Seasons, Panama Pacific International Exposition, San Francisco, 1915. Photo courtesy of the National Sculpture Society. Photographer: A. B. Bogart.

A glance at the catalogs of the two major exhibitions sponsored by the National Sculpture Society in 1923 and 1929 reveals that by the third decade of the twentieth century, an astonishingly large number of women had achieved prominence, and a few were among the most prolific and successful academic sculptors of the era. The works of Evelyn Longman, Gertrude Vanderbilt Whitney, and Edith Woodman Burroughs were featured in monumental installations at the 1915 Panama–Pacific International Exposition in San Francisco, and Anna Hyatt Huntington and Malvina Hoffman were earning worldwide reputations. Magazines repeatedly carried interviews and feature stories announcing that women sculptors were now the equals of their male colleagues.

Several exhibitions emphasized this point. In 1913, New York's Gorham Galleries, the leading dealers in small bronzes, exhibited the work of thirty-six women sculptors; in 1914 they showed fifty-five. In 1916 the Plastic Club of Philadelphia mounted an exhibition of seventy-four women—a kind of Who's Who of women sculptors of the day.[1] Rodin happily agreed to lend his

Janet Scudder, VICTORY (1914), bronze, height 2′2½″. Courtesy of Brookgreen Gardens.

Several factors contributed to this flowering. American women were finally receiving excellent art training; and in the last quarter of the nineteenth century they had gradually proven their ability to produce excellent work. As the suffrage movement gathered into a great wave, winning the vote for women in 1920, the vitality and spirit accompanying this campaign energized women to new levels of achievement. Janet Scudder and Abastenia Eberle marched under the sculptors' banner in suffrage parades; Eberle arranged exhibitions to raise funds for the suffrage movement, and Scudder designed a statue of *Victory* to celebrate the event. World War I put every available woman to work, proving once and for all that women could function intelligently outside the home, and after the war they began to enter graduate schools and train for professions—in fact, a larger percentage earned graduate degrees in the 1920s than in the 1950s.

Moreover, in the area of morals and manners, a new freedom was permeating society. Eroticism and self-expression found outlets in the dance forms of Loie Fuller, Isadora Duncan, and Ruth St. Denis, and in the breathtaking abandon of ballerina Anna Pavlova. The dance had a great influence on sculptors, who used these images to portray women as sensual, passionate, uninhibited. The exoticism of the Ballet Russe, and the costumes of Bakst also had a great effect on sculpture and on costume and design.

In general, women were developing a radically different sense of their own bodies. Figures such as tennis star Helen Wills Moody and airplane pilot Amelia Earhart were culture heroines. The slim androgynous body, short skirt, and boyish short hair of the 1920s made it clear that women were throwing off the corsets and confines of the past. Even conservative sculptors like Harriet Frishmuth and Malvina Hoffman portrayed the slender, dancing "new woman" in their art.

name to a Rodin Medal designed expressly for the occasion; it was awarded to Anna Hyatt for her *Joan of Arc.*

Harriet W. Frishmuth, JOY OF THE
WATERS (1917). Photograph courtesy of
the National Sculpture Society.

NEW GENRES

Small Bronzes Women sculptors found a
profitable new market in the growing demand
for small bronzes—table-top figures, animals,
bookends, and other objects for the home, which
were the rage in the early decades of the century.
The National Sculpture Society promoted exhi-
bitions of small bronzes because they could be
cast in large editions and sold at prices the mid-
dle-class homeowner could afford.

Garden Sculpture Although a demand still
existed for patriotic public sculpture, in general,
after the disillusionment of World War I, there
was a turning away from the virile, chest-thump-
ing monument. Instead, in a period of great pros-
perity, wealthy patrons increasingly commis-
sioned delightful statues and fountains to serve
as eye-catching focal points amidst the vistas of
their estate grounds.

With the proliferation of trains, motor cars,
and good highways, more and more wealthy peo-
ple chose to live, or spend their weekends, in
country places on Long Island and in other posh
suburbs. John D. Rockefeller, Sr., maintained an
estate at Pocantico Hills so huge that three
hundred gardeners were required to keep it in
trim.

Estate owners, feeling themselves to be suc-
cessors to the patrons and merchant princes of
the past, wanted their landscapes to evoke nos-
talgic overtones of the Boboli and similar Italian
gardens, in which statuary serves to carry the
eye from point to point, from light to shade, down
alleys and into open formal spaces. This was an
art for those who wished to get away from the
rude reality of the city, with its ever-present pov-
erty, and escape into a refreshing retreat of na-
ture and make-believe.

As we saw in the last chapter, women sculp-
tors, barred for the most part from large monu-

Anna Coleman Ladd, LEAPING SPRITES
FOUNTAIN. Garden of Mrs. E. S. Grew.
Illustrated in *Art and Progress,* September
1912, p. 741.

mental commissions, found a rewarding field in
this genre. Charming fauns piping in grottos, and
children cavorting with fish, were subjects
thought of as suitable for feminine talent. On the
whole, male sculptors looked down on such as-
signments and did them only if major commis-
sions were not forthcoming.

Garden sculpture is being reassessed today.
Long viewed as innocuous, especially by ab-
stract artists and the social realists of the 1930s
who considered it an expression of the idle rich,
it is now seen to be a mode in which sculptors
could often be more playful, expressive, and ex-
perimental than in public monuments. Two 1985
exhibitions, *Fauns and Fountains: American
Garden Statuary* (curated by Michele H. Bo-
gart) and *Long Island Estate Gardens* (curated
by Judy Collischan Van Wagner), contributed to
a new appreciation of these works.

GARDEN SCULPTORS

Janet (Netta Deweze Frazee) Scudder (1869–1940)

Who that has a garden would be without one of these
radiant, ebullient children or young maidens—a
veritable fountain of perennial youth in the midst of
the flowers and trees?
—Ada Rainey[2]

Janet Scudder is recognized today as a trend-
setter who, perhaps more than any other sculp-
tor, helped create the vogue for bronze fountain
figures of small children and elfin sprites to
serve as focal points in the gardens of the
wealthy.

She came from an unlikely milieu. Her home
in Terre Haute, Indiana, lay under the pall of an
uncongenial housekeeper and a grieving wid-
ower father who was struggling to raise seven
children. Amidst this gloom Scudder's gentle,
blind grandmother, who lived with the family,
provided a happier note for the young girl: she
told Netta stories by the hour and gave her two
large books of Longfellow's poems, "which be-
came so precious to me not on account of the po-
etry in them, but because of the illustrations. . . .
I immediately spent the entire day copying
[them] on bits of discarded letters and envel-
opes."[3] Seated on a black horsehair chair pulled
up to a marble-topped table, the small child cop-
ied a picture of a Viking in armor a hundred
times. Later, when the house caught on fire and
people shouted to take the most valuable things,
Netta was seen lugging the two heavy books
down the steps.

Scudder had her first artistic triumph when
her friend Caroline Peddle suggested they sub-
mit work to the Terre Haute county fair. Along
with china painting and painting on velvet, the
young artist submitted a hammered brass tray
with the head of Medusa on it. No later award
ever matched the experience of seeing Medusa,

with its prize ribbon, lying among the jams and jellies.

At Saturday drawing classes at the Rose Polytechnic Institute, the director was so impressed that he urged her father, who could ill afford it, to send her to the Cincinnati Academy of Art. There Scudder studied wood carving and was able to support herself through school by carving grapes, bowknots, and acanthus leaves on furniture and mantelpieces. One day she wandered into the clay modeling room. As she rolled the clay between her fingers and began a study of a foot, she sensed at once that this was her medium and enrolled in the course. Her teacher was most encouraging: "Dear old Professor [Louis] Rebisso. He . . . never knew what he meant in my life. I asked him "Will I ever be a real sculptor, like you?" . . . He took my hands . . . in his sticky clay ones. . . . "I'm going to tell you something. You've got it in you—the feeling for the clay . . . one of these days you will be a much greater sculptor than I am. You are going way beyond me."[4]

Scudder had a hard time after graduation. Her father died, leaving her with no means of support, so she took a job as a furniture carver in a Chicago factory. But the union representative soon fired her—women were not admitted to the union. The artist later remembered that she shouted at him in desperation, "Women need to work as well as men!"

As it happened, the shop steward had unwittingly done her a favor. Lorado Taft was hiring assistants to help him with sculpture for the 1893 Chicago World's Columbian Exposition. The fair opened a path to a major career.

In her autobiography, *Modeling My Life,* Scudder has left a vivid description of how thrilling it was for the group of women sculptors to be working alongside their male colleagues on large sculpture projects for the fair. When the White Rabbits received their first salary, they exuberantly threw a shower of five-dollar bills into the air and then carpeted the floor with them. The taste of financial independence was sweet to these women of the late Victorian era.

Scudder also carried out independent commissions, a figure of *Justice* for the Illinois Building and one for the Indiana Building. The exposition was a turning point. Seeing Frederick Mac-Monnies's neobaroque extravaganza *The Barge of State* made her yearn to study with him in Paris. With the money she earned at the fair she was able to go to Paris with Taft's artist-sister, Zulime.

There, after several rebuffs, Scudder all but forced her way into MacMonnies's busy all-male atelier at 16 rue Impasse du Maine, and was put to work helping him finish ornaments and details. She also studied drawing at the Academy Colarossi and organized a private class of women students who took criticism from Mac-Monnies. After two years as his assistant, Scudder returned to New York in 1896 with his letters of recommendation, expecting to be hired by a leading sculptor. MacMonnies remained an important friend who promoted her career in the following years.

In New York City, Scudder faced an indifferent world. Saint-Gaudens refused to admit her to his atelier; an architect used a fake commission for a lamppost as a ploy in order to harass her sexually. Reduced to living on a bottle of milk and a can of beans a day, she sat on a park bench amidst the derelicts in Union Square and thought about the fate that awaited her. She would be a "surplus woman," a maiden aunt, an unpaid servant in her sister's home, wiping the noses of other people's children.

At this nadir in her life, Scudder received a helping hand from a sister artist, Matilda Auchincloss Brownell. Brownell's father recommended her to design the seal for the New York

Janet Scudder, LOUISE HARTSHORNE
MOORE (1901), plaster (?). Unlocated.
Photo: Library of Congress. A bronze cast
is at the Indianapolis Museum of Art.

State Bar Association—a commission that soon
led to orders for memorial tablets and portrait
medallions.

Scudder developed a distinctive, crisply delin-
eated, detailed style of profile relief, in which
she included objects or clothing that indicated
the sitter's profession or major interest. For ex-
ample, in *Master Billy Fahnestock* (1904, Met-
ropolitan Museum of Art), a small boy in a sailor
suit, holding some toys, is surrounded by an or-
namental border of his pets. Carried out in
bronze or silvered copper, the plaques have a
decorative effect, with a literal, almost Victorian
air about them, different from the spiritual feel
of Saint-Gaudens's reliefs.

Scudder was honored when the Luxembourg
Museum in Paris acquired several of these—

their first sculptures by an American woman.
The Indianapolis Museum of Art owns fourteen
pieces, among them *Bishop Hare* (1904), *Alice
Jones* (1900), and *Louise Hartshorne Moore*
(1901). One of her finest portrait reliefs is the
strong profile of her artist friend *Matilda Brow-
nell* (bronze, c. 1901, private collection) at work
with palette and brushes and wearing a flowing
bow tie and artist's smock.

Not wishing to do funerary monuments and
cemetery urns (her principal sources of income)
for the rest of her life, Scudder was searching for
a personal form of expression. During a visit to
Italy (1899–1900), she was impressed by works
like Verrochio's lively *Eros and Dolphin* and de-
cided to create fountains in this vein. She had no
doubt also seen Frederick MacMonnies's *Pan of
Rohallion* (1894) and *Boy with Duck* (1895).
The decision was timely. Beaux Arts architects,
such as McKim, Mead and White, were looking
for ornamental sculpture for the neo-Renais-
sance formal gardens of their clients. What could
be more appropriate than updated versions of
the playful putti of the Renaissance?

Back in her Paris studio, Scudder was men-
tally prepared to take advantage of the situation
when a small street urchin, hoping to earn a few
pennies as a model, wandered in and danced
around the room: "At that moment a finished
work flashed before me. I saw a little boy danc-
ing, laughing, chuckling all to himself while a
spray of water dashed over him. The idea of my
Frog Fountain was born."[5] *Frog Fountain*
(1901), a lively chubby urchin dancing on a base
surrounded by three water-spouting frogs, be-
came the start of an important new phase in her
career.

Stanford White, a leading Beaux Arts archi-
tect, ordered the *Frog Fountain* for clients' es-
tates, and the Metropolitan Museum of Art
bought another. It was followed by *Tortoise
Fountain* (bronze, c. 1908, Brookgreen Gardens,
South Carolina), a winged Cupid poised on the

Janet Scudder, FROG FOUNTAIN (modeled 1901, carved 1904). In the garden of the former James Lawrence Breese Estate, The Orchard, Southampton, N.Y., c. 1915. Stanford White, architect. Photo: Mattie Edwards Hewitt. Courtesy of the Nassau County Museum Reference Library.

back of a turtle that sprays water from its mouth; *Young Diana* drawing her bow (c. 1911, Chrysler Museum, Norfolk, Virginia); *Fighting Boys Fountain* (public library, Cairo, Illinois); *Little Lady of the Sea,* a nude figure draped in seaweed, (Virginia Steele Scott Gallery for American Art, Huntington Gardens, California); and a piping Pan (1911) for a grotto on John D. Rockefeller's Pocantico Hills estate.

Janet Scudder, SEATED PAN (1911), bronze. Commissioned for the estate of John D. Rockefeller, Sr., Collection, National Trust for Historic Preservation and Private Collections. Photo: National Archives. Photographer: A. B. Bogart.

The Rockefeller commission attracted a full-page interview in the *New York Times,* in which Scudder expressed her views on life, women, and art. Said the reporter: "Miss Scudder is tall, slim, and very simple in manner and dress. She affects no frills or furbelows. Her costume is eminently suited to studio work and to occasions when, as for the Rockefeller fountain, she has had to pass strenuous days clambering over ice-covered acres to study, from every vantage point, the selected situation for her work."[6]

Scudder explained that it was much cheaper and easier for her to live and work in Paris. She also expressed her dislike of conventional pompous equestrian and portrait statues:

> in Washington I was asked . . . by a Senator if I would be interested in doing a statue of Longfellow. I said I considered it a shame to put up another statue in a Prince Albert coat. I suggested that a memorial of the great American poet take the form of a beautiful garden in which would be a place for a fountain or other artistic memorial.
>
> Washington has been almost disfigured by equestrian statues. . . . You can hardly look in any direction, but a huge, bronze figure intervenes. . . . If I had my way I would make it a law that no more of them should be placed there or in any city which makes pretensions to municipal beauty. I would not destroy these . . . but I would place them along a boulevard stretching from the Washington Monument to the new Lincoln Memorial. That effect would be superb. . . . Such an arrangement of statues has been made in Berlin.[7]

A feminist who marched in suffrage parades and was on the art committee of the American Woman Suffrage Association, she objected to

separate women's exhibitions or the use of "Mrs." or "Miss" before a woman artist's name, adding, "Where once upon a time sculpture was declaimed as being too strenuous a profession for women . . . argument has been silenced by the exhibition of the work which women have done." After all, she pointed out, "In the lowest classes the scrub women are on their knees most of the working day. No one has ever objected that they are physically unfit."[8]

In 1913 Scudder bought a house at Ville d'Avray, outside of Paris, where she could view her sculptures in a garden while working on them; she lived and worked there for the next twenty-five years. Her career burgeoning, she had a solo show in New York that year, and nine garden sculptures were displayed at the 1915 San Francisco Panama Pacific International Exposition, winning a silver medal.

After America entered the war, the artist turned over her Ville d'Avray home to the YMCA until the end of hostilities, and worked for the Red Cross. In her later career, her style became more serious and reserved and she began to do paintings. She returned to the United States at the outbreak of World War II, where she died of pneumonia in 1940.

Scudder's garden statuary, carefully designed for its setting, can be best appreciated on the site with water playing over it. A figure representing *Japanese Art* on the facade of the Brooklyn Museum is one of her few architectural commissions. Her bronzes are in more than fourteen museums around the country.

Scudder had one of the most successful careers of any woman artist in the early twentieth century. Basically a traditionalist, she had expressed her views about the value of tradition versus modernism in the *New York Times* interview:

I think too much stress is laid in America on the fact of being original. The insistence of that idea has been almost a death knell to our art. Everyone expects to be struck between the eyes with something tremendously bizarre, and the artists try to meet that demand with a supply of the weird instead of the wholesome. Why not be interested in doing a beautiful thing just because it is beautiful? Why not develop old ideas? Why seek to change a worthy influence? The work which came out of the studios of the old masters could not oftentimes be told from that of the master himself. Has the world lost anything by this? In Japan the student takes his teacher's name.[9]

The dancing figures of **Harriet Whitney Frishmuth (1880–1980)** express the sense of bacchic liberation, particularly of women, so characteristic of the early twentieth century. Loring Holmes Dodd selected one of her works for the cover of his book *The Golden Age of American Sculpture* (1936) because, he said, her nude figures "represent the modern ideal of energy, of action, of swift movement . . . as representative of our times as the Venus of Melos of its."[10]

The sculptor was born in Philadelphia, the daughter of Frank Benoni and Louise Otto (Berens) Frishmuth. Her mother left for Europe with her three daughters when Harriet was very young because of "domestic difficulties."[11] Raised principally abroad, Harriet attended private schools in Paris, Dresden, and Philadelphia.

Her career began accidentally. One evening, when the nineteen-year-old girl was stopping at a Swiss pension, another guest named Mrs. Hinton asked her whether she was a musician, because her "hands looked like those of a violinist," she said. Harriet replied shyly that she couldn't even carry a tune, but had "always had

a yearning to see if I could model." Her new friend, evidently a sculptor, replied, "I have plasteline up in my room. Come and we will see what you can do."[12]

After deciding to become a sculptor, Frishmuth studied in Paris with Gauquié, Injalbert, and Rodin, whose advice had a permanent influence on her: "First always look at the silhouette of a subject and be guided by it; second, remember that movement is the transition from one attitude to another.... It is a bit of what was and a bit of what is to be."[13] This quality of instantaneous transitory movement seized on the wing became the hallmark of her art.

Frishmuth had long years of thorough training. She spent two years in Berlin assisting Prof. Cuno von Euchtritz on monuments for that city; studied with Hermon A. MacNeil and Gutzon Borglum at the Art Students League; assisted Karl Bitter for a year; and did dissections once a week at the College of Physicians and Surgeons. Borglum finally told her to open her own studio, find her own style.

During this period the impecunious artist lived and had a studio in the Park Avenue home of her uncle, Dr. T. Pasmore Berens. Her first commission was a bronze bas-relief of *Dr. Abraham Jacobi* (1910) for the New York County Medical Society. She eked out a living by designing bronze bookends, ashtrays, and small figures, sold in editions by the Gorham Company, and also executed several serene, classicized large-scale figures more or less in the tradition of Daniel Chester French—the *Saaki Sundial*, the *Gold Sundial* (1913), and *Morning, Noon and Night* (1916).

It was not until she moved into her own studio-home at Sniffen Court, a picturesque alley near Thirty-sixth Street where sculptors lived and worked in remodeled stables, that Frishmuth's own uninhibited, lyrical style began to emerge. During the years at Sniffen Court—the happiest and most productive of her career— she taught sculpture and carried out her major works.

Frishmuth was inspired by the ballet and in particular by the model, Desha, a beautiful Yugoslavian adagio dancer who had been in Fokine's ballet troupe.

> Desha was sent to me by Miss Frances Grimes, a sculptor whose work I admired. It was in 1916 that [she] knocked at my studio door and asked if I could use her. When we had finished our little chat she went out skipping, half dancing and singing through the courtyard to the street... At first I used her for my class.... Then one week I had her pose just for me and as neither of us knew exactly what we wanted I put a record on the victrola. It was *L'Extase* by Scriabin. Desha started dancing and one pose intrigued me. I carried it out and called the finished bronze "Extase" after the music.[14]

Frishmuth asked Desha to freeze in an instantaneous gesture, on tiptoes, reaching up with overlapping hands, eyes closed in ecstasy, forming a long sinuous vertical s-curve. Desha was not only a model; she became a lifelong friend, who took a profound interest in Frishmuth's work.

Up to that time the sculptor's work had been restrained, but beginning with *The Thread of Life* (1916) she began a series of nudes on tiptoes or bending, swaying, leaping, in wildly joyous moods. The slender androgynous figure of the 1920s replaced the serenely classical forms.

At age forty-two, Frishmuth achieved great popular success with *The Vine* (1921), a woodland nymph holding a vine, bending backward on tiptoes in an exaggerated arabesque. More than

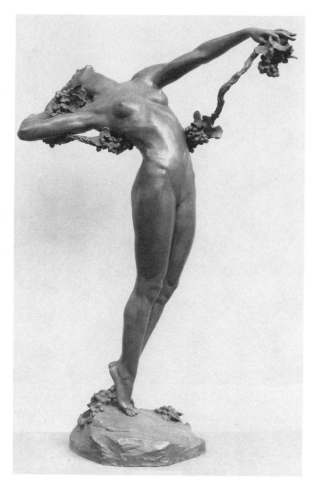

Harriet W. Frishmuth, THE VINE (1921), bronze, 7′3″. The Metropolitan Museum of Art, Rogers Fund, 1927. (27.66)

300 casts of the small statuette were sold. A larger than life-size version greets visitors entering the American wing at the Metropolitan Museum of Art.

Other dance sculptures are *Slavonic Dancer* (1921), expressing male strength and pounding feet, and two-figure compositions called *The Dancers* (1921) and *Fantaisie* (1922). Fountain and garden figures include *Playdays,* a girl tickling a toad with her foot; *Call of the Sea,* a girl riding a fish with one arm flung vertically into the air; and *Crest of the Wave* (bronze, Botanical gardens, St. Paul, Minnesota). Frishmuth's marble bust of *Woodrow Wilson* (1924) is in the State Capitol, Richmond, Virginia, and she also carried out several monumental tomb sculptures.

A striking departure from her lyrical, graceful figures is the "moderne" art deco sculpture, *Speed* (1922). The artist described the moment of inspiration for this work: "I was in a theater watching Michel Fokine dance. I was making a portrait of Fokine at the time.... The big curtain was down and I saw this vision of a figure pass across the great screen, and I could hardly wait to get back to the studio to start modeling it.... I made a sketch of it, and then I got this very lovely English girl, Blanche Ostrehan, to pose for it."[15]

The sleek figure, kneeling on a globe, and reaching forward in a streamlined movement, was used as a hood ornament on expensive cars and was scaled up to a life-sized marble relief on the Telephone Building in Erie, Pennsylvania. It sold in large bronze and silvered editions. As one patron said, "Your *Speed* represents better than anything else the culture and mode of America, its eagerness and its promise."[16]

When the depression of the 1930s and the subsequent wave of abstract art affected the sale of

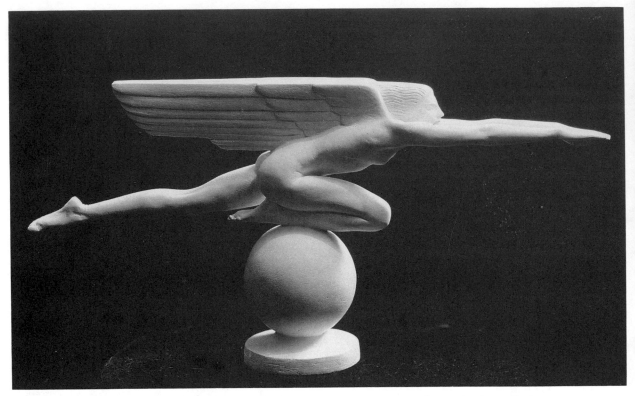

Harriet W. Frishmuth, SPEED (1922), plaster. Unlocated. Photo courtesy of the National Sculpture Society. Photographer: Nickolas Muray.

her work, the artist closed her New York studio and moved back to Philadelphia; her output declined and a fall from a scaffold at age sixty left her permanently injured.

Like Janet Scudder, the artist expressed her hostility to modern art in a 1946 interview: "Their colors are mud, their . . . works spiritless. They are so afraid their originality will be stifled that they are unwilling to learn the craft." She said that at age sixty-six she still strove for absolute truth, although she would never immortalize a pot belly, a flat foot, or an appendicitis scar in bronze. And she *hated* the word "sculptress."[17]

In her last years, as the tide of taste changed once again, she had the satisfaction of seeing her work revived and sought eagerly by collectors. It was now that her figure, *The Vine*, was taken out of storage and given a prominent place in the new American wing at the Metropolitan Museum.

A particularly rewarding place to study Frishmuth's work is in the outdoor sculpture garden of the Cincinnati Art Museum, which contains four of her life-sized bronzes from different periods—*The Star* (1909), one of her serene and classical early nudes, reaching up to the heavens with one arm; *The Thread of Life* (1916); *The Vine*; and *Joy of the Waters* (1912). Syracuse University owns seven bronzes.

Maude Sherwood (Jewett) (1873–1953), like her teacher Harriet Frishmuth, created slender

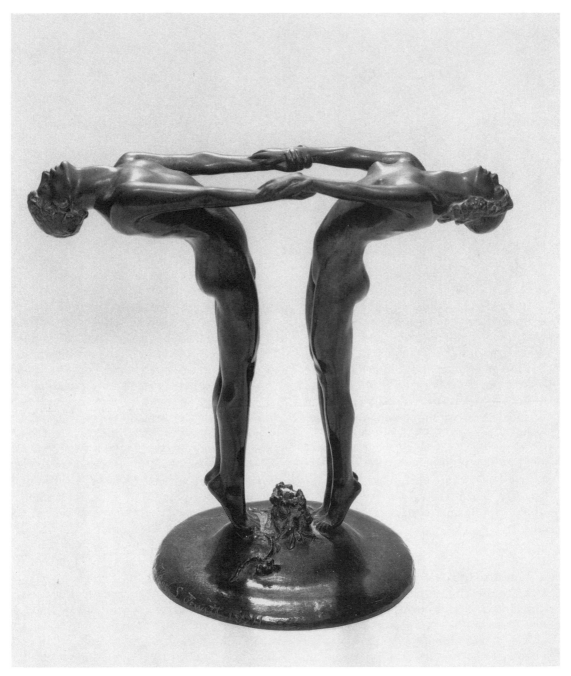

Maud Sherwood Jewett, BACCHANTE FLOWER HOLDER (1924), bronze, 10½″. Photo courtesy of Douglas Berman/Peter Daferner, Inc., N.Y.

Maud Sherwood Jewett, FIGURES IN NICHES NEXT TO POOL (c. 1928). Major Fullerton Weaver Estate, East Hampton, Long Island. Photo: Mattie Edwards Hewitt. Courtesy of the Nassau County Museum Reference Library.

dancing figures, such as *Male and Female* (1924), a bronze flower holder consisting of two figures on tiptoe holding hands and whirling about. The charm of her garden pieces can best be seen in vintage photographs of them in estate settings—for example, a bronze *Piping Pan* and a companion figure *Midsummer,* seated in wall niches alongside the swimming pool on the Major Fullerton Weaver estate, East Hampton.

Jewett's studio was in New York (1910–30). After moving to The Inkpot on the dunes in East Hampton, she became active in club and community life. Her World War I *Soldiers and Sailors Memorial* stands on East Hampton's memorial green.

Beatrice Fenton (1887–1983), a Philadelphia sculptor who created lighthearted fountains and figures for that city, was inspired to enter the field of sculpture by the realist painter Thomas Eakins, a friend of the family.

As a little girl she had set out to become an animal painter like Rosa Bonheur and spent days sketching at the Philadelphia Zoo. When her father showed her sketches to Eakins, the painter suggested that she would strengthen her knowledge of form by doing sculpture studies. This advice led her to her métier.

At age sixteen she modeled from antique casts under the supervision of Alexander Stirling Calder at the Industrial School of Art, and then studied for years with Charles Grafly at the Pennsylvania Academy (1904–12). She was part of an exuberant coterie of women artists (painters Elizabeth Sparhawk-Jones, Alice Kent Stoddard, and sculptor **Emily Clayton Bishop**) who were so enthused that they persuaded Grafly to add composition and portrait classes to the sculpture program. Fenton remained devoted to Bishop and after her early death gave a collection of her works to the Philadelphia Museum and the National Museum of American Art. Fenton won three prizes at the Pennsylvania Academy and exhibited annually there, beginning in 1911. She earned an honorable mention for a bust of *Peter Moran* at the 1915 Panama-Pacific Exposition.

Best known for imaginative, playful fountains, her first such commission was *Seaweed Fountain,* a study of a child draped in seaweed standing on a turtle (bronze, 1920, Fairmount Park, Philadelphia, and Brookgreen Gardens). The artist posed a frisky six-year-old on a box in her third-floor studio on Chestnut Street, and borrowed a live green turtle to study from the Fairmount Waterworks aquarium. The piquant figure has a gawky authenticity, "posing in her seaweed festoons with all the coy bravado of one caught in the act of dressing up in her mother's clothes before a mirror. Her toes grip the turtle's back, and her stocky torso balances awkwardly atop thin and knock-kneed legs."[18] In 1961 Fen-

ton added rhythmic groups of bronze angelfish on either side of the figure.

Influenced by years of study with Grafly, Fenton's figures are faithfully realistic and anatomically accurate, yet, unlike him, she managed to infuse them with whimsical and fanciful qualities; for example, in a sundial in Rittenhouse Square, Philadelphia, two exuberant nude children hold up a sunflower, with the stalk trailing between them (*Evelyn Taylor Price Memorial Sundial,* bronze, 1941).

Other garden pieces include *Fairy Fountain* (Witter Park), *Wood Music* (Wilmington, Delaware), *Star Fish Fountain* and *Nereid Fountain,* a dancing figure poised on the backs of three dolphins. She also did animal studies and portraits and in 1931 completed four limestone figures of children for the gateposts of Philadelphia Children's Hospital.

Fenton taught at the Moore Institute and School of Design (now the Moore College of Art) for eleven years and was awarded an honorary degree. Sixty-eight works were exhibited at Philadelphia's Woodmere Art Gallery in 1952. After working into her late years in her Mount Airy studio, Fenton died at the age of ninety-six.

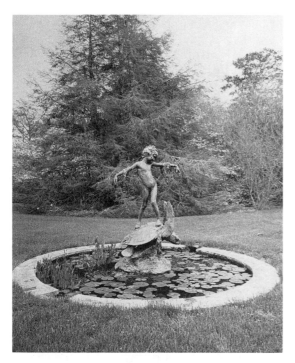

Beatrice Fenton, SEAWEED FOUNTAIN (1920), bronze, height 6′2″. Collection of Brookgreen Gardens. Photo courtesy of the National Sculpture Society.

Cited in books are *Ariel Sundial* (Shakespeare Garden, University of Pennsylvania); portrait busts of *William Penn* (Penn Club, Philadelphia) and *Felix Schelling* (Furness Library, University of Pennsylvania); memorial plaques for *Charles M. Schmitz* (Philadelphia Academy of Music) and the poet *Lizette Woodworth Reese* (Enoch Pratt Free Library, Baltimore); animal studies: *A Shoebill Stork, Wattled Crane* (Pennsylvania Academy), and *Leopard* (1944, limestone); and figures: *The Oarsman* (a trophy for the Arundel Boat Club, Baltimore) and *Runner.*

Anna Coleman Watts Ladd (1878–1939) wanted to "work for all outdoors, to produce sculpture to be placed on street corners, on walls, on the open roads."[19]

This feeling for public sculpture was undoubtedly stimulated by her childhood years, for, although she was born in Pennsylvania, she was educated at Miss Yeatmann's School near Paris and spent time in Rome—cities that abound in splendid monuments. At age twenty-two she began to model, receiving criticism from Rodin, from Ettore Ferrari and Emilio Gallori in Rome, and from Charles Grafly in Philadelphia.

After marrying Boston physician Maynard Ladd in Salisbury Cathedral, England, in 1905, she settled in his city and studied for three years at the Boston Museum School with Bela Pratt. She was soon completing garden fountains for estates on the North Shore, where the couple had a summer home. She also turned out sleek portraits of the fashionable and celebrated, such as a seated figure of Italian actress *Eleonora Duse* (1914, Farnese Palace, Florence) and a bronze bust of Boston socialite *Maria de Acosta Sargent* (1915, Isabella Stewart Gardner Museum, Boston). The hauteur in the tilt of the head, the slender elegant hands, and fine-boned bare shoulders capture the Brahminism of the American Renaissance.

When the Ladds vacationed in Italy in 1911, Anna, ecstatic at being back in Rome ("it's the Place!"), was able to cast a number of works, and on her return had solo shows at the Macbeth and Gorham galleries, New York, and the Corcoran Gallery, Washington, D.C. (1912, 1913). An article in *Art and Progress* (September 1912) included photographs of two fountains installed in North Shore gardens—a gilded *Sun God* drawing his bow, and an uninhibited *Leaping Sprites Fountain* (location unknown), with figures dancing in the spray, the whole set on a base hollowed out of living rock. The tender, thoughtful fountain figure, *St. Francis* (bronze, 1911, Museum of Fine Arts, Boston) in monk's robe, blesses a bird held in his hand.

Obsessed with her idea of creating sculpture for "all outdoors," Ladd exhibited work in the Boston Public Garden, organized the first outdoor sculpture exhibition in Rittenhouse Square, Philadelphia, and was invited to display five fountains at the 1915 San Francisco Panama-Pacific Exposition. *Wind and Spray* (private collection), a circle of nude male and female figures dancing in a ring of waves, was placed in the lagoon in front of the Palace of Fine Arts. *Triton Babies* is now in the Boston Public Garden.

A friend of famed collector Isabella Stewart Gardner and other important international patrons, the sculptor was leading a comfortable and productive life when America entered World War I, but in 1917 she and her husband gave up these comforts to aid wounded soldiers in France. Dr. Ladd ran a hospital near Toul, and Anna Ladd opened a Red Cross studio in Paris, where she made "new faces"—thin metal masks for disfigured soldiers awaiting reconstructive surgery. For this she was later made a Chevalier of the Legion of Honor by the French government.

One of Ladd's early sculptures, *The American*—a brawny aggressive-looking figure holding a fierce American eagle on his head—displays the jingoistic nationalism of the era, but her attitude changed during the war. In *The Manchester War Memorial* (1924, Rosedale Cemetery, Manchester, Massachusetts), one of the medallions shows an expressionistically distorted decaying corpse of a soldier on barbed wire. Some works, such as a statue of Peace choking War, display a heavy-handed emotionalism.

Prolific, hardworking, and active in the com-

munity, Ladd was a founder of the Guild of Boston Artists, exhibited with the National Sculpture Society, and in 1920 had a solo exhibition at Isabella Gardner's palazzo, Fenway Court (now the Gardner Museum). The Ladds retired to Montecito, California, and after her death Dr. Ladd operated their summer estate, Arden, in Beverly Farms, Massachusetts, as a public museum of her art. A good friend continued to show her work for many years after Dr. Ladd's death, but the large collection was eventually sold at auction.

Many of Ladd's early works show Rodinesque romantic realism (*The Slave,* 1911, bronze, Museum of Fine Arts, Boston), with flickering bronze highlights and passionate emotions. She later emphasized broad masses, simplifying forms in a transitional modernist way as in the six-foot *Risen Christ* holding a child which symbolizes humanity (1927, Forest Hills Cemetery).

Edith Barretto Stevens Parsons (1878–1956) is one of a number of women sculptors who specialized in babies; often they were featured in fountains. *Joy Fountain* has two children peering over the rim of a bowl. The pool in the small sculpture gallery at Brookgreen Gardens contains her bronze *Frog Baby,* in which a laughing nude child, standing on a globe supported by four crouching frogs, dangles a frog by the leg in each hand. Others are entitled *Turtle Baby* (Cleveland Museum, Ohio), *Bird Baby* (Brooks Memorial Art Gallery, Memphis, Tennessee), and *Fish Baby.*

Born in Houston, Virginia, Edith Stevens studied with Daniel Chester French and George Grey Barnard at the Art Students League, where she won a sculpture prize and scholarships (1901–2). For the 1904 St. Louis Exposition she did figures for the Liberal Arts Building and in 1908 showed

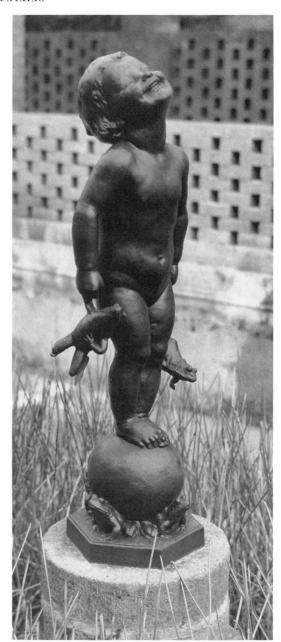

Edith Barretto Stevens Parsons, FROG BABY (c. 1917), bronze, height 3′3½″. Courtesy of Brookgreen Gardens.

Earth Mother at the National Academy of Design.

That year she married Howard Crosby Parsons. With a studio on the upper floor of her home, she managed to combine home and sculpture successfully, but her work changed from the monumental to the sweet: "The mother, the homemaker, and the sculptor are one.... Her own children love to pose for her because new and wonderful things to play with appear at such times, real ducks and turtles and other wriggly, strange things that children love."[20]

Duck Baby, a garden figure of a laughing child with a duck in each hand, was one of the popular hits at the 1915 Panama–Pacific Exposition. The author of the exposition handbook wrote, "In the presence of so much that is weighty and powerful, this popularity of the 'Duck Baby' is a significant and touching indication of the world's hunger for what is cheerful and mirth-provoking."

She also created busts, a memorial at Saint Paul, a fountain dedicated to John Galloway in Memphis, and a World War I monument at Summit, New Jersey. She was a fellow of the National Sculpture Society.

Mabel Viola Harris Conkling (1871–1966) produced fountains and figures with titles like *Lotus Girl, Goose Girl, Song of the Sea, Temptation, Nymph and Satyr, Bacchante,* and *Joy of Life.* She also created cemetery urns, a relief-decorated Vase of the Four Winds, and nymph panels for a swimming pool. Conkling studied for ten years in Paris at the Julien, Vitti, and Colarossi academies, with Injalbert and Collin, and with the Americans James McNeil Whistler and Frederick MacMonnies, who encouraged her to become a sculptor. Born and raised in Boothbay, Maine, she married sculptor Paul B. Conkling and lived in New York City but continued to spend summers in her hometown. Active in New York City organizations, she was president of the National Association of Women Painters and Sculptors.

ANIMAL SCULPTORS

Anna Hyatt Huntington echoed the feelings of many sculptors of the early twentieth century when she said, "Animals have many moods and to represent them is my joy." Using the animal theme as a vehicle for a wide range of expressions, sculptors like Huntington worked in the conventions established by Barye and the nineteenth-century French *animaliers,* whereas early modernists created more stylized art deco forms or carved directly in wood and stone without preliminary models.

Today this vogue for animal subjects is seen as a transitional stage between the traditional monuments of the late nineteenth century and modern abstract sculpture. It provided an opportunity for experimentation and exploration.

The renowned animal sculptor, **Anna Hyatt Huntington (1876–1973)**, whose monuments can be found in places as far apart as New York, France, and Spain, broke new ground for women artists. Her *Joan of Arc* was the first heroic equestrian statue by a woman; and she was the first woman sculptor admitted to the Academy of Arts and Letters. Her life, too, was a work of art. During a prolific seventy-year career that ended at age ninety-seven, the artist became a leading patron and philanthropist.

The daughter of Audella and Alpheus Hyatt II, a distinguished M.I.T. zoologist and paleontologist, she grew up surrounded by animals, both living and dead. From the age of two, at the family's seven-acre summer home in the seaside village of Annisquam, Massachusetts, she indulged her love of animals. It was said of her that "as

soon as she could crawl, she headed for horses' hoofs to examine them, and long before she could swim, peered so intently at minnows that she toppled off our dock at Annisquam into the running tide and hauled herself back with the painter of a boat.... All her life she understood how to control animals, caressing dangerous dogs without being bitten and breaking colts without breaking her bones."[21]

Hyatt attended the Misses Smith's private school in Cambridge and set out to become a concert violinist. She stumbled into her vocation when, during an illness, she helped her sculptor sister, Harriet, mend the broken foot on a sculpture. She then modeled the family's Great Dane so successfully that she decided to become a sculptor.

Hyatt's formal training was surprisingly short. Independent by nature, she studied briefly with Boston's Henry Hudson Kitson (according to her, he threw her out when she pointed out some flaws in the anatomy of one of his horse sculptures), but for the most part worked directly from nature. When Bostock's animal circus came to Boston, she obtained permission to model the animals at close range. Once, a chained killer elephant filled his trunk with dirty water and drenched her. Another time, she barely escaped clawing by a tiger who swept her clay model to the ground.

The two sisters dreamed of opening an art academy, but after Harriet married, although she produced a modest amount of work, her time was taken up with family cares. Anna, on the other hand, developed an illustrious career. Tall, quiet, a prodigiously hard worker, she became a role model for her young nephew, A. Hyatt Mayor (later a distinguished museum curator): "Like gray-eyed Athena high above the battle ... her presence set us a model of order and concentration, of time scrupulously used, of energies unobtrusively channeled. The minute she came

home, she changed into her work clothes and reached for her clay to shape what her mind's eye had been revising.... As a girl her name in the family had been The Clam."[22]

For a Boston patron, Thomas Lawson, she carved two Great Danes in blue granite. She showed small pieces in the shop of the Boston jewelers, Shreve, Crump, and Low, and in 1901 had a solo show of fifty pieces at the Boston Art Club. This prodigious output characterized her entire career. She worked incessantly, sometimes even on trains and trolleys.

In 1903, Hyatt moved to New York, studied briefly with Hermon A. MacNeil at the Art Students League and with Gutzon Borglum, and shared an apartment on Thirty-third Street with two women musicians and the young sculptor Abastenia Eberle. Hyatt and Eberle became close friends and collaborated on a bronze, *Men and Bull* (Eberle did the figures and Hyatt, the animals) that won a bronze medal at the 1904 Louisiana Purchase Exposition. They soon went their separate ways, however, Eberle becoming a socially conscious sculptor of small working-class subjects, while the more conservative Hyatt became an internationally renowned animalier.

A *New York Times* reporter came across her at the Bronx Zoo in 1905—"a tall, young woman in tailor made frock and red-plumed hat ... her clay on a high stool ... doing a clay study of a bison." The artist revealed that her career was already at full tide: her Boston patron had ordered horse groups and the bisons, and the Gorham Galleries were showing *Winter Noon*, a shivering team of dray horses huddled together in the cold (bronze, 1902, Metropolitan Museum of Art). When asked whether she would go to Paris, Anna replied "Not until I feel strong enough artistically to stand it. One ought to be perfectly independent in one's work and above outside influence ... before going abroad."[23]

In 1907 Hyatt went to France, not to study

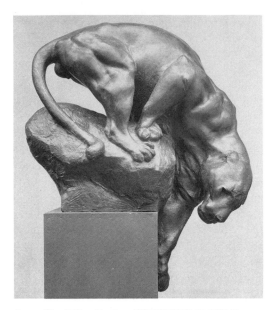

Anna Hyatt Huntington, REACHING JAGUAR (1906), bronze, height 45″. The Metropolitan Museum of Art. Gift of Archer M. Huntington, 1925.

with a French academician, but, with characteristic independence, to look at French art and work on her own. In a studio at Auvers-sur-Oise she modeled two of her finest animal sculptures, *Reaching Jaguar* (bronze, Metropolitan Museum of Art) and *Jaguar,* from studies made at the Bronx Zoo.

Her career received a big push forward when she was commissioned by a women's group, the Decorative Art Association of Steele High School in Dayton, Ohio, to execute a large bronze lion for the school grounds. She consented to contribute her labor free if they would pay for the expense of casting and shipping the work. At the 1908 dedication ceremonies, Hyatt thrilled the students by describing how she had stood on a table in a Naples foundry supervising the pouring of the molten metal. After this, commissions poured in.

In 1909 Hyatt, now a successful animal sculptor, put aside a profitable career to realize a dream—since her teens she had wanted to do an equestrian statue of Joan of Arc. The sculptor rented the former stable-studio of the French sculptor Jules Dalou in Paris's Latin Quarter and immersed herself in research about the saint. She traveled to Rouen and other places where the Maid of Orleans had lived; read Lamartine's account; searched the streets of Paris for the right kind of horse, and, after seeing a magnificent Percheron as it was coming out of the stables of the Magasin du Louvre, brought it to her studio through the convenient stable doors.

Hyatt now achieved a remarkable feat—a labor of Hercules. Shutting herself in her studio and working ten hours a day, she massed three and a half tons of clay, built the armature, and carried out the work in four months. The plaster model of Saint Joan astride her steed won an honorable mention in the Paris Salon of 1910.

Because Hyatt knew that, like Harriet Hosmer and other women artists of the past, she would be accused of having men do her work, she carried out the project with only one woman assistant. Even so, the male judges at the salon did not believe she had done the work entirely alone; otherwise they would have given her a medal.

Around this time, a Joan of Arc Committee in New York was commissioning a statue in honor of the five hundredth anniversary of the saint's birthday. The committee was headed by J. Sanford Saltus, of Tiffany and Company, who became a great supporter of the artist. Huntington's model, in competition with sculptors of many nationalities, won the commission.

In her studio at Annisquam, Hyatt perfected her conception. After modeling the figure from the nude, she added the armor, thoroughly researching the details with the aid of the curator of armor at the Metropolitan Museum of Art. Ac-

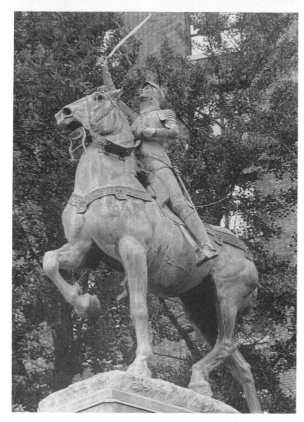

Anna Hyatt Huntington, JOAN OF ARC (1915), bronze.
Riverside Drive. Collection of the City of New York. Photo
© Shoshana Rothaizer, 1987.

tual stones from the saint's Rouen dungeon were
incorporated into the base. After the unveiling at
Riverside Drive and Ninety-third Street in 1915,
the artist was inundated with praise—World
War I was on, and sympathy for the French peo-
ple added a special edge to the occasion.

Other sculptors had shown the young saint as
a robust peasant or a frail girl, but Hyatt concen-
trated on her spiritual intensity:

> I thought of her there before her first battle,
> speaking to her soldiers, holding up the ancient
> sword. Her wrist is sharply back to show them
> the hilt, which is in the form of a cross . . . a
> spiritual person, almost fanatic. It was only her
> mental attitude, only her religious fervor, that
> could have enabled her to endure so much

physically, to march three or four days with
almost no sleep, to withstand cold and rain.
That is how I have thought of her; that is how I
have tried to model her.[24]

The artist's own "mental attitude" resembled her
heroine's.

Recognized as one of the finest equestrian
statues by an American, *Joan of Arc* compares
favorably with versions by the Frenchmen Fré-
miet and DuBois. Replicas stand in the Garden
of the Bishops at Blois, France, in front of the
San Francisco Palace of the Legion of Honor,
and in Gloucester, Massachusetts. In 1922 an-
other fine figure study, *Diana of the Chase,* a
slender girl holding up a bow, won the Saltus
Gold Medal.

By 1912 Hyatt was one of only twelve Ameri-
can women earning $50,000 a year. She was
sharing a handsome studio on Twelfth Street
with sculptor Brenda Putnam and had no
thought of getting married. She met the wealthy
scholar-poet-philanthropist Archer Huntington
while serving on a committee to plan a sculpture
exhibition at the Hispanic Museum, which he
had founded. Huntington's wife had left him for
a theatrical producer, and his depression was af-
fecting his health. A big bear of a man, he soon
fell in love with Hyatt and begged her to marry
him, but she, at the height of a successful career,
was understandably reluctant to change her life-
style. When he became extremely ill, however,
she relented. In 1923 they surprised everyone by
getting married quietly in the studio, without
fanfare.

Both were tall, imposing figures; they shared
cultural interests and a sense of noblesse oblige
toward their community. It was said of Archer
Huntington that wherever he put his foot down,
a museum sprang up.

Anna now had the financial resources to work
on a scale that might not otherwise have been

possible. On the other hand, life with the owner of huge estates, a man who constantly entertained visiting dignitaries and intellectuals from many countries (the ambassador from Spain was a frequent guest) involved time-consuming obligations.

A lifelong scholar of Spanish culture, Archer had translated the epic poem, *The Song of El Cid* and had built the Hispanic Museum. A project that occupied her over a period of years was sculpture for the central court being added to the museum—a heroic equestrian statue of *El Cid,* the medieval Christian warrior of Spain; stone reliefs of *Don Quixote* and *Boabdil*; and other works.

The effort of running their various homes and a summer camp in northern New York and of settling the estate when Huntington's mother died, while never ceasing to work on her sculpture, took its toll. In 1927, Anna, who had been fighting bronchitis for a year, was diagnosed as tubercular.

For seven years the Huntingtons dropped everything and traveled in an attempt to recover Anna's health. In Asheville, North Carolina, where they spent a wretched winter, her doctor called her a "rich spoiled woman" and suggested that any woman who was an artist had dubious morals.[25] They spent much of their time in warmer climates. After dedicating a cast of *El Cid* at Seville, Anna was awarded the Grand Cross of the Order of Alfonso XII.

After her recovery in 1933, Archer bought an estate near Haverstraw in commuting distance from New York. This gave them some peace and quiet, and Anna was able to keep a full zoo of animals, including boars, bears, and tigers, on the grounds to serve as models.

In 1930 the couple had also bought a ten-thousand-acre tract of land in South Carolina, the site of four old plantations that stretched from the Maccamaw River to the Atlantic Ocean. After building a house on the ocean, Anna, without a landscape architect, laid out a huge butterfly-shaped formal garden, punctuated with pools and fountains, amidst ancient moss-draped live oaks, leaving the rest of the land as a nature preserve.

Archer had intended the garden as a display space for Anna's sculpture, but the generous artist, after placing some of her works there, began to add those of her colleagues, until the collection grew to over three hundred. Brookgreen Gardens, now a state park, is today the largest outdoor garden of academic sculpture in the United States. Visitors are greeted at the entrance by Huntington's gigantic aluminum *Fighting Stallions* (she was a pioneer in the use of aluminum in sculpture), and her works are located all over the grounds.

In 1936 the American Academy of Arts and Letters mounted a retrospective of 170 works by its only woman sculptor, and in 1937 an exhibition of about 70 pieces traveled across the country.

Basically a person of simple, earthy values who loved nature, the sculptor had found it oppressive to live in ornate city mansions requiring too many servants. So, in 1939, she persuaded Archer to buy a wild stretch of nine hundred acres in Redding, Connecticut, on a ridge overlooking the Long Island Sound. At Stanerigg (Scottish for "stoney ridge"), they built a stark twenty-room cement block house and studio. Here the sculptor maintained a working farm, where she could often be seen cleaning stables, milking cows, and working in the garden. On the grounds, amidst ponds, fields, and forests, Anna kept many animals, including kennels of more than a hundred much-loved dogs. She worked assiduously at her sculpture, and he published articles, wrote poetry, and engaged in far-flung

philanthropies. Every Sunday they had "at home" teas, attended by intellectuals and distinguished people from various walks of life. Anna presided over the tea table, while Archer could be found quoting long passages from Cervantes and other Spanish poets.

The Huntingtons were responsible for the founding of fourteen museums and the preservation of four wildlife preserves donated to the American people. When the couple left their Fifth Avenue mansion, they gave it to the National Academy of Design (its present headquarters). A $100,000 donation enabled the National Sculpture Society to mount a huge 1929 exhibition, accompanied by a catalog that is a major source of information about American academic sculpture.

When modern abstract art came into vogue, the sculptor was disturbed by the emergence of what she regarded as an "overwhelming flood of degenerate trash drowning sincere and conservative workers in all the arts."[26] She felt sympathy for her less fortunate colleagues, who were struggling to survive.

According to Doris Cook, she began during the forties and fifties to believe (like many others in that period) that "Marxist sponsors had infiltrated the fields of art and literature, and had drawn into their camp artists and writers who had formerly commanded respect. She was naturally shocked to realize that she and people she knew were members of an organization labeled 'subversive'."[27] At that time Congressman George Dondero was investigating "Communist subversion" by art publications, dealers, critics, and even members of conservative art organizations.[28]

Continuing to reap honors from the more conservative segments of the art world, Huntington was elected an Honorary Fellow of the National Sculpture Society and was awarded a second Watrous Gold Medal. The American Institute of Decorators made her an honorary member for the creation of Brookgreen Gardens (she insisted that her husband also get credit); and in 1952 she received the Grand Cross of Isabel the Catholic from the government of Spain. (Years before, France had made her a Chevalier of the Legion of Honor for *Joan of Arc.*)

When her husband became ill, she devoted herself entirely to his care—the first time in a life of ceaseless work that Huntington was unable to do much sculpture. But after his death, she returned to her work. At age eighty, when asked to do an equestrian statue honoring Cuba, she chose as her subject the Cuban patriot José Martí, who lived in New York in the 1880s, writing and agitating for the freedom of Cuba from Spain, and then fell in the first battle after returning to his homeland. The statue of Martí, however, was caught up in political events: the dictator Batista was unseated by Fidel Castro, and as the date of the unveiling approached, pro- and anti-Castro groups rioted at the anticipated site, Fifty-ninth Street outside Central Park. The unveiling had to be canceled. Years later, in 1965, the statue was erected secretly at dawn. A quiet unveiling followed in a few weeks, with the old artist and Martí's grandson, actor Cesar Romero, in attendance. Martí is shown falling from a rearing horse at the instant when he was hit by Spanish bullets.

Although Anna Huntington received awards for her figures and monuments, her greatest gift undoubtedly lay in her portrayal of animals. In her endless studies of rippling jaguars, dogs, horses, tigers, birds, elephants, and other animals, Huntington combined the acute observation of a naturalist with empathy, expression, and a sense of rhythm and design. A number of her early bronze bird compositions have a decorative art nouveau quality (*Cranes Rising, Pea-*

cocks Fighting). Some of her finest works are tiny bronze studies of deer, monkeys, and other animals, captured in motion. "I suppose that the strongest characteristic of my work is that I like movement and motion. I don't care for the still sort of studies or single subjects. I like groups that make a design and pattern," she once said. Her art historian nephew described her method: "She had a flashlight memory for poses. At the Bronx Zoo she modeled all day from an instant glimpse of a jaguar halted by a shout as it descended from its branch to its breakfast meat."[29] It was from these rapid studies of "Senor Lopez," the ferocious Paraguayan jaguar at the zoo, that she was able to capture the authentic gesture in Reaching Jaguar.

Huntington's figurative works are more problematic. The splendid Joan of Arc is a landmark in the history of women sculptors. Another early work, Diana of the Chase (bronze, 1922), a half-draped girl standing on a globe, holding a bow while a greyhound leaps at her heels, is filled with tense energy, expressed in s-curves that travel from the upheld bow down through the drapery and into the sleek arcs of the animal. Casts of this sculpture are in museums and parks in the United States, France, Cuba, and Japan. Youth Taming the Wild (1933), a boy reining in a wild horse, and In Memory of the Workhorse, a figure leading a horse into the wintry blast, are romantic visions of man and animal. But in later years, some of the artist's figurative monuments, became heavy-handed.

On her ninetieth birthday the artist was showered with congratulations. She reportedly was still at work on a bust of composer Charles E. Ives (Scott-Fanton Museum, Danbury).

Most Bostonians are familiar with the bronze dolphins leaping in front of the New England Aquarium. They were sculpted by **Katherine**

Ward Lane Weems (1899–1989). She told an interviewer that she became an animal sculptor because "animals do not talk back. They do not bring their relatives to see how you are coming along and say, 'There's something wrong with the mouth.' If you specialize in the human figure you are always doing a variation on a theme. But if you do animals, enormous variation can be found among them, all held together by the thread of comparative anatomy."[30]

Weems grew up with animals and art. She received riding lessons early and had her own pony. Her father, Gardiner Lane, a railroad magnate, was president of the board of trustees of the Boston Museum of Fine Arts and took her to see John Singer Sargent at his studio. Her friends saw her as an artist who rode.

In addition to studying sculpture with Charles Grafly at the Boston Museum School, she received instruction and inspiration from Anna Hyatt Huntington. Whereas Grafly was rough, demanding, and ruthlessly honest, Hyatt was always encouraging. During summers Lane worked in a barn on the grounds of The Chimneys, the family summer home on the North Shore, and brought her work to Hyatt's nearby summer studio at Annisquam for criticism. Noting her special feeling for group compositions of animals, Hyatt invited the young artist to work in the large, beautiful New York studio she shared with Brenda Putnam and made arrangements for her to model animals at the Bronx Zoo.

In Lane's memoirs, she describes how valuable it was to have the mentoring of these professional women.[31] Hyatt took her to studios and introduced her to leading figures in the National Sculpture Society, whereas her society mother warned her to hide her intense commitment because people would think her odd. Even her beloved grandfather, a classics professor, doubted

Katherine Ward Lane Weems, RACING WHIPPET (1925), bronze on marble, 9½″ x 15″ x 5″. Private collection, N.Y. Photo: Scott Bowron. Courtesy of Conner-Rosenkranz, N.Y.

that she would "do very much, with all that money."

Lane surprised her family by winning a bronze medal for *Pygmy African Elephant* (Museum of Fine Arts, Boston) at the 1926 Philadelphia Ses quicentennial Exposition and the Widener Medal from the Pennsylvania Academy for *Narcisse Noir* (1926), an elegant statuette of a whippet sitting back on its haunches. Exhibitions followed at Boston's Doll & Richards Gallery (1930) and elsewhere. Like her friend, sculptor Paul Manship, Lane is one of those sculptors who, in the 1920s, began to reduce details and stylize forms to emphasize structure and design. One of her finest works, *Racing Whippet* (1925), shows the sleek lines of the elegant creature, which is chewing on a rag to calm down after a race. The negative shapes around the forms are carefully considered.

Around this time Weems created one of her rare figure compositions, a work that shows her underlying feminist feelings. *Revolt* (1926, Mu-

seum of Fine Arts, Boston), a truculent female figure striding forward, expressed, she said, the anger of women athletes who were at that time shut out of many opportunities.

In 1933 Lane began an unusual complex of sculptures to relieve the barren façade of Harvard University's red brick biological laboratories building. Carving directly in the brick with a pneumatic drill, she created three linear friezes of over thirty animals (elephants, tigers, and bisons) across the top story of the façade. The inspiration was an incised Han dynasty tomb sculpture at the Boston Museum.

She then designed three bronze front doors— an elegant fretwork of decorative life forms— and later completed two larger-than-life bronze rhinoceroses that stand on the front steps flanking the entrance. Harvard students have always enjoyed the powerful forms of these tough-skinned creatures. Lane was well acquainted with rhinos. Years before, while drawing the rhino Victoria at the Bronx Zoo, the animal man-

aged to put her head through the bars and was dragging the sculptor forward, until she gave her a smack and shouted "drop me!"

Lane created a film *From Clay to Bronze* (1930), served on the Massachusetts Arts Commission (1941–47), was elected to the National Institute of Arts and Letters, was on the council of the National Sculpture Society, and became a full academician of the National Academy.

After resisting marriage for many years, in 1947, at the age of forty-eight, the busy artist married her longtime friend, the engaging F. Carrington Weems, a man who had shown a great interest in her work and helped her with technical problems. She moved to his home in New York City, spending summers on the North Shore. Inevitably, the life of a well-to-do society matron—managing two homes and entertaining guests—as well as caring for an ailing mother, ate into her time. Her husband was upset when she exhibited under her maiden name, and she found herself repeatedly torn between conflicting obligations. It was a source of deep frustration to have to turn down two large architectural commmissions because of a lack of time to complete them. But she managed to finish a few small works, including one of her finest medallions, *God Made the Beast and Every Winged Fowl,* which earned her the Saltus Gold Medal at the National Academy.

In 1965 a permanent gallery devoted entirely to a collection of forty of Weems's small animal sculptures and drawings was established in Boston's Museum of Science. At age eighty, having resumed her work after the loss of her husband, and concerned about the destruction of dolphins by tuna fishermen, she completed a bronze group of six dolphins leaping on the waves for the plaza in front of the New England Aquarium. In 1987 the Boston Museum established the Katherine Lane Weems Chair in Decorative Arts.

The Museum of Fine Arts, Boston, owns seven of her works. Brookgreen Gardens has *Circus Horse, Doe and Fawn, Whippet* and *Greyhounds Unleashed* (1928). *Kangaroo* (1940) is at the Pennsylvania Academy, *Greek Horse* is at the Baltimore Museum, and *Lotta Fountain* is in Boston's Esplanade Plaza. Harvard's Spees Club owns a bronze *Bruin.*

Gertrude Katherine Lathrop, BROOKGREEN GARDENS MEDAL (1945), bronze, diameter 3″. Courtesy of Brookgreen Gardens.

Gertrude Katherine Lathrop (1896–1986), primarily an animal sculptor and medalist, emphasized decorative elements—the way fur or feathers curl, the line of tusk or beak: "I chose to model animals because of their infinite variety of form and texture and their great beauty, for even the lowliest of them have beauty, yes, even the wart hog, with his magnificent tusks."[32]

Lindsey Morris Sterling, FISHERMEN AND DANCERS (1926), bronze relief, 62½″ x 15″. Private collection. Photo: Scott Bowron. Courtesy of Conner-Rosenkranz, N.Y.

Born in Albany, New York, daughter of a painter and sister of Dorothy Lathrop, an author and illustrator of children's books, she grew up working together with them in a studio in the house. Later the sisters had joint exhibitions and shared a Connecticut studio.

Lathrop studied with Solon Borglum and Charles Grafly, and beginning in 1921 earned many honors and awards. An emphasis on decorative rhythms is evident in all her work. In *Great White Heron,* the sinuous curves of head and neck extend into the rhythms of breast, wing, and back feathers. In medallions like *Conserve Wild Life* and *Brookgreen Gardens,* the decorative ornamental lines play an even greater part.

Lathrop designed a war memorial for Albany, New York, and a wrought-iron grille for the Detroit Public Library. She was a fellow of the National Sculpture Society, a member of the National Academy, and one of the few women elected to the National Institute of Arts and Letters.

Lindsey Morris Sterling (1876–1931), a sculptor of animals and bas-reliefs, was also a distinguished scientific illustrator.

Daughter of Francis and Ella Morris, of Dutch and English ancestry, she was born in Mauch Chunk, Pennsylvania, and studied painting as a girl with Kenyon Cox at the Art Students League (1892–96). Her husband died only three years after their marriage. In order to support herself and her child, she became an artist in the vertebrate paleontology department at the American Museum of Natural History, designing models of vertebrate skeletons in wax and plaster and doing line drawings for the museum bulletin. She became head of the department's art staff, working there for thirty years. Meanwhile, she studied sculpture with James Earle Fraser at the Art Students League and with Bourdelle in Paris (1909), exhibiting for the first time at the 1910 Paris Salon.

Sterling modeled vigorous animal groups, such as *Sheep with Twin Lambs,* exhibited in 1929 at the National Sculpture Society. A 1926 bronze allegorical relief panel of dancing nymphs and muscular fishermen hauling in a net is inscribed with uplifting quotations on either side: "Give us strength, give us courage and gaiety, and the quiet mind."

Sterling maintained a home-studio at Edgewater, New Jersey, and a summer home at Jay in

Essex County, New York. She won a bronze medal at the 1915 Panama Pacific Exposition, and the 1923 Joan of Arc Medal at the National Association of Women Painters and Sculptors. She exhibited at the Ferargil Gallery (1929), the Architectural League, National Academy of Design, and Allied Artists of America.

In the introduction to his book *Proboscidea* (1936, American Museum of Natural History), illustrated with several hundred of Sterling's pen drawings and diagrams of mastodons and elephants, Professor Henry Fairfield Osborn wrote that the artist ranked among the leading scientific draughtsmen of the twentieth century. The National Sculpture Society awards a Lindsey Morris Sterling Memorial Prize for bas-relief each year.

> Other works mentioned in the literature are *Blown by the Wind of Destiny, Afternoon of a Faun, Young Kid, Character Studies of a Goat, Pastoral, In the Adirondack Woods, Stork Girl,* and *Mare and Colt.*

MONUMENT SCULPTORS

Although, on the whole, large-scale commissions for public buildings were awarded to men, a few women achieved prominence in this field. Evelyn Longman created a number of monuments, including a quintessential symbol of corporate capitalism, the statue *Electricity* atop the Western Union Building in New York City. Gertrude Whitney, Malvina Hoffman, Anna Huntington, Laura Gardin Fraser, and a few others also carried out large-scale public works. Their achievements were strikingly evident at the 1915 Panama–Pacific International Exposition in San Francisco, where Gertrude Vanderbilt Whitney, Edith Woodman Burroughs, Evelyn Longman, Anna Coleman Ladd, and Janet Scud-der all received major commissions, alongside their male colleagues.

At the turn of the century, the overwhelming influence was Auguste Rodin. He emphasized the block, strong modeling, powerfully felt emotional expression, flickering impressionistic surfaces, and melting forms of figures emerging from roughly textured marble. His more daring experiments in composition, using fragments of the body, were largely disregarded. Rodin's influence is evident in the early work of Malvina Hoffman, Gertrude Whitney, Meta Vaux Warrick Fuller, and many others.

Gradually sculptors began to study with men like Emile Bourdelle or the Yugoslavian carver, Ivan Meštrović, who transformed their forms into more stylized and decorative patterns. The change to art deco or simplified and stylized forms can be seen, for example, in some of the later work of Malvina Hoffman after she studied with Meštrović, or in Gertrude Whitney's *Columbus* and her silvery theme statue *Spirit of Flight* at the 1939 New York World's Fair. The truly radical departures, influenced by cubism and other modern movements and the trend toward direct carving, are discussed in the next chapter.

(Mary) Evelyn Beatrice Longman (Batchelder) (1874–1954), the only woman whom Daniel Chester French accepted as an assistant in his studio, was a successful Beaux Arts sculptor, working with architects on large monuments and public commissions. Longman's work glorifies the status quo with grand symbols of patriotism and technological progress in the nationalistic spirit of the early twentieth century.

In the American rags-to-riches tradition, the sculptor was born in a log cabin near Winchester, Ohio, one of six children of an improvident English musician who was earning a living as a farmer. The family was so poor that she had to

Evelyn Beatrice Longman, chapel doors, United States Naval Academy, Annapolis (1906–9), bronze, 276″ x 120″. Courtesy of the U.S. Naval Academy Museum.

quit school and go to work at age fourteen. While working in a Chicago dry goods warehouse, Longman was inspired by an evening class at the Chicago Art Institute and the wonders of the 1893 World's Columbian Exposition. She scrimped and saved for six years to study art at Olivet College, Michigan, and then returned to study for two years with Lorado Taft at the Art Institute of Chicago.

Immensely capable, she became his teaching assistant, graduated with highest honors, and taught at the institute that summer and fall. Since sculpture commissions were hard to come by in Chicago, Longman went to New York City (with only forty dollars in her pocket) and was hired by sculptor Hermon MacNeil and then by Isidore Konti to assist with decorations for the Pan-American Exposition.

Longman applied for work in the atelier of Daniel Chester French. He had vowed never to hire a woman because he would "have to be polite" to her; but he was so impressed by her ability and general demeanor (and by a letter of recommendation from his brother, William French, director of the Chicago Art Institute) that he hired her to help with lettering on inscriptions and other ornamental details. Capable, reliable, cheerful, Longman became not only a colleague but a cherished family friend. When he was an old man working on his last statue he still sought her advice. In 1930 he wrote, urging "the necessity of your coming over here to sit in judgment on my to be world famous statue of Andromeda. . . . I have kept it covered up, and hardly anyone has seen it, and I am in the usual uncertainty whether it is good for anything or not."[33]

After three years, Longman gradually took on independent commissions and opened her own studio. In 1904 she won national acclaim and a silver medal at the Louisiana Purchase Exposition, St. Louis, when her statue *Victory,* which

was originally intended for a minor position at the fair, was made the theme statue and transferred to the top of the Festival Hall dome. Reduction copies of the exuberant seminude male figure holding up a wreath were later used as trophies by the Atlantic Fleet and are at the Metropolitan Museum of Art, Toledo Museum, Brookgreen Gardens, and elsewhere.

In 1906, competing against more than thirty leading male sculptors, Longman won the twenty-thousand-dollar commission for the twenty-foot-high bronze doors of the chapel at the U.S. Naval Academy, Annapolis, Maryland. Her design expresses the nationalistic spirit of that era. The horizontal panel over the doors shows an American eagle and the inscription "Not for Self But for Country." On the left door (symbolizing the navy in time of peace) Science instructs a midshipman; on the right (symbolizing the navy in time of war) a youth steps forward to answer the call of Patriotism, shown as a classically draped seated figure with her fist clenched upon a cannon. In the background Victory lures the young warrior with a laurel wreath. An enclosing border of knotted nautical ropes completes the design. Daniel Chester French praised the rich effect: "Miss Longman is the last word in ornament."

At French's studio, Longman became thoroughly acquainted with collaboration between sculptors and Beaux Arts architects. Now she began a long working relationship with architect Henry Bacon in which she designed the sculpture and he the architectural elements on a number of monuments. Some of these are the three-figure granite *Foster Mausoleum* (Middleburg, New York); a *Fountain of Ceres* for the 1915 Panama-Pacific Exposition in San Francisco, a war memorial at Naugatuck, Connecticut, and the *Centennial Monument* (1918, white granite) in Logan Square, Chicago. Celebrating a century

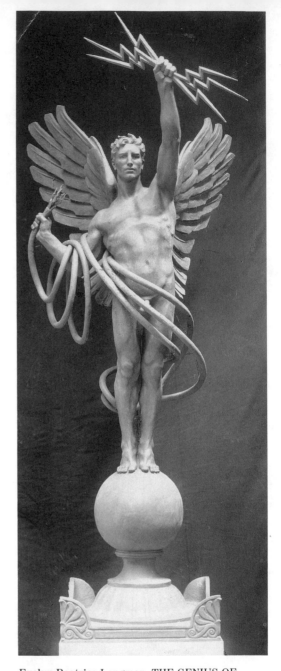

Evelyn Beatrice Longman, THE GENIUS OF ELECTRICITY (1916). Photo courtesy of the National Sculpture Society. Photographer: A. B. Bogart. Gilded 20-foot version is at the American Telephone & Telegraph Corporate Headquarters, N.Y.

of Chicago history, the *Centennial* column, topped with an eagle, rises from a drum carved with low-relief Indians, pioneers, and other symbolic figures. Standing on a landscaped mound at the center of radiating avenues, it brings a note of dignity and grace to a depressed Chicago district.

All these works embody a style that art historian Milton Brown has dubbed "Imperial Classicism," because it calls up the spirit of Imperial Rome. When Henry Bacon and Daniel Chester French were designing the *Lincoln Memorial,* Longman was invited to the planning sessions. Few people know that she created the ornamental eagles and wreaths on the memorial, contributing her labor, without recompense, as a gift to the nation. Bacon admired Longman's work so much that he designed and presented her with a classical gold filet for her head as a gesture of appreciation.

The sculptor reached the height of fame in 1916 when her twenty-thousand-pound gilded bronze statue, *The Genius of Electricity,* was hoisted to the top of New York City's Western Union Building at 195 Broadway. Longman had won this commission in competition with seven leading male sculptors. The twenty-foot muscular winged male nude on a globe, one of the largest single architectural figures in New York City, stretches one arm skyward, grasping bolts of electricity, while coils of cable wind around his other arm and torso. Affectionately dubbed "Golden Boy" by the telephone company workers, it gleamed for many years on the New York skyline and was used as a symbol on the cover of the nation's telephone directories.

In 1920, when Longman, at age forty-six, married Nathaniel Horton Batchelder, headmaster of the Loomis Institute (a boy's preparatory school in Connecticut), the wedding was held at Chesterwood, Daniel Chester French's studio-estate

in the Berkshires (now a museum). Longman helped raise her stepson and played an important role at the school (the boys affectionately called her "Mrs. B."), while continuing to produce monuments in a studio built for her on the grounds. These include a war memorial for Windsor, a *Monument to Pioneers of Industry* at Hartford, and a carved decorative frieze for the Post Office and Federal Building, Hartford (1933).

The couple retired to Osterville, Massachusetts, on Cape Cod a few years before her death. There the artist created the modestly elegant art deco *Hinkle Monument* in the Centreville cemetery, incised with a stylized pine tree and bands of ocean water.

Longman's profile relief of *Daniel Chester French* (National Portrait Gallery) seated before a frieze of his most famous sculptures, is characteristic of her competent, dignified traditional style. Ideal statues include *Nature* (a reclining

Evelyn Beatrice Longman, DANIEL CHESTER FRENCH (1926), bronze bas relief, 50″ x 61″. National Portrait Gallery, Smithsonian Institution, Washington, D.C. Gift of the artist, 1936.

nude); *Consecration* (an embracing nude couple); *The Future* (an adolescent girl, bronze, The Parthenon, Nashville, Tennessee), and *Torso* (Metropolitan Museum of Art, New York).

The fickle changes of artistic taste caught up with Longman. During the depression of the 1930s, when people developed a profound skepticism about unchecked capitalism and jingoism, and direct carving was the mode, followed by abstract art, Longman's work seemed the embodiment of stale academicism. A *New York Times* review tore her to shreds:

> Evelyn Beatrice Longman, whose recent work will be on view at the Grand Central Galleries until the end of the month, is only too representative of the rank and file of popular American sculptors. [She] is a competent portraitist [but] when Miss Longman essays symbolism . . . the reviewer is torn between tears and laughter. The oversize youth who reads a newspaper, quite oblivious of the mechanical gadgets at his feet, is labeled "Industry." An armed warrior with gritted teeth and clenched fist, supports on his chest a lad suffering from fatigue; this is called "Service to Mankind." . . . Miss Longman's masterpiece of bathos, however, is her "Consecration."[34]

But today, in the postmodern era, the artist is having the last laugh. Critics and the public are once again looking back nostalgically to traditional forms. In 1983, when architects Philip Johnson and John Burgee designed the American Telephone and Telegraph Building on New York's Madison Avenue, Longman's statue, *The Spirit of Communication* (as it is now called), was taken down from its rooftop on Broadway, regilded at great expense, placed on a granite pedestal, and installed in the six-story lobby as the theme statue of the building. There it gleams,

gold and gray, the ultimate corporate symbol. At its 1984 unveiling on the new site, Mayor Koch said: *"The Spirit of Communication,* symbolized artistically by this historic statue and symbolized corporately by A.T. & T., is the spirit on which New York was founded. It is the spirit that continues to infuse our city with the energy, the dynamic interaction, the awareness and the creativity that makes us the unchallenged communications capital of the world."[35]

> Other portrait busts are *Henry Bacon* (Metropolitan Museum of Art); a six-foot colossal bust of *Thomas Alva Edison* (Naval Research Laboratory, Washington, D.C.); *Bacchante,* the merry wreathed head of Daniel Chester French's daughter Margaret (Holladay Collection, National Museum of Women in the Arts); and black singer *John Wainwright* (Hampton Institute).

Malvina Hoffman (1885–1966), one of the most famous American sculptors of the 1920s and 1930s, was perhaps more than any other woman of the period committed to the grand and the heroic. She was a familiar figure in the media in her white beret and artist's smock, carving away on some high scaffolding.

Hoffman grew up in New York City, the youngest child of concert pianist Richard Hoffman and a devoted mother, Fidelia Lamson Hoffman. Her home was filled with the sound of chamber concerts and song recitals by opera star friends. When the child began to sketch and model, her father played games with her that sharpened her powers of observation and lectured to her on the principles of art. Unlike other little girls her age she was bored by dolls, "whereas electric batteries, mechanical toys were of real interest to me."[36]

The Hoffmans did not have much money, but their home provided other riches. Intellectuals from many fields visited, and at turning points were always around to assist Malvina and smooth the way. At the beach in Little Boars Head, New Hampshire, her first sculpture lessons came from a family friend, a Harvard professor, who taught her to find wood and carve it into beautifully finished boat models.

At age fourteen, she was already taking life classes at the Art Students League and evening classes at the Women's School for Applied Design, while attending the demanding Brearley School. When her grades and her behavior at Brearley began to suffer, James Croswell, the perceptive headmaster, soon discovered that Hoffman was carrying a triple load. Forming a secret bond, he told her to henceforth bring him her drawings without telling any of her schoolmates about it, because he intended to "keep track of what you're doing.... you must learn to save energy for each task you undertake."[37] When she fell ill, Croswell and his wife brought her to their vacation home on Deer Isle, Maine, encouraged her to paint watercolors, and read aloud to her from translations of Greek classics.

Hoffman studied painting with John Alexander and sculpture with George Grey Barnard and Herbert Adams. Her first important sculpture—a portrait of her ailing father—so impressed Gutzon Borglum, a family friend, that he urged her to submit the plaster cast to the 1909 National Academy exhibition. After her father's death she decided to carve it in marble. Another friend, sculptor Phimister Proctor, taught her the rudiments of carving and offered her his studio in MacDougal Alley while he was away for the summer. Working on the sculpture of her father helped blunt the pain of his last illness: "Carving became a harbor of safety into which I could steer my thoughts and sense a sort of salvation by self obliteration. It became the deciding factor in my decision to be a sculptor."[38]

After her father's death, desperate for income, she designed wallpaper and did any other hackwork. Fortunately, a windfall in the form of a thousand-dollar legacy made it possible for Hoffman and her mother to set out for France, where she hoped to study with Rodin. Hoffman had already held Rodin's work in her hands at the Fifth Avenue home of the collector Mrs. John Simpson and never forgot the awesome effect it had on her: "To this day I can close my eyes and feel the spirits of Good and Evil hovering with their heavy wings over the seated figure of Youth.... for hours I sat studying and drawing."[39]

The sculptor and her equally dedicated friend, Samuel Grimson, a rising concert violinist, made the sacrifice of separating temporarily so that each might establish a fully developed career.

Arriving at Rodin's door in 1910 with a letter of recommendation from Gutzon Borglum, she was turned away five times. She finally announced that she would not leave until she was admitted, adding that she had regards from Mrs. Simpson, Rodin's patron. This brought an immediate response:

"Wearing his velvet tam o'shanter, [Rodin] stepped forward.... He gave me the impression of dynamic force; an elemental giant was facing me, short and stocky, with a keen hooded look as he peered out from under a massive brow."[40]

At the moment, Rodin was showing a group of black-coated dignitaries around the studio. Waving his arms in the air and expounding on a sculpture by quoting from a poem by Alfred de Musset, the sculptor suddenly found himself groping for the last lines. When Hoffman completed the poem in French, Rodin looked at her sharply and decided that this was not a female Sunday painter who had come to waste his time. He examined the photographs of her sculpture,

gave her the keys to his studio, and told her that she could visit him weekly for instruction.

Hoffman studied with Rodin for thirteen months; she became an assistant and close friend and continued to work with him intermittently until the outbreak of World War I. Art historian Linda Nochlin writes of Rodin's influence:

> Rodin's melting and evocative marble style and the poetic, symboliste generalization of his conceptions may be felt in Hoffman's marble sculptural groups, like her *Mort Exquise* or her *Column of Life* ... a kind of vertical version of Rodin's famous *The Kiss* in which the embracing male and female figures literally seem to take shape from the rough-hewn marble block they are carved from, and into which their smoothly modeled, almost symmetrical forms seem to melt. Other works show the Rodinesque play between the sensuously polished marble flesh of the figure and the roughly chiseled marble block.[41]

Nochlin points out that Hoffman's portrait busts reflect "Rodin's characteristic combination of naturalistic description, dramatic generalization, and poignant sense of inwardness." A visit in 1910 to Keats's room on the Spanish Steps in Rome inspired *John Keats* (University of Pittsburgh). She had a vision of the poet, made sketches on the spot, and then worked for years to perfect the marble image. Hoffman's four interpretations of her friend *Ignace Paderewski*, pianist and Polish patriot, show him variously as statesman, man, friend, and artist.

Aware that there were no women sculptors in the art history texts, Hoffman learned every aspect of her craft—building armatures, carving hard stones, going so far as to cast twenty-seven small bronzes in a homemade fireplace in order to learn every step of the lost-wax process. On the advice of Rodin she studied anatomy for a year at the Cornell University College of Physicians and Surgeons in New York City. Later, she expressed concern about the superficiality of American art students, who could not bend pipe or repair a tool.

At the same time, Hoffman was caught up in the heady atmosphere of "The City of Lights," where the Ballet Russe was enchanting audiences, Jean Cocteau was leading the avant-garde, and a constant round of parties, salons, and musicales kept her at a high pitch of excitement. Janet Scudder, who had hired her as a studio assistant, took her to visit Gertrude Stein, "who sat like a Buddha" amidst the works of Picasso and Matisse.

It was not these artists, however, who made a great impression on Hoffman; it was her first glimpse of the world-famous Russian ballerina Anna Pavlova. "Fireworks were set off in my mind ... impressions of ... dazzling vivacity and spontaneity.... The incomparable Anna cast her spell over me."[42]

Even before she met the dancer she created several sculptures inspired by her—works that brought recognition and sales. *Russian Dancers,* a small bronze of Pavlova and Mordkin in a frenzied orgiastic dance, won a prize in the 1911 Paris Salon, and sold a large edition in New York City. The fourteen-inch *Autumn Bacchanale,* showing them rushing forward, holding a fluttering drapery over their heads, was commissioned in heroic size for the Luxembourg Gardens, where it stood until it was destroyed by the Nazis in World War II. (A large version is at the Cleveland Museum.)

Hoffman finally met her muse in New York City in 1914 at a tea arranged by Mrs. Otto Kahn, wife of the director of the Metropolitan Opera: "The fragile, pallid sprite comes into the room—dressed in black—with fiery flashing eyes—quick unexpected movements—simple, *real,* inspired

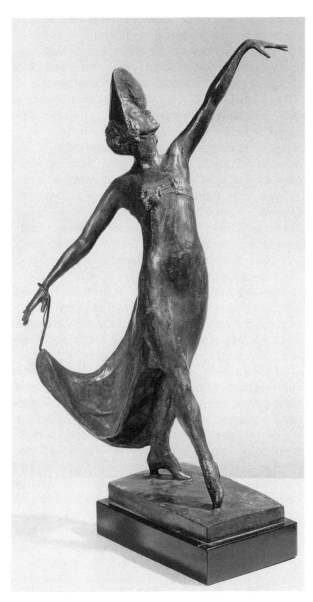

Malvina Hoffman, PAVLOVA IN LA GAVOTTE (1915), bronze, 14″ x 8″ x 5″. The Malvina Hoffman Estate. Courtesy of Berry-Hill Galleries, N.Y. Photo: Helga Photo Studio.

from within, a child of nature, a great artist.... I watch her, as a panther might crouch in a thicket and watch a bird. Every gesture records its line on my sensitive plate."[43]

Pavlova permitted Hoffman to make studies backstage. The dancer posed in her studio, sometimes with male partners, usually late at night after performances. The sculptor's heart would race when her lively friend signaled their secret code at the doorbell and came up the stairs calling out "Malvinou—shka!" Hoffman captured the incredibly slender lightness of the artist's movements in *La Gavotte,* a composition of balanced diagonal lines, playing against the swinging curves of the skirt.

Dissatisfied with the inadequacy of films of her performance, Pavlova hoped to immortalize the principal movements of her wildly erotic pas de deux *Bacchanale* in a long sculpture frieze. Dreaming of creating an academy of the dance where the twenty-six-panel frieze would be mounted in an architectural setting, the dancer posed intermittently for years, with partners, while the sculptor attempted to distill the essence of the movements. Janis Conner has analyzed the frieze and the unusual relationship between the two women artists in her 1984 catalog *A Dancer in Relief: Works by Malvina Hoffman.*

Photographs show the dynamic abstract qualities of the preliminary clay sketches (since destroyed), with lines of force scratched into the background. In the final, earnest polishing, some of this raw energy was lost, but the final plaster casts are a rhythmic tour de force, punctuated by rococo curves of Grecian draperies and scarves. Other works inspired by Pavlova are *Les Orientales* and *La Péri* (1921), a two-figure composition in which Pavlova, dragging a lily, leans back in a swooning arc, supported by her male partner.

Malvina Hoffman, PANEL FROM THE BACCHANALE
FRIEZE (1915–24), plaster. The Malvina Hoffman Estate.
Courtesy of Berry-Hill Galleries, N.Y.

For Pavlova's birthday, Hoffman threw a masked costume ball for two hundred people in her Sniffen Court stable-studio, transforming it with exotic red and gold hangings and roping off the alley where dancers and mimes in fantastic masks and jeweled costumes performed all night long. At midnight the gilded doors of a giant icon opened, revealing Pavlova posed as a Byzantine madonna, hands held together in prayer. Hoffmann preserved this image in a sculpture, *Byzantine Madonna.*

The war brought personal tragedy—her friend, Samuel Grimson, injured by a grenade, could never play professionally again. The two artists had been postponing marriage while each of them developed a career—now there was no point in waiting. They married in 1924. In 1922 Hoffman completed the stone carving, *The Sacrifice* (Harvard University Memorial Chapel). Commissioned by the wife of ambassador Robert Bacon, it now stands as a memorial to the Harvard students who lost their lives in World War I. The carving shows a madonna-like female figure mourning over a fallen crusader, somewhat in the manner of a medieval tomb sculpture.

This archaizing sculpture marked Hoffman's entry into a heroic phase. In 1924, she executed a rather heavy-handed two-figure composition, representing Anglo-American friendship, on the façade of Bush House in London. Colossal figures of England and America holding a torch above a Celtic altar fill the tympanum in an archaic neo-Greek relief style, with flattened folds, characteristic of the moderne ornament of buildings of the twenties.

This trend was carried further in plans for a monument to medicine, *The Four Horsemen of the Apocalypse,* to be placed in front of Harvard Medical School. In order to learn more about architectural and equestrian sculpture, Hoffman went to Yugoslavia in 1927 to study with the sculptor Ivan Meštrović, whom she had met in 1925 when he came to the United States for a retrospective of his work. At that time he posed for a heroic full-sized portrait, showing the vigorous, bearded, open-shirted sculptor, standing, legs wide apart, gazing at a sculpture in his right hand (Brooklyn Museum). Hoffman learned every aspect of stone carving. Unfortunately *The Four Horsemen of the Apocalypse* never received funding and remains only a vision in drawings and studies.

Hoffman now had a successful career but was restlessly searching for new inspiration. A trip to Africa inspired powerful African heads (*Martinique Woman, Senegalese Soldier,* black Belgian marble, Brooklyn Museum). She wrote later that she "was deeply impressed by the sculptural quality of these Senegalese types. The planes of their great cheek bones and strongly marked jaws shone out in the moonlight like polished metal."[44]

The African studies presaged the major commission of her career. In 1929 Chicago's Marshall Field Museum commissioned her to portray "the living races of man" in time for the 1933 Chicago World's Fair. Hoffman managed to convince museum officials to give her the entire job, originally intended for three artists. This enormous undertaking—104 sculptures of racial types involving years of work and journeys around the world to study people on the site—is described in her book *Heads and Tales.* She began the project in Paris where she had built a house and second studio.

At the outset, Hoffman was fortunate to secure models in Paris, because a colonial exposition had brought people from Africa and Asia to that city. She then traveled to Japan, India, Africa, China, Bali, and elsewhere. Pneumonia, sunstroke, an infection that nearly took her arm, and other ailments felled her periodically, as she and her husband journeyed by steamer, train, or Chinese junk to remote places. Her husband was her photographer as they moved twenty-seven trunks and sculpture materials around the globe.

Forced to work closely with anthropologists who checked on the accuracy of the work, she sometimes took a wry view of some of their racist attitudes and left the Nordic or "Aryan" type to the last, because there was so much disagreement about it. The anthropologists, she said, "would have to fight this one out with Mr. Hitler." When she finally selected a handsome narcissistic model in New York, she noted ironically that he considered himself "God's gift to women."

Hoffman wanted to show the dignity of all peoples, and noted the oppressive effect of white colonialism on Hawaiians and American Indians. After finishing the main part of her project in time for the 1933 Chicago Century of Progress Exposition, she traveled to the Southwest, where she completed a series of noble heads of American Indians on Hopi mesas and in Navajo country. She then visited her old friend, Mabel Dodge, whom she had last seen in 1910 at her villa in Florence. In a huddle of pink-beige adobe buildings surrounded by fields of lavender and gold flowers, Dodge had once again created a salon with herself at the center and found spiritual peace through identification with the Native American heritage. Dodge and Hoffman's belief that the Indian seemed to have a better understanding of the secrets of essential and healthy living than the white man was part of a general attraction to primitivism in art and life in that era—reflected in everything from Picasso's cubism to the "direct carving" school of sculpture.

On the other hand, as Linda Nochlin has noted, the sculptor sometimes showed little insight into the cataclysms of history that swirled about her. Although she was aware of starvation in India, she noted, with annoyance, "the advanced and violent opinions on politics and life often expressed by 'young India.' The swarming millions seem to preserve an endless supply of mental energy and saliva when it comes to expressing rather inconsistent programs of reform and freedom of thought."[45] Hoffman preferred the older generation of venerable scholars who extended gracious hospitality amidst clouds of incense and collections of ancient paintings.

Today most of Hoffman's sculptures for the Hall of Man at the Field Museum are in storage. Scattered pieces stand between glass cases of ethnographic artifacts. Only in old photographs can one glimpse the overall impact made by the original installation of one hundred studies, surrounding a central column depicting the so-called white, black, and yellow races, topped by a central globe. The commission brought income and publicity, but one may seriously question the

Malvina Hoffman, AMERICAN WORLD WAR II MEMORIAL (1948), incised relief. Épinal, France. Photo courtesy of the National Sculpture Society.

impact of the assignment on her life's work. Years of grueling effort, at the peak of the artist's creative period, were devoted to a project that, as Nochlin points out, "lies somewhere between science and art."[46]

In the 1930s, however, the project brought Hoffman great fame. Large exhibitions of the figures and busts, in various sizes, were held by New York's Grand Central Art Galleries and Boston's Vose Gallery. Hundreds of the works were sold, and the sculptor gave slide lectures around the country, describing her experiences in exotic places.

Unfortunately, just as she was reaching the height of success, Hoffman was struggling with a foundering marriage. At Paderewski's suggestion, she began to write *Heads and Tales* to divert her mind from the great emotional stress that overwhelmed her. It was published in the same year that she became divorced.

With the help of friends, she went on. For the 1939 New York World's Fair she created a cylindrical dance fountain carved with reliefs of dancers of many nations (see chapter 7). Late works

include reliefs for a monument to the fallen American soldiers of World War II at Épinal, France, and a frieze depicting the history of medicine for Joslin Diabetes Center, Boston, in which Hoffman again adopted an incised, "Egyptian" art deco style suited to architecture.

The sculptor received the highest honor awarded by the National Sculpture Society (a gold medal), and had a 1937 retrospective at the Virginia Museum of Fine Arts, Richmond. An admirer of Brancusi and a devotee of African and primitive sculpture, Hoffman made a cool assessment of herself in relation to the modern movement. Excited but troubled by the 1913 Armory Show, she wrote:

> The violence of the rejections and cheers disturbed me, and I could not make up my mind how I felt. . . . I was very much aware of the Brancusi head . . . his courage in slashing away all the details . . . but some of the other work in the exhibition seemed false, and I resented any touch of falseness. . . . I thought Classic work has endured, and there must be a reason. . . .

And even what is "modern" isn't altogether new.[47]

Although she wondered if she should have been more experimental, aimed for an individual style, she decided that her fundamental interest was really in the personality of each of her sitters, not in some new formal approach. Indeed, Hoffman was not as "modern" as Rodin, who once showed her that a broken fragment of one of her works was a complete expression. Only rarely did she take such liberties with nature.

In reviewing Hoffman's oeuvre, some of her finest works are the small bronzes and portraits. The studies of the dancer Pavlova convey passion, freedom. A prolific sculptor, Hoffman portrayed a broad spectrum of society, from working-class subjects (*Bill Working,* 1923, bronze,

Malvina Hoffman, HEAD OF JOHN KEATS (1926), marble. University of Pittsburgh, University Art Gallery.

Museum of Fine Arts, Springfield, Massachusetts, a study of her devoted studio handyman cleaning the floor) to such elite figures as the elegant long-necked society hostess *Rita de Acosta Lydig* (1929, alabaster, Rosenbach Collection, Philadelphia), Henry Clay Frick (1920, Frick Museum), and Hoffman's generous patron, Mrs. Harriman. During a prodigious career, Hoffman earned the highest honors of her profession, including five honorary degrees. Her Sniffen Court studio and her home in Paris, the Villa Asti, were gathering places for prominent intellectuals and leaders, who not only respected her as an artist but enjoyed her rich personality and her gifts as a raconteur.

Gertrude Vanderbilt Whitney (1875–1942), founder of the Whitney Museum of American Art, was the daughter of the richest man in turn-of-the-century America, Cornelius Vanderbilt II. Groomed from birth to become a society leader, she became instead a capable academic sculptor of public monuments and arguably the greatest patron of American artists. A complex personality, Whitney functioned on four levels—as a proper society matron and devoted mother, as a dedicated artist, as a patron and philanthropist, and as a secret bohemian, determined to live intensely.

Raised in a Renaissance palace on Fifth Avenue in New York City, Gertrude was an intelligent, sensitive child. From the age of four she recognized that girls led stifling lives; her father reserved his active ambitions for her brothers. Boys had "a jollier time," and "men do what thrills them," she wrote to herself.[48] At Brearley School the director noted that she was an inspiring pupil, who, he felt, would become a high-minded and intelligent woman.[49]

Although swept up into the conventional debutante whirl, she also felt the isolation of the super-rich. The position of heiress was intolerable, she confided to her journals. Fortune hunt-

ers pursued her, while the authentic people whom she really wanted to know avoided her because they didn't want to appear to be chasing after money. Sincere lovers were too much in awe to voice their feelings.[50]

In 1896 she married the boy who lived in a palace across the street—the handsome, polo-playing Harry Payne Whitney. She was very happy at first, but the newlyweds soon found that they had different interests; Gertrude was not comfortable with the small talk and superficiality of society life. Her husband began to spend most of his time away, following his favorite sports (he was the greatest polo player of the era) and engaging in business deals and occasional relationships with other women.

At this time a friend, the artist Howard Cushing, encouraged her desire to become a sculptor. Voluminous journals, diaries, and unmailed letters became the secret safety valves for her feelings: "I wanted all the good and conservative things of home life ... but probably through my own fault I could not get them ... then I lay down and it seemed as if the sorrows of the world piled themselves upon me ... I struggled, ineffectually at first. ... And now I don't want good and conservative things ... I love my work because it has made me happy and given me confidence in myself. ... It is not dependent on humanity, it is something that I have made for myself. There is no question that I have also cultivated a love of excitement ... I like admiration and I get it."[51]

Her society friends and the public smiled tolerantly at the artistic efforts of a woman of wealth. A long struggle was necessary just to be taken seriously.

In 1900, after a vain attempt to be taken as a student by Saint-Gaudens or Daniel Chester French, Whitney began to study with the academic sculptor Hendrik Christian Andersen. She

built a studio hanging over a cliff facing the sea on the grounds of her summer villa at Newport, Rhode Island, where her instructor, while reading Ibsen aloud and stimulating her imagination with tales of the artist life in Rome and Paris, rigorously supervised her modeling. Whitney also took criticism from James Earle Fraser, a friend and adviser through the years. *Aspiration* (1900), a Rodinesque full-length male figure raising his arms in supplication, was accepted at the 1901 Pan-American Exposition in Buffalo.

She was very self-critical about her early work, and after viewing the ancient masterpieces in Athens and Rome, confided to her journal that it was "desecration" for her to "dabble" in art. She was too old; she would never be able to master the techniques. To go beyond mediocrity she would have to sacrifice her family. The classic conflicts that women have faced broke to the surface.[52]

Fearing that judgment of her work would be prejudiced by her wealth, Whitney exhibited under an assumed name. In 1908 she won a prize from the Architectural League for a figure of *Pan*. Finally, when the Rodinesque marble *Paganism Immortal* (1907) won a distinguished rating at the National Academy of Design in 1910, the artist began to exhibit under her own name.

In 1907, as part of her move to establish an independent identity as an artist, she set up a studio away from her Long Island home, in a remodeled stable on MacDougal Alley in Greenwich Village. During repeated trips to Paris, where she set up another permanent studio, Whitney studied with Andrew O'Connor, who encouraged her taste for monumental public work. In 1911, while working on *Head of a Spanish Peasant* (1911, Metropolitan Museum) and a

caryatid, she was thrilled to receive private criticism from Rodin (clearly the dominant influence on her early work). She kept as treasured talismans the small red clay figures he quickly modeled to demonstrate basic principles.

For Whitney, Paris was a magical place where she could throw off the constraints and inhibitions of a society leader. An amusing 1913 photo shows her as the only woman in the company of artist friends at an all-night Arabian Nights feast in a tent, where she improvised a veiled dance in a harem costume designed by Bakst.

An important influence at this time was her friend, Robert Chanler, an artist from her own upper-class background, who, in the era just before World War I, when women were beginning to rebel against Victorian repression, urged her to express herself fully, to live to the hilt. Chanler decorated her MacDougal Alley studio with fantasy murals of undersea life and sculpted artificial red and gold plaster flames around the fireplace that climbed all the way to the ceiling. Whitney also maintained an elegant Beaux Arts studio on grounds where peacocks strutted at her Westbury, Long Island, estate. To the impoverished artists around her, she appeared to be a creature from another world. Robert Henri painted her, slim and elegant, reclining in harem pants.

While developing as a sculptor, Whitney had also resolved to become the patron of advanced American artists, who were at that time largely shut out of museums and important exhibitions. Witnessing the plight of the struggling young artists who lived and worked in the neighborhood around her MacDougal Alley studio, she helped many of them literally to survive by purchasing a work, sending a check anonymously if she heard that someone needed coal for heat or money for an operation, or providing a stipend for study abroad. The artists, in turn, gave her something very important. Impressed by her serious dedication to sculpture, they supported and encouraged her work. Malvina Hoffman, at that time a fledgling sculptor, later recalled her reaction to "the perfect order of Gertrude Whitney's splendid place ... Mrs. Whitney herself, tall, thin and fragile in appearance, worked tirelessly but was never too busy to help young sculptors."[53]

In 1908 Whitney bought four paintings from the pioneering show of "The Eight" at the Macbeth Gallery, a revolutionary act at the time. The ash can school was just beginning to rebel against academic art, and she was one of the first to support the new movement. Whitney picked up the deficit of the newly formed Society of Independent Artists which was promoting open, unjuried shows. For the landmark Armory Show of 1913, she contributed $1,000, one-tenth of the initial budget, for the pine bough decorations that created a festive atmosphere.

Whitney saw the need for an artist's community. In a building adjoining her studio she set up a gallery to show the work of young artists and in 1918 established the Whitney Studio Club which became the heart of the art community—a place where artists could meet and socialize, draw from the model, organize exhibitions, and sell their work in an atmosphere of relaxed revelry and sometimes high jinks. Peggy Bacon has left an amusing image of the regulars in her etching *Frenzied Effort.*

In 1914, to facilitate her projects and permit more time for her own work, Whitney hired Juliana Rieser Force, originally a secretary from a poor family in Pennsylvania, to carry out administrative chores. Force soon became a driving spirit behind the galleries, the club, and ultimately, the Whitney Museum. By 1928 the Whit-

ney Studio Club had become unwieldy, with four hundred members. Having served its purpose of creating a sense of community, it was replaced by the Whitney Studio Galleries, where a variety of exhibitions, primarily featuring young artists who had no commercial dealers, were held.

In lieu of awards or prizes, Whitney bought the best works from these exhibitions, amassing more than six hundred paintings and sculptures. In 1929, she offered the collection to the Metropolitan Museum, with an endowment to support a new wing. The director's response was: "We have a basement full of American work. We don't need any more." The next day, infuriated by this contempt for American talent, Whitney called a luncheon meeting with Force and the critic Forbes Watson and decided to open her own museum. In 1931 the Whitney Museum of American Art opened on Eighth Street with Juliana Force as director.

Today, when American art occupies a leading position all over the world, it is difficult to comprehend the immense role that Gertrude Whitney played in raising it to that position. Artists like John Sloan, Robert Henri, Edward Hopper, Peggy Bacon, Marguerite Zorach, Stuart Davis, and others who are now American "old masters and mistresses," received early recognition at the Whitney Museum. In an article entitled "The End of America's Apprenticeship," she argued that American art was no longer the provincial stepchild of Europe.[54] In 1920–21 she sent the Overseas Exhibition to Venice, London, Paris, and Sheffield. She founded *Arts Magazine,* the leading liberal journal of American art in the 1920s, and supported research through the publication of books and catalogs by scholars like Lloyd Goodrich and John Bauer, both of whom served as curators and directors of the museum.

The first major studies of artists such as Thomas Eakins were made possible through her sponsorship.

Although a relatively traditional sculptor, Whitney championed artistic freedom, repeatedly coming to the aid of avant-garde art. She helped support Brancusi's legal fight when ignorant customs inspectors declared that his sculpture was not art and therefore was not duty-free. She even gave a sum to the madcap Dada publication, *The Blindman* (1917). A conservative Republican by background, Whitney did not hesitate to sponsor an exhibition of avant-garde Soviet posters in 1920 when the United States was in the throes of a postwar red scare (the Palmer raids were an earlier version of the McCarthy era).

While she was becoming a modern Medici, Whitney continued to pursue her own sculpture career. The red stone hexagonal *Aztec Fountain* (1910), set in a pavement of decorated tiles in the patio courtyard of the Pan American Building in Washington, D.C., has a rich ethnic flavor. A column of three figures representing the Mayan, Aztec, and Zapotec eras, supports a double basin, and water pours from the mouths of eight feathered serpent heads. The *Arlington Fountain* (1910, bronze, Whitney Museum), a Rodinesque white marble composition of three muscular male caryatids supporting on their heads a large basin decorated with leaves, grapes, and fish, the whole surrounded by vivid green water plants, was a very effective focal point at the 1915 San Francisco Panama-Pacific exposition.

On the eve of World War I the sculptor was working simultaneously on two other major projects: the *El Dorado Fountain* for the Panama-Pacific Exposition, and a commission, won in an open competition, for a monument to those

Gertrude Vanderbilt Whitney, HEAD FOR TITANIC MEMORIAL (1924), marble, 12¾″ x 7″ x 9″. Collection of the Whitney Museum of American Art, N.Y. Photo: Geoffrey Clements.

who lost their lives on the ill-fated ocean liner, the *Titanic*. (This project took on poignant intensity when her brother Alfred was subsequently drowned in the torpedoing of the *Lusitania*.) Dedicated to the men who gave up their places in the lifeboats in order to save the women and children, the monument features a central figure representing self-sacrifice—the image of a departing spirit in a moment of transcendence. Whitney struggled to keep the forms and planes large and simple, the outstretched arms creating a strong cruciform silhouette. The eighteen-foot-high pink granite figure now stands in Washington Channel Park in Washington, D.C., soaring above a thirty-foot-wide stone exedra bench ornamented with dolphins.

The *Fountain of El Dorado* (1913), one of the most ambitious sculptures at the 1915 San Francisco Panama-Pacific Exposition, consisted of two curved walls covered with Rodinesque reliefs of more than forty figures struggling toward a central doorway. Eclectic and moody, the forms seem to quote variously from Michelangelo's *Medici Chapel* and Rodin's *Gates of Hell*. Whitney told a *New York Times* reporter that *El Dorado* symbolized "all the material and spiritual advantages for which human beings yearn—quickly acquired wealth, extraordinary power . . . love. . . . the seekers had had a glimpse of El Dorado [the elusive spirit of wealth and power] who had just disappeared through the gateway."[55]

During World War I, despite the protests of her husband, who urged her to give money but not risk her life, Whitney sailed for France with twenty-five doctors and nurses and for five months directed her own field hospital at Juilly, near the front lines. Back home, profoundly affected by the horrors she had seen, Whitney worked fervidly on a series of small bronzes based on her experiences and in 1919 held an exhibition at the Whitney Studio of twenty-six of these sketches, entitled *Impressions of the War*. Rapidly executed emotional works with titles like *Gassed, On the Top, His Bunkie, Blinded*, done in a loose, free style, they are different from the romanticized academicism of her earlier pieces. The artist may have been influenced by the realistic sculpture of her good friend Jo Davidson.

At the time of this exhibition, an interview in the *New York Times* was headlined "Poor Little Rich Girl and Her Art: Mrs. Harry Payne Whitney's Struggles to Be Taken Seriously as a Sculptor without Having Starved in a Garret." In the article, Whitney discussed the problems she had faced: "Let a woman who does not have to work for her livelihood take a studio and she is greeted by a chorus of horror-stricken voices, a knowing lift of eyebrows."[56] She told of how her wealthy friends had ridiculed her early efforts, and how much it

Gertrude Vanderbilt Whitney, TITANIC MEMORIAL (1931), granite, height 15′. 4th and P Streets, S.W., Washington, D.C. United States Department of Interior, National Parks Service photo.

had meant to her to receive support and encouragement from her fellow artists in Greenwich Village.

The small composition *Bunkies,* showing a soldier helping his wounded comrade, became the basis for the *Washington Heights Memorial* (bronze, 1921), a pyramidal composition of a soldier, sailor and, marine installed at 168th Street, New York City, for which the sculptor was awarded a gold medal from the New York Society of Architects "for the most meritorious monument erected during the year."

In 1923, Whitney had a well-received retrospective at New York's Wildenstein Galleries. She must have been especially pleased to receive the following note from John Sloan, an artist of social conscience: "I felt the impressiveness and firm beauty of your sculptures. . . . I feel right sure that no

sculpture equalling yours has sprung from the demands of sculptural records of the Great War."[57]

The year before, Whitney had received a commission from the state of Wyoming that resulted in her most popular monument, a bronze equestrian statue of *Buffalo Bill.* Seeking to create an image of the mythic scout as "a pathfinder . . . riding ahead along the trail," she portrayed him reining in his rearing horse with one hand and holding his gun overhead with the other, while he leans over to investigate footprints.

The artist went to great lengths to make this work authentic. She brought to New York a genuine Wyoming cowboy and the horse Smoky from Buffalo Bill's own ranch; she took movies of them, cantering and going through their paces, from which she made many sketches. A special rotating platform was built in her MacDougal Alley studio so that she could approach the heroic-sized work from all sides. It won a bronze medal (the highest award given to a foreign artist) at the 1924 Paris Salon.

The unveiling of *Buffalo Bill* at sunset on 4 July 1924 by the scout's granddaughter was celebrated with a stampede and rodeo. The bronze work is dramatically effective on its outdoor site adjacent to the Buffalo Bill Historical Center. The dynamic diagonal lines of the thirteen-foot rearing horse and rider, atop a sloping plinth of pink granite rocks, echo the diagonal lines of the snow-capped Rocky Mountains behind it. As viewers walk up a pathway to examine the work at close hand, they can smell the sage in the western plantings on the base.

Whitney's most colossal monument, and one that approaches modernism, is the 114-foot stone *Columbus,* a huge columnar figure looking down on the site of the explorer's departure for the New World in the port of Palos, Spain. Its geometric, simplified forms were perhaps in-

Gertrude Vanderbilt Whitney with THE SCOUT (BUFFALO BILL) (1923), bronze, height 12′5″. Courtesy of the Buffalo Bill Historical Center, Cody, Wyo.

spired by a visit to Egypt not long before. When she saw the giant stones lifted into place, the fifty-two-year-old artist wrote to her teacher and colleague, Andrew O'Connor: "Why worry that old age has come if it has not come with atrophied mind and energy. The face may fall but the spirit may rise."[58]

With the decline of traditional sculpture, Whitney received few commissions in her last years. Her 1936 retrospective at the Knoedler Gallery earned mixed reviews. Emily Genauer in the *World Telegram* attacked the work as "facile" modeling: "a romantic, decorative conception of sculpture, rather than one springing from a combination of searching expression and a formal recognition of masses, volumes." Genauer singled out for praise a few compact late works that more closely resembled the direct-carving style then in vogue—*Nun* and *Gwendolyn,* a strong, stylized head of a black woman in smooth Belgian marble.[59]

One of Whitney's last commissions was a theme fountain for the 1939 New York World's Fair, a curving silver arc, culminating in three wings from which two figures soar upward. A tribute to aviation, the streamlined art deco monument entitled *To the Morrow* (*Spirit of Flight*) expresses the mood of the fair—faith in progress and American technology despite the troubles of the depression. After the fair, Whitney was involved in a frustrating attempt to locate it permanently at La Guardia Airport, but along with most of the other sculpture, it was destroyed.

The sculptor's last commission was a rugged bronze figure of *Peter Stuyvesant* (1939, Stuyvesant Square, New York) gripping a cane in one hand, jaw thrust out in truculent defiance. Of Dutch descent herself, the sculptor painstakingly researched details of costume and personality of the peg-legged last Dutch governor of

New Amsterdam. This work seems influenced by Saint-Gaudens's *The Pilgrim,* but it has a more rugged, simplified realism.

In her last years, the artist spent much time on her writing. Throughout her life she had written diaries, poems, short stories, a play. Her strange novel *Walking in the Dusk* was published under a pseudonym in 1932 and *A Love Affair* was published in 1984, more than forty years after her death.

Yet at the same time, the artist never abandoned her role of devoted matriarch. She and her husband, while leading separate lives, remained in their own way devoted to one another. Today her children and grandchildren express their continuing devotion to Whitney's memory and ideals by continuing to play an important role at the Whitney Museum.

After a life that encompassed enough activity for a dozen ordinary people, Whitney died at the age of sixty-seven. Juliana Force organized a memorial retrospective exhibition at the Whitney Museum. Eulogies from leading figures in the art world pointed out that Whitney had almost singlehandedly raised American art to a prominent international position.

A humanistic artist who wished to create public monuments that were readily accessible to the community, the sculptor had little interest in developing a personal style or an innovative concept of form. In a 1940 radio program, when the interviewer asked her which style she preferred—the symbolism of *Spirit of Flight* or the realism of her *Stuyvesant* statue—she replied that she had no preference for one or the other, except "as either symbolism or realism would be the best form for the embodiment of my idea." She varied her approach according to the theme, site, purpose. The eclectic, moody *Fountain of El Dorado,* influenced by Rodin, harmonized

Gertrude Vanderbilt Whitney, PETER STUYVESANT (1939), bronze. Collection of the City of New York. Photo: © Shoshana Rothaizer, 1987.

with the moody, romantic buildings at the San Francisco Exposition. On the other hand, the *Aztec Fountain,* based on pre-Columbian forms, works well in the Hispanic setting of the Pan American Union building. The *Titanic Memorial'*s compressed form and cruciform silhouette seem to suit its transcendent mood. Whitney chose a straightforwardly realistic style, reminiscent of works by Frederic Remington and other western sculptors, for *Buffalo Bill,* whereas the shiny metallic art deco fountain, *Spirit of Flight,* expressed the science fiction mood of the 1939 fair.

The thread that runs through all these stylistically diverse works is Whitney's sense of drama, of staging (indeed, she once tried her hand at stage sets), and the effectiveness of her public sculptures can be understood after visiting the sites.

Laura Gardin Fraser (1889–1966), one of America's finest medalists, and the creator of several large monuments, lived a shared life in art with her husband, sculptor James Earle Fraser. Although she had the total respect and support of her husband, she had to struggle against society's pressure to submerge her in his shadow.

Born in Morton Park near Chicago, Laura Gardin developed a love of animals (often her subjects) and a gift for modeling in clay under the guidance of her mother. Alice Tilton Gardin, "whom we affectionately called Neo," she said, "was a talented painter. She taught us girls [two sisters] and encouraged us to study the arts."[60]

By the time Gardin graduated from New York City's Horace Mann High School in 1907, she had already modeled a portrait of *Maude Adams* as Peter Pan, a *Rough Rider,* and many sketches of animals. Enrolling in the Art Students League classes of James Earle Fraser (sculptor of *End of the Trail*) she proved to be a brilliant student, winning the Saint-Gaudens Medal in her first year, a scholarship in her second, and the coveted Saint-Gaudens Figure Prize in her last term. Between 1910 and 1912 she was an instructor under Fraser's supervision. They were married in 1913.

The couple bought a two-hundred-year-old colonial house in Westport, Connecticut, and built a fieldstone studio on the grounds, in which they worked for the rest of their lives: "We designed our studio for our future together. It was 30 feet by 60 feet and a story and a half high. Big as it was, we kept it full most of the time. We loved it."[61]

Their home was visited by such distinguished friends as the poet Edwin Arlington Robinson (who stayed for months and loved to play poker with them every night), and artists and leaders from every walk of life. The Frasers returned to their New York apartment and studio each year for the winter season.

While James Fraser was securing such large commissions as *Alexander Hamilton* for the U.S. Treasury Building, Laura Fraser was at first relegated to the "female" categories of small animals, faun fountains, and a Better Babies Medal for the *Woman's Home Companion.* Soon her talent garnered the 1916 Helen Foster Barnett Prize for *Satyr and Nymph* and a commission for the National Institute of Social Science Medal. Subsequent coin and medal commissions included the United States Army and Navy Chaplain's Medal, Alabama Centennial Half-Dollar, Grant Memorial Gold Dollar and Half-Dollar, American Bar Association Medal, National Sculpture Society Medal of Honor, Medal for Society of Medalists, National Geographic Society's Richard E. Byrd Medal, George Washington Bicentennial Medal, Charles

A. Lindbergh Medal of Congress, General George C. Marshall Medal of Congress, Wildlife Conservation Medal, and others.

Laura Fraser was the first woman to receive the Saltus Gold Medal of the American Numismatic Society and the first woman to design a coin for the U.S. Treasury (for the Philippines after World War II). Like the miniature paintings of early times, coins and medals somehow seemed "proper" for the talents of a woman. But, Laura Fraser's reputation grew to the point where she also received several large commissions, among them the *Hitt Memorial* in Rock Creek Cemetery, Washington, D.C., the *Drinker Memorial* at Lehigh University, and the monumental double equestrian statue, *Robert E. Lee and Stonewall Jackson* (1936–48) in Wyman Park, Baltimore, Maryland. The only woman among six sculptors (including Lee Lawrie and Paul Manship) invited to compete, her design was chosen unanimously. Twelve years of hard work went into this project:

Hard work, horses, research. . . . A sculptor's life is measured in large chunks of time. A statue like the Lee and Jackson becomes a part of you. It's like raising a child. Of the one hundred thousand dollars I received for Lee and Jackson, I might have netted fifteen thousand dollars. The architecture alone cost fifty thousand dollars. Then there was the casting and shipping cost. Of course, there is no satisfaction quite like that of a beautifully complete and acceptable creation.[62]

Another monumental project consists of three relief panels depicting the history of the United States from prehistoric times to the development of atomic fission. For years the sculptor worked on this concept with little thought of a commission; it was a kind of ode to the country. Today the bronze panels adorn the entrance wall of the library at the United States Military Academy, West Point. *Pegasus* (1946–51), a white granite figure, symbolizing Inspiration and riding a

Laura Gardin Fraser, SPECIAL MEDAL OF HONOR OF THE NATIONAL SCULPTURE SOCIETY (1929), diameter 4″. Photo courtesy of the National Sculpture Society.

Laura Gardin Fraser, PEGASUS (1946–51), granite, height 15′3″. Courtesy of Brookgreen Gardens.

winged horse, creates a dynamic image in a reflecting pool at Brookgreen Gardens, South Carolina.

Although Laura Fraser won many honors and commissions, she was constantly battling for her artistic integrity: "Jimmy and I had standing jokes between us. One of them was when I finished a job and it was presented, we would wager how long it would be before someone would comment to me, 'Bet Mr. Fraser helped you on this one.' One time, in fun, I snapped back at a wealthy patron, 'Just who is this James Earle Fraser I keep hearing about?' ... Jimmy never did tell me what to do, he never superimposed his ideas, ever on another sculptor."[63]

A case in point is the history of the sculptor's four-by-twenty-two foot relief panel *Oklahoma Run,* depicting the opening of Oklahoma to settlement in 1889. Containing more than 250 horses, figures, covered wagons, and stagecoaches careening in mad galloping motion, it was originally ordered from James Fraser for the Oklahoma City fairgrounds, but since he was in failing health, he arranged with officials before his death to transfer the commission to Laura. Although James Fraser did absolutely no work on the panels—his only input was praise and encouragement—after its completion Oklahoma City officials dragged their feet about funding it, insisting that his name should appear on the work along with hers. *Oklahoma Run* was good enough to exhibit, but only with the male cachet. She kept the work until her death, when it was bought by Oklahoma City's National Cowboy Hall of Fame and Western Heritage Center.

As typically happens, Fraser frequently assisted her husband with his projects; for example, she carried out the entire pediment for the National Archives Building on Constitution Avenue in Washington, D.C., from his twelve-inch drawing. Her generous husband carved her name on one side of it and his on the other, but she disclaimed any credit for the work because it was his design. The only project on which they actually collaborated was the Oregon Trail Memorial Half Dollar.

A member of the National Sculpture Society and the National Academy of Design, Laura Fraser won the National Arts Club Medal of Honor (1915), the Julia L. Shaw Prize (1919), the Saltus Gold Medal of the National Academy of Design (1924 and 1927), the Agar Prize of the National Association of Women Painters and Sculptors (1929), and the Watrous Gold Medal of the National Academy of Design (1931). Among many portraits are *Gilbert Stuart* and *Mary Lyon* in the Hall of Fame, New York University, and a marble relief of *Mrs. Edward H. Harriman.* Her exceptional ability to model horses brought commissions such as *Fair Play,* a life-sized bronze for Elmendorf Farm, Lexington, Kentucky, and the United States Polo Association Trophy.

Laura and James Fraser led a life of harmonious dedication to their métier and to one another. As she put it: "We talked and laughed and competed all our lives."[64] Syracuse University owns thirty-six works (including *The Wrestlers* and a bust of *Edward Arlington Robinson*) as well as her private papers. A building at the Cowboy Museum of Western Art in Oklahoma City is devoted entirely to the plaster models and personal effects of both Frasers.

Sculptor **Gail Sherman Corbett (1870–1952)** and architect Harvey Wiley Corbett were another successful husband and wife team in the early twentieth century—a time when sculptors frequently collaborated with architects on public monuments and outdoor sculptures. Lorado Taft called Gail Corbett's monuments "dignified and impressive."

Born in Syracuse, New York, Gail Sherman studied with Luella M. Stewart at Syracuse University and then in New York with Caroline Peddle Ball (1893) and at the Art Students League with Saint-Gaudens and George de Forest Brush. After a trip to Paris in 1896, she spent two years teaching at Syracuse University and then returned to Paris in 1899. She opened a studio there, received criticism from Saint-Gaudens, and studied anatomy at the École des Beaux-Arts. It was at the École that she met her future husband, Harvey Corbett, an architecture student.

She and Corbett submitted a design for a monument that she knew was under consideration in Syracuse (she designed the sculpture, and he the architectural setting). Art historian Calvin Hennig, whose dissertation on Syracuse monuments is a major source of information about the sculptor, describes the wrangling that took place before she was finally awarded the commission in 1901. Despite her years of training and the excellence of her model, people were reluctant to give the job to an unknown female newcomer, even if she did come from Syracuse. Sherman had to obtain a letter from Saint-Gaudens stating that she was capable of doing the job and that he would advise her along the way. Later, when he fell ill, she had to get a similar letter from Daniel Chester French.[65]

After receiving this commission, Gail Sherman opened a studio in New York City. A perfectionist like Saint-Gaudens, she refused to let the work go out until she was completely satisfied with it, even though she went several years over deadline. Handling her difficult situation as an untried woman sculptor with admirable tact and cool diplomacy, she kept the entire project in mystery until the final unveiling, believing that the work itself would make the best argument in its favor.

The *White Memorial* was erected in memory of Hamilton S. White, a much loved Syracuse citizen who, as organizer and volunteer head of the city's fire department, had saved many lives and had lost his own life in a fire. The sculptor placed a bronze bust of White on a tall stone shaft, flanked on one side by a robust seated male figure in a fireman's greatcoat, representing courage and manhood, and on the other by a woman and child, symbolizing the caring, generous side of White's nature. The little boy holds a fire engine and looks up at his role model. Harvey Corbett designed the pedestal and the exedra (a curved stone bench). Hennig points out that the sculptor drew inspiration from figures in Michelangelo's Medici Chapel and from the French sculptor Paul Dubois's *Tomb of General Lamoricière* at Nantes Cathedral.[66]

The community, which had been dubious along the way, was well satisfied with the impressive monument. Immediately after the unveiling in Fayette Park in 1905, the Corbetts were married.

While working on the *White Memorial,* Sherman received another Syracuse commission in 1902 for the *LeMoyne Fountain,* dedicated to Dr. William Kirkpatrick, the man who had for many years been in charge of Syracuse's

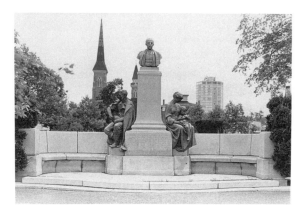

Gail Sherman Corbett, WHITE MEMORIAL (1905), bronze. Syracuse, N.Y. Photo courtesy of Calvin Hennig.

Gail Sherman Corbett, FIREMAN, DETAIL OF WHITE MEMORIAL (1901), bronze. Syracuse, N.Y. Photo courtesy of Calvin Hennig.

Onondaga Salt Springs, a major source of salt in the United States. On a drum-shaped fountain with basins below it, she modeled a frieze portraying the discovery of the salt springs by white men in 1654. All the lines of the well integrated design lead to the central image of Father Le-Moyne tasting the salt from a cup given to him by the Onondaga Indians.

Unveiled in 1908, the fountain was later dismantled and only the drum was moved into Washington Park and filled with concrete. But even in this condition the frieze is still a fine example of relief composition on a public monument.

In subsequent years Harvey Wiley Corbett became one of the most successful architects in the United States. For his firm's Masonic National Memorial in Alexandria, Virginia, Gail Corbett created a stone medallion relief of *George Washington* on the pediment. In 1913, for the Municipal Building, Auditorium, and Tower of Springfield, Massachusetts, designed by the Pell and Corbett architectural firm, she created bronze panels on three doors, portraying the history of the city, as well as a bronze zodiac and compass in front of the tower. The Corbetts also collaborated on the *Leeds Memorial* cemetery monument in Sleepy Hollow Cemetery, Tarrytown, New York.

In 1929 she created the bronze memorial figure, *The Spirit of Youth* (1929), for Witherby Park, Providence, Rhode Island. Mr. and Mrs. A. Foster Hunt, having lost their talented sixteen-year-old poet daughter, Constance Witherby, dedicated a children's park to her. The lines inscribed on the granite base of the statue are from one of her poems:

> The wind roars by
> I feel it blow
> And know that I
> Am free to go

Corbett created a generalized figure—not a portrait—of a young girl, her draperies blowing in the wind, looking ahead with a faraway gaze. It has been said that *The Spirit of Youth* shows the "influence of Saint-Gaudens.... the richly modeled plastic form at once touches us through its particular emotional sentiment and at the same time evokes the idealized form of aspiring yet hesitant youth."[67] The semicircular granite base was designed by Harvey Corbett.

Gail Corbett exhibited at the Pennsylvania Academy between 1902 and 1913. She won a bronze medal at the 1915 San Francisco Panama Pacific Exposition, served on the National Sculpture Society council in 1923, and exhibited a figure of *Artemis Agrotera* holding a bow in its 1929 exhibition.

> Other works by Corbett include the plaque *Dean Leroy Vernon* (1902, auditorium, Crouse College, Syracuse); memorials to John N. Hazard and Augusta Hazard in Peacedale, Rhode Island; a bust of *Rev. Samuel R. Calthrop* (1910–11, May Memorial Church, Syracuse); *Young Narcissus;* and sundry garden fountains and sundials.

Nancy Coonsman Hahn (1887–1976), from St. Louis, Missouri, carried out several large war memorials.

Daughter of Henrietta and Robert A. Coonsman, Nancy studied for three years at the St. Louis School of Fine Art and at George Julian Zolnay's School of Sculpture. She then went to New York, where, according to her son Charles, she studied privately with Gutzon Borglum and Abastenia Eberle.[68]

After returning to St. Louis, the artist first came to public attention when she won the commission for the *Margaret Kincaid Memorial Fountain* in Lucas Park. Because her winning design included figures of two nude little girls, it was regarded as obscene, and she was denied the prize until she submitted another design. The surrounding publicity probably helped her career.

After marrying Manuel Hahn in 1919 and having a son, the artist won the competition for a *Missouri War Memorial* to be erected at Varennes, France. The Hahns traveled there for the unveiling and remained in Europe in 1922 and 1923. The Daughters of the American Colonists selected her design for a *Memorial to Pioneer Women* (1928), a bronze mother and child, which stood on a granite base between two fountains in front of the Jefferson Memorial Building, Forest Park, St. Louis. But after being stolen and recovered in the 1970s, it was placed inside the building. (The plaster model is at the Son of the Middle Border Museum, Mitchell, South Dakota.)

Nancy Coonsman Hahn working on THE DOUGHBOY (1928), World War I memorial. Now in Veteran's Park, Memphis, Tenn. Photo courtesy of Charles Hahn.

Hahn carried out *The Doughboy* (1928) for Veterans Park, Memphis, Tennessee. A photograph of the artist working on the huge figure of a soldier lunging with a bayonet contradicts all stereotypical images of women artists. Like Theo Alice Kitson, Hahn worked in the mainstream tradition of nationalistic patriotic sculpture. During this period (1916–24), Hahn exhibited at the Pennsylvania Academy, the Art Institute of Chicago, and the Architectural League.

The Hahns lived in Buenos Aires, Burlington, Wisconsin, and elsewhere, before settling permanently in Winnetka, Illinois, where the sculptor became a moving spirit in the North Shore Art League. She spent the last part of her life teaching, doing portrait busts, studies of children, and garden sculpture.

Sally James Farnham, SIMON BOLIVAR (1921), bronze. Collection of the City of New York. Photo: Charlotte S. Rubinstein.

Few of the thousands who pass the large equestrian statue of Venezuelan liberator-hero *Simon Bolivar* at New York's Central Park, know that it was created by a woman, **Sally James Farnham (1876–1943)**, whose artistic career didn't begin until she was married and raising children.

Sally James came from a wealthy family in Ogdensburg, New York. Her father, Col. Edward C. James, a prominent trial lawyer, took her with him when he traveled abroad. Although at the time she was not interested in an art career, she appreciated the great museum collections, especially the sculpture.

Her real interests as a child were riding and hunting on the family estate, activities that gave her the intimate knowledge of horses and other animals that was so important in her later work. In 1896, after attending Wells College, she married Paulding Farnham, who designed silver for Tiffany and Company; they moved to Great Neck, Long Island, and had three children.

During a hospital convalescence in 1901, her husband gave her some plasticine to relieve her boredom. Soon absorbed in the new hobby, she showed a finished piece, *Spanish Dancer* (1901), to her Ogdensburg friend, Frederick Remington, the renowned artist of Western cowboy themes. He urged her to pursue sculpture seriously. She opened a studio and became a professional.

As she worked, she received criticism from Remington, Henry Schrady, Frederick Roth, and others. Over the years, like Remington, she did a series of small bronze cowboys and horses, such as the early *Horse and Rider,* a cowboy falling off his horse (Remington Art Memorial Museum, Ogdensburg, New York), *Scratchin' 'Im,* a cowboy with a rope on a bucking bronco, and *Sun Fisher* (1920), both at the R. W. Norton Art Gallery, Shreveport, Louisiana. *Pay Day Going to Town* (1931, Woolaroc Museum,

Bartlesville, Oklahoma) shows a hilarious galloping group in the same mood as Remington's *Off the Range.*

Farnham's first commission, a *Bacchic Maiden* for a garden fountain in Baltimore, was followed by a *Soldiers and Sailors Monument* for Ogdensburg—a dramatic but conventional figure of Victory holding a laurel wreath, with a flag billowing out behind, atop a tall classical shaft. She also created other war memorials for Rochester and Fultonville, New York, and Bloomfield, New Jersey.

In 1910 she won acclaim for four relief panels depicting the early history of the New World for the board room of the new Pan American Union Building, Washington, D.C. This work was so successful that two portrait busts of South Amer-

Sally James Farnham, FATHER JUNIPERO SERRA (1925), bronze. Brand Park, Department of Parks, Los Angeles. Photo: Charlotte S. Rubinstein.

ican patriots were commissioned for the same building. While working on them, Farnham became immersed in the study of South American history. This background equipped her to win a competition against twenty leading international sculptors for a heroic statue of Venezuelan liberator *Simon Bolivar* (1921), outside of Central Park. For her portrayal of the Great Liberator as a proud caped figure astride a fiery steed, the Venezuelan government (which sponsored the competition) honored her with the Order of the Bust of Bolivar.

Farnham's life-sized bronze statue of *Father Junipero Serra* (c. 1925), the intrepid Franciscan founder of California missions, shown striding forward with a staff in one hand and his other resting protectively on the shoulder of a young Indian boy, stands in Brand Park in front of the San Fernando Mission, San Fernando, California. At the time of the dedication ceremonies, a pageant depicting the founding of the missions was enacted in the mission courtyard.

Other works include portrait busts of actresses *Lynn Fontanne* and *Mary Pickford,* violinist *Jascha Heifitz,* presidents *Theodore Roosevelt, Warren Harding,* and *Herbert Hoover, Marshal Foch,* and other notables; a figure of *Will Rogers* on his pony; and a grieving figure of a woman on a memorial commissioned by Irene Castle for the grave of her husband and dancing partner, Vernon Castle (1922, Woodlawn Cemetery, New York, and Brookgreen Gardens).

Bashka Paeff (1893–1979), born in Minsk, Russia, came to Boston as a small child with her parents, Louis and Fanny Paeff. She enjoyed a long career as a Boston sculptor of realistic portraits, war memorials, fountains, and animals.

Paeff studied with Cyrus Dallin at the Massachusetts Normal School (now the Massachusetts College of Art) and on scholarship with Bela Pratt at the Boston Museum School in 1914. While still a student, she became known in Boston as the "subway sculptor" because she worked on assignments while earning tuition as a ticket taker.

Early in her career, Paeff won competitions for war memorials. One is dedicated to Massachusetts chaplains (Hall of Fame, Massachusetts State House). A bas-relief is on the War Memorial Bridge, Kittery, Maine, and a six-figure *Minute Men Memorial* is in Lexington, Massachusetts.

One of her best-loved works, *Boy and Bird Fountain* in the Boston Public Garden—a crouching nude boy with bird in hand—was inspired by walks through the Public Garden in art school days when she watched children feeding the birds.

After working in Beacon Hill studios and spending two years in France (1930–32), where she exhibited in the Paris Salon, Paeff married Samuel Montefiore Waxman, professor of Romance languages at Boston University, and thenceforth worked in their Cambridge home.

Especially noted for faithfully realistic portraits, done with strength and dignity, her subjects included *Justice Oliver Wendell Holmes* (Washington, D.C.), *Jane Addams* (Hull House, Chicago), *A. J. Philpott,* editor of the *Boston Globe* (Boston Museum of Fine Arts), *Edward MacDowell* (Columbia University), *Justice Brandeis* (Brandeis University), and the *Reverend Martin Luther King* (Boston University). A thoroughly competent technician, Paeff carved the marble portraits herself.

Paeff received the 1961 Daniel Chester French Award from the National Academy of Design for

Bashka Paeff, BOY AND BIRD FOUNTAIN (1934), bronze. Boston Public Garden, City of Boston. Photo: Peter A. Juley & Son. Courtesy of the National Sculpture Society.

sculpture "in the classical tradition" and a medal from the City of Boston. She was a fellow of the National Sculpture Society. A list of her works would extend over many pages.

Portrait sculptor **Margaret French Cresson (1889–1973),** daughter of Daniel Chester French, grew up in New York and at Chesterwood, the family's 150-acre estate and studio near Stockbridge in the Berkshire Hills. The Frenches were frequently visited by diplomats, curators, and artists (it was a tradition for Prix-de-Rome artists to visit them on their way home).

Cresson attended Brearley School, New York, and studied at the New York School of Design, but she was twenty-five before she took up sculpture seriously. Her teachers were first her father, then Abastenia Eberle in New York, and later George Demetrios in Boston and Gloucester. Some of her portraits include *Daniel Chester*

French (1923, N.Y.U. Hall of Fame); *Commander Richard C. Byrd* (Corcoran Gallery of Art, Washington, D.C.), *James Monroe* (National Gallery of Art, Washington, D.C.), *Unknown Soldier, Olga Meštrović,* and *Francesca* (Chesterwood Museum).

In 1921, after marrying Maj. William Penn Cresson, a former diplomat, she lived in Washington and had her studio there, but spent summers working at Chesterwood. Both her husband and father died in the 1930s, but Cresson continued an active career, becoming an academician of the National Academy of Design and living at Chesterwood for part of each year. In 1969 she gave the magnificent estate and studio to the National Trust for Historic Preservation to be maintained as a public museum. A collection of her father's and her own works are on view there.

Meta Vaux Warrick Fuller (1877–1968), a sculptor of Rodinesque bronzes, often dealt in her early work with romantic, horrifying subject matter. But in her maturity she turned to subjects dealing with black awakening and her roots. Because of this focus and her emphasis on the real culture of African Americans, she is today regarded as the pioneering sculptor of the Harlem Renaissance.

Meta Warrick was born into a middle-class Philadelphia family which gave her every advantage. She received drawing and riding lessons and grew up in a genteel, upwardly mobile atmosphere. Her father was a barber who owned several shops, and her mother was a hairdresser in fashionable beauty salons.

At eighteen Meta won a three-year scholarship to the Pennsylvania Museum and School for Industrial Art (now the Philadelphia College of Art) where she was one of very few black stu-

dents. At the end of three years she won a postgraduate scholarship to study sculpture, graduating with honors in 1899.

With some misgivings, her family agreed to let her study in Europe. Arrangements had been made for the distinguished black artist Henry O. Tanner, an uncle's friend, to meet her at the boat. When they missed each other, Meta went on to the American Girls' Club in Paris where she had arranged to stay. But she was turned away because of her race, and Tanner had to help her find a small room in a hotel. The episode was ironic; one of the reasons the family had allowed Meta to go to Europe was the generally held belief in the black middle-class community that European society was more racially tolerant and that she was less likely to have such experiences there. Her mistake had been to arrange for an American hotel.

Between 1899 and 1902, Warrick studied drawing with Raphael Collin at the École des Beaux-Arts and sculpture at the Colarossi Academy with Injalbert and others. In 1902 she exhibited *The Thief on the Cross, The Wretched, Man Carrying a Dead Comrade,* and nineteen other works at M. Bing's important gallery, L'Art Nouveau, and was encouraged by several sales she made at that time. Her romantic images of death, sorrow, and wretchedness, done in expressionistic realism, caused her to be known as "Meta Vaux Warrick, sculptor of horrors." Invited to the studio of Rodin, who reportedly looked at her small plaster model of *Secret Sorrow* and said, "You are a sculptor; your work is powerful," she received criticism from him during her last year in Paris. Warrick exhibited several works in the 1903 Paris Salon. The small painted plaster *Man Eating Out His Heart,* one of her few remaining early works, shows the extraordinary expressionism of this period

(c. 1905–6, private collection). While in Paris she renewed a friendship with the black leader, W. E. B. Du Bois, who encouraged her to turn her attention to the depiction of her own people.

After returning to Philadelphia in 1903, Warrick opened a studio and exhibited frequently at the Pennsylvania Academy of Fine Arts along with Sargent, Cassatt, Chase, and Eakins. Dealers largely ignored her, however, despite the fact that she had been well received at the Paris Salon. In 1907 she received a gold medal for *The Jamestown Tableau,* a fifteen-piece work commissioned for the Jamestown Tercentenary, depicting "the progress of the Negro in America" from the settlement of Jamestown in 1607 (destroyed).

In 1909 Warrick married the distinguished Liberian-born Dr. Solomon C. Fuller, the first black psychiatrist in America, noted for his original work on dementia and Alzheimer's disease (the Solomon C. Fuller Mental Health Center in Boston is named after him). There was much now to divert her from her work. The couple moved into a house they built in Framingham, Massachusetts. Here they had to force their way into the community over the objection of upper-middle-class white neighbors. They had three children and the house was always filled with guests. But the reception of blacks at local hotels was uncertain so that distinguished visitors like Du Bois had to be put up in their home. Moreover, Dr. Fuller expected his wife to devote herself to their children and to his work and was not sympathetic with the needs of an artistic career.

Meta Fuller channeled her artistic impulses through such outlets as the Episcopal church, the Boston Art Club, Zorita, a woman's service club (of which she was president), and other groups. Finally, using her own money and without telling her husband, she built a studio by a pond a short walk from their house, where she continued to work and see students. At first upset when he learned of it, Dr. Fuller decided that if she could carry out such a feat—build an entire building without outside help—she deserved his support.

In 1910 a warehouse fire destroyed most of her early work. But during the next ten years—a period of awakening consciousness and protest against racial injustice in the black community—Fuller produced a group of sculptures that anticipated the Harlem Renaissance.

Emancipation Proclamation was modeled for the 1913 Emancipation Exposition in New York City (plaster, 1913, Museum of the National Center of Afro-American Artists and Museum of Afro-American History, Boston). Fuller explained her theme:

> I represented the race by a male and a female figure standing under a tree, the branches of which are the fingers of Fate grasping at them to draw them back into the fateful clutches of hatred.... Humanity [is] weeping over her suddenly freed children, who, beneath the gnarled fingers of Fate, step forth into the world, unafraid.... The Negro has been emancipated from slavery but not from the curse of race hatred and prejudice.[69]

Emancipation Proclamation was never cast in bronze, because Fuller had done it hurriedly for the exposition and felt that it was not yet finished. For many years this Rodinesque work was lost, and was only recently discovered moldering in a garage. It will be restored when funds become available.

Ethiopia Awakening (1914, bronze, Schomburg Center, New York Public Library) is regarded as a pivotal work in the history of Afro-American art (see p. 253). Symbolizing the emergence of "the New Negro,"

the composition reveals a partially wrapped mummy, bound from the waist down but with the hair and shoulders of a beautiful African woman. The suggestion of death [is] evident in the lower half of the figure while the upper part of the torso is alive and expressive, evoking . . . the rebirth of womanhood, and the emergence of nationhood. The woman wears the headdress of an ancient Egyptian queen . . . but . . . in title and spirit she is unquestionably the image of Ethiopia, mythical symbol of Black Africa. . . .

At a time when Picasso and followers of the modernist tradition gleaned design elements from the art of non-Western societies without being responsible for the cultural context out of which the work came, Fuller's art evidenced a hereditary union between Black Africa and Black America. . . . The symbol of Africa who reaches forth from bondage to freedom connotes the awakening of the forces . . . in rebellion against colonialism and European exploitation of African peoples and resources.[70]

W. E. B. Du Bois and Alain Locke saw in both the condensed "Egyptian" forms and the content of this work a new direction for black artists—one that found its full flowering in the 1920s.

In 1917, when Fuller read about a parade of ten thousand black New Yorkers, who marched in silence down Fifth Avenue as a protest against the lynching of Mary Turner, the artist expressed her feelings in a small sculpture, *Mary Turner: A Silent Protest Against Mob Violence* (1919, painted plaster, Museum of Afro-American History, Boston). It is an introspective female figure, rendered in a loose expressive style, rising up from a sea of flames and tormented faces.

Fuller's major work of the 1930s is *The Talking Skull* (bronze, 1937, Museum of Afro-American History, Boston), a nude black man on his knees, communing with a skull on the ground in front of him. Is he thinking of his ancestors or of those who suffered and died in slavery? She also created many religious sculptures, as well as genre pieces like *Waterboy* (1930). She exhibited in Harmon Foundation shows and served as a juror. After the rise of Hitler, the artist showed the breadth of her feeling for the oppressed in a small sculpture of a refugee Jew trudging forward with a walking stick (*Refugee*, 1940, painted plaster, private collection).

Fuller was one of the organizers of the Framingham Dramatic Society, directed plays, made costumes and sets, and staged tableaux vivantes. Her grandchildren remember that she took a great interest in them and let them model in clay as they kept her company in her studio.

After Dr. Fuller's death, Meta Fuller contracted tuberculosis and was in a sanatorium for two years. Unable to model at that time, she wrote poetry expressing her personal and religious convictions. Afterward she continued to receive commissions until the end of her long life.

Meta Vaux Warrick Fuller, THE TALKING SKULL (1937), bronze, 28″ x 40″ x 15″. Museum of Afro-American History, Boston. Photo (of plaster model): Harmon Foundation Collection, National Archives.

In 1973, the town of Framingham, which sixty-three years earlier had tried to keep the Fullers from settling in their new house, dedicated a public park in their honor. The sculptor received a full-scale retrospective at Framingham's Danforth Museum of Art, and in 1987 she was featured as the pioneering figure in an exhibition and catalog on the Harlem Renaissance at the Studio Museum in Harlem.

> Other works include such religious subjects as *Good Samaritan* (1964) and *Madonna and Child* at St. Andrews Church, Framingham; *Head of John the Baptist* (before 1914), and *The Good Shepherd* (1926). Dance themes include *Isadora Duncan, Danse Macabre,* and *Bacchante* (1930); genre subjects such as *Lazy Bones in the Sun* and *Lazy Bones in the Shade* (1937); portraits, *Richard B. Harrison* as "De Lawd" in *Green Pastures* (Howard University), *Maude Cuney Hare* (Radcliffe College), and plaques of *Solomon Fuller, Frederick Douglass, Harriet Tubman, Phillis Wheatley,* and others. Many works are in the Meta Warrick Fuller Legacy and in other family collections.

May Howard Jackson (1877–1931) was, according to Samella Lewis, "one of the first black sculptors to reject European tastes and to deliberately use America's racial problems as a thematic source of their art."[71]

Her life shows a striking parallel to Meta Vaux Warrick Fuller's. Both artists were born in Philadelphia in 1877 and both began their art training there. Jackson attended J. Liberty Tadd's art school and received a scholarship to the Pennsylvania Academy of the Fine Arts, but, unlike Fuller, she went no further in her training. Both women married successful professional men—Jackson, a school principal; Fuller, a psychiatrist.

In 1902, after her marriage, Jackson moved to Washington, D.C., and gained a reputation there as a portrait sculptor of such prominent African-Americans as poet *Paul Laurence Dunbar* (bronze, Dunbar High School, Washington, D.C.), *W. E. B. Du Bois,* and *Dean Kelly Miller* (1914, Howard University). Critic Cedric Dover has called them "forthright portraits of forthright men."

Prof. James V. Herring invited Jackson to join the faculty of the newly formed art department at Howard University, where she taught modeling for several years. Art historian James Porter, who was in her class in the late 1920s, recalled the beauty of her "lyrical and positive style."[72]

Working largely in the manner of Augustus Saint-Gaudens and other traditional sculptors, Jackson was not a stylistic innovator, but her depiction of African Americans, as in *Head of a Negro Child* (1916), substituted "a sensitive and intensely humanistic approach to the portrayal of black folk types" for the "demeaning [stereotypes] that white America has nourished so carefully for nearly four centuries."[73] In *Bust of a Young Woman* (n.d., plaster, Howard University), Jackson gave a special empathic lilt to the beauty of a young woman, whose expression embodies all the refinement of soul denied to black people by the white community in that era. The tilt of the head, counterbalanced by the lines of shoulder and hair, creates a subtle compositional balance and at the same time suggests a proud, sensitive personality. The textured hair forms a wavelike crest; the long arc of the neck and the delicate bones of the shoulder hint at the beauty of the unseen body.

Jackson exhibited in the New York Emancipation Exposition (1913), the Corcoran Art Gal-

May Howard Jackson, BUST OF A YOUNG WOMAN (n.d.), plaster, height 24″. Permanent collection, Howard University Gallery of Art. Photo courtesy of Bethune Museum and Archives National Historic Site.

lery (1915), and the National Academy of Design (1916). She mounted a solo show at Washington's Veerhoff Gallery in 1916 and won an award in 1928 from the Harmon Foundation. Nevertheless, on the whole, her career was hampered by the absence of exhibition outlets for black artists, the virulent racism in the white community, and the lack of support from people within her own community. W. E. B. Du Bois wrote in 1927 that she became "temperamental, withdrawn, reclusive,"[74] and his posthumous eulogy of her, vividly articulated her tragedy:

> With her sensitive soul she needed encouragement and contacts and delicate appreciation.... In the case of May Howard Jackson the contradictions and idiotic ramifications of the Color Line tore her soul asunder. It made her at once bitter and fierce with energy, cynical of praise and above all at odds with life and people. She met rebuffs ... in her attempts at exhibition, in her chosen ideal of portraying the American mulatto type; with her own friends and people she faced continual doubt as to whether it was worth while and what it was all for. Thus the questing unhappy soul of the Artist beat battered wings at the gates of day and wept alone.[75]

Florence Wyle (1881–1968) and **Frances Loring (1887–1968)**, two Americans who became leading sculptors in Canada, are now so revered that a small park in Toronto is dedicated to their memory. They met in 1907 at the Art Institute of Chicago. Wyle was studying carving with Charles Mulligan and assisting Lorado Taft in his studio when Loring, who had studied in Paris, registered in the sculpture program. The

two outspoken feminists became lifelong friends and opened a studio in Greenwich Village, but Loring's shocked father closed it, insisting that they move to Canada where the family was living. After arriving in Toronto in 1913 they exhibited Rodinesque bronzes at the Royal Canadian Academy and the Ontario Society of Artists, and at the close of World War I received commissions from the War Records Organization for bronze statuettes honoring the munitions workers.

Living under conditions of severe hardship, the two colorful bohemians remodeled a rundown picturesque church building that became the gathering place for intellectuals in the twenties and thirties, including filmmaker Robert Flaherty, painter F. H. Varley, and scientist Frederick Banting. Known as "The Church," it has become a Toronto landmark. Both artists helped found and led Canadian art organizations. Loring was often concerned with social and ethnic themes, as in *Derelicts* (1929), *Miner,* and the over-lifesized *Eskimo Mother and Child* (c. 1938). She carved the art deco recumbent stone lion at the foot of the Queen Elizabeth monument in Toronto's Kwozki Park and in her old age completed a bronze figure of *Robert Borden,* the prime minister, which stands before the parliament building in Ottawa. Wyle created more modest figures, portraits and studies of animals—often simplified art moderne direct carvings such as the robust marble *Torso* (c. 1930), which resembles the work of Maillol.

In their last years critics began to see that "The Girls," as they were dubbed in Toronto, had helped to spearhead the development of Canadian sculpture and had captured in their work a phase of Canadian history—Eskimos, miners, war heroes, and Canadian personalities. The Art Gallery of Ontario houses 185 of their pieces. In 1987 curator Christine Boyanoski organized a major retrospective.

Florence Wyle, HEAD OF F. H. VARLEY (c. 1922), bronze, height 49.5 cm (including base). Art Gallery of Ontario, Toronto. Purchase, Luella McCleary Endowment, 1969.

Frances Loring, ESKIMO MOTHER AND CHILD (c. 1938) painted plaster, height 190 cm. Art Gallery of Ontario, Toronto. Gift of the Estates of Frances Loring and Florence Wyle, 1983.

DESIGN AND CRAFTS

The arts and crafts movement reached an apogee in the first decades of the twentieth century. Women were leaders in the arts and crafts societies that sprang up in Boston, Chicago, and other cities and in the settlement houses that promoted crafts as a means of improving the lot of the impoverished immigrant population.

Among those who worked on handmade furniture were **Zulma Steele** and **Edna Walker**, two Pratt art school graduates hired in 1902 to design ornamental motifs for the craftsman-style

Adelaide Alsop Robineau, CRAB VASE WITH STAND (1908), porcelain. Collection Everson Museum of Art, Syracuse.

furniture produced at Byrdcliffe, a "Ruskinian" utopian crafts community set up in Woodstock, New York. Byrdcliffe was the start of the famed Woodstock art colony.

In the Bay Area, **Lucia Kleinhans** married her painting professor, Arthur Matthews, and together they set up the Furniture Shop after the 1906 earthquake to design Arts and Crafts furniture, standing screens, and other objects that brought beauty into all aspects of the home (many pieces are at the Oakland Museum). Lucia Matthews, a leading California tastemaker, carved and painted frames for her watercolors that are as beautiful as the paintings themselves. She brought a distinctive color sense and use of native motifs, such as the California poppy, into the work.

Harriet Frishmuth and other sculptors designed bookends and small bronze objects. The 1987 exhibition catalog *The Art That Is Life: The Arts and Crafts Movement in America: 1875–1920* revealed the work of a whole group of extraordinary metalworkers: **Madeline Yale Wynne,** who pioneered the use of bold, unrefined hammered and enameled jewelry; **Josephine Hartwell Shaw,** a leading jeweler in the Boston Society of Arts and Crafts; **Florence Koehler,** whose jewelry was so magnificent that the avant-garde critic Roger Fry wrote an article declaring her work to be "of the same order as those which the 'Fine Artist,' the creator of great figurative design, displays." Some others who created enameled cloisonné, jewelery, or silver objects were Boston's **Elizabeth E. Copeland,**

Indianapolis's **Janet Payne Bowles,** and Cleveland's **Mildred G. Watkins.**

An enormously influential woman throughout this period was **Elsie de Wolfe (Lady Mendl).** In New York City, France, and later Los Angeles, she revolutionized the concept of interior design, moving it away from the dark, heavy, formal interiors of the Victorian era to the light, open, and practical style of the 1920s. An international celebrity, she is discussed in Isabelle Anscombe's book, *A Woman's Touch: Women in Design from 1860 to the Present Day.*

Women working in art potteries—Rookwood, Newcomb, Pewabic—continued the progress begun by Maria Longworth Nichols and Marie Louise McLaughlin. The woman who won the highest international ceramics awards for the United States was **Adelaide Alsop Robineau** (see chapter 4) of Syracuse, New York. Ceramics historian Garth Clark points out that her world-famous, intricately carved *Scarab Vase* expressed America's growing mastery of technical skills. A consummate craftswoman, she developed to perfection the difficult technique of incising designs on the dry but unfired clay. Each of her pieces advanced the art of ceramics, exploring some new and difficult aspect of porcelain firing, glazing, or decoration. Unlike earlier china painters and decorators, Robineau was as concerned with the creation of splendid pottery forms as with their surface design.

After World War I, art deco and other machine-age trends emerged. They are discussed in chapter 6.

• 6 •

Women in the Avant-Garde: 1905–1929

Although, as we have seen, most American sculptors continued to create traditional fauns, fountains, and monuments, a small group—influenced by European movements—was beginning to invent radically new and disturbing forms.

The mere copying of the external appearance of things could no longer adequately express the dynamism of the twentieth century, the machine age of speed and dizzily accelerating change—of skyscrapers, motor cars, and airplane travel. Revolutionary thinkers like Einstein, Planck, and Freud were challenging previous conceptions of the universe and the human psyche. Underneath the appearance of a stable, ordered, and rational world, all matter was in motion, all viewpoints were relative, and the actions of human beings seemed to be driven by irrational impulses beyond their control. At the same time, the first world war revealed the abyss that lay beneath the shining exterior of technological society, causing many intellectuals to question the values of so-called civilization.

Although American artists lagged behind Europe, a handful of pioneering sculptors influenced by Picasso and Brancusi began to fracture

forms, strip them down to their essence, or invent new ones that never existed in nature. There was a revival of direct carving in stone and wood, and a new interest was manifested in primitive art. Stieglitz exhibited modern art at his gallery; the 1913 Armory Show brought cubism and futurism before a shocked public; and the newly formed Society of Independents challenged the jury system by opening its exhibitions to all artists and all forms of expression. Women sculptors played a role in all these developments.

POSITION OF WOMEN

For women it was an era of radical new lifestyles and social reform. Emma Goldman and Margaret Sanger dared to raise the previously taboo issue of birth control; both endured jail sentences for demanding the legalization of contraceptives. The anarchist Goldman called for woman's right to enjoy her sexuality in new, nonexploitative relationships. Although she was ultimately deported for opposing America's entry into World War I, she had a great influence on artists and intellectuals in the era leading up to the war.

Social reformers, particularly in the Women's Trade Union League, fought against the economic exploitation of women. Bessie Abramowitz, Rose Schneiderman, and other women were early organizers of the garment workers. The notorious Triangle Fire of 1911, in which 143 women garment workers were burned alive, sent thousands of them into the streets to protest unsafe factory conditions. And of course, after seventy years of struggle, women finally won the right to vote in 1920.

Part of the liberation of women was their radically new sense of their own bodies. Women athletes, like tennis star Helen Wills Moody,

achieved fame. We have already seen the influence of this new image of woman in the dancing figures of such traditional sculptors as Harriet Frishmuth and Malvina Hoffman, but it also appears in the work of modernists such as Alice Morgan Wright.

In 1925 this female radicalism was reflected in a new art organization. The New York Society of Women Artists, a group of twenty-six modernists who broke away from the relatively traditional National Association of Women Painters and Sculptors, held their first exhibition at the Anderson Galleries, New York, in 1926. Marguerite Zorach, by then a well-known modernist, was the first president, and four sculptors were among the founding members—Ethel Myers, who was treasurer, Sonia Gordon Brown, Minna Harkavy, and Concetta Scaravaglione.

SALONS AND PATRONS

In the new bohemias that flourished in Paris and Greenwich Village, and in the art colonies that had sprung up in Provincetown, Woodstock, Taos, and elsewhere, women were influential salon leaders and patrons of modern art.

In Paris, the avant-garde author Gertrude Stein and her companion Alice B. Toklas held forth at 27 rue de Fleurus. One of the earliest collectors of Picasso, Stein introduced cubism to artists and intellectuals from two continents, and her sister Sarah Stein, with Edward Steichen, initiated the first American exhibition of Matisse's work at the gallery 291. The Cone sisters of Baltimore were among the first collectors of Matisse's paintings, which are now in the Baltimore Museum's famed Cone Collection.

The volatile, flamboyant Mabel Dodge, an heiress from Buffalo, first saw modern art at Gertrude Stein's apartment. After returning to New York, she became caught up in the excitement of the Armory Show—"I am working like a dog on it. . . . I am all for it!"—and wrote an article about it for *Arts and Decoration.* Between 1913 and 1917 she made her Fifth Avenue apartment into a salon frequented, she wrote, by "Socialists, Trade-Unionists, Anarchists, Suffragists, Poets, Lawyers, Murderers, . . . Psychoanalysts, I.W.W.s, Women's-Place-is-in-the-Home-Women, Clergymen, and just plain men . . . [who] all met there and stammering in an unaccustomed freedom a kind of speech called Free, exchanged a variousness in vocabulary called in euphemistic optimism, Opinions."[1] Dodge's salon was the catalyst for many new ideas in art and other fields. After settling in New Mexico, she attracted to her sprawling adobe hacienda D. H. Lawrence, Malvina Hoffman, Georgia O'Keeffe, and others and inspired an interest in American Indian culture.

Louise and Walter Arensberg, stimulated by the Armory Show, began to collect the work of modernists such as Marcel Duchamp, and opened their New York apartment to a New York dada group that included Duchamp, Picabia, Man Ray, Beatrice Wood, the Baroness Elsa von Freytag-Loringhoven, and Katherine Dreier. Dreier, with Duchamp, opened the first museum of modern art in America. Agnes Meyer, a member of the inner circle around Alfred Stieglitz, helped write and publish the avant-garde periodical *291*; in 1914, having discovered some Congo carvings in a London gallery, she and her husband arranged to have them exhibited at 291—one of the first exhibitions of primitive sculpture in the United States. In 1916 she was a backer of Marius de Zayas's Modern Gallery which presented some of the earliest exhibitions of American abstract sculpture.

Painter Florine Stettheimer and her sisters, known as "the Stetties," created an important modernist salon in their New York apartment af-

ter World War I. Editors Margaret Anderson and Jane Heap introduced modern art to the American public in the pages of their *Little Review* (they also went to jail for printing the "obscene" novel *Ulysses* by James Joyce). The Baroness Hilla Rebay interested Solomon Guggenheim in forming a collection of abstract and nonobjective art that ultimately became the Guggenheim Museum, and Galka Scheyer, a prophet in the southern California wilderness, argued the merits of European expressionism and formed a core collection that is now part of the Norton Simon Museum. Abby Aldrich Rockefeller, Lillie Bliss, and Mrs. Cornelius J. Sullivan co-founded the Museum of Modern Art.

THE ASH CAN SCHOOL

The first major challenge to the conservative Beaux Arts tradition was the realistic "ash can school," a group of painters and sculptors who began, around 1904, to portray in a loose, free, reporterlike style the downtrodden, the immigrant, and the everyday life of people in slums and big cities. These artists reflected a time of social reform—the Progressive Era—when muckraking writers like Lincoln Steffens and Upton Sinclair were exposing the corruption of politicians and the exploitation of the poor by uncontrolled monopolies.

Abastenia Eberle and Ethel Myers modeled small lively bronze genre studies that, although not radical departures in form, presented a fresh new content. Two drawings by Myers express the spirit of the era, contrasting "the Classes" and "the Masses": *Drawing* savages the gross, overfed devotees of "conspicuous consumption" whom Thorstein Veblen castigated in his books; *Hester Street* (1904, Syracuse University) shows poor immigrants in New York's East Side slums.

(Mary) Abastenia St. Leger Eberle (1878–1942) portrayed, in earthy small bronzes, the everyday life of poor immigrants on New York City's East Side. Her *Ragpicker* (1911) could serve as the symbol of the ash can movement. A socially conscious artist, she once said that "the artist has no right to work as an individualist without responsibility to others. He is the specialized eye of society.... An artist can be a leader just as well as a writer ... [and] should open [the people's] eyes to the meaning of today."[2] She had a tremendous love for the common people and chose to live among them so as to experience their lives and portray them truthfully. She once said, "Among the tenements the people do not appeal to me as poor people. They are human beings through whom I get at the living spirit of humanity more vitally than elsewhere."[3]

Born in Webster City, Iowa, and raised in Canton, Ohio, Eberle was the daughter of a doctor who took an interest in her development but never provided her with much income. Her professional career was always something of a struggle.

Eberle's mother gave piano lessons and encouraged her musical talents; in fact, the young girl was studying the cello professionally until "One day I pinched up a clay mask in the garden.... [It] struck my father as good and he took me with him next day to see a patient of his who made busts.... Through him I got some modeling wax, for I knew as soon as I saw his work that I could do that."[4] Eberle began to copy the tombstones in the town cemetery—the only sculpture in the community. Anxious to receive training, she singlehandedly rounded up ten pupils when she heard that sculptor Frank Vogan would come to Canton and teach a class. For two years she studied with him: he "happened to be very good and gave me invaluable help." When the young sculptor studied with George Grey

Ethel Myers, DRAWING (n.d.). Collection of Ira and Nancy Glackens. Copy photo: Christman.

Edith Dimock (Glackens), THE OLD SNUFF-TAKER, (n.d.), wash drawing. Collection of Ira and Nancy Glackens. Copy photo: Christman.

Ethel Myers, HESTER STREET, NEW YORK CITY (1904), ink and pencil on wove paper, 7¼" x 7". Courtesy of the Syracuse University Art Collection.

Barnard at the Art Students League, she won immediate recognition, earning her tuition with scholarships and prizes. Even so, she sometimes had to make dinner out of a bag of peanuts.

While visiting her family in Puerto Rico (where her father was now an army doctor), she made clay sketches of subjects seen on the streets. *Puerto Rican Mother and Child* (1901) was the first time she depicted the life of the poor.

Eberle shared a studio on Thirty-third Street with two musicians and another talented sculptor, Anna Hyatt. A pleasant bohemian ambience pervaded the women's studio as the composer played exotic Indian music while the artists worked. Eberle's stone bust of Hyatt at this time captures her friend's calm dignity (1905, San Diego Museum of Art).

The two women collaborated on *Men and Bull* (Hyatt did the bull and Eberle modeled two muscular men restraining it), which won a bronze medal at the 1904 St. Louis Exposition and brought them publicity in the *Craftsman.* But the two artists soon went their separate ways to very different careers—Hyatt as a creator of animal sculpture and large monuments, and Eberle, the social reformer, as the sculptor of small bronzes of the common man and woman.

As early as 1906 Eberle completed a lively clay study of an urchin careening down the street on roller skates (*Roller Skater,* Whitney Museum of American Art). The first of her studies of New York street life, it was created two years before "the Eight" introduced the ash can school to the public at the Macbeth Galleries.

In May 1907, Eberle went to Naples, Italy, to supervise the casting of her small bronzes. At first the foundry workmen, who had never seen a woman sculptor, were scornful, doubting that she had done them, but after they watched her

retouch the delicate wax models and were reprimanded by her for sloppy work, they came "to the conclusion that I knew what I was about. . . . then every wish was anticipated and half a dozen hands would reach out to give me whatever I might happen to need." Passersby looking through the open door continued to exclaim "Dio Mio. A woman doing man's work?"[5] Eberle loved the Neapolitan people and took a great interest in the workmen and their families. Struck by the realization that street urchins scrambled for the scraps she threw to the cat and that the workmen subsisted on a hunk of bread until dinner time, she gave them all a lavish farewell breakfast, described amusingly in an article in the *New York Sun*.

Returning from Italy, where, she said, she had steeped herself "in the classic arts and was filled with the past," Eberle suddenly awoke to her true subject matter: "When I landed in New York I began again to sense the modern spirit and to live in the present workaday world with all its commonplaces and yet with its idealism. . . . I smelt the city's pungent odors and saw its children playing."[6] That summer she became a settlement worker on the Lower East Side in order to "study the people there and the conditions under which they live, to be near them and to learn from them." She modeled children in action on the playground in works like *Bubbles* (1908), a study of a little girl blowing soap bubbles.

After moving into a studio in Greenwich Village (a melting pot of immigrants, noted for its pushcart-lined streets, low rents, and bohemian intellectual fervor), she created some of her most powerful works. Art historian Milton Brown has pointed out that the ash can painters, such as Sloan and Luks, despite their notoriety as the radical "Black Gang," were not very political in their art; for the most part their work shows a kind of democratic empathy with the exuberant street life of the poor.

Abastenia Eberle, ON AVENUE A (or DANCE OF THE GHETTO CHILDREN) (1914), plaster, height 36.8 cm. Collection: Kendall Young Library, Webster City, Iowa.

Abastenia Eberle, RAGPICKER (1911), plaster, height 33 cm. Collection: Kendall Young Library, Webster City, Iowa. Photo: William C. Rubinstein.

Eberle used similar themes of children dancing to the hurdy-gurdy (*On Avenue A,* or *Dance of the Ghetto Children,* 1914, plaster, Kendall Young Library, Webster City, Iowa; *Girls Dancing,* 1907, Corcoran Gallery), but she also created works that cry out for social justice. *Ragpicker* (1911, plaster, Kendall Young Library, Webster City, Iowa) is a kerchiefed immigrant beggar woman hunting for castoffs in a garbage pail; *Old Woman Picking Up Coal* (1906, bronze, Hirshhorn Museum, Washington, D.C.) portrays a poor Italian woman scavenging in the streets for bits of coal for her stove. *Unemployed* (unlocated) is the figure of a dejected man with hands hanging impotently at his sides. For eco-

nomic reasons, Eberle also turned out subjects with more appeal to the conventional buyer—dancers in swirling veils and the fashionably exotic *Omar Khayyam* bookends (1913).

One of her most popular works, *The Windy Doorstep* (1910), came not from her East Side experiences but from summers spent in Woodstock, the art colony near New York. The sight of the local farm women sweeping their stoops on a windy morning inspired a lively study of circular rhythms and strong diagonal oppositions, which won the Barnett Prize for the best piece by a sculptor under thirty-five at the 1910 National Academy of Design exhibition. Cast in an edition, it was bought by several museums (To-

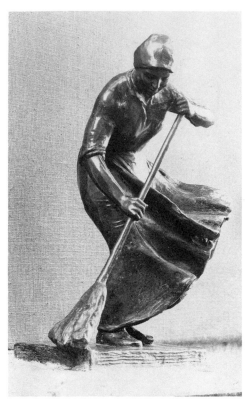

Abastenia Eberle, THE WINDY DOORSTEP
(1910), bronze. Collection of Brookgreen
Gardens. Photo courtesy of the National
Sculpture Society.

ledo Museum of Art; Brookgreen Gardens) and
was reproduced in magazines. Eberle later rec-
ognized that she was expressing a subconscious
urge to "sweep out" the stale academic tradi-
tions of the past and substitute a new approach.

Invited to exhibit in the 1913 Armory Show,
Eberle submitted *Girls Wading,* a study of three
girls at the Coney Island beach, and *White
Slave,* a shivering nude adolescent, arms pin-
ioned behind her, being auctioned into prostitu-
tion by a gross, hand-waving auctioneer. This
work caused storms of controversy when it was

reproduced on the cover of the *Survey,* a maga-
zine devoted to social reform. Readers protested
that such a cover was unfit to be displayed on a
table in a decent home.

White Slave was Eberle's response to muck-
raking newspaper stories describing the fate of
poor immigrant girls forced into an underground
network of prostitution rings. Her bony, shiver-
ing girl is very different from the erotic nine-
teenth-century images of women in such sculp-
tures as Hiram Powers's *Greek Slave. White
Slave* reflects Eberle's growing social con-
science. Stirred by the writings of Jane Addams,
she had formed friendships with social reform-
ers and was a strongly committed feminist who
marched at the head of a contingent of women
sculptors in a 1911 suffrage parade.

Art News, reviewing a 1909 exhibition of
small bronzes at the Macbeth Gallery, stated that
"one counts on Miss Eberle as one of the Amer-
ican sculptors who will develop the art of her
own land with fearlessness and beauty." After
the public flocked to see Belgian sculptor Con-
stantin Meunier's small bronzes of laborers at
Columbia University, the Macbeth Gallery de-
cided to hold a 1914 show of American work,
Everyday Life of the Common People. The *New
York Times* praised Eberle's pieces: "The scrub-
ber scrubs, and the sweeper sweeps, even the
Little Mother holds her charge with a certain
ease and buoyancy. Not a sentimental view of the
toiling millions, but . . . a true one . . . [with] sim-
ple and even noble rhythms."[7]

The following year Eberle coordinated a
theme show, The Dance as Interpreted by Amer-
ican Sculptors, at the Macbeth Gallery, in which
she exhibited both her dancing street urchins
and Isadora Duncan–type dancers. In 1915 she
organized a large exhibition of women artists at
the Macbeth to raise funds for the suffrage
movement.

Now well established, Eberle became concerned that her work was losing its lusty proletarian character—a fear confirmed by a friend's giving her a tea cart in appreciation of the many tea parties she had attended in Eberle's studio: "The tea wagon showed her that she was in danger of settling down to make sculpture for an audience that liked tea and cake with its art. The day after receiving the teacart Eberle went down to the lower East Side, tramping through the swarming streets looking for a place to set up a studio."[8]

On the top floor of a squalid tenement, under the roaring traffic of Manhattan Bridge, Eberle set up a studio with a playroom in it. Using toys and stories as lures, she attracted children to serve as her models (*Playing Jacks*, c. 1914). Here she sculpted the figure of a mother she had seen in a street fight, shaking her fist in defiance as she clutches her child in one arm (*You Touch My Child and I'll!*, c. 1914, Corcoran Gallery of Art). Raw and spontaneous, with an unfinished look of fingers in the clay, this work exudes pure feeling. *The Old Charwoman* (1919, plaster, Kendall Young Library, Webster City, Iowa) is a warm portrayal of an Irish immigrant woman with dustpan and broom, who cleaned business buildings.

The Macbeth Gallery honored her with a solo show in 1921, but by then Eberle was very ill with heart trouble and her work tapered off. During the depression, the artist, who was perpetually burdened with unpaid bills, was rescued by a former pupil, Virginia Thornburn Hart, who took her into her apartment, spent summers with her in a remodeled barn in Westport, Connecticut, and cared for her to the end.

With the rise of abstract art in the 1940s, Eberle's work was ignored. Modernist critic Barbara Rose dismissed her as "hardly . . . imaginative" in the survey *American Art from 1900.*

Not until the Whitney Museum's bicentennial exhibition, 200 Years of American Sculpture (1976), did Daniel Robbins select her as a pioneer sculptor of the ash can school, along with Mahonri Young.

Fortunately, Eberle had given a large group of plaster models to the Kendall Young Library in her hometown, Webster City, Iowa, so that in 1980, when Louise Noun mounted the first comprehensive retrospective of Eberle's work, with an important catalog, she had a fairly complete collection to draw on.

Mae Ethel Klinck Myers (1881–1960)

Is it too much to call these the *tanagras* of early
Broadway, these votive shapes of the shop girl
dressed to kill, the cleaning woman in day-off finery?
—Leslie Katz[9]

Ethel Myers (born Lillian Cochran) was recognized as one of the most original American sculptors in the Armory Show, but she subordinated her career to that of her husband, the ash can painter Jerome Myers.

An orphan tossed around from family to family, Lillian Cochran was finally adopted by a well-to-do couple, Michael and Alfiata Klinck, who renamed her Mae Ethel Klinck. She studied music, encouraged by her mother, until she decided at Newark High School to be an artist.

Ethel Klinck studied for six years at the Chase School of Art (later the New York School of Art) with William Merritt Chase, Robert Henri, and Kenneth Hayes Miller, in classes where her fellow students included Edward Hopper, Joseph Stella, and others destined to become leaders of American art. She became the school's assistant director, later claiming that it was she who persuaded the school to hire Robert Henri—the teacher who became such an influence on her and other artists of that era. Henri urged his stu-

dents to express themselves freely and to capture the spirit of contemporary life in all its rawness and immediacy.

As early as 1904 she was making hundreds of expressionistic ash can sketches, such as the droll East Side street scene *Hester Street*. Fascinated by the ash can paintings of Jerome Myers, Klinck was curious to meet him; she visited his studio and three months later he proposed to her. Although she was engaged to someone else at the time and her mother was opposed to the union, the impetuous artist married Myers in 1905. A year later their daughter, Virginia, was born in their studio.[10]

After the birth of her daughter, Myers switched from painting to modeling small figures in wax or clay. She claimed, in her notes, that the studio was too small for two painters, but perhaps the real reason was that she did not want to compete in the same field as her husband.[11]

Myers's loosely modeled caricature types, like her drawings, have a droll and quirky quality, with faint echoes of Gaston Lachaise and Honoré Daumier. Broad parodies, they show grandes dames at the Metropolitan Opera, bosomy matrons balancing ridiculous 1910 hats, the exaggerated "Lillian Russell" look of a young coquette, a paunchy gambler. The sculptor also did portraits of society women (*Mrs. Albert Lewison*) and theatrical stars (*Florence Reed*). Her works deal with middle-class and theater subjects, in contrast to Eberle's proletarian studies.

Myers was sensitive to the expressiveness of clothing. Recognizing that "clothes make the man (or woman)" and that we all wear "uniforms," she used the sweep and rhythm of costume, the broad gesture, to define personality, in contrast to the faces which are barely suggested. Unable to afford to cast more than a few works in bronze, she painted the plaster casts with brownish-tan, blue, or green tones. According to

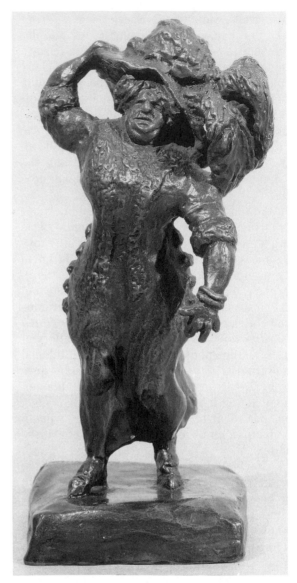

Ethel Myers, THE MATRON (1912), bronze height 8″. Courtesy of Kraushaar Galleries, N.Y.C. Photo: Geoffrey Clements.

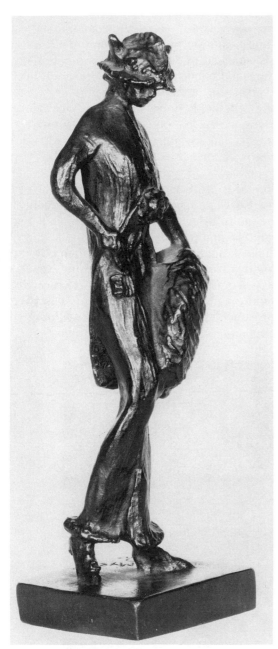

Ethel Myers, MRS. DANIEL H. MORGAN (c. 1910), bronze, height 8½". Collection of Nancy and Ira Glackens. Copy photo: Christman.

art historian Saul Zalesch, the colored plasters have a vitality that is sometimes lost in bronze.

In 1912, fifteen sculptures at the Folsom Galleries, New York, were favorably reviewed in the *Craftsman* magazine as "miniature pieces of sculpture holding mighty satire on the more or less undeveloped feminine humanity, the by-product of a huge, heartless city.... Clothes to them become almost the sum total of human achievement.... Their enjoyment of life is flamboyant and their expression of it showy and tawdry.... all of the lines and curves and eccentricities that make for fashion are exaggerated in their pose and garments."[12]

Fifth Avenue Gossips portrays three bustled girls in huge flower-garden hats, arm in arm in a huddle, whispering about passersby. *Miss Broadway* is a cruel portrait of "senile coquetry." A skinny little girl (*The Apprentice from Madison Avenue*) rushes along in a huge unwieldy hat with a gigantic plume jutting out behind it. These studies seem to be social critiques—part of the dress reform movement of the early twentieth century. Recognizing her originality, the reviewer in the *Craftsman* concluded: "In the past Mrs. Myers has been better known to the artist world as a painter of courage and skill; for the future she must rank ... as a sculptor with the power of presenting through her work a knowledge of life and understanding of human psychology as rare as it is interesting."[13] When nine of these small sculptures were shown at the Armory Show, they were much admired, even described as "a revelation."

The Myerses went abroad in 1914, hoping to study in Paris, but, caught in World War I, they had great difficulty returning home. In order to help support the family, Ethel Myers became a dress designer, with a shop staffed by several seamstresses. William Glackens's son Ira (author of *William Glackens and the Ash Can*

School) remembers how the plump, blonde little woman functioned efficiently, putting up meals ahead of time so that they would be ready for company when she got home from work. This didn't leave much time for sculpture. She sublimated much of her artistic drive by promoting the career of her husband and pushing her daughter to pursue a ballet career.

Myers exhibited from time to time (reportedly at the Berlin Gallery, 1914; Knoedler's, New York, 1920; Pennsylvania Academy, 1920; Carnegie Hall Gallery, New York, 1940). After her husband's death, she organized a retrospective and set up a gallery of his work, lecturing about it around the country. From 1949 to 1959 she was director of the fine arts and ceramics department of Christodora House.

For several decades Myers's work was neglected until art historian Milton Brown reconstructed the Armory Show in an exhibition, and the George Schoelkopf Gallery, followed by the Kraushaar Gallery, brought her original, expressionistic work into view once more.

CUBISM, FUTURISM, AND ABSTRACT SCULPTURE

Even before the Armory Show, American artists such as Max Weber, Andrew Dasburg, Anne Estelle Rice, Marguerite and William Zorach, and others went to Paris and were stimulated by the sight of radical new art forms at the Salon d'Automne and the Salon des Independents. And Alfred Stieglitz showed fauve and cubist works at his New York gallery 291.

In 1913, a group of Americans organized an international exhibition of modern art, the Armory Show, to acquaint the United States with the exciting trends that were taking hold in the art world, both here and abroad. Sculpture by Americans in the show (including nine women),

however, was still relatively conventional compared to that by Europeans: the public was utterly shocked by such European modernists as Brancusi, Lehmbruck, Archipenko, and Picasso. Nevertheless, a handful of Americans, among them Adelheid Roosevelt and Alice Morgan Wright, were soon exploring cubist, futurist, and nonobjective sculpture forms. These were early tentative efforts by a small avant-garde.

Alice Morgan Wright (1881–1975), one of the first American sculptors to experiment with cubism and futurism, divided her energies between sculpture and political activism.

The daughter of Emma and Henry Romeyn Wright, a wealthy merchant in Albany, New York, she began to whittle at age ten after receiving a jacknife as a gift. By the time she was twelve, she knew that she wanted to be a sculptor.

Alice Morgan Wright in Paris studio with her sculpture THE FORCE (or THE MOUNTAIN) (c. 1912). Photo courtesy of the National Sculpture Society.

At Smith College, the spirited, independent girl—an intellectual with wide-ranging interests—edited the *Smith Monthly,* was a member of the student council and hockey team, wrote a version of the Sankskrit drama *Sakuntala* for the senior play, and was almost expelled for directing a parody of the religious play *Everyman.* Wright later published poetry in *Harper's,* the *Literary Digest,* and elsewhere, but her main focus remained sculpture.

While studying at the Art Students League with Hermon A. MacNeil and James Earle Fraser, Wright attended boxing and wrestling matches to study the male figure because women could not at that time work from the male nude. Having won the Gutzon Borglum and Saint-Gaudens prizes and exhibited at the National Academy, Wright made the pilgrimage to Paris in 1909. She studied at the École des Beaux–Arts and the Colarossi Academy, producing works in her own studio that were shown at the 1912 Paris Salon, the 1913 Salon d'Automne, the Royal Academy in London, and in the United States. The influence of Rodin can be seen in the two-figure *Wayfarers* (1909, marble) rising from a rough-chiseled block and a sculpture of figures moving a great mass, called *Force* or *The Mountain* (1910, plaster).

That same year Wright began to "move mountains" in another way. She and two friends organized a large meeting in Paris for Emmeline Pankhurst, a leader of the British suffrage movement. Wright then crossed the Channel to join a suffrage demonstration in London that culminated in window smashing. As she and a group of suffragists were carried off in a police van, they sang the "Votes for Women Song" to the tune of "La Marseillaise." Sentenced, along with Pankhurst, to two months in Holloway Prison, Wright joined a hunger strike in the cells and narrowly missed being force-fed when she was released early. During this time, the artist managed to have smuggled in some plasteline with which she modeled a head of the inspiring *Mrs. Pankhurst* (1912, Smith College). Later the artist looked back wih nostalgia at the comradeship and spirit of those days.

Although advanced in her political views, Wright was not yet advanced in her judgment of art. In 1910 she wrote home from Paris that Matisse was "nutty.... His work is the most screamingly funny stuff that I ever laid eyeball on."[14] But after returning to New York City in 1914 during the post–Armory Show ferment in Greenwich Village, Wright began to abstract her work and introduce the overlapping planes of futurism. In 1916, Marius de Zayas showed her abstract sculpture and that of two other American modernists, Adolf Wolff and Adelheid Roosevelt, at his Modern Gallery, along with the work of the Europeans Modigliani and Brancusi. It was a landmark show; only a handful of Americans (such as John Storrs and Max Weber) were as advanced as these sculptors.

A founding member of the Society of Independent Artists, Wright exhibited *Wind Figure* (1916) at the 1917 opening show, where it was bought by Arthur B. Davies, one of the organizers of the Armory Show. At the same time, Wright continued her political activity, marching in suffrage parades, joining the New York State Women's Suffrage party, and helping found the New York State League of Women Voters in 1921.

Wright's creativity peaked between 1916 and 1920. Among her highly abstracted works representing dancers or windblown figures are *Wind Figure* (1916, bronze), a dancing, ghostly, hooded figure, reduced to simplified planes; *Leaping Figure* (bronze), reduced to an elemental upreaching rhythm; and *Dance I* and *Dance II* (1920, plaster), futuristic plaques in which lines of force are emphasized in overlapping rhythms. The semiabstract figures of *Lady Macbeth* (1918) and *Medea* (1920), and the *Trojan*

Alice Morgan Wright, WIND FIGURE (1916), bronze, height 10½". Hirshhorn Museum and Sculpture Garden, Smithsonian Institution. Gift of Elinor Fleming, 1983.

Women (1927), a chorus of swirling figures in overlapping rhythms, reflect Wright's continuing interest in literature.

The artist's most dynamic work, *The Fist* (1921, plaster, Albany Institute of Art and History), sometimes called *The Prize Fight*, twists in powerful rhythmic forms like a forceful blow, changing as it is viewed from different vantage points. Its faceted, abstract, overlapping planes are reminiscent of Duchamp-Villon's futurist *Horse* of 1914.

After returning in 1920 to Albany, where she remained for the rest of her life, the sculptor set up a studio on the top floor of her parents' home. Her sculpture tapered off, and after 1930 most of her energy went into writing and organizing for various causes, such as humane treatment of animals, for which she traveled all over the world.

Alice Morgan Wright, THE TROJAN WOMEN (1927), back view. Unlocated. Photo courtesy of the National Sculpture Society. Photographer: De Witt Ward. A bronze cast is in the collection of the Albany Institute of History and Art.

Alice Morgan Wright, THE FIST (1921), plaster, height 34″. Collection Albany Institute of History and Art. Gift of Mrs. Clark Fleming. Photo courtesy of the National Sculpture Society.

Art historian Betsy Fahlman has pointed out that even during her peak period, Wright vacillated between conventional art and modernism. Although she created some original and advanced works, she nevertheless also turned out an occasional faun and other sculptures that range from Rodinesque romantic realism to art deco. A woman of independent means, she did not have the economic pressures that might have led to a longer and more developed career. Yet a small body of her works are among the earliest and strongest avant-garde sculptures created by an American.

Fahlman resurrected Wright's life and career in a 1978 retrospective at the Albany Institute of Art and History. The accompanying catalog is the source of many details and insights.

Adelheid Lange Roosevelt (1878–1962), a shadowy, tantalizing figure whose work is known to us principally through photographs, was another vanguard abstract sculptor around 1915. Douglas Hyland, who brought her career to light, said that "no other American sculptor, with the possible exception of Max Weber and Alice Morgan Wright, was producing such advanced work."[15]

Born into a wealthy St. Louis family of German heritage, "Heidi" was educated in Germany as a child and later earned a degree in architecture from the Zurich Polytechnic Institute in Switzerland.

Beginning in 1903, Lange was one of the first practicing women architects in the United States, working for St. Louis architect Theodore Link. After she met and married André Roosevelt (a relative of Theodore Roosevelt), daredevil film director, mountain climber, and aviator, they lived in Paris and New York and were au courant about avant-garde currents in both countries; their friend Francis Picabia introduced them to Léger, Gertrude Stein, Brancusi, and others.

Greatly stimulated by her first glimpse, at the 1912 Salon d'Automne, of cubist sculpture (which to her architect's mind seemed strongly related to architecture), she embarked on studies with the cubist sculptor Raymond Duchamp-Villon, who became a close friend. Her first works were simplified figures and heads reduced to bold planes (*Nude Man Striding Forward,* 1912–13; *Bust of a Woman,* 1912–13, both unlocated).

Enthralled by the historic 1913 Ballet Russe production of Stravinsky's *Rite of Spring,* Roosevelt modeled two statuettes that expressed the lines of force of the dancers' movements—her first attempts at abstraction: "It was not the individual dancers, not their beautifully shaped bodies, but the imaginary curves they made when dancing that gave me that deep inner emotion, my love for subtle beauty."[16]

Roosevelt also spent time in the studio of Constantin Brancusi. According to Douglas Hyland: "Brancusi's total disregard of conventions and his freedom of self-expression appealed to this rebellious, enthusiastic woman, who shared his views on life."[17] He notes that her small sculpture, *Bird* (c. 1913, cherrywood, Spencer Museum of Art, Lawrence, Kansas), a rare surviving work, clearly shows his influence. Its tapering form, reduced to a few soaring arcs balanced on a slender point, resembles Brancusi's bold simplifications.

After the sculptor returned to New York at the outbreak of World War I, Marius de Zayas, director of the pioneering Modern Gallery, included three of her works—*Atoms, Tennis Player,* and *Tennis Player–Serving*—in an exhibition with two other American modernists, Adolf Wolff and Alice Morgan Wright, and the Europeans Modigliani and Brancusi. Hyland points out that *Tennis Player–Serving* (unlocated) was very advanced:

Photograph of Adelheid Roosevelt's TENNIS PLAYER—SERVING (c. 1915), plaster, dimensions unknown. Formerly in the Quinn Collection; present location unknown. Photo Adelheid Roosevelt Papers. Archives of American Art, Smithsonian Institution.

The artist has reduced the human form to a series of radically simplified parts, based on a sculptural vocabulary derived from an understanding of Synthetic Cubism. Completely removed from the tradition of modeling, the sculptor has achieved an almost architectural realization of space relationships... *Tennis Player–Serving* is charged with a sense of implied movement [which] would also link it to the works of the Italian Futurists.[18]

Although the avant-garde magazine *291* printed a photograph of *Tennis Player–Serving,* a conservative reviewer strongly criticized her sculptures when they were shown at the first exhibition of the Society of Independent Artists in 1917: "Mrs. A. Roosevelt goes to the Negroes of the Niger basin for her inspiration for her bronze statuette, 'The Tennis Player,' while she goes freely over to the mumbo-jumbo fetish idea of art in her slightly carved piece of wood stained brown, entitled 'Munga,' which belongs to the 'sticks and stones and worse than senseless things' of the African taboo."[19] From this description, *Munga* also sounds reminiscent of Brancusi's simplifications.

After creating these singularly advanced works, however, "A. Roosevelt" (as she called herself professionally) stopped making sculpture. She spent some turbulent years during and after the war moving constantly with her husband, who failed in several businesses and then became interested in filmmaking, aviation, and other women. After they were divorced, the artist settled in Thompson, Connecticut, in the 1920s. She wrote to her friend Duchamp-Villon, who was storing her works, to destroy them. In Connecticut, although a friend of Alexander Calder, she became a recluse who practiced a little architecture and did some painting.

Painter **Georgia O'Keeffe (1887–1986)**, best known for her blow-ups of flowers and abstract desert landscapes, created a small number of sculptures that are landmarks of American modernism.

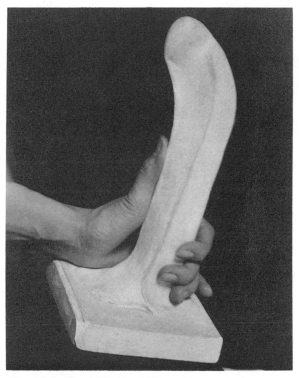

Alfred Stieglitz, GEORGIA O'KEEFFE: A PORTRAIT— SCULPTURE (1919). National Gallery of Art, Washington, D.C. The Alfred Stieglitz Collection.

Alfred Stieglitz, GEORGIA O'KEEFFE:
A PORTRAIT—SHOW AT "291," 1917.
National Gallery of Art, Washington,
D.C. The Alfred Stieglitz Collection.

Around 1917, at the same time that she astonished her future husband, photographer Alfred Stieglitz, with her first abstract charcoal drawings, O'Keeffe created a plaster "figure" comparable in its stripped-down simplicity to Brancusi's quintessential abstractions. A photograph by Stieglitz shows that it was displayed with her drawings at her first exhibition in his 291 Gallery, New York. With customary wit, and Freudian intent, Stieglitz took another photograph of her hand holding the work, which emphasizes its phallic character. (Later he photographed it in front of her painting *Music—Pink and Blue* [1919], an open form that has vaginal or pelvic overtones.)

The sculpture is so daringly nonobjective it was included by Roberta Tarbell in the catalog *Vanguard American Sculpture: 1913–1939* (Rutgers University, 1979). Tarbell points out that only a handful of American artists—Max Weber, John Storrs, Robert Laurent, Adelheid Roosevelt—were employing this degree of abstraction so early. O'Keeffe also created a ten-inch spiral form.

She returned to three-dimensional forms late in life, when her near-blindness was making painting difficult. Juan Hamilton, a ceramist who became her assistant and companion at Abiquiu (the remote town in New Mexico where she lived), encouraged her to try pottery and sculpture. Like Degas, who modeled dancers in wax after losing his vision, she made use of the haptic sense when the optical sense was almost gone.

A ten-foot high aluminum spiral (*Abstraction,* 1980) was included in a 1982 sculpture exhibition at the San Francisco Museum of Modern Art. O'Keeffe reportedly completed about forty three-dimensional works.

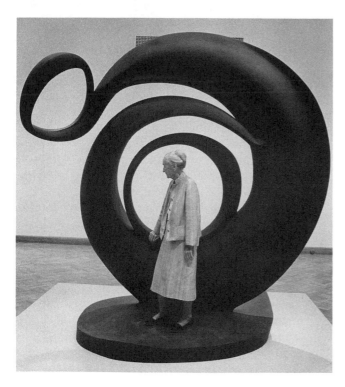

Georgia O'Keeffe with sculpture ABSTRACTION (1980), aluminum, 10′. Collection of the Estate of Georgia O'Keeffe. Photo: Ben Blackwell, San Francisco.

WOMEN IN NEW YORK DADA

The Frenchman Marcel Duchamp, after outraging the public with his futurist painting *Nude Descending the Stairs,* became, during the following years, the unofficial leader of the anarchistic, iconoclastic New York dada movement (which preceded Zurich dada). Disturbed by World War I, which to him and a small coterie of intellectuals such as Picabia, Man Ray, and others revealed the moral bankruptcy of European civilization, he thumbed his nose at the conventions of the past. A new idea, a new concept, was the important thing. Thus he submitted a urinal to the first exhibition of the Society of Independent Artists, declaring that by placing it on a pedestal he was forcing the viewer to view this commercially manufactured object in a totally different way.

The dada group congregated at the New York salon of art collectors Walter and Louise Arens-berg—among them the Baroness Elsa von Lor inghoven, who dressed and created art in a manner so unconventional the hippies and punks of later years look tame in comparison. Beatrice Wood, later a famous potter, was at that time also drawn to the irreverent dada attitude.

Baroness Elsa von Freytag-Loringhoven (1874–1927) was one of the most outrageous figures in the New York dada movement. A poet and artist, she collected all manner of objects from garbage cans and the streets to use in art works or as costume ornaments.

At a time when women were still tightly corseted, the baroness—head shaved bald and lacquered red—sometimes appeared half nude, ornamented largely with spoons, sardine cans, and occasionally fresh vegetables, or she would parade down Fifth Avenue with a coal scuttle on her head. It was all very well to talk about chal-

lenging the rules of society while sipping drinks and eating eclairs at the Arensberg salon, but to live this challenge as von Loringhoven did was quite another matter. To preach free love was one thing, but when Loringhoven offered her body—indeed *forced* it—on certain males in the avant-garde, they scuttled away in terror.

In retrospect, she seems a remarkably prescient figure. As Robert Reiss has pointed out, not only was she one of a handful of artists using ready-made objects and assemblages in sculpture as early as 1915, but like artists of today she broke down the barriers between life and art. Her daily life was a performance, her clothing a collage:

> F. Loringhoven personified the temperament of the artist rebel. Notable for being the creator who, as it were, used her own body for canvas and clay, F. Loringhoven through this dadaist gesture, simultaneously symbolized a victory for dada and women's dress reform, helping to ... overthrow stereotypes of the then corsetted female body. Freytag-Loringhoven's critique of bourgeois values through the medium of her body-art and emancipated attire, prefigured by seven decades the objectives and fashions of "new wave" and "punk" styles which were to come in the 70s and 80s.[20]

In the book *New York Dada*, Reiss describes how the baroness rebelled against her family, moved to Berlin, played in dubious, sleazy theatricals, and upon coming into a small inheritance, began to study art and live the bohemian life.[21] After marrying businessman Baron von Loringhoven and coming to New York, they reportedly lived at the Ritz until he decided at the outbreak of World War I to return to Germany and then shot himself.

Thrown on her own resources, the baroness earned starvation wages modeling for artists such as Robert Henri and William Glackens, worked in a cigarette factory for a while, and then migrated to Greenwich Village where, inspired by Duchamp, she became part of the Arensberg salon.

Some time around 1917, von Loringhoven seems to have helped Morton Schamberg create his iconoclastic dada sculpture *God*. This assemblage, a piece of bent plumbing pipe containing a sink trap set into a miter box, has come to symbolize the ironic love-hate attitude toward industrial civilization that characterized the dada movement; it appears in many surveys of American art.

William C. Agee, an authority on Schamberg, reported Francis Naumann's discovery that "when Walter Arensberg gave his collection to the Philadelphia Museum of Art, the inventory of the collection stated that the construction was made by both Schamberg and the Baroness."[22] In the Philadelphia Museum's 1954 catalog of the Arensberg Collection, however, this was changed to read that Schamberg was "assisted" by the baroness. Today, scholars often skip over the fact that she had anything to do with it at all. Agee and Reiss suspect that the main conception of *God* may have been the baroness's: "Certainly, after viewing [Schamberg's] pastels we are likely to be truly astonished that this same artist could also be the author of the famous plumbing sculpture *God*. . . . The construction would be more in keeping with [the Baroness's] taste and temperament."[23] Europeans were more prone to laugh at Americans' obsession with plumbing.

Margaret Anderson and Jane Heap, publishers and editors of the avant-garde *Little Review*, were the first to recognize von Loringhoven's authenticity. In 1918 von Loringhoven walked into Heap's office:

slowly but impressively with authority and a clanking of bracelets. . . . she began strolling about the room, examining the contents of the bookshelves. She wore a red Scotch plaid suit with a kilt hanging just below the knees . . . high white spats with a band of decorative furniture braid around the top. Hanging from her bust were two tea-balls from which the nickel had worn away. On her head was a black velvet tam o'shanter with a feather and several long ice-cream-soda spoons. . . . "I have sent you a poem, she trumpeted."[24]

The December 1918 issue of the *Little Review* contained the baroness's apostrophe to Marcel Duchamp:

The sweet corners of thine tired mouth Mustir
So world-old tired tired to nobility . . .
and silly little bells of perfect tune
ring in thine throat . . .

Poet William Carlos Williams first learned of the baroness at Heap and Anderson's Greenwich Village apartment. In that black-walled room where the bed hung on chains from the ceiling, his eyes fell upon a strange object—something that looked like waxen chicken guts under a glass bell. He was told that it was the work of von Loringhoven, who was dying to meet him. After they met for lunch, their short explosive relationship, recounted in Williams's autobiography, ended in physical assaults and verbal duels in the *Little Review.*

Dickram Tashjian points out that her critique of Williams was not just a savage personal attack, but an insightful "statement about the . . . aesthetic problems which the Baroness senses are endemic to American culture. . . . She sees Williams's facade as 'the inexperience that shines forth in sentimentality—that masqueraded in brutality; male bluff . . . the savage Amer-ican, arch-primitive, without any great tradition to build upon . . . a country lout . . . trying to step into tights.'" Williams counterattacked that the baroness symbolized corrupt Europe in contrast to "a maiden America."[25]

Muralist George Biddle, later one of the architects of the Federal Arts Project during the 1930s, described his first encounter with her in 1917. She appeared at his Philadelphia studio door on a windy, rainy morning and "in her high pitched German stridency" offered her services as a model. When he asked to see her figure she grandly pulled open a red raincoat revealing a nearly naked body. "Over the nipples of her breasts were two tin tomato cans, fastened with a green string about her back. Between the tomato cans hung a very small bird cage and within it a crestfallen canary."[26]

She had come to the United States in search of freedom, she said, but was disillusioned; the police had arrested her several times for bathing in the public fountains at the railroad station. The baroness then showed Biddle one of her color poems, painted on a piece of celluloid—a symbolic portrait of Marcel Duchamp, his face represented by a light bulb dripping icicles. The long, pendulous ears, she explained, represented his genitals, "the emblem of his frightful and creative potency"; the light bulb and icicles showed that he is "frightfully cold . . . all his heat flows into his art."[27]

The good-natured Biddle sometimes gave her a few dollars, ostensibly to review his exhibitions. At an opening at the Belmaison Gallery, the baroness rehung each picture at a dizzy angle, some upside down, and placed others face down on the carpet. Then she stood at the top of the stairs shrieking at the "sheeplike crowd below, who had come for their homeopathic dose of modernity."

Biddle later visited the baroness's studio and saw the tragic poverty that actually characterized her life, but he also took a perceptive look at her work. She lived in a cold water loft near the river, filled with

> bits of ironware, automobile tires, ash cans, gilded vegetables, a dozen starved dogs, celluloid paintings ... every conceivable horror, which to her tortured, yet highly sensitivized, perception became objects of formal beauty ... [Yet] it had.... quite as much authenticity as, for instance, Brancusi's studio in Paris ... or the many exhibitions for children's work, lunatic's work, or dadaist or surrealist shows, which ... absorb the New York and Paris intellectuals. As I stood there, partly in admiration yet cold with horror, she stepped close to me so that I smelt her filthy body.... She said "You are afraid to let me kiss you."

Pitying her, he allowed her to kiss him:

> Enveloping me slowly, as a snake would its prey, she glued her wet lips on mine. I was shaking all over when I left the dark stairway and came out on 14th Street.[28]

Von Loringhoven seems to have made a series of inventive images of Marcel Duchamp. A droll *Portrait of Marcel Duchamp* (c. 1919), cited in a private collection in Milan, shows Duchamp's wry face with a pipe, a wheel, the word *Marcel*, and other elements interestingly composed on an irregular shape. It was reproduced in the book *New York Dada* (ed. Rudolf Kuenzli, 1986).

In 1922 the *Little Review* published a two-page spread by the baroness. On the right was Charles Scheeler's photograph of her sculpture *Portrait of Marcel Duchamp,* concocted out of wheels, feathers, gears, and other odds and ends. The accompanying poem read

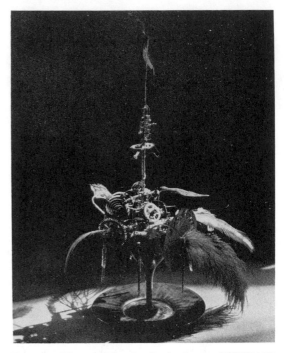

Baroness Elsa von Freytag-Loringhoven, PORTRAIT OF MARCEL DUCHAMP. Photo by Charles Sheeler, in the *Little Review,* Winter 1922. Henry W. and Albert A. Berg Collection; The New York Public Library; Astor, Lenox and Tilden Foundations.

> Wheels are growing on rose-bushes
> gray and affectionate ...

Harriet Monroe, editor of *Poetry* magazine, protested: "The trouble is *The Little Review* never knows when to stop. Just now it is headed straight for Dada; but we could forgive even that if it would drop Else [*sic*] von Freytag-Loringhoven on the way."[29] Jane Heap defended the baroness in an article entitled "Dada":

> Miss Monroe should watch the poetic situation a little more carefully. The Baroness is the first American Dada.... We published her with joy in

June, 1918. Dada wasn't so very old in Europe at the time. . . . When she is dada she is the *only one living anywhere* who dresses dada, loves dada, lives dada. However, we do intend to drop the Baroness—right into the middle of the history of American poetry!

Is Miss Monroe against Dada because dada laughs, jeers, grimaces, gibbers, denounces, explodes, introduces ridicule into a too churchly game? Dada has flung its crazy bridges to a new consciousness.[30]

Growing increasingly hostile to American materialism, the baroness vented her anger in the pages of the *Little Review*: "Americans are trained to invest money, are said to take ever desperate chances on that, yet *never* do they invest beauty or take desperate chances on that. With money they try to buy beauty—after it has died—famishing—with grimace. Beauty is ever dead in America."[31]

In 1923, von Loringhoven's friends took up a collection to pay her way back to Germany, among them, George Biddle and William Carlos Williams, who was delighted to contribute two hundred dollars to help get her out of the country. In inflation-ridden Germany, the freezing, starving, baroness was reduced to selling newspapers on the street. She wrote to Margaret Anderson: "My heart is abode of terror and a snake—they stare at each other . . ."[32]

Friends helped her move to Paris in 1926. Author Djuna Barnes, who had come to believe that her work was significant, commissioned her memoirs. Soon after, in 1927, the baroness was asphyxiated in her sleep by gas from a defective fixture. Janet Flanner wrote her obituary in the *New Yorker*: "Installed through the kindness of Parisian friends in the first comfortable quarters she had recently known, she and her little dog were asphyxiated by gas in the night, both victims of a luxury they had gone too long without."[33]

Today there is renewed interest in the artist's poems and memoirs. A collage, *Dada Portrait of Berenice Abbott* (before 1918) is at the Museum of Modern Art, New York.

Beatrice Wood (1893–)

I met them in 1916, and all this group was in real revolt. You see, it was the first time, in the First World War, that civilians had been killed, and this little group, these European—should we say visitors?—they knew what it was. They were all in revolution against so-called civilization and that, in a way started a revolutionary approach to art.
—Beatrice Wood[34]

Beatrice Wood is today a world-famous ceramist, who wears shimmering Indian saris with heavy jewelry and lives atop a mountain in Ojai, California. But in 1916, at age twenty-three, she was part of the anarchistic New York dada group, defying convention along with her friend Marcel Duchamp.

Born into a wealthy San Francisco family and raised in New York, Wood could not bear her parents' suffocating conventionality and at age fourteen fought with her mother for the right to become a bohemian artist. She was finally permitted to go (with a chaperone) to Giverny, where she peered worshipfully at white-haired Monet in his garden and painted from morning till night until her domineering mother took her away from her "filthy" studio.

After taking a few courses at the Académie Julien, Wood studied acting with a Comédie-Française actor. But World War I intervened and she returned to New York and joined the French Repertory Theater. She had performed in sixty

roles when a chance meeting drew her into the world of dada.

Wood met Marcel Duchamp in 1916 at the hospital bedside of the avant-garde composer Edgard Varèse. "At the time," says Wood, "my ideal was to paint like Maxfield Parrish." In her ignorance of modern art, she commented to Duchamp that "anyone could do such scrawls." Duchamp drily dared her to try.

Letting her subconscious run free, Wood made a drawing showing a plant (or figure?) being entrapped by a pretzel-like entwining form with a kind of clumsy foot at the end of it (*Mariage d'une amie*). To her astonishment, Duchamp published it in the December 1916 issue of the avant-garde magazine *Rogue*. Duchamp then gave her the key to his studio and urged her to work there. He admired those drawings that seemed to be free expressions of the unconscious, and Wood soon developed the antic dada spirit.

In 1917, one of those "free expressions" plunged Wood into notoriety. The newly formed Society of Independent Artists, trying to break free of tradition, sponsored a landmark unjuried exhibition where anyone paying the entry fee could exhibit. Wood submitted a painting of a headless nude female torso rising from the bath. She planned to paint a bar of soap, like a fig leaf, over the genital area, but Duchamp suggested that she attach a real bar of soap to the critical triangle. Underneath this image she inscribed the title *Un peu d'eau dans du savon* ("a little water in some soap").

Crowds gathered in front of the picture; gentlemen tacked calling cards to the frame; critics sneered. The reviewer in *International Studio* wrote: "Another freak picture was chiefly remarkable for a large cake of Vinolia soap carefully nailed to the centre of attraction. The public took little interest in the composition but felt an immense sympathy with the soap.... Rumour obtains that the artist was kept quite busy substituting new cakes for those examples removed."[35] A less polite critic called it "the keynote of childish whim, the unbridled extravagance, the undisciplined impudence and immature ignorance and even derangement that have been allowed free fling."[36] The painting was, in fact, a very early example of innovative assemblage—hovering between two and three dimensions.

By this time Wood was leading an exciting bohemian life in a ménage à trois with Duchamp and her lover, Henri-Pierre Roché (who later wrote the novel *Jules and Jim* about the trio, the source of Truffaut's film). They spent lively evenings with Duchamp, Picabia, Man Ray, and others at the salon of Walter and Louise Arensberg. Intimate glimpses of this coterie and their shenanigans can be found in her drawings and in her autobiography, *I Shock Myself*.

The Society of Independent Artists, despite its expressed policy of total freedom, refused to exhibit Duchamp's sculpture *Fountain*—a urinal signed "R. Mutt." According to traditional standards it was not art since he had not made it. Wood, Roché, and Duchamp, in their dada magazine *The Blind Man*, created a seriocomic tempest in a teapot over the incident, but out of it came a serious statement of a key part of the ideology of modernism: it doesn't matter how a work of art is made—the concept or idea is what is important:

> Whether Mr. Mutt with his own hands made the fountain or not has no importance. HE CHOSE it. He took an ordinary article of life, placed it so that its useful significance disappeared under the new title and point of view—created a new thought for that object.
>
> As for plumbing ... The only works of art

Beatrice Wood, SOIRÉE (1917), pencil, ink, and watercolor on paper, 8¼″ x 10⅞″. Collection of Francis M. Naumann, N.Y.

America has given are her plumbing and her bridges.

The famous statement is usually attributed to Duchamp, but according to Wood was written by her.[37]

Duchamp used Wood's drawing of a stick figure thumbing its nose at the world on a poster advertising a dada ball sponsored by the *Blindman*—an insolent image that has become a symbol of the antiauthoritarian dada attitude.

Cut loose from her overprotective wealthy family, "Beato" (as she is known) went through hard times, was treated badly by a duplicitous husband and lovers, and in 1928 decided to join her friends, the Arensbergs, who had settled in southern California.

She turned to pottery quite by chance. During a trip to Holland to hear lectures by her Indian spiritual mentor Krishnamurti, she bought six Dutch luster plates. When she couldn't find a teapot to match, she enrolled in a pottery class at Hollywood High School in 1933, in order to learn to make it herself.

Wood began a new life as a ceramist. She studied with Gertrud and Otto Natzler, Glen Lukens, and Vivika and Otto Heino, all masters of modern ceramics. Despite poverty and disasters (a flood destroyed her home and kiln in the San Fernando Valley), the artist slowly developed a personal style, and her fame grew.

Wood does not approach ceramics like a traditional potter—to her, pottery is like painting or sculpture. Still whispering in her ear is Marcel Duchamp, who once told her "rules are fatal to the progress of art." At first she decorated plates with art deco or cubist designs, but soon began to create her own distinctive glazes, in which

Beatrice Wood, THE BLINDMAN'S BALL (1917), poster, 27½" x 9½". Collection of Francis M. Naumann, N.Y.

with light. Some have tiny craters, as if formed by the evolutions, contractions and expansions of the earth itself. Some seem made of gas-filled lava. Some are jewelled like crushed sea shells or pearls ... others are iridescent ... like the trailways left by satellites."[38]

Beatrice Wood, TEAPOT WITH FIGURES (1986), earthenware with lustres, height 18¾". Photo: Anthony Cuñha. Courtesy Garth Clark Gallery, Los Angeles/New York.

sensual pinks or turquoises, shimmering with gold luster, are combined in oddly contradictory ways with a pitted, eroded surface, and humble—even crude—forms. This combination of the opulent and the rustic or humble relates to the Zen Buddhist spirit of Japanese tea wares that embody the quality of *wsabi* ("poverty")—the embodiment of beauty through a kind of imperfection or crudity that gives an effect of effortless simplicity and artlessness. Ceramics authority Garth Clark noted these qualities in the catalog for the 1983 Wood retrospective at California State University, Fullerton.

Wood's luster glazes remind one of Egyptian glass antiquities that derive their patina from centuries of burial in the earth. Her friend, Anaïs Nin described them thus: "Her colors are molded

Instead of applying luster on top of the glaze, Wood's innovation was to mix it right into the glaze, embedding it in the wall of the pot. She also takes advantage of accidental effects from the kiln: "Instead of using the vessel as a canvas on which to paint luster surfaces in the traditional sense, Wood worked abstractly with the entire vessel as a three-dimensional field of intense shimmering color.... here was a form of 'action painting' with the volatile nature of the technique and the vagaries of the kiln ... an outgrowth of the modern art sensibility."[39]

Since 1948, after years of struggle, "Beato" has found peace on her mountain in Ojai, California. Influenced throughout much of her life by the teachings of Krishnamurti, she now has her home and studio on the grounds of the Happy Valley Foundation School of the Theosophical Society. In 1961, the Indian government, recognizing the connection between her art and Eastern spirituality, asked the U.S. State Department to send her on a fourteen-city tour of India to exhibit her work and lecture on American pottery. She was profoundly affected by this and subsequent journeys to Israel, Nepal, and Afghanistan. In 1965 she photographed Indian folk art.

Although the world has paid the most attention to her lusterware dishes and bowls, she prefers the naive folk-art figurative groups she has made through the years. These truly "dada" works comment wryly on conventional values. For example, a sculpture called *Solution to the Mideastern Problem* shows a woman lying on top of a man whom she is kissing—a droll way of expressing her outrage at continuing violence in the nuclear age. These sculptures are now receiving increasing attention. (*The Naughty Snake* [private collection] was shown at the 1986 Venice Biennale.)

Wood had three major exhibitions in 1978

Photograph of Beatrice Wood. Courtesy Garth Clark Gallery, Los Angeles/New York. Photo: Marlene Wallace.

alone (Everson Museum, Syracuse; Hadler Gallery, New York; Philadelphia Museum of Art). Curator Dextra Frankel celebrated Wood's ninetieth birthday with a retrospective at California State University, Fullerton. Francis M. Naumann, who pioneered in recognizing the importance of Wood's drawings and sculptures, organized a 1990 retrospective of her figurative work at the Oakland Museum.

WOMEN SCULPTORS IN THE ARMORY SHOW

The American jury for the Armory Show selected what they regarded as the progressive tendencies of the day, but on the whole the Americans were not as modern as the Europeans. Cubism had barely touched the United States; the nine women sculptors in the exhibition were not radical innovators.

Ash can artists Ethel Myers and Abastenia Eberle, discussed earlier, were featured prominently. Enid Yandell and Bessie Potter Vonnoh, discussed in the preceding chapter, were probably viewed as impressionists. The rest were middle-of-the-road sculptors—Nessa Cohen, Myra Musselman–Carr, Margaret Hoard, Grace Mott Johnson, and Edith Woodman Burroughs. Burroughs was just beginning to feel the influence of Maillol, a precursor of modernism.

Edith Woodman Burroughs (1871–1916) was described in *Arts and Decoration* as "a modern in whom the spark of tradition has not been permitted to die out. She looks ahead but not radically. Her figures have dignity and refinement . . . but [are] nevertheless captivatingly expressive of life."[40]

Daughter of Webster and Mary Woodman of Riverdale-on-the-Hudson, New York, Edith was only fifteen years old when she began to study drawing with Kenyon Cox and modeling with Saint-Gaudens at the Art Students League. At eighteen she was already supporting herself by designing ornamental objects for Tiffany and Company, such as a bronze lamp supported by a ring of angels for a Brooklyn church.

In 1892, her fiancé Bryson Burroughs, a fellow student at the League, received a fellowship to study painting abroad, and they were married in England. They went on to Paris, where she studied sculpture with Jean-Antoine Injalbert and was influenced by the neo-baroque French style.

Edith Woodman Burroughs, CIRCE (1907), bronze height 20¼". Private collection. Courtesy Berry-Hill Galleries, N.Y. Photo: Helga Photo Studio.

During a year of travel, she was also greatly moved by the Gothic cathedral sculpture at Amiens and Chartres.

After she returned home, Burroughs's work reflected the lively French neo-baroque manner in small bronzes like *Circe* (Corcoran Gallery and Newark Museum), which won the Shaw Prize at the National Academy of Design. In this amusing work, the enchantress from the Odyssey is shown whirling about, snapping her fingers at the snout-nosed swine (men transformed by lust) around the decorative base. In *Summer Sea* (1908), a nude leans on a rocky ledge, chin on crossed hands, gazing at the waves.

On a second trip to France in 1909, the sculptor was affected by the purity of line of muralist Puvis de Chavannes and the simplified forms of Aristide Maillol, a forerunner of modern sculpture. *L'Arrière Pensée* (1910, Betty Burroughs Woodhouse collection), a small bronze of a woman turning to look behind her, shows this increasing simplification. It is also evident in *At the Threshold* (1912, stone, Metropolitan Museum of Art), a dreamy adolescent standing nude.

Burroughs did exceptionally expressive portraits. In the Armory Show was her bust of *John La Farge* (1908, Metropolitan Museum of Art), shown with his long bony fingers on his cheek and oriental-looking heavy-lidded eyes revealing the introspective, superaesthetic temperament of the painter—one of the first to promote a love of Japanese design in America. In contrast, the *Bust of Mr. Bigelow* (1910 Museum of Art, Rhode Island School of Design) displays a vigorous, forthright temperament. The small head of *Leo Ornstein* (1914, private collection) captures the whimsical humor and sensitivity of the young avant-garde composer-pianist. Burroughs also did a small medallion portrait of her friend, the avant-garde British critic *Roger Fry* (1911, Metropolitan Museum).

In 1915 Burroughs's *Fountain of Youth* and decorative *Arabian Nights Fountain* were prominently displayed at the San Francisco Pan-Pacific Exposition, winning a silver medal. That year a retrospective of thirty-nine works at the Berlin Galleries was described as "one of the sensations of the season." Critics noted the influence of Maillol in her "suppression of detail, unified modeling, repose of gesture, solidity and restraint." *Acquiescence,* a cross-legged seated girl, was described as "generalized, calm, solid, yet subtle and sophisticated."[41]

Edith Burroughs had a reputation of being a challenging and forward-looking woman. Guy Pène du Bois wrote, tongue in cheek, that "she

Edith Woodman Burroughs, JOHN LA FARGE (1908), bronze. The Metropolitan Museum of Art, Rogers Fund, 1910.

analyzed contemporary problems, had a passion for resurrecting those buried in the Victorian era. She may have had designs on the moral standards."[42] The sculptor's daughter, **Betty Burroughs Woodhouse** (a sculptor and former museum education curator), remembers her mother as "a dynamic person of great intensity, a leader in social reform—a personage."[43]

In 1916, at the height of a career that showed every promise of moving in the direction of modernism, Edith Burroughs, aged forty-five, died suddenly of influenza at her Flushing, Long Island, home.

Grace Mott Johnson (1882–1967), whose animal sculptures were in the Armory Show, was at one time married to the pioneer American cubist Andrew Dasburg, but was perhaps more advanced in her life-style than in her art. Her work, however, shows a struggle toward a more modern direction.

Johnson had an unusual upbringing. Her widowed father, a New York City Presbyterian minister, remarried and became a recluse on a farm in Monsey, New York, where he educated his eight children according to his own John Deweyan notions of "learning by doing." None attended public school; in fact, they seldom went into town. The children built a nature museum and wrote and illustrated a newspaper about their daily activities. Grace, who loved animals and cared for them on the farm, drew pictures of them and carved them in soap and plaster. The sight of Rosa Bonheur's painting *The Horse Fair* at the Metropolitan Museum of Art further inspired her.

Such an upbringing fostered an independent mind. At twenty-one, after receiving a modest inheritance from her grandmother, Johnson took off on a bicycle for New York City, enrolled in sculpture classes with Hermon MacNeil and Gut-

zon Borglum at the Art Students League, and was soon recognized as an outstanding animal sculptor. There, in 1907, she met painting student Andrew Dasburg, who, impressed by her talent and drive, regarded her as his mentor. During long walking tours in upstate New York, she encouraged the insecure artist to pursue his work.

Having heard about exciting modern movements in Paris from their friend Charles Morgan Russell (pioneer of synchromism), they sailed for France in 1909 with their sculptor friend **Florence Lucius** and became part of the American modernist coterie in Paris that included Arthur Lee, Morgan Russell, and Jo Davidson. Johnson and Dasburg were married in a civil ceremony in London, with Arthur Lee as witness. But "no traditional vows were exchanged, for Johnson wanted theirs to be a completely free alliance."[44]

The two artists led very independent lives; for example, Johnson, after exhibiting a study of Percheron horses at the 1910 Paris Salon, returned to the United States ahead of Dasburg. She shared a studio in New York City with her friend **Lila Wheelock**, while Dasburg, teaching and working in Woodstock, was swept up by the new cubist and fauvist influences. When their son, Alfred, was born in 1911, they took six-month turns caring for him so that Johnson—by this time a well-known animal sculptor—could continue working. In 1912 she bought a house in Woodstock.

While Dasburg was introducing cubism to the American scene, Johnson was haunting the circus to study elephants and other animals for such works as *Mighty of Ringling Circus, Bebe* (carved in plaster) and a frieze of elephants cut directly in stone. Modeled from memory, they show a lively simplification, different from the detailed realistic studies of the academic *ani-*

Grace Mott Johnson, CHIMPANZEES (1912, unlocated). Photo: Mt. Pleasant Public Library, Pleasantville, N.Y. Photographer: Bogart Studio. A bronze cast is in the collection of the Woodstock Artists Association, Woodstock, N.Y.

maliers. Her aim was to make them seem vital and alive, with little regard for finish, often giving the surface a sketchy quality.

Both Johnson and Dasburg exhibited in the Armory Show. Johnson showed *Greyhound Pup, No. 2* (bronze) and *Chimpanzees* (1912, bronze, Woodstock Artists Association), which shows a feeling for space relationships and expressive simplification. In 1919 she also had a joint exhibition with Florence Lucius at the Whitney Studio Club.

Around the time of the Armory Show, Andrew Dasburg became infatuated with Mabel Dodge and her New York salon. He was subsequently invited to her ranch in Taos and after that spent time in New Mexico. Johnson, not one to trail after a husband, also spent periods of time in New Mexico but never became a resident. In 1922 the artist divorced Dasburg (who married another sculptor, **Ida Rauh**) and had another joint exhibition at the Whitney Studio Club, this time with Lila Wheelock.

Inspired by a 1924 trip to Egypt, and prehistoric cave drawings, Johnson incised lines and modeled broad simple planes in plaster and bronze reliefs. Art historian Rilla Jackman wrote, "Few artists are able to express so much with a simple outline.... Her panel *Elephants,* modeled very simply, scarcely more than in line, is a masterpiece of its kind."[45] She used color on plaster animal sculptures in a 1935 show at the Argent Galleries, which was described as "weirdly effective ... a bizarre and interesting talent."[46]

Lamb and Ewe was shown in the National Sculpture Society's 1929 exhibition, and she won prizes from the National Association of Women Painters and Sculptors in 1917 and 1936.

Grace Johnson has been described as a "free spirit." An early civil rights activist, she insisted on staying at the Harlem YMCA when she visited New York City. According to her daughter-in-law, she was "a one-woman liberation army," who in the 1930s demanded that her black friends be admitted to Jones Beach, at that time still segregated.[47] These concerns were reflected in a 1930s series of sympathetic studies of black people, such as *Mary Moore,* a bronze bust of a

child (Whitney Museum of American Art).

To some she was an eccentric. In Pleasantville, New York, where she lived for a number of years, her advocacy of advanced ideas, from civil rights to nude sunbathing, proved a bit too avant-garde for some of the staid villagers.

After losing her studio during the depression, the artist lived with various friends and family members, but finally had a breakdown and produced little sculpture in the last twenty years of her life. She kept her spirit, her sense of humor, and her interest in social causes. *Goat* (bronze) is at Brookgreen Gardens, South Carolina, and her lively papers, the product of an original mind, are at the Beinecke Library, Yale University.

Myra V. Musselman-Carr (1880–?) was evidently an early direct carver and may have been something of a modernist because William and Marguerite Zorach taught in her school in their early years.

Born in Georgetown, Kentucky, she studied at the Cincinnati Art School and the Art Students League, and with Antoine Bourdelle in Paris. In 1913 she exhibited two statuettes, *Electra* and *Indian Grinding Corn,* in the Armory Show.

Around 1915–17 she was co-owner and sculpture teacher at the Modern Art School on Washington Square, which advertised as "a school that gives complete liberty to its students in working out individual ideals; the only modern center in America."[48] William Zorach taught painting there, and both Zoraches were scheduled to teach a summer session at Provincetown, but the classes failed to materialize. Illustrations in *International Studio,* April 1917, show that sculpture students at the Modern Art School were simplifying their work into compressed masses.

In 1928 Musselman-Carr's sculpture, exhibited jointly with her husband Charles Bateman's paintings at the Weyhe Gallery, was described as showing "the very interesting modern tendency of making sculpture compact through the energy of the subject. As the 'Mother and Child' hug each other or as the 'Lady with Folded Arms' hugs herself they perform the double duty of pleasing themselves and strengthening the form."[49]

It would be interesting to track the interaction between her work and that of William Zorach, who became a leader of the direct-carving school. She was a member of the Woodstock Art Association.

Margaret Hoard (1879–1944) studied with James Fraser at the Art Students League and showed a *Study of an Old Lady* at the Armory Show. Her compact marble *Eve* is at the Metropolitan Museum of Art.

(Helen) Nessa Cohen (1885–1976), a Barnard graduate, studied with James Earle Fraser and in Paris with the forerunner of modernism, Despiau. In 1912 Cohen exhibited *Hopi Relay Runner* and *Sunrise* (1911), a study of an Indian praying to the morning sun, in a National Sculpture Society show of small bronzes at the Herron Art Institute, Indianapolis.

Sunrise was in the Armory Show, along with a colored plaster statuette called *Age.* It was a companion piece to *À La Gare* (unlocated), a seated old woman with bundles, huddled in bulky winter garments and waiting for a train. Other works are *Havana, Cuba, Navajo Watching Women at Work,* and a group of sculptures of Southwest Indians (unlocated).

Cohen exhibited with the National Sculpture Society (1923), won a bronze medal in 1928 for a sculpture at the Ninth Olympiad in Amsterdam, Holland; belonged to the Society of Indepen-

dent Artists and the Architectural League; and showed paintings with the American Artists Professional League as late as 1956–58.

Nessa Cohen, SUNRISE (1911), unlocated. Armory Show—50th Anniversary Papers, Archives of American Art, Smithsonian Institution.

DIRECT CARVING

Traditionally a sculptor made a clay study and an artisan carried out the work in marble or cast it in bronze. In the early years of the twentieth century, however, a group of sculptors, influenced by primitive and archaic art, returned to direct carving in stone and wood. Robert Laurent, John Flannagan, William Zorach, and others asserted that there was a fundamental dishonesty in having an artisan carry out the work. True integrity, they felt, came from allowing the material itself—the shape of a rock, the grain of wood or stone—to influence the form that gradually took shape under the sculptor's hand.

Their sculpture has a primordial, elemental quality, a sense of reaching for some metaphysical "essence of life." Art historian Roberta Tarbell has said that the slow process of carving was felt "as a respite from the machines and speed of the twentieth century."[50]

Marguerite Zorach experimented briefly with primitivist carving, and in the 1920s a number of women—Bessie Callender, Simone Boas, Nancy Prophet, Eugenie Gershoy, Concetta Scaravaglione, and others—were working in this mode.

Some of these early direct carvers are discussed in the next chapter rather than here because the most important phase of their careers came in the 1930s.

Marguerite Thompson Zorach (1887–1968), an early fauve and cubist painter, also noted for her modern tapestries, experimented very early, but only briefly, with primitivistic wood carving.

Rebelling against her Fresno, California, family's expectations for her, she went to Paris to study painting at the avant-garde atelier La Palette, where she met, and later married, future sculptor William Zorach. After settling in Greenwich Village, the two showed fauve paintings in

the 1913 Armory Show and the 1916 Forum exhibition, and experimented with a variety of media in their early careers.

During a summer in New Hampshire, they found wood pieces on the fronts of bureau drawers and experimented with carving. Marguerite's incised decorative wood panel *Mother and Child* (1917, Collection of Judith Wolman Harris), reminiscent of Gauguin's carvings and African sculpture, is now recognized as one of the earliest American primitivist abstract sculptures. The following summer both artists experimented with ceramic sculpture, but most was lost in kiln explosions. One of the few remaining pieces, Marguerite's *Standing Nude* (bronze, 1918), shows undulating, stylized forms reminiscent of the work of Elie Nadelman. Her small sketch *Crawling Baby* seems to have inspired William's sculpture of the same subject.

William became a leader of the direct-carving movement, but Marguerite returned to painting and tapestries.

Simone Brangier Boas (1895–?) worked in the direct-carve mode in the 1920s.

Born in France and raised in California, she graduated from the University of California in Berkeley (1917), studied with Leo Lentelli at the San Francisco School of the Arts, and went to France in 1918 to help World War I refugees. While working with the Red Cross, she studied for two years with Bourdelle at the Académie de la Grande Chaumière. In Paris the sculptor met George Boas, who was stationed there with the American army. After their marriage in 1921, they settled in Baltimore, where he was a philosophy professor at Johns Hopkins University. She continued her sculpture while raising two girls.

Imbued with the "truth to materials" aesthetic, Simone Boas carved massive, stylized heads and figures directly in wood and stone with no open-

Marguerite Zorach, STANDING NUDE FIGURE (1918), bronze, cast from terra cotta. Private collection. Photo: Geoffrey Clements.

ings or penetrations in the forms. The Cone sisters, Etta and Claribel, famous Baltimore collectors of Matisse and other moderns, appreciated the advanced character of her work and bought the mahogany *Cérès* (1926), a compact half-figure holding a cornucopia (the only American sculpture in the Baltimore Museum's Cone Collection). The Baltimore Museum also owns a marble head with flowing hair (*La reine des eaux,* 1929–30) and two other heads, and the Philadelphia Museum of Art owns *Woman,* a marble three-quarters figure.

Simone Brangier Boas, CERES (1926), wood, height 18¼". The Baltimore Museum of Art: The Cone Collection, formed by Dr. Claribel Cone and Miss Etta Cone of Baltimore, Md. BMA 1950.393.

A founding member of the Sculptors Guild, her work was shown in the 1939 New York World's Fair American art exhibition.

Only a few terse heads in stone and wood remain to show the potential of **Nancy Elizabeth Prophet (1890–1960).** Her intense works are today regarded as beacons of the Harlem Renaissance, but social and economic pressures prevented the full development of her gifts. She once described herself as a graduate of "the College of serious thought & bitter experience, situated on the Campus of Poverty & Ambition."

Born in Warwick, Rhode Island, to a Narragansett Indian father (a Park Department employee) and a mother who described herself as a "mixed Negro," Prophet's family tried to discourage her dreams of a career in art. They thought she should accept her lot as a housemaid or, at best, as a teacher of black children. But determined and assertive, the artist worked her way through the Rhode Island School of Design—the only black student enrolled at that time—graduating as a painting major in 1918.

She scrimped and saved in order to go to Paris. Blossom Kirschenbaum, in an article in *Sage* magazine (the source of many of the following details), reports that she also had a Providence patron, Ellen D. Sharpe, who believed in her talent and helped support her (albeit meagerly) during the difficult years of study abroad. Although only close friends knew it, Prophet, while still in school, had married Francis Ford, one of very few black students admitted to Brown University at that time. They went abroad together.[51]

Prophet spent ten years in Paris. Accepted at the prestigious École des Beaux-Arts, she worked very hard in a tiny studio under conditions of extreme privation. According to reports, her Ivy League husband was forced to work as a chef, the marriage disintegrated, and he

returned to the United States, leaving her to fight her battles alone. To an interviewer who later came to her tiny studio on the rue Broca, she said, "I tried sleeping with my figures, but it was so full of dust that I almost smothered, so I partitioned off a little corner myself with old boards, and I've been in this one spot for six years."[52]

Black poet Countee Cullen found the slender, attractive artist in Paris, dressed *à la vie bohème* with "flowing black cape and a broad felt hat ... living low and thinking high." She resisted the idea of being pegged as a "black artist" and described her work to him as "distinctly unracial." Yet Cullen felt that although it was "to a degree non-African," it "showed something of the Negro in it," and he noted that she kept herself informed regarding cultural affairs in the Harlem Renaissance in America.[53]

Prophet's sculpture earned praise at the Salon d'Automne (1924, 1927), the Paris August Salons (1925, 1926), and the Salon des Artistes Françaises (1929). A direct carver, her white marble bust *Silence* and other works were described by a French critic as "vigorous and energetic, conceived in a nervous, supple, assured style." The same article described her as a loner who did not hang out with the bohemian set, but worked obsessively by herself.[54]

One person she did stay in touch with in Paris was the renowned black painter Henry O. Tanner, who recommended her for the Harmon Foundation Prize (1929). In 1930 she returned briefly to New York to accept the $250 award for her wood carving *Head of a Negro* (Museum of Art, Rhode Island School of Design). At this time Prophet also exhibited work at International House and other galleries.

Prophet returned to America permanently in 1932. That year her work was shown at the Boston Society of Independent Artists, the Vose Gal-

Nancy Elizabeth Prophet, CONGOLAIS (1931), wood, 16¾″ x 7¾″ x 7½″. Collection of the Whitney Museum of American Art, N.Y. Purchase. 32.82. Photo: Peter A. Juley & Son.

leries, Boston, and she exhibited six works at the Art Association of Newport, Rhode Island, winning the grand prize (the Richard Greenough Prize) for her fine polychromed wood head *Dis-*

content (Museum of Art, Rhode Island School of Design). Gertrude Vanderbilt Whitney, whose work was also in that exhibition, was very much impressed. She bought the wood carving *Congolaise* which is now in the Whitney Museum and invited Prophet to share her studio that fall.

At this time Prophet received a great deal of favorable publicity. She was shown drinking tea with wealthy Rhode Islanders, and an article in the *Crisis,* October 1932, described her as a model of what black Americans could accomplish if they worked hard and persevered. But none of this paid her bills. The depression was on, and it was almost impossible to make a living as a sculptor.

In 1933 she took a job as art instructor at Atlanta University, introduced sculpture into the curriculum, became head of the sculpture department at Spelman College, and taught there until 1944, producing a small amount of sculpture and exhibiting sporadically. An admired faculty member who was devoted to her students, she dressed with flair and cut a dramatic swath when she walked across campus. Nevertheless she evidently kept to herself a good deal. Around 1944, according to Kirschenbaum, she experienced a breakdown and returned to live in the house her father had left her in Rhode Island.

Prophet felt dislocated and never fit into any community. She had always felt confused about her identity, sometimes referring to herself as an Indian and later refusing to be included in Cedric Dover's book on black artists. She had wanted to be an "artist," not a "black artist"—a hope denied by racism and artistic segregation.

For the next sixteen years, the sculptor lived in isolation, poor and embittered, and was unable to continue her art. Kirschenbaum says that she repeatedly tried to secure a means of support to enable her to go on working: she applied for a teaching job in the Providence schools, appealed

to the Harmon Foundation for funds, and attempted to produce commercial ceramics. For a short time she worked as a maid in the home of an official in the Providence Department of Education.

At her death, the woman whom W. E. B. Du Bois described as "our greatest Negro sculptor" was almost buried in a pauper's grave, but a few people discovered it in time to give her a proper burial.

With the advent of the women's movement and the new interest in the art of minority groups, Prophet's work has been included in several exhibitions (Four from Providence, Rhode Island College Art Center, 1978; Forever Free, 1981). Today both the Narragansett Indians and the black community of Rhode Island claim her as their own.

Prophet's heads are not portraits; they are broadly generalized expressions of different moods. Directly carved, they have an inner tension that is the result of long thought and struggle. The male head *Discontent,* with its "strong, serious face, knitted brow, tight-lipped mouth, and helmet-like headdress," was, said Prophet, "the result of a long emotional experience, of restlessness, of gnawing hunger for the way to attainment." And *Silence,* (Rhode Island School of Design) a white marble female head with a visionary expression, "done after months of solitary living in her little Paris studio, hearing the voice of no one for days on end," represented, she said, "the unifying quality of the body, mind and soul."[55] The strong, noble *Negro Head* which won the Harmon Prize—eyes filled with sadness and mouth drawn down in pain— rises in compact form from the rough-hewn tree trunk that forms the base. A changing rhythm of chisel marks extends from the rough strokes on the base, up through the smoother marks on the head.

Congolaise (1930, cherrywood, Whitney Museum) comes the closest to realizing the ideals of the Harlem Renaissance propounded by W. E. B. Du Bois and Alain Locke because its expressively abstracted forms draw on her Afro-American heritage. Other works are in the Prophet Collection, Rhode Island College, and at the Black Heritage Society, Providence.

Eugenie Frederica Shonnard (1886–1978), a direct carver of the 1920s, became known for her strong, blocky studies of the Indians of the Southwest.

Born in Yonkers, New York, daughter of a Civil War major and a mother descended from a signer of the Declaration of Independence, she began to model in clay while studying with the art nouveau leader Alphonse Mucha at the New York School of Applied Design for Women. After further work with James Earle Fraser at the Art Students League, she went to Paris in 1911 where she worked on her own, receiving some criticism from Émile Bourdelle.

Early works include a portrait medallion of *John Bigelow,* ambassador to France (1910), and a bust of *Alphonse Mucha* (1917). She soon, however, turned to sculpture of animals and birds, emphasizing the decorative patterns in nature as in *Marabou* (1915) and *Two Herons* (1924) where the wing and breast feathers form an abstract pattern. These animal studies later became more stylized with simplified planes and less decorative pattern.

Returning to France after World War I, Shonnard won praise in the Paris Salons for a series of stolid Breton peasant subjects, done with the same massive simplification. A 1926 solo show of sixty works at the Galerie Allard, Paris, including *Brittany Peasant Morning* (1924) and *Head of a Breton Peasant* (bronze, Metropolitan Museum of Art, New York), won acclaim, and

resulted in the purchase of a bronze rabbit for the Luxembourg Museum.

Sensing the strong self-contained character of her Breton heads, Edgar L. Hewett, director of the School of American Research in Santa Fe, felt that she was ideally suited for sculpture of the American Indians and invited her to settle in New Mexico. He praised her 1927 exhibition at the Museum of New Mexico:

> I have long felt that these people of the American Southwest were incomparable as material for sculpture. The Indians who have lived here through the ages are a part of it, as are the winds, clouds … rocks … and all other elements of its mesas, canyons and deserts. I marvel that you have so powerfully expressed it. You have felt the forces that made this race what it is. You are producing … art that springs from our own soil and is truly American.[56]

This statement is characteristic of the 1920s love affair with the "primitive" reflected in modern art, direct carving, and the novels of D. H. Lawrence.

Shonnard's hieratic, dignified Pueblo Indians, wrapped in the broad planes of their blankets, are carved with elemental simplicity out of granite, mahogany, and other hard materials. *Pueblo Indian Woman* and several relief panels depicting Native Americans are at Colorado Springs Art Center; *Indian Chief Sitting* (1926, mahogany) and *Heroic Indian Head* (1938, sandstone) are at the Museum of New Mexico, Santa Fe.

Shonnard had Santa Fe exhibitions in 1937 and 1954. She developed a cement material called Keenstone, in which she did some sculpture and architectural work; carved wooden doors and furniture; and developed designs for ironwork. Projects included decorative panels for the Waco, Texas, post office, and an entire ensemble of sculpture, liturgical objects, and ar-

Eugenie Frederica Shonnard, PUEBLO INDIAN WOMAN (1926), hardwood (satina), 17½″ x 6½″ x 5⅛″. Colorado Springs Fine Arts Center.

chitectural ornamentation for a private chapel at Black Forest, Colorado.

Shonnard was an exhibitor in group shows at the Whitney Museum and Museum of Modern Art, New York; a fellow of the National Sculpture Society; and a member of the Société Nationale des Beaux-Arts and the Société du Salon d'Automne, Paris.

ART DECO OR ART MODERNE

Throughout this period, sculptors like Paul Manship and W. Hunt Diederich, influenced by archaic styles—early Greek, Etruscan, Oriental—were stylizing the lines of their work into decorative rhythms. Although they were not abstract artists, they simplified forms and eliminated naturalistic details to emphasize structure and design in a manner that can be regarded as a transitional bridge between traditional academic art and the modern movement.

This trend had begun earlier in the 1890s, with art nouveau, a decorative movement that emphasized flowing lines and organic curvilinear forms based on plants and growing things. In the twentieth century these decorative rhythms tended to become increasingly geometric and planar, influenced on the one hand by the machine age, the skyscraper, and cubist art, and on the other by North American Indian and Mayan motifs. The style found full expression at the 1925 International Exposition of Modern Decorative and Industrial Arts in Paris and was known thereafter as art deco.

The machine-age speed and elegance of the twenties was expressed in the stylized streamlines of art deco, a vague term: many traditionalists discussed in the last chapter and direct carvers in this one could be included under this heading. For example, Harriet Frishmuth, a traditional artist, created *Speed,* which was used as a radiator cap for automobiles. Some works by

Malvina Hoffman, Alice Morgan Wright, and others who appeared earlier are art deco in style.

Brenda Putnam (1890–1975) was a successful academic sculptor who made the transition to an art deco style and hovered on the border of modernism.

Born in Minneapolis, the granddaughter of publisher George Putnam and daughter of Herbert Putnam, head of the Library of Congress, her talent for modeling small animals was encouraged by her father. When she decided, at age twelve to be a sculptor, he bought her clay and tools and permitted her to use his private den as a workshop.

Putnam studied with Mary E. Moore and Bela Pratt (1905–7); at the Boston Museum School; and with James Earle Fraser at the Art Students League. She also studied portrait sculpture one summer with Charles Grafly.

After opening a studio in New York, she produced Rodinesque works between 1910 and 1911 and also turned out roguish sundials and garden figures with titles like *Water-Lily Baby* and *Mischievous Faun* (1920, Dallas Museum of Fine Arts) that sold well and brought awards. In the early 1920s the artist shared an elegant New York studio with Anna Hyatt.

Dissatisfied with the limitations of academic art, Putnam went to Florence to study with Libero Andreotti; she also admired the work of cubist sculptor Archipenko. Her own work became increasingly compact and stylized—well suited to architectural commissions. The flattened archaizing forms of *Puck,* an elegant monument outside of the Folger Shakespeare Library, Washington, D.C., and circular profile reliefs of *Maimonides, Solon,* and *Triborian* over the doorway to the visitor's gallery, U.S. House of Representatives, are examples of her art deco style.

During the 1930s the artist carried out lunettes

Brenda Putnam, PUCK (1932), marble. Photo: Charlotte S. Rubinstein, by permission of the Folger Shakespeare Library.

glorifying the American farmer and woodsman for post offices at Caldwell, New Jersey, and St. Cloud, Minnesota (see chapter 7), and sculpted a fountain figure for the 1939 New York World's Fair. *Orientale,* a female figure whose rounded forms are expressively exaggerated in an almost Indian manner, was reproduced in Jaques Schnier's *Modern Sculpture in America. Midsummer* (Norton Gallery of Art, West Palm Beach, Florida) is a ripe, fecund reclining figure.

Putnam's marble bust of *Amelia Earhart* (Syracuse University) captures the soul of the aviator in forms reduced to their essence. Other portraits are *Pablo Casals* (bronze, Hispanic Museum, New York) and *Wanda Landowska* (shown at the Argent Galleries in 1931), a bas relief of author *William Dean Howells* for the Institute of Arts and Letters, and a bust of *Susan B. Anthony* (1953, New York University Hall of Fame).

Brenda Putnam, AMELIA EARHART (1932), marble, 18″ x 9″ x 8″. Courtesy of the Syracuse University Art Collection.

The well-trained artist wrote a book on technique, *The Sculptor's Way* (1937). Despite her own success she was sensitive to the problems faced by most women sculptors in her day:

> After a man has learned to model the nude figure in a school of sculpture, he can go into the studio of some great sculptor. He is like a medieval apprentice who hired out to a medieval master. He learns, in this way, what no school teaches, drapery, lettering, columning. . . . He sweeps the floor . . . makes the plaster casts. But women, you see, are not accepted by men as apprentices. Women get in the way! So to learn these technicalities, we must teach ourselves. But it takes stamina.[57]

Hilda Kristina Gustafson Lascari (1885–1937), an art deco classicist, produced sculptures of hushed restraint in marble, stone, and bronze.

Swedish-born, she began her studies in Stockholm and continued them in Greece and southern Europe. After coming to the United States in 1916 she married the painter Salvatore Lascari and went to Rome with him in 1919. They later shared a studio in the Lincoln Arcade Building, New York.

Her figures are characterized by quiet detachment and a formal, rather melancholy harmony. In *Dawn* and *La Nymphéa* (a fountain figure standing on a lotus and holding two lotuses), the eyes are downcast, with half closed lids, so that they do not make contact with the viewer. In *Autumn Leaves* (1936) a girl is sinking to the ground with closed eyes. Aside from *Pueblo Indian Mother and Child* and *Thanksgiving* (a kneeling bonneted Puritan woman), the bulk of her work was classicized in subject and treatment. She also created calm, flowing cemetery memorials.

An associate member of the National Academy of Design and a member of the National Sculp-

In 1931 a fire swept the Lascaris' studio, destroying many of their works. In 1937 at age fifty-two, the artist was hospitalized for severe depression. She leaped to her death from the sanatorium's eleventh floor.

A memorial exhibition held at the Wildenstein Galleries included *Mystic Garment* (c. 1937), in which two stylized shallow-relief figures wrapped in the same garment hold it up before a mystic sun-symbol. This work could be a metaphor for the entwined lives of the Lascaris, reaching for the ineffable in art.

> Other works include a relief over the door of the Museum of Art, Springfield, Massachusetts; a portrait statue of Father Nardiello, Bloomfield, New Jersey; Lafayette memorial, Brooklyn, New York; J. Louis Schaefer memorial, Woodlawn Cemetery; and *Madonna,* Museum of Fine Arts, Boston.

Renée Prahar (1880–1962) was called "a pioneer in the fantastic and the grotesque" by the modernist critic Henry McBride. He applauded her Aubrey Beardsleyan fantasies as a fresh vision.

An actress for nine years before becoming a sculptor, she played leading ingenue parts with Richard Mansfield. She already had a sculpture career in mind, however, and was continually doing sculpture sketches for the entertainment of her fellow actors.

The artist studied in Paris with Bourdelle, Injalbert, and at the École des Beaux-Arts; she exhibited in the Paris Salon and in a major exhibition of women sculptors organized by the Plastic Club, Philadelphia, in 1913.

In 1922, a strikingly original solo show, representing five years of work, drew attention at the Kingore Galleries, New York. Prahar installed a series of fantastic rooms for a home, in

Hilda Lascari, AUTUMN LEAVES (1936), marble, height 4′. Courtesy of Brookgreen Gardens.

ture Society, Lascari had a distinguished reputation. She won the Watrous Gold Medal of the National Academy of Design in 1926 for *Awakening* (Newark Museum), a quiet standing figure of a girl, and again in 1936 for *Zephyr,* a bronze fileted head, reminiscent of the *Charioteer of Delphi*; and the McClees Prize from the Pennsylvania Academy of the Fine Arts in 1934 for *Mother and Child* (Philadelphia Museum of Art).

which she showed how polychrome sculptures could be used to harmonize an architectural interior. The entrance hall was a "monkey room," in purple, blue, and cerise, with brooding, attenuated cobalt blue monkeys mounted on columns and carved decorative monkeys on all the fittings. Twenty-seven little monkeys on the fireplace mantel poured jets of water out of their mouths that sparkled in rainbows as they fell in front of the fire into a blue pool-trough. McBride wrote in the introduction to the exhibition catalog: "Startling? Don't be provincial! Remember, the war is over and we are at the beginning of a new era. The andirons, it should be noted, are rusty iron monkeys, prodigiously clever and worthy of the best traditions of the Japanese. . . . There is a strain of the fantastic in all her decorative work. [America needs] the fantastic touch, we need the spirit of play in order to have an art."[58]

A gold and orange breakfast room was ornamented with birds "that never dwelt on land or in air" and window boxes decorated with green, deep blue, and vermilion dragonflies and birds. Relief panels in the music room showed nymphs and galloping fauns among decorative trees, inspired by Diaghilev's Ballet Russe production, *Afternoon of a Faun.*

Even her portrait busts were described by McBride as "far from conventional": "The Baroness de Meyer in faceted marble is possibly cubistic; Mrs. Cyril Hatch's portrait, a lead intaglio set in ebony has unexpected lights due to its treatment and material."[59] A stylized marble head of the actress *Nazimova* had a faceted headdress behind the tight-boned face. Prahar used art deco combinations of pewter, silver, black basalt, colored marble, and painted wood. The critic in the *New York Times,* 5 February 1922, spoke of "the angularity of the modeling . . . the sharp little contour line where plane meets plane."

Prahar was in the National Sculpture Society's 1923 exhibition, and her *Russian Dancer* is at the Metropolitan Museum of Art. One of Prahar's students was the young Betty Parsons, later the pioneering impresario of abstract expressionism.

Lucy Fairfield Perkins Ripley (1874–1949) studied with Saint-Gaudens and Daniel Chester French, and then made pottery and garden ornaments whose stylized forms show Assyrian, Egyptian, and early Greek influences. On a trip to Europe, her sculpture *Seated Woman* reportedly made such an impression on Rodin that he recommended it for exhibition at the Société des Beaux-Arts and took her on as a pupil.

Back in America an exhibition in her studio brought her to the attention of architect Stanford White, who recommended her work for the estate gardens of such wealthy Americans as Mrs. E. H. Harriman, Mrs. Payne Whitney, and Mrs. Walter Bliss. White bought one of her Venetian-influenced well heads for his home at St. James, Long Island.

The reclining figure *Life's Symbol,* also called *Dawn,* shown at the Plastic Club exhibition of women artists in 1916, has Chinese overtones in its facial features, bound feet, and draperies; the seated figure *Meditation* is clearly Greek in its roots. Oriental influences are also evident in the slanting eyes, stylized draperies, hand gesture, and tranquil inwardness of *The Inner Voice,* shown at the Milch Galleries in 1921. "This work," Lula Merrick wrote, "shows her to be a thinker in bronze, a spiritual associate with poets, the possessor of concepts apart from commonplace existence."[60]

Ripley's style was well suited to the design of medals, such as the one for World War I aviator Douglas Campbell. Critics noted her "broad masses, sweeping planes, purity of line . . . stress

on architectonic elements. . . . This artist departs from the conventional and is highly individual."

THE HARLEM RENAISSANCE AND THE INDIAN REVIVAL: AFRICAN AMERICAN AND NATIVE AMERICAN ARTISTS IN THE 1920s

We have tomorrow
Bright before us
Like a flame.
—Langston Hughes

In the 1920s Harlem was a mecca for black culture—a place of hope and promise. The mass migration of black Americans to the north, the high employment rate during World War I, and the general prosperity of the 1920s provided the soil for a flowering of talent that became known as the Harlem Renaissance.

Several important black intellectuals provided leadership to young artists. Howard University professor Alain Locke urged them to draw inspiration from the life of their own people and from their African heritage, instead of imitating white mainstream art. W. E. B. Du Bois presented a vision of the future in which dark-skinned people would join forces against colonialism and enter a new era of self-determination and progress. Soon, the infectious spirit of the New Negro movement was spreading in ripples of cultural activity to Boston, Philadelphia, and elsewhere.

Magazines and newspapers hailed the era of "the New Negro." Alain Locke persuaded William Harmon, a wealthy white real estate entrepreneur, to set up the Harmon Foundation to sponsor exhibitions and prizes for black artists and writers. Knopf and other publishers sought out the works of black authors Zora Neale Hurston, Langston Hughes, Claude McKay, and others; and as jazz became the dominant musical mode of the 1920s, it was fashionable for white people to go up to Harlem to listen to it.

There were interracial salons both in Harlem and downtown. A'Lelia Walker, the richest woman in Harlem, attracted to her palatial brownstone home, "The Dark Tower," a mixed group of Harlem celebrities and an international elite that included grand dukes and people listed in New York's Social Register. New York society was delighted with one party she arranged where white guests were served chitterlings and bathtub gin while blacks received champagne and caviar. Meanwhile, downtown, the white author Carl Van Vechten served as host to an interracial artistic salon.

Picasso and other modern artists, as well as dealers and collectors like Alfred Stieglitz and Albert Barnes, were making the public aware of the greatness of African and other "primitive" art. They saw in it bold, daring new forms, but with little understanding of its actual symbolism or meaning within its culture. As David Levering Lewis points out in *Harlem Renaissance,* many white cultural leaders thought that "Western civilization had been badly wounded by runaway industrialism. . . . One heard it said . . . that the Negroes had retained a direct virility that the Whites had lost through being overeducated. . . . The Black American, excluded from . . . university, office . . . corporation, was the ideal symbol of innocence and revitalization."[61]

Although white critics patronizingly encouraged black artists to embrace primitivism in their work, black artists were seeking something different when they turned back to their African heritage for inspiration—they looked for forms that would express the dignity and aspirations of their people. As we have seen, Meta Vaux Warrick Fuller is recognized today as a forerunner of the Harlem Renaissance, one of the first to draw on African and black folk themes, beginning around 1913. Although she and May How-

Meta Vaux Warrick Fuller, ETHIOPIA
AWAKENING (c. 1914), plaster, height 13¼".
Courtesy of the Meta Warrick Fuller Legacy,
Inc. Photo courtesy of the Danforth Museum
of Art, Framingham, Mass.

Meta Vaux Warrick Fuller, WATERBOY (1930), 13½" x
4½" x 4½". Photo: Harmon Foundation Collection,
National Archives.

ard Jackson were included among traditional
sculptors in chapter 5, they can, in another
sense, be viewed as members of an avant-garde.
Nancy Prophet, Augusta Savage (see chapter 7),
and later, Selma Burke, were also part of it. All
of them won recognition in the Harmon Foun-
dation shows, although Prophet, Jackson, and
Fuller did not live in Harlem.

Similarly there was a new interest in Native
American culture. It was in this era that great
potters such as **Nampeyo** and **Maria Martinez**,
and basket makers like Dat So La Lee (see chap-
ter 1) created a renaissance of Native American

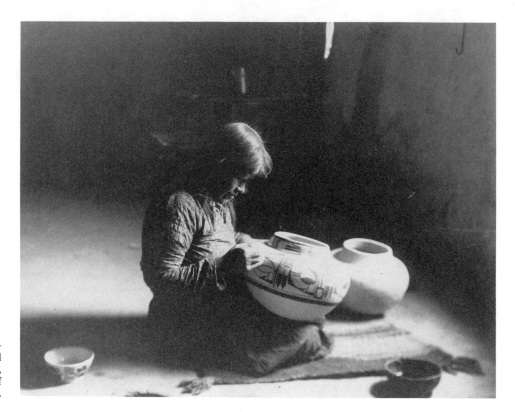

NAMPEYO—
POTTER, Edward
S. Curtis photo,
1900. Library of
Congress.

crafts. Anthropologists further encouraged them to revive their ancient heritage.

Native American design had an influence on the art deco movement—its geometric motifs appeared in the work of architects, sculptors, and designers, and Native Americans were in turn influenced by the art deco movement. Taos became an art colony. Mabel Dodge, who married Tony Luhan, a Pueblo Indian, gathered around her a coterie who shared her devotion to American Indian rituals and philosophy. John Sloan, who began to spend summers in the Southwest, became deeply devoted to Native American culture and insisted on integrating Native Americans with white artists in the Independent shows. He sponsored the first museum exhibi-

tion that showed Native American work as art rather than ethnography.

ART DECO DESIGN

Hildreth Meière (1892–1961), an art deco designer of the 1920s and 1930s, is best known for the interior of the Nebraska State Capitol and the medallions on Radio City Music Hall.

At age nineteen, she spent a year in Italy, where she traveled through hill towns and cities studying the murals of the Renaissance masters. The experience permanently influenced her to work in large public spaces in collaboration with

architects. Ten years of study followed at the Art Students League and elsewhere, and at New York's Beaux Arts Institute of Design with architectural muralist Ernest Peixotti, who "gave me my real professional equipment."[62]

Her portfolio was so impressive that when she applied for work to Bertram Grosvenor Goodhue, a leading art moderne architect, he immediately hired the inexperienced young artist to design the ceramic tile decorations for the vestibule and huge rotunda of the Nebraska State Capitol. When he handed her the blueprints for the 110-foot-high dome, she turned pale, but in the next few years Meière became one of his chief collaborators on the interior of the National Academy of Sciences, Washington, D.C., and many church interiors.

After his death in 1924, she continued for eight more years on the Nebraska capitol, covering the arches, vaults and floors with richly colored art deco ceramic mosaic designs that symbolize the history and tradition of the state of Nebraska. The central dome is adorned with figures in the form of Indian Yei spirits (the images most of us know from sand paintings) that represent the guiding virtues of the state—Charity, Hope, Courage. Their heads and wings, radiating from the center, form a star motif from which the giant chandelier hangs.

One of the most prolific architectural designers in New York City, Meière worked in many media, including mosaics for St. Bartholomew's Church, Temple Emanuel, and the Lady Chapel in St. Patrick's Cathedral, New York, and on St. Louis Cathedral, a huge Byzantine-style church in that city. She also did interiors for ocean liners (S.S. *United States,* S.S. *America,* and S.S. *President Monroe*), designed eleven projects on four buildings for the 1939 New York World's Fair, including a brass and aluminum art deco relief representing *Hippocrates* over the entrance to the science and education pavilion, and

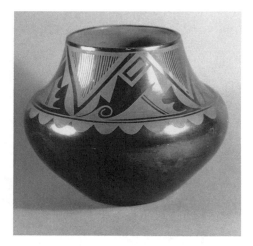

Maria Martinez, BLACK-ON-BLACK JAR (c. 1923–25), height 9¾″. Courtesy of the Bowers Museum, Santa Ana, Calif. Photo: Armand J. Labbe.

created an aluminum art deco outline design representing *Mercury and the Winds* on a wood wall in the Chicago post office.

Meière's three enameled metal medallions representing *Dance, Song,* and *Drama* on the exterior of Radio City Music Hall, each eighteen feet in diameter, were reportedly the largest enameled metal decorations in the world when they were installed in 1932. Their stylized forms harmonize with the art deco design of the building.

Meière combined a demanding career with an astonishing number of civic activities. The first woman on the New York Municipal Arts Commission (1946–52), she became its director and was president of the National Society of Mural Painters, vice president of the New York Architectural League, president of the Liturgical Arts Society, and a member of the Board of Control of the Art Student's League. She won medals from the Architectural League (1928) and the American Institute of Architects.

Hildreth Meière (designer), SONG (1932), circular enamel and metal medallion, diameter 18′. Courtesy Radio City Music Hall, Rockefeller Center, N.Y.

Ilonka Karasz (1896–1981), one of a handful of pioneering American modernist designers in the 1920s, was the only woman in a group that included Donald Deskey, Paul Frankl, and Richard Neutra. Born in Hungary, Karasz studied at the Royal School of Arts and Crafts in Budapest and moved to New York City around 1915. Sculptor William Zorach remembered that "in the early twenties ... Karasz was one of the outstanding personalities of the Village. It was the period of Wiener Werkstatte design in furniture, colorful and original textiles, and astonishing interior decoration from Austria. Ilonka belonged to this movement. She had such talent and ability that I think she could have done almost anything in the way of creative art."[63] Karasz may have absorbed the Viennese influence from her longtime friends and neighbors, Pola and Wolfgang Hoffman, the son and daughter-in-law of the Viennese modernist architect Josef Hoffman.

Believing in total design, she created furniture, tea sets, dishes (some for Buffalo Pottery), geometric textiles, wallpapers, lighting, tiles, toys, and theater and ballet set designs. Beginning in 1925, she designed 186 covers for the *New Yorker* magazine (exhibited at the Galerie de Braux, New York, in 1954). Her work reflects the "skyscraper style" of art deco, but some of her furniture has a chunky purity of line and form resembling Stickley's mission furniture and Frank Lloyd Wright's prairie style. Her ceramic teapot (1935, Metropolitan Museum of Art) has a Bauhaus purity of form, and Paul Frankl included her geometric salt cellars and tea set in his 1930 book *Form and Re-Form*. Revived in a 1984 exhibition at New York's Fifty-50 Gallery, Karasz was included in the 1987 Brooklyn Museum exhibition, The Machine Age in America.

Brenda Putnam, THE SOUTHWEST AND THE NORTHEAST DIVIDED BY THE MISSISSIPPI (1939), plaster. Treasury Department Section of Fine Arts commission for post office (moved to Minnesota Job Services Office), St. Cloud, Minn. Photo courtesy National Sculpture Society. Photographer: De Witt Ward Studio.

•7•

A New Deal for Sculpture: The 1930s

When the boom of the 1920s was followed by the bust of the 1930s, American art was of course affected by the spirit of the times. During the Great Depression many sculptors turned to social themes—images that glorified or showed compassion for farmers, workers, blacks, the downtrodden common man and woman. Artists presented visions of a better social order. Even some abstract and nonobjective artists believed that the structure and harmony of their works were a kind of paradigm for a better society. The use of new industrial materials, such as plastics and steel, reflected an enthusiasm for technology and the potential benefits of a well-organized, egalitarian industrial society.

While citizens as a whole joined groups and worked for causes, artists formed their own organizations. Inspired by the growing trade union movement, they organized the Artists Union to demand jobs for unemployed artists. Women artists, such as Gertrude Greene, Lee Krasner, Esphyr Slobodkina, Alice Neel, Brenda Bryson,

and Rosalind Bengelsdorf served as organizers and marched on the picket lines with the men.

As fascism spread across Europe, artists formed the American Artists Congress to oppose it and to work on larger cultural issues. Sculptor Minna Harkavy was on the executive board. Later, a group of artists who felt that the American Artists Congress was following every twist and turn of the party line split off and founded the Federation of Modern Painters and Sculptors.

Artists still reminisce fondly about those days. Esphyr Slobodkina remembered a sit-down strike in which artists invaded the Federal Art Project's New York office and spent the night sleeping on desks. On one occasion Artists Union picketers, protesting layoffs from federal art projects, were thrown in jail and had to wait for the union lawyer to arrive and arrange for their release on bail. When the police asked for their names, one woman shouted from behind bars "Rosa Bonheur!"[1]

Marion Sanford, WEIGHING COTTON, (1939), plaster, a Treasury Department Section of Fine Arts commission for post office, Winder, Ga. Now in the Barrow County Historical Society Collection. Photo courtesy National Sculpture Society.

THE FEDERAL ART PROGRAMS AND WOMEN ARTISTS

To sculptors, one of the most important consequences of the New Deal was a series of government programs that provided jobs for thousands of artists. The first such program, the Public Works of Art Project (PWAP) of 1933–34 was followed in 1935 by the Federal Art Project (FAP), a division of the Works Progress Administration (WPA), and several other agencies.

At a bare subsistence wage, unemployed painters and sculptors were put to work decorating schools and other state and municipal buildings; turning out easel paintings, sculpture and prints; and teaching art classes. For the first time a large number of American artists could work full time at their profession, meet and share ideas, and feel a new dignity and camaraderie. It is generally recognized by scholars today that the Federal Art Project was the seedbed for the great blossoming of American talent that led to America's leadership in world art in the 1940s.

Since government programs were supposed to be free of discrimination, women artists, for the first time in history, donned overalls, climbed ladders, and worked in public spaces in large numbers, side by side with their male colleagues. An example of what the government art programs meant to women sculptors is the case of Louise Nevelson, at that time struggling and unrecognized. She taught children's classes and churned out quantities of early experimental sculpture while working for the FAP between 1935 and 1939. It was this work that she showed in 1941 to Karl Nierendorf, director of the prestigious Nierendorf Gallery, resulting in her first important solo exhibition—a turning point in her career. It was in a WPA workshop run by Louis Basky and Alexander Tatti that Nevelson learned exciting new sculpture techniques. In general, artists were encouraged to invent and experiment with new materials, especially if they provided inexpensive ways of creating large numbers of works for the people.

Another agency, the Section of Fine Arts of the

Gladys Caldwell Fisher, ROCKY MOUNTAIN SHEEP (1936), stone. Central post office, Denver, Colo. A Treasury Relief Art Project commission (now under jurisdiction of General Services Administration). Photo: W. Rubinstein.

Concetta Scaravaglione, AGRICULTURE (1938), limestone relief. A Treasury Department Section of Fine Arts commission (now under jurisdiction of the General Services Administration), Federal Trade Commission Building, Washington, D.C. Photo: National Archives.

Treasury Department, sponsored anonymous (gender-blind) competitions for federal building commissions, and under these democratic conditions women often emerged as the winners. The aluminum figures of postal workers executed by Concetta Scaravaglione and Berta Margoulies for the federal post office in Washington, D.C., are examples.

From the top down, women played leading roles. The First Lady, Eleanor Roosevelt, was very supportive; for example, she attended the ceremonies that marked the opening of the Harlem Community Arts Center. Mrs. Elinor Morgenthau, wife of the Secretary of the Treasury, was one of the instrumental figures in the creation of the Treasury Department's Section of Fine Arts. Juliana Force, director of the Whitney Museum, was New York regional director of the early Public Works of Art Project, and Audrey McMahon headed the New York division of the Federal Art Project that followed. A number of women headed statewide programs—for example, Angela Gregory in Louisiana and Enid Bell who headed the sculpture division in New Jersey.

The equal-opportunity federal art programs had their limitations, however. Since the government refused to allow two members of a family to draw checks from the FAP, in practice, if both husband and wife were artists, the man usually got the job. Couples sometimes found it necessary to get a divorce or "live in sin" in order to qualify for the pittance that would permit them to survive. Dorothy Dehner remembers being excluded from the FAP because her husband, sculptor David Smith, was enrolled. (Similarly, in the 1930s, thousands of married women teachers and workers in other fields were forced out of their jobs on the theory that their husbands were supporting them; they were urged to stay home so an unemployed man could have their job.) Despite these shortcomings, however, women artists, on the whole, were able to function as professionals on an unprecedented scale.

SCULPTURAL STYLES OF THE 1930s

In general, the public was hostile to modern art; traditional academic sculptors, mostly in the National Sculpture Society, continued to receive the bulk of major architectural commissions. Two groups, however, sought to advance the cause of the avant-garde—the Sculptors Guild and the American Abstract Artists.

The **Sculptors Guild** was a loose amalgam of progressive artists who turned away from traditional academicism, which they associated with official art, and sought more expressive, simplified, and sometimes distorted forms to embody their humanistic and figurative themes. They rebelled against the stale forms of equestrian statues, war memorials, and allegorical figures that now seemed like pompous expressions of the status quo.

Many sculptors, such as Concetta Scaravaglione, continued the trend toward direct carving, inspired by primitive art. They identified with the ethos of artists as workers, using their own tools, in contrast with the Beaux Arts sculptors, who employed artisans to do the carving . "Truth to materials" was the byword. A stone carving should not be like a work created for the fluid material of bronze. A good work in stone should be compact enough to be rolled down a hill without breaking, whereas a piece designed for ductile metal should permit extensions and openings.

Artists like Berta Margoulies and Helene Sardeau, who were primarily modelers for casting in bronze, were influenced by European expressionists such as Lehmbruck or Barlach. Whereas sculptors in the previous decades yearned to study with Rodin, now many had studied in Paris with Bourdelle, Maillol, or Despiau, or in New York with Archipenko. All these sculptors, however, no matter how much they departed from re-

alism, continued to base their work on forms in nature.

On the other hand, a small, embattled group of avant-garde sculptors rejected figurative art altogether. Inspired by European modernists such as Picasso, Arp, Miró, Mondrian, and the constructivists Pevsner and Gabo, they believed that abstract or nonobjective art was the truly revolutionary art of the twentieth century. Critic Barbara Rose has called the 1930s "the decisive decade" because it was in this era that a small cadre of artists began to forge some of the new forms that would, after World War II, emerge as a new and distinctly American school of abstraction.

WOMEN IN THE SCULPTORS GUILD

The Sculptors Guild was organized in 1937 because progressive artists were having a particularly difficult time surviving during the depression; traditional academicians continued to receive most of the large public commissions. Its declared purpose was "to stimulate and uphold new artistic values and combat all reactionary tendencies . . . to oppose all attempts to curtail freedom of expression . . . [and] to encourage and support government recognition of the arts."[2]

Approximately one-third of the members were women (seventeen out of fifty-seven), and some were prime movers and shakers. On the executive board were Sonia Gordon Brown, Minna Harkavy, Berta Margoulies, and Concetta Scaravaglione. Margoulies served as secretary and Anita Weschler as treasurer. In addition to these women, other charter members in the first exhibition were Simone Brangier Boas, Cornelia Van A. Chapin, Louise Cross, Alice Decker, Eugenie Gershoy, Dorothea Greenbaum, Genevieve Karr Hamlin, Margaret Brassler Kane, Dina Mel-

icov, Helene Sardeau, Mary Tarleton, and Marion Walton.

In the 1940s the group included Doris Caesar, Rhys Caparn, Lu Duble, Franc Epping, Clara Fasano, Cleo Hartwig, Lily Landis, Mitzi Solomon (who later worked in England), and others.

Eager to get their work out to the people, the guild organized an outdoor show for their first exhibition in April 1938. Mayor Fiorello La Guardia allowed the group to use an empty lot located at Thirty-ninth Street and Park Avenue. Marguerite Zorach designed the poster and catalog cover, and there was much publicity in the press. Mrs. Roosevelt lent her support by attending the show, and thousands came, paying ten cents for admission.

Although some critics were supportive, other segments of the community found the new forms a bit hard to take. Mayor Fiorello La Guardia no doubt expressed the feelings of many members of the public when he looked at one piece and said, "If that's a man, I'm a monkey's uncle."

Berta Margoulies (O'Hare) (1907–) says that childhood memories of war and insecurity shaped the expressionistic humanism of her art. After her Polish-Jewish family migrated to Belgium, the country was invaded by the Germans during World War I. Her father was imprisoned and the others fled to Holland, then England.

There she attended the Howard School in Simsbury Park for seven years. In the manner of other immigrants of her generation, the four Margoulies children then came to New York City, where they managed to support themselves through college without outside help. Berta was a Phi Beta Kappa student in anthropology and languages at Hunter College.

The deadening art classes at college nearly turned her off. Margoulies, working as a French and German translator, stumbled into sculpture by accident when she went down to the Educational Alliance to take some evening classes solely for amusement. As she tells it, "There was a classroom with all this clay, you know, and some people working. There wasn't an instructor . . . or a model . . . and the minute I got my hands in the stuff I said, 'Oh my God! This is it.' I went there every evening."[3] She was soon working part time and taking sculpture classes with Edward McCartan at the Art Students League.

Margoulies progressed so rapidly that in 1928 she won a Gardner Foundation scholarship for a year in Paris. She hoped to study with Emile-Antoine Bourdelle, whom she greatly admired, but he died while she was crossing the Atlantic and the school was in chaos. Disappointed, Margoulies learned all she could at the Julien and Colarossi academies and took anatomy briefly at the École des Beaux-Arts. Already a modernist interested in the broad forms of Maillol and Despiau, Margoulies found the Beaux-Arts too traditional. "It got to be *awfully* anatomical," she said. "Who wants to know more than you need to know? The blood and guts? . . . I tell my students, the anatomy for an artist is completely different. . . . you want the bones mainly, and the muscles (not too many muscles), the movement. . . . You want to perceive the figure without knowing the gory details, which don't do anything for you. . . . They just obfuscate things, actually."

Margoulies returned to New York in the middle of the depression and she supported herself for a year as a social worker. At the same time she opened a studio and, during a short stint at the Art Students League, became a close friend of her teacher William Zorach and his wife, Marguerite. She spent several summers with them in Maine and even shared a large piece of Tennessee marble with William, her half becoming the statue *Maternity,* a warm earthy immigrant figure, arms crossed on the stomach, typical of the

direct-carving style of the 1930s. It was in the first show of the Sculptors Guild. But Margoulies—primarily an expressionist—found the work of Zorach and the direct carvers "a bit thick" and preferred the looser, more fluid clay and bronze, which she subsequently employed.

The sculptor's career received a strong boost from the New Deal art programs. After doing a colossal head of *Andrew Jackson* for the WPA, she won, in competition, one of the coveted commissions from the Treasury Section of Fine Arts, for a statue of a *Colonial Postman*—an aluminum figure for the central post office in Washington, D.C. (Concetta Scaravaglione did the *Railway Mail Carrier, 1863*). The jurors—William Zorach, Paul Manship, and Maurice Sterne— selected her work from thirteen applicants.

Margoulies still remembers what it meant to her to get the federal commission—to create art for the people: "I tell you very frankly, I was terribly excited about getting a job to do for a purpose that people will *see*; and that I had *won* it. I remember [my] brother, when he heard about it, meeting me on the street and throwing his arms around me—it was wonderful. It was not only the three thousand dollars."

Margoulies had never done a costume piece, which she associated with stale academic public sculpture ("I had no great sympathy for all the buttons"). But rising to the challenge, she made the work as historically accurate as she could, at the same time keeping it simplified and carrying it out with as much aesthetic integrity as possible. While researching the costume—the tricorne hat, the leggings—she even managed to dig up an authentic colonial leather mailbag from the Smithsonian Institution. Her brother, a "stalwart pioneer type," was the model.

Even learning how to design a figure for a niche was a challenge. Margoulies "studied and studied" Donatello's *St. George,* a Renaissance masterpiece that also involved a figure in a niche.

A charter member of the Sculptors Guild and a leading organizer as the first secretary, Margoulies still remembers the excitement of its inception:

> Several of us got together ... our purpose was very simple: we wanted to get the sculptor away from his dead academic situation ... All the jobs were going to the architectural sculptors ... we also wanted to get the sculpture *out to people.* So our purpose was to have sculpture outdoors. We didn't own anything, we didn't have anything.... So we went to Mayor La Guardia—that nice gentleman—and we said, "We want to do thus and so—give us, lend us—not money, just give us some space." There was an empty lot at Park Avenue and Thirty-eighth Street, and he said, "You can have the lot for next year." And we just worked like crazy, planting it, and building stands.... I think Wheeler Williams and the National Sculpture Society were awfully angry, especially when we made such a splash.... It was a very beautiful outdoor show. People lined up around the block.

The guild ended up with four thousand dollars in its treasury, despite the low admission fee.

Margoulies worked on another important commission, *Woman and Deer,* for the garden court of the Federal Building at the 1939 New York World's Fair: "I wanted something that had to feel garden. I couldn't think of anything more garden—particularly since I had this feeling about deer and animals—than a woman with a deer."

In 1942 Margoulies created the powerful bronze group *Mine Disaster* (Whitney Museum of American Art), a work whose slashing angular planes are reminiscent of Kaethe Kollwitz (whom Margoulies admired). Sympathetic to the

Berta Margoulies, MINE DISASTER (1942), bronze, 23″ x 29½″ x 12½″. Collection of the Whitney Museum of American Art. Purchase. Acq. #45.10.

oppressed, Margoulies shows the miners' families waiting apprehensively behind a spiky fence for news of their loved ones.

During these years, Margoulies won the 1937 Avery Award from the Architectural League and another from the Society of Arts and Letters in 1944, as well as a Guggenheim fellowship in 1946. Also in the forties, she sculpted *Strike* (bronze, 1948), a strong, stylized composition showing unity between white and black workers. It is in the collection of the Graphic Communications International Union.

Her later works became increasingly fluid and expressive. *Panic* (1961), for example, shows fleeing figures in flowing, diagonal rhythms reminiscent of Barlach's *Avenger*. Conscious of her cultural heritage, Margoulies dealt with Jewish themes in *Blessing Candles, The Ritual, Remembrance of Things Past* (a carved Hebraic head), *Wailing Wall* (an abstracted group of figures praying at the wall); and the loose, fluid bronze, *Promised Land,* a Moses-like figure rising up, his arm lifted in prophecy. Margoulies said that these works are "humanistic—certainly not religious.... Being very much *aware* of the world and *caring* about people, and perhaps my social work, and the anthropology, and so forth [were part of the same thing]."

Despite the strong abstract elements in her work, Margoulies found that she could not, with integrity, switch to total abstraction and thus went through "the agony of all artists of conscience who would not go with the five yearly change of style or fashion."[4]

The sculptor had a long happy marriage with Eugene O'Hare, an author who was working with the Special Skills section of the New Deal when she met him. After living in Flanders, New Jersey, for many years (she taught at Finch

Berta Margoulies, STRIKE (1948), bronze, 24″ x 16″ x 13″. Collection of the Graphic Communications International Union, Washington, D.C. Photo: Peter A. Juley & Son, courtesy of the artist.

Community College), she settled in Brookline, Massachusetts, near her son, a professor at Harvard's Kennedy School, and continues to work and exhibit.

Minna Harkavy (Taubes) (1895–1987) expressed compassion for the oppressed in modernist forms that have a distinctive, instantly recognizable quality. Her work, said Andrew Rit-

chie, has "a bitter flavor of social consciousness and criticism of the established order."[5]

Born in Estonia, Harkavy studied at Hunter College (B.A), the Art Students League, and with Bourdelle in Paris. From the late 1920s she was a well-known modernist in Paris and New York. She exhibited at the Jeu de Paume and the Salon d'Automne, was a founding member of the avant-garde New York Society of Women Artists (1925), and had solo shows at the Morton Gallery, New York (1929) and the Ring Gallery, Paris (1932).

A left-wing artist, her work was shown in 1931 at the Moscow Museum of Western Art, which at that time purchased her head of the black composer and director of the famed choir of Negro spiritual singers, *Hall Johnson* (bronze, Pushkin Museum, Moscow), shown with his chin cupped meditatively in one hand. *Negro Spiritual* (1930, bronze, private collection), a head of a black man with clasped hands, carried away with religious fervor as he sings, has bold, exaggerated forms. *American Miner's Family* is a compassionate study of a miner, his wife, and their three children. The ovoid, primitivizing forms and elongated heads seem influenced by Modigliani and African art. In many of her works, there is something blunt and shocking about the way she chops off hands or heads and integrates them into the compositions. The taut head, *New England Woman* (private collection) was in the 1939 New York World's Fair exhibition of American art.

A founder of the Sculptors Guild, Harkavy exhibited regularly with them. In the second outdoor show (1939) was a half figure of a mother wrapping her arms protectively around a child (*My Children Are Desolate Because the Enemy Prevailed*) which perhaps refers to the spread of Nazism in Europe. A noted antifascist, Harkavy served on the board of the American Artists Congress and was a friend of Carlo Tresca, the Italian-American journalist and enemy of Mussolini.

Minna Harkavy, AMERICAN MINER'S FAMILY (1931), bronze, height 27″, at base, x 23″ x 19¾″. Collection, The Museum of Modern Art, N.Y. Abby Aldrich Rockefeller Fund.

iconoclastic personality of the famed collector of Matisse in firmly abstracted planes. It was singled out for its originality and sculptural qualities in an *Art News* review of a group show at the Whitney Museum. Other portraits are of *Oskar Kokoschka* and *Henri Barbusse,* the French socialist author whose novel *Le Feu* is a brutal depiction of the horrors of war.

Harkavy taught sculpture in her penthouse studio at the Hotel Ansonia, New York. Later she spent many years in a nursing home suffering from a deteriorative condition.

Minna Harkavy, NEW ENGLAND WOMAN (1939), terra cotta, 19½″. Courtesy Douglas Berman/Peter Daferner, Inc., N.Y.

After he was gunned down, probably by Fascist agents, on the streets of New York, she did a portrait bust of him that stands in Carlo Tresca Plaza at the entrance to the public gardens in Fulmona, Italy. It bears the inscription "Socialist—Exiled Martyr of Liberty."

Some of Harkavy's works have a haunting, existential quality—for example, *Martyr,* a plaster head with haunted eyes shown in the 1942 Sculpture for Freedom exhibition at Rockefeller Center; *Dialogue (Two Men),* a symbol of human communication; and the tragicomic seated *Clown,* shown at the 1950 Sculptors Guild exhibition.

The bust of Gertrude Stein's brother *Leo Stein* (plaster, 1932, private collection) captures the

Concetta Scaravaglione (1900–75), the daughter of poor Italian immigrants, studied carving with Robert Laurent in 1924 and became one of the early direct carvers in the United States. In the 1930s she was a leading public sculptor of humanistic themes.

A child of the ghetto, Scaravaglione appreciated the opportunities that opened to her in the United States:

> If my parents had stayed in Italy and had I been born there, it probably would have been impossible for me to become a sculptor. The opportunities given to me by the free schools of New York would not have come my way in a Calabrian village.... For a woman to think of entering a profession or to dream that she was the equal of man politically, is still a shocking thought. Even after my parents had settled in America, the idea that their children might enter professions was inconceivable. Poor people from the hills do not expect such good luck.[6]

Indeed her parents thought she was crazy when she said she wanted to go to art school. But her elementary school teacher had already discovered her talent and convinced her parents that Concetta, the youngest of nine children, deserved the opportunity.

At the National Academy of Design she attended a special free sculpture class for young women taught by a hard taskmaster, Frederick Roth. All the girls dropped out of the rigorous program except Concetta, who was already beginning to win medals in 1917 and 1918. The academy, deciding it was too much of a luxury to support a class for one student, canceled it.

Scaravaglione then took a job filling perfume bottles in a factory to earn tuition for the Art Students League. She remembered that the reek of cheap perfume entered the pores of her body so completely that bathing would not rid her of it; she was embarrassed by the smell when riding

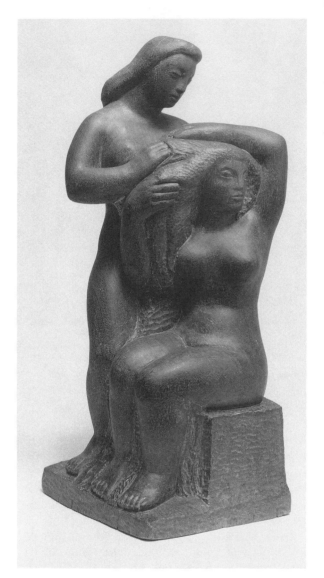

Concetta Scaravaglione, GROUP (1935), mahogany, 24½″ x 10½″ x 10″. Collection of the Whitney Museum of American Art, N.Y. Purchase. Acq. #36.4. Photo: Geoffrey Clements.

on the subway. She never forgot this job, which made her appreciate her chosen profession all the more.

Scaravaglione studied at the league with Boardman Robinson and took direct carving from Robert Laurent at the Masters Institute. Her direct carvings were among the early examples of this style in the 1920s.

Scaravaglione's mahogany, teakwood, and marble carvings combine the bulky massiveness and closed forms of the period and her own characteristic flowing lines. In *Group* (1935, Whitney Museum of American Art, New York), a standing and a seated female figure flow together in one unbroken mass. The polished mahogany surface is accented by textured chisel marks in the hair.

By 1925 she was exhibiting at the Whitney Studio Club and then at the Whitney Museum, the Museum of Modern Art, and the Pennsylvania Academy, where she won the Widener Gold Medal in 1934. In the 1930s she received several of the coveted commissions from the Treasury Department Section of Painting and Sculpture. These were won in anonymous competitions not aimed at helping unemployed artists.

Railway Mail Carrier (1935) is a cast aluminum figure for the federal post office and *Agriculture* (1937) is a two-figure limestone bas-relief on the Federal Trade Commission Building, both in Washington, D.C. A horse and Indian in high relief, *Aborigines,* is at the post office in Drexel Hill, Pennsylvania.

Her largest commission was the fourteen-foot-high *Woman with Mountain Sheep* (1939) for the garden court of the Federal Building at the 1939 New York World's Fair (destroyed; a small plaster maquette is at the General Services Administration, Washington, D.C.) All of these are broad public symbols, basically classical in feeling, which Scaravaglione imbued with warm humanism and a modern simplification of form.

A socially conscious artist, Scaravaglione joined the utopian Architects, Painters and Sculptors Collaborative in 1937—a group whose members believed that the arts should be used to improve the lot of the common people. That year she designed *Dawn* as part of a community center project for the New York World's Fair, but it was never executed.

At the first outdoor show of the Sculptor's Guild, Scaravaglione's *Girl with Gazelle* (1936) won praise and was featured on the cover of *Art Digest.* The curving rhythmic forms of figure and animal have a tactile, yet tense quality; one can sense the sculptor's hand caressing the forms.

In 1941, Scaravaglione had a solo show at the Virginia Museum of Fine Arts. Continuing to grow and develop, the sculptor experimented with metal welding with Theodore Roszak and was the first woman to receive the Prix de Rome to study at the academy in Rome (1947–50). Her copper and bronze figure pieces of later years, shown at the Kraushaar Galleries, New York, in 1974, became more abstract and experimental, with hollow and open forms.

The sculptor's long distinguished teaching career began at the Educational Alliance (1925), and continued at New York University, Sarah Lawrence College, Black Mountain College, and Vassar (1952-67).

During a long, successful career, **Helene Sardeau (1899–1969),** another charter member of the Sculptors Guild, created emotional expressionistic figures influenced by Lehmbruck and Epstein.

Born in Antwerp, Belgium, Sardeau came to the United States with her family at age fourteen. After studying at Barnard College, Cooper Union, the Art Students League (1921–22), and the School of American Sculpture (1924–25), Sardeau made the obligatory trip to Paris. There she worked on her own between 1926 and 1929,

receiving extensive criticism from the French early modernist Charles Despiau, who took an interest in her and influenced her style. In 1928 she showed at the Salon d'Automne.

Returning to New York in 1929, Sardeau opened a studio on Sixty-seventh Street, had a successful show at the Ehrich Galleries, and was commissioned to do two liturgical relief panels for the New York Young Men's Hebrew Association, but the models were destroyed in a studio fire.

In 1931 Sardeau married George Biddle (of the distinguished Philadelphia Biddle family), a socially conscious muralist in rebellion against his conservative background. They had a son, Michael, in 1935 and maintained a long harmonious marriage, sharing humanistic views and sometimes collaborating on public commissions. Biddle believed strongly in art for the people and was one of those who first suggested the idea of the federal art programs to President Franklin D. Roosevelt. The couple lived in Croton-on-Hudson, New York, spending summers in Truro on Cape Cod, where they had separate studios.

The year after their marriage they traveled to Italy and had a joint exhibition sponsored by the Italian Syndicate of Fine Arts at the Galeria di Roma. Soon after returning to the United Sates in 1933, Sardeau received her first major commission, *Slave,* one of a group of statues by such noted sculptors as Robert Laurent and John Flannagan, for the Ellen Phillips Samuel Memorial—a large outdoor sculpture garden in Fairmount Park, Philadelphia.

This powerful six-foot limestone carving of a kneeling, manacled black man was in the Museum of Modern Art's exhibition, The Melting Pot, before being shipped to Philadelphia. Her interest in portraying black Americans was not new. As early as 1926 she had created a group of lively semiabstract figures inspired by the Tuskegee Institute *Spiritual Singers.* A later figure

Helene Sardeau, SLAVE (1933), limestone, height 6′. In the Ellen Phillips Samuel Memorial, Fairmount Park, Philadelphia. Photo: Philadelphia City Archives.

of a sorrowing black woman, *Negro Lament* (Philadelphia Museum of Art), illustrates a poem about a lynching, "Oh Lord—What Have They Done," by Katherine Garrison Chapin.

At the historic first outdoor exhibition of the Sculptors Guild, Sardeau showed a pair of *Dancing Figures* circling atop a columnar base, whose chunky simplified forms are reminiscent of Maillol and Despiau, but are more open and animated. The theme of dancers, begun in the 1920s, was one that she developed, with increasing expressionism, throughout her career. She also created several figures of *Joan of Arc* at the stake, with features that resemble her own.

Inspired by the great Mexican muralists, Rivera, Orozco, and Siqueiros, Sardeau collaborated with her husband on monumental, multimedia commissions in South America and Mexico. At

the National Library in Rio de Janeiro, her bronze symbols of *Humanity, War,* and *Peace* were mounted on the wall below Biddle's frescoes. In Mexico City's Supreme Court building her bronze relief figures symbolizing *Destruction* and *Despair* were integrated into her husband's frescoes. She also carried out federal commissions for the post offices at Ossining, New York, and Greenville, Massachusetts (three glazed terra-cotta reliefs, *Planting, Mother and Child,* and *Reaping,* 1947).

Sardeau's heroic falling figure *Icarus* (Philadelphia Museum of Art) was the centerpiece of a 1952 sculpture show at the Metropolitan Museum of Art. Her work was becoming more expressionistically attenuated in the manner of Lehmbruck and Epstein, as in the kneeling *Fig-*

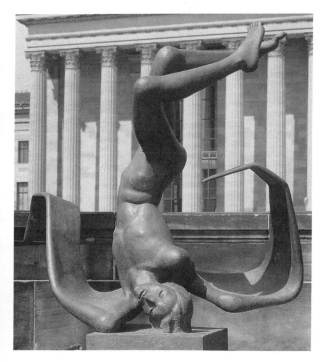

Helene Sardeau, ICARUS (1951), bronze, 75⅞" x 75½" x 43". Philadelphia Museum of Art: Gift of a group of friends in memory of Dr. Edward Weiss.

ure (1952) and *Amazon,* both at the Pennsylvania Academy of the Fine Arts.

In the last decade of her life, she obsessively pursued the theme of dancers in elongated, almost tortured forms that she called "shadows"; they were perhaps expressive of her own suffering from a severe form of arthritis.

Like many of her colleagues in the Sculptors Guild she disliked the wave of nonobjective sculpture that engulfed the country in the 1950s and explained her viewpoint in a 1956 interview:

> Throughout the ages great art has drawn from life its moods and deep emotions. These know no barriers of race or geographical boundaries. . . . It is unfortunate today that so much sculpture has become dehumanized, divorced from nature and earthly emotions. There is too much . . . preoccupation with techniques. Playing with wire and strings often becomes escapism. Technique is never valid per se. It is what is expressed with it that is important. Much of such work is novel, with good decorative quality, but lacking in the fundamental structure and feeling of sculpture.
>
> I believe in experimentation. It has always been the precursor of great periods of art. But most of these experiments had better be kept in the laboratories. Time, the great equalizer, will eventually determine the survival of good art.[7]

Anita Weschler, another founding member of the Sculptor's Guild, developed an innovative expression of the collective spirit—blocky group sculptures in cast stone that show people marching, fighting, and the like. She says, "The groups concern themselves with universal subjects. The forms used convey idea and emotion by means of simple planes and contrasting repeats."

Born in New York City, Weschler graduated from Parsons School of Design, studied at the National Academy of Design, the Pennsylvania Academy, with Albert Laessle, and with William

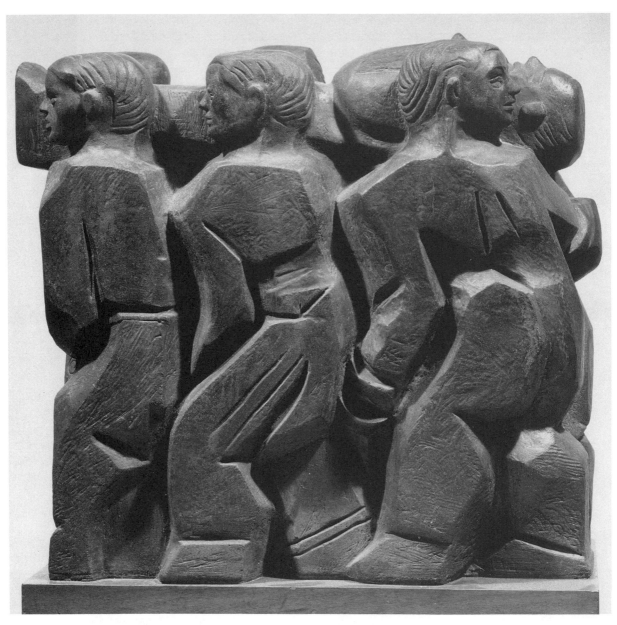

Anita Weschler, A TIME TO DIE (1945), cement, height 21¼″. Collection of the Whitney Museum of American Art. Gift of an anonymous donor, by exchange. Acq. #57.14. Photo: Oliver Baker.

Zorach at the Art Students League. She had a 1937 solo show at the Weyhe Gallery.

In the 1938 outdoor exhibition of the Sculptors Guild, Weschler exhibited *Drafted* (Syracuse University), a group composition in which a leader is beckoning to marching men with rifles who follow like robots. This work was one of an antiwar series entitled *Martial Music* that also includes *Shrapnel, Starvation, Bacteria and Gas* (Syracuse University), and *Spoils,* all in her characteristic blocky style. *A Time to Die* (Whitney Museum, New York) shows six women bearing the prone figure of a fallen man, and *Victory Ball* (Metropolitan Museum of Art) celebrates the end of war.

The artist completed a sculpture for the U.S. Post Office at Elkins, North Carolina, and did portraits of *William Zorach,* Irish author *Padraic Colum,* and dancer *José Limon* (also called *Prologue,* Syracuse University).

Weschler has made excursions into abstraction—assemblages of driftwood and stone (*Midnight Rendezvous*) and translucent paintings in light boxes (*Primeval Haze #3,* University of Iowa). She has had twenty-five solo shows and received fellowships to Yaddo and the Mac-Dowell Colony.

Marion Walton (1899–), an early member of the Sculptor's Guild and a direct carver in the 1920s and 1930s, later became an abstract artist. She experienced both the pleasure and the discomfiture of creating for the public through the government art programs.

Born in New Rochelle, New York, Walton lost her father when she was very young. Her mother, a pianist and noted patron of modern composers (such as Bartók, Schoenberg, and Varèse) surrounded her and her sister with music. A gift of plasticene, however, started the dreamy child modeling in clay.

After a year of unfocused studies at Bryn Mawr, Walton left at age sixteen to nurse wounded soldiers in World War I, and in 1920 went to France to drive a truck for the American Committee for Devastated France. "It was a tremendous experience," she wrote, "but after many months I wanted so desperately to study sculpture that I left to study at the Académie de la Grande Chaumière under Antoine Bourdelle, and lived in a little studio nearby, with no heat, running water, gas or electricity, but with enormous charm. Albert Giacometti was in my class at the Académie. It was then that I fell in love with Paris."[8]

Walton came back to the United States to get a firm foundation at the Art Students League and at the Borglum School with Mahonri Young, a warm, encouraging teacher. Then she returned to Paris for two more years with the dominating Bourdelle.

Walton almost became a member of the "lost generation":

> At that time many young American artists were living in Paris, shunning the United States as unsympathetic, and I was strongly tempted to settle down there too. But a feeling had been slowly gathering force in me that I as an American belonged in America.... I felt also that though sculpture in America had been in the past largely based on European traditions, it should as a young country be independent artistically.... I felt that I wanted to work in my humble way toward this end.[9]

Back in New York in 1925, Walton opened a studio and went through a soul-searching period, trying to throw off the influence of Bourdelle. Gradually she found her way into direct carving:

> I often thought of sculpture as something that could be held, compact and comfortable, in the hollow of a giant hand, but built solid and

strong like a building. I began to want to work directly with that form in its final mediums without the intermediate stage of clay and plaster . . . carving blocks of stone and wood, keeping the figure or figures subservient to the mass as a whole. I tried to build them architecturally because sculpture, I believed, should have a quality of strength and permanence. I know now that many other young sculptors must have been trying the same thing at that time, but as I knew none of them then, direct carving was a real experiment for me and an exciting experience.[10]

After she married publisher James Putnam, the exciting world of publishing and the care of her son ate into her time for a while. But "through a system of neglect on my part, and tolerance on theirs" she gradually resumed her career. She had a 1933 one-person exhibition at the Weyhe Gallery, New York, and showed in Whitney Annuals and group shows.

Walton gradually worked toward stylized forms, very flattened in the block. She was an early member of the Sculptor's Guild and remembers: "The early outdoor shows were especially exciting. . . . I particularly remember the one on Park Avenue at 38th Street when Helen Keller came in and was taken around from piece to piece, running her hands over them with an expression of intense concentration and pleasure. She especially seemed to like my African wonderstone *Family* with its smooth forms and incised lines."[11]

Walton's experiences with the government art projects of the 1930s provide insight into the stresses faced by artists attempting to bring art to the people. She won a competition for a fourteen-foot plaster *Farmer and Calf* for the garden court of the Federal Building at the 1939 New York World's Fair. "The $1,000 I was paid was great," she wrote, "but the success was greater."

This resulted in a post office commission for Pittston, Pennsylvania: "I read about Pittston history and . . . settled on a large bas relief in limestone of a group of miners descending in an elevator and another showing an early local hero who had saved the town by driving attacking Indians over a cliff." Alas, the locals were not ready for modern art. While the reliefs were being installed on the post office wall, people stood around, making scathing remarks: "Jesus, my twelve-year-old daughter could do better than that . . . awful . . . tear it down." The artist was not tough enough to take the criticism in stride. She destroyed all records and publicity relating to the project and tried to have the work destroyed. Years later, Walton's son visited the post office and found that he liked the sculpture very much.

Extremely self-critical, Walton also destroyed the powerful *Man with Jackhammer,* shown in the 1939 exhibition of the Sculptors Guild, in which, she wrote, she "tried to show the dominance of machine over men, but did not feel it succeeded." This socially conscious work, characteristic of the 1930s, bore some resemblance to a work by her teacher, Mahonri Young, but hers was more geometric and abstract.

Influenced by Brancusi and Henry Moore, the sculptor's work grew increasingly nonobjective and was included in both Ludwig Brummé's book *Contemporary American Sculpture* and Michel Seuphor's *The Sculpture of This Century.* Walton lived in Paris for many years, becoming well known abroad. She won a gold medal at the 1979 Biennale Internationale, Ravenna, Italy, and was in the 1978 Triennale Européenne de Sculpture at the Palais Royale. She now lives permanently in New York City.

Marion Walton, STONE DRILLER (MAN WITH JACKHAMMER), composition stone, 5' (destroyed). Courtesy of the artist. Photo: Walter J. Russell.

Dorothea Schwarcz Greenbaum (1893–1986) showed in her work and life her concern for human dignity. Described as a "romantic realist" whose sculptures "radiate serenity," she also served as a leader in the Sculptors Guild, Artist's Equity, and other organizations.

Born to well-to-do Brooklyn parents, she attended the New York School of Design for Women and studied painting at the Art Students League with Kenneth Hayes Miller. She shared a Union Square studio with Peggy Bacon and exhibited "Fourteenth Street School" paintings of urban realism at the Whitney Studio Club.

After marriage in 1925 and the birth of two sons, she switched to sculpture. *Sleeping Girl* (1928, cast stone) was in the 1933 Chicago Century of Progress exhibition. Her first solo exhibition at the Weyhe Gallery included bronzes like *Tired Shopper* (c. 1938) and *Fascist* (c. 1938), an oversized brutal head—subjects that reveal her humanistic and social concerns. In 1938 Greenbaum helped organize the outdoor exhibition of the Sculptors Guild and later served as director. In the guild's first show she exhibited a sensitive full length bronze realistic study of her adolescent son *David* (IBM collection) and a plaster *Acrobat*.

Greenbaum worked in a modified traditional mode, moving from clay modeling to direct carving and later to hammered lead, a medium she found very alive and responsive (*Bathsheba,* 1955, Newark Museum). In *Drowned Girl* (1950, Tennessee marble, Whitney Museum), an Ophelia-like head growing out of the natural shape of the stone, the polished face contrasts with the tool marks and rough texture of the shell-encrusted hair. In *The Snob,* an amusing recumbent limestone camel, the curved forms of the haughty head are echoed in the two great humps, while a textured play of varying tool marks accents the surfaces. Greenbaum won awards

Dorothea Greenbaum, TINY (1939), bronze, height 5′.
Collection of the Institute for Advanced Study, Princeton,
N.J. Photo courtesy Daniel and Patricia Greenbaum.
Photographer: Leonard N. Weinstock.

twice at the Pennsylvania Academy—the 1941 Widener Medal for *Tiny,* and the Ford Foundation Purchase Prize for *Braided Hair. Dancing Class,* a bronze figure of a little girl in leotard taking a ballet position is at the National Museum of American Art.

A founder of Artist's Equity, Greenbaum worked for improved rights and economic opportunities for artists and in 1952 was one of seven American delegates to the UNESCO conference on the future of the arts in Venice, Italy.

In 1947 the American Academy of Arts and Letters honored Greenbaum "in recognition of sculpture of a high order replete with a warm and sensitive appreciation of the human spirit." A joint show with Isabel Bishop at the New Jersey State Museum in 1970 pointed up the connection between these two warmly humanistic artists.

Eugenie Gershoy (1902–88) expressed her good-humored wit in a distinctive genre of polychrome sculptures that she developed when she was with the Federal Art Project in the 1930s. Her work anticipated the fantasy polychrome sculpture of such present-day artists as Red Grooms. Gershoy expressed her credo in an essay written for the Federal Art Project: "The function of fantasy and humor in sculpture, as in all other forms, is of prime importance today.... It takes the role of commentator; as satire it becomes propaganda; it laughs with or at human beings—a salvo against boredom and deceit."[12]

Born into a family of Russian-Jewish intelligentsia who fled from pogroms at the turn of the century, she began her career as a young child by copying reproductions of Michelangelo and da Vinci from her parents' library of art books. She had no idea at the time that some of these were three-dimensional sculptures.

At thirteen, after illustrating *Little Women*, she decided to be a painter-illustrator and won a scholarship to the Art Students League in 1921. A quirk of fate led her to sculpture. The painting class was full, so a friend suggested she take a modeling class. "What's a modeling class?" asked Gershoy.

She studied sculpture with A. Sterling Calder, drawing with Boardman Robinson, and painting with Kenneth Hayes Miller. Although her scholarship was renewed, the free-spirited artist left after a year and went to Woodstock, New York, the lively colony of artists and writers—in those days a center of avant-gardism, radicalism, and high jinks. There, influenced by her neighbor, John Flannagan, a pioneer of direct carving, she carved quintessentially simplified forms from local fieldstones, apple wood, old gravestones, and cast-off oaken beams. *Figure* (1930, Whitney Museum), for example, grows out of the shape of the alabaster stone.

After doing some freely modeled terra-cottas on themes like *Europa and the Bull,* Gershoy in the 1930s created a rogue's gallery of lively two-foot-high plaster portraits of artist friends. Eleven bronze casts of these are in the National Museum of American Art. *William Zorach* hacks away at stone with mad intensity, whereas *Raphael Soyer* gently places a dab on canvas and *Concetta Scaravaglione* wields a hammer energetically, her dark Italian eyes emphasized by the undercut of the clay. *Lucille Blanch* (a lifelong friend) paints demurely, seated with palette on lap, while her then-husband *Arnold Blanch* stands, burly and virile, regarding his canvas with brushes in fist. Said a critic, "These spontaneous impressions, often tongue in cheek, show unerring observation. . . . What might decline into mere caustic statement in a more bitter soul . . . is rendered more often into whimsey that reveals the artist to be irremediably committed

Eugenie Gershoy, THE VERY STRONG MAN (c. 1936–40), dextrine/polychromed, 23″ x 13⅞″ x 9⅝″. National Museum of American Art, Smithsonian Institution. Gift of Erwin P. Vollmer.

to a faith in humanity's essential goodness no matter what lengths they go to to prove their ridiculousness."[13]

Gershoy tasted the joys of polychrome sculpture for the first time when she created a fifteen-foot-high painted papier-mâché *Moloch* for a Maverick Theater production of Flaubert's *Salammbo* at Woodstock. In 1938, hired by the Federal Art Project to decorate a children's library in Astoria, New York, and eager to delight her young audience, she experimented with materials that would permit an exuberant fairy-tale quality. She invented polychrome (made of dextrine, glue, and plaster) which, after drying, is lightweight but very hard. *The Very Strong Man,* lightly holding up an elephant in the palm of a hand, *Trapeze Artist,* and *Cancan Dancer,* all have open, rollicking, colorful forms.

Thirty-one sculptures in various media were shown at the Robinson Galleries, New York (1940), and the Metropolitan Museum of Art bought *The Equestrienne,* an upside-down rider balanced precariously on the back of a rearing unicorn, as a purchase prize in the 1942 Artists for Victory show.

When the Federal Art Project folded, the artist turned to the cheapest materials she could find—papier-mâché painted in egg tempera, over chicken wire—to execute four large commissions for the nightclubs Café Society Uptown and Downtown. From the 1940s to 1960 Gershoy taught ceramics and sculpture in San Francisco public schools, exhibiting at Gump's (1955) and at the Pantechnicon Gallery. She traveled widely and had three resident fellowships at Yaddo (1940, 1941, and 1952).

Returning to New York around 1960, Gershoy lived at the Hotel Chelsea (made famous in Andy Warhol's movie), the residence of many artist friends, and continued to create papier-mâché whimsies. In fact, a group portrait of fifteen of the Hotel Chelsea's "characters" standing together on a glass plate hangs from the ceiling in the lobby.

In 1984 the National Museum of American Art recognized the avant-garde character of her work in an exhibition, Fantasy and Imagination: Sculpture by Eugenie Gershoy, covering a fifty-year span. A 1986 show at the Sid Deutsch Gallery, New York, further revealed that this artist had anticipated by fifty years certain sculptural trends of the 1980s.

OTHER HUMANIST SCULPTORS

A critic wrote of **Sylvia Shaw Judson (1897–1978):** "The great interest her work has for me is in its quietness and peace." A transitional figure, bridging the gap between traditional and modern styles, she invested her work with an almost Zen feeling of inner calm.

Shaw's mother was a well-known poet; her father, Howard Van Doren Shaw, was a noted architect who taught her early that there should be a harmony between sculpture and architecture. Growing up with every advantage, she was educated at the University of Chicago's Laboratory School and Westover School, Middlebury, Connecticut. She received her first instruction in sculpture during the summer of 1915 from Anna Hyatt at her studio in Annisquam, Massachusetts. Then she studied with Albin Polasek at the Art Institute of Chicago (1915–18), modeling "head in the morning and figure in the afternoon." The training was rigorous, with none of the work "worth keeping," according to Polasek.

During a 1917 trip to the Far East with her

father, she was strongly influenced by the simplicity and strength of Chinese sculpture, especially the animals. She kept Roger Fry's statement about Chinese animal sculpture pinned up in her studio: "The Chinese sculptor respects the essential character. There is no attempt to read human feeling into it. It keeps its own vague mysterious animal life."

Shaw worked on her own in a New York studio for a year before leaving for Paris in 1920 to study with Bourdelle at the Académie de la Grande Chaumière: "There I learned more from the other students than from the master, who, when he came, sat on a high stool in the corner and talked metaphysics in a difficult dialect."[14]

A stronger influence at this time was Aristide Maillol, whose studio she visited. She admired his "passionate striving for unity and simplicity," a quality she also found in Seurat's charcoal drawings and tried to emulate in her work. Later she came to admire the German expressionist Gerhard Marcks.

In 1921 Shaw married Chicago attorney Clay Judson and had two children. She felt lucky to be making enough money from commissions to hire someone to take the babies for a stroll while she was at work. Her life, she realized, had not been one to "produce an art of protest."

Early commissions were primarily garden sculptures of children and animals. *Little Gardener,* a girl with a plant and watering can, which won the 1929 Logan Prize at the Chicago Art Institute, is in the White House Rose Garden, Washington. Other garden sculptures are *Girl with Squirrel* (Brookgreen Gardens and Kosciuszko Park, Milwaukee) and *Apple Tree Children* (1967, public library, Lake Forest, Illinois), two bronze children perched in the branches of a stylized wooden tree. Of this work she wrote

"children climbing on sculpture give it a fine patina." Daniel Catton Rich pointed out that her garden sculptures "are miles removed from ... the superficial and ornate 'statuary' that haunts our formal landscape, being large and simple in feeling. She is principally interested in harmonious relations of mass and line."[15]

Judson's work was in all three world's fairs of the 1930s—Chicago, San Francisco, and New York; her 1938 retrospective at the Art Institute of Chicago traveled to five midwestern museums; she had solo shows at New York's Arden Gallery (1940) and the Sculpture Center (1957); and she was in group shows at the Whitney Museum and the Museum of Modern Art.

In the 1940s the Judsons moved permanently to Ragdale, the beautiful arts and crafts–style summer home built by her father in Lake Forest. She attributed some of the serenity of her work to her studio, which looked out over a peaceful nature preserve. The sculptor's daughter, Alice Ryerson, has established Ragdale Foundation there (now a National Historic Site) as a retreat for artists and writers, and Judson's studio is part of it.

The sculptor, who had joined the Society of Friends in 1943 and had deep feelings about the Quaker ethic, won a 1958 competition for a memorial to the martyred Quaker preacher, *Mary Dyer.* The bronze figure, quiet and determined, her hands resting on her lap, sits outside the Massachusetts State House, facing Boston Common, where she was hanged by the Puritans in 1660. Other casts of this deeply moving work are in front of the Center for the Society of Friends, Philadelphia, and in Richmond, Indiana.

Judson's dramatic *Theodore Roosevelt Memorial* at the Chicago Zoological Society, Brook-

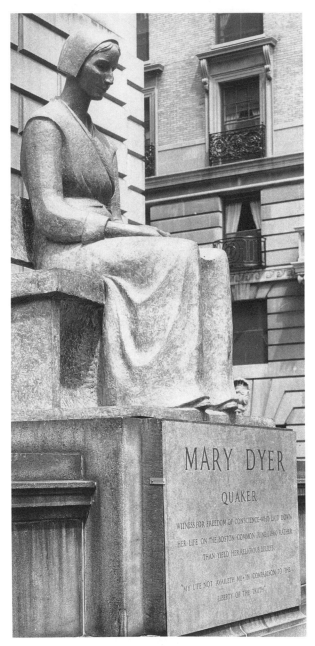

Sylvia Shaw Judson, MARY DYER (1959), bronze. Massachusetts Statehouse, Boston. Photo courtesy of Alice Ryerson.

field, Illinois, consists of four pylons, topped by four bronze horned animal skulls.

Her late work became increasingly abstract and reductive. *Stations of the Cross* (1961–62, Church of the Sacred Heart, Winnetka, Illinois), whose tragic theme occupied her after her husband's death, is reduced to almost linear motifs, as in Matisse's chapel at Vence, yet the images remain recognizable. After teaching sculpture in 1963 at the American University in Cairo, Egypt, she moved even further toward simplification. *Cairo Girl* (1964) and *Nubian Boy* (1964) look like grave objects.

In 1963 Judson married Sidney Haskins, a British Quaker living in Pennsylvania. A full academician of the National Academy of Design, she continued to work consistently into her seventies. Often quoting T. S. Eliot's "still point in a turning world," she once said, "A work of art as well as a life is better for a coherent design."

> Other works include an art deco relief *Electricity* (1929), holding lightning bolts, on the power station overlooking Daley Plaza, Chicago; a granite *Madonna* at the entrance to Queen of Heaven Cemetery, Hillside, Illinois; a guardian angel (relief) over the door of Presbyterian Saint Luke's Nurses Home, Chicago; *Rain Tree Fountain,* Junior Museum, Art Institute of Chicago; and *Farm Children* holding their pets, Children's Zoo, Brookfield, Illinois.

Janet de Coux (1904–) has throughout a long career been a sculptor of stylized reliefs and carvings, primarily for churches and other religious institutions, that have a stark, spiritual quality expressed in greatly simplified forms. Since she was the youngest daughter of an Episcopal clergyman, her interest in religious sculpture has deep roots.

Born in Niles, Michigan, de Coux moved with her family to the farm town of Gibsonia, Pennsylvania, near Pittsburgh when she was eight. Showing early talent, she took Saturday sculpture classes at the Carnegie Institute of Technology while still in high school, and then studied full time there with Joseph Bailey Ellis (1925–27).

In the tradition of the Renaissance, de Coux apprenticed for many years in the studios of leading architectural sculptors. The first was C. Paul Jennewein, who was working on the pediment for the Philadelphia Museum of Art. When she applied for a job in his atelier, Jennewein, expressing disdain for women assistants, was about to turn her away even though she carried a letter of introduction from architect Whitney Warren. But de Coux demonstrated on the spot that she could use hammer and saw as well as any man. She then worked for Aristide Cianfarani in Providence, Alvin Meyer in Chicago, Gozo Kamura in New York, and James Earle Fraser in Westport, Connecticut.

De Coux also managed to complete some independent work—*Adam* and *Eve* (1934, Brookgreen Gardens) and a limestone half figure of *Savonarola* (Carnegie Institute of Technology). In 1935, she took a long-awaited bicycle pilgrimage through Europe to look at sculpture in wayside shrines, cathedrals, and museums. After winning a prize for stone heads of *Moses* and *Aaron* at the 1936 Pittsburgh Associated Artists Exhibition, de Coux began to work independently out of her own studio at the family farm in Gibsonia.

De Coux won Guggenheim fellowships in 1938 and 1939 and awards for *Annunciation to Sarah and Abraham*. Appointed a resident sculpture instructor at Cranbrook Academy of Art (1942–45), she was impressed by the work of faculty member Carl Milles, the Swedish sculptor

Janet de Coux, SAINT BENEDICT (1948), limestone, lifesize. St. Vincent Archabbey Art Collection, Latrobe, Pa. Photo courtesy of the artist.

whose art deco fountains and sculptures adorn the campus.

Greatly simplifying her style to achieve a stark spiritual quality, she switched from Old to New Testament subjects, which she describes as "intellectual, supernatural and mystical—also very human." Among many works in this pared-down taut manner are a life-sized *Saint Benedict* with a bird on his shoulder (limestone, St. Vincent's Archabbey, Latrobe, Pennsylvania), a seven-foot kneeling *Madonna* flanked by two angels (polished granite, St. Mary's Church, Manhasset, New York), and an eight-foot kneeling *St. Stephen* (bronze, Episcopal Church, Sewickley, Pennsylvania).

Honored as Pittsburgh's Artist of the Year in 1951 and Distinguished Daughter of Pennsylvania in 1954, she is a member of the National Sculpture Society and the National Academy of Design. The sculptor recently completed an immense eighteen-foot *William Penn* for the William Penn Museum, Harrisburg, Pennsylvania.

Other works include a limestone relief, *Christ and the Children* (1947, Sacred Heart Elementary School, Pittsburgh); five sculptures, including a seven-and-a-half foot stone crucifix, for St. Scholastica's, Aspinwall, Pennsylvania; *St. Angela* (Ursuline College, New Rochelle); and a pierced metal frieze of silhouettes of athletic figures over the entrance of the bathhouse at the Highland Park swimming pool, Pittsburgh, Pennsylvania (1981.)

Eleanor Mellon (1894–1979) was another distinguished sculptor of ecclesiastical subjects (*St. Christopher,* Brookgreen Gardens). A full academician of the National Academy of Design, she won awards and held positions there.

Allie Tennant, TEJAS WARRIOR (1936), gilded bronze, 9'. Texas Hall of State, Fair Park, Dallas. From the Historic Photograph Collection of the Dallas Public Library.

Allie Victoria Tennant (1898–1971) created one of the theme statues of Dallas, Texas—the gleaming, gilded figure of a Tejas Indian warrior on the façade of the Hall of State in Fair Park.

Born in St. Louis, Missouri, Tennant grew up in Dallas. Encouraged by her English father, an amateur painter, she began making sculpture at the mudpie age. After studying with local teachers and at the Art Students League, New York, with Edward McCartan (1927–28), she opened a studio in Dallas and won prizes almost yearly at the Dallas Museum's Allied Arts Exhibition.

At the time of the Texas Centennial Exposition, Tennant was commissioned to create a sculpture for the façade of the newly erected Hall of State. Since Texas is named after the Tejas Indians, she chose to represent a member of this tribe as a symbol of the state. The dynamic nine-foot gilded figure drawing a bow, mounted against a turquoise mosaic wall, creates a strong focal point at one end of a promenade of art deco public buildings in Fair Park.

In the 1930s, Tennant and **Dorothy Austin** became the leading sculptors of Dallas—the only sculptors in an inner circle of artists called "The Dallas 13" who showed at the Lawrence Gallery. *Negro Head* (1935), a heroic direct carving in black Belgian marble, received the Kleist Memorial Purchase Prize at the Dallas Museum in 1935.

Tennant was in the American art exhibition at the 1939 New York World's Fair and showed at the Metropolitan Museum of Art, the Whitney Museum, and the Pennsylvania Academy. She was an associate member of the National Sculpture Society.

Other monuments include a relief, *Cattle, Oil and Wheat,* for the U.S. Post Office, Electra, Texas; and two memorials to heroes of the Texas Revolution—a seated bronze of *José Antonio Novarro* at Corsicana, Texas, and an eight-foot bronze of *James Butler Bonham* for Bonham, Texas. Tennant also did fountains, reliefs and portraits, such as *Dr. Edward H. Cary,* Southwest Medical Foundation, and two Dallas artists, *E. G. Eisenlohr* and *Frank Klepper.*

Augusta Christine Fells Savage (1892–1962) exerted a shaping force on the development of African-American art both as a sculptor and as a leader of the Harlem Art Center. She had to fight every step of the way. Seventy years had passed since Edmonia Lewis had achieved fame in Rome at the time of the Civil War, but the obstacles in Savage's path were almost as great as those faced by her predecessor.

The seventh of fourteen children born to an impoverished house painter and sometime minister, Edward Fells, in Green Cove Springs, north Florida, Augusta began to fashion ducks out of the local red clay when she was only six years old. Her strict father was angered to learn that she had skipped school to make "graven images." She later recalled, "father licked me five or six times a week and almost whipped all the art out of me."[16] Augusta had to hide her work from him.

When the family moved to West Palm Beach, Augusta was befriended by the school principal, who recognized her talent, talked away her father's hostility, and set up a special class in clay modeling at the high school, making Augusta the teacher at the wage of a dollar a day. Inspired to be a teacher, she enrolled at Tallahassee State Normal School (1919–20, now Florida A&M University) but dropped out to become an artist.

Savage's career began at the Palm Beach County Fair. After pleading for the chance to run a booth (the first black woman to do so), she sold clay ducks and chickens to wealthy white tour-

ists and won a prize for the most original exhibit. The fair superintendent encouraged her to study in New York and gave her a letter of recommendation to his friend, sculptor Solon Borglum. But when she traveled north to seek admission to his classes, he told her, "Young ladies who come here to study with me ... pay immense fees."[17] He sent her to Cooper Union with a letter that got her admitted despite a long waiting list.

At the Cooper, within a month, Augusta had skipped the second-year courses and was placed in a life class taught by portrait sculptor George Brewster. But then she ran out of money, and facing eviction from her Harlem room, she realized that unless a miracle happened she would have to quit school. Learning of this, the principal, Kate Reynolds, went before the Advisory Council and convinced the members to finance the living expenses of this talented student, one of the first black women admitted to the school.

Historically the Schomburg branch of the New York Public Library has played a strategic role in the advancement of black Americans living in Harlem. Hearing of her financial difficulties, the Friends of the Library commissioned a bust of W. E. B. Du Bois. While working on his portrait, Savage was greatly influenced by the personality and philosophy of this leader.

In 1923 Savage encountered a stone wall of racism. Eager to study in Europe, she sent an application to an American summer program at the Palace of Fontainebleau near Paris. Friends had pledged the fare and living expenses, but to her astonishment the scholarship she had received was withdrawn. Savage wept with frustration when she learned that much less talented students had been accepted. The administrators of the program did not want to raise the hackles of southern students who would be in her classes.

Alfred Martin, of the New York Ethical Culture Society, broke the story to the newspapers, where it ran for months, and distinguished peo-

Augusta Savage, GAMIN (c. 1930), bronze, height 16¾″. Schomburg Center for Research in Black Culture, The New York Public Library. Astor, Lenox and Tilden Foundations.

ple like anthropologist Franz Boas came to her support, but the admissions board refused to back down. Hermon MacNeil, sculptor of Indians, became ashamed of his role on the committee and tried to make amends by inviting her to work at his atelier in College Point, New York. According to one account, Savage was now looked upon as a troublemaker and shut out of museums and galleries. For years she ironed clothes in laundries and did other hard labor that left little time for sculpture. In 1926 she was again frustrated when she received a scholarship to study in Rome, but this time couldn't raise the money for travel and living expenses.

Savage somehow continued to make and exhibit small figures of everyday black people. Attracted by the appealing face of her young nephew, Ellis Ford, she asked him to pose for her in his cap and soon "had created a head in clay that caught the vitality, the humanity, the tenderness and the wisdom of a boy child who has lived in the streets."[18] The portrait, called *Gamin* (c. 1930, bronze, Schomburg Center, New York Public Library), aroused so much admiration that she was able to obtain a Rosenwald Fund Fellowship enabling her at last to study in Europe.

Savage studied with Félix Beauneteaux at the Grande Chaumière and later with Charles Despiau, exhibited at the European salons, and traveled through Europe. Upon her return to the United States, she modeled busts of black poet *James Weldon Johnson* (Schomburg Center) and surgeon *Walter Gray Crump*. Now a well-established artist and active in the Harlem Renaissance, she exhibited, along with Max Weber, Robert Laurent, and Reginald Marsh, at New York's Anderson Galleries and was the first black woman admitted to the National Association of Women Painters and Sculptors. *Envy, Martyr,* and *Woman of Martinique* (black marble) were works of this period.

By this time the depression was on, and Savage had to face the fact that she could not support herself through her art; her visions of doing great monuments faded. Turning her energies to the community at large, she started classes in her Harlem basement studio that mushroomed into a large adult education program sponsored by the State University of New York. She rescued kids from park benches and made her workshop a magnet for talented black youths who traveled from all the boroughs to work with her. Among them were Jacob Lawrence, William Artis, Norman Lewis, and Gwendolyn Bennett, all of whom became well known.

As the WPA got under way Savage fought for the right of black people to work on the Federal Art Project not only as artists but as administrators. The fiery sculptor badgered politicians, led delegations, and talked to reporters. She had learned to appeal to the media during her "battle of Fontainebleau." Savage also organized the Vanguard Club, where black artists met to discuss the artistic and social issues of the day, helped organize the Harlem Artists Guild, and became the first director of the Harlem Community Art Center (part of the Federal Art Project), a national showcase, where more than fifteen hundred Harlem residents took classes.[19] At the same time the busy artist continued to create a few works (*Realization* and the small dancing figures, *Suzi-Q* and *Truckin'*).

In 1938, Savage received a monumental commission for the New York World's Fair. Except for composer William Grant Still, she was the token black artist—other black participants were janitors or menials. Inspired by Rosamund and James Weldon Johnson's black anthem, "Lift Every Voice and Sing," she modeled a large harp formed of singing black boys and girls, all held in a huge hand. In front, a kneeling black youth reached out to the audience, holding a bar of musical notes. It was placed in a prominent position on Rainbow Alley at the entrance to the building that housed the big exhibition American Art Today. After the fair, this work, like many others, was leveled by bulldozers because money could not be raised to cast it in bronze. Small souvenir versions sold at the fair are at the Beinecke Library, Yale University, and the Schomburg Center.

Having taken a leave from the Harlem Art Center, the sculptor now found her position filled by someone else. After attempting to run the first exhibition gallery of black artists in the United States, Savage retired in 1945 to a farm in rural Saugerties, New York. She died in 1962 at the

Bronx apartment of her daughter by an early marriage, with whom she had remained close.

A central figure of the Harlem Renaissance, Savage was a gifted realist who expressed aspects of her culture through images of black heroes and everyday people. Much of her work has disappeared because she could never afford to have it cast. In 1988, Deirdre L. Bibby curated an important exhibition at New York's Schomburg Center for Research in Black Culture, the repository of a large number of her works. The catalog, *Augusta Savage and the Art Schools of Harlem,* documents her career and shows the tremendous role she played in the development of African American art.

She never regretted the fact that much of her energy was diverted to helping young black artists. "If I can inspire one of these youngsters to develop the talent I know they possess, then my monument will be in their work," she said, and added, "No one could ask more than that."[20]

Evelyn Raymond (1908–), born in Duluth, became a pioneering Minnesota sculptor under conditions of great adversity. As a child she spent months in the wilderness with her father, who cleared land for developers. She says that the forms of the rugged landscape and icy lakefront became her inspiration.

When her art school (today the Minneapolis School of Art and Design) fired her favorite teachers, John Haley and Charles Wells, for teaching abstract art, she responded (although a scholarship student needing the money) by becoming the first student at the school to do an abstract sculpture. She was one of the rebels who formed a new school in protest.

Her life became more difficult in the early 1930s when her father died and her mother fell ill. She had to take over her mother's job as cook on a dairy farm, where she produced three meals a day for twenty-four workers, cooking from five

Evelyn Raymond, ERG (1938), nickel bronze, 19″. Collection of the artist.

in the morning to midnight. For eight years art work was impossible.

Like so many artists in the 1930s she was rescued by the Federal Art Project. To qualify, she moved to Minneapolis and submitted a sculpture

Erg (1938), a semiabstract blending of human and machine, symbolizing the utopia potentially available when technology and humanism would join (a popular theme of the day). For seventy-five dollars a month, Raymond taught and made public sculptures, such as a cement bas-relief of athletes for the stadium of International Falls High School. Because the project was supposed to bring art to the people, the supervisors sometimes required her to work on a high scaffolding in front of crowds at the Walker Art Center.

When the project ended, Raymond became head of the sculpture program in a new art school at the Walker (1938–51). In the 1940s she founded and served as president of the Minnesota Sculpture Society. In 1958, the state commissioned an eleven-foot statue of *Maria Sanford* for the U.S. Capitol. Other Minnesota commissions are a gilded *Good Shepherd* (1949) for the Lutheran Church of the Good Shepherd in Edina; a hammered copper *St. Augustine* (1962) that echoes the copper roof of St. Austin's Church, Minneapolis; a limestone *St. Joseph* (1980) on the façade of St. Joseph's Church in Hopkins; and six walnut figures for the Farmer's Exchange Building, St. Paul.

All this time Raymond was also creating abstract sculptures, cutting sheet metal into squares or circles and bending the forms into dancing curved or triangular shapes. For thirty years she has taught so many Minneapolis citizens in private classes in her craftsman-style home located in St. Louis Park that they greet her wherever she goes.

In 1976 the Bicentennial Commission honored her for contributions to the quality of life in Minnesota. In her seventies she completed *Legacy* (1982), a large welded abstract figure of a mother and child in front of Fairview Hospital. Her eightieth birthday was celebrated by a public proclamation from the governor. The robust artist enjoys her roots in Minnesota: "Why

Evelyn Raymond, LEGACY (1982), sheet bronze, height 16′. In front of Fairview Riverside Hospital. Photo reprinted with permission of Fairview Hospital and Healthcare Services, Minneapolis, Minn.

should everything come from the East or the West? ... I hope to go on working til I die. It hasn't been easy but it's been exciting."[21]

Marion Sanford (1904–87) is noted for bronzes of robust, earthy women doing household chores—washing clothes, scrubbing floors, churning butter. These images come from memories of the Swedish neighbors whom she observed as a child growing up on a farm in Warren, Pennsylvania.

Sanford studied at Pratt Institute, took sculpture with Leo Lentelli and Robert Laurent at the Art Students League, and apprenticed for three years with sculptor Brenda Putnam (1937–40). She did the pen-and-ink illustrations for Putnam's book, *The Sculptor's Way.* Her work was

in the 1939 New York World's Fair exhibition of American art and she completed a lunette, showing black workers bringing cotton to be weighed, for the Winder, Georgia, post office.

Sanford and sculptor **Cornelia Chapin** shared the remodeled stable-studio on Thirty-eighth Street that had belonged to Gutzon Borglum. After winning a 1941 Guggenheim fellowship, she began her "working women" series. *Harvest* (1941, Pennsylvania Academy of the Fine Arts), a woman bending over to pick up apples to place in her apron, has swinging rhythms and bold, simple lines. The curves of the chunky seated *Butterwoman* (Corcoran Gallery, Washington, D.C.), drape across her lap and are echoed by the bowl in which she is stirring. *Scrubwoman* is on her knees wringing a cloth into a bucket.

Marion Sanford, HARVEST (1941), 14″ x 13″ x 9½″. The Pennsylvania Academy of the Fine Arts. Henry D. Gilpin Fund.

De Profundis, a grief-stricken figure, was awarded the Watrous Gold Medal at the National Academy of Design, and *Dawn,* a quiet seated adolescent girl, also won a 1947 prize at the academy.

In a 1947 interview Sanford said, "There's beauty in movements one makes while performing homely useful chores . . . and . . . unconscious grace in the succession of movements as the work proceeds." Her works have an elemental sweep, close to the earth.

Other works include a nine-foot limestone *Hippocrates* for a hospital, Warren, Pennsylvania; and *Cornelia Chapin at Work* (George Walter Vincent Smith Art Museum, Springfield, Massachusetts), *Ploughing, Lullaby,* and *Little Lamb* (Brookgreen Gardens).

Anna Glenny (Dunbar) (1880–?), of Buffalo, New York, was widely recognized in the 1930s for sensitive bronze portrait heads, "concerned with expression and the handling of surface," somewhat in the manner of Jacob Epstein. She studied with Bela Pratt at the Boston Museum School (1908) and with Émile-Antoine Bourdelle in Paris (1909–11).

Portrait of Mrs. Wolcott (1930), shown in a 1932 Museum of Modern Art exhibition, is an unflinching characterization of an older woman, rendered with the loose surface touch of fingers in the clay. Glenny exhibited eight works at MOMA in 1930, and showed at the Whitney Museum, the Art Institute of Chicago, the Hudson Gallery, New York (1936), and the 1939 New York World's Fair.

Other works include *Bronze Torso* (1927), *Abandoned* (1927), *Head of Chinese Woman* (1928), and *Portrait of Katharine Cornell* (1930).

Anna Glenny, MRS. WOLCOTT (1930), bronze, height 15½". Collection, The Museum of Modern Art, N.Y. Gift of A. Conger Goodyear.

Clara Fasano (de Marco) (1900–), creator of modernized classicist figures in terra-cotta and stone, was the first female sculptor in generations of Italian carvers and modelers. She learned to work in clay at the same time she learned to walk and talk. When she was three, she and her family came to New York City, where her father, Pasquale Fasano, carved marble architectural ornaments.

After studying at Cooper Union, the Art Students League, and Adelphi College, Fasano spent ten years in Europe studying with Arturo Dazzi in Rome and at the Julien and Colarossi academies in Paris, where she exhibited at the Salon d'Automne. Returning to New York City, she worked on the Federal Art Project (1933–37), completing reliefs for the Middleport, Ohio, post office and other buildings, and exhibited at the 1939 New York World's Fair.

A modernized classicism infuses her work, although she freely exaggerates where needed. The aim is for harmony and warmth rather than troubling expressionism as in the terra-cotta *Penelope,* a seated waiting figure at the National Museum of American Art, and *Dolce Far Niente,* a humorous sleeping figure inspired by observing Romans taking their customary siesta after the noonday meal (Chrysler Museum, Norfolk, Virginia).

A fellow of the National Sculpture Society and a full academician of the National Academy of Design, Fasano was awarded the academy's Daniel Chester French Medal in 1965 and an American Academy of Arts and Letters grant in 1952. She taught sculpture at the New York School of Industrial and Fine Art (1946–56), the Dalton School, and Manhattanville College of the Sacred Heart, Purchase, New York (1956–66).

Fasano and her sculptor husband, Jean de Marco, now live and work in Cervaro, Italy, but spend several months a year in the United States. Still very active, she recently completed fifteen portrait busts of leading Italians.

Clara Fasano, ROMAN SEAMSTRESS (1962), unique terra cotta, 20″ x 14″ x 12″. Private collection. Photo: Jean de Marco, courtesy of the National Sculpture Society.

OTHER CARVERS OF THE 1930s

The polished granite *Giant Frog* that stands in Rittenhouse Square, Philadelphia, is by a direct carver of the 1930s, **Cornelia Van Auken Chapin (1893–1973).**

Born in Waterford, Connecticut, Chapin attended New York private schools, and was inspired by Egyptian sculpture at the Metropolitan Museum of Art. She studied sculpture with Gail Sherman Corbett, and then shared a studio with Genevieve Karr Hamlin and later with Marion Sanford.

Cornelia Van Auken Chapin, GIANT FROG (1941), granite, height 38″. Rittenhouse Square, Philadelphia. Given to the city in 1941 by the Rittenhouse Square Improvement Association. Photo: Philadelphia City Archives.

From the beginning Chapin was interested in animal forms of solid simplicity and therefore turned to direct carving, exhibiting *Goat's Head* at the National Academy of Design in 1930. In 1934 she began to study this difficult technique in Paris, working in granite and other hard stones with sculptor Mateo Hernandez.

Every day Chapin pushed a small cart containing tools and a block of stone to the Vincennes zoo, where she carved directly from the animal model using only a rough sketch as her guide. Her mastery was confirmed in 1936 when she showed *Tortoise* (volcanic rock, Brooklyn Museum) at the Salon d'Automne, and was immediately elected to the salon—the only woman sculptor and only foreigner admitted that year.

Influenced by Assyrian and Egyptian art, Chapin seldom opened the solid mass. Selecting animals of simple outline, she polished the stones to a high luster, sometimes accenting decorative details with incising or low relief, as in *Giant Frog*. *Bear Cub* (volcanic rock, Washington, D.C.), shown in the first outdoor exhibition of the Sculptors Guild in 1938, stands at the entrance to the National Zoological Gardens.

Two insects in cast stone are *Black Beetle* (1945, Pennsylvania Academy) and a giant grasshopper, *Midsummer Knight*. Among Chapin's public commissions is *Christ the King*, a crucifix above the high altar at the Cathedral of St. John the Divine, New York.

After returning from Paris at the outbreak of World War II, Chapin served on the New York City Art Commission (1951–1953). She was one of the first women to earn a pilot's license, and was also an actor and a book collector.

Another carver of superbly stylized animals was **Bessie Stough Callender (1889–1951).** Growing up on a farm in Wichita, Kansas, Bessie Stough learned to love all forms of nature, especially animals. She was a brilliant student, quiet and refined, yet a hardy outdoor girl, too. After marrying Harold Callender, journalist for the *New York Times,* and moving to New York, she studied drawing with George Bridgman at the Art Students League and then took modeling with Bourdelle at the Académie de la Grande Chaumière after they were transferred to Paris.

Having long admired the grace and beauty of animals, Callender began to carve animals in stone, under the supervision of the French *animalier,* Georges Hilbert. At the Jardin des Plantes, she would observe an animal closely, making many sketches and plasticene studies until she had analyzed not only the outer form, but the spirit of the creature as well. Only then did she begin to work on the stone.

Her friends were amazed to see the delicate, refined sculptor tackle five-hundred-pound blocks of granite and marble with mallet and

Bessie Stough Callender, BABOON (c. 1930), limestone, 26″ x 16⅛″ x 13⅞″. National Museum of American Art, Smithsonian Institution. Given as a memorial to the artist by her husband, Harold Callender.

All of them have tense, condensed forms, swelling with inner energy, reduced to their essential rhythms. Polished surfaces contrast with rough textured elements in the hair or base; no openings or projections break the solid mass. Immediately recognized for their quality, they were shown at the Salon d'Automne, the Royal Academy in London, and the Walker Art Gallery in Liverpool.

After her early death from cancer, her husband wrote a book describing Bessie's remarkable personality and empathy with living creatures[22] and presented a group of her works to the National Museum of American Art.

Grace Turnbull (1880–1976), from a cultured publishing family in Baltimore, Maryland, became a well-known sculptor in that city.

She studied painting at the Maryland Institute and the Pennsylvania Academy with Thomas Anshutz, William Merritt Chase, and Cecilia Beaux. In the spirit of those days, her mother informed her that if she painted from the nude model she would cause her father's death. In Paris as a student, she visited Gertrude Stein and saw her collection of Picassos and worked as a Red Cross volunteer on the battle front in France during World War I.

Turnbull shifted from painting to sculpture in 1928, when she discovered that she enjoyed carving furniture and door frames for the studio-home she was building in Baltimore. Basically self-taught, she had studied modeling only briefly with Moses Ezekiel in his studio in the Baths of Diocletian in Rome and with Ephraim Keyser in Baltimore.

A direct carver in wood, stone, and marble, she created figures and animals with reduced, generalized planes. The tool marks create a pitted texture on some works, while others are polished to reveal the grain.

Animal sculptures include a hippo head, *Gra-*

chisel, wearing a beret, a dusty smock, workmen's gloves, and a French peasant's wooden sabots. Strongly influenced by Egyptian sculpture, which she regarded as the finest in the world, she reduced the forms to their essence.

Callender sometimes took a year to refine one piece. Approximately eight animal carvings were created in the next four years, beginning with *Guinea Hen* in 1929. (The obliging hen posed for many weeks on a nearby stone, until one night it was eaten by the studio's French bulldog.) A resting black marble *Antelope* captures the shy, sensitive grace of the gentle creature. These were followed by *Baboon, Eagle, Caracal Lynx, Falcon,* and *Ram.*

Grace Turnbull, GRACIOUS COUNTENANCE (or HIPPOPOTAMUS HEAD) (1945), black Belgian marble, height 20″. Collection of Community College of Baltimore. Photo courtesy of the National Sculpture Society.

cious Countenance, (1945, black Belgian marble, Community College of Baltimore), *Sleeping Calf* (1944, sandstone, Corcoran Gallery), and *Python of India* (1941, green marble, Metropolitan Museum of Art). The Baltimore Museum has two figures, *The Bath* (1944, limestone) and a streamlined silver-plated figure of a woman leaning over (1937). *Naiad,* a bronze kneeling nude leaning back with arched spine, is located in a landscaped area alongside the well-known Washington monument in Baltimore.

Turnbull exhibited at the Delphic Studios, New York, in 1931, at the Corcoran Gallery in 1949, and, from 1926 to 1952, at the Baltimore Museum, which had a solo show of her paintings and sculpture in 1974. Turnbull described her travels and experiences in her book, *Chips from My Chisel* (Rindge, N.H.: Richard R. Smith, 1953).

Angela Gregory (1903–1990), the doyenne of Louisiana sculpture, worked on the art deco exteriors of many public buildings during the 1930s. She has remained a public sculptor and community leader throughout a long career.

Born in New Orleans, she is the daughter of Tulane University engineering professor William B. Gregory and Selina E. Bres Gregory, a talented amateur painter who inspired Angela by describing how thrilling it had been to watch stone carvers cutting an angel on the exterior of Newcomb Chapel. She recalled, "She used to tell me she loved to hear the sound of the tapping on [the stone]. . . . Well, I was determined to do stone cutting."[23]

Noticing that her mother had subordinated her career to the needs of her husband and children, she chose to remain single and said years later: "I have to do my sculpture all the time. I feel a little selfish about it because I've always done what I wanted to do. It wasn't that way for my mother."[24]

At fourteen, Angela was modeling in clay and casting in plaster in summer classes at Tulane. She studied with Ellsworth Woodward at Newcomb College, took sculpture with Charles Keck in his New York studio in 1924, and then completed the B.A. in design at Newcomb in 1925, winning a scholarship to the Paris branch of the Parsons School of Fine and Applied Art.

The scholarship to study illustration was just a pretext to get to Paris in order to study carving with Émile-Antoine Bourdelle. In his classes at the Académie de la Grande Chaumière, her limestone copy of the head of the fifteenth-century Beauvais Christ so impressed him that he gave her the keys to his private studio where she worked under his supervision between 1926 and 1928. When she timidly asked what the tuition would be, he drew himself up to full height and said, "Madame, I am an artist, not a business-

man." He refused to take a penny. Gregory became a lifelong friend of Bourdelle and his wife, Cleopatre.

Returning to New Orleans in the summer of 1928 was a shock: "There was no music, no art. It was hot as Hades. There was nothing. I thought I would go out of my mind. But after a while I realized that if you don't have it inside you, it doesn't matter if you are here or in Paris."[25]

Fortunately, at this time she received support from an older artist, Helen Turner, who was also feeling lost in New Orleans after a career as a painter in New York City. New Orleans, said Turner, was interested only in food, drink, and Mardi Gras: "We are like Alpha and Omega—you are at the beginning of your career and I am at the end of it." From then on they called themselves "Alpha" and "Omega." Turner introduced Gregory to Harriet Frishmuth and many other important people in the art world.[26]

Soon after setting up a studio on Pine Street where she has lived ever since, Gregory was visited by architect General Allison Owen. Impressed by her thorough knowledge of stone carving, he commissioned her to do the sculpture for the new Criminal Courts Building that his firm was erecting on Broad Street.

The stark art deco façade of the courthouse is punctuated by crisp geometricized forms in an almost Egyptian mood. Sculptured fasces are carved over the words "Law" and "Order" on pilasters on either side of the front stairs. Under the pediment are two stylized pelicans, symbols of the state of Louisiana. She also did reliefs of figures representing Liberty and Justice and three medallions for the floor of the interior.

In 1931, when Governor Huey Long decided to erect a new state capitol at Baton Rouge, Gregory, working on a team with Lee Lawrie and other famous sculptors, did eight relief profiles of noted Louisianians for the façade, and bronze medallions on the railing around the great seal of Louisiana in the hall. In 1932 she carved the art deco head of *Aesculapius* over the doorway of the Hutchinson Memorial Building, Tulane Medical School.

Becoming an instructor at Newcomb Art School in 1935, Gregory completed the first master of arts degree in architecture at the college (1940), while completing the limestone sculptural façade of the St. Landry Parish Courthouse, Opelousas, Louisiana.

During the depression, Gregory became involved with the federal art programs. For the Public Works of Art Program she created a heroic bust of *John McDonough* (1933–34, Duncan Plaza, New Orleans Civic Center). In 1941 she was appointed state supervisor of the Federal Art Project for Louisiana.

During World War II, Gregory put aside personal ambitions to design camouflage for the Corps of Engineers, and then became a personnel counselor in the shipyards. Although the versatile artist showed remarkable ability as a counselor (she wrote a book on the subject), she returned to sculpture after the war. Commissions included the restoration of the sculpture on Gallier Hall, New Orleans; sculpture for Woodlawn School, Bertranville, Louisiana; sculpture murals for the Louisiana National Bank, Baton Rouge (now a state office building); and more than two dozen portraits.

A major project of the 1950s, the bronze *Bienville Monument* in front of Union Station, portrays the first French governor and founder of New Orleans, de Bienville, accompanied by a pioneering priest and an Indian. The artist made several trips to France for bronze casting and research. President Charles de Gaulle personally

Angela Gregory, carvings on Orleans Parish Criminal Courthouse (1929–30). Photo: Geoff Winningham, Seagram County Courthouse Archives, © Library of Congress.

commended her, and in 1982 she was named Chevalier de L'Ordre des Arts et des Lettres by the French minister of culture.

One of her strongest works is the brooding nine-foot cast stone figure of Saint Louis in the Archdiocesan Administration Building (the Chancery) in New Orleans (1962). While teaching sculpture for twenty years at St. Mary's Dominican College, she enriched the campus with aluminum-on-walnut panels for the interior of the John XXIII Library, a relief of the Blessed Mother for the Mother House, and other works. Gregory had solo shows at the Houston Museum of Art, the Delgado Museum, and the Bienville Gallery, New Orleans. In 1981 Newcomb College organized a joint tribute to Gregory and her mother, Selina Bres Gregory, who had been the sculptor's first art teacher.

Although her work is representational, Gregory has no quarrel with modern sculpture: "It's very expressive of the times we live in." But her heart is still with stone carving: "I was trained to put sculpture on buildings. . . . I'd rather do stone cutting than anything else in the world. . . . Stone cutting doesn't go with the 20th century, though. I don't think there's enough money in the world now to pay for the work you do in stone cutting. There are too many distractions."[27]

The vibrant artist's studio at 630 Pine Street has for almost sixty years been a meeting place for musicians, diplomats, distinguished guests from France, writers like close friend Thornton Wilder, and actors like Kirk Douglas, who was married in her studio. There is little she would have changed in her life: "Too often a woman is torn by conflicting obligations, as a mother, a wife, sister, daughter. Unless she can stay on the track, she becomes a dilettante. To be an artist sometimes requires sacrifice, yet I have found it thrilling."[28]

How many American sculptors have named after them a permanent gallery of their work, a community center, and a street? **Selma Burke (1900–)** can claim these honors and many more. Although she has played a very important role as an art educator of black Americans, in her carvings and bronzes she addresses people of all races and backgrounds, using themes of timeless universality.

Born in Mooreshead, North Carolina, one of ten children of a Methodist minister, she dug up clay from nearby riverbeds as a child and modeled small figures. She first trained and worked as a nurse, but after moving to Harlem in the 1920s, during a brief marriage to poet Claude McKay, Burke met writers like Langston Hughes and Eugene O'Neill, and became part of the group of talented writers, musicians, and artists who created the Harlem Renaissance. In this milieu her interest in art was reawakened.

With the aid of scholarships, Burke earned a graduate degree at Columbia University (1936–41), where she assisted sculptor Oronzio Maldarelli, and studied abroad with Povolney in Vienna (1934) and with Aristide Maillol in Paris (1937). Strongly influenced by Maillol, a modernist-classicist who kept the wholeness and integrity of the figure as a massive, integrated form, Burke's sculpture, on the whole, retains this feeling although she sometimes veers toward expressionism. *Temptation* (1938, limestone, Winston-Salem State University, North Carolina), a group of three figures compressed in the block—one praying heavenward, while on either side the other two whisper evil thoughts in her ear—clearly shows the influence of the direct-carving school.

During the depression, Burke taught at the Harlem Community Art Center (founded by Augusta Savage) and completed a sculpture of *Lafayette* (1938) for the Federal Art Project. In 1943 she re-

ceived national recognition by winning a competition for a relief portrait of *Franklin Delano Roosevelt,* which was unveiled by President Harry Truman in 1945. Eleanor Roosevelt came to see it and heartily approved the bronze tablet, on view in the Recorder of Deeds Building, Washington. In a way, all Americans indirectly own a work by Selma Burke, because the sculptor for the mint, who subsequently modeled the profile of Roosevelt on the dime, asked for permission to use her relief as a major source for his work.

Over the years Burke exhibited at the Julien Levy Gallery, New York (1945), had a solo show at the Avant-Garde Gallery, New York (1958), and has been in group shows at the Philadelphia Museum of Art, the Pennsylvania Academy, and elsewhere.

While continuing to create sculpture, in 1946 Burke opened the Selma Burke Art School in New York City and later founded and directed the Selma Burke Art Center in Pittsburgh, where she introduced thousands of young black students to art and maintained a gallery. She also served on the Pennsylvania Council on the Arts. For all these varied contributions, both as an artist and in the community, Governor Milton Shapp proclaimed 20 July 1975 as Selma Burke Day in Pennsylvania.

Although grounded in the modern aesthetic, Burke rejects nonobjective, formalist trends. She describes herself as "'a people's sculptor,' one who deliberately creates a work that anyone [the non-art-oriented] can, in some way, relate to."[29]

Despair (1951, travertine) is a compressed carving of a kneeling figure, bent over with head in hands. *Mother and Child* (1968, pink alabaster, Winston-Salem State University, North Carolina) emphasizes the warm relationship in flowing, curved rhythms that grow expressively out of the shape of the stone. *Falling Angel* (1958), a carved pearwood flying figure with sweeping lines, is reminiscent of figureheads on sailing vessels, but

at the same time it is very modern in its cantilevered defiance of gravity. *Together* (1975), a five-foot-high bronze relief expressing family love is on the façade of Hill House Center, a Pittsburgh settlement house. In her eighties, the artist completed a nine-foot statue of *Martin Luther King* for a park in Charlotte, North Carolina.

An entire permanent gallery devoted to the work of Selma Burke opened at Winston-Salem State University in the 1980s. More than fifty sculptures (imaginative works as well as portraits of *Duke Ellington, Mary McLeod Bethune, A. Philip Randolph,* and other black Americans), along with her personal collection of works by other black artists, gathered throughout a lifetime, were installed by curator Haywood Oubré.

In 1979, the Women's Caucus for Art honored Burke, along with Louise Nevelson, Georgia O'Keeffe, and Isabel Bishop, at a ceremony conducted at the White House by President Carter. In 1987 she was selected as one of nine outstanding American sculptors at the National Sculpture Conference: Works by Women, in Cincinnati. Burke earned a doctorate at Teemers University, North Carolina, and has also been awarded several honorary doctorates. Now retired in Pennsylvania, living on a street named after her, she is working on her autobiography.

> Other works are *Grief* (stone, Albany Institute of History and Art); *John Brown Memorial,* (Lake Placid, New York); and *Story of Communications* (Dry Dock Savings Bank, New York).

Pegot (Wolf) Waring (1908–83) was one of the best-known direct carvers in southern California. Born in Dallas, Texas, she attended Washington University, St. Louis, and married a Chicago attorney, but she left to study sculpture with

Carl Milles at Cranbrook Academy in Michigan. After moving to California with her small daughter in 1936, she exhibited in the 1939 New York World's Fair, already showing an interest in direct carving.

Around this time she met the man who became her mentor—Bruno Adriani, former director of the Berlin Museum and a collector of Olmec sculpture, who gave her a profound understanding of pre-Columbian art. He promoted her work and in 1945 published *Pegot Waring: Stone Sculptures*, issued by the Nierendorf Gallery. Karl Nierendorf, the sponsor of Louise Nevelson, showed Waring's work in the early 1940s.

Waring abstracted and reduced animals and figures to their essence, attempting to create "a three-dimensional microcosm without beginning and end" which leads the eye in subtle planes and hollows through a never-ending movement. Each creature is a metaphor—the spread-winged *Bat* (1944) suggests the potential destructive force of aviation; the *Bull* (1945) is a metaphor for pent-up power. A mystic who believed herself reincarnated from ancient Egypt, Waring felt that she was transmitting a spiritual force to these works.

In 1950 Waring was the first woman to have a solo exhibition at the Pasadena Art Institute. Critic Arthur Millier wrote: "No other sculptor at present working in Southern California could, in my opinion, present quite such a distinguished display. . . . The forms she digs out are not merely beautiful in themselves; they express the essentials of the ideas she conceives about the creature she depicts."[30]

Despite this recognition, as abstract expressionism swept the art world, Waring had an increasingly hard time. Much of her energy went into teaching. A close friend says, "she was bitter about aging and lack of recognition. She reminded me of an actress who missed the days when she was a top movie star."

Other works are *Reptile* (Los Angeles County Museum of Art); *Lovers* (private collection); and *Baboon, Frog,* and *Hippo,* (collection of Alice Cates, Malibu, California).

Ruth Cravath (Wakefield) (1902–) has been since the 1920s a well-known public sculptor in the Bay Area. Raised in Chicago, she studied at the Art Institute, then at the California School of Fine Arts (1922–25) with Ralph Stackpole, who preached the gospel of direct carving in those early years. Cravath became a member of the faculty (1927–33) and studied with Beniamino Bufano, another early West Coast modernist.

In 1924 Cravath began exhibiting and winning prizes at the San Francisco Art Association and Society of Women Artists. Early works include *Madonna and Child* (1926, Church of the Nativity, San Rafael), a marble fountain of three draped females holding a basin (Zen Center, San Francisco), and three reliefs at the Lunch Club, San Francisco Stock Exchange.

For the 1939 San Francisco Golden Gate Exposition on Treasure Island, she created three figures for the fountain in the Court of Pacifica (*Eskimo Boy, Mexican Boy,* and *North American Woman*), and also demonstrated stone carving as part of the Art in Action program at the fair.

Among her religious commissions are *St. Theresa* (1946, St. Basil's Church, Vallejo); an exterior limestone relief, fourteen *Stations of the Cross* and a life-sized crucifix for the Archbishop Hanna Center for boys at El Verano; and *St. Dominic* (1960, pink Tennessee marble, St. Albert's College, Oakland). Her best-known portrait is a bronze bust in San Francisco City Hall

of *Mayor Angelo J. Rossi* (1949), shown with his ever-present smile and a trademark carnation in his lapel.

Cravath later branched out into abstract forms. The giant twenty-seven-foot concrete and Plexiglas figure of *St. Francis* that towers at the entrance to Candlestick Park, has a yellow Plexiglas halo, a face reduced to a blue triangle, and a red Plexiglas cross over the heart that contrasts with the white geometric concrete forms of the figure.

Enid Bell (1904–), a good example of a woman artist who flowered as a result of government art programs, was head of the sculpture division of the New Jersey Federal Art Project (1939–40). Primarily a direct carver in wood, she created panels for the Marcus Garvey School (formerly the Robert Treat School) in Newark, the Hoboken and Union City libraries, and the Boonton and Mt. Holly post offices. She also did many smaller sculptures in the round.

Born in London and educated at Scotland's Glasgow School of Art and New York's Art Students League, Bell had solo exhibitions at the Ferargil Gallery, the Arden Gallery, the Museum of Santa Fe, New Mexico, and elsewhere. Her figurative works range from relatively realistic to more stylized and abstracted forms that grow out of the shape and grain of the wood.

Hannah Small (Ludins) (1908–), Art Students League graduate and longtime resident of the famed art colony of Woodstock, New York, lived next door to sculptor John Flannagan, whose influence led her to begin carving directly on native stones found in the area in the early 1930s. Throughout a long career she has continued to carve warm and elemental female figures, contrasting smooth areas with rough textures.

Some other fine direct carvers and figurative artists are **Ethel Painter Hood,** who created vigorously modeled figures of boxers and everyday "American Scene" types; **Ruth Nickerson,** who completed a brown stone tympanum (*Dispatch Rider,* New Brunswick, N.J., post office) for the Treasury Section of Fine Arts and other federal commissions and who won a Guggenheim fellowship; **Gladys Edgerly Bates** of Mystic, Connecticut, who won many awards in the 1920s and 1930s; **Margaret Brassler Kane,** who carved an eighteen-foot limewood relief depicting the history of humanity; and **Elfriede Abbe,** whose carved oak frieze is in the library at Cornell University. **Ellen Key-Oberg, Helen Beling, Emily Winthrop Miles, Mary Tarleton, Elizabeth Seaver,** and **Frances Rich** are also noteworthy. A number of other well-recognized women artists in the American art exhibition at the 1939 New York World's Fair are included in the accompanying book, *American Art Today* (New York: 1939).

ABSTRACT AND NONOBJECTIVE ARTISTS

A small band of avant-garde artists, inspired by European modernists, produced abstract and nonobjective art. They encountered opposition not only from the public but from galleries and even from museums supposedly devoted to modern art.

Regionalists and isolationists who sought to glorify the American scene labeled their work "un-American" and "radical"—imitative of alien European ideas and an assault on native traditions. On the other hand, left-wing social realists felt that nonobjective and abstract art was reactionary and lacking in feeling for the needs of the people in a time of economic hardship.

The frustration of the abstract artists reached an explosion point when the Museum of Modern Art, ostensibly founded for the purpose of promoting modern art, mounted a 1936 exhibition entitled Cubism and Abstract Art that did not include a single American. Determined to find ways to get their work out to the public, they formed a new organization, the American Abstract Artists. Among the founders were a number of women—Gertrude Greene, Rosalind Bengelsdorf, Alice Trumbull Mason, Esphyr Slobodkina, Mercedes Carles (Matter), and Ray Kaiser. By 1938 the group included Anna Cohen, Margaret Peterson, Florence Swift, Dorothy Joralemon, Agnes Lyall, Janet Young, and Suzy Frelinghuysen, later followed by Irene Rice Pereira, Lee Krasner, Claire Falkenstein, Rhys Caparn, and others. The pioneering role of the American Abstract Artists, long neglected, has been reevaluated in such exhibitions as Abstract Painting and Sculpture in America: 1927–1944, at the Whitney Museum (1983).

In the 1930s, however, critics called the work "decorative" and "derivative" of European modernists. Even the open-minded Henry McBride joked about mistaking two members' works for a Hélion and a Miró.

As fascism spread in Europe, the group welcomed refugee artists such as Piet Mondrian, Josef Albers, Hans Hofmann, Jean Hélion, and Gyorgy Kepes. Abstract art made strange bedfellows: the AAA consisted of two groups—a cluster of struggling bohemian artists and a small clique of wealthy, patrician connoisseurs, including George L. K. Morris, his wife Suzy Frelinghuysen, Charles Shaw, A. E. Gallatin. With more means at their disposal and contacts in the community, this well-to-do coterie was able to do a great deal for the struggling group. Gallatin purchased works from his hungry colleagues and

Claire Falkenstein, FIGURE (1937), wood/gesso/tempera, 40″ x 9½″ x 10″. Unlocated. Created for the Federal Art Project. Photo courtesy of the artist.

founded the Museum of Living Art at New York University, one of the earliest galleries of abstract art in the United States. Morris, who had studied in Europe with Léger, had valuable contacts with European modern masters and acted as a spokesman.

In the second volume of her self-published autobiography *Notes for a Biographer,* Esphyr Slobodkina describes with considerable humor the contrast between the wild and wooly bohemians, some of whom went in for every kind of "advanced" expression including nudism and mate-swapping, and the upper-class members who came to meetings in mink coats and elegant tweeds.

(Claire Falkenstein, one of the most advanced modernists of the 1930s, was already creating totally nonobjective ceramic and wood sculptures, but because her work flowered in the 1940s, it is discussed in the next chapter.)

Gertrude Glass Greene (1904–56) was, in the 1930s, one of the first American sculptors to make nonobjective painted wood reliefs. Full recognition of her achievement did not come until twenty-five years after her death.

Born in Brooklyn, the youngest child of well-to-do Latvian Jewish immigrants, Gertrude Glass showed her fiery spirit early. When her adored, cultivated mother died and her father remarried, she left home at age eighteen and opened an outdoor nursery school.

At the same time (1924–26), she studied sculpture in the evenings with Cesare Stea at the conservative Leonardo da Vinci School, where students drew from plaster casts. Gertrude soon allied herself with the nucleus of radical young students who eagerly sought out exhibitions of modern art at such avant-garde centers as Stieglitz's Intimate Gallery.

Apparently the experience of teaching nursery school enhanced her interest in art. Already a modernist, she responded to the children's fresh vision: "We made little things with our hands, from clay, paper and raffia. . . . When it rained we rode to the Museum in Brooklyn [where the children] attempted to draw what they saw. It's wonderful how children can see better than the adult."[31]

Gertrude met her future husband, Balcomb Greene, in the Egyptian gallery at the Metropolitan Museum. Shortly before their marriage, as she was making arrangements to close her school, she wrote a letter to him that revealed her idealism and love of freedom. She hoped that each of her pupils would remain throughout life "a child in spirit that can dream and feel real values in nature and humanity . . . defy the gods—rejoice in the freedom of his limbs and mind."[32] That is precisely what she did herself.

The Greenes moved to Hanover, New Hampshire, where Balcomb taught English at Dartmouth College while Gertrude set up a studio and worked on expressionistic figures and heads. During trips to New York City, they studied the work at the newly opened Museum of Modern Art and the Museum of Living Art at New York University.

As soon as they had saved enough money, Gertrude urged Balcomb to go to Paris with her. In 1932 they took a small studio in Montparnasse, where Balcomb wrote novels on the balcony while Gertrude worked inside. Intrigued by her enthusiasm, he tried his hand at painting; soon she was showing him how to stretch canvases and he was taking classes at the Académie de la Grande Chaumière. This was a rare reversal of historical precedent, in which an artist wife inspired her husband to become an artist.

The Greenes saw exhibitions of Arp, Brancusi,

Picasso, and Mondrian, and hotly debated their merits with colleagues at sidewalk cafés. Gertrude was especially drawn to the pure nonobjective forms of the Russian émigré constructivists Naum Gabo and Antoine Pevsner, who were not only experimenting with new concepts of space but also presenting her with a total worldview—the notion that the order and harmony of nonobjective art could serve as a paradigm and inspiration for a new and better society. The use of modern industrial materials, such as plastics, glass, and metal, reflected their optimistic dream that the machine age could bring about a world free of poverty.

Returning to New York City in 1933, the Greenes opened a studio on Seventeenth Street, where Gertrude set up a forge in her fireplace and experimented with materials. Influenced by the biomorphic forms and painted wood reliefs of Miró and Arp, she gradually developed a personal vocabulary. In her first relief, *La Palombe* (1935–36, Ertegun Collection), she superimposed two Monel Metal strips on an Arp-like bird form mounted on a Masonite board. After this, Greene purged representational elements from her work.

With a jigsaw she cut out eccentric biomorphic and geometric wood shapes and glued or screwed them onto Masonite boards, overlapping several layers of interlocking negative and positive forms. She painted the forms white, black, blue, and gray and occasionally warmer colors. Sometimes illusionistic painted shadows added complexity to the real shadows cast by the thickness of the wood cutouts. From the beginning, the odd shapes were very personal and distinctive.

Construction in Blue (1937, collection Barbara Millhouse) is a bold, jazzy counterpoint of white, black, and royal blue biomorphic and geometric cutout wood shapes, stabilized along a diagonal axis. In *Construction* (1937, Berkshire Museum, Pittsfield, Massachusetts), two eccentric masses form a seesaw, teeter-tottering across the fulcrum of a small disc. The artist was overjoyed when A. E. Gallatin bought this work for the Museum of Living Art. In 1937 the Baroness Hilla Rebay included Greene's work in the opening show of the new Guggenheim Museum of Non-Objective Art.

Greene increasingly worked variations on a square. In some compositions a characteristic hammerlike or paddle shape is the active agent, directing the eye in dynamic movements (*Construction in Ochre,* Brooklyn Museum). She developed her ideas in beautiful cut-paper collages, but since she regarded them as temporary studies, few remain.

In 1936 the Greenes were at the first gathering at Ibram Lassaw's studio that resulted in the formation of the American Abstract Artists. Balcomb was its first chairman, and Gertrude organized the first exhibitions; in fact, she was their first salaried employee. Although the critics attacked them, the artists were elated when fifteen hundred people attended the opening exhibition. They had established a beachhead for American abstract art.

Dark-eyed, voluble, and enthusiastic, Gertrude was described by Lee Krasner as an "out-front type" who was involved in the Artists Union, the American Artists Congress, and later the Federation of Modern Painters and Sculptors. When Balcomb became a professor of art history and aesthetics at Carnegie Tech, Gertrude commuted between her Seventeenth Street studio and Pittsburgh. Finding it difficult to cart heavy tools and materials back and forth, she solved the problem by working with lightweight strips of wood lathe that could be cut and glued

Gertrude Greene, CONSTRUCTION (1937), wood construction, 20″ x 40″. Collection of the Berkshire Museum, Pittsfield, Mass. Gift of A. E. Gallatin. Photo: Bartlett Hendricks.

to a board. This resulted in a fascinating series of compositions.

White Anxiety (1943–44, Museum of Modern Art) is a dynamic white-on-white composition of linear elements spilling downward in seemingly casual diagonal movements that are actually held in disciplined balance. The shadows cast by the layers of wood strips add to the intricacy of the design. The gestural movement in this composition already prophesies her subsequent move into action painting.

In 1947 the Greenes bought a large piece of land, far from telephone lines and electricity, on a cliff above the sea at Montauk Point, Long Island. The two artists camped out in a damp dugout in sleeping bags while they built the first part of their austere cement block and glass home. After it was inhabitable, they invited weekend guests to help them finish the house— a medley of poets, painters, and psychiatrists turned weekend carpenters. The free-spirited Gertrude, who loved crowds of people, cooked for them all and, according to reports, encouraged freedom in all things—life-style, art, and ideas.

Perhaps the presence of the abstract expressionist painters, many of whom lived nearby in the Hamptons, influenced the sculptor to free up her forms in the 1940s and 1950s. At first this showed up in brushy color shapes painted into her wood slat compositions. In *Construction* (1946), diagonal movements of thin black and white slats are painted with brushy areas of gray, blue, black, bright red, and patches of yellow. This handsome composition combines painting and sculpture in a very original way. In the 1950s, she evolved a brushy painting style that still incorporated structural elements, such as the square. In her late palette knife paintings, she was "building" or "constructing" with paint as she had with wood or metal.

The sculptor's first solo show at the Grace

Gertrude Greene, WHITE ANXIETY (1943–44), painted wood relief construction on composition board, 41¾″ x 32⅞″ × 2⅞″. Collection, The Museum of Modern Art, N.Y. Gift of Balcomb Greene.

Borgenicht Gallery (1951) was followed by one at the Bertha Schaefer Gallery (1955). Her untimely death of cancer was deeply mourned in the art community.

Not until long after her death did Gertrude Greene's painted reliefs receive proper recognition. After one was included in the 1976 Whitney Museum's bicentennial survey, 200 Years of American Sculpture, a 1981 retrospective followed at New York's A.C.A. Gallery. Today, when the combination of three-dimensional forms and painting has been taken up by many artists, it is apparent that Gertrude Greene was ahead of her time.

Rhys Caparn (Steel) (1909–), born in Onteora, New York, has been recognized since the early 1930s for her moonstruck abstractions of birds and animals and for nonobjective landscapes that have a quiet, inward quality.

Caparn came from a creative family. Her mother taught music until the age of eighty-five; her father, Harold Caparn, a landscape architect who designed the Brooklyn Botanical Gardens, imbued her with an interest in forms in the landscape. In an art history class at Bryn Mawr, she was so overwhelmed by the beauty of Greek art that she left college in 1929 to become a sculptor.

Caparn went to Paris where she studied with the *animalier* Edouard Navellier at the Ecole Artistique Animaux and modeled directly from live animals. After that she studied in New York with the cubist sculptor Alexander Archipenko, who stressed the tension between concave and convex forms, and greatly influenced her work (1931–33). Archipenko wrote the catalog for Caparn's first solo exhibition at the Delphic Studios in 1933:

> Rhys Caparn is one of those rare artists who creates lyrical poetry with pure form. The lines of her statuettes remind one more of a quiet melody than of the anatomical lines of the human body. . . . Her art is purely feminine in sentiment but not in the sense of pretty sentimentalism. . . . it is full of power, expression and refinement. Rhys Caparn is the first woman

in America who had enough courage to use the new combination of form and line for self-expression. And in this combination it is easy to recognize the feeling which we often find in the music of Chopin.[33]

Despite the hostility to abstract art at the time, her highly abstracted figures and heads (*Torso*, 1932) were described in *Art News* as "completely creative." The *Christian Science Monitor* spoke of "subtle transitions of planes," and Henry McBride praised her "grace" and "truth." From that time forward Caparn's work has shown remarkable consistency, while continually developing.

In 1937 she began a series of very abstracted animals (*Tiger*, 1938; *Stalking Cat*, 1938–39) and bird images with flowing shell-like forms and hollows (*Bird*, 1939; *Fighting Birds*, 1940), which she exhibited at Wildenstein & Company in 1944 and 1947. In 1941 she was included in the Museum of Modern Art exhibition Fifteen Sculptors. Caparn and five other American women were in the 1950 exhibition New York Six, at the Petit Palais, Paris. (The others were Sardeau, Harkavy, Caesar, Simkhovitch, and Helen Phillips.)

Caparn became the focus of a controversy when she received second prize for *Animal Form 1* at the Metropolitan Museum of Art exhibition American Sculpture 1951. The National Sculpture Society declared that modernism was becoming a "serious cancer in the culture of our nation." Another critic suggested that her forms were stolen from the Italian artist Marino Marini. But Caparn had never seen Marini's work; she had arrived at a similar form independently.

After World War II, Caparn was greatly affected by "a visit to Warsaw . . . in 1948. . . . I was much affected by the ruins, by their shapes and strange separations. My interest in fragments of

Rhys Caparn, HILLSIDE (1966), hydrocal, height 36″. Collection of the artist. Photo: Peter A. Juley & Son.

architecture, in terms of both visual form and meaning, began at this time.... I have concentrated more and more on making 'places' in sculpture, spacing abstracted architectural fragments to suggest a world half-way between man and primal nature."[34] Among these are curious amalgams of buildings acted upon by nature, and landscapes built directly in plaster, having a curious shell-like or fossil-like quality (*Grand Teton Mountain,* 1959; *Hillside,* hydrostone, 1966). The slightly inflected forms breathe and ripple beneath their sensitive skins. Some of her works have welcoming arches and openings that seem to shelter internal ovoid forms in a womb-like manner (*A Dream of Mountains,* 1966). The same shell-like forms appear in groups of birds (*Marsh Birds in Moonlight,* 1955; *A Gathering of Birds,* 1954, Whitney Museum). Caparn has stated that her bird groups are metaphors for different themes.

Despite the inward quality of her work, Caparn has been very much out in the world. Beginning in the late 1930s she exhibited with the Sculptors Guild and American Abstract Artists; taught sculpture for years at the Dalton School; was president of the Federation of Modern Painters and Sculptors (1944 and 1963–65); served on the Mayor's Committee for the Beautification of the City of New York (1963–64); and was a founding member of the Harlem Cultural Council. She is a fellow of the International Institute of Arts and Letters.

Esphyr Slobodkina (1908–), a founding member of American Abstract Artists, has been not only a sculptor but a designer in many fields, from painting and children's book illustrations to clothing, jewelry, and textiles. To her, the meaning of abstract art is everywhere.

Raised in a well-to-do Jewish family in Si-

beria, she fled with them in 1922, settling in Harbin, Manchuria, on the Russo-Chinese border. During her adolescence in that exotic melting-pot city, she took private art lessons and was influenced by the flat planes and glowing colors of Byzantine art.

After the family migrated to the United States in 1928, Slobodkina attended the National Academy of Design (1929–33) and there met painter Ilya Bolotowsky who introduced her to modern art. "He laughed at me because I was an impressionist," she has said. "He was brilliant and crazy, a walking encyclopedia in English and Russian ... even though he mumbled under his mustache. He gave me the basic principles in condensed form."[35]

After they married in 1933, they became part of the lively group of artists—Balcomb and Gertrude Greene, Alice Trumbull Mason, Albert Swinden—who formed American Abstract Artists. Slobodkina exhibited in the first AAA group exhibition at the Squibb Building in 1937, remaining a staunch defender of the organization and its secretary for thirty years. "Alice Mason and I fought like tigers to keep the group in existence, when others tried to dismantle it," she said. Also in the Artist's Union, she was a founding member of the Federation of Modern Painters and Sculptors after it broke away from the American Artists Congress.

As early as 1935, Slobodkina created collages and constructions of biomorphic and geometric wooden shapes and wire, glued onto boards (*Construction No. 3,* 1935, Ertegun Collection Group). Some of her sculptures and paintings suggest the masts and sails of boats. In *Untitled* (1938), open biomorphic forms swing out freely, enclosing negative space. A. E. Gallatin sponsored her first one-person show at his Museum of Living Art, New York University, in the 1940s.

Esphyr Slobodkina, UNTITLED (1938), wood, 38½″ x 30½″ x 15″. Courtesy Sid Deutsch Gallery, N.Y.

After divorcing the volatile Bolotowsky, Slobodkina used her design sense to eke out a living: she even painted trays and made lampshades, worked as a dress designer, and ran an experimental textile design factory. She then became an award-winning author-illustrator who pioneered in the use of contemporary abstract forms in children's books. Her classic *Caps for Sale* (1940) has been translated into many languages. Her editor, Margaret Wise Brown, the famous author of children's books, became a close friend, and some of her happiest memories are of vacations at Brown's summer home in Maine.

Most of Slobodkina's sculptures made through the years, are witty visual puns derived from found objects. *Table Top Gazelle* (1938–40), an animal head made of rhythmic curved abstract forms, is constructed from wooden pieces taken from a cheval glass. After marrying an importer, Slobodkina used the cast-off Indian weaving shuttles that she came across in their business. *Thrust,* a dynamic counterpoint of curves and angles supporting itself on points, is constructed from weaving shuttles and pieces of clothes hangers. *The Sadly Sagging Educational Spiral* (1984, collection of the artist) is one of several works constructed out of old typewriter parts and an electric fan. (She has also made jewelry from the typewriter parts.) "I'm trying to use up all the materials I have, so when I die there will be nothing to throw out. Everything gets used in this house," says Slobodkina with a laugh.

Slobodkina lives and works in Hallandale, Florida. With the recent revival of interest in the pioneering role of American Abstract Artists, her work was included in exhibitions at the University of New Mexico and the Whitney Museum, and in solo exhibitions at the Sid Deutsch Gallery, New York.

Vehement and outspoken, Slobodkina has pub-

lished several volumes of her autobiography, *Notes for a Biographer,* in which she pulls no punches in her comments on the snobbery and corruption in the art world, amusingly describing everything from Nierendorf's attempt to seduce her in exchange for exhibitions in his gallery to the antics of the avant-garde in the American Abstract Artists group.

San Francisco–born **Florence Alston Williams Swift** (1890–1977), a charter member of American Abstract Artists, studied at the Art Students League with Hans Hofmann and exhibited an iron and textured concrete nonobjective relief, *Ornament for a Garden,* in one of the first exhibitions of American Abstract Artists and in the California contemporary art show at the 1939 San Francisco Golden Gate Exposition. Swift exhibited frequently in the Bay Area and designed abstract iron and cement plaques for gardens and architecture. For the Federal Art Project she did a tile mosaic on the east facade of the old art gallery at the University of California, Berkeley.

Dorothy Rieber Joralemon (1893–), daughter of a portrait painter and a University of California, Berkeley, philosophy professor, studied at the Art Students League. She did portraits until she was introduced to modern art in the 1930s by Vaclav Vytlacil at the California College of Arts and Crafts. A nonobjective textured relief was in one of the first shows of American Abstract Artists and others were in the 1939 San Francisco Golden Gate Exposition. Vision problems halted her career.

Edris Eckhardt, MID DAY (1938), glazed earthenware, height 22″. Private collection. One of a series of sculptures about farm life created for the Federal Art Project.

DESIGN IN THE 1930s

In the 1930s the Federal Art Project sponsored crafts and design projects all over the country. The Index of American Design, a nationwide research project, was initiated by **Ruth Reeves,** one of America's leading textile designers. Constance Rourke was editor of the index between 1935 and 1936. Hundreds of artists (including many women) made painted renderings of traditional and folk art objects in every state, resulting in a permanent archive of this heritage.

One of the most creative ceramists on the Federal Art Project was **Edris Eckhardt** (1907–). Raised in Cleveland and trained at the Cleveland Institute of Art, she was already an established ceramist when she became involved in the Public Works of Art Project (PWAP) in 1933–34, and initiated a program to produce small-scale sculptures for use in children's library programs—charming images of *Mother Goose, Alice in Wonderland* and other subjects from children's literature.

After becoming director of the Federal Art Project's ceramics sculpture program in Cleveland, she developed a large-scale program of ceramic decorations for public buildings. Since the 1940s, Eckhardt has also become a pioneer of new techniques in glass, laminating gold foil and other materials between sheets of glass. She won Guggenheim fellowships in 1956 and 1959 and a Louis Comfort Tiffany fellowship for work in stained glass. She continues to exhibit.

On the whole, the zigzag forms of machinelike art deco and art moderne dominated the 1930s. Ilonka Karasz continued to design objects, Ruth Reeves designed the rug for Radio City Music Hall, and Hildreth Meière created the medallions on the exterior (see chapter 6). **Vally Wieselthier** and **Susi Singer,** leading members of the Wiener Werkstätte group of designers in the 1920s, came to the United States from Vienna, bringing with them a bold, gay, and irreverent attitude expressed in "flapperish" ceramic figures and decorative ceramics. They influenced American ceramists to be freer and more playful in their approach. In her 1984 book, *A Woman's Touch,* Isabelle Anscombe suggests that the playful attitude, as well as the loose, sometimes eccentric forms and boldly splashed colors, had a lasting influence that can still be felt today in the funk school of ceramics.

The Bauhaus school of severe modern functional design, already fully developed in Germany and other European countries, began to affect the United States toward the end of the 1930s as Marguerite Wildenhain, Gertrude and Otto Natzler, Moholy Nagy, Josef and Anni Albers, Walter Gropius, and Mies van der Rohe fled from fascism to the United States. Their influence was most strongly felt in the 1940s and is therefore discussed in the next chapter.

WOMEN SCULPTORS IN THE WORLD'S FAIRS OF THE 1930s

Amidst the gloom of the depression, the three great expositions in Chicago, New York, and San Francisco were dream factories where corporations and government agencies promoted the view that progress and utopian prosperity could be achieved through industrial technology. Looking back from the present era of environmental disaster, historian Charles Beard's statement in the book accompanying the 1933 Chicago Century of Progress Exposition seems wistfully naive:

> The concept of progress ... implies that mankind by making use of science and invention can progressively emancipate itself from plague, famine, and social disasters, and subjugate the materials and forces of the earth to the purposes of the good life....
>
> As a result of the general transference of muscular labor to machines, American culture becomes distinctive. In fact, the story of the marvelous inventions—the tools of American life—is one of the great historical romances.[36]

One of the best expressions of this theme at the Chicago fair was the art deco fountain created by **Louise Lentz Woodruff,** *Science Advancing Mankind,* in the rotunda of the Hall of Science. A giant blocky robot, pushing a man and woman forward, symbolized "the onward movement of science, with its powerful hands on the backs" of humanity. On the sides of the hexago-

Gertrude Vanderbilt Whitney, SPIRIT OF FLIGHT (destroyed). New York World's Fair, 1939. Whitney Museum of American Art, Gertrude Vanderbilt Whitney Papers, Archives of American Art, Smithsonian Institution. Gift of Flora Miller Biddle. Photo: Braganca-Herrick.

nal pedestal were art moderne motifs representing Physics, Mathematics, and so on.

Woodruff was the wife of George Woodruff, a wealthy banker from Joliet, Illinois, who was, perhaps not coincidentally, the treasurer of the Century of Progress Exposition. According to her obituary in the *Chicago Tribune,* 15 July 1966, she had been a poor but beautiful orphan who went to work in her teens as a secretary at Woodruff's bank and captured his fancy. He had her educated for three years in America and Europe and then married her in 1915. She became a sculptor, studying at the Art Institute of Chicago and with Bourdelle in Paris. She maintained a studio in her home, an elaborate Italian villa in Joliet, Illinois. The artist donated the fountain to her alma mater, the Joliet Central High School.

Another monumental project for the Chicago fair was Malvina Hoffman's group of bronzes representing the "races of mankind" for the Hall of Man at the Marshall Field Museum. The American art exhibition in Chicago included works by some capable traditional women sculptors and direct carvers, but no abstract artists. Represented were Olga Chassaing, Dorothea Greenbaum, Elizabeth Haseltine, Sylvia Shaw Judson, Viola Norman, Mabel C. Perry, Margaret Sargent, Janet Scudder, Ruth Sherwood, Eugenie Shonnard, Bessie Potter Vonnoh, and Gertrude Vanderbilt Whitney.

At the 1939 New York World's Fair in Flushing Meadows, the overall theme of progress through technology was well expressed by Gertrude Whitney's winged fountain, with its silvery streamlined arc formed out of a man and woman. Malvina Hoffman's drum-shaped *International Dance Fountain* was covered with low reliefs of exotic dancers, and Augusta Savage's harp-shaped *Lift Every Voice and Sing* stood at the

Augusta Savage, LIFT EVERY VOICE AND SING (1939), cast sculpture (destroyed). Photo: Carl Van Vechten. Collection of American Literature, Beinicke Rare Book Library, Yale University. Courtesy of the Estate of Carl Van Vechten, Joseph Solomon, executor.

entrance to the mammoth exhibition American Art Today. The garden court of the Federal Building contained three major works by women: Marion Walton's *Young Man and Calf,* Concetta Scaravaglione's *Woman with Mountain Sheep,* and Berta Margoulies's *Woman and Deer.* Hildreth Meière's striking art deco *Hippocrates,* a relief in colored metals, brightened the façade of the Science and Education Building. Figurative sculptors and direct carvers dominated the American Art Today exhibition, which

included more than eighty women sculptors. The lone abstraction was Helen Wilson's plaster *Dance.*

On the West Coast, the 1939 Golden Gate Exposition on Treasure Island in San Francisco Bay stressed the theme of harmony between California and all the peoples bordering on the Pacific Ocean. Women artists were exceptionally active in San Francisco, and this was reflected at the fair, particularly in the Court of Pacifica, a large plaza with a splashing fountain in the center.

Women sculptors created the entire inner circle of twelve figures for this fountain. The three-figure groups included Ruth Cravath's *North America,* Adaline Kent's *South Sea Islanders,* Helen Phillips's musicians, and Cecilia Bancroft Graham's *South America.* (Graham was a Mills College graduate who had studied with Carl Milles at Cranbrook Academy.) Eugen Neuhaus commented, "The inner circle formed by the ladies was full of ideas, not trite or stereotyped . . . teeming with vitality, insistently so in some aspects."[37] He singled out Ruth Cravath's cross-legged *North American Woman* for excellence, and called Adaline Kent's *Polynesian Young Man Improvising Music* "one of the finest pieces of plastic art which the exposition offers out of doors."

Dominating the Court of the Pacifica was a 157-foot-wide colored wall relief entitled *The Peacemakers.* This theme mural, expressing "harmonious social and cultural relations of the peoples living on the borders of the Pacific Ocean," was the collaborative creation of three sisters, Helen, Margaret, and Esther Bruton, well-known Bay Area designers. It showed a stylized procession of Occidental and Oriental figures meeting before a forty-four-foot Buddha, surrounded by the Great Wall of China, an Aztec pyramid, and American skyscrapers. Glowing with light at night, it was called

Malvina Hoffman, INTERNATIONAL DANCE FOUNTAIN (destroyed). In front of trylon and perisphere, New York World's Fair, 1939. Peter A. Juley and Son Collection, National Museum of American Art, Smithsonian Institution (J0035321).

an adventure in mural decoration, unusual and bold, both in its great size and . . . technical novelty . . . one of the largest undertakings of this type . . . carved out of several superimposed layers of wood fiber insulation material of different thicknesses . . . attached to plywood boards. It is in fact both painting and sculpture at one and the same time. . . . The color scheme is restrained but effective . . . ochres and terra cotta to more brilliant reds. The processions are clearly defined in light ivory . . . against a gold background.[38]

Anna Coleman Ladd's *St. Francis* stood on the south lawn of the Court of Honor. In an exhibition hall given over to the Art in Action program, Diego Rivera sat on a high scaffold, munching French bread and working on a mural, assisted by WPA artists, while Ruth Cravath carved a stone horse, using live horses as models; Margaret Bruton demonstrated mosaics; and Ger-

trude and Otto Natzler made ceramics. In the prestigious international art exhibition were works by Cornelia Chapin, Laura Gardin Fraser, Minna Harkavy, Anna Huntington, Sylvia Shaw Judson, Helene Sardeau, and Arline Wingate. In the California art exhibition, Claire Falkenstein's abstract polychromed terra-cotta sculptures were probably the most avant-garde works at the entire fair (see next chapter).

The hoopla and glitter of the world's fairs faded as World War II approached, ushering in a completely different era in American art. The peaceful Pacific Basin theme of the Golden Gate Exposition ended in irony as Japan invaded Manchuria and China and bombed Pearl Harbor. The expositions on both coasts were bulldozed and the temporary sculptures were for the most part destroyed. With their destruction went the memory of the high position and important work created by women artists for the world's fairs of the 1930s.

•8•

The Triumph of Abstraction: 1940–1959

World War II brought tremendous changes in American art. The social realism and regionalism of the 1930s faded before the cosmopolitan internationalism imported to these shores by European artist-refugees from fascism, who poured into New York City. Under their inspiration, Americans were heavily influenced by surrealism and abstract art. During the war a new kind of American abstraction was forged out of these diverse influences, and in the postwar period New York became, for the first time, the world center of vanguard art; its dominant style, abstract expressionism, became the culmination of modernism.

American sculptors employing new techniques and materials—welding, assemblage, junk sculpture, plastics—broke out of the straitjacket of monolithic carving to create dynamic, open, interpenetrating forms with surrealistic or constructivist overtones. These methods and materials permitted a new spontaneity that ultimately expanded sculptural forms into total environments.

International modern art forms became symbols of the freedom we were fighting for. Although isolationists had previously attacked abstract art as un-American, radical, and revolutionary, after the Nazis declared abstract art degenerate, American intellectuals saw in it the unique expression of the free individual. Picasso's *Guernica* had shown that abstract art could be used to address the great human and social issues of the day.

With Europe in flames, America became the refuge and the bastion of high culture. American artists, who had up to this time seen themselves as at best disciples and imitators of the great European modernists, now hoped to outstrip their European mentors (particularly the giant Picasso, who overshadowed them all) and create a new and distinctively American abstract art on an imposing scale, suited to America's place as leader of the free world.

On the other hand, although often overlooked, many excellent figurative sculptors also continued to work during this period.

THE POSITION OF WOMEN

During the war, women took over men's jobs in factories and offices, as they had in World War I. With the men away, they achieved status and independence as members of the work force, but most of the gains of the period were lost when the war ended; the defense jobs melted away and the men came back to compete for what was left.

As soon as Rosie the Riveter put down her tools, a man picked them up, and she was exhorted to return to the kitchen and her children. This was the time of the baby boom, the station wagon, the flight to the suburbs. The same Freudian theories that were to affect art were used to influence women to accept passive, traditional female roles again. A brilliant psychoanalyst, Karen Horney, helped her patients see that

they were being victimized by social values, not by their "essential" biological nature. For this she was under constant attack from the psychoanalytic societies.

It is not surprising, therefore, to find that the postwar art scene became extraordinarily macho. The men who were forging the new American art felt called upon to act like supermen; the cult of the individual male genius was at its height. Louise Nevelson remembered that men artists repeatedly told her that she "had to have balls" to be a sculptor. Only a few women became prominent—in the cases of Louise Bourgeois and Louise Nevelson, not until decades later. It took great strength to persevere.

ABSTRACT SCULPTURE

Among the leaders of European abstract and surrealist art streaming to our shores in the 1930s were Max Ernst, Yvez Tanguy, André Masson, Matta, Jacques Lipchitz, Naum Gabo, Piet Mondrian, Jean Hélion, Hans Hofmann, Stanley Hayter (and his Atelier 17 print workshop), and many others who created an artistic melting pot in New York City and dazzled young American artists. Women sculptors like Day Schnabel and Elizabeth Model were also refugees.

One of the dominant movements among them was surrealism—and with the immense popularity of the writings of Freud and Jung, the surrealist influence on Americans was enormous. There was a new interest in the mythic, the world of dreams, and the subconscious. Many left-wing artists, disillusioned with the Soviet Union after the Moscow trials and the Nazi-Soviet pact, now believed that the problems of the world perhaps lay deeper than social systems, buried in human nature and the collective unconscious.

In the early 1940s, artists began, in imitation of André Breton, to experiment with automatic writing and free, intuitive forms of expression that would liberate them from premeditation and rational control and put them in touch with the subconscious. While Jackson Pollock was drip painting and Willem de Kooning was slashing brush strokes that led him through the "act" of painting, sculptors began to weld, braze, drip metal, pick up junk and various forms of detritus, and freely assemble and collage them. Louise Nevelson began to assemble the cast-off debris of New York City into larger and larger forms that eventually became architectural.

Disturbed by what seemed to be the failure of urban "civilized" rational society, American sculptors, like their surrealist mentors, turned to so-called primitive art for inspiration. The creation of totemic forms—magical personages or "presences" (greatly abstracted images that could bring in the human element while avoiding figurative representational styles)—engrossed a generation of sculptors. Louise Bourgeois carved a room full of tall slender abstract totems for her first exhibition at the Peridot Gallery.

All in all the surrealist influence allowed Americans to imbue their abstract art with expressive and intuitive content; but Americans rejected surrealism's completely accidental or nihilistic aspects. They were serious; they believed that art should deal with profound and universal themes. Thus Nevelson ended up creating entire mythic worlds—rooms that transport the viewer to another dimension of time and space with magical actors and architecture.

After the war came the threat of the atom bomb, the cold war, and the repression of free speech during Senator Joe McCarthy's witch-hunts; all combined to produce an apocalyptic mood filled with angst. Artists were influenced by Jean-Paul Sartre's existentialism—the idea that each human being has the heroic task of

creating meaning, carving out an authentic identity in the face of a meaningless universe.

Interestingly, although women sculptors were influenced by the same broad trends that affected the men, there seems to have been a rather striking difference between the work of the two sexes in this period. On the whole, fewer women used the metal cutting and welding and the violent forms employed by such sculptors as Theodore Roszak and David Smith. The imagery of birds of prey and destruction is relatively absent. Nevelson, who worked primarily in wood, stated that she found metal welding to be "warlike"; only in later years when she was receiving large public commissions did she turn to metal, and even then she said that her method of using it was like "folding satin ribbons." Her forms have strength and power, but not violence. Louise Bourgeois's wood, latex, bronze, and marble forms suggest growing organic life, sexual organs, and the volcanic inner struggle of the psyche.

Claire Falkenstein was one of the rare women welders. Yet her wire thickets, enriched with shimmering hunks of glass, seem like galaxies in outer space or growing nature forms rather than violent emblems of destruction. Even Lee Bontecou, who has admitted that her frightening central core totems begun in the late 1950s were sometimes inspired by thoughts of the Holocaust, and who welded the frames out of steel rods, covered them with canvas and gave them a form that suggests imprisonment or mystery.

But this was not because women were not daring and inventive. An area in which they seem to have been particularly advanced was in creating large sculptural environments. Their particular contribution was to fill a room with "personages" who interacted, whereas male artists like Frederick Kiesler and Herbert Ferber sometimes created environments that were architectural frameworks to walk through. Perhaps women's more social role in society—interrelating in a human way and bringing people together—had some influence on these forms. Bourgeois was raising sons, and Nevelson's home was a meeting place where artists and such groups as the Four o'Clock Forum gathered to discuss life and art.

Nevelson's 1943 installation *The Circus: The Clown Is the Center of His World,* containing figures and animals knocked together out of found objects and pieces of glass and wood, was far ahead of its time. In it she presented a metaphysical world in which various figures seem to represent aspects of her own psyche. There were kinetic pieces that the audience could pull around or reassemble, electric lights and posters—in a dozen different ways she anticipated approaches that were to become prominent much later. Nevelson destroyed this work in a fit of despair because of the total failure of the public to recognize its importance.

The feminist content in some of this work—Nevelson's metaphysical vision of herself, which enabled her to endure the long years of neglect, and Bourgeois's deeply human statements about the mistreatment and vulnerability of women—were not understood until the 1970s.

Women were sometimes technical pioneers and inventors. Claire Falkenstein invented a way to melt glass and bond it chemically to metal; Sue Fuller took out patents on methods of embedding filaments in plastic.

Women artists were part of the great ebb and flow, the international exchanges that took place during and after the war. In the 1950s Claire Falkenstein worked in Paris and was part of the expatriate group that included Sam Francis; Helen Phillips, a West Coast sculptor, met and married the European printmaker Stanley Hayter and went to Paris with him after the war; Dorothea Tanning married the European surrealist Max Ernst and later lived with him in France until his death. Stone carver Pat Diska

and Niki de Saint Phalle are two other artists who have become well known in France.

PEGGY GUGGENHEIM AND
WOMEN PATRONS AND DEALERS

During this period women played key roles as patrons and impresarios. The maverick expatriate heiress Peggy Guggenheim had been collecting modern art and running a gallery in London. As the Nazis approached Paris she went into a frenzy of buying and shipped the whole collection to New York. Then she herself fled to the United States, bringing with her the surrealist Max Ernst, soon to be her husband. In 1942 she opened a gallery called Art of This Century, where she showed the work of the European surrealists and abstract artists. At openings and lectures at her gallery and at parties at her Beekman Place home, she introduced young Americans to the Europeans and soon promoted the work of Jackson Pollock, Robert Motherwell, and others at the start of their careers. She sponsored two important exhibitions of the work of women artists, including Louise Bourgeois and Louise Nevelson.

In this period the artist and gallery owner Betty Parsons became "the midwife of the New York School"; gallery owner Marian Willard was one of the earliest sponsors of sculptor David Smith; Baroness Hilla Rebay, who had promoted the work of many American abstract artists, was the guiding genius behind the creation of the Solomon R. Guggenheim Museum; and in the late 1950s, Dorothy Miller, curator at the Museum of Modern Art, "discovered" Louise Nevelson.

Louise (Berliawsky) Nevelson (1899/1900?–1988), one of America's greatest modern sculptors, is best known for her cubistic walls of mysterious wooden box forms, filled with fragments of discarded furniture and debris. Her commissions are found in public spaces all over the country. The story of her thirty-year struggle to find her own style and public recognition is part of the mythology of American art.

Born in Kiev, Louise Berliawsky was four years old when she came with her family to Rockland, Maine, where her father started a successful lumber and construction business. There were very few Jews in the provincial seacoast town, and Louise felt alienated. Every year the prettiest girl in Rockland was selected as "Lobster Queen" and driven through the streets on a float. Louise knew that she could never be in the running for this honor despite her striking appearance. She soon began to compensate for external realities with a rich inner life in which she would be her own kind of "queen" or "star" living in a palace of her own creation.

Her doting, upwardly mobile parents gave their children music and voice lessons and fine clothes. Shy at school, Louise loved to sing and perform at gatherings in the home and was as interested in acting as in art at that time. At school her art teacher, a Miss Cleveland, told her that she was talented and would do great things. In a certain sense one can trace the fantasy of constructing a mansion, an environment of the mind, to these early years. Some of the young artist's first drawings are careful watercolor studies of interiors, rendered with devotion to the architecture and structural details of furniture. According to her sisters, the energetic child constantly arranged and rearranged the furniture in their house, an obsessive practice that she continued, even in adult life, whenever she returned to Rockland. Later, the artist created

LOUISE NEVELSON, 1980. Photo © Lynn Gilbert,
courtesy The Pace Gallery, N.Y.

her work in a kind of restless dance, picking up
pieces and rearranging them, collaging them into
some sort of architecture.

Louise absorbed strong traits from each par-
ent. Her intense father was an "empire builder"
who built and bought more and more property in
Rockland until he was the fourth richest man in
the city. (He also had a craving for antiques
which he piled up in warehouses.) Nevelson
later said that she wanted to "build an empire,"
and her ceaseless construction of forms in wood
and her piling up of masses of found objects are
like echoes of her father's creative nature. Her
mother was a beautiful woman, but a depressive.
She had been coerced into an unhappy marriage
and always felt like an outsider in Rockland,
where she spent much of her time in bed. Seeing
this example of a woman trapped and wretched
in marriage, Louise developed a deep resistance
to the idea of losing her identity in a relationship.
Nevertheless, she identified with the proud car-
riage and handsome finery of her mother, who
dressed as if she were living on Park Avenue in-
stead of in Rockland, Maine. The artist spent her
life living out the unfulfilled dreams of this un-
happy parent. "A woman like that," she later
said, "should have lived in a palace."

Shy and sensitive, but already enormously
ambitious—filled with dreams of becoming a
great artist or actress—she soon found a way out
of her confining life in Rockland. When Charles
Nevelson, a much older man from a well-to-do
Jewish shipping family, proposed to her, she
leaped at the chance to escape to New York City.

Nevelson bore a son, Mike, and soon found
herself smothered by the life of a bourgeois so-
ciety matron. Seeking creative outlets, she stud-
ied voice with Estelle Leibling and art with Ann
Goldthwaite and Theresa Bernstein, and began
a lifelong search for metaphysical truths by
studying Eastern philosophies. Krishnamurti
imbued her with the idea that each person is re-
sponsible for, and creates, his or her own reality.

Nevelson first saw the work of Picasso, Pica-
bia, and others at the 1926 International Theater
Exposition organized by Jane Heap, editor of
the *Little Review,* and the avant-garde expatri-
ate Viennese architect-sculptor Frederic Kiesler,
and subsequently enrolled in an experimental
theater laboratory run by Kiesler and Princess
Matchabelli.

All these diversions were reluctantly endured
by her jealous husband as long as they remained
dilettantish, but any professionalism was se-
verely discouraged. Charles Nevelson also dis-
liked Louise's tendency to dress in flamboyant
outfits rigged up out of unconventional materials
(such as her best table napkins)—a practice she

continued throughout her life. Depressed and frustrated during these years, she reached a turning point when she saw an exhibition of magnificent kimonos for Japanese Noh drama at the Metropolitan Museum of Art. Moved to tears by their beauty, she enrolled full time in 1929 at the Art Students League with Kenneth Hayes Miller and Kimon Nicolaides, an early proponent of modernism.

In Nicolaides's class Nevelson heard that the German artist Hans Hofmann was the greatest teacher of modern art concepts in the world. With the encouragement of her mother, who wanted her daughter to be free, Nevelson left her small son in Rockland and traveled to Germany in 1931.

According to Nevelson's sister, Hofmann, preoccupied by his imminent departure to the United States, told her that she had no talent, and dropped her from the class.[1] In despair, Nevelson briefly considered returning to her earlier interest in acting and took a bit part in a movie in Vienna.

On the way back the artist was overwhelmed by a sense of dislocation and guilt about leaving her family. But in Paris she saw the work of Picasso and the primitive art at the Musée de l'Homme, and propelled by a renewed drive, she divorced her husband and resumed her work. For many years, she lived in wretched lofts and spaces, moving constantly. Despite the hardships, however, she never again entered into a permanent relationship with a man. Instead, the one stable factor in her life was the uninterrupted production of vast quantities of work, except for brief periods of depression and illness. Anyone else would have been discouraged by Hofmann's earlier rejection, but Nevelson had the strength to take classes with him again at the Art Students League after he came to the United States. This time her wiry Matisse-like contour

drawings of the figure won his admiration.

In 1933, when Mexican muralist Diego Rivera was working on murals in New York City, Nevelson was his assistant and lived in the same building with him and his wife, the painter Frida Kahlo. Rivera was visited by intellectuals and leaders from all classes; he introduced her to the glories of pre-Columbian art and presented her with a vision of what an artist-"star" might be.

At this time Nevelson began to study modern dance with Ellen Kearns, an activity she pursued through the years. Dance "centered" her, tapped into her primal instincts, gave her strength and energy, and significantly influenced her art. There is a strong kinetic feeling in her work—a sense of stately hieratic movements. She actually created her sculptures in a kind of moving dance—rapidly picking up pieces and combining them intuitively. The frontal, illusionistic character of her "walls" seems related to stage sets.

During the depression, Nevelson taught WPA art classes (1935–39). She had viewed herself as a painter, but around this time she took Chaim Gross's sculpture class at the Educational Alliance, where she showed extraordinary talent from the first day. In a Federal Art Project sculpture workshop run by Louis Basky and Alexander Tatti, she began to use Tattistone (a kind of cast cement aggregate he had invented) and later relied on the help of these two artisans for firing clay pieces, and other operations involving technical know-how.

Nevelson created blocky cubic figures, mostly in clay, plaster or Tattistone, often painted in contrasting primary colors on each plane in order to emphasize the architectonic character of the forms. Exhibited in American Artists Congress shows at the ACA Gallery (1936–37), they won an honorable mention and some favorable reviews. But termination of her WPA job in 1939 left her in difficult circumstances (she was never

actually poor). In letters to her son, Mike, then in the Merchant Marine, she expressed suicidal despair, and he acted as the parent, comforting her and sending her an allowance from his earnings. Nevelson has said of this period, "For thirty years I wanted to jump out of windows. . . . I paid the full price."

Nevertheless the sculptor continued to churn out work without sales, filling up her studios, so that, she says, she was forced to move from place to place. The moment of truth came one day in 1941 when a rich relative came to town and squandered a huge sum on a casual afternoon's food and entertainment. The contrast between his profligate extravagance and her relative poverty and anomie filled her with rage. Storming out of the Hotel Plaza the artist decided to take extreme measures to get her work out into the world. Without an appointment she marched down to the Nierendorf Gallery, one of the leading galleries of modern art at that time, and confronted the owner, Karl Nierendorf. Sensing the charisma, the vital force of this woman, he visited her studio, saw the quantities of piled-up work (much of it rescued from the Federal Art Project when they were about to dump it), immediately bought a piece, and made a slot in his gallery's heavily booked schedule for her first solo show in 1941. Nevelson has called Nierendorf her "spiritual godfather." In the next few years he encouraged her, exhibited her work, had a personal relationship with her, and supported her with sums of money, although few sculptures were sold.

In 1943, Nevelson created an innovative total environment so radical that even Nierendorf refused to show it; instead it was exhibited at Jimmy Ernst's Norlyst Gallery. Entitled *The Circus: The Clown Is the Center of His World* (destroyed), it contained five-foot figures with eyes made of colored electric lights and animals crudely knocked together out of triangles and blocks of wood; they stood on wheeled slabs of tree trunks, so they could be pulled around with ropes. There were circus posters on the walls and sand and marbles on the floor. Art historian Laurie Wilson has noted that Nevelson's *Ferocious Bull*, resembled Picasso's pioneering *Bull's Head* of the same year, although it is very unlikely that she knew of it. The clowns represented different aspects of the artist's persona: a clown's head was shown with a key, a saw, and a giant metal scissors cut out of a cast-off sign ("the collagist"); another, made of pipes and wood, was a tightrope walker ("the performer"); and a third wept tears of broken mirror. There was also a many-headed totem representing an "audience." *The Circus* was an early statement of Nevelson's worldview—the notion that the human mind creates its own reality; that everything around it is a reflection of that reality. Thus the clown (Nevelson) is the center and creator of her own world.

But the world was not ready for it. Not a single work was sold. Nevelson hauled the large structures back to her loft where they took up so much space she was forced to burn them in the backyard. Only photos remain.

Around this time, in the early 1940s, Nevelson said that she began to feel as if she were "breathing the air of Surrealism."[2] Refugee surrealists were swarming into New York City and her friend Peggy Guggenheim was promoting their work, which often included collages of disparate objects. Joseph Cornell was showing his poetic collage-boxes. It was in this period that Nevelson began to pick up wooden debris in the streets to use in her art. Emily Genauer praised the wood assemblages in her 1944 exhibition at the Nierendorf Gallery: "In few instances has Miss Nevelson carved her own shapes. Instead she has taken existing objects, a wooden duck

decoy, a hatter's block, a chair rail, a ten pin, sanded them down and assembled them into complex constructions of astonishing interest and variety."[3]

Her last show at the Nierendorf Gallery in 1946 included surreal landscape-assemblages that hint at ancient civilizations. *Ancient City* (1945, Birmingham Museum of Art) includes two carved ceremonial lions standing before a vertical totem on a raised platform, harbingers of her future "royal cities."

Nierendorf's sudden death in 1948 was a blow. Without a gallery or patron, run down and depressed, she kept her art alive by doing some carvings at the Sculpture Center and small clay pieces. With customary inventiveness and freedom, she rolled the clay out like dough and cut out shapes as if with a cookie cutter. Then she drew designs on them with a pointed instrument and assembled the pieces into figures on dowels mounted on bases of varying heights in such a way that many of the shapes were movable, making an exciting kinetic grouping (*Moving-Static-Moving Figures,* c. 1947, Whitney Museum of American Art).

Around 1950 she and her sister, Anita, took two crucial trips, one to Yucatan to see ancient Mayan architecture and another to Guatemala. Seeing ancient Mayan art in its setting had an enormous impact: "Yucatan was a world of forms that at once I felt was mine . . . a world of geometry and magic. . . . The sculpture, the power, and the organization was overwhelming. . . . When you walk up the pyramids, you go into the ethers . . . you get light headed . . . the . . . strength, the balance of it . . . makes you feel that . . . we are the primitive country."[4]

Refreshed and stimulated by these journeys, Nevelson entered a fruitful period. Her family bought her a home on Thirtieth Street that gave her for the first time some stability. The five-story brownstone became a kind of artist's head-quarters where various groups, such as the American Federation of Painters and Sculptors and the Four o'Clock Forum, met to discuss theory and practice. Although she had no gallery, Nevelson felt rooted in the art community and now decided to make her bid for greatness by "flood[ing] the market with my work until they know I'm here."[5] She churned out great quantities of work, exhibited in every available place no matter how seedy, pushed herself forward at parties and art openings, and held office in Artist's Equity and other organizations in an attempt to go public.

She did, in fact, attract the attention of Colette Roberts, director of the Grand Central Moderns Gallery, who invited her to exhibit in 1955. Nevelson created a total environment called *Ancient Games and Ancient Places.* This time the public was ready. In the wave of abstract expressionism, American art had become much more sophisticated.

In subsequent exhibitions, *Royal Voyage* (1956) and *Moon Garden + One* (1958), Nevelson came into her own. Working with discarded fragments of furniture, balustrades, hat blocks, jagged scraps of packing crates, she transformed them into new life by unifying all the forms with black paint. She churned out so many black assemblages that she was forced to stack one on top of the other in order to make room for more in her studio. The sculptor began to enclose the constructions in boxes and piled them up into wall-like structures that ultimately reached the ceiling. The sheer volume of work led her by a serendipitous process into a fresh, original form—a new vision of sculpture.

In *Moon Garden + One,* Nevelson transformed the gallery into a world of illusion. The spectator entered a dark room lit by a few blue lights, where mysterious objects and richly encrusted walls could be dimly perceived. The blue lights intensified the shadows cast by the forms,

Installation view from the exhibition "16 Americans," 16 December 1959–17 February 1960. The Museum of Modern Art, N.Y. Photo courtesy The Museum of Modern Art, N.Y.

so that they became as important as the solids. Nevelson has called herself "the architect of shadows" and has declared that the shadows, or "fourth dimension," are as important as the solid forms in her work.

This exhibition included *Sky Cathedral,* one of Nevelson's major mature creations, now in the collection of the Museum of Modern Art. *New York Times* art critic Hilton Kramer immediately recognized that she had broken through into a new dimension. He called the works

> utterly shocking in the way they violate our received ideas on the limits of sculpture . . . They follow the lead of current abstract painting in projecting an image so large that the spectator is invited to feel "placed" within it. . . . I think . . . Nevelson succeeds where the

painters often fail. Where they have progressively emptied their image in order to enlarge it, she insists on proliferating more and more detail, arresting the eye with a brilliant or subtle "passage" wherever its glance falls . . . a kind of gluttony of images . . . something entirely new . . . a sculptural architecture.[6]

Art historian Robert Rosenblum also related *Sky Cathedral* to abstract expressionist painting:

> In some ways . . . Nevelson's vast wooden walls recall the iconoclastic innovations of the new American painting. . . . In scale alone the architectural magnitude of these forests of black boxes parallels the awesomely large paint expanses of Rothko, Still or Newman. . . . Like

the churning labyrinths of Pollock, her shadowy facades are inexhaustibly complex, affording endless explorations to the eye.... her walls, like Pollock's mural spaces, are boundless— infinitely extendible.[7]

These critics, imbued with the spirit of the 1950s, related the assemblages to abstract expressionism, but the walls are rich in multiple associations. They have the push-pull movements and overlapping planes of cubism; the theatrical frontal quality of stage sets, derived from her study of acting, cinema, and modern dance; the awesome totemic imagery and rich surface ornament of Mayan art; but perhaps more pervasive than all of these is the echo of the skyscrapers of New York. Nevelson has said: "Seeing those high risers, bigger and bigger and bigger.... This is what I have lived in.... Now if you take a car ... and you come down on the West Side Highway toward evening or toward morning, when the buildings are silhouetted ... you will see that many of my works are real reflections of the city."[8]

In the 1970s, feminists discovered other levels of meaning. The densely structured boxes which alternately reveal and hide their contents seem like the inner core of a woman, sometimes exposed, sometimes hidden behind a self-protective shell. Nevelson herself proudly asserted that her work could have been done only by a woman. Despite its strength and scale, she said, "it is delicate, like needlework."

From this time forward, despite a few setbacks, Nevelson's position in the art world was assured. Although she was almost sixty years old, she had never had a museum show. Now curator Dorothy Miller invited her to exhibit in the Museum of Modern Art's Sixteen Americans (1959). The sculptor, at the point of entering a more successful phase of her life, abandoned the dark mysteries of her black rooms and created her first all-white environment, *Dawn's Wedding Feast* (1959). In this work, two blocky totemic figures—a royal bride and groom encrusted with collages of wood pieces— appear to be arriving on an unknown shore lined with architectural walls, including a "cathedral." There are also "spectators," a "wedding pillow," and a "wedding cake" made of finials that look like the domes of Russian cathedrals. The dazzling white forms, wrote critic Dore Ashton, gave the effect of morning light on a Victorian seacoast town (Rockland, Maine?). A celebratory quality pervades this joyous marriage of Nevelson and the world.

Dawn's Wedding Feast is one of a number of Nevelson's works dealing with the theme of a royal voyage or journey. The king and queen, or bride and groom, seem to represent the Jungian animus and anima, the two sides of her nature ("I am my own queen—my own king"), embarking on a mythical journey of aspiration to some unknown shore, some unattainable higher state of self-realization, peace, and achievement: "I'm not talking about royalty, because I don't believe in that. But there is such a thing as royalty of mind."[9]

Successes followed. Chosen to be one of the representatives of the United States at the international Venice Biennale, she created an all-gold installation, perhaps reflecting a new sense of splendor and achievement. She showed at the Martha Jackson and Sidney Janis galleries and in 1963 joined the Pace Gallery, which has promoted her work ever since. The Whitney Museum of American Art gave her a major retrospective in 1967 and later, to celebrate her eightieth birthday, reassembled a number of her environments.

Nevelson moved to a stark many-roomed building in New York's Soho district, which she turned into a kind of a factory, and there worked at a furious pace in a variety of media—prints, translucent Plexiglas, aluminum, steel. She had

long resisted welding, which seemed to her like an alien, aggressive, male activity. But now the sculptor carried out large commissions in steel, scaled up from small cardboard maquettes, at the Lippincott plant in Connecticut. Like a stage director she ordered huge sheets of metal to be lifted on giant cranes and cut, bent, rolled, and welded under her supervision. With characteristic freedom, she created "tropical gardens" from cast-off scraps that she found at the plant, welding them with the same spontaneity that she brought to her wood assemblages. Working with steel seemed effortless—"like bending satin ribbon," she said.

In Nevelson's large commissions of recent years, she related the sculpture to the setting; for example, she chose organic treelike forms of black painted steel (*Transparent Horizon,* 1975) to stand against I. M. Pei's starkly modern engineering building at the Massachusetts Institute of Technology in Cambridge, whereas *Atmosphere and Environment XIII (Windows to the West)* in Scottsdale, Arizona—a geometric open screen, pierced by circles and rectangles—frames the desert landscape.

Among her commissions are: the fifty-four-foot *Sky Tree* growing up through two floors in the San Francisco Embarcadero Center; *Bicentennial Dawn* in the federal courthouse, Philadelphia; *Dawn Shadows* (1982), Madison Plaza, Chicago; and *Night Sail* (1983–84), Crocker Center, Los Angeles. In the 1980s a street containing seven of her sculptures in New York's financial district was named Louise Nevelson Plaza. The artist was receiving more public commissions than any other American sculptor with the possible exception of Isamu Noguchi.

Nevelson lived out her life as a work of art. Her outrageous wit and bizarre costumes were almost as well known as her sculptures. Tall and regal, with the carriage of a dancer, masklike face, eyes fringed with three sets of fake black

Louise Nevelson, SKY TREE (1976), black painted steel, height 54′. Comm: John Portman/Embarcadero Center, San Francisco. Photo courtesy The Pace Gallery, N.Y.

eyelashes, and a cigarillo drooping from her mouth, she wore flamboyant combinations of Japanese kimonos, Mexican folk skirts, denim work shirts and massive jewelry of her own design. Sometimes she looked like a cross between a Kabuki actor, a bag lady, and one of her own collages. She enjoyed her family—her son (a sculptor) and grandchildren—but was often sarcastic on the subject of marriage. The artist said: "I never doubted that my life would fulfill itself . . . or I wouldn't have had the courage. You see, I hate the word *compromise*. . . . I knew that I needed to claim my total life. That means my total time for myself. . . . very often at night when I went to sleep, my figures would move as if they were real people. . . . I am closer to the work than to anything on earth. That's the marriage."[10]

Louise Bourgeois (1911–), recognized today as one of the major sculptors of the last four decades, was for many years largely overlooked because her work did not conform to trends in the art world. She affronts the viewer with pendulous, bulbous, or flayed abstract sculptures in marble, latex, bronze, and wood that express volcanic subconscious feelings.

Bourgeois says that her work grows directly from painful childhood experiences. She was born in Paris, the daughter of Louis and Josephine Bourgeois, who opened a tapestry restoration workshop in a rambling old house on the Bièvre River, five miles south of Paris. Here, amidst weavers and dyers, Louise at the age of ten helped her parents by completing the designs for the damaged parts of ancient tapestries. Many had been used as horse blankets—their bottoms eaten away by the urine of animals—so her drawings consisted mainly of feet or furniture legs. To this day the quivering lines of her abstract pen-and-ink drawings resemble skeins of wool, or weavings. "Art was real work, not elitist or a luxury," she has said. "Later I felt no guilt about being an artist. It was serious work for me."[11]

There was a stormy side to her childhood, however. Whereas her mother was reliable and nurturing, her father was a volatile, charming womanizer. "He ran after every woman in sight," she said. Since she had been his favorite child, when he had an affair with their young English tutor, Sadie, the situation aroused feelings of betrayal, jealousy, and confusion, as well as sympathy for her long-suffering mother. Bourgeois has spent a lifetime exorcising these feelings through her art. Indeed she once said of the spiral configurations in such works as *Labyrinthine Tower* (c. 1962), "Twisting is very important for me. When I dreamt of getting rid of the mistress, it was by twisting her neck."

At the Lycée Fénélon in Paris and later at the Sorbonne, Bourgeois, an excellent student, temporarily abandoned art for mathematics. The anxiety-ridden girl had found in geometry a certainty and order that brought her a sense of stability and peace: "It was precise and irreversible." Indeed, she has often said that her sculpture is a meld of powerful emotionalism and the controlled order of geometry. But at the age of twenty-five, stimulated by the cubist and surrealist movements in Paris, she decided to return to art.

Bourgeois took art history at the Louvre and studio classes at the École des Beaux-Arts and the Julian and Grande Chaumière academies. She also studied in the atelier of the cubist Fernand Léger, who interested her in sculptural form. When she tried to render the exact curve of a spiral wood shaving, he told her that she could "let go" a little—it was not necessary to be

so rigid and mathematically precise in art.

Bourgeois met many of the surrealists and cubists whom she later encountered in New York City during the war—Marcel Duchamp, Max Ernst, André Breton (she timidly regarded him as "a god" from afar), as well as a young American art historian, Robert Goldwater, who was completing his doctoral dissertation on the relationship between primitivism and modern art. When Goldwater assured her that his father had always been faithful to his mother, he made her feel safe ("He was kind, I felt I could trust him"). Married in 1938, they came to New York that year.

In an alien skyscraper-city, raising three small boys, Bourgeois missed her French family and her culture very much. She enrolled at the Art Students League and began to turn out drawings, prints, and paintings, shown at the Norlyst Gallery in 1947, that sometimes contain startling surreal images of "women-houses" (*Femmes-Maisons*)— women's naked bodies crowned by heads in the shape of houses that express the feelings of entrapment and identity-loss sometimes experienced by women when they become wives, mothers, or sex objects. A plume of hair seems to be escaping from the chimney and arms wave from windows; at the same time the welcoming front steps invite the viewer into the gaping front door.

As Breton, Ernst, Léger, Ozenfant, and others fled to New York City during World War II, Bourgeois was in a unique position to serve as interpreter and liaison, and was affected by the surrealist dream imagery that was at that time influencing the rising young American artists of the New York School. "Duchamp was stimulating as a personal critic," she said. Bourgeois was included in the 1945 show of women artists at Peggy Guggenheim's gallery.

Dissatisfied with the limitations of painting, Bourgeois turned to sculpture. The family had moved to an apartment house designed by Richard Morris Hunt—a mansard-roofed New York landmark (since destroyed), known as "Stuyvesant's Folly," that seemed comfortingly European. On the roof she found the privacy and space to carve "personages"—tall, spindly totems that she later realized were a replacement for her lost French family. Bourgeois has explained that each sculpture was, to her, a real person, created with the same fetishistic sense of reality that African carvers bring to their figures. Touches of color, stripes, openings, slight leaning gestures, gave each one a distinct personality. One was a portable brother, Pierre, whom she could carry around. A more hostile image had nails driven into it.

Art historian Wayne Andersen has pointed out that these "asparagus-shaped" works bear some resemblance to Max Ernst's *Lunar Esparagus* (1935), but Bourgeois did something different with the forms. In 1949 and 1950 a group of her sculptures was installed very inventively at the Peridot Gallery. Bourgeois, like Nevelson, was one of the earliest Americans to create a complete environment in a gallery. Her "figures" were sparsely placed, alone or in couples, around the room—their hooded, spiked forms suggesting loneliness, alienation, and fear of contact. Of these, Alfred Barr bought *Sleeping Figure* for the Museum of Modern Art.

Bourgeois's alienation was undoubtedly exacerbated during the McCarthy period. The sculptor, along with Duchamp and Ozenfant, had to appear before inquisitorial government committees at the time that she was applying for citizenship. She vented her feelings about an era of conformity in *The Blind Leading the Blind* (1947–49, Detroit Institute of the Arts), in which

two lines of pointed red and black wooden stakes march behind one another under a joined wood lintel.

Bourgeois was a respected but marginal member of the New York School, exhibiting alongside Mark Rothko and others. Her work was reproduced in The *Tiger's Eye,* a periodical published by members of the abstract expressionist group, and she was invited to participate in an important all-day seminar that explored new directions in the art world.

In the 1950s, Bourgeois's carved wood sculpture moved away from themes of alienation to relationships or "families" as she called them; groups of bulbous forms grow from a single base. "The attenuated organic curves suggest . . . a human group, its members alike but various, leaning towards one another in an intensity of feeling that unites them even as it leaves each one silent and alone (*Quarantania I,* Museum of Modern Art; *One and Others,* 1955, Whitney Museum).[12]

In the 1960s Bourgeois turned to more flexible materials—latex, plaster, cement and wire—that could be twisted, poured, and folded into visceral forms. Shown at the Stable Gallery in 1964 were cocoonlike "lairs"—headless, hollow, womb-like forms, sometimes hanging like wasps' nests, or containing pockets where young could nestle. These works imply withdrawal, hiding, nurturing, and shelter. A brutal headless, armless plaster self-portrait, *Torso* (1963–64) suggests painful feelings about one's body. There were also squashy "landscapes" in paradoxical materials, for example, the turdlike *End of Softness* (1967) in hard bronze.

In the 1960s, when the art world was dominated by male superstars, Bourgeois was largely ignored—her work did not suit the era of minimalism and pop art. The artist was too timid to push her work:

I had a guilt complex about pushing my art, so . . . that every time I was about to show I would have some sort of attack. . . . I decided it was better simply not to try. I had the feeling the art scene belonged to the men, and that I was in some way invading their domain. Therefore the work was done and hidden away. I felt more comfortable hiding it. On the other hand, I destroyed nothing. I kept every fragment.[13]

In 1965, critic Lucy Lippard, recognizing a movement developing in opposition to the dominant minimalist mainstream, included Bourgeois's work, along with that of Eva Hesse, Bruce Nauman, and others in an exhibition entitled "Eccentric Abstraction" at New York's Fischbach Gallery. Bourgeois was delighted to be called "eccentric" because the word means "away from the center" and the artist has always regarded herself as an independent, working outside the mainstream.

Bourgeois has alternated between violent painful images and peaceful comforting ones. In the late sixties and early seventies, she completed a series of explosively and explicitly sexual images that express these opposing themes. The painful latex *Fillette* (ironically meaning "Little Girl," 1968) looks like a mouldering half-flayed penis impaled on a hook. It also looks like a vulnerable female image. On the other hand, images like *Sleep* (simultaneously a woman's head falling forward on her chest and a flaccid penis), or *The Trani Episode* (c. 1971, hydrocal and latex), two breasts nestling on top of one another, express the peaceful, nurturing side of life. According to the artist, *Janus* (bronze), a double phallus hanging from a hook, "is a reference to the polarity I experience . . . a drive toward extreme violence and revolt and a retiring . . . need for peace, a complete peace with the

Louise Bourgeois, BLIND MAN'S BUFF (1984), marble, 36½″ x 35″ x 25″. Courtesy Robert Miller Gallery, N.Y. Photo: Allan Finkelman.

self, with others and with the environment."[14]

In recent years Bourgeois has devoted much time to her Cumul series, suggested by the round, breastlike forms of cumulus clouds. These works consist of rounded huddled forms, sometimes emerging from a membranelike covering. Like many of the artist's works, the forms can be read ambivalently as male or female; they all, however, suggest fecundity and the life force—growing, bursting, or sometimes (in latex versions), dessicated and decaying. One source of inspiration came during a flight over the Sahara Desert when she looked down and saw "little huts nestling together near water—a metaphor of loneliness and togetherness."

Paradoxically, along with these tactile, organic images, the artist sometimes produces very controlled geometric works as in *Systems* (1970), two opposing groups of truncated cylinders on a marble disc—a reference to the divided social systems in the world. Another work composed of a thousand of these truncated cylinders arranged in a group, *The No March* (1972, Storm King Art Center), was inspired by the antiwar demonstrations of the early 1970s.

Neglected, Bourgeois had no solo shows from 1964 to 1974. But in the 1970s, the women's movement proved very strengthening to her morale, and gave her the freedom to expose her feelings openly. In 1974 she aroused considerable attention with an environmental installation, *The Evening Meal* (also called *The Destruction of the Father*), at 112 Greene Street, New York. Inspired by a visit to the Lascaux cave in France, Bourgeois created her own anthropomorphic lair. Breastlike latex forms bulged from the ceiling, and breast and penis forms projected up from a floor strewn with half-eaten animal parts (cast from animal legs). In one corner rolled the head of the "father." The whole scene hinted at an unspeakable oedipal revenge. In the room-sized *Confrontation* (1978) at New York's Hamilton Gallery, latex breasts and penises laid out on a stretcher were surrounded by tall triangular wooden forms that looked like a crowd of witnesses or judges viewing the outcome of some long-impassioned human drama.

Feminist critics saw in her work a powerful expression of female protest and emotions re-

Louise Bourgeois, NATURE STUDY (1986), bronze, black patina, 12½″ x 33″ x 16½″. Courtesy Robert Miller Gallery, N.Y. Photo: Allan Finkelman.

pressed during the hard-edged, high-tech 1960s: "Bourgeois's images of women and woman's experience are ... ambivalent, juxtaposing a nurturing power of growth and emergence with the sharp threat of oppression." Her series of "knife-women" (*Femmes-Couteaux*) were described as "wrapped and folded marble blades with delicate pudenda exposed.... [They] embody the polarity of woman, the destructive and the seductive.... the woman turns into a blade because she is terrified of the world."[15] Bourgeois's early paintings of the 1940s—her "femmes-maisons"— were used on posters and on the cover of Lucy Lippard's book of feminist art criticism, *From the Center.*

As pluralism and expressionism came to the fore, Bourgeois's reputation soared, culminating in her first retrospective, after four decades of work, at the Museum of Modern Art (1982). *New York Times* critic John Russell wrote: "If one of the functions of art is to make trouble for the stuffed shirt, then that function could hardly have been better fulfilled than by Louise Bour-

geois.... [She] has few rivals when it comes to looking into corners of the psyche that are normally kept dark, and she does it with a finality that can leave the observer gasping."[16]

Up to that time the sculptor had been reticent about discussing her themes. As late as 1978, when the author was interviewing Bourgeois at her brownstone in New York's Chelsea district, she pointed to a circular geometric wooden piece on the floor and said, "This is an altar to my mother, but don't say anything about it." The freedom afforded her by feminism and the openness of the times finally released her to discuss the painful early sources of her art; she was even able to give lectures showing pictures of her family.

As Daniel Robbins pointed out in *Art Journal,* however, it is too easy to succumb to the artist's personal mythology and fail to see the formal beauty and consistently unfolding development of motifs through the years.[17] Although Bourgeois's work seems to take on a baffling variety of forms and materials, there are recurrent for-

mal themes that link the spindly "personages" of her first works and the "cumuls" to recent works such as *Partial Recall* (1979), a mounting series of flat semicircular wooden forms that rise up like clouds or gravestones. It too, contains "cumul" forms organized into a poetic relationship. As the ex–mathematics student once said, "It is a given that I search for the most perfect form."

In 1977, when Kingman Brewster, then president of Yale University, awarded Bourgeois an honorary doctorate of fine arts, he summarized her contribution to American sculpture:

> You have reminded us through your sculpture that art speaks to the human condition. You have offered us powerful symbols of our experience and of the relations between man and woman. You have not been afraid to disturb our complacency. The precision of your craftsmanship, the range of your imagination, and your fearless independence have been exemplary.[18]

Mary Callery (1903–77) wove linear figures of acrobats and dancers, as slim as spaghetti and as flexible as India rubber, into openwork bronze and steel forms. A friend of Picasso, she was one of those who brought the good word of French modernism to America at the start of World War II.

Born in New York City, Callery grew up in Pittsburgh, the daughter of Julia and James Dawson Callery, president of the Diamond National Bank. By the age of twelve she was already modeling a bear cub in clay. After graduating from Miss Spence's School, New York, she studied sculpture at the Art Students League with Edward McCartan, a traditionalist (1921–25). She then married attorney Frederic Coudert, Jr. (later a congressman), and had a daughter, but the marriage ended in divorce.

In 1930, Callery went to Paris and studied for two years with the Russian-French sculptor Jacques Loutchansky, working in a simplified classicism reminiscent of Maillol. She was then swept up into the modern movement—the café life that surrounded Pablo Picasso—and became friends with Amédée Ozenfant, Henri Laurens, and art critic Christian Zervos. Callery described this period as "those Paris days ... when life looked beautiful, quivering with the dreams of the mind."[19]

Picasso influenced her thought process, although not her specific style. When she was too timid to show him her work, he teased her by asking if she was "painting a seascape" and then advised, "Don't work from a model. What do you need a model for? You know that a human body has a head ... and two legs."[20] She remembered an afternoon in his flat on the rue La Boétie, when, in the midst of seeming chaos, with mail and debris strewn all over the floor, he pulled out painting after painting, explaining the source of inspiration for each work.

But the revelation came when she and friends visited Picasso's sculpture studio in a barn behind his small chateau at Bois-Geloup, north of Paris. The barn door was open, and from a distance she glimpsed his "big tree-like white plaster figures.... What a revelation! ... Often he 'seeded' his sculpture in the chateau park. Sometimes they had an exotic, plant-like quality.... they just grew, without a base or an arranged setting as though they had sprung from the earth."[21]

During this period Callery married Carlo Frua de Angeli in 1934 and divorced him two years later. She had exhibited at the Salon des Tuileries by the time World War II broke out. Returning to the United States after France fell, her last glimpse of Picasso was in an underground vault where he was forced to work.

In Callery's first New York exhibition at the

Mary Callery, STUDY FOR "THE FABLES OF LA FONTAINE" (1954), painted steel, 30¼″ x 66¼″. Francoise and Harvey Rambach, courtesy Washburn Gallery. Photo: Geoffrey Clements.

Buchholz Gallery in 1944, she was already elongating and abstracting her figures, as in *Reclining Figure.* In her second show in 1947 she emerged with a distinctive style of slender calligraphic figures, weaving and balancing in witty pyramids and curves, like bronze contour drawings of thinning and thickening lines, through whose spaces the air flows freely. Some of these "drawings in metal" are reminiscent of David Smith's early openwork weldings; indeed Smith admired Callery's work very much.

The open frieze *Amity* (1937) is a linked procession of five figures, and in *The Curve* (1947, Cincinnati Museum of Art) slender figures are mounted on a curve. A 1950 show included *Pyramid,* three balancing acrobats (1949, bronze, San Francisco Museum of Modern Art), *Equilibrist,* a slender balancing act of two figures made of iron rail painted in colors, and a series of collaborations with Fernand Léger—

polychromed abstract shapes set against his painted backgrounds.

Callery exhibited at the Curt Valentin Gallery in the fifties and at Knoedler's in the sixties. Among her architectural commissions are *The Fables of La Fontaine* (1954) for Public School 3 on East Twelfth Street, New York City, designed for schoolchildren to climb and crawl through, *Acrobats, Monument* (1955) for Wingate Public School, Brooklyn, and three aluminum sculptures suspended in the glass entrance of the Aluminum Company of America headquarters, Pittsburgh—*Constellation I, Constellation II , Three Birds in Flight.*

Callery also modeled distinguished portraits. In the 1960s her fountains and other forms became more plantlike and complex. The artist, who enjoyed a reputation as a pioneering modernist throughout her lifetime, maintained a residence in Paris until her death.

Claire Falkenstein (1908–)

> Claire entered the gates of paradise.
> She was met by Saint Peter who said "What are you
> doing here uninvited?
> No one can pass these gates without my permission."
> "But," replied Claire, "I made these gates myself with
> my own hands."
> "In that case," replied St. Peter, "you are welcome,
> my child."
> —Peggy Guggenheim[22]

Peggy Guggenheim wrote this parable in praise of sculptor Claire Falkenstein, who had just completed welded gates for her Venetian palace. Guggenheim called them "the new gates of paradise" because, although they were in a totally new idiom, she felt that they rivaled Ghiberti's famous "Gates of Paradise"—the Renaissance baptistery doors of the Florence cathedral.

Falkenstein's innovative thickets and cobwebs of welded wire or metal tubing seem to reach out endlessly in all directions, reflecting the Einsteinian worldview. Indeed, as Allan Temko pointed out, her sculpture has always been based on a philosophical investigation of the nature of things—molecular structure, topology, the nature of the cosmos. As early as the 1930s she was working with forms that twist and bend in upon themselves, suggesting a continuum of infinite motion.

Falkenstein was born in Coos Bay, Oregon, a small lumber town on the Pacific Ocean. Her supportive parents gave her freedom. She rode her horse on the beach to watch the sunrise and looked at seaweed, shells, and other nature forms that still influence her work:

> My earliest memories are making small animals out of wet clay at the edge of the bay. When I was seven, my family spent the whole summer on the beach in three big tents (one for guests). I began to amuse myself by making an

environment around the trunk of a tree. I made a house and gardens, and found little pieces of glass for lakes and pools.... I remember it as my first creative work done freely. It relates closely to what I'm doing now—entirely free.[23]

Falkenstein's father was manager of the lumber mill, the only industry in Coos Bay, and her mother, she said, was "one of those remarkable women—little formal education, but native intelligence.... She made a beautiful home—she had an instinct for interval and space. I remember she placed great branches of greenery around the house. That was my first exposure to the idea of 'interval.'"

There was little art in Coos Bay, but there was one collector who had a great influence on her:

> L. J. Simpson, son of the owner of the lumber mill, he built a mansion, Shore Acres, above the ocean and tried to make it a work of art. He combed Europe for art objects. From the age of six to thirteen, I was invited there with my family. As I came down the grand staircase I was greatly stimulated by the sight of a real honest-to-God oil painting—a big mythological painting of somebody chasing somebody—and a bronze tiger on the piano.

Claire entered Berkeley as an art major, minoring in philosophy and anthropology. She was more interested in the study of primitive peoples than in the rather dull academic art classes that were being offered, but in her junior year she took a life class with George Lusk, who had studied in Paris with André Lhote: "He only lasted a year at Berkeley.... he was an independent who reflected the French culture.... Lusk told me to respond to the *inside,* not the *outside* of the form. The model was there, but I could do anything with it. It freed me to be myself—not to take ideas from anyone else." The Berkeley art

faculty was so upset by Falkenstein's radical charcoal drawings in which the figure is exploded and fractured, becoming part of the total space, that they almost kept her from graduating. In 1929, while she was still in college, the East-West Gallery in San Francisco exhibited these exploded cubist figure drawings.

Falkenstein taught for a while and then obtained a grant enabling her to study at Mills College with Archipenko, who introduced her to cubist abstraction in sculpture, emphasizing the importance of hollows and negative shapes. Hired to teach at Mills, she took advantage of the kiln and ceramics facilities to experiment in the 1930s with fired clay sculpture in organic Möbius-like shapes that are some of the most advanced nonobjective sculptures of the decade. Instead of the flat planes of cubism, these twist and bend in upon themselves, suggesting a continuum of infinite motion (*Form, 1939,* collection of the artist).

In the early 1940s Falkenstein made wood sculptures that "explode the volume"—they have movable parts (*Set Rotation*) or can be taken apart and reassembled (*Connections*). "The interval, the space between, has always been as important as the form to me," she said. Except for two pieces bought by New York's Solomon Guggenheim Museum, the artist could not find a market for these pioneering works.

Falkenstein had a 1940 solo show at the San Francisco Museum of Art and was president of the lively San Francisco Society of Women Artists. She was hired to teach at the California School of Fine Arts—then a hotbed of West Coast abstract expressionism. Faculty member Clyfford Still became a good friend: "I admired him and found him to be a seminal influence in San Francisco painting and one of the great painters of the world." Influenced by abstract expressionism, Falkenstein, seeking freer and more open forms, learned to weld and had a 1948 solo show

of small welded pieces at the San Francisco Museum of Art.

In 1950 Falkenstein left for Paris, an experience that opened up a whole new world of ideas. There she met Arp and Giacometti; became friends with Mark Tobey, the Northwest Coast artist influenced by Zen philosophy; and was part of a group of young American expatriates, including Sam Francis and Paul Jenkins, who were pushing the boundaries of abstraction.

In Paris Falkenstein met logicians, mathematicians, psychiatrists—a group clustered around Michel Tapié, an art impresario who promoted the work of young artists and introduced them to new concepts based on Einsteinian mathematics. At this time Falkenstein was greatly influenced by Siegfried Giedion's book, *Space, Time and Architecture,* integrating science and art.[24]

Living on a low budget in a tiny Left Bank apartment, Falkenstein explored these concepts. Because it was cheap and available, the sculptor used thin stove-pipe wire to create a series of weblike Suns that move out in all directions—forms that, like Jackson Pollock's paintings, look as though they can be extended indefinitely. Some are dense and bristly, others are cloudlike; all permit space to flow through and around them—a kind of dematerialized sculpture in which the open spaces and interstices are as important as the solids. Through Tapié she received a commission that led to a breakthrough:

> Tapié introduced us to the Italian gallery owner and architect, Luigi Moretti, and we were invited to exhibit in an international show at his gallery in Milan. I brought a sculpture and Sam Francis brought a painting. Moretti was building a new gallery in Rome and commissioned me to create a welded bannister for the staircase. He said, "Why don't you incorporate glass—something that will cast color on the floor?"
>
> I had advanced from cubism to topology and

Claire Falkenstein, CORONA (1971), brazed copper and fused glass, 8¼″ x 12¼″ x 7½″. National Museum of American Art, Smithsonian Institution. Gift of Mr. and Mrs. David K. Anderson, Martha Jackson Memorial Collection.

refused to do anything using flat planes of glass. So I experimented and invented a new technology, fusing glass to the web of welded metal by putting both in a kiln together. Engineers said it couldn't be done, but I found a way to make a molecular bond. Instead of being flat, the molten glass flowed around in different directions, caught in the three-dimensional web of metal.

After this breakthrough, Falkenstein received commissions—gates for the sea grotto of Princess Pignatelli, a window on the Grand Canal for the Salviatti glass works, and the welded garden gates Peggy Guggenheim ordered in 1961 for her palazzo, in which jewel-like globs of colored glass are caught in multilayers of metal webbing, like stars in a galaxy. "Crowds of people stand in front of my house admiring the gates at all hours," Guggenheim later rejoiced.

By the time Falkenstein returned to the United States (1962) and built a house on the sea in Venice, California, she was widely known in Europe and was recognized as one of the few American sculptors who, like the painters of the New York School, had created a new kind of abstraction.

In the following decade she carried out many large commissions in California: a welded tube and glass fountain in front of California Federal Savings and Loan (1965) on Wilshire Boulevard, Los Angeles, another at the Long Beach Museum of Art, three sculptures for a Fresno mall (representing smoldering, leaping, and spreading fire), a welded sculpture for a reflection pool at Long Beach State University. Other works are in

the sculpture gardens of the University of California at Los Angeles and the San Diego Museum. The sculptor exhibited at the Martha Jackson Gallery, New York, the Esther Robles Gallery, Los Angeles, the San Francisco Museum of Art, and in a show that toured Italy.

Falkenstein received the greatest challenge of her career when she was commissioned to do the welded doors and colored glass windows for the starkly modern concrete St. Basil Church in Los Angeles. In 1969, she completed nine 80-foot-high nave windows, three narthex windows, four bronze doors, two 177-foot-high tower windows, and two 40-foot-high steel rectory screens. One hundred skilled workmen assisted in their completion. "The doors and rectory screens," she said, "are all based on the idea that I had developed in the Guggenheim gates and elsewhere, of the never-ending screen in which the repeated motif and the spaces between them look as though they could extend indefinitely beyond the limit of the format."

The windows defy tradition. Instead of being flat, the planes of colored glass, held within welded frames, move in and out. As a result, when the viewer moves around inside the church, the colors keep changing in a kaleidoscope of prismatic patterns, producing a sense of ever-changing movement: "When you move, the sculpture moves. You are *part of the sculpture.* In a way this also expressed the no beginning, no ending, and the interpenetration of time, of the time element."

Never allowing herself to be caught in an endlessly repeated signature style, Falkenstein continued to experiment. For the Eileen Norris Film Theater at the University of Southern California, she curved what looks like a giant strip of colored film into a Möbius-like form; She did a series of works combining sail-like canvas forms and bamboo, and drawings based on the idea of

Claire Falkenstein, STAINED GLASS WINDOWS (1969), Cor Ten steel and stained glass. St. Basil Church, Catholic Archdiocese, Los Angeles, Calif. Photo: William C. Rubinstein.

"the moving point"—a repeated brush motif that keeps expanding and growing in all directions.

As she approached her eighth decade, the artist completed a sixty-four-foot welded relief for the Department of Motor Vehicles, Los Angeles, and an outdoor environment on the grounds of California State University, Dominguez Hills. Dedicated to the memory of A. Quincy Jones, a West Coast architect who integrated nature and architecture, it consists of great trusses of rough logs that create spaces where students can meet, interact, and move through and around the forms. Solo shows were mounted at the University of California, Riverside (1984), and the National Museum of American Art (1985), and a miniretrospective was held at the Jack Rutberg Gallery, Los Angeles (1986).

Although her works seem totally abstract, Falkenstein says that they are all metaphoric. For example the motif of the letter *U* (used in her sculpture *U as a Set* at Long Beach State University) "is a form that can interconnect and interpenetrate with other forms. To me it is a . . . symbol for love or connectedness."[25]

There is an ethical component in her seemingly nonobjective art: "Science and technology have given us a new view of the universe. There is no one fixed point. We are *in* the scene, not on the outside looking on. The universe is expanding and we are in it. I feel as though we are not separate from nature—we are part of nature. Unless we realize this we will destroy ourselves."[26]

Hilda Morris (1911–)

The bronzes by Hilda Morris are immensely rugged, and grand in gesture. They are like ancient rocks, sculpted by the wind and the sea, or ancient tree trunks, or the huge bones of ancient animals.
—Alfred Frankenstein[27]

Hilda Morris, of Portland, Oregon, is a leading sculptor of the Northwest. A very private person who avoids the New York art scene, she works quietly on abstract bronzes in a studio set amidst tall pines. Nevertheless, she has gradually won a national reputation and large commissions in Seattle, Portland, and Tacoma.

Born in New York City, the artist studied at the Art Students League and Cooper Union, and then left for Spokane, Washington, to be a teacher on the Federal Art Project. She is remembered as one of the few teachers who encouraged abstract art in Spokane in those early years.

There she met and married painter Carl Morris, a rangy Californian who was at that time (1938–39) the director of the WPA Spokane Art Center. In 1940 they lived on a houseboat on Lake Union in Seattle and began a close friendship with Mark Tobey, whose Zen philosophy has had such a strong influence on his artist friends. In the following years the Morrises continued to exchange ideas with Tobey, Morris Graves, and other members of the Northwest group.

When Carl won a competition for a WPA mural for Eugene, Oregon, they moved to Portland, where they have lived ever since, and raised a son. Hilda Morris's early works, exhibited in solo shows at the Portland Art Museum in 1946 and 1955, are attenuated figures, somewhat in the manner of Lehmbruck (*Solo* 1944, Seattle Art Museum). But gradually they turned into abstract forms made of cement on armatures that resemble skeletal spires or pointed fir trees.

Pointing out the relationship of both Hilda's and Carl's works to nature and the atmosphere of the Northwest, Rachael Griffin writes, "One has only to look from their house and studios on a wooded hillside, and the forest in which their own plantings merge with the native growth (and almost with those mythic presences, the

sculptures of Hilda) ... to sense a very close relationship."[28]

Later works like *Four Point Winds* (1972), a four-pointed image penetrated by openings, or the twelve-foot, rough-surfaced *Wind Gate* (1981–82, bronze, Reed College, Portland, Oregon) resemble sails in the wind and at the same time mythic figures and pointed trees of the Northwest.

Hilda Morris, WIND GATE (1981–82), bronze, height 12′. Reed College collection, Portland, Oreg. Photo: Carl Morris.

Morris was in group shows at the Metropolitan Museum of Art (1951) and the Museum of Modern Art, has had more than thirty solo shows at the Portland Art Museum and elsewhere; and received a Ford Foundation Fellowship in 1960. Since 1974, when she began casting large bronzes in Italy, she has spent periods of time working in Pietrasanta.

In the 1960s she began a "ring" series of open circular bronze images. The *Ring of Time* (1967, Standard Plaza, Portland), a nine-foot circle of cast bronze "somehow suggest[s], instead of the weight of metal, a swift sumi brushstroke. Placed near the entrance of a downtown building in Portland, its simplicity comforts the eye and spirit."[29] The analogy with sumi painting is not quixotic. For many years Morris has been interested in Oriental art and has developed her own personal calligraphy in large sumi ink paintings that have influenced her three-dimensional forms. In her "ring" sculptures, the simple minimalist circle is expressed in rough, textured metal that suggests a dragged brush.

Despite her interest in Oriental art and long association with the "mystic painters of the Northwest," Morris says that she is not a mystic. Rather, she claims, her interest in abstract art resembles that of her high school mathematics teacher who first pointed out that signs and symbols (such as those of mathematics) permit us to penetrate the layers of reality and discover the unknown.

Adaline Kent (1900–57)

> The high places are worth all risk.
> —Adaline Kent

Adaline Kent, of San Francisco, was one of very few California sculptors to receive recognition in New York as part of the avant-garde movement of the 1940s. She and her sculptor husband, Robert Howard, are regarded as im-

portant West Coast transitional figures—the link between European modern sculpture and subsequent Bay Area modernism.

Kent was born in Kentfield, a Marin County town named after the family of her father, Democratic state legislator William Kent. An adventurous outdoor girl who ran hard to keep up with her brothers, she was a camper and hiker and, like Amelia Earhart whom she resembled, learned to fly a plane.

After earning a BA at Vassar, she studied with Ralph Stackpole, a leading exponent of direct carving, at the California School of Fine Arts in 1923, and then with Bourdelle in Paris in 1924. Her early direct carvings of figures and animals (*Grasshopper,* 1929, granite, Thacher School, California; *Pelican,* marble, 1927) have an imaginative quality of form clearly distinguishable from the mass of look-alike direct carvings of the period. *Springtime* (1929) is a whimsical, stylized brass bird in a branch.

Already well recognized when she married Howard in 1930, Kent had two daughters and continued to work in her studio home on Russian Hill. She had married into the brilliant Howard family of Bay Area artists—the sons and daughters-in-law of the principal architect of the Berkeley campus, John Galen Howard. They included sculptor **Blanche Phillips** and painters Charles and John Howard, Madge Knight, and Jane Berlandina. They sometimes exhibited together and were the focus of a 1988 Oakland Museum exhibition, The Howards: First Family of Bay Area Modernism.

In the 1930s Kent showed massive carvings such as the marble *Mother and Child,* won prizes at the San Francisco Art Association, and carried out commissions for the 1939 Golden Gate Exposition on Treasure Island. Her reclining figure of a Polynesian playing a guitar, one of three South Sea Island figures for the fountain in the Court of Pacifica, was described as

one of the finest pieces of plastic art which the Exposition offers out of doors.... It possesses both outer form and inner life. It is more than decorative. [However] a little more attention to technically refined execution would have added to the clarity.... Her two accompanying figures of girls ... are too distorted to explain themselves satisfactorily, although in their strained postures they emphasize the repose of the central figure.[30]

Neuhaus had noted a quality that was also mentioned by Edwyn A. Hunt in *California Art and Architecture,* in December 1938. Visiting her studio, Hunt characterized some of her figures as almost shockingly primitive and earthy compared to the more polished and decorative work of other sculptors at the fair. The artist explained that she was not interested in the decorative, that she had a different intention. She already wanted to strike out in a more modern direction—"invite the subconscious ... participate in the adventure of our time."

In the early 1940s Kent began to make semi-abstractions such as *Tumblers* (1940), the two-figure *Adagio* (1944, terra cotta), and *Self Portrait* (1943), a whimsical terra-cotta jester-mask. Open forms replaced the bulky masses. During World War II, her proposed *Monument to Heroes* was a biomorphic abstraction in the form of a spiral sliding pond to be actually used by the spectator. Kent thought the veterans would enjoy this far more than a figure of a soldier with a gun.

These were followed by forms that look like totems, rocks, bones, or surrealistic shapes pierced by openings and painted with stripes or incised with lines. Works like *Presence* (1950, magnesite, San Francisco Museum of Art) and *Dark Mountain* (1945, hydrocal, San Francisco Museum of Art), carry forward the modern tradition of Henry Moore and Picasso.

Adaline Kent, FINDER (1953), magnesite, 70″ x 40″.
Private collection. Photo: M. Lee Fatherree, courtesy of
the Oakland Museum.

A Californian born and bred, Kent drew inspiration from the mountains and rivers of the High Sierras during summer camping trips. Her studio was filled with rocks, shells, driftwood, and abstract sketches of rock forms or the movement of swirling waters. Increasingly influenced during frequent travels by primitive masks and fetishes from Africa, Oceania, and Mexico, she wrote that she wanted her work to embody "the power of Stonehenge and the magic of the South Pacific in language of the Wide Present."[31]

Kent was now using hydrocal and magnesite, a kind of plastic cement originally used for making floors, which she modeled onto metal armatures and then carved as it slowly dried. Like plaster it could be wetted and added onto or painted, permitting open forms that would be very difficult in stone.

Kent's work began to receive national prominence. She had a 1948 solo show at the San Francisco Museum of Art, was in Whitney Museum annuals, and in 1949 and 1953 exhibited at New York's avant-garde Betty Parsons Gallery (where Jackson Pollock came to fame).

She was also featured in the Museum of Modern Art's Abstract Painting and Sculpture in America (1951), the San Francisco Museum of Art's Four Sculptors of the West (1953), and the Paris National Museum of Modern Art's 1954 exhibition of contemporary U.S. art.

Clement Greenberg, the guru-critic of the period, singled her out as a promising American abstract sculptor. And in 1953 her sculpture *Finder* (1953, magnesite, private collection) was praised in *Art Digest* as "one of the best sculptures that have been shown in these parts in a long time . . . a tall, stylized architectural figure holding a strange object—bird or bone?—horizontally over its head . . . bold in conception, constantly interesting in its masses and spaces."[32]

The work suggests a creature putting out antennae, a metaphor for the artist.

Kent was trying to push beyond surrealism and Henry Moore—to take risks. In the1950s, after trips to Greece and Egypt, she began to work on odd archaic terra-cotta vaselike forms. She said of their small size: "I see no reason for a thing to be big. . . . space can be infinite and infinitely moving within small dimensions. . . . an ever-growing appreciation of space . . . bears on me to desist from cluttering the world with much physical mass."

Some of her pieces look like ancient jars dug out of the ground. Interesting to feminist critics are those that suggest the mother goddesses of early Crete (*Bird Woman,* terra-cotta; *Queen Mother,* 1957, terra-cotta) or an open spiral form (*Last Piece,* 1957).

Kent's notebooks show an obsession with other-worldly themes shortly before her death: "Art substantiates the Universal Mind—Plan—Intelligence—Rhythm—gives understandable proof while reaching beyond. Far deeper than the appearance there is a core of ORDER—the center of everything—where Art, God, Magic, Soul . . . Thought are one."[33]

In March 1957, the artist was killed instantly when her car plunged over a cliff while she and her daughter were driving on the winding coast highway near Stinson Beach. Memorial retrospectives were held at the Betty Parsons Gallery and the San Francisco Museum of Art in 1958.

Adaline Kent's generous and beautiful spirit elicited a great outpouring of feeling, expressed in philanthropy. A redwood grove was created in her memory and an Adaline Kent Award is given yearly to a Bay Area artist. Her husband created a poetic autobiography out of her scattered notes, diaries, and photographs of her work, the source of most of the above quotations.

Dorothy Dehner (1901–) is today a widely recognized abstract sculptor of the New York School. Throughout her twenty-five-year marriage to the brilliant but volatile sculptor David Smith she struggled to maintain her identity, but only after she left him did her career flower.

There are many analogies between her life and that of Jackson Pollock's wife, Lee Krasner. Like Krasner, Dehner was more sophisticated artistically than her husband was when they met. Like Krasner, too, she provided support and stability for a stormy temperament.

Dehner was born in Cleveland, Ohio, to cultured, free-thinking parents who encouraged creativity. But they and her sister died when she was still small. Dehner suffered greatly from these early losses and believes that her long period of self-effacement stems from those early years. Raised in Pasadena, California, she started out to become an actress-dancer "because I could lose my shyness, become someone else."[34] Her idol was Isadora Duncan. Inspired by her musician-aunt Cora's tales of European bohemia, she went abroad in search of herself after a boring freshman year at UCLA. Dazzled by the 1925 Paris Exposition and the work of Picasso, Matisse, and Braque, she decided to be a sculptor because "you could accomplish something alone; you didn't need other people."

Returning to New York, Dehner enrolled at the Art Students League. One afternoon a young man, David Smith, who was living at the same rooming house, knocked on her door. He wanted to become an artist and asked her advice. After she recommended the league "because real artists taught there," they sat up all night talking about her European travels and Picasso, Matisse, and other modernists. They attended classes together, and on Christmas Eve, 1927, they were married.[35]

Dehner had intended to be a sculptor but found the direct-carving approach of her teachers William Zorach and Robert Laurent to be so *retarditaire* after her exposure to Picasso and Lipchitz in Paris that she switched to drawing with Kimon Nicolaides and painting with Jan Matulka, a cubist who had studied with Hans Hofmann in Germany. In Matulka's exciting evening class were Irene Rice Pereira, Burgoyne Diller, and other students who were also taken with modernism. At that time there was hardly any modern art to be seen in New York: "When we heard that there were two Braque paintings at the French Embassy," she said, "the whole class rushed over to see them."[36]

At a party, the couple met John Graham, an eccentric White Russian émigré painter-theoretician, today regarded as the prophet of abstract expressionism. His insight into the role of intuition, impulse, and myth (expressed in his book *System and Dialectics in Art,* 1937), and his excitement over the mystery and emotional impact of African and other primitive art greatly influenced Smith and Dehner. Graham introduced them to Arshile Gorky, Kiesler, and other avant-gardists.

In 1931, inspired by Gauguin's book *Noa Noa,* the couple left civilization for the still untrammeled Virgin Islands, where they painted cubist-abstract landscapes and still lifes. David Smith picked up a piece of coral on the beach and carved his first sculpture, a small head. With war coming, they decided to see Europe while they still could. In Paris, Graham zipped them around and introduced them to the surrealists and the galleries. They befriended Stanley Hayter, printmaker and director of the Atelier 17 print workshop. Even at that time, they knew that the Nazis had a price on his head and he would soon have to flee. Later, Hayter's workshop, transplanted to New York, would be impor-

tant to Dehner's development. The couple traveled on to Greece, Malta, and even the Soviet Union where they saw modern works at the Museum of Western Art. Dehner later drew on her reservoir of memories of this time for sculpture themes.

Returning to New York in the midst of the depression, Smith worked on the Federal Art Project, but Dehner could not because the government did not allow both husband and wife to be on the payroll. In 1940 they moved to a farm at Bolton Landing in upstate New York, where Dehner's small income from an inheritance made it possible for Smith to devote most of his energy to sculpture. He set up a welding studio in the barn while Dehner worked on a drawing table in a corner of the living room.

The following years were ones of pleasure and pain. As Smith became prodigiously productive, Dehner played the role of the good wife—grew vegetables and canned them, plucked chickens, killed pigs, made clothes, helped build a new house, and taught modern dance at a nearby school—all while continuing to paint and draw. Dehner's charming series of egg tempera paintings *Life on the Farm* (1942–44, Storm King Art Center, Mountainville, New York) depicts, in minute detail, their life together.

Although today Dehner chooses to remember the beautiful, enriching aspect of this bucolic period, there was another side to it. Smith, on the verge of achieving great fame, was a deeply conflicted man, increasingly subject to extreme mood swings and outbursts of rage. Dehner was very sensitive to his criticism. She sometimes hid her work so he wouldn't see it and was afraid to exhibit in New York City; instead she showed at the Albany State Museum, Skidmore College, and elsewhere locally. All this time she wanted to try sculpture.[37]

As art historian Joan Marter has pointed out,

Dehner's notebooks of this period contain drawings of skulls, weeping heads, and birds falling on jagged mountains (*Bird of Peace,* 1946). Once, in 1945, she fled from Bolton Landing, but Smith urged her to return.

Inspired by a book, *Art Forms in Nature,* Dehner began to paint a series of abstract watercolors, including one entitled *Star Cage* (1949), in which galaxies of diagonal lines end in small points of yellow light. Smith told her that he wanted to make a sculpture based on it. When she suggested that they collaborate, he candidly replied that he was "too jealous" for that. His sculpture *Star Cage* (1949) seems to be related to Dehner's drawing.[38]

One night in 1950, after an outburst of violence from Smith, Dehner sought refuge with friends. In 1952 she divorced him.

Dehner's ego was at a low ebb after years of working so hard without pay. Needing to support herself in expensive New York City, where she had moved, she crammed a degree from Skidmore College into one year, receiving credit for her many years as a professional artist. In the exhausting period that followed, she taught at three different schools simultaneously. Eventually, however, she was able to devote herself entirely to her art.[39]

As self-esteem and creativity burgeoned, she was in a 1950 Whitney Annual and had a 1952 solo show of watercolors at the Rose Fried Gallery, New York. One day, while studying printmaking at Stanley Hayter's Atelier 17 in New York City, Dehner was happily digging into a copper plate with a burin when she had an intuition that sculpture tools might be sympathetic. She began to model small abstract sculptures in wax, a material that immediately felt comfortable. Louise Nevelson, who was also in Hayter's workshop, encouraged her.

Man in Cage (1956), one of her earliest sculp-

Dorothy Dehner, RITES AT SAL SAFAENI #1 (1958), bronze, 26½″ x 12″ x 14″. Collection of the Wellesley College Museum.

tures, seems like an attempt to at long last create the repressed *Star Cage,* but this version shows a small figure inside of cagelike towers, perhaps symbolizing the fledgling sculptor's dreams of creation. Early works, such as *Two Saints* and *Second T Beam* (1960, bronze, American Telephone and Telegraph Company), suggest totem-like mythical heroes or religious icons in vertical masses, whose surfaces show the sensitive manipulation of wax in an almost painterly manner.

Works such as *Rites at Sal Safaeni #1* (1958, Wellesley College Museum) echo her memories of the mystery and awe she had felt when viewing a prehistoric ritual rock chamber in Malta, during travels twenty years before. Hieroglyphs of relief elements play over the shape, pierced by signals, gateways, and simultaneously, totemic figures. Moving to a more monumental scale, Dehner's seven-foot *Low Landscape #2* (1961, bronze, American Telephone and Telegraph Company), a wide, low cagelike structure, is punctuated by collections of forms strung together like bits on an abacus.

In 1955, she began a long association with the Marian Willard Gallery. That year she also married Ferdinand Mann, a dealer in art reproductions, and took a studio at 14 Union Square where she has worked ever since. In 1965 she was accorded a ten-year retrospective at the Jewish Museum.

During this period Smith encouraged Dehner's career. Soon divorced from his second wife, he remained friends with Dehner until his death in a car crash. Once he invited her up to Bolton Landing and handed her a wrapped bundle of her surviving early paintings, along with a group of related ones by him. Unfortunately, most of her work had been allowed to rot in the barn.

Beginning in 1974, Dehner constructed smooth wood geometric forms—circles and rectangles, echoed in negative circular and rectangular openings (*Gateway,* Metropolitan Museum of Art, 1979). She also carried out some of these architectural structures in steel. In general, Dehner's work expresses a lyrical, peaceful temperament; it emphasizes line and plane more than volume. Sensitivity, balance, and harmony are combined with a feeling for the mystery and spirituality of the ancient and prehistoric past.

Looking back, Dehner blames herself for her diffident early years and has a message for women: "I could have asserted myself much earlier. Fear keeps us all back." Generous in her assessment, she attributes some of the emotional difficulties of her husband and those of many of the artists of his generation to the enormous effort of creating a new vision.

In recent years Dehner's reputation has soared. She has had more than fifty exhibitions; her paintings and prints are in many major museum collections, including the Museum of Modern Art, the Dresden Museum, the British Museum, and elsewhere. She is honored with awards and with requests for scholarly articles.

In the late 1970s, when a prominent museum curator visited Dehner's studio and purchased a work for the permanent collection, he remarked happily that it was a "nice" occasion. Thinking about her long struggle and her age, Dehner later told her friend (the fine abstract painter Jan Wunderman) that she replied wryly: "A 'nice occasion' ! It's something like becoming a bride at eighty—it's 'nice' but it's a little bit late!"

Jean Frances Follett (1917–) was, along with Richard Stankiewicz, one of the pioneers of junk assemblage in the early 1950s.

Descended from pioneering Unitarian ancestors who made their way west in covered wagons, Follett was born in St. Paul, Minnesota,

graduated from the University of Minnesota (1940), studied at the St. Paul School of Art (1936–40), served as an army sergeant in World War II (1943–46), and then went to New York to study painting with Hans Hofmann (1946–50).

Hofmann's classes attracted lively students who became younger leaders of the New York School. One of them, Richard Stankiewicz, became her close friend and shared a studio with her (1950–60). They went to Paris together to study for a year with Fernand Léger and sculptor Ossip Zadkine (1950–51). Follett writes:

> I had first thought of doing junk assemblage in Paris when Richard and I were studying with Zadkine after which we took a studio on Bond Street in New York together. . . . I introduced him to the junk school of art, advising him to weld the parts together, which he later did so successfully, while I myself kept my work flat on plywood.[40]

Irving Sandler corroborates this in his book *The New York School: Painters and Sculptors of the Fifties:*

> Stankiewicz's development of junk sculpture was considerably influenced by a constant exchange of ideas with Follett. . . . Before he ventured into assemblage, she was applying paint so thickly that her pictures look three-dimensional, and she had also taken the short step of embedding found materials in the impasto. Throughout the fifties, Follett assembled black-and-white bas-reliefs from paint, plaster, pieces of wood, metal, horsehair, string, nails, and heavier substances. These *objets trouvés* were formed into figures and faces, the fetishes of a private order.[41]

In 1952 a group of former Hofmann students (Wolf Kahn, Jan Müller, and others) rented space on East Twelfth Street, named it the Hansa Gallery in honor of their teacher, and invited Follett, Stankiewicz, and Alan Kaprow to join them as founding members. In 1954 they moved uptown. The Hansa artists worked in widely divergent styles and often argued about whom to include, but one group (John Chamberlain, Lucas Samaras, and others) tended to construct their work from found materials.

Follett was in group exhibitions and had four solo shows at the Hansa (1952–59). She and the other junk sculptors were at first treated to mixed reviews; the introduction of "brutish" objects from the city environment was unpalatable, making it difficult for viewers to perceive the formal aspects. Critic Leo Steinberg at first blasted the work of the assemblagists, asking of Follett's work "But is it art? . . . Really, I haven't the faintest idea."[42] The following year he apologized. Art historian Meyer Schapiro included Follett's work in a 1957 show, Artists of the New York School: Second Generation. She was also in the traveling exhibition Recent Sculpture U.S.A. (1959) and in shows at the Stable Gallery.

Follett and Stankiewicz continued to allude to subject matter, sometimes making witty surreal analogies between machines and humans. For this reason abstract artists of the New York School attacked the work, and some critics found it amusing but trifling. They were called "neo-dada" because the dadaists had incorporated ready-mades into their art. But whereas the dadaists of World War I were nihilists, attacking society and all art traditions, Follett and other assemblagists were incorporating city rubbish because it suggested the raw, exciting, yet brutal character of the urban environment. In 1961 the Art of Assemblage exhibition at the Museum of Modern Art, New York, finally established this movement as a major current in the art world.

From 1951 to 1962 Follett had been supporting herself as an electronic draftswoman. After the Hansa Gallery closed in1959 she exhibited sporadically—at the Leo Castelli Gallery in 1960—and was in the first group of artists to receive a National Endowment award in 1966. Returning to St. Paul for health reasons, she had to stay on to care for sick parents. She was later prevented from returning to New York by the exorbitant price of loft space.

There is wry surreal humor in a work such as *Lady with the Open Door Stomach* (1956, Whitney Museum), in which a figure made of rods seems to be scooping in a mass of material, suggesting one who is readily "taking in" experiences. This design has the female open-womb image. The whimsical *Many-Headed Creature* (1958, Museum of Modern Art, New York), made of electric plugs, springs, and other industrial cast-offs on a gritty textured ground, is a tightly controlled grid composition. Recent works in Minneapolis—black wood reliefs incorporating injection needles—have a morbid quality. "I am in the business of probing the subconscious and the mysterious secrets of the human soul," she says.[43]

The famous gallery owner **Betty Parsons (1900–82),** known as the midwife of the New York School because she promoted the careers of Jackson Pollock and others, was also an artist who studied with sculptor Renee Prahar (see chapter 5) and with Bourdelle and Zadkine in Paris. From the 1950s on she made poetic assemblages and totemic structures of natural materials such as stones and driftwood painted with stripes, dots, and other abstract motifs reminiscent of Native American art.

Blanche Dombek (1914–1988) constructed totemic wooden "personages" with the Jungian and primitivist aura so characteristic of sculpture of the 1950s.

Jean Follett, MANY-HEADED CREATURE (1958), assemblage: light switch, cooling coils, window screen, nails, faucet knob, mirror, twine, cinders, etc., on wood panel, 24″ x 24″. Collection, The Museum of Modern Art, N.Y. Larry Aldrich Foundation Fund.

Born in Brooklyn, Dombek studied with Alexandre Zeitlin and Leo Amino, a pupil of Noguchi. Her works of the 1940s, shown in Whitney Museum Annuals and at the Pinacotheca Gallery, New York (1945), are "simplified expressionistic figurative statements in hard, smooth woods ... bulging volumes, sinuous contours and dramatic use of light."[44] The undulating, beautifully grained rosewood forms of *The Determinant* and the two faceless figures reaching upward of *Unity* were reproduced in Ludwig Brummé's *Contemporary American Sculpture* (1948).

In the 1950s Dombek simplified the forms further into Brancusi-like images, such as the six-foot *Figure* (1956), in which the cracks in weathered wood are enhanced by the artist's incisions. *At the Zoo* (a totemic animal) and *Spirit*

of the Cat (1956) are penetrated by holes. *Marine Sculpture*, a stacked totem of polished wood pieces, progresses from rounded forms down to blocky ones at the base.

Dombek exhibited at the Peridot and Colette Allendy Gallery (1954), at the Whitney and Brooklyn museums, and with American Abstract Artists and the Sculptors Guild. She received six fellowships from the MacDowell Colony, five from the Huntington Hartford Foundation, and one from Yaddo.

Jane Simon Teller (1911–) makes stacked totemic wood sculptures, reminiscent of Stonehenge and other prehistoric forms. They are

Blanche Dombek, MARINE SCULPTURE (1957), yew wood, 37″ x 29″. Collection of Nancy Brown, N.H. Photo courtesy estate of the artist.

rooted in the same mystical and existential concerns about the nature of the universe that occupied the minds of artists like Mark Rothko and Jackson Pollock.

Daughter of the president of a wood molding and frame company in Rochester, New York, she drew, painted, and often played with pieces of wood at her father's workshop.

Jane studied art at the Mechanics Institute (now Rochester Institute of Technology), earned a B.A. at Barnard in 1933, and that year married author Walter Teller. While living in New York City, she was profoundly influenced by her photographer friend, Aaron Siskind, who taught her to perceive abstract forms in nature. She also took sculpture in WPA classes with Aaron Goodelman and Karl Nielson.

After moving to a Pennsylvania Dutch farmhouse in Bucks County, the artist raised four sons, but managed to produce at least one major sculpture a year, despite the demands on her time. In 1947, when Siskind took her to see paintings by New York School abstract expressionists at the Egan Gallery, she "was zonked by it.... There was a power or force that came from the work; it had spirit."[45] Sculptor Ibram Lassaw also moved her, when, during a demonstration of welding, he spoke of how the philosophy of Zen guided his work as he intuitively fused the molten metal.

Teller had a solo show in New Hope, Pennsylvania, in 1949 and another at the Parma Gallery in New York City in 1957. *The Grove* (1952), a group of sensitively shaped vertical ash wood forms set on a cast stone base, suggests a crowd of people—all similar, yet each slightly different (reminiscent of Bourgeois's early groups). Later she began to build and stack forms into architectural totems that look like universal symbols.

The peculiar power of these pieces comes partially from a feeling for the wood itself. Organic forms incorporate both the grain and the acci-

Jane Teller, OPEN WALL (1962), maple, cherry, charred fir, 71″ x 45″ x 12″. Collection of the artist. Photo: Clem Fiori.

dental cracks, knots, and surface nicks. There is a primordial sense of the tree trunk and a feeling of the sculptor's tools hacking or shaving the irregular surfaces. Like the abstract expressionist painters, the artist does not start with a preconceived plan, but trusts the forms to lead her. Interesting pieces of wood lie around the studio, and she shifts them around, until at a certain "wonder moment," as she puts it, they seem to align in a way that takes on life—that teeters or balances in a unified stance or gesture. At such moments she feels a mystical connection with the universe, "swinging with the Big Rhythm . . . in touch with its energy."[46]

These forms have symbolic universal meanings for the artist; for example, a circle symbolizes wholeness and the feminine principle. In *Open Wall,* four blocky forms support three irregularly shaped open circles, which in turn support two interlocking arcs, suggesting integration and relatedness.

Since 1964 the Tellers have lived in Princeton, New Jersey. The artist has been in more than fifty solo and group shows, including a 1987 retrospective at the Montclair Art Museum.

Jean Woodham (1925–), raised in rural Alabama, still draws inspiration from natural forms. One of the first women to study welding at the Sculpture Center, her work was well reviewed in New York exhibitions in the late 1940s and 1950s. Since then her energy has been devoted to large public commissions for Alabama State University, Montgomery; the General Telephone and Electronics Corporation, Stamford, Connecticut; the International Bank for Reconstruction and Redevelopment in Washington, D.C.; and others. **Dorothy Berge (1923–),** another public abstract sculptor, who began welding in 1953, has completed a number of commissions in Atlanta, Georgia, and Minneapolis, Minnesota.

Jeanne Reynal (1902–) has produced mosaics that have the improvisational character and techniques of action painting and the three-dimensionality of sculpture. Early in her career she threw away the preliminary sketches of traditional mosaicists to create directly in stones, tesserae, magnesite, and other materials. At the same time her work became increasingly three-dimensional so that *Emperor's Greys* (1969–71, collection of the artist), for example, consists of three irregularly shaped columns, reaching to almost eleven feet, encrusted with mosaics. They look like the clubs or staffs of some mythical African king or deity.

Geraldine Hamilton McCullough (1922–)

I am more concerned with the uniqueness of my essence than the existence of my Blackness.... Only my personal search for the ability to refine, and define, an intuitive organization of space into a plastic art-object with an inner life, that speaks within a universal context—will say ME—I—MYSELF.[47]

Chicago sculptor Geraldine McCullough, born in Kingston, Arkansas, has, since the late 1950s, created welded sheet copper and brazed and cast bronze sculptures that relate to abstract expressionism. The metal is stretched and twisted into free-flying forms that sometimes resemble birds or animals.

McCullough earned an M.A. in art education at the Art Institute of Chicago (1955). Since 1964 she has been a professor and then chairperson in the art department of Rosary College at River Forest, Illinois. Although on the whole her concerns have been the same as those of white mainstream modernists, the eclectic sculptor draws on a variety of stylistic forms depending on the theme or commission. For example, her bronze statue of Martin Luther King (*Our King*, 1973), for a Chicago housing project on West Madison Street, looks like a Benin tribal sculpture. It stands in front of apartments that replaced structures burned out during the riots following King's death:

> To call attention to his philosophy of nonviolence, she placed in one hand a broken sword with cross-shaped handle. The other hand holds a prayer wheel, meant to refer to universal prayer and Gandhi's philosophy of passive resistance. Around the figure's muscular neck are a necklace of tigers' teeth worn by Beni royalty and the Nobel Peace Prize medallion awarded to King in 1964.... Above ... is a dove of peace.[48]

Oracle, an abstract sculpture in the lobby of the Johnson Publishing Company, Chicago, inspired by a visit to the ancient Greek shrine at Delphi, is a rock-shaped sheet copper form supporting a translucent polyester resin sphere symbolizing the eye of the oracle. Slender protuberances on the rock represent those who come to seek advice and wisdom.

Sari Dienes (1899–), sculptor, painter, collagist, has for fifty years allowed her restless energies to flow from one medium and material to another. Influenced by Zen philosophy, the artist is more interested in revealing the spirit in all things, than in creating a group of objects. Art historian Josephine Withers pointed out that she was a process artist long before it became a recognized movement.

Born in Hungary and encouraged by her cultured family, the artist studied with Fernand Léger and André Lhote in Paris and with Henry Moore in London; she also served as assistant director of the Ozenfant School. In 1939, as part of the wave of refugee artists fleeing fascism, she came to New York where she again taught at Ozenfant's school, the Parsons School of Design, and the Brooklyn Museum Art School. A solo show of paintings at the New School for Social Research was followed by four exhibitions at the Betty Parsons Gallery, but Parsons dropped her because she refused to stick to one trademark image.

Influenced by her friend John Cage, the avant-garde composer, she began to use the flotsam and jetsam of the city—lint, bones, broken bottles, mylar, feathers, mirrors, copy machines. In 1955 she made ink rubbings of the patterns on manhole covers and gratings (*Sidewalks*). These had an influence on younger artist friends, such as Robert Rauschenberg and Jasper Johns, who incorporated the ready-made images of the city. Art dealer John Myers remembers her as perpetually surrounded by a young coterie.[49]

After studying wood-block printing and ceramics in Japan (1957–58), the artist developed a Zen sense of inner peace and freedom, and art became to her "a sphere without a circumference, where the center is everywhere.... Everything that I do, everything that I see.... I walk in the street and that influences me." She received an American Federation of the Arts grant for a film, *Painting in the Snow* (1971), in which she poured paint on the snow and took photographs of the changing colors and forms while it melted.

A characteristic work is *Bonefall* (1974). Dienes collected bones for decades and then, one day, strung them all together in a kind of waterfall. Other works are *Fuji* (a mountain of bricks with a pine cone growing out of the top) and *Thread Piece* made of spools of thread.

Dienes became a mother figure in the New York feminist art movement. Active at the AIR women's cooperative gallery, her halo of white hair was a familiar sight. Martha Edelheit created a film about her, *Hats, Bottles and Bones* (1977), and she received a 1981 Women's Caucus for Art award.

American Indian artists look back to **Yeffe Kimball (Slatin) ("Wandering Star") (1914–78)** as the inspiring foremother who opened up new vistas to them. Shattering the stereotype of the Native American artist as an unsophisticated primitive, she studied in Paris and New York, became a mainstream avant-garde artist, and fought throughout her life for the right of Amerindians to exhibit alongside their white colleagues. Kimball began as a painter, but in the late 1950s her acrylic forms began to jut out of the canvas and become sculptural.

Born on a reservation in Mountain Park, Oklahoma, daughter of an Osage father named Other Star Good Man and Martha Clementine Smith, Kimball spent her childhood on her grandfather's Missouri farm. She graduated from the University of Oklahoma, where the art department had a long history of encouraging Indian artists.

In the 1930s, at a time when Native Americans were being encouraged to paint scenes of native life in a flat decorative style, Kimball dared to break away from these limitations. She went to New York to study at the Art Students League (1935–39) and to France for lessons with Fernand Léger. By the time she returned to New York City at the outbreak of World War II, Kimball was a confirmed modernist, but never attached herself to one artistic group or movement, preferring to find her own path.

In 1946, *New York Sun* critic Henry McBride hailed the first of several solo shows at the Rehn Gallery, New York: "Georgia O'Keeffe had better watch out. Her rival now appears on the desert horizon.... *Black Fantasy* is a matter of animal horns with something mystical, something strange in it, as though the artist's blood was asserting itself, in spite of her art training, to put meanings that a mere tourist would not find in these horns."[50] And Peyton Boswell wrote in *Art Digest:* "While Miss Kimball often seeks her source in the lore of her people, she has rejected the traditional symbols to create pictorial statements built around the modern concept that a painting must be constructed in the same sense that an architect blueprints a building. Behind this success lies ... the eager searching ... for something personal.... these paintings have not been painted before."[51]

Kimball exhibited at the National Academy of Design (1942), the Whitney Museum, and the Carnegie Institute; she subsequently generated more than sixty solo exhibitions from her New York studio. At the same time she engaged in activities promoting Native American culture. In the summer of 1948 she worked at the laboratory of anthropology in Santa Fe on a survey of Indian paintings made in sixteenth-century missions. In 1952 critic Emily Genauer reported that Kimball had cataloged six thousand Northwest Indian masks and ritual objects for the Portland Art Museum, and this had had an influence on her art: "One of her most successful pictures is entitled The Call. It is a mask really, all open mouth and empty sockets ... a thing of terrible agony and urgency, and the cry it sounds is the one Catlin heard a hundred years earlier."[52]

The artist selected Indian art for a State Department traveling exhibition in 1953, did research for film strips and television shows, wrote twelve books on Indian life and illustrated many more, wrote entries for encyclopedias, and appeared on radio and television. She was a vice president of the Art Students League and was active on behalf of the new Institute of American Indian Arts in Santa Fe, organized to give Native American artists a sophisticated contemporary art education.

After marrying Dr. Harvey Slatin, a nuclear physicist, in the gardens of the Museum of New Mexico (1952), Kimball, fascinated by discussions among scientists that she heard in her home, began to create abstract visions of outer space. One effect of this was a new three-dimensionality in her work, exhibited at Boston's Nova Gallery in 1960:

> For several years she has worked in her New York and Provincetown studios experimenting with new techniques and mediums. Sculptured (acrylic) pigments suggest the cragginess of distant planets, intense yellows and reds burn across her canvases with the fury of a comet of a midnight sky. Recent photographs taken at Mount Palomar ... bear a startling resemblance to Miss Kimball's work shown a year ago.[53]

The prescient artist had anticipated views of the universe that science later corroborated! Three-dimensional craters and volcanoes, somewhere between painting and sculpture, were shown at New York's Martha Jackson Gallery in 1965. Kimball worked on oval shapes "with concave and convex surfaces.... They are all fiery hot looking ... like molten lava.... The imagery is rich and varied ... so are the surface tensions she creates ... rock hard to the touch but seemingly about to dissolve in a pool on the floor."[54] When these interpretations of the cosmos led to a commission from NASA to paint versions of outer space, Kimball attended the Apollo launches at Cape Kennedy and showed her work at the Houston Space Center.

Yeffe Kimball with SOLAR CONTINUUM (1962), now in the collection of the Everson Museum of Art, Syracuse, N.Y. Gift of Dr. Harvey Slatin. Photo courtesy of the United States Department of the Interior, Indian Arts and Crafts Board, Southern Plains Indian Museum and Crafts Center.

A striking example of her three-dimensional work of this period is *Solar Continuum* (1962, Everson Museum of Art), a ten-foot cylinder on which she painted swirling red and blue galaxies, expressing the constant motion and infinite continuum of the cosmos. The minimalist cylindrical form is combined with the loose brushwork of abstract expressionism to create a metaphor for the universe. It was included in a thirty-year traveling retrospective that opened at the Philbrook Art Center, Tulsa, Oklahoma, in 1966.

When Kimball curated an exhibition of the Indian art collection at Provincetown's Chrysler Art Museum, she organized a festival and coauthored and illustrated *The Art of American Indian Cooking* (Doubleday). The gala opening featured buffalo meat, venison, and juniper berry punch, and the guests of honor were chiefs of the local Wampanoag Indians—descendants of the Algonquins who first met the Pilgrims in 1620—who, it turned out, were thriving in such urban centers as New York and Boston. Newspaper photos show Kimball wearing long braids, seated cross-legged on the ground in a Cherokee patchwork costume, working on a sandpainting for the festival.

In her last years, Kimball returned to her roots. She spent summers in Santa Fe, became active in the American Indian movement, and worked on a series of ceremonial masks and prayer shields—*Sage of Medicine, Magic Spinner* (a spider image), *Keeper of the Night* (an owl), and so on. A characteristic sculpture from this period is *Comanche-Brave Horse* (private collection), an oval shield from which the vague and ghostly white head of a horse emerges, evoking memories of the past.

She also painted six-foot-high portrait heads of controversial Indian leaders, like Red Cloud and Russell Means, and was collecting thou-

sands of slides of art by young Indians for INCA, the American Indian artists' foundation that she helped organize and headed. A solo exhibition was held at the Everson Museum, Syracuse. Her husband recalls that "she was a powerhouse.... Her personality was most engaging and she easily won the affection and attention of any who met her. She had no hesitation to use anyone to accomplish her cause—to help the American Indian. She seemed to know everybody ... senators, presidents, artists, musicians, you name it, came to our house. It was remarked that the Kimball house was like the old Paris salon."[55]

After her death there was a great outpouring of feeling. At a memorial service where people read poems they had written, and talked about the impact of her life on the Native American community, Ronald A. Kuchta, director of the Everson Museum of Art, spoke of her importance:

> Till the end, Yeffe was a visionary ... with aspirations to envision the unknown and to achieve recognition not only for herself but also for an important but neglected part of our American culture. Her works were included in museums across the land, and during her lifetime she had an almost unparalleled number of exhibitions for a woman and an Indian, in America as well as abroad—from Birmingham to Edinburgh, from Tulsa to Provincetown, from Dayton to Santa Barbara, from New Orleans to Athens, from Santa Fe to Syracuse. We will never forget Yeffe's indomitable spirit nor her heroic art.[56]

A large collection of Kimball's works and archival materials are at the Southern Plains Indian Museum in Anadarko, Oklahoma. Other works are at the Philbrook Art Center, National Gallery, Boston Museum, Baltimore Museum, Institute of American Indian Art, and Bureau of Indian Affairs, Washington, D.C.

CONSTRUCTIVISM AND BAUHAUS INFLUENCES

Abstract expressionism was not the only influence in the 1940s. Constructivism and the Bauhaus affected a number of artists.

Ruth Asawa (Lanier) (1926–)

I would like to recapture the times when cathedrals were built and the whole village worked together.
—Ruth Asawa[57]

San Francisco's Ruth Asawa began her career in the 1950s with acclaimed wire mesh forms that hang from the ceiling like interpenetrating crocheted metal bubbles. But her concern for family and community life led her into a wider arena as a public sculptor and educator.

A Japanese-American who suffered hardship and discrimination during World War II, she could have become alienated and bitter, but instead turned every disaster into an opportunity. One of seven children of hard-working vegetable farmers in Norwalk, Southern California, Ruth, along with her brothers and sisters, helped with the eighteen-hour-a-day labor. After Pearl Harbor, the government began rounding up Japanese-Americans and shipped them to internment camps in the interior of the country, away from the coasts. Ruth's father was sent to a New Mexico camp, while the rest of the family was held at the Santa Anita Racetrack. The Asawas were not reunited until 1946.

Among the internees at Santa Anita were three Walt Disney studio artists who kept the uprooted children constructively occupied with art lessons. Ruth, who had always dreamed of being an artist, drew five hours a day, sometimes into the night. "No other sixteen-year-old Americans were receiving (and still aren't) such training—many hours of instruction and practice with professional artists."[58]

When the family was transferred to a relocation center at Rohwer, Arkansas, Asawa finished high school and was allowed to enroll in the teacher training program at Milwaukee State Teachers College. But after three years the art department chairman advised her that it would be difficult to place her in a teaching job because of anti-Japanese feeling in the country. This was very upsetting, but turned out to be a blessing. Asawa dropped the teaching program and obtained a scholarship to study in Black Mountain College's avant-garde art program.

Brilliant instructors, such as Buckminster Fuller and German refugee Josef Albers (who had a profound respect for Asawa's Zen Buddhist heritage and became a friend) provided "enough inspiration . . . to last for the rest of my life." It was a work-study program; students helped with the chores and participated in all the arts—dance, music, drama; they studied philosophy and spent a good deal of time thinking about *why* they were doing what they were doing.

Albers promoted the utopian idealism of the Bauhaus School, where he had formerly been a professor. In design classes he taught students to use art as a way to think clearly, analyze form in a disciplined way, study the nature of materials, and consider one's responsibilities to the community as a whole. Fuller taught her to explore new concepts, regardless of public opinion. There was often stormy debate at the democratically run school—an excellent preparation for later community life.

At Black Mountain, Asawa met her future husband, architecture student Albert Lanier, and in 1949 they settled in San Francisco, just after California repealed a law forbidding interracial marriages. While her husband became a well-known architect, she raised six children in a Maybeck-style house on Castro Street and continued her career.

Ruth Asawa, NUMBER 1–1955 (1955), brass and iron wire, 60″ x 67½″ x 15″. Collection of Whitney Museum of American Art. Gift of Howard W. Lipman. Acq. #63.38. Photo: Oliver Baker.

Experimenting with a technique of "crocheting" wire—a folk method of making baskets that she had learned during a 1947 Quaker summer work program in Mexico—Asawa allowed the materials to lead her into new forms. A ceiling-hung rounded basket narrowed into a bottleneck and then opened into other basket forms below. Sometimes she hung groups of wire sculptures at different heights so that they could be seen through one another from different angles. Asawa also experimented with truncated inter-penetrating cones and lettucelike, lacy forms.

When the sculptor first tried to exhibit these in the San Francisco Art Association Annual, some jurors objected that her work was "craft," not sculpture, but soon she was exhibiting widely and was accorded a solo show at New York's Peridot Gallery (1954). A reviewer said that the pieces had "no beginning and no end. . . . Mysterious [how] one shape is suspended within another . . . in the bewildering imprisonment of a . . . sphere within a globe . . . tantalizing. . . . such novel innovations that one is obliged for the present to treat them as phenomena rather than art."[59]

Gerald Nordlund correctly analyzed her work as an outgrowth of constructivism:

> Despite an "oriental" feel, these works grow out of the attitudes of the Constructivists. . . . Miss Asawa's sculpture meets these intangible criteria with an elegance appropriate to the austere architecture of the mid-century's International Style. . . . The mesh provided tangible surface forms while it permitted the transparency which only Gabo and Calder had found the ability to express prior to Asawa's generation. . . . No distinction is made between interior and exterior and a free flow of form and space is produced—the very dialogue of sculpture. Asawa has . . . turned inside into outside.[60]

Asawa described her working method: "As I'm working I judge how I'm progressing by watching the space around the forms I'm building. I'm concerned with the airy spaces surrounding the sculpture."[61]

In the 1950s, Asawa's work was acquired by the Whitney Museum, the Chase Manhattan Bank, and the Oakland Art Museum; she was in a Whitney Sculpture Annual, showed at the New York Museum of Modern Art, and had a solo exhibition at San Francisco's De Young Museum in 1960. In one decade, while raising six children, Asawa had become nationally known.

Some of her public commissions included woven wire sculptures for Joseph Magnin department stores; copper tied-wire "trees" for the restaurant of J. L. Hudson, Detroit (1965); a copper tubing fountain, Fox Plaza, San Francisco (1965); a mosaic mural for Bethany Center, San Francisco; and two bronze tied-wire sculpture fountains in the Civic Plaza, Phoenix, Arizona (1972). A retrospective was held at the San Francisco Museum of Modern Art in 1973.

When she became more populist in her thinking, Asawa used fantasy mermaids, turtles, and frogs in a bronze *Mermaid Fountain* (1968) for Ghirardelli Square. In the 1970s she became thoroughly involved in the community. While serving on the San Francisco Art Commission, she and art historian Sally Woodridge developed the Alvarado School Arts Workshop, a program that brought professional artists into classrooms and developed creative projects there. The program grew, with government and private funding, until at its peak it was operating in fifty schools and included School Works Unlimited, a shop in the Emporium-Capwell department store, which sold paintings, ceramics, and other art by students from kindergarten through high school. She was on the State Arts Council and the National Endowment for the Arts Education Panel.

Ruth Asawa, SAN FRANCISCO FOUNTAIN (1970–73), bronze, height 7′, diameter 14½′. Courtesy Hyatt on Union Square, San Francisco. Photos: Charlotte S. Rubinstein.

Firmly believing in the arts as a vital focus for education, Asawa never wanted a studio outside the home; it was a cardinal point to involve her six children along with her as they were growing up. The artist developed a sculpture medium for them—baker's clay, made of flour, salt, and water—to use in group projects and later for large collective friezes in the schools.

Asawa used this unlikely material for one of the most famous monuments in San Francisco, the drum-shaped *San Francisco Fountain* (1970–73) on the steps of the Hyatt Hotel on Union Square. When she received the commission, the sculptor decided to demonstrate that the entire community—adults and children—could be involved in a public art project:

> We have this egocentric idea that the artist has
> to do his own thing alone. Because of
> this I think art has become weaker . . . less
> able to satisfy us. There have always been
> great individuals in art, but great art has
> also been produced by skilled people working
> together. . . . We see this in science, in the space
> program, but we have lost it in art. Since we
> have no real folk art or craft tradition any more
> in this country, this kind of activity has to be
> recreated to bring families and communities
> together.[62]

With the aid of her mother, daughter, and friends Mai Lee and Sally Woodbridge, she rolled out a layer of dough on a full-sized model of the drum-shaped fountain, divided it into sections that could fit into a bronze foundry, mapped out the districts of San Francisco, and put groups to work on baker's clay reliefs that showed all the multifarious life of the city—cable cars, people, City Hall. Groups of children worked on sections that portrayed their districts, and Asawa's relatives and friends (including photographer Imogen Cunningham) worked on it when they dropped by the house. Today people come up to the richly textured bronze monument at all hours, touching it and looking for specific details and locations. Originally a fountain, it is now planted with flowers.

In 1976 the artist drew on her ethnic heritage in fountains for Japan Town's Buchanan Street Mall—fluted rusted steel forms resembling traditional origami folded paper shapes, whose color contrasts with the texture of gray stone basins and steps around them. The public can sit on the steps and enjoy the fountains as a respite from the fatigue of shopping.

A populist who believes in art for the people, Asawa has varied her style and approach to suit the specific needs of each commission. No wonder the mayor proclaimed 12 February 1982 to be Ruth Asawa Day.

Sue Fuller (1914–) is a constructivist who embeds nylon strings or threads in translucent plastic forms. She was born in Pittsburgh; her father was an engineer of bridges and her mother crocheted and knitted. Fuller likes to think that her work combines this dual heritage.

In 1932 Fuller studied at Carnegie Tech with Joe Jones, an American scene painter, and won prizes for American scene watercolors; but she was soon propelled toward modernism. In 1934 she took a summer class with Hans Hofmann at the Thurn School of Art in Gloucester, Massachusetts. Then, at the end of a year at Teachers College, Columbia University, she went to Europe, where in Munich she saw a show called German Degenerate Art. Hitler was using the exhibition as a propaganda device to heap contempt on the great German modernists, but Fuller was overwhelmed by them. "A companion exhibition approved by the Nazis was embarrassingly bad academic work. With clarity I realized just how much *freedom of expression* meant to me," she wrote.[63]

Sue Fuller, STRING COMPOSITION W-253 (1983–84), Honduran mahogany, brass, and nautical cord, 12′ x 14′. Courtesy of the McNay Art Museum, San Antonio, Tex. Gift of Robert L. B. Tobin and the Friends of the McNay.

After she returned to New York, Fuller was making prints at Hayter's Atelier 17 workshop when the noted Bauhaus weaver, Anni Albers, opened her eyes to Bauhaus concepts of weaving and collage at a workshop conducted at the Museum of Modern Art. Stimulated to experiment, she pressed one of her mother's lace collars into the etching ground (*Hen,* 1949) and then began to see the possibilities of making designs out of threads. An exhibition of the work of Naum Gabo and Antoine Pevsner at the Museum of Modern Art led her to try three-dimensional string structures, one of which was accepted in the Museum of Modern Art exhibition, Abstract Art in America (1951). Guggenheim and Tiffany fellowships and a grant from the Institute of Arts and Letters supported further experimentation.

In the following years (1950–60) Fuller produced hundreds of string compositions and spent a great deal of time and effort solving technical problems—the threads had a tendency to sag, no matter how tightly she stretched them in a frame. Around 1960 she began to embed threads and plastic monofilaments in transparent plastic poured around them and allowed to harden. She has received several U.S. patents for her technical discoveries in this field.

Nevertheless Fuller is not so buried in technical problems that she fails to recognize that her work is ultimately intuitive. Her poetic sculptures resemble crystals, spider webs, or complex mathematical models, their interweaving forms expressing the new sense of space and "the fourth dimension" of the twentieth century. The sculptor had six shows at the Bertha Schaefer Gallery, New York (1951–69) and has exhibited widely; her work is at the Museum of Modern Art, the Guggenheim and Whitney museums, and elsewhere. A large wood and string structure hangs in the stairwell of the Tobin Library at the McNay Art Institute, San Antonio, Texas.

In Fuller's own words: "Light, transparency, and balance is the aesthetic of our day.... My work in terms of linear geometric progressions is visual poetry of infinity in the space age.[64]

Marie Zoe Greene-Mercier (1911–), a constructivist who spent years abroad and carried out commissions in France and Italy, was influenced by her early training at Chicago's New Bauhaus.

Born in Madison, Wisconsin, to parents of French heritage and raised in Cambridge, Massachusetts, she still remembers a magical childhood visit with her family to Augustus Saint-Gaudens's studio museum in Cornish, New Hampshire. She earned a degree in art from Radcliffe College (1929–33), but knew little about modern movements until the following summer, when she worked as a gallery attendant at the University of Chicago. James Johnson Sweeney had brought an exhibition of Picasso, Braque, and others from Paris. In particular a small white wood relief by Arp made an enormous impression on her. Every day, before switching on the gallery lights, she studied how a narrow band of sunlight in the darkened room caused the sculpture to cast changing shadows on the wall. "Its simple message was that certain organic forms can give aesthetic satisfaction without a narrative support."[65]

In 1937 (the year she married Wesley Hammond Greene) the artist took a postgraduate program at Chicago's New Bauhaus, directed by refugee László Moholy-Nagy. There she went through the rigorous program of experimentation with the properties of materials—wood, clay, plaster, film, paper—in the workshops of Gyorgy Kepes, Alexander Archipenko, and others. She never forgot how Moholy-Nagy got down on his hands and knees before his astonished students and invited them to do the same thing in order to observe the fascinating appearance of a group of chair legs. Since that moment Greene-Mercier has always "applied selective attention to unusual aspects of objects from different viewing points."[66] A "hand sculpture," which she made of mahogany and string, is in the Bauhaus-Archiv Museum, West Berlin.

Marie Zoe Greene-Mercier, MULTIPLICATION OF THE LOAVES AND FISHES (1956), bronze, height 6'. Collection: First Baptist Church, Bloomington, Ind. Photo: Vories Fisher, Chicago, courtesy of the artist.

While raising three sons, the artist created nonobjective sculptures and completed a series of *Polyplanes* (1945–55), twenty-three collages of paper, string, and other materials sandwiched between layers of glass. These were exhibited at the Art Institute of Chicago.

In 1953 Greene-Mercier began an Arboreal series, influenced by the shapes of trees of the northern woods. This has been an ongoing theme, varying with the materials and methods being used. In bronze, the shapes are often calligraphic open forms, planned so that the environment, seen through the openings, functions in the design. Later, when working in welded steel, the tree forms developed into cubic shapes.

Greene-Mercier also did a series of abstract linear interpretations of figurative subjects, such as her Miracle series (*Multiplication of the Loaves and Fishes*, 1956) and Orpheus compositions. *Orpheus and Eurydice II* (1965, Radcliffe College) is an example of the looping, interweaving bronze bands in this style.

Dividing her time between Europe and the United States, Greene-Mercier exhibited abroad and won commissions in France. Some of her painted welded sheet steel compositions built up out of cubic forms (*Twenty-Cube Composition*, 1977, painted steel, Verlaine Junior High School, Saint Nicolas-lez-Arras, Pas-de-Calais, France) have affinities with David Smith's *Cubi* series, but Greene-Mercier points out that the very nature of certain materials and methods leads a number of artists to arrive at similar solutions simultaneously.

The artist won awards in France; had a forty-year retrospective at Amerika Haus, West Berlin (1977), and at the Galerie Musée de Poche, Paris (1978); and exhibited in Hamburg, Venice, and Florence. Works are at Grinnell College, Iowa, Roosevelt University, the University of Chicago, the Landratsamt, Hamburg, and the Museo d'Arte Moderna Ca Pesaro in Venice.

Helen E. Phillips (Hayter) (1913–), a direct carver in the 1930s, later became an internationally known abstract sculptor. Born in Fresno, California, she studied with Ralph Stackpole at the San Francisco Art Institute from 1931 to 1936. At twenty-two the precocious sculptor completed a commission for St. Joseph's Church in Sacramento, California, and won a purchase prize from the San Francisco Museum of Art for *Young Woman,* a chunky seated limestone figure with head in hands.

Phillips won a scholarship to study in Paris (1936–39) and then worked in London for a year. Returning to New York during World War II, she exhibited there for the next ten years, and met and married the famed abstract printmaker Stanley Hayter. Returning to Paris with him in 1950, she has lived there ever since and is better known in Europe than in the United States.

Phillips creates a variety of welded and cast bronze totemic and dancing abstract figures and forms. She has exhibited often at the Salon de Mai and the Paris Museum of Modern Art and is included in *Sculpture of This Century* by Michel Seuphor and *Sculpture: An Evolution of Volume and Space.*

Day Thalberg Schnabel (1898–) is one of many refugee artists who enriched American culture during the war. Born in Vienna, she studied painting at the Vienna Academy of Fine Arts and architecture and sculpture in Holland, Italy, and Paris. Coming to New York City in 1940, she became an American citizen in 1946. While working as an occupational therapist Schnabel studied with Zadkine and exhibited at the Mortimer Brandt (1946) and Betty Parsons Gallery (1947, 1951, 1957).

The Town (stone, 1953, Brooklyn Museum) suggests, in crisply defined planes, a walled city with ramps and buildings leading up to a cylindrical tower. Even in the more fluid bronze,

Woman Entering a Temple, a rapidly moving figure seems to be entering an open structure. All these have an architectural edge, but some works have a more organic look of growing forms (*Transformations,* marble, Whitney Museum).

After the war Schnabel settled in Paris, where in the 1960s she was designing monumental sculpture in association with architects and designers. Michel Seuphor described her work as "the pursuit of a sculptured architecture endowed with spirit."[67]

Guitou Knoop (1902–87), another refugee artist, created classic, elegant nonobjective compositions, stripped to their essentials, in stone and bronze. Born in Moscow of Dutch ancestry, Knoop left in 1927 to study with Bourdelle in Paris, becoming a French citizen in 1933. She was exhibiting in New York at the outbreak of the war (Wildenstein Gallery, 1936, 1939, 1942) and remained in the United States for several decades.

Around 1948, under the guidance of Jean Arp, she became a nonobjective sculptor, exhibiting at the Betty Parsons Gallery (1959) and the André Emmerich Gallery (1962, 1964). Her work is in the Metropolitan Museum of Art, Art Institute of Chicago, Albright-Knox Gallery, Boston Museum of Fine Arts, and elsewhere.

Gwen Lux (Creighton) (1908–), a Chicago-born architectural sculptor, came to public attention during a heated controversy over her *Eve,* commissioned for the Radio City Music Hall. The theater owner went into shock when he saw the nudity and modernity of her sculpture and others by William Zorach and Robert Laurent. Critics and artists rallied to their defense, however, and they were installed.

She had studied at the Maryland Institute of the Arts and with Ivan Meštrović in Yugoslavia. She received a 1933 Guggenheim Foundation fellowship and exhibited in the 1934 Paris Salon d'Automne.

The Radio City *Eve* was followed by many postwar commissions in collaboration with architects. Some of these are the Shakespeare panels for Edward Durrell Stone's University of Arkansas theater; *Power* and *Direction* for Eero Saarinen's General Motors Technical Center, Detroit; and *Synergy* for the State Office Building, Lihue, Hawaii.

Now living and working in Honolulu, Lux uses cast polyester resin and steel in architectural commissions. She has worked toward "a rediscovery of the integration of the arts of sculpture and architecture."[68]

FIGURATIVE SCULPTORS

The canon of art history gives the impression that the only sculpture created during the 1940s and 1950s was abstract; but, in fact, excellent figurative sculptors continued to work. Much of their art, like that of figurative painters during this period, has an expressionistic and haunted quality, often filled with existential despair. It was dubbed the "New Images of Man" in a 1959 exhibition at the Museum of Modern Art.

In the 1950s figurative sculptors began to use the new technique of welding. Many of them came out of the Sculpture Center, a combination gallery and workshop (originally Dorothea Denslow's Clay Club in Greenwich Village), where the director, Sahl Swarz, taught the technique. Their work was exhibited at the center alongside that of abstract artists David Smith, Theodore Roszak, and others.

Art historian Wayne Andersen characterized these welded figurative works as "spiky threatening frenetic forms . . . primordial fantasies . . . screaming mothers . . . a monstrous production of expressionistic sculpture that seemed to justify itself by a literal interpretation of the violence

inherent in the process of forming sculpture with the intense heat of an acetylene torch."[69]

True, the method had an effect on the work, but perhaps a deeper reason for the sense of angst can be found in the wartime sense of tragedy, the Holocaust, and later, the atomic threat and the cold war. This feeling pervades the work of abstract and figurative artists alike and emerges in other media, such as bronze and clay. Both groups were seeking more open, fluid forms, in contrast with the massive closed forms of the previous era.

Some sculptors, however, continued the tradition of direct carving. In general, figurative artists were influenced by modernism and abstraction. Elizabeth Catlett and Marianna Pineda studied with Zadkine, and Doris Caesar with Archipenko. Luise Kaish's early work has a gestural quality that relates to abstract expressionism.

Although **Luise (Meyers) Kaish (1925–)** describes herself as a humanist rather than a religious artist, she once said: "I have always been attracted to the first five books of the Bible. . . . I honestly feel that all experience is in the Bible and I think it is as true now as it was then."[70]

In the 1950s she embodied her humanistic visions in a series of deeply moving expressionistic bronze and welded sculptures, which combine the gestural qualities of abstract expressionism with figurative content.

Born in Atlanta, Georgia, and raised in New York, Luise was five when her kindergarten teacher called in her parents and advised them to give her art lessons.

After earning a B.F.A. in painting at Syracuse University (1946), the artist attended the Escuela de Pintura y Escultura in Mexico City (1946–47), where she first became interested in sculpture. On a full graduate scholarship she returned to Syracuse University to study with the Yugoslavian sculptor Ivan Meštrović (M.F.A., 1951):

> He was one of the most magnificent people I ever met . . . a truly great man and a great artist. I think the thing about him was that he was only interested in working. We were a very small group and we were allowed to use the studio at any time at all—late at night, weekends. And most of us did. He brought to us in the autumn of his life a quality of spirit, a way of seeing form and light, and a total commitment to hard work.[71]

At Syracuse the artist met her future husband, painter Morton Kaish, with whom she has shared exhibitions and visiting professorships. They have a daughter, Melissa. In 1951, when Luise received a Louis Comfort Tiffany grant, the Kaishes went to Florence, Italy, where she studied bronze casting and stone carving at the Institute d'Arte. On a second visit in 1956—this time to Rome—Kaish discovered that attending orthodox services at the Great Synagogue encouraged meditation and contemplation: "There was something about being back in Italy. . . . my feelings about morality received a great jolt."[72]

The resulting sculptures on biblical themes, shown at the Sculpture Center (1955, 1958), were described in *Arts* magazine:

> The blistering pain of revelation infuse[s] with grandeur forty-six exquisitely cast or welded bronzes and coppers. . . . *The Angel of Joshua*, swirling like a manta ray, with surfaces like withering bark . . . scorches the air with his prophecy of unbearable pain. . . . *The Vision of Jeremiah*, a flat, flaking lichen, trembles behind his shoulder and above his head, uttering divine promptings.[73]

Kaish received a Guggenheim fellowship and a monumental commission for an *Ark of Reve-*

Luise Kaish, ARK OF REVELATION (1961–64), bronze, 13½′ x 15½′. Temple B'rith Kodesh, Rochester, N.Y. Photo courtesy of the artist.

lation (1964) for Temple B'rith Kodesh in Rochester, New York. Kaish said of it, "I have sought to give visual form to the words of patriarch and prophet in an unremitting dialogue with God."[74]

The thirteen-by-fifteen-foot ark stands in a lofty prayer hall under a wood and glass dome designed by architect Pietro Belluschi. Eighteen bronze panels are welded together around a curtained opening which holds the Torah. Modeled with tremendous energy, in a highly abstracted and expressionistic manner, the panels depict key episodes in biblical history: *Moses Receiving the Tablets of the Law, The Angel Staying the Hand of Abraham, Jacob Wrestling with the Angel,* and others. A Rochester journalist wrote, "One has a feeling of being seized and swept along on a wind that blows across the pages of all the long history of the Jewish people."[75] Others compared it to the tradition of Ghiberti or Rodin.

Avram Kampf has written:

> The tension and elemental experience of the encounter between man and God is expressed in the poetic handling of the bronze. The surface is roughened by the spirited touch of the artist's hand which leaves its mark in the sharp cuts, deep incisions and nervous penetrations. The surfaces tremble as light breaks over the raked, hollowed and furrowed metal. As light advances and recedes, it alternately hides and reveals the wing of an angel, the leaf of a plant, the strings of a harp, a row of mourning men, or a figure blown by a gust of wind.[76]

Other commissions followed for Beth El Synagogue Center, New Rochelle, New York; Continental Grain Company, New York; Holy Trinity Mission Seminary, Silver Springs, Maryland; and elsewhere.

On a fellowship to the American Academy in Rome (1970–72), Kaish, perhaps influenced by the minimalism of the 1960s, abandoned rough, gestural surfaces and produced works in mirror-like polished stainless steel with movable parts (*Voyage 1, Voyage 11,* and *In the Beginning*), which suggest an analogy between space travel and spiritual revelation. For these she used a new technique of hammering and stretching metal over carved wood forms.

One of the artist's most moving works is *Holocaust* (1974–75), a black bronze stele at the entrance to New York's Jewish Museum. An arch curves above an open door, which suggests an entrance into death, or a gas oven, below which delicately modeled plants grow. On the one hand, it implies the horror of death; on the other, it pays homage to those who died and implies rebirth.

Kaish, who has received many honors, is chairperson of the Department of Sculpture and Painting at Columbia University. In the 1980s her reawakened interest in light and color led her back to collages and paintings, shown at the Staempfli Gallery, New York. Some are burned and torn, pulled back in layers that reveal a burst of white light, evocative of the same sense of spiritual revelation found in her sculpture.

Barbara Hult Lekberg (1925–) developed a flexible, innovative technique of welding strips of steel, one-sixteenth of an inch wide, into dynamic expressionistic figures. They seem "to live in the focus of a cyclone, striving against nature's forces."[77]

Born in Portland, Oregon, Lekberg studied at the University of Iowa with Philip Guston and Mauricio Lasansky, and took sculpture with Humbert Albrizio (M.A., 1947). In 1948 she came to New York City and learned to weld from Sahl Swarz at the Sculpture Center, exhibiting there from 1952 on.

Barbara Lekberg, THE FALL, (1964), welded steel, 78″ x 24″ x 24″. Collection of Dr. Helen Boigon. Photo: Otto E. Nelson, courtesy of the artist.

Lekberg's figures dance in ecstasy, cry out in pain, or prophesy darkly (*Prophecy,* 1955). The ribbons of steel welded into cagelike anatomical forms give rise to "lines of force defining space, rather than mass.... she celebrates the interaction of contour and air."[78]

Some of her early figures have a torn, eviscerated look. All are in dynamic motion. The sculptor explains: "From earliest childhood I have studied the way things move ... the way sheets billow in the wind ... the stress and release of athletes and dancers, people, walking, singing, crying ... Hopefully such charged motion is ... transmuted to a plastic form, a state of being."[79]

The Fall (1964, welded steel) is a gesturing, falling column. In *Pushing the Limits III* (1971, cast and welded bronze) a straining figure inside an open wheel pushes at the periphery.

Dissatisfied with the way welded steel weathers outdoors, Lekberg turned to bronze casting (sometimes she combines both methods), but her sculpture has lost none of its windswept motion. The fluid movements of Martha Graham, Loie Fuller, and other dancers inspired many works.

Lekberg was accorded a major retrospective at Mount Holyoke College Museum of Art in 1978, and she received Guggenheim fellowships in 1956 and 1959. She has carried out commissions for the Socony-Mobil Building, New York; the Beldon Stratford Hotel, Chicago; the Museum of Fine Arts, Birmingham, Alabama; and is in the collections of the Whitney Museum, Des Moines Art Center, Montclair Museum, Mount Holyoke, and the Jewish Museum, New York.

Ruth Chai Vodicka is another Sculpture Center alumna, who began to worked in welded metal in the 1950s. Her groups of shardlike or leaflike pointed forms, with dripped-on textured surfaces, suggest human figures.

Doris Porter Caesar (1892–1971), an expressionist sculptor of elongated bronze nudes, shows affinities with Matthias Grünewald, Wilhelm Lehmbruck, and generally with the German expressionist tradition.

Born in a fashionable brownstone in Brooklyn, New York, she lost her mother at a young age and was raised by her father, an attorney, who took her with him on leisurely trips to Europe and supported her desire to be an artist (at that time still a faintly disreputable career for a woman). By the age of sixteen she was attending the Spence School for girls in the morning and then dashing over to the bohemian world at the Art Students League, where young artists argued over art and politics.

After her marriage in 1913, Doris Caesar had to put art aside for twelve years to raise two sons and a daughter and deal with all the complications of an affluent household. But in 1925 she wandered into the small Fifty-seventh Street studio of Archipenko, recently arrived from Paris. Searching for a way to renew her creative life, she ruminated to herself: "Perhaps modern art? Sculpture certainly—new, hard, something to grasp—not painting."[80]

Caesar became Archipenko's student. Although a cubist, he helped his students search for their own direction. Thus Caesar received a solid foundation, working from the model, creating essentially Rodinesque life studies.

In 1927 she cast her first bronze piece and carried it timidly to Erhard Weyhe, a perceptive dealer who ran a bookstore–art gallery on Lexington Avenue. Weyhe took an interest in her and showed her the works of German expressionists Barlach, Lehmbruck, Kollwitz, and the French satirist Daumier in his collection. From the beginning Caesar intuitively turned away from serene classical forms and began to distort her figures until they eventually became extremely attenuated, almost sticklike. In 1934, Weyhe introduced Caesar to the sculptor Rudolf Belling, a German refugee. His critiques had, in her own words, "a terrific impact" on her,[81] leading to more severe distortions of the figure.

Caesar had solo shows at the Weyhe Gallery in 1935, 1937, and 1947. During these years Caesar, an admirer of Eliot and Auden, published poems in *Poetry Review* and two volumes of poetry, *Phantom Thoughts* and *Certain Paths*.

In the 1940s, Caesar developed a loose, emotional style, with unsmoothed thumb marks in the clay (*Descent from the Cross,* 1950, Wellesley College; *Girls Reading,* 1943, Newark Museum; *Self Portrait,* University of Iowa). The intense artist often worked through the night at her studio in the Sherwood Building and was active in artists' organizations. In 1948 she and five other women, Rhys Caparn, Minna Harkavy, Helen Phillips, Helena Simkhovitch, and Arlene Wingate, were in a very successful show called The New York Six, at the Argent Galleries, New York. They were invited to exhibit at the Petit Palais in Paris in 1950.

In the 1950s after moving to a home in the country fifty miles north of New York, Caesar arrived at a fully developed personal style. "On a boulder-strewn hillside confronting a distant lake, she found a kind of tranquility which she call[ed] 'the freedom of maturity and age.' In the Salem Center Studio—and at Litchfield, Connecticut, where she moved in 1957—her finest work has been done, and it came in a sudden blossoming, as if released from the restless experiment and thought which had gone before."[82]

Caesar now restricted herself largely to one subject—long, attenuated naked female bodies, sometimes with small masklike "African" heads. (*Torso* 1953, Whitney Museum; *Standing Woman,* 1958; *Seated Woman Looking Up,* 1958, Wadsworth Atheneum). John Bauer described these in the

Doris Caesar, TORSO (1953), bronze, height 58″.
Collection of Whitney Museum of American Art. Gift of
the artist by exchange. Acq. #54.30. Photo: Oliver Baker.

Whitney Museum catalog *Four American Expressionists* (1959): "The flesh ... is hacked and furrowed, hollowed and bossed by childbirth, by desire, by submission and the stresses of experience.... She has concentrated on a single theme— and she has wrung from it a poignant expression of what it is to be a woman, or perhaps one should simply say of what it is to be."[83]

Seen in the context of the period, Caesar reflects in these sculptures the same kind of existential angst found in the work of Lu Duble, Helene Sardeau, and a number of other artists working in the 1940s and 1950s.

Caesar also completed several large religious commissions. Her papers and a number of works are at Syracuse University.

The jagged, expressionist style of **Lu Duble (1896–1970)** can be seen in the wailing, tormented figures of *Weeping Woman, Cain, and Widow*. Born into a family of painters and writers in Oxford, England, Duble came to the United States as a child in 1903. She once said that her mental set was shaped by an invalid mother who was constantly praying.

Duble studied at Cooper Union, the Art Students League, and the National Academy of Design, but the pretty garden figures that she was taught to make in art school seemed totally unrelated to the deep religious feelings and stark pain she saw daily in her invalid mother. When she won a 1937 Guggenheim fellowship, she decided to go to Haiti to study voodoo religions. This resulted in an exhibition of ecstatic clay dancing figures, shown at the Marie Sterner Gallery, New York (1938), and the Toledo Museum, Ohio (1939).

A second Guggenheim fellowship enabled her to travel to Mexico to study Mayan culture. There the sight of religious women in Mexican churches made her feel "that women who wept

and prayed somehow made sense. . . . I was convinced that what is merely physical can be negated or changed by the spiritual."[84]

Soon after this Duble had an epiphanal experience:

> One day I entered a church to pray. On the steps of the altar I saw what looked at first like a heap of old rags. But the rags pulled themselves together through a wonderful series of angular movements until they reached a praying position. I watched fascinated as a crippled man threw off the handicaps of his body. As he rose you were conscious not of his twisted limbs but of the light that shone in his face. After that I could never go back to the pretty figures.[85]

During World War II, a group of women was visiting one of her exhibitions, and distressed by the painful emotions in her work, they urged Duble to see a psychiatrist in order to rid herself of her "guilt complex." She laughed about this because she felt that this was her way of expressing the spiritual aspirations of the human race: "We learn most from the hard things we live through and do something about. All through man's history it has been the same. It is the same now, with numberless refugees and displaced persons passing through a modern vale of tears."[86]

The life-sized *Dark Mother,* a kneeling sorrowing woman reflectively holding her chin in her hands, was inspired by the war poems of Walt Whitman and symbolizes all mothers who weep for their sons lost in wars. In *Cain* (Whitney Museum), the guilt-ridden fratricidal figure holds up clasped hands to heaven. These works have sharp, angular planes reminiscent of Barlach and the German expressionists.

In 1947 the sculptor was in a joint exhibition with Cornelia Chapin and Marion Sanford at the Grand Central Galleries. After studying and teaching for three years in Archipenko's atelier and studying with Hans Hofmann, she envied the freedom of the younger generation of artists who had moved all the way into abstraction; her own early training prevented her from going beyond a certain starkness of form.

Nina Koch Winkel (1905–), another artist who, beginning in the 1940s, expressed stark emotion in strongly chiseled planes, was born in Germany and came to the United States as a refugee after being held in a concentration camp in France. She worked and exhibited at the Sculpture Center in New York, and served as director.

Arch of Triumph (1945, plaster, SUNY Plattsburgh Art Museum), a tribute to the martyrdom of the first victims of the Nazis in France, expresses the suffering and yet the triumph of the human spirit struggling against despotism. (A bronze cast is in a private collection). This work won one of five gold medals the artist has received from the National Academy of Design. Winkel worked at first mainly in terra cotta and then branched out into welding, bronze, and her own technique of working with sheets of copper. An entire sculpture courtyard at the art museum of the State University of New York in Plattsburgh is devoted to her work. Over two hundred terra cotta sketches are in the museum's collection.

Another refugee sculptor, **Elizabeth Dittman Model (1903–),** born in Bayreuth, Bavaria, studied at the College of Art in Munich and with the Russian sculptor Moisse Kogan (1934–36) in Amsterdam and Paris. After a narrow escape from the Nazis in 1941, she and her husband and children settled in New York City, where she exhibited at the Norlyst and Pinacoteca Galleries (1946), at the Brooklyn Museum and other museums, and frequently with the Federation of Modern Painters and Sculptors. Her figurative bronzes, in the highly abstracted tradition of

Nina Winkel, ARCH OF TRIUMPH (1945), plaster. SUNY Plattsburgh Art Museum, Plattsburgh, N.Y. Photo courtesy of the National Sculpture Society.

Henry Moore, are in the collections of the Corcoran Gallery of Art, the Hirshhorn Museum, the Wadsworth Atheneum, and the Jewish Museum.

Elizabeth Catlett (1915–) has a different orientation from that of her white mainstream colleagues. In 1982 she told author Virginia Watson Jones: "My purpose is twofold; one, to present black people in their beauty and dignity for our race and others to understand ... two, to exhibit publicly where black people can visit and find art to which they can relate."[87]

In the 1970s she wrote: "I have gradually reached the conclusion that art is important only to the extent that it aids in the liberation of our people.... I have now rejected 'International Art' except to use those of its techniques that may help me make the message clearer to my folks."[88]

Catlett did not come to these conclusions because of a lack of sophistication about avant-garde movements. On the contrary, she studied with Zadkine and has a master's degree from the University of Iowa. But she believes that much art produced today is irrelevant to the broad masses of people. Indeed she advises her colleagues not to chase after approval from dealers, curators, and museums who control the art world. "They buy you and sell you," she says.

Born and raised in Washington, D.C., Catlett had ex-slave grandparents who struggled to educate all their children. Her father, a mathematics teacher at Tuskegee University, died shortly before she was born, and her mother, although trained as a teacher, worked as a cleaning woman at first, eventually becoming a truant officer to support her children. She remains devoted to the memory of her strong-minded mother who, she wrote, "encouraged my interest in drawing and painting, giving me materials, a place to work and time apart."[89]

Precociously talented, Catlett graduated from Washington's Dunbar High School with honors.

But when she applied for admission to Carnegie Tech's art department, she was refused, although her work was praised during the entrance examinations. Catlett overheard one examiner whisper to another, "It's too bad she's colored."

Enrolling at Howard University, a college for black students in Washington, D.C., she found a mentor in Professor James Porter, who allowed her to spend time in his library and talked to her at length about life and art. While still at college, Catlett, already a person of conscience, embarrassed her family's middle-class friends by standing in front of the Supreme Court with a noose around her neck as part of a protest against lynching.

In 1937, Catlett became an art teacher in the public schools of Durham, North Carolina, which were at that time still segregated. Rebelling at the gross disparity between the salaries of black and white teachers, Catlett helped organize a campaign to equalize the pay. Bitterly disappointed when the head of the teacher's association sabotaged the campaign, she left to take a graduate degree in the new studio art program at the University of Iowa.

Catlett was not allowed to room in dormitories with white students (she had to live off campus), but she was greatly inspired by her teacher, the regionalist painter Grant Wood, a progressive, enlightened man who encouraged high standards and fine craftsmanship. A master carpenter himself, he introduced Catlett to wood carving in one of his classes, an experience she found so satisfying that she switched from painting to sculpture, becoming the first student to earn a master's degree in sculpture at the University of Iowa.

Catlett's dissertation piece, *Mother and Child* (1940, limestone, University of Iowa), demonstrates the powerful, direct communication that has remained the hallmark of her art. The seated black mother, eyes closed in maternal love presses her child to her body. Catlett raised this timeworn theme to a new level through the use of tense, compact forms and the force with which she managed to convey sincere feeling. It won first prize at the Diamond Jubilee, a black exposition in Chicago.

Hired to chair the art department at Dillard, a black university in New Orleans, Catlett introduced nude models into the life classes and challenged the segregationist South by bringing her students to a Picasso exhibition at a museum located in a park that was customarily off limits to black people. She got around the problem by bussing her class right to the door.

In 1942, after Catlett married artist Charles White, they moved to Harlem, then an exciting milieu, where black intellectuals—poet Langston Hughes, painters Aaron Douglass, Jacob Lawrence, Romare Bearden, and others—congregated and exchanged ideas. Catlett and White exhibited in Edith Halpert's Downtown Gallery and elsewhere.

Catlett had experienced racism as a student and teacher; now, as a wife, she experienced sexism. She was often treated as "the artist's wife" by her colleagues, whereas the men were taken seriously.

Nevertheless this was an important period of growth. Catlett studied privately with Zadkine (1942–43) who prodded her to become more experimental—to be concerned with the interaction between negative openings and the solid masses in her work. She remembers Zadkine as "another non-conformist and hard worker with a set pattern for his life," but "we used to argue about my doing black people. He felt that art should be international so that it would be understood by all national groups. I felt and still do, that it should be a nationalist experience projected towards international understanding—the same as the blues or spirituals."[90] In contrast,

Grant Wood had encouraged her to work from her own experience.

Catlett also studied lithography at the Art Students League (1944) and joined the faculty of the George Washington Carver School in Harlem, an alternative school where working people came to study Afro-American history, economics, the arts. Under the direction of Gwendolyn Bennett, Catlett devoted herself idealistically to the school—did public relations, taught sculpture and dressmaking, even swept the floor if necessary, leaving little time for her own work.

One incident made a vivid impression. On a hot June night, about 350 people ("janitors, laundresses—poor black people who served others") were squeezed into a small room with the windows closed and shades drawn because of the World War II blackout, sweating and listening to Shostakovich's Seventh Symphony. When the Juilliard Music School professor suggested they take a break to refresh themselves with cold punch "our students politely refused. They said no, the break can wait. We want to hear it all together. Now, ignorant me! I had thought they weren't interested in classical music."[91] It was an eye-opener to Catlett who realized that she had formed a stereotype about the cultural capacities of working people.

In 1945 and 1946 Rosenwald fellowships enabled Catlett to work on a series of prints dealing with the lives of black women. She decided to work in Mexico, a land where artists had for decades created public murals for the common people. There, poor peasants brought their families on pilgrimages to Mexico City to look at the work of the *Tres Grandes,* Rivera, Orozco, and Siqueiros.

Catlett joined the *Taller de Grafica Popular,* a workshop dedicated to creating prints for the masses, and there, after her divorce from Charles White, met Francisco Mora, painter and printmaker, whom she married in 1947. Catlett and Mora have had a long, harmonious marriage, exhibiting together and raising three sons.

While her children were small and the family was living in a cramped apartment, Catlett restricted herself largely to printmaking, but when they were a little older she returned to sculpture, studying woodcarving with José Ruiz. In 1958 she became the first woman professor at the School of Fine Arts, National University of Mexico, serving as chair of the sculpture department from 1959 until her retirement in 1976. She now lives and works in Cuernavaca, devoting all of her time to sculpture.

Catlett's powerful images have the taut, disciplined form that characterizes Egyptian and African sculpture. The cubist training she received from Zadkine is evident in the sharply defined multifaceted planes and the interchange between solids and voids in her work.

For example, in *Homage to My Young Black Sisters,* an abstracted figure of a woman raising her arm and fist in defiance, Catlett makes effective use of a hollow opening in the figure to accentuate the stretching, reaching effect. *Maternity* (1978, terra-cotta) an abstracted half figure, has an opening in the body where a removable child image is placed, as in the womb. *Black Unity,* a wood carving of two masklike female heads on one side and a clenched fist on the other, synthesizes the artist's social concerns with forms derived from African masks.

Catlett's public commissions include a ten-foot bronze *Olmec Bather* (1966, National Polytechnic Institute, Mexico City), a bust of poet *Phyllis Wheatley* (1973, bronze, Jackson State College, Mississippi); a twenty-four-foot relief, *Students Aspire* (Howard University), and bronzes of former Mexican secretaries of education, *Torres Bodet* and *José Vasconcelos* (1981, Secretariat of Education, Mexico City). Linocuts and lithographs also deal with black oppression and the beauty and dignity of black people. In the much

Elizabeth Catlett, BLACK UNITY (1968), front and rear view, walnut, 21″ x 24″. Courtesy of the Brockman Gallery, Los Angeles. Photo: Jethro Singer.

reproduced linocut *Migrant Worker,* the head of an agricultural laborer in a straw hat is hacked out with powerful strokes that seem related to sculpture.

Catlett received the Woman's Caucus for Art award and was one of nine sculptors honored at the 1987 National Sculpture Conference: Works by Women in Cincinnati. Her message to black artists is: "I know it's very easy to follow trends, but we must think in terms of *creating* trends. We [black artists] have a special culture in the United States that came from living under segregation; our trends in music—blues and jazz—have already been accepted internationally."[92]

Laura Ziegler (1927–), an expatriate sculptor living in Italy, creates bronze figures and terracotta portraits.

Born in Columbus, Ohio, Ziegler studied at Ohio State University (B.F.A., 1943–46) and Cranbrook Academy (1948). Her sculpture teacher, Erwin Frey, taught her that "everything you put on should remain, like a pointillist painting. Every glob should have meaning. In theory you should never take anything away . . . and in the end finish with every form resolved."[93]

Ziegler won a 1949 Fulbright scholarship to Florence, Italy, where she studied polychrome ceramics for nine months at an artisan's workshop and then took a studio in Rome next door to sculptor Pericle Fazzini, who invited her to become one of his student-assistants: "He taught me what discipline meant. . . . Work started at 8 a.m. and ended at 10 p.m. Inspiration was unnecessary. Fazzini said you worked whether you wanted to or not."[94]

After returning to Columbus when her mother became ill, the artist continued her disciplined habits. She vanished each morning into a coal bin–studio in the basement and emerged late at night. Ziegler received two commissions in Co-

Laura Ziegler, EVE (1958), bronze, 70″ x 23½″ x 24″. Hirshhorn Museum and Sculpture Garden, Smithsonian Institution. Gift of Joseph H. Hirshhorn, 1966.

lumbus: a twenty-four-foot abstract steel and Plexiglas cross for St. Stephan's Episcopal Church, and a forty-four-foot welded copper *Burning Bush* (1959) for Temple Emanuel.

After her mother's death, Ziegler returned to Rome and set up a studio, where she worked during the day, continuing with Fazzini in the evenings. Returning to the United States for a solo show at New York's Duveen-Graham Gallery, she was still unpacking her work there when Alfred Barr (then director of the Museum of Modern Art) came in with Senator William Fulbright and Mrs. John D. Rockefeller. Barr was so impressed by the work strewn around the floor that he bought eight pieces. Word got around and the show was sold out before it opened.

Ziegler shows the influence of Italian sculptors Manzu and Marini in fluid bronzes like *Man with a Pickaxe* (1954, Museum of Modern Art) and *Portrait of Henrietta* (1956, Neuberger Collection). The six-foot bronze *Eve* (1958, Hirshhorn Museum) has a strong silhouette of sweeping curved rhythms. She also does terra-cotta portraits, built up in rough pellets of clay and glazed in earth tones, which probe through expression and body language to the very heart of her sitter (*David Levine,* 1974, Brooklyn Museum; *Joseph H. Hirshhorn,* 1974).

Ziegler lives and works in Lucca, a quiet Tuscan town, and is married to Herbert Handt, an American concert musician who performs primarily in Europe. She retains a pied-à-terre in Rome and is well known in the American sculptors' colony, where, she says, Americans like Jack Zajac, Elbert Weinberg, and Robert Cook "have created a Renaissance." The artist has had solo shows at the Columbus Gallery of Fine Arts, Ohio; Knoedler's; the Forum Gallery, New York; Dartmouth College; and the Magnes Museum, San Francisco.

Marianna Pineda (1925–) is almost an anomaly in an age of restless experimentation, shock, and alienation. Her bronze figures, primarily of women, radiate a classical warmth and serenity, modified by a modernist sense of form. These values come from her early years:

> I was raised near Chicago and was treated to a feast of visual arts, dance and music . . . from the time I was a small child. . . . [I was] encouraged to be an artist by both parents. They had considerable talent of their own which they subordinated to the needs of the family. (So I received two messages.) I was fortunate to see Greece and Egypt at age nine, the South Seas and India at twelve. . . . these travels had a great influence on me.[95]

As a child, Pineda haunted the galleries of Romanesque and early Gothic sculpture at the Art Institute of Chicago. "Early German sculpture influenced me before I knew of Barlach and Lehmbruck," she says. At seventeen, Pineda studied with Carl Milles one summer at Cranbrook (she remembers his collection of Greek and Roman marble sculptures) and then with Simon Moselsio at Bennington College (1942–43); Raymond Puccinelli at the University of California, Berkeley (1942–44); and Oronzio Maldarelli at Columbia University (1944–46). While working in a summer children's program at the Museum of Modern Art, New York, she became intimately acquainted with the modern sculpture collection.

In 1946, Pineda married sculptor Harold Tovish, who has been a supportive colleague. Nevertheless, although she won the Albright Art Gallery award in 1947, she was temporarily derailed when her first two children were born, but soon got back on track:

> Going to Paris (1949–50) with our two-and-a-half-year-old daughter and five-month-old son

Marianna Pineda, PRELUDE (1957), bronze, length 5'4". Collection of the artist.

was my liberation. Having swallowed the dictum of my male instructors that I would "cease wanting to make sculpture when I started to make babies" I had foolishly set aside a life-long obsession for three years. In Paris we worked in Zadkine's atelier and had day care and help at home for the children. Later we found a studio across the street from our house and began producing our first authentically personal work in a city that seems made for artists. . . . It's not easy to combine child rearing with a commitment to art, but it can be done. The take is worth the give. A grant from Radcliffe's Bunting Institute (1962–64) was a tremendous help.

Pineda, who has lived and taught in Boston since returning from Europe, describes her approach: "I am fascinated by the human form as a metaphor for emotional states, relationships between women and men, women and women. . . . I find the pregnant female form beautiful. It seems to have been a taboo subject except for the medieval cult of the Virgin, African art and certain Egyptian and Indian deities."

Warmth and sympathy imbue works like *The Visitation* (1956, bronze, Munson-Williams Proctor Institute, Utica, New York), which shows a woman announcing her pregnancy to her mother, and *Winter Sleepers* (1972), a simplified carving of a couple huddled together beneath a blanket. A series of *Oracles,* portraying woman as seer or shaman, seem prophetic of the women's movement. *Aspect of the Oracle* (1968) on the Radcliffe College campus in Cambridge is a female figure seated on a tripod, arm raised in the act of divine prophecy.

These works show the influence of modernism in their simplified planes, stripped-down forms, and dramatic compositions. Pineda says: "My materials and subjects are time-honored; but I feel free to . . . use focus, abbreviation, merger of forms—whatever seems appropriate to convey the meaning."

Commissions have included a two-figure bronze group, *Twirling,* for East Boston's Housing for the Elderly and a stately bronze statue of the Hawaiian queen *Lili'uokalani* (1979, Honolulu) for the state of Hawaii. She has had solo shows at the Walker Art Center and the Honolulu Academy of Art.

Una Hanbury (1905–) was permanently influenced by the impressionistic realism of her teacher, Jacob Epstein, and by her thorough early training. Born in Middlesex, England, she was the daughter of cultivated parents, and granddaughter of Harwick Rawnsley, canon of Carlisle Cathedral, who fought to preserve the Lake District and founded the Keswick School of Art.

While still a child, she studied with Frank Calderon, the animal artist, and later with Jacob Epstein and the March brothers. After four years at London's Polytechnic School of Art, she spent three more at the Royal Academy, winning the coveted Landseer Prize. During summers at the family villa in Capri, she learned stone carving from their neighbor, Axel Munthe.

After becoming Mrs. Hanbury, she was preoccupied with house, garden, two daughters, and fox hunting in the Hampshire countryside, until her husband left to serve in World War II, and she came to Washington, D.C.

After the war, now divorced with several children to raise, Hanbury resumed her sculpture career, completing a symbolic bronze relief for the lobby of the Medical Examiners Building, Baltimore; a ten-foot cast stone family group for St. Mark's Lutheran Church, Springfield, Virginia, and other works.

She became a renowned portrait sculptor, using Epstein's technique of applying impressionistic pellets of clay to the form. Some of her busts are of *Georgia O'Keeffe, Rachel Carson,* and *Robert Oppenheimer,* all at the National Portrait Gallery, photographer *Laura Gilpin* (Wheelwright Museum, Santa Fe), *André Segovia* (1968), *Buckminster Fuller, Enrico Fermi,* and *Richard Neutra.* Hanbury's patinas reinforce the expression; for example, she chose black for O'Keeffe to reinforce the impression of impenetrability and rock-hard strength. Neutra's bust was patined in gray because she saw him as somewhat insecure. She is also known for her studies of horses, a favorite subject since childhood.

In 1972 the sculptor was invited to Yugoslavia to execute a twelve-foot marble column entitled *Wonder Is the Beginning of Wisdom,* in the Beli Vance Sculpture Park, Arandjelovas. The government feted her in ceremonies at which she was the only woman and her taxi driver invited her to his mountain home, where she feasted on roast pig and plum brandy. Touched by the kindness of the Yugoslavian people, she donated a playground sculpture to a children's day care center.

In the 1940s Hanburg spent three months living in the pueblo of famed potter Maria Martinez, and in 1970 she moved to Santa Fe. Her front door is guarded by a giant *Phoenix* perched on a boulder, with wings uplifted, a symbol of resurrection and the undefeated spirit.[96]

Leonda Froelich Finke (1922–) is another warmly humanistic sculptor, whose rough-surfaced bronze female figures, broadly stated in generalized volumes, express major themes, such as bondage or survival.

Nancy Spero (1926–), a leading feminist painter-collagist, whose running female figures, tongues thrust out at a patriarchal society, are drawn, as Donald Kuspit has put it, "with a street fighter's razor," created a few remarkably prescient sculptures around 1950. *Mummified* (1950), a primitivistic figure fashioned out of plaster, ny-

lon stockings, paint, and paper, is a wrapped-up, repressed half-woman, half-phallic form that reflected her own feelings at the time—of being totally submerged, out of tune with society and with the wave of abstract art that seemed alien to her social and artistic concerns.

Nancy Spero, MUMMIFIED (c. 1950), plaster, nylon stocking, string, newspaper, height 15″. Collection of the artist. Photo: David Reynolds.

DIRECT CARVING

Some excellent sculptors continued to work in the direct-carving tradition in the 1940s and after. Several were students of José de Creeft, a pioneering exponent of direct carving in the United States.

Cleo Hartwig (1911–1988) epitomizes the direct carver in massy animals and figures, whose forms are often dictated by the shape and grain of found stones. Raised in rural Michigan, where she learned to love the animals that were so often her subjects, she graduated from Western Michigan University (1932) and came to New York to study with José de Creeft. After that she worked with remarkable consistency, preferring the unhurried contemplative process of developing an image from the stone without preliminary sketches. Hartwig's first solo show at the Clay Club (1943) was followed by others with the Sculptors Guild and at leading museums.

Hartwig met sculptor Vincent Glinsky at a meeting of the Sculptors Guild in 1951. After their marriage they worked side by side harmoniously in a New York studio, accommodating working hours, teaching schedules (she taught at the Montclair Art Museum), and the care of a son. Hartwig pruned the forms of animals and figures to their abstract essence in bulky swelling forms with no openings or holes. A full academician of the National Academy of Design and a fellow of the National Sculpture Society, she won many honors and was a leading figure in artists' organizations.

Two other excellent direct carvers who studied with José de Creeft are **Isabel Case Borgatta (1922–)** and **Lorrie Goulet (1925–),** both of whom carve flowing, elemental female figures in stone and wood. Borgatta emphasizes the play of rough textures against smooth.

Cleo Hartwig, SEED POD (1948), rosso antico marble, height 17″. Private collection. Photo courtesy Douglas Berman/Peter Daferner, Inc., N.Y. Photographer: Walter Russell.

Jane Wasey (Mortellito) (1912–), a student of Paul Landowski in Paris, and John Flannagan, Heinz Warneke, and Simon Moselsio in the United States, has, since her 1934 show at Montross Gallery, New York, been noted for direct carvings in wood and stone of animals and figures whose purity and simplicity of mass remain unpenetrated by holes or openings. She taught sculpture at Bennington College (1948–49), had a 1949 solo show at Philbrook Art Center, Oklahoma, exhibited at New York's Kraushaar Galleries, and won prizes at museums and at the Architectural League (1955). *Bather* in butternut wood is at the Whitney Museum, *Polar Bear* (1947, marble) at the Pennsylvania Academy, and a granite monument of a seal, *André* (1978) at Rockport, Maine.

Although men are traditionally the wood carvers in the Native American community, **Amanda Crowe (1928–),** a Cherokee from North Carolina, broke through the stereotype. She began to carve and draw at the age of four and was already selling carvings of animals and birds at age eight. Encouraged in high school, she won a teaching fellowship that enabled her to earn an M.F.A. in sculpture at the Chicago Art Institute. On graduation, a John Quincy Adams fellowship enabled her to study with José de Creeft at the Instituto Allende in San Miguel, Mexico.

In 1953 she returned to her beloved North Carolina mountains, where she has been an influential teacher at Cherokee Central High School for many years. She exhibits her work with the Qualla Arts and Crafts Mutual in Cherokee. Crowe has won many awards for her direct carvings in native woods of animals (often bears) and wild life in her region, as well as figures. In

Amanda Crowe (Cherokee), INDIAN MADONNA (1959), mahogany, 35⅞". Collection of the Indian Arts and Crafts Board, W-63.26. Photo: U.S. Department of the Interior, Indian Arts and Crafts Board.

the classic direct-carving traditon, she reduces the forms to their essence and brings out the grain of the wood.

CERAMICS AND DESIGN

American crafts and design flowered in the 1940s and 1950s, benefiting from the influx of talented refugees who brought with them modernism, technical knowledge, and the Bauhaus approach to functional design. The melding of European and American talent had the same invigorating effect that it had on painting and sculpture.

The influence of abstract art and abstract expressionism can be seen in the free experimentation with glazes and increased sensitivity to abstract form and color. Japanese ceramics, with their emphasis on simplicity, functionalism, abstract form, and freely brushed calligraphic design, also had a great influence.

Several places became centers of explosive creativity. Moholy-Nagy and others opened the New Bauhaus in Chicago. Josef Albers, nonobjective painter and former Bauhaus design professor, and his wife, weaver Anni Albers, set up an experimental program at Black Mountain College, North Carolina, and then revolutionized the staid art department at Yale University. Cranbrook Academy in Michigan, under the visionary leadership of the Saarinens, was another center that became associated with such leaders of modern design as Ray and Charles Eames, Florence Knoll, and ceramist Maija Grotell.

One of the great movers and shakers of the American crafts movement in this period is **Aileen Osborn Webb,** a philanthropic woman who began by opening a shop in her home town in

1940 to help unemployed artists during the depression. It mushroomed into New York City's America House, the first serious American crafts gallery. She then founded *Crafts Horizon* magazine and the American Craft Council (which in 1956 opened the Museum of Contemporary Crafts, now the American Crafts Museum, the leading museum of crafts in the United States). In 1964 she organized the World Crafts Council, which brought together leading craftspeople from around the world. **Rose Slivka,** managing editor of *Crafts Horizon* is another leading spokeswoman for the American craft movement.

THE CRANBROOK GROUP

Women designers have played a significant role at Cranbrook Academy in Michigan since the 1920s, when **Loja Saarinen,** wife of the director, Eliel Saarinen, was in charge of the weaving department. Two internationally famous women industrial designers came out of Cranbrook in the 1940s.

Ray Kaiser Eames (191?–1988) To the general public the name *Eames,* and Eames furniture, has largely meant Charles Eames. This is not because he made any attempt to suppress the importance of his wife Ray's contribution. On the contrary, Charles Eames always made it clear that Ray was a full and equal partner in all their projects. It is simply the way the world has regarded creative couples, assuming that the wife merely basks in reflected glory. Only in recent years has the full extent of her participation been demonstrated in such exhibitions as Design in America: The Cranbrook Vision.

Ray Kaiser was already a pioneering abstract painter who had studied with Hans Hofmann and been a founding member of American Ab-

Ray Eames, MOLDED PLYWOOD SCULPTURE (1943), walnut. Collection of Lucia Eames Demetrios. Photo: © The Eames Office.

stract Artists when she went to study at Cranbrook in 1940 and met staff member Charles Eames, architect and designer.

After their marriage in 1941, the couple moved to Los Angeles and opened the firm of Charles and Ray Eames. While they were developing their revolutionary molded plywood chairs for mass production, Ray Eames experimented with

Charles and Ray Eames, Eames® MOLDED PLYWOOD CHAIR (1946). Courtesy of Herman Miller, Inc.

the properties of the material by creating some nonobjective molded plywood sculptures whose forms prophesy and relate to the plywood furniture. The couple collaborated on such world-renowned designs as the Eames "potato chip" chair and a variety of stackable storage units and other furniture for the Herman Miller company. Ray created much of the innovative advertising that accompanied the introduction of their products in the Herman Miller brochures.

With tremendously wide-ranging interests, they became famous in later years for films and revolutionary exhibition installations using multiple-screen displays that assault the viewer with a near-overload of information. They were hired by IBM and other companies to install displays at museums, world's fairs, and expositions. The permanent *Mathematica* exhibit at the Los Angeles Museum of Science and Industry introduces visitors to basic math concepts.

Florence Schust Knoll (Bassett) (1917–) studied at Cranbrook and became, along with Charles and Ray Eames, one of America's most influential interior designers of the 1950s and 1960s. As chief designer for the Knoll furniture company, she created sleek high-tech couches, desks, and wall units and planned total installations that became the hallmark of American corporate environments.

Maija Grotell (1899-1973), head of Cranbrook's ceramics department (1938–66), had a major impact on ceramics in the United States, both as an artist and as a teacher.

Born in Finland, Grotell studied art at Helsinki's School of Industrial Art and then took ceramics for six years with Englishman Alfred William Finch. After emigrating to the United States in 1927 and teaching at Rutgers and elsewhere, she was invited by a fellow Finn, the visionary

Maija Grotell, VASE (1949), stoneware, height 12⅝", diameter 10⅜". Collection Everson Museum of Art, Syracuse, N.Y. Photo: © Courtney Frisse.

architect Eliel Saarinen, to head the Cranbrook ceramics department.

Grotell's early style, featuring painted art deco motifs, won awards at the 1929 Barcelona and 1937 Paris expositions. Later, at Cranbrook, her glazed motifs related to the thrust lines and proportions of the vessels. Never content to play it safe, she was always searching for new methods, even if they sometimes led to disaster. "Once I have mastered an ... idea," she said, "I lose interest."[97]

An unorthodox teacher, she discouraged imitation of her work by students and encouraged them to discover their own bent, thereby making

Cranbrook a place of artistic ferment and excitement. Among her students were such famous potters as Richard de Vore, John Glick, and Toshiko Takaezu.

Hawaii-born **Toshiko Takaezu (1929–)** studied in Honolulu and then became one of Maija Grotell's outstanding students at Cranbrook Academy. She taught at Cranbrook and elsewhere, but since 1968 has been associated with the Creative Arts Program at Princeton University, while devoting more time to her own work.

Takaezu's influences come from East and West. A wonderful Zen spirit in the forms is combined with abstract expressionist modes of painting. In the 1950s she became a pioneer by closing the tops of her vessels, thereby announcing that they were really sculpture, or pure expressive form, rather than functional objects.

Takaezu's closed bulbous forms or shafts standing in groups on a bed of stones are enhanced with extraordinary glazes that have been called "color clouds" and often suggest landscapes. Sometimes she places a few pebbles in her pieces before firing so that when they are lifted a faint sound is heard. Recently she has produced bronze sculptures based on similar forms.

Living in a country farmhouse in New Jersey, the artist feels a harmony between all aspects of living, from raising vegetables to making ceramics.

OTHER CERAMISTS

Gertrud Natzler (1908–71) studied at the Kunstgewerbeschule in her native Vienna and began in 1933 to collaborate on ceramics with her husband, Otto. They decided on a simple division of labor: she threw the forms and he did the glazes.

By 1937 they had won the silver medal at the Paris International Exposition, but had to flee from fascism the following year, settling in California in 1939.

There they exerted a great influence on the ceramics movement—in fact, they were demonstrating ceramics at the San Francisco World's Fair on Treasure Island soon after their arrival. Beatrice Wood, Laura Andresen, and others learned much of their craft from the Natzlers.

Each of over 25,000 pieces on which they collaborated embodied a search for the perfect marriage of form and glaze. They kept systematic records in order to develop technical and aesthetic perfection. Gertrud's classic, elegant functional forms bearing Otto's unusual lavalike pitted glazes are in more than thirty-five leading museum collections around the world (Metropolitan Museum of Art, Museum of Modern Art, Art Institute of Chicago, Philadelphia Museum of Art, and so on).

Another refugee who brought Bauhaus ideals to America is French-born **Marguerite Friedlander Wildenhain (1896–)**. A student of Max Krehan and sculptor Gerhard Macks at the Bauhaus, she was imbued with the school's ideal of designing for mass production and industry, becoming a designer for the Royal Berlin porcelain factory. In 1933 she and her husband (also a ceramist) fled to Holland and then to California, where she opened the Pond Farm Pottery in Guerneville, soon a renowned workshop attracting students from all over the world. Harrison Macintosh and others speak of the effect on them of Wildenhain's personality and spirit during the extraordinary summer programs.

Although Wildenhain had long preached the gospel of design for mass production, she returned to a craft approach in the 1950s, feeling the increasing mechanization and loss of values

Marguerite Wildenhain, TEA SET (1947), stoneware. Collection Everson Museum of Art, Syracuse, N.Y. Given by Richard B. Gump. Photo: © Courtney Frisse.

in technocratic society. "Today," she wrote "I feel it is increasingly important again to stress the values of the way of life of a craftsman, to try to educate towards a basic understanding of the essence of life dedicated to an idea that is not based on success and money, but on human independence and dignity."[98] After that Wildenhain concentrated on stoneware ceramics decorated with reliefs and incised or glazed designs, and some primitivistic ceramic sculpture.

Laura Andresen (1902–) set up the ceramics program at UCLA when the community was still raw and untutored in the field and taught there until her retirement. In 1948 she began to work in the classic Japanese stoneware style, influenced by her friend and colleague, the famed Shoji Hamada. In 1957 she branched out into porcelain.

Andresen claims that she is simply creating utilitarian pots and vases, but their stripped-down classic forms in the Scandinavian modern tradition and their glowing glazes have made them objects of great eloquence. Their luminous peach glow and luster glazes seem to hark back to her youth, when she was growing up among the orange orchards and snow-capped mountains of San Bernardino, California.

Two graduates of Alfred University's renowned ceramics program are **Vivika Heino (1909–)**, who with her husband, Otto, lives in Ojai and produces award-winning decorative and functional

Eva Zeisel, DINNER SERVICE (designed c. 1942–43), porcelain, Castleton China Company, New Castle, Pa. Collection of the designer. Photo: Walter Civardi.

wares, often for architecture, and **Karen Karnes (1920–),** who taught at Black Mountain College and designs functional stoneware dishes, garden

seats, and other forms in the timeless Japanese-influenced tradition. **Mary Scheier (1910–),** with her husband, Edwin, creates superb wheel-thrown useful objects decorated with glazed and incised ornamentation inspired by pre-Columbian, African, and Oceanic sources.

Eva Zeisel (1906–), born in Budapest, was already a distinguished designer of mass-produced ceramics when she came to the United States in 1938. Here she became world famous, designing exquisite modern dinnerware and other objects for Castleton and other leading companies. The Rosenthal China Company in Germany issued one of her dinner services, named *Eva* after her.

California jeweler **Margaret de Patta (1903–64),** inspired in 1941 by her Bauhaus training at Moholy-Nagy's New School for Design in Chicago, returned to the Bay Area where she created abstract jewelry that is magnificently architectural and sculptural in design. A number of works are at the Oakland Museum. **Margret Craver (1910–)** is credited with revitalizing hollowware metalwork in the United States. She also revived the ancient technique of en résille enameling, incorporating the translucent enamels in magnificent abstract jewelry.

• 9 •

High Tech and Hard Edge: The 1960s

As the bold, expansive decade of the 1960s began to unfold, American art, reflecting America's postwar emergence as a superpower, now dominated the Western world. In Tokyo, Milan, and Berlin, artists were dripping paint like Jackson Pollock or welding sculpture like David Smith.

However, abstract expressionism had passed its peak and many sculptors now abandoned the emotionalism and complexity of the 1940s and substituted the clean geometry of minimalism. They sought machine-surfaced forms that could be perceived as great quintessential holistic images—as "objects" or "primary structures."

One influence was technology. In a brave new world of computers and space travel, sculptors eagerly experimented with electronics, lasers, light, motion, and new materials such as Plexiglas, polyester resin, and Cor-Ten steel. As they began to have their works industrially fabricated on a heroic scale, corporations and communities around the nation commissioned bold abstract public works for outdoor spaces.

Some of the excitement of the new sculpture came from daring feats of engineering—forms that cantilevered out from ceilings and walls, seemingly defying gravity. At the end of the decade, curator Maurice Tuchman organized an Art and Technology show (1970) at the Los Angeles County Museum of Art to bring together artists, scientists, and industry in the search for new forms.

In this period Chryssa developed neon sculptures; Beverly Pepper fabricated gleaming cantilevered forms that mirror the environment; Anne Truitt created minimalist painted wood boxes that were vehicles for experiencing color; and other women sculptors worked with clean reductive forms.

Pop art reintroduced the figurative, recognizable object. This was the era when Jasper Johns and Andy Warhol introduced elements from the mass-produced industrial society—Brillo boxes and beer cans. Marisol sculpted a Coke bottle in someone's mouth to equate eroticism with the mass-produced material object.

Yet on close examination, few women really purged their work entirely of metaphor or human content. Truitt's boxes refer to certain experiences; Pepper's forms are often metaphorical (and she often works the surfaces by hand); Marisol's so-called pop art, far from merely copying commercial images, deals with many human and social issues.

By the mid-sixties a new mood was seizing the country. The civil rights movement, the assassinations of President Kennedy and Martin Luther King, the widespread popular resistance to the Vietnam War all contributed to a questioning of beliefs and values. Like the dadaists during World War I, many young Americans began to create a new culture to counter what they felt to be a crass, unfeeling, and materialistic society. This new mood was soon reflected in art.

Critics identified a trend called "eccentric ab-

straction," or "anti-form." They saw in the work of a group of abstract artists a visceral use of nonrigid materials in loose indeterminate arrangements that approached disorder and chaos. Others reintroduced gut-level sensuality and emotion in sculpture. Eva Hesse injected a quality of the absurd into her strange abstractions made of latex and other limp non-art materials.

The monolithic mainstream—in which one movement dominates the scene—was breaking up. Artists, resisting the use of their work as a commodity to be bought and sold and eager to interract more directly with the audience, began to break out of the galleries and into "happenings"—events and performances. Toward the end of the 1960s some of them moved out onto the land to construct earthworks and siteworks that were actually part of the environment. Others "dematerialized" the object, producing emphemeral conceptual works based on ideas, words, and systems.

ART AND TECHNOLOGY

Chryssa (1933–) is the "sculptor of high voltage; the calligrapher of electricity."[1] Coming from Greece to New York as a young woman, she was greatly moved by the flashing lights of Times Square and became one of the first artists to use neon-light tubing as the form of sculpture.

Chryssa earned a bachelor's degree in sociology in Athens, but a brief, embittering experience as a social worker (children went homeless after an earthquake while money was used to rebuild monasteries) caused her to abandon social work for art. She studied in that city with the abstract painter Anghelos Prokopion and then went to Paris in 1953, where she took classes at the Grande Chaumière and met André Breton and other surrealists. She found the milieu uninspiring, however. After migrating to the Cali-

fornia School of the Arts (1954), she was deeply moved by her first sight of Jackson Pollock's work and rushed home to experiment with paint dripped onto canvas from cans with holes in their bottoms. Although these experiments did not satisfy her, they opened up new possibilities of pure form.

In 1955, at the age of twenty-two, Chryssa came to New York City, and excited by the visual assault of the media, advertising, lights, and signs, she introduced everyday urban motifs into her art. She responded to these stimuli in a fresh, detached way that would have been unlikely for a native New Yorker. For example, her first sculptures were plaster castings inspired by the insides of packing crates. When looking at these mundane forms, she saw in them shapes that reminded her of the forms on the heads of cycladic figures (*Cycladic Books,* 1955). These minimal bas-reliefs with virtually nothing on them except a slight suggestion of shallow Ts, anticipated the sculpture of the minimalists of the sixties.

The following year Chryssa arranged raised letter forms in meaningless bands, purely for aesthetic reasons, on monumental anodyzed aluminum tablets, thus forcing the viewer to regard the letters as abstract forms. She also arranged repeated plaster forms of a single letter at different angles in a box, creating poetic designs from the changing directions of the cast shadows.

Fascinated by newspapers—the varying textures and patterns created by classified ads, the stock page, the weather patterns—Chryssa used these repeated forms in a series of subtly modulated paintings and also cast a series of folded newspaper type molds (*Folded Newspaper,* 1958, Museum of Modern Art). Also intrigued by the commonplace objects of contemporary American life, she painted some of the earliest pop art repeated images in *Automobile Tires* and *Cigarette Lighter* (1959–62). In 1961 she had solo

Chryssa, FIVE VARIATIONS ON THE AMPERSAND (1966), neon light constructions in tinted Plexiglas vitrines, one 30¾" x 14¼" x 12⅜", four 29½" x 14¼" x 12⅜". Collection, The Museum of Modern Art, N.Y. Gift of Dominique and John de Menil.

shows at the Betty Parsons Gallery and the Solomon Guggenheim Museum.

To Chryssa, the lights on Times Square seemed as glowing as the gold backgrounds of Byzantine icons: "America is very stimulating, intoxicating for me.... The vulgarity of America as seen in the lights of Times Square is poetic, extremely poetic.... Times Square I knew had this great wisdom—it was Homeric—even if the sign makers did not realize that."[2]

Deciding to use commercial signs and neon in her sculptures, she apprenticed to a sign maker. At first she cut up discarded signs and made them into new images. While combining these icons in a crowded piece called *Times Square Sky* (1962, Walker Art Center, Minneapolis), she found the effect suffocating and interjected a section of blue neon-tube script in the upper right that spelled *air*. According to art historian Sam Hunter, this was the first work in which neon tubing was incorporated as a form in a sculpture.

The artist then explored the endless possibilities of the medium. She made variations on the letters *W* and *A* in banks of parallel neon lights; timers turned the lights on and off in long, tension-creating intervals; she used black glass or smoky gray Plexiglas cases to give the effect of night and recapture her original inspiration. The neon forms echoed and reechoed in reflections on the sides of the cases. Instead of trying to hide the wires and rheostats, the sculptor incorporated them as part of the form. A particularly beautiful series of variations on the ampersand were shown at the Museum of Modern Art.

In 1964 Chryssa began the heroic *Gates of Times Square* (1964–66, Albright-Knox Art Gallery, Buffalo, New York), which incorporated all the different avenues she had been pursuing—letter boxes, neon tubing, and commercial sign techniques. The artist even included the blueprints she had made for it in Plexiglas cases on the front of the sculpture.

The ten-by-ten-by-ten-foot construction in

neon, steel, aluminum, and Plexiglas is a giant cube whose entrance is framed by a huge *A*. Critic Pierre Restany has pointed out that this *A* form suggests many things—A for America, A for Alpha, and also, the A-shaped entrance to Mycenean beehive tombs.

The *Gates of Times Square* demanded all of Chryssa's toughness and practicality. She became a general contractor, supervising subcontractors who were not accustomed to her new forms and strange demands. Impatient with mediocrity, she eventually rented a loft in Brooklyn solely for this project and built most of the sculpture with her own hands, helped by hired glassblowers and foundries. (She had a similar experience in Europe two years later when she produced the sixteen-foot-high *Clytemnestra* 1968 for the Documenta 4 show in Kassel, Germany. She had to scour Europe to find subcontractors skilled enough to assist her.)

The artist invested her money, her health; sometimes she worked for weeks around the clock, sleeping in her clothes. In her journal Chryssa described the strange feeling she had when *Gates of Times Square* was finally completed. After finishing the various segments, the artist brought in industrial craftsmen to assemble the parts: "The men arrived and mounted the pieces. Then everything was finished, there was a great silence. . . . I went back to New York, I had dinner in Union Square. For two years I'd had no desire to see anyone."[3]

As Restany put it, "Times Square symbolizes the America of the mass media." Chryssa called it "the square of the times." It epitomizes the marriage of art and technology that took place in the early 1960s, an era of unparalleled optimism about the future of American science.

Like other artists of the period Chryssa was reacting against the emotionalism of abstract expressionism. Her works embody control and precision. Many of her paintings have the systemic grid and refined grayed modulations also seen in Agnes Martin (whom Chryssa admires), and her sculptures often look like machine products, although they have a sensuous beauty of their own.

In a lecture at New York University in 1968 she stressed the need to retain a "cool mind"; such a mind is bombarded by information in modern society and constantly tries to organize it in new ways. The artist should never do the same thing twice, but should constantly search for new forms, a new logic.

The contradiction between Chryssa's "hot" personality and her public adjurations to be "cool" is embodied in her huge *Clytemnestra II,* a sixteen-foot-high *S* in neon, inspired by the curves of the actress Irene Pappas's body as she screams on hearing of the death of Iphigenia in Euripides' play. A version in three colors, lit up in timed sequences, caused a sensation at the 1968 Documenta show and was purchased by the National Gallery, West Berlin. After this the artist was invited to create a sequence of murals for Count Peter Wolf Metternich's castle near Kassel, Germany.

A virtuoso piece from this period was a billboard-sized triptych that included *Today's Special,* based on the sales signs in grocery stores, *That's All,* glowing with fragments of multicolored neon letter forms (Metropolitan Museum of Art), and *Times Square Boogie Woogie.*

In the 1980s the artist made aluminum and neon wall pieces inspired by the calligraphy in Chinese newspapers—the Chinatown series. For these she cut forms out of the aluminum sandwich used in the aircraft industry. Solid letters are echoed in negative counterparts and reverse images, accented by neon elements.

Chryssa exhibited at the Centre Pompidou in Paris, had a miniretrospective at the Albright

Knox Gallery in 1983, and showed at New York's Castelli Gallery in 1987. Looking back, one is struck by the prescience of the artist. Pierre Restany points out that Chryssa's work can be seen as a metaphor for the importance of the form and structure of language and communication symbols. Her art anticipated the spirit of the age of television, computers, mass communications, and semiotics.

Lili Lakich (1944–) continues Chryssa's role as a pioneer of neon art. Since her first neon work in 1966, she has become the founder and director of the Museum of Neon Art in Los Angeles and has assumed the task of preserving neon signs (which are threatened with extinction), showing the work of neon artists, and promoting neon technology, which, in the hands of artists, has become increasingly complex.

Unlike Chryssa, Lakich uses figurative themes, sometimes stylized in a manner derived from art deco commercial neon sources—for example, *Drive-In* (Unity Savings Bank, Los Angeles) or *Elvis,* an homage to the rock-and-roll singer. Symbols often create metaphors for emotional states. In 1988 Tokyo's Touko Museum of Contemporary Art purchased eight works and also organized a retrospective that traveled to several countries.

Lili Lakich, DRIVE-IN (1984), argon with mercury and neon in glass tubing, aluminum, copper, brass, '57 Chevy fender, tire, 216″ x 120″ x 24″. Collection: Unity Savings, Beverly Hills, Calif. Photo courtesy of the artist.

Lin Emery (1926–)

> I juggle and juxtapose to achieve the movement I
> want; often I am surprised as the finished work
> invents an added dance of its own.
> —Lin Emery[4]

Lin Emery creates kinetic fountains and forms that swoop and bend, flutter and dip—driven by wind, water, magnets. A public sculptor who has done architectural commissions throughout the United States, her works have grown in size as their motions have grown in grace and complexity.

Born in New York City, Emery went to Paris in 1949 to become a writer and was doing translations when she met Ossip Zadkine who lived across the street. Although she knew nothing at all about sculpture, she became interested, and he took her into his studio. Zadkine emphasized that every sculpture has a thousand different profiles, every one of which must be composed with equal care. Emery later recognized that the motion in kinetic sculpture adds far more. Furthermore, the element of randomness present in it renders composing such a sculpture immensely more complex.

Emery was also influenced in Paris by Romanesque sculpture because it gave visual shape to spiritual values, "and that is precisely what I am trying to do today. My work is definitely not concerned with alienation, but with consciousness expanding and with spiritual peace." The crescent shapes in her mobiles "derive to a certain extent from the example of Romanesque Christs."[5]

After studying with Zadkine (1949–50), she learned to weld at New York's Sculpture Center (1951–52) and exhibited welded abstractions there. She then moved to New Orleans where she makes her home.

In 1957 Emery began to create "aquamobiles" (water-propelled fountains), and in 1969 exper-

Lin Emery, MAGNETMOBILE (1973) aluminum, 29′ x 12′ x 8′. South Central Bell Building, Birmingham, Ala. Photo courtesy of the artist.

imented with magnets to initiate the movement of forms. Since 1978 she has concentrated on air-propelled sculptures moving on ball bearings, expanding the tradition of Alexander Calder and George Rickey. The polished shapes of steel, aluminum, and other space-age metals flash in the light.

Her works seek to convey themes. For example, in *Eternal Flame* (1979), a memorial to a New Orleans philanthropist mounted on the façade of the Jewish Community Center on St. Charles Avenue, the turning of metal elements imitates the undulating motion of fire. And Emery has described the origin of *Variations* (K & B Building lobby, New Orleans) thusly: "Look at the way the wind moves through the grass and trees down by the Mississippi River and you'll see what I was trying to express with moving metal." In the same article, she said that in *Aquamobile* (1972, Longvue Gardens, New Orleans), a fountain in which "one form appears to be feeding off another," she was communicating feelings about motherhood which "I was experiencing for the first time."[6]

Her work is imposing but approachable, as in the twenty-five-foot *Morrison Memorial Fountain* (1967, New Orleans Civic Center Plaza), where porpoiselike forms swim, rise, and dip while intermittently shooting jets of water. Emery's sculptures are also in San Antonio, Dallas, Oklahoma City, Philadelphia, and other cities. In 1988 she completed a commission for Marina Centre, Singapore.

Perhaps her most monumental work is in the fifth-floor outdoor courtyard of the Hotel Inter-Continental, New Orleans. The space is dominated by Emery's fifty-six-foot aluminum and steel *Tree Sculpture* (1983). Working with composer James Drew, she invented musical pipe forms that hang on the wall and are activated by the wind, creating random sounds. In this project, Emery also enjoyed collaborating with physicist Robert Morriss, mosaicist Patricia Whitty Johnson, and mathematician Ronald Knill: "In the types of art I admire the most—Egyptian for one—the artists worked totally as a team. . . . Romanesque art was inspired by their faith, of course. It didn't matter whether you were a sculptor or a painter or an architect—you all worked on the same thing for a higher good."[7]

Liliane Lijn (1939–), an internationally known light and motion artist based in London, was born in New York. She is working on computerized figures that will respond to each other's light and voice signals.

The daughter of Russian-Jewish parents of the Upper West Side, she attended high school in Switzerland and then went to Paris where she became interested in Zen physics, Buddhism, and the Greek kinetic sculptor Takis. There she experimented with motorized forms and in subsequent years with a variety of works that seemed to dematerialize the object and reduce them to light. Some of them produce an almost hallucinatory meditative mood.

Lijn worked in New York (1961–62) and Paris and then spent two years with Takis in Greece, where they built a round house into an Athenian hillside (1964–66). She had a transcendental experience in that country: "The light there, the purity of the land, a spectrum emanating from prisms in a shop window, changed my state of mind . . . what could well be called enlightenment, in the truest sense—and I was illuminated by it and made happy—whole."[8] But while subsequently working on an exhibition at the Signals Gallery in London, she decided to settle there.

Lijn was in the 1967 "Lumière et Mouvement" exhibition in Paris; has worked with prisms, holograms, computers, motors; and has written poetry and published a science fiction novel *Crossing Map,* which embodies her transcendental

Liliane Lijn, SPLIT-SPIRAL-SPIN: Project for a
Structure as an Interference System (1980–82),
perforated stainless steel, galvanized mild steel, height
38′. Commissioned by the Warrington Development
Corporation for the Birchwood Science Park, Warrington,
England. Photo: Stephen Weiss, courtesy of the artist.

philosophical ideas. She created the twenty-foot
White Koan for a shopping center in Plymouth,
England, in which lines of colored light whip
around a white cone making the heavy mass ap-
pear to dematerialize into a moving line of color.
In *Split-Spiral-Spin* (1980–82, Birchwood Sci-
ence Park, Warrington, England), forty-foot
overlapping steel-mesh vanes create moiré pat-
terns that shift constantly as the viewer moves
around them.

In 1983 she completed *Lady of the Wild
Things,* "a larger than life, winged female fig-

ure, which responds with light signals to the
sound of the human voice. Lijn envisages this as
an emblem of the unconscious mind speaking
through the machine. The *Lady of the Wild
Things* has a . . . companion entitled *Woman of
War* . . . the two sculptures . . . converse."[9] More
recently, Lijn evoked the transformative power
of the Goddess in *The Bride* (1988) and *The
Electric Bride* (1989), sculptures that interact
with the audience.

Lijn played a role in the British feminist art
movement by pressuring the Hayward Gallery to
permit women to jury an exhibition—the first
show there in which women predominated. Now
a prominent artist, she has described the diffi-
culties she faced in the past, saying they were

> apart from the usual problems of total lack of
> support for years on end . . . the feeling of being
> an alien. The sense that my work does not fit
> into a convenient box or label because it comes
> from a complex experience which has little
> precedent. The experience is that of a woman
> artist who individuates as a woman and not
> within an existing male school or parameter;
> also not within the framework of so-called
> woman's work.[10]

Visitors to the 1974 exhibition of work by **Ruth
Landshoff Vollmer (1899–1982)** at the Ever-
son Museum in Syracuse might at first have
thought that they were in a museum of science
and industry. In works like *Spherical Tetrahe-
dron* (1970), *Archimedian Screw,* and *Steiner
Surface* (1970, Plexiglas), which grew out of an
extended investigation of speculative geometry,
Vollmer attempted to make visible the systems
that lie at the heart of all forms.

After growing up in a cultured family in Mu-
nich, Germany, and marrying a Berlin physician,
Vollmer was influenced by Bauhaus modernism
before fleeing from Nazism to the United States.
Her home became a gathering place for such

Ruth Vollmer, STEINER SURFACE (1970), Plexiglas, 12″ x 11½″ x 11½″. Collection of Whitney Museum of American Art, N.Y. Gift of Eric Green. Acq. #71.1. Photo: Geoffrey Clements.

of a glowing plastic sphere that sank into the base as spectators approached and then revealed a series of abstract designs to the viewer who peered down into it. Fascinated by her first glimpse of computer art at this show, she began to work with engineers and scientists at Bell Labs and elsewhere. Today she is one of the leading creators of animated computer art films and documentaries.

Lila Katzen, Marisol, and many other women experimented with lights, motors, and other technology. Intermedia artist Carolee Schneemann's thirty-foot motorized installation *Kinetic Umbrellas* (1963) was included in *Avantgardia: 1950–1990* at the 1990 Venice Biennale. Today performance artists such as Laurie Anderson and many video artist continue to explore the complexities of art and technology. Boston's Harriet Casdin-Silver became a pioneer in the use of holograms as an art form.

younger vanguard artists of the 1960s as Robert Smithson, Donald Judd, Sol LeWitt, Carl André, and especially Eva Hesse, who drew strength from the relationship. A leading spirit in discussions of the relationship between science, philosophy, and art, Vollmer was acknowledged by these younger and more recognized artists as an influential theoretician of the conceptual and minimalist movements of the late 1960s and early 1970s.

Lillian Schwartz (1927–) began as a traditional watercolorist but allowed herself to be swept up into the art and technology movement. Her work *Proxima Centauri,* in the 1968 Museum of Modern Art exhibition The Machine as Seen at the End of the Mechanical Age, consisted

MINIMALISM AND HARD-EDGE ABSTRACTION

The painted boxes of **Anne Dean Truitt (1921–),** seem at first sight to express the reductionism of the 1960s. Clement Greenberg called them "presences" which have the power to "move" and "affect" the viewer.

To Truitt they are not simply sculpture, but three-dimensional paintings—the very embodiment of color standing in the real world. She juxtaposes bands of hues, that saturate the work with a distinct mood. For example, in *A Wall for Apricots* (1968, private collection, Washington, D.C.), the six-foot tall box is divided into three color areas—the bottom third is orangy yellow, the midsection lime, and the top third white. The effect is of glowing sunlight rising to transcendent white. This work is a memorial to her late artist-friend Mary Meyer who loved the radiance

Anne Truitt, installation at the André Emmerich Gallery, March 1980. Courtesy André Emmerich Gallery, N.Y. Photo: Bettina Sulzer.

of "apricots" and "white walls." Rather surprisingly, each of Truitt's works originates in some remembered experience.

Anne Dean was raised in an eighteenth-century house on Maryland's Eastern Shore. There was a sense of quality to everything—from the handmade brass doorknobs to the Canton china dishes that her mother's ancestors (New England captains of clipper ships) had brought home from their voyages. This sense of quiet rightness and order can be felt in Truitt's work today. Her intellectual mother instilled in her good habits, discipline, and devotion to duty.

After graduating from Bryn Mawr with a B.A. in psychology, she worked at a hospital for a while, but found herself uncomfortable with the attitude of bureaucratic institutions toward the mentally ill. Along the way she took a night class in sculpture and found that it came naturally to

her. After marrying journalist James Truitt, the artist spent the next years moving to the locations of her husband's assignments and raising three children. But everywhere she managed to pursue her sculpture training. Critically important was study at the former Institute of Contemporary Art in Washington, D.C. (1948) where she learned her craft from an encouraging Alexander Giampietro and became friends with another faculty member, the color field painter Kenneth Noland. She also studied with Octavio Medillin in Dallas (1950), among others.

Upon returning to Washington in 1960, Truitt renewed her friendship with Noland, renting his studio after he left for New York. According to Walter Hopps, "Her conceptual foundation of art was beaten out during a series of dialogues with ... Noland, who ... shared with her his own highly intelligent and intuitive understanding of

an artist's involvement with his life and work."[11]

Truitt had explored many media, always with the idea of "figures" or "people" in mind, no matter how abstract. The turning point came in 1961 when, during a visit to the Guggenheim Museum, she saw the paintings of Barnett Newman, particularly his vast *Onement VI*. Swept away by the huge expanses of color, she was unable to sleep that night as she sat on her hotel bed, a new vision of sculpture looming in her mind.

After returning home, she made patterns and working drawings for large boxes to be fabricated by a carpentry shop. She then painted them with carefully worked out smooth brushless areas or bands of acrylic color. Form and color merged. The form *was* the color, and the color *was* the form. The artist had destroyed the illusionism that is inevitable when painting on a two-dimensional surface. The slightest mark on a canvas immediately implies depth. Now she had completely eliminated depth by having the color projecting out into real space. Color became an *object*.

In an outpouring of work, the artist completed thirty-two pieces of sculpture in 1962. When she showed these to Noland, he immediately called in his friend, critic Clement Greenberg, who felt that they had "changed the direction of modern sculpture." André Emmerich offered her a show at his gallery in 1963 and others followed. In 1973–74, Truitt had retrospectives at the Whitney Museum and the Corcoran Gallery in Washington, D.C. The rigorous artist destroyed all of her early work and an entire group of aluminum sculptures done while her family lived in Tokyo between 1964 and 1967. Somehow the light wasn't right, and her colors went off, she says.

Each of Truitt's works has a distinctive resonance. For example, *Wish* (1969), painted in pale grayish blue to violet, is like a yearning wish, and *Knight's Heritage* (1963), a stocky form divided into vertical bands of black, gold, and deep terra-cotta, produces a heraldic effect—like a medieval or Renaissance banner. She is sometimes concerned with how bands of color travel *around* the sculpture, conveying a sense of passage of time.

Like a number of talented women artists, Truitt is also a writer and has, in recent years, published two well-received books, *Daybook* and *Turn,* which record her introspective journey to self-realization. Through diary entries she explores the pain of her dissolving marriage, her husband's subsequent death, the public's incomprehension of her austere art, the struggle to maintain a creative relationship with her children, and her gradual integration as an artist and a human being. Truitt also describes the interludes at Yaddo, the artists' retreat, where the peaceful milieu made it possible to work during chaotic periods, and where she served a stint as director.

Beverly Pepper (1924–)

[Her] ambition is to be the first woman to orchestrate all the elements of vast public works, the way medieval master builders supervised all the aspects of erecting cathedrals.
—Barbara Rose[12]

Beverly Pepper embodies in her work the heroic stance of post–World War II sculpture. Her steel, stone, and concrete abstract sculptures are found around the world, from Dallas, Texas, to a sculpture park in Barcelona, Spain. One of them is an amphitheater that holds a thousand people.

Pepper has journeyed from a middle-class home in Brooklyn to the fourteenth-century villa in Italy where she lives and works today. She was the wunderkind of her Russian-Jewish parents—a child prodigy who completed her older brother's and sister's school art projects and was

accused by her teacher of copying her artwork from books.

At Pratt Art Institute, where she majored in advertising design, she drove herself without sleep, attending evening classes at Brooklyn College with Gyorgy Kepes, the Bauhaus designer, because she thought she wasn't learning enough. By the age of twenty, Pepper held a lucrative position as an art director in an ad agency, designing everything from toothpaste tubes to boxes that turned into toys. She was good at working with tools and solving engineering and technical problems, interests that served her well when she began to study sculpture. But at twenty-one, close to a breakdown, Pepper realized that she detested the world of advertising. She cut all her ties with the past and took an ocean liner to Paris in 1949, determined to be a full-time artist.

There Pepper studied with André L'hote and Léger, and peered with awe into the ateliers of Zadkine and Brancusi. She found the situation difficult—trying to find her way with no guidelines.

At this time Pepper met and married Curtis William Pepper, author-journalist. He had majored in art history, so the couple had an enchanting time visiting the museums in Europe. During the following years, while raising a son and daughter in France and then in Italy, Pepper painted semiabstract expressionist pictures with a certain amount of social content. The poverty and destruction in postwar Europe had touched her.

In 1960, as a result of a trip to see the awe-inspiring monuments at Angkor-Vat, Pepper found her true medium. The image of the jungle growing over the ancient forms never left her, and she has since that time been concerned with the interaction between sculpture and the landscape. On her return to Rome, she found thirty-nine trees fallen in a field next to her house and

immediately set to work on them with saws and electric drills. Those early wood sculptures, followed by rough-textured bronzes, have an organic look, reminiscent of Moore or Hepworth.

The direction of Pepper's career was changed by an unexpected invitation. The critic Giovanni Carandente, unaware that she knew nothing about welding, invited her to submit welded pieces to the forthcoming outdoor sculpture exposition at Spoleto. Pepper hesitated for a moment, but hearing that David Smith and Alexander Calder would be in the show, with customary brashness she agreed and immediately apprenticed herself to an ironmonger.

When the facilities of a steel plant were put at her disposal, Pepper felt intimidated:

> I had almost no experience with a welding torch, and I had to convince the men in the factory that I knew what I was doing. It wasn't easy.... No woman had ever made art in a factory. Once I had convinced them that I *could* pull all this heavy metal together they accepted me. The hardest part, though, was eating the onion and sausage sandwiches at 7:00 A.M. and again at 11:00 A.M. when the men took their breaks. I knew I had to do it to be really accepted as an equal and a comrade.[13]

While Pepper was working on welded pieces, David Smith, impressed by the coiled and rolled forms she was creating, encouraged her to continue in the medium. They shared experiences; she discovered that even Smith had terrors and feelings of failure—a sense of being always on the edge of disaster. Inspired by this mentor, Pepper discarded all representational elements in her work and addressed herself to pure form.

When asked why she remained in Italy during the 1950s and 1960s when New York was considered the place to be, she pointed out that she and her husband could live there on a hundred dol-

Beverly Pepper, EX CATHEDRA (1968), painted stainless steel, 101½″ x 90″ x 83″. Hirshhorn Museum and Sculpture Garden, Smithsonian Institution. Gift of Joseph H. Hirshhorn, 1980.

lars a week and afford the domestic help that freed her to be a sculptor: "Bill and I knew all the writers, directors, ... and politicians in Rome. It was exciting to be in the middle of all the artistic ferment."[14]

Pepper works in series that mark the decades. After the early gestural calligraphies of metal (*Spring Landscape,* 1962; *Wind Totem,* 1962), she explored shiny, hollow box forms that teeter in precarious stacks. Perhaps initially inspired by Smith's early cubi-forms, Pepper developed the idea in a fresh, original way. The polished stainless steel exteriors mirror the earth and sky, changing with the light and reflections; the interior surfaces are enameled a contrasting color—orange, white, or ultramarine blue. The

openings serve as windows permitting the landscape to function visually as part of the sculpture. Thus, paradoxically, the solid forms appear dematerialized while the empty spaces they enclose, the voids, seem solid—a play on illusion and reality.

In the early 1970s, Pepper constructed triangular forms that thrust forward and support themselves at seemingly impossible angles (*Phaedrus* 1978, Federal Building, Philadelphia; *Excalibur* 1976 Federal Building, San Diego). These works sometimes contain triangular openings that bevel in odd directions so that when seen from different sides they seem discontinuous. To Pepper these openings are metaphors for the mysterious inward forces that propel the outer self. *Alpha* consists of wavelike orange and black tent shapes that support themselves in an unexplainable balance, anchored to the ground by invisible concrete supports. Another series followed—bundles of skeletal steel rods rushing off at dynamic angles, seemingly about to fall, but held in mysterious suspension.

In the late seventies Pepper radically changed her vocabulary of forms to totemic vertical "presences" that have a transcendental aura. Believing that sculpture should affirm the continuity of the human spirit despite the threat of nuclear and racial holocausts, she called them "altars" and "sanctuaries." Perhaps their inspiration was her good friend Barnett Newman's *Broken Column* (1963–67, Mark Rothko Chapel, Houston), dedicated to Martin Luther King.

Many of these totems resemble the forms of tools—tuning forks, files, screw drivers, drill bits—standing on end. Four of them stand in the ancient piazza of Todi. In the stone carving *Basalt Ritual,* a group of four "figures," like two couples, confront one another on a circular stone base. Reminiscent of ancient cycladic idols or Greek columns, the tapered shafts crowned with arcs or wedge forms stand like gods and god-

Beverly Pepper, BASALT RITUAL (1985–86), basalt, 7′11″. Collection of Koll Company, Irvine, Calif. Courtesy of Lonny Gans and Associates, Marina del Rey, Calif. Photo: André Emmerich Gallery, N.Y.

desses against the sky, each slightly different from the next—just as we are all different from one another, yet share a common humanity.

These forms have a timeless, ancient resonance that Phyllis Tuchman has called "archaeological minimalism." Living amidst the peaceful sheep-dotted Umbrian landscape, in a centuries-old building that she remodeled with rubble from nearby ancient ruins, Pepper feels a sense of continuity, the past merging with the present.

The sculptor's public site works grow increasingly ambitious. *Land Canal,* a series of concrete prism shapes in a Dallas shopping center, was followed by *Amphisculpture* (1974–76, Bedminster, New Jersey) a sculpture in the form of a concrete amphitheater penetrated by a wedge form, partially overgrown with grass. *Thel,* on the grounds of Dartmouth College, New Hampshire, is a sitework of shifting concrete forms partially set into the land, and a grassy earthwork and tree grove is at Laumeier sculpture park, St. Louis (1985).

For the past few years she has been working on *Sol y Ombra* (Sun and Shadow), a park in Barcelona, Spain. The size of two football fields, it consists of two areas—an undulating sun-drenched earthwork and a shady spiraling grove of trees. Inspired by Barcelona's Gaudi, she is embellishing the forms with colored tile surfaces and has even designed sculptural light fixtures.

Pepper has successfully combined a career and family. Her daughter, Jorie Graham, is a prize-winning poet, and her son, John Pepper, is a film director-actor; her granddaughter delights her. An intense high-energy person and famous hostess who loves people around her and has written three cookbooks, she has attracted other Americans in the arts to the hills around Todi—now affectionately referred to as "Beverly Hills."

Since her earliest days Pepper has pushed herself to the edge to respond to great challenges. A 1986 retrospective traveled from the

Beverly Pepper, AMPHISCULPTURE (1974–76), concrete and ground covering, height 8′ x diameter 270′ x depth 14′. American Telephone & Telegraph Long Lines Building, Bedminster, N.J. Photo: Gianfranco Gorgoni, N.Y., courtesy André Emmerich Gallery, N.Y.

Albright-Knox Art Gallery in Buffalo, New York, to the Brooklyn Museum and two other cities.

Doris Leeper (1929–), constructs geometric, hard-edged "color forms" that stand in airports, museums, and corporate centers, primarily in Florida and the southeastern United States.

Leeper has been known as "Doc" since her early days as a premed student at Duke University. There, a professor in a lab course pointed out that her scientific drawings were extraordinary, leading her to study painting and earn a degree (Phi Beta Kappa) in art history in 1951. Atter ten years as a successful commercial graphic artist, she was able to move to New Smyrna Beach on an empty stretch of the Florida coast and devote all her time to sculpture and painting.

The artist worked her way from representational art to nonobjective shaped canvases that move forward from the wall plane and then to free-standing sculptures "which cause line and color to function in space." Like Tony Smith and Donald Judd, she rejected the emotional abstract expressionism of the 1940s. "Today," she says, "works of art are presented straightforwardly as objects rather than as mysterious renderings shrouded in metaphysical symbolism."[15]

Leeper's color forms rise directly from the ground without a base. *Untitled* (1972), in front of Reserve Insurance Company, Orlando, Florida, consists of three Fiberglas diamond-shaped forms that are painted in permutations of rich red and red-purple, and stand side by side on

sliced-off points. Many have an arrowlike diagonal or cantilevered thrust that seems to say "go!" (*Untitled,* 1970, Jacksonville Art Museum, Florida). The sculptor designed four forms that can be mass produced in color-stained concrete multiples for use in sculpture gardens or playgrounds "with wide latitude in their arrangements and juxtapositions."

Leeper exhibited at New York's Bertha Schaefer Gallery (1969, 1972) and has had more than twenty other solo shows, including traveling exhibitions organized by the Hunter Museum of Art (1975) and Loch Haven Art Center, Orlando (1979–80). Her works are at the National Museum of American Art, Wadsworth Atheneum, Chase Manhattan Bank, and more than eighty other collections.

"Doc" Leeper is also a force in Florida cultural life and in the ecological movement. Her white hair, sunburned face, and athletic gait are seen in many board rooms and committee meetings. She conceived of the Atlantic Center for the Arts and became the prime mover in its development. Passionately fond of the grassy dunes at the Canaveral seashore near her home, she played a major role in preserving them from destruction by overdevelopment and pollution. She was appointed by the U.S. Secretary of the Interior to serve on the Canaveral National Seashore Advisory Commission and is also on the Board of the Florida Conservation Foundation.

Betty Gold (1935–) of Los Angeles creates constructivist steel sculptures that she describes as "halfway between Alexander Calder and Richard Serra."

After graduating from the University of Texas at Austin (1955), she spent four years in the Dallas studio of sculptor Octavio Medellin (1966–70) and has since created outdoor monuments all over the United States and abroad.

In the Holistic series, rectangular sheets of steel are cut into from three to nine curved and rectilinear shapes, which are then painted and welded together in various compositions. The title "holistic" comes from the notion that the "whole is greater than the sum of its parts"—the simple rectangle gives rise to endlessly complex and varied structures. One, on the University of Texas campus in Austin, consists of a roughly triangular dark brown form. The vertical lines of the piece echo the vertical lines in the architecture behind it, while the cutout curved openings reveal a changing vista of trees, sky, and architecture, as the viewer walks around it.

Gold has had solo exhibitions at art museums in Phoenix, New Orleans, the Milwaukee Art Center, and elsewhere. Among her sculptures are those at the Indianapolis Museum of Art (1980) and Pittsburgh's Hartwood Acre Park, as well as a two-part sculpture for the new Museum of Contemporary Art in Seoul, Korea, commissioned in time for the 1988 Olympics.

It may come as a surprise to find **Judy Chicago (1939–)** included among sculptors of the 1960s since she has become identified so strongly in the public mind with the feminist movement of the following decade. But, in fact, after graduating from UCLA she was already an established painter and minimalist sculptor in 1965, when she created *Rainbow Pickett,* a row of six pastel colored beams, progressively larger in size, that leaned against a wall. Her work was in the 1966 Primary Structures exhibition at the Jewish Museum, and a room was devoted to her large fiberglass colored cylinders in the Los Angeles County exhibition, Sculpture of the Sixties. Very few women were included in that high-powered show.

As Chicago began to break away from accepted forms and express herself honestly as a woman, she found that the male-dominated art world was incapable of understanding her work.

A trio of spray-painted breastlike dome forms shown in a 1970 solo exhibition at the California State University art gallery in Fullerton was among her first attempts to inject a new female image into art. In this period she created innovative colored smoke "atmospheres" and fireworks pieces.

Chicago's subsequent history as an innovative leader of women artists is described in the introduction to chapter 10. One of her important contributions is *Through the Flower,* a remarkable autobiography describing her transformation.

After two monumental collaborative projects, *The Dinner Party* and *The Birth Project,* the artist returned to her own individual work in a 1986 exhibition entitled *Power Play* at New York's A.C.A. Gallery. In propaganda paintings and large bronze reliefs of tormented male heads, the female gaze is turned on men who are shown as victims of enforced role-playing that drives them, and thus the world, to violence and destruction. Figurative and realistic, these works depart from the artist's earlier abstract symbolism, but they continue to serve her belief that art should have an impact on society. Chicago is working on new imagery connected with the Holocaust and with the state of the world in general.

In the 1960s **Lila Katzen (1932–)** explored light and space. Today she bends steel into rolling curves that invite the viewer to sit, climb on, or walk through them .

Raised in Brooklyn, New York, the daughter of a widowed working mother, Katzen identified early with her grandfather, an immigrant painter from Russia, who decorated public buildings and showed her how to paint fake wood and marble or apply thin, glittering sheets of gilt to a surface.

Katzen was one of those New York kids who spent her spare time roaming through the New York museums. After earning a degree in painting at Cooper Union and working as a commercial artist, she moved with her husband to Baltimore. When her two children were born, she fitted them into her work schedule, sometimes painting until two in the morning when they were asleep. Classes with Hans Hofmann turned her toward abstraction. Along with her Baltimore friend, Morris Louis, she was one of the earliest to drip and stain painterly gestures into raw canvas.

In the late 1950s, driven by a desire to have the forms "leap forward," Katzen began experimenting with fluorescent paintings on sheets of Plexiglas mounted in stands one behind the other and lit from below with black light. In 1960 sculptor George Segal saw these works in Provincetown and told her very seriously, "what you want to be is three-dimensional."[16]

Like many artists of the 1960s, Katzen was enthralled by new technology. In 1968 she constructed *Light Floors*—three rooms whose acrylic floors were lit with fluorescent tubes that changed color as you walked across them. One room had black walls that produced the sensation of falling into a bottomless pit if the viewer moved off the lit floor. In 1969, inspired by the moon landing, Katzen constructed an imaginary moonscape in front of a projected transparency of the far side of the moon at New York University's Loeb Center. For the 1970 São Paulo Biennal, she built a sixty-five-foot octagonal tunnel lined with colored fluorescent liquids in vinyl pouches. Critic Grace Glueck said that walking through it was "like looking through an opal."

In 1970 Katzen created her first steel pieces for the exhibition *Liquid and Solid* at the Max Hutchinson Gallery and since then has been bending it into springy curves, working at fabrication plants and in her own studio. In contrast to the prevailing cold style of minimalist public steel sculpture, her works often invite the spec-

Lila Katzen, WAND OF INQUIRY (1983), a two-part sculpture, textured stainless steel and Cor Ten, 19′ x 10′ x 10′ and 10′ x 10′ x 10′. Commissioned and sited for the Rosenstiel Basic Medical Sciences Research Center at Brandeis University, Waltham, Mass. Photo: Courtesy Katzen Studio, Inc.

tator to interract with them. The loops of Cor Ten and brushed stainless steel in *Oracle* (1974, University of Iowa Art Museum, Iowa City) often serve as a jungle gym for children. Other works are *Priapos* (1976, Greenwich, Connecticut), *Traho* (Wadsworth Atheneum, Hartford), a 1979 commission for HUD in Miami, and several commissions for the Saudi Arabian royal family.

In *Wand of Inquiry* (1983) in front of the Rosenstiel Medical Research Center, Brandeis University, the form in front suggests a book or scroll, while on a higher step behind it a vertical ribbon of steel unfurls toward heaven like an upraised arm, suggesting aspiration—a fitting metaphor for the reach of scientific research.

After a trip to Chichén Itzá and Uxmal, Katzen's work took a more baroque direction in the 1984 traveling exhibition, Ruins and Reconstructions. Painting and sculpture are combined in flamboyantly decorative installations that evoke the magic and mystery of ancient rituals. *Personage with Feathered Headdress*, a gold and silver totem with unfurling "hair" and

upraised arm, stands, like a high priestess, against screens painted with sculptural motifs from pre-Columbian façades.

Critic Donald Kuspit points out a feminist subversiveness in these "Mayan" works:

> The allusions to Mayan sculpture and architecture are made in the spirit of feminist appropriation of signs of male dominance and aggression.... She speaks of "seduction ... opulence and grand ease" rather than of violence, angry gods, human sacrifice. She uses the language of traditional feminine sensibility rather than language appropriate to the male self-glorification embodied in her sources....[17]

Katzen, since the early 1970s, has been a spokeswoman in the feminist art movement, serving on the boards of the Women's Caucus for Art and the College Art Association. Her theatrical new works, with their curves and calligraphies of gold and silver, flaunt the "pattern and decoration" ethos introduced by feminist artists in the 1970s. They send a hidden message of female power.

Some other sculptors producing distinguished large-scale abstract welded steel commissions are **Marcia Wood (1933–)** in Michigan; **Jean Woodham (1925–)** in Connecticut; **Dorothy Berge (1923–)** in Georgia; **Jane Frank (1918–)** in Maryland; and **Johanna Jordan (1919–)** in California.

Sylvia Stone (1928–) creates abstract forms out of large transparent planes of intersecting bronze, green, and smoky gray Plexiglas. Paradoxically, she uses this clean constructivist mode to create intuitive, lyrical works that suggest ideal dream spaces of the mind.

Stone has spoken of their obsessive psychic origins. Art has always been a refuge for her, a safe place in an insecure world. Born in Toronto, she was in and out of foster homes as a small child and then endured years of hardship with her struggling mother. She drew continually, often pictures of imaginary homes to replace the shifting ugliness around her. She still creates imaginary palaces.

Precociously talented, she was admitted to a public high school for gifted students where the teachers encouraged her. On her own at sixteen, she dreamed of being an artist in New York and saved up enough money from a window display job to go there in 1947. Soon married, with children, Stone nonethless struggled to go on painting, bringing her work for criticism to Vaclav Vytlacil at the Art Students League.

In the 1960s, when artists were experimenting with shaped canvases, Stone began to make wall reliefs from sheets of Plexiglas painted in acrylics, shown in 1967 at the Tibor de Nagy Gallery. After this she discarded painting entirely and worked with transparent Plexiglas in environmental three-dimensional forms.

Another Place (1972) consists of planes that intersect at angles with two arcs. *Manhattan Express* (1974), like its title, is a dynamic thrust of multicolored triangles in which colors shift and change as they overlap. In *Egyptian Gardens* (1975–76), composed of green-tinted triangles, Stone "dissolves much of whatever mass there is in her tranparent medium, using its reflections and refractions to produce a shimmering, cool green-tinted light, a poetic atmosphere ... that changes surprisingly with the viewer's slightest shift in position."[18]

The sculptor sometimes sands surfaces to produce varying opacities or introduces occasional opaque acrylic or aluminum planes. The seams and joins of the Plexiglas edges create internal "lines" that make a linear counterpoint to the forms. The viewer sees one plane floating past another while walking around the work.

Stone was in the Bicentennial exhibition 200 Years of American Sculpture at the Whitney Mu-

Sylvia Stone, GREEN FALL (1969–70), wood, stainless steel, and Plexiglas, 67½″ x 20½″ x 62″. Collection of Whitney Museum of American Art. Gift of the Howard and Jean Lipman Foundation, Inc. Acq. #71.3. Photo: Geoffrey Clements.

seum, New York. She uses a cold industrial material and a constructivist mode to create a "multi-referential, spatially disorienting, intuitive and lyrical vision."[19]

Raquel Rabinovich (1929–), born in Buenos Aires and trained at the University of Cordoba in Argentina, creates architectural and mazelike structures out of gray or bronze plate-glass rectangles. Their changing transparencies and layers create a mysterious play of illusion and reality. Somewhat related to the works of artists like Sylvia Stone and Larry Bell, these structures have no Latina content, but rather belong with the light and space trends of the late 1960s.

An international artist who trained at the Atelier André Lhote in Paris and first showed abstract paintings in London, Copenhagen, and Argentina, she lives in New York City, has shown at the Susan Caldwell Gallery (1975), and installed structures at SUNY in Stonybrook and the Heckscher, Suffolk, and Bronx museums.

Rabinovich's deceptively simple structures explore complex, ambiguous ideas about reality. For example, *Cloister, Crossing, Passageway* (1978), shown at the Jewish Museum, New York, explores a "vision of the world as if we were looking at it from the inside and outside at the same time." *The Map Is Not the Territory* (1982), shown at the Center for Inter-American Relations, New York, is a mazelike structure in which the viewer enters baffling cul-de-sacs, but is able to see tantalizing, shifting spaces through the glass.

Several other abstract sculptors have explored the aesthetic possibilities of new manmade materials. **Freda Koblick** of San Francisco, a pioneer in the use of plastic as an art medium, attended San Francisco State College and then trained at the Plastic Industry Technical Institute during World War II. In the 1950s she poured acrylic monomer into prism shapes for use in wall reliefs, lighting fixtures, and so on. A twenty-five-foot wide back-lighted plastic wall in the lobby of the Morton Salt Building, Chicago, uses the motif of translucent salt crystals outlined with anodized aluminum strips embedded in the plastic. Other works are in the Crocker-Anglo Bank, San Francisco; Rohm & Haas Company, Philadelphia (1964); and San Francisco International Airport (1978). She had solo shows at the Museum of Contemporary Crafts and Arizona State University at Tempe. She was a Guggenheim Foundation fellow in 1970–71.

Deborah de Moulpied (1933–), born in Manchester, New Hampshire, studied at the Yale School of Art and Architecture (M.F.A., 1962). In the 1960s she created nested shell-like forms, taking advantage of the translucency and flexibility of heat-molded vinyl (*Form No. 4,* 1960). She continues to explore molded sheet plastic in mobiles and abstract wall reliefs—organic abstract forms that sometimes suggest flying skeletal shapes (*Endo-Exo Series,* 1980s). An architectural designer from 1972 to 1978, de Moulpied received the Design in Steel Award (1975) from the American Iron and Steel Institute for excellence in design in environmental enhancement.

Others who have created distinguished abstractions in plastics are **Jeanne Miles, Harriet FeBland, Miki Benoff, Fran Raboff, Jennie Knight,** and **Linda Levi.**

ASSEMBLAGE AND GESTURAL AND ECCENTRIC ABSTRACTION

Lee Bontecou (1931–) has created menacing icons of canvas stretched over a welded steel frame. With their gaping central holes and sawblade teeth, they seemed to sculptor Donald Judd like "threatening and possibly functioning" objects whose "image extends from something as social as war to something as private as sex, making one an aspect of the other."[20] Critics have seen other things in Bontecou's works— machines and monsters, airplanes, ancient goddesses and kayaks. In the 1970s, feminist artists found in them a blatant expression of powerful vaginal imagery.

Bontecou was one of the few token women who, in the 1960s, were accepted at a top gallery—in fact, she was at that time the only woman carried by the prestigious art dealer Leo Castelli. Recognized at age thirty-three as one of the most original assemblage sculptors in the United States, her work was snapped up by collectors and museums.

Born in Providence, Rhode Island, and raised in Westchester County, New York, she spent summers with her family in a cottage in Nova Scotia, her mother's place of origin. This was a vivid part of her life—squishing barefoot on mud flats filled with crabs and fish, where the dangerous tides would suddenly come up and catch her unawares. She was already whittling little ox carts and building small environments in the marsh grass.

The birds, crustaceans, and other creatures turned up in her sculpture later on. But there was another vivid image that played a role in her subconscious. Her elementary school had an old airplane from World War I, and she loved to climb over it and play pretend games inside with her friends. Later she was impressed by the force and power of jet planes and by the marvel-

ous way in which they are riveted together.[21] These forms influenced her art.

Bontecou had very energetic parents (her mother loved working in a factory wiring submarine parts during the war, and her father invented the first aluminum canoe), and she grew up feeling independent—that she could make or do anything if she had the tools.

A student of William Zorach and John Hovannes at the Art Students League, she won a Fulbright fellowship to Rome in 1957–58 and the Louis Comfort Tiffany Award in 1959. At that time Bontecou was creating aggressive-looking abstract bronze birds (*Grounded Bird,* 1958, Pennsylvania Academy of Fine Arts) and figures that were somewhat like Henry Moore's. In her first show at the G Gallery in 1959, two figures were described as showing "mechano-organic innards seen through openings in the metal skin"[22]—in other words they were already showing a strange synthesis of the machine and the living organism. Constructed by casting the bronze parts and welding them together, this method of putting together a mosaic of pieces led up to her major oeuvre.

Bontecou lived in an unheated New York loft in a poor neighborhood, struggling to find her own expression. In an effort to get sculpture up off the floor and hang it on the wall, she was welding steel frames and filling the spaces with a skin of metal pieces (like an airplane). But it was still so heavy that when she tried to hang it the wall crumbled.

Bontecou discovered the lightweight material she needed through one of those serendipitous insights that seem to happen to creative people. She was living over a Chinese laundry and had drilled a hole through the floor to let the heat come up into her freezing loft space. Retrieving the used canvas conveyor belts and old laundry bags she saw the laundry throwing out, she tried lashing this material to her welded rod frames

with thin flexible wire. This produced precisely the kind of light, strong structure she needed.

Bontecou became a scavenger, hunting for canvas carcasses—old tents, knapsacks, hoses, whatever came to hand, their weathered tans and dirty tones revealing a kind of poetry that appealed to her. Soon she was incorporating gears, wall plugs, and other industrial castoffs into her canvas and steel forms. But always, the central focus was a large gaping opening that mesmerized the viewer with its mystery. What lay behind the uncanny and compelling imagery in these works? For a long time, Bontecou did not answer this question because she didn't want to restrict the imagination of viewers.

Critic Dore Ashton saw in them the mythic references so characteristic of the art of the New York School:

> In contemplating the black vacant centers with their tiers of protective shelves, the mind could . . . go to wells, tunnels, sequestered and mysterious places that are not necessarily menacing. The circularity of Bontecou's central shapes can be seen as an inspired evocation of a deep-seated human hunger for the *axis mundi,* the central point around which the cosmos circulates. Her image recalls Mircea Eliade who has written persuasively of the symbolic importance of the center, the consecrated point on which all so-called primitive mythologies are based.[23]

Only much later did the artist reveal the direct inspiration for these images (of course, it is likely that other unconscious factors were at work). Like many young people of her generation, Bontecou was reacting to the cold war and the horror of the nuclear age. Listening to United Nations programs on her shortwave radio as she worked, remembering the Holocaust, she often became angry and depressed.

The sculptures with teeth were "like war

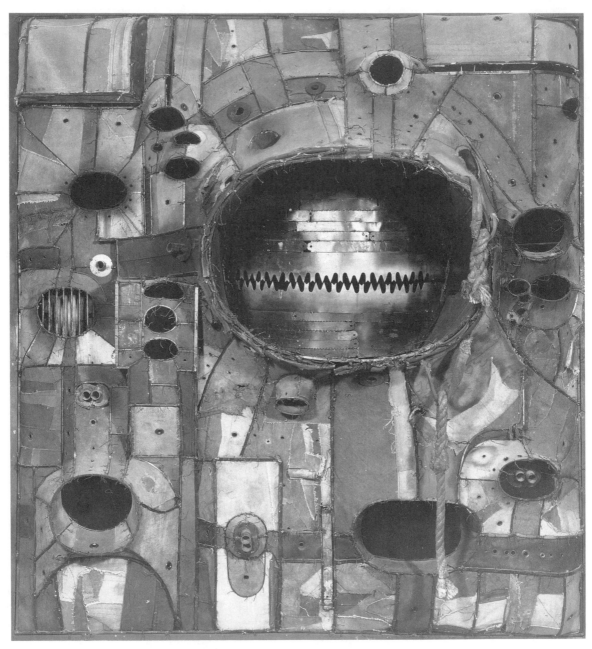

Lee Bontecou, UNTITLED (1961), welded metal and canvas, 72″ x 60¼″ x 26″. Collection of Whitney Museum of American Art. Purchase. Acq. #61.41. Photo: Geoffrey Clements.

equipment."[24] (But she also made others that were more open and optimistic, with one single opening that led into deep space, like "opening up into the heavens.")

In *Untitled* (1961) at the Cleveland Museum of Art, the central opening seems to hold an imprisoned human eye looking out through the bars of an oval prison grating—even the faded numbers printed on the canvas suggest Auschwitz. In another work, the opening is lined with black velvet, and in still another it is painted white, reminding Ashton of "the ribbing of an abandoned hull."

Bontecou branched out into forms that resembled airplane wings and engines. For the New York State Theater at Lincoln Center, she built a twenty-foot-wide mythical flying machine using canvas, velvety pieces of yellow chamois, molded fiberglass forms, even the Plexiglas turret of an old World War II bomber. Architect Philip Johnson declared that this piece functioned in the stairwell "as well as a baroque statue in the niche of a baroque hall." *Life* magazine on 10 April 1964 carried an article entitled "Young Sculptor Brings Jet Age to Lincoln Center," saying that "the artist herself has soared spectacularly up through the art world."

On the whole, the compelling force of Bontecou's work can be explained by its role as a totem of our self-destructive age. In purely formal terms, the artist is also an innovator. Donald Judd pointed out that she was "one of the first to make the structure of a three-dimensional work co-extensive with its total shape.... The periphery is as much a part of the single structure as the center."[25]

Lee Bontecou, UNTITLED (1964), welded steel, epoxy, and canvas. Collection: New York State Theatre. Photo: Courtesy Leo Castelli Gallery.

A rich effect is created by the varied tones of the materials lashed within a visible welded steel outline, like stained-glass windows or cloisonné. Despite their powerful and sinister look, the method is basically rooted in the ancient female heritage of sewing and patchwork, albeit with wire instead of thread, combined with the very contemporary technique of welding.

In a 1971 show at the Castelli Gallery, the artist moved into a completely different mode. She was experimenting with large vacuum-formed transparent plastic fish and flower forms suspended from the ceiling with plastic tendrils and stems, which, she said, had an ecological theme. These works did not totally satisfy her, however. Caring little for the hoopla of the art scene, she has been working in seclusion, while raising a daughter and searching for new forms.

Eva Hesse (1936–70)

> Absurdity is the key word. . . . it has to do with contradictions and oppositions in the forms . . . order versus chaos, stringy versus mass, huge versus small. . . . I would try to find the most absurd opposites. . . . it was always more interesting than making something average, normal, right size, right proportion.
> —Eva Hesse[26]

It took a victim of the Nazi persecutions to fully appreciate and express the absurdity of life in limp, dangling, wrapped, bound, obsessively repeated forms that violate all accepted notions of "beauty." Hesse died at thirty-four of a brain tumor. Yet in her short life she became a leading figure in the movement to bring back the personal, the erotic—in short, the human—into abstract art.

Born in Hamburg, Germany, the daughter of a Jewish lawyer, Hesse was two years old when her family was forced to flee from the Nazis. She and her sister were put on a children's train to Amsterdam, but her uncle failed to meet the train. The terrified child found herself among strangers in a Catholic children's home.

Although the family eventually reunited and migrated in 1939 to New York City, life was never the same for the Hesses. Eva's creative, sensitive mother committed suicide when Eva was ten years old, and Hesse spent most of her years in therapy, trying to overcome the terrors of abandonment. Fortunately, her more resilient father remained very supportive.

By late high school she was recognized as a talented art student. After studying painting at Cooper Union, Hesse attended the Yale School of Art and Architecture (B.F.A., 1959), where she was a dedicated scholarship student, a favorite of Josef Albers, chairman of the art department. She disliked Albers's rigid Bauhaus geometry, however; she already felt more in tune with the loose, intuitive gestures of abstract expressionism, which he railed against. Other teachers were pressuring their students to adopt various conflicting styles.

In this confusing setting Hesse plunged into a period of intensive reading—Gide, Joyce, Dostoevsky—in an attempt to get in touch with her own beliefs and feelings. In later years, Hesse said that her work bore a relationship to the plays of Samuel Beckett, master of the theater of the absurd. She began to do capable, but relatively unoriginal, abstract expressionist drawings and paintings.

After graduation the artist headed for New York. She was simultaneously very insecure, often acting like a wistful child, and fiercely ambitious—"determined to *fight* to be a painter, fight to be healthy. No mediocrity for me." She was prepared to take risks, to work "*against* every rule I or others have invisibly placed."[27]

While supporting herself by working in a

Greenwich Village jewelry store, Hesse made loose, free drawings, some of which bore the seeds of her mature sculptures. The washy drawing *Untitled* (1961, Lucy Lippard collection) shows a boxlike form from which a tangle of lines droop absurdly. Exuberant now, she was beginning to sell her work and was making friends with artists such as Sol LeWitt. In 1961 she was in a show, "Drawings: Three Young Americans," at the John Heller Gallery, New York. Some of these drawings show the influence of Lee Bontecou's circular center images. (She had seen Bontecou's work at the Castelli Gallery and had admired the sculptor.)

After Hesse married sculptor Tom Doyle, she faced the classic problems of the husband-wife artist team. He was accepted and known everywhere, whereas she was seen as "Tom Doyle's wife." She found it difficult to work.

An unexpected opportunity proved the turning point of Hesse's career. Arnhard Scheidt, a German tycoon, invited Doyle to spend a year working at his expense in Germany in exchange for his output. Hesse came along as his wife.

In 1964 they traveled to Kettwig-am-Ruhr and were soon installed in the huge vacant top floor of a former textile factory. Doyle worked enthusiastically, but for Hesse it was nightmare-time. Back in the land where many members of her family had been murdered, she visited her birthplace and found out what had happened to them. Unable to sleep or work, Hesse had a small studio constructed in the center of the factory floor so that she could huddle in the security of its womblike walls.

In an alien land, far from her New York art world friends, Hesse became acutely conscious of her position as a woman artist. After reading Simone de Beauvoir's *The Second Sex,* she saw that her lack of self-confidence, her constant need for approval and acceptance, her rage at the fracturing of her time with female tasks,

Eva Hesse, UNFINISHED (1966), nine units, dyed nets, plastic, weights. Collection of Mrs. Victor W. Ganz, N.Y. Photo: Gretchen Lambert.

were socially conditioned and not personal failings.

Forcing herself to work despite the traumas, Hesse noticed the cast-off factory junk lying around—dismembered weaving machines, pipes, nozzles, piles of cord, supplies of plaster and spackle. Before long she was incorporating some of these shapes in biomorphic and erotic line drawings.

She wrote to Sol LeWitt that her drawings were "crazy like machines . . . larger, bolder . . . have really been discovering my weird humor," but "everything for me is glossed with anxiety." He wrote back that her work sounded wonderful: "Stop thinking, worrying, looking over your shoulder, grumbling, bumbling, stumbling. . . . Stop it and just DO."[28] Hesse played with plaster and spackle forms and with the piles of cord. Wrapping it over the plaster, she arrived at relief forms that led her in the direction of sculpture. *An Ear in a Pond* (1965) shows a weird penis-machine attached to an ear-vagina from which a cord dangles loosely, falling below the form. The artist worked obsessively, pressed by the sense of a deteriorating marriage. She wrote in her diary that she had better throw herself into her work because "I might soon be on my own." A group of these reliefs were shown at the Kunsthalle in Düsseldorf at the end of the year.

By the time the two artists returned to New York, Hesse knew that she was a sculptor, and the feeling of the absurd, the visceral, had emerged in her work. While rebounding from renewed anxieties caused by separation from her husband, Hesse began her first fully three-dimensional forms. Some of these early works are ludicrous sausagelike forms, hanging down in skinny bundles, made of papier-mâché obsessively wrapped with cord and painted in shiny black enamel. Mel Bochner later described them as "atrophied organs and private parts."[29]

In 1966, Hesse created *Hang Up* (1966), which for the first time captured the "absurd" quality she sought. It was a large, empty picture frame hanging on a wall, obsessively wrapped and painted gray, from which a curved loop of metal jutted unaccountably ten feet into the room. Hesse called it "the most ridiculous structure I ever made and that is why it is really good. It has . . . the kind of depth or soul or absurdity . . . that I want to get."[30] *Hang Up* was in the exhibition Abstract Inflationism and Stuffed Expressionism, organized by Joan Washburn at the Graham Gallery.

Critic Lucy Lippard saw in the work of Hesse and several other artists an emotional, visceral quality that broke away from the rigid forms of minimalism and geometric abstraction then dominating the art world. She included Hesse in a 1966 show called Eccentric Abstraction at the Fischbach Gallery.

At this time Hesse was also influenced by the rigorous logic of minimalism and serial art. She was part of a group of artists—Sol LeWitt, Robert and Nancy Holt Smithson, Mel Bochner, Robert Ryman and Ruth Vollmer—who met regularly and gave her support and advice.

Hesse could not stay long within such a restricted format, however. She soon turned the idea of repetition into its ludicrous extreme in a work called *Addendum*. From the centers of breastlike domes arranged in a row on a narrow horizontal strip of board, long strings hang down. The trailing cords, hanging seven feet, create an absurd, pathetic effect, as of dripping or weeping breasts.

Hesse began to experiment with latex and fiberglass—materials with a kind of translucent, nonart quality—which led to her culminating works. *Repetition Nineteen, III* (1968, Museum of Modern Art) seems like a travesty of serial art. A repetitive group is composed of translucent

forms resembling giant drinking glasses (or elephant shoes!). They are all derived from an identical mold, but each one leans and sags in a way that mocks the rigid repetitive format. In *Accretion* (1968) fifty tall translucent fiberglass tubes lean against the wall in slightly varying directions. Massed together in the large white Fischbach gallery, they had a light-filled grandeur, combined with a quirky quality. They were "nothings" that bore no resemblance to anything, yet evoked strange emotions.

John Perrault called them "'surreal serialism' or 'anti-form.' . . . the more you look at [them] the uglier and more interesting they become . . . Pathetic Objects. . . . the kind of queasy uneasiness they evoke makes one want to stroke them gently, to soothe and smooth them down and reassure them that they will not really disintegrate entirely."[31] In a statement for the show Hesse described her search for the ineffable: "It is my main concern to go beyond what I know and what I can know. The formal principles are understandable and understood. It is the unknown quantity from which and where I want to go."

Symptoms of her illness now began to appear, but the artist, pushing ahead, ignored them. In April 1969, she collapsed in her studio and was operated on twice for a brain tumor.

The artist now had to rely on assistants to help her complete the visions crowding into her brain. Doug Johns left his fiberglass fabricating business for a time and moved into her studio to help her carry out her last works. It was difficult for Hesse, who loved the actual act of touching, making, wrapping, but this harsh necessity led her into a new scale and spontaneity. She no longer programmed every detail in advance, but allowed the process to lead into unanticipated forms.

The last works are remarkable. A masterpiece of absurdity is *Untitled: Seven Poles* (1970).

Seven huge irregularly shaped "feet" of translucent fiberglass and polyethylene wrapped over wire stand around uneasily on the floor, held upright by thin lines suspended from the ceiling. Like human existence, they hang in uneasy suspension, perpetually on the point of falling or disintegration.

Contingent (1968–69, National Museum of Australia, Canberra) consists of translucent sheets of ragged-edged fiberglass over rubberized cheesecloth that hang from the ceiling, one behind the other, in a musical progression of varying distances, getting longer and longer, until one trails on the ground. They filter the light, giving an almost dematerialized effect. Hesse wrote of this work:

> they are tight and formal but very ethereal.
> sensitive. fragile . . .
> Not painting, not sculpture. it's there though.
> I remember I wanted to get to non art, non
> connotive,
> non anthropomorphic, non geometric, non,
> nothing,
> everything, but of another kind, vision, sort.
> from a total other reference point. is it possible?
> I have learned anything is possible . . .
> that vision or concept will come through total
> risk,
> freedom, discipline.[32]

The artist went in a wheelchair to see her work at the opening of the 1969 Whitney show "Anti-Illusion: Procedures/Materials." After her death, a memorial exhibition was held at the Guggenheim Museum. Hesse's reputation continues to grow, as, in the 1980s, artists repeatedly acknowledge her influence on them. In 1986 her work was included in the Guggenheim Museum exhibition "Transformations," honoring pivotal sculptors who transformed modern sculpture.

Mary Bauermeister (1934–), born in Frankfurt, Germany, was one of many artists attracted to New York during the heady 1960s. Her assemblages, inspired by music and philosophy, include lenses that refract and distort complex images, hinting at the ambiguous and relativistic nature of things.

Bauermeister began to paint in 1953, and after opening a studio in Cologne in 1957, she became part of a group of musicians, artists, writers, and scientists creating a new avant-garde amidst the spiritual ruins of postwar Germany. Her studio was a rendezvous for concerts and happenings.

Working nearby was a pioneer of electronic music, Karlheinz Stockhausen, who attracted an international coterie, including John Cage, Merce Cunningham, Nam June Paik, and the Paris New Realists—Tinguely, Yves Klein, and Arman. In a 1961 seminar with Stockhausen, Bauermeister applied the serial techniques of musical composition to the visual arts. She began to structure pebbles, drinking straws, and other materials in counterpoints of order versus amorphousness, relief versus flat, and in graduated sequences of light, color, volume, time (*Ordnungsschichten,* 1962–63).

In her first major solo exhibition at the Stedelijk Museum, Amsterdam, in 1962, she divided one picture into spatially separated elements spread throughout the gallery—some close together, others separated. She thus added a metaphysical component of time to the works (*Gruppenbilder*). She also showed her first lens boxes.

After she came to New York that year, her first works consisted of a sand-covered floor scattered with pebbles and other objects that appeared to grow up out of the sand and onto pictures on the walls. "Musical sequences" of graduated pebbles were glued onto interrelated square boards (*Progressions,* 1963, Museum of Modern Art, New York). These were followed by assemblages incorporating lenses. In *Poème Optique* (1964) Bauermeister glued lenses to glass panes (densely covered with drawings) that rotated, so that as the viewer turned the panes, paradoxical and unexpected complexes of words, sentences, and drawings turned up, one behind the other. In another play on illusion and reality, the viewer looked through a lens and saw a drawing of an eye looking back. In other works, surfaces encrusted with lenses, shells, bones, sand, pebbles, all connected by a fine graphic line, appeared to undulate strangely. At her 1964 exhibition at the Bonino Gallery, New York, an audience of prominent patrons and connoisseurs attended a slide show of her work, accompanied by Stockhausen's electronic music.

Bauermeister married Stockhausen and returned to Germany, where, in the 1970s, she devoted herself to "the art of living," raising four children and growing an organic garden on her studio roof. These experiences led her to create gardens for building complexes in Bonn, Cologne, and elsewhere. They incorporate tall glass prisms that project rainbows into the garden, hanging glass shapes covered with lenses, serpentine paths outlined in stones, and plantings that change with the seasons. Philosophical concepts about light and time are reflected in these examples of "land art."

From a feminist point of view, it is interesting to read H. H. Arnason's description of Bauermeister's densely worked assemblages as "overwhelmingly decorative in their appeal. One is reminded of the bibelot shelves of Victorian England."[33] These are the stereotypical terms in which women's work is all too often discussed. Bauermeister seems to be expressing the complex multileveled nature of consciousness, where reality is not fixed, but elusive.

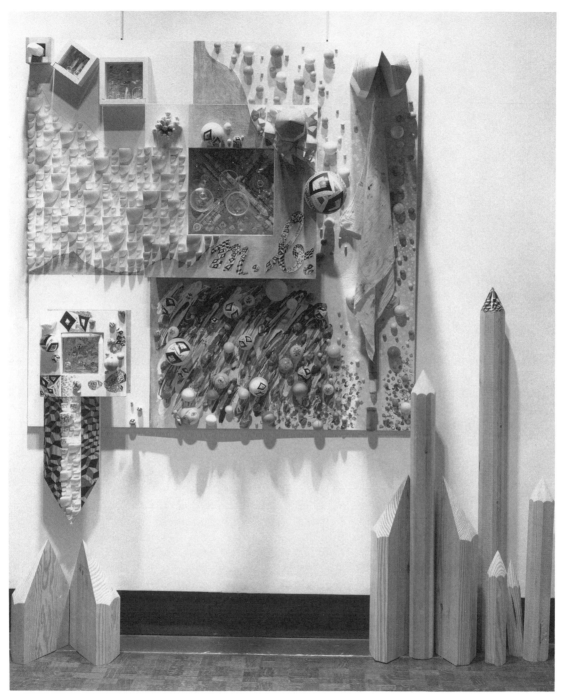

Mary Bauermeister, M.B.: MORE BOSOMS (1970), mixed media, 48″ x 48″. Collection: Fernanda Bonino. Photo: Peter Moore, courtesy Galeria Bonino.

Alice Adams (1930–) began as a weaver, but was led by her materials into "eccentric abstraction" and finally into wood architectural constructions.

After studying painting at Columbia University (B.F.A., 1953), Adams became interested in weaving during a Fulbright travel grant that allowed her to study at the Aubusson tapestry works in France. On her return to New York City, she began to introduce unorthodox materials, such as tarred ropes, into woven forms. Finding a roll of steel cable on the street, she experimented by looping and hanging the cable from steel plates and plastic grids. Writers for *Craft Horizons* pointed out that these "woven" constructions had become "sculptures."

Continuing to experiment, Adams used chain-link fencing and other industrial meshes to create irregular tubular and cloudlike forms that looked like protozoic organisms (*Big Aluminum,* 1965). Lucy Lippard included one in the 1966 Eccentric Abstraction show.

A studio fire destroyed most of these early works. While rebuilding her studio, Adams, influenced by the process, moved into architectural imagery. *Wall Section* (1967), a slab of mesh on a wooden support, with plaster spread on it in irregular patches (the standard technique of creating plaster walls in the building industry), was followed by incomplete arches and vaults of lathe and wood that move out into nowhere (*Greensboro Column,* 1974, University of North Carolina; *Three Arches,* 1978).

Adams's first outdoor site work, the temporary *Adams House,* built for the 1977 Wood show at the Nassau County Museum, was a memorial to her parents and the house where she grew up in Jamaica, Queens. Using the actual plan of her home, she built the framing of two rooms, leaving one side unfinished, with half-completed arches. The open skeletal structure evoked poignant thoughts about home and the passing of time. Adams continues to create such metaphorical structures.

On the misty shores of Lake Bastineau in northern Louisiana, **Clyde Connell (1901–),** around the age of sixty, began to fashion archetypal abstract sculpture from the rattan and cedar that grew in the swamps and Spanish moss around her home. By the age of eighty she had become a national figure. Although discovered at a late age in a rural area, Connell is decidedly *not* a naive Grandma Moses; her work grows out of a sophisticated awareness of modern movements, particularly abstract expressionism, and is grounded in a concern for the issues that face humanity.

Clyde (named after the River Clyde), daughter of a Scottish cotton plantation owner in Belcher, Louisiana, was raised by cultivated parents who discussed the issues of the day in an open-minded way around the dinner table. "There were always two sides, even about the Russian Revolution," she remembers.

Clyde took art classes at Brenau College, Gainesville, Georgia, married, moved to Shreveport, Louisiana, and raised three children. Nevertheless she continued painting and taking classes at the nearby Louisiana State Museum.

While helping her husband run a low-security penal farm, she became concerned with the problems of black people in the South. For many years she taught black children for the Presbyterian church and still remembers threatening visits from night riders trying to intimidate her and the children's families.

As a delegate to the World Council of Churches, Connell traveled frequently to New York. During visits to the Museum of Modern Art, she was deeply moved by the abstract expressionists,

particularly Frederick Kiesler, whose *Endless House* reminded her of the wasps' nests she saw at home.

When the Connells retired in 1959 and built a house on Lake Bistineau, the artist entered a new phase of her life, living close to nature. She became sensitized to the sounds—the bees, the crickets—and began to interpret this natural "music" in calligraphic notations that she worked into collages (*Swamp Sounds*).

Influenced by the swamp setting, Connell picked up knobby rattan and cedar branches and built them into forms that she covered with a skin—a grayish mash made from newsprint or brown paper and white glue—that could be embedded with sticks, stones, nails, or pieces of rusty farm machinery or incised with calligraphy: "While examining nests . . . around the lake I began to realize that the mixture of paper, glue and plastic had a quality related to the material used to build dirt dobber, wasp and moth nests. Also the mixture had characteristics of mortar and plaster used to build homes for people and cities. It seemed a good medium for concepts of union with nature."[34]

Deciding to create a sculptural environment, Connell created a series of works that stand around the grounds—"Posts and Gates," totemic guardian figures, and anthropological groups representing families. Perhaps the artist's best-known works are her "habitats." Into knobby rattan structures, lashed and nailed together into openwork cages, the artist modeled the habitats—altars, "nests," or cubbyholes between the branches—that sometimes contain stones, suggesting birds' eggs, precious relics, even human hearts.

Living in a remote area, however, did not keep Connell out of touch with the mainstream. She was part of a small group of Shreveport artists

Clyde Connell, RAIN PLACE (1978), rattan, glue, paper, stone, 84″ x 54″ x 36″. Collection of Laura L. Carpenter, Dallas. Photo: Martin Vandiver, Dallas.

who brought in leading people to critique their work. Connell remembers a visit from Judy Chicago in the early 1970s that made her aware of the female content—the hollows and openings—in her imagery. But the sculptor's multileveled work also reflects other concerns, as in *Numbered and Filed,* which deals with the treatment of black people in apartheid South Africa.

Connell can be compared with someone like James Surls of Texas, who also expresses a pantheistic feeling for nature in his gnarled sculptures. As her public reputation grew, she exhibited widely and received an award from the Women's Caucus for Art. She finally achieved national recognition when she was included in the Hirshhorn Museum exhibition Different Drummers, honoring a group of maverick artists who worked independently of trends in the art world. In 1988 a book on her life and work was published by the University of Texas Press.

Pat Diska (1924–), born in New York City, has lived abroad and made her career primarily in France, where she is known for monumental public abstract works, mostly carved directly in stone. Organic forms in granite, marble, limestone, and sometimes oak rise in totems or stand in rough-hewn Stonehenge-like groups, looking as if they grew on the site.

Diska earned a degree in economics at Vassar College and went to Paris on an economics research project in 1947. There she became interested in sculpture, studying at the Academy Julien with Joseph Rivier and learning to carve from Marek Szwarc.

After some years in a studio in Paris's Marais district she had the opportunity in 1965 to work at the splendid quarries in Lacoste, in the Vaucluse. In 1969 she moved to that hillside village overlooking the ruins of the chateau of the Marquis de Sade. There, in an ancient cavernous vaulted quarry, she has carried out more than twenty commissions from the French government for schools and public places at Amiens, Rosny-sous-Bois, and elsewhere. The artist particularly enjoys creating sculpture playgrounds that children can climb on or crawl through, which provide amusement yet are serious examples of contemporary art.

At Aix-en-Provence she constructed an abstract fountain called *Dragon Crag.* An outdoor environment called *Chess Game,* made of rough hewn black and yellow stone pieces with freeform limestone benches, is in a plaza in Crest. For the remodeled Place Lamanon in Salon-de-Provence, Diska completed a stone fountain, an oak playground piece made of roughly shaped tree trunks lying on the ground, sculptural limestone benches, and a group of interlocking forms called *Jeux de Boules* (*Ball Game*), consisting of large pairs of notched upright stones that support stone "balls" between them at three different levels.

Diska has recently worked in metal. *Monument to the French Resistance* (1985) is a cast iron flame or fistlike form set on rough stones for the town of Saint-Ouen. An inspiring teacher, she influenced younger artists like the Colorado sculptor **Elaine Calzolari,** who learned from her the technique of working with large organic forms carved directly in stone.

An underrecognized artist who deserves more attention in this country, Diska has participated in many international sculpture symposia and her works are in international sculpture parks. She had solo shows at the Galerie Colette Allendy, Paris (1961), Southern Methodist University, Dallas (1965), and the Municipal Gallery in Mainz, West Germany (1986).

Pat Diska, CHESS GAME (detail, the "white" pieces) (1979), ochre-colored stone, concrete base, white limestone benches. Secondary school, Crest (Drôme), France. Photo: Pat Diska.

POP AND FIGURATIVE SCULPTURE

In the 1960s **Marisol Escobar (1930–)** became famous for her multimedia collage sculptures satirizing the stereotypical family and other aspects of American society. Over a period of thirty years she has portrayed politicians, heads of state, art world gurus, and jazz musicians as well as the poor and the hungry. She has depicted people driving cars, getting off airplanes, attending cocktail parties. Taken together, these works constitute a portrait of a culture.

The artist's bold style is distinctive, immediately recognizable, typically consisting of wooden blocklike torsos onto which real objects are fastened. Faces, hands, and other elements are also carved, cast, painted, or drawn. For example, in *Women and Dog,* (1964, Whitney Museum), three women, a child, and a dog are constructed from four blocks of wood to which are attached multiple casts of faces, carved legs, a photograph, a purse, a stuffed dog's head, and a real child's hair-bow.

Although her early work was viewed as urbane and witty, there is a dark, surreal side to it. In a bronze group (*My Mother and Me,* 1968) the artist shows herself as a child with a pained expression, holding a sheltering umbrella over her mother's head. In *The Blacks* (a king and queen who suggest archetypal parent images) she appears locked inside of the "father's" body.

Her iconoclasm can be traced to painful early years that made her a perceptive outsider.

Marisol was born in Paris to wealthy Venezuelan parents who traveled with her in Europe and then returned to a huge mansion in Caracas when she was five years old. There, she told an interviewer, her parents "had a party almost every night—sort of wild parties ... I was furious." Her mother died when Marisol was eleven. "I was sent to a boarding school on Long Island. That was the end of family life. I decided never to talk again ... I really didn't talk for years except for what was absolutely necessary in school and on the street. People thought I was crazy."[35]

At thirteen she went through an intensely religious stage (she walked on her knees until they bled and lashed ropes painfully tight around her waist). The sisters at her parochial school thought she would become a nun, but in the following years she turned rebel instead. She often felt unreal, and the constant use of her own head and body parts in sculpture later on was perhaps part of a search for identity.

Art became her anchor. Even as a child she thought of da Vinci and Rembrandt as her heroes and spent hours copying their drawings. After studying in Los Angeles and Paris, the artist headed for Greenwich Village, where in the 1950s she became part of the Beat generation with Alan Ginsberg and others. She was in complete rebellion against bourgeois values.

At first Marisol worshipped the abstract expressionists—de Kooning, Pollock—and studied painting with Hans Hofmann. She taught herself sculpture and was soon showing amusing terra-cottas, influenced by pre-Columbian and Mexican folk art, at the Tanager and other Tenth Street galleries. She then saw the early American folk art in the collections of sculptor William King and his friends in Maine, and it had a powerful effect on her work. "But I'm not really a folk artist," she commented, "that's ridiculous. It's like saying that Picasso is an African artist."[36]

Rough-hewn wood groups, such as *The Family* (1955), shown in a cart like an early American toy, were well received at the Leo Castelli Gallery in 1957. Finally, a 1962 exhibition at the Stable Gallery established her reputation. There, and in subsequent exhibitions at the Sidney Janis Gallery, she emerged with a unique signature style. Influenced by the pop art movement exploding all around her, Marisol began, like Jasper Johns, to incorporate objects from daily American life, along with casts of her own face and body parts. The viewer's eye is carried from a blocky wood carving to a painted surface to a plaster cast to a real object in surprising juxtapositions and push-pull movements.

Marisol's witty assemblages are scathing comments on American society. A cast of an upturned face sucking on a real Coca-Cola bottle (*Love*, 1962) mocks the eroticizing of consumer products. Several works satirize the stultifying roles assigned to women. In the outrageous *Family* (1969, Brooks Memorial Art Gallery), the mother, a haloed Madonna with swollen bejeweled belly, worships the infant, glorified on a garish neon pillow. In *The Family* (1962–63) a stylish mother in hat, real gloves, and high-heeled shoes pushes a real baby carriage containing two blocky, vicious-looking infants (one is blowing bubble gum) while two look-alike little girls in Mary Jane shoes stand beside her. The two breasts plastered on the fashion-plate image of the mother suggest the primeval role that the woman is forced to play. At the back of the group a man in a gray flannel suit fades into the wall.

Critic Roberta Bernstein calls these works bitter comments on the "Happy Housewife Heroines" promoted as the ideal for women of the

1950s and 1960s. In contrast with these conventional female images, Marisol seems to show herself as an alienated but self-sufficient outsider.[37] In *Dinner Date* (1963) she eats with two other images of herself. In *Women Leaning* (1965–66) four figures, each with a cast of her face, are shown with their ears glued to the wall, listening to unknown voices or sounds, perhaps to suggest the artist's role, the outsider listening for new previously unheard concepts.

The artist satirized aspects of the power structure in works such as *The Generals* (1961–62, Albright Knox Art Gallery); *John Wayne*, a figure on a galloping horse, brandishing a six-shooter, the American hero of violence; and *The Dealers* (1965–66), a group of blocky figures peering ahead to spot the next trend through projecting telescope eyes.

During the Kennedy era, Marisol found herself caught up in a brief euphoria. Pop art was at its zenith; she was in Andy Warhol's underground movie *The Kiss* and appeared, elegantly dressed, at openings and glitzy parties. The artist herself was transformed into a pop art icon by the press, which mythologized her as a silent, exotic glamour girl. Looking back, she recognizes the great loneliness in it all—huge noisy affairs with no real intimacy or contact with people. The sculptor quintessentialized the experience of the "lonely crowd" in a room-sized environment, *The Party* (1965–66). Women in fantastic costumes, each with a varying Marisol face, gather in a room with a many-headed waiter who holds a real tray and glasses. A television set blares in the head of one figure.

After the Kennedy and King assassinations changed the mood of the country, Marisol left for a while. She traveled in Cambodia and Thailand and spent several months scuba diving in Tahiti. It was, she says, a purifying experience. Overwhelmed by the sculpture at Angkor-Vat, she returned to New York and carved a series of elegant fish combined with her head—images of harmony between humans and nature. She was no longer interested in satire, but wanted to create something truly beautiful, such as she had seen in the Far East. Since that time she has done much more actual carving on her sculpture.

Western civilization struck Marisol with a shock. A series of strange, disturbed, but exceedingly beautiful drawings of this period reveal the artist torn by conflict. In iridescent colored pencil, using forms and rubbings of her own body parts—fingers, hands, profile—the artist created erotic images. Sometimes hands are clutching; pistol-like forms are shooting at bodies (*Lick the Tire of My Bicycle*, 1974; *The English Are Coming*); there are suggestions of pregnant women and fetuses. Roberta Bernstein has analyzed these as powerful expressions of a woman's sexual needs and conflicts, with important political implications, even though the artist may not have had such a message in mind.[38]

In recent years Marisol's works have become more celebratory. The artist created a series of carved and assembled figures of admired mentors—*Picasso* (1977), *de Kooning* (1980), *Nevelson* (1981), and others. Marcel Duchamp sits on his famous high-backed carved chair, looking extremely intellectual, whereas Georgia O'Keeffe, whom the artist studied in person during a visit to Abiquiu, sits on a wood slab that looks like a rock, accompanied by her chow dogs. The lined and wrinkled faces are suggested by the rough carving strokes and natural cracks in the wood. The shiny eyes are intense. The bodies are blocky, with touches of paint and charcoal, and the hands are used expressively.

Concerned with the desperate poverty she sees during trips to her homeland in South America, the sculptor has recently done a series of sculptures portraying the poor and the hungry

Marisol Escobar, THE FAMILY (1963), mixed media assemblage, height 79″. Robert B. Mayer Family Collection. Photo: Courtesy Milwaukee Art Museum.

Marisol Escobar, detail of THE FAMILY (1963), mixed media assemblage, height 79″. Robert B. Mayer Family Collection. Photo: Courtesy Milwaukee Art Museum.

(*Mother and Child with Empty Bowl,* 1984; *Poor Family,* 1989). In 1982 she created a room-sized reinterpretation of Leonardo's *Last Supper* (Metropolitan Museum of Art, 1982). The serene Christ, carved in stone, contrasts with the relatively flattened wood forms of the disciples. A figure of Marisol sits in the gallery, meditating on this universal image of betrayal.

A world-famous artist, Marisol resists the image of glamorous fashion plate and party girl the press created in the 1960s. She has repeatedly pointed out that she has always spent nearly all of her time in the studio. She is indeed a consummate craftswoman who has taught herself all the skills of carpentry, and even electric wiring to create lighting effects. She has had to fight her way against the labels used to minimize the work of a woman artist, such as "decorative," "folk artist," and "doll maker." The artist asserts, "If I am famous, I deserve it; there's a lot of thought behind my work. It's a recognition of all the hard work I've done."[39]

Vija Celmins (1939–) began her career as one of the Los Angeles group of artists loosely associated with the pop art movement of the late sixties. At age ten she had fled with her family from war-ravaged Latvia, settling in Indianapolis. After earning an M.A. in painting at the University of California, Los Angeles in 1965, she began to record the uneasy ambience of life in that city in grayed paintings of such subjects as a hand with a gun, a falling plane, a T.V. set with a disaster image on it, and the Los Angeles freeways.

At the same time she sculptured out of wood a number of ordinary objects, such as a six-foot school pencil, giant *Pink Pearl Erasers* (Newport Harbor Art Museum), and a huge tortoise shell *Comb* (Los Angeles County Museum of Art). These works go beyond the commercial look of pop art with such superreal rendering of surface detail that they evoke memories of childhood. A few three-dimensional houses painted with images of flames, a falling plane, and a Magritte-like train crashing through a wall express the pervasive anxiety caused by her early wartime years.

Turning to more serene, cosmic imagery, Celmins became well known for her obsessively and exquisitely rendered graphite drawings of compositions derived from photographs of the surface of the moon, the ocean, and the desert. Like Jasper Johns's targets and flags, the surfaces become co-existent with the picture plane. She has created accompanying sculptures showing a real rock side by side with a painted bronze rock, that address similar issues of reality versus illusion. Celmins had a solo show at the Whitney Museum and a 1980 retrospective at the Newport Harbor Art Museum.

Niki de Saint Phalle (1930–)

Why don't we give art leave to romp, to play, to roar outrageously at our human foibles and self importance? . . . A number of . . . artists in this century [Miro, Klee, Calder] have done just that. And to this . . . life-oriented band . . . must be added the name of Niki de Saint Phalle. Her work . . . is a delightful retelling of age-old myths and fairy tales in the imagery of today's peculiar lunacy.
—Theodore Wolff[40]

Niki de Saint Phalle, an international artist claimed by both France and the United States, began her career in the 1960s with violent, destructive art forms (she shot at her own assemblages with a gun); but today she is peopling the world with brilliantly colored sun birds, snake-people, and dancing female figures covered with flowery patterns. Hers is a three-decades journey from rage to affirmation.

In retrospect Saint Phalle can be seen as an innovator. Her earth goddesses of the 1960s were harbingers of the women's movement; her

patterned sculptures forecast the pattern and decoration movement of the 1970s. But more than that, Saint Phalle's work represents an attack on formalism and obscurantism.

Born in Paris, the daughter of a French father of aristocratic lineage and an American mother, Niki came to New York with her family when she was two years old and became an American citizen. She grew up in large apartments on Park Avenue and attended the Convent of the Sacred Heart.

At seventeen she ran away with and married poet Harry Mathews. They traveled in France, Italy, and Spain, and had two children. For two years she studied drama in Paris and thought of becoming a director. But at age twenty-two she found herself overwhelmed by a severe depression. During two months in the hospital, working her way through an identity crisis, Saint Phalle began to paint—densely patterned Jungian images that reflect a search for the self. These works immediately show the rich colors and patterns, the mystic symbols that remain in her art today. When she was twenty-five, Saint Phalle saw Antonio Gaudi's fantasy cathedral and park in Barcelona. "It was like a turning point. . . . I decided, this is my destiny."[41] Saint Phalle made a total break with conventional bourgeois life, went to Paris, and there fell in with one of the most wildly experimental groups in the art world—the New Realists who described themselves as "40 degrees beyond Dada."

In this group she met Jean Tinguely, noted for his eccentric kinetic machine-sculptures. The first person to take her work seriously, "Tinguely gave me my dimension, and the confidence in myself," she said. "Like most women I was afraid of technique. He said: The technique is nothing, the dream is everything."[42] Tinguely helped her with construction problems, and they married. Although no longer together, the two artists still work amicably on collaborative projects. A fountain combining his black metamatic machines and her colored sculptures stands in front of the Centre Pompidou in Paris (*Strawinsky Fountain,* 1982–83).

Saint Phalle was filled with anger against the bourgeois values that she felt had led to her breakdown—values that she equated with repression and violence in the society at large, at a time when France was engaged in the Algerian war and the United States was in Vietnam. She made white plaster assemblages—strange altars where crucifixions are combined with bats and other symbols of evil, and hearts are crammed with toy guns, soldiers, skulls. At public events, she "completed" the works by shooting at aerosol paint cans embedded in them or at balloons filled with paint that dripped down over the pieces. Guests invited to an exhibition of her all-white assemblages were not admitted until they shot paint all over the works. A columnist described a Saint Phalle happening in New York: "A roll of the drums. At the back of the orchestra, behind everybody's heads, out steps a boldly beautiful girl in a white leather [jump]suit. There is a rifle in her hand. She puts the rifle to her shoulder, aims at a white plaster-of-Paris statue up on the stage, fires. Red blood bursts from a hole in the statue. She fires again. Blue blood. Again. Yellow blood. Again. Orange blood. Again."[43]

Such events may seem to have been mere stunts aimed at the media. They were, of course, satirical attacks on action painting. But surprisingly enough, the assemblages themselves manifest a sinister power and beauty. The triptych *King Kong* (1963) is a vitriolic attack on existing social forces. On the left, the artist enters the trap of love and marriage which turns out to be death. In the middle are faces of political leaders. On the right, King Kong runs off with the girl, while airplanes bomb the skyscrapers of New York.

Niki de Saint Phalle, KING KONG (1962), mixed media, 276 cm x 611 cm. NMSK2133. Collection of the Moderna Museet, Stockholm, Sweden. © de Saint Phalle. Photo: Statens Konstmuseer.

Putting her shotguns aside, Saint Phalle created a series of torn and ravaged female prostitute images covered with creepy-crawly forms—guns, spiders, soldiers, and spaghettilike yarn texture. These "crucified ones" make a strong statement about female oppression.

Soon the ravaged figures were transformed into powerful female deities representing woman as the source of life and creativity. In one, a standing earth goddess, in the act of giving birth, holds the emerging infant like a phallus, thus embodying both male and female power. They were followed by the famous *Nanas*—rounded, dancing female figures covered with brilliantly painted flowers and patterns in papier-mâché or polyester. In 1967, Saint Phalle and Tinguely designed *Fantastic Paradise,* a combination of the dancing "Nanas" and Tinguely's black machine-sculptures, for the French pavilion at the Montreal World's Fair (now at the Modern Museum, Stockholm).

Black Venus (Whitney Museum of American Art, New York) and *Black Is Beautiful* are two of a series of *Nanas* that pay homage to black women. As a child Saint Phalle loved her family's black cook who gave her warmth and comfort; she hated the racism that she saw in some of her white relatives.

An immense temporary project entitled *Hon: A Cathedral* (1966), at the Modern Museum in Stockholm, was an eighty-three-foot pregnant female figure painted in brilliant patterns, lying on its back with legs spread apart, its great breasts and belly forming a billowing landscape. The public entered the figure through an oval vagina (Tinguely called it the "portal of life"). A minitheater was in one breast, and a restaurant on the stomach had windows looking out over the "female landscape." The figure was designed by Saint Phalle; Tinguely and Per Olof Ultvedt, a Swedish sculptor, helped build it and designed the interior displays. *Hon* (the Swedish word for

Niki de Saint Phalle with sculptures included in her exhibition of Monumental Projects, 3 April–23 May 1979. Photo: March 1979, Malibu, Calif., courtesy Gimpel & Weitzenhoffer Ltd., N.Y.

"she") was made of chicken wire stretched over a steel frame and covered with a skin of plastic-impregnated, painted canvas. Thousands of people crowded into this human "cathedral" dedicated to the worship of woman as the source of life. It was at once a sculpture and a work of fantasy architecture of the kind she had dreamed of ever since she first saw Gaudi's Barcelona buildings.

Other architectural works include houses shaped like women's bodies in the south of France; in Israel she created *The Golem* (1972), a playground in the form of a mythical monster. Children slide down three red tongues that come out of the monster's mouth.

Refusing to be limited by one medium, the artist performed in happenings with Robert Rauschenberg and other artists; designed sets for Rainier von Diez's production of *Lysistrata;* coauthored the play *Ich* about her own life; wrote and directed several films; and makes quantities of prints and drawings.

Huge sculptures satirize bourgeois life and conventional women's roles—*Sunday Promenade* (a dull-eyed couple) and *Devouring Mothers.* Three brightly painted polyester *Dancing Nanas* (1974) enliven the central square of the city of Hanover, Germany. More and more her work resembles a kind of sophisticated, over-scale folk art.

In the late 1960s Saint Phalle developed emphysema from the toxic effects of working with polyester. When the doctors gave her little chance of recovery, she went to Switzerland, where several years of exercise, fresh air, and contact with nature saved her.

Saint Phalle felt like a phoenix risen from the ashes; indeed many of her images show a phoenix growing out of a woman's head—a kind of spirit form. She has created a series of dematerialized open linear pieces that she calls "Skin-

Dorothea Tanning, LES COUSINS (1970), synthetic fur over cotton stuffing with wood base, 60″ x 25″ x 21″. Courtesy of The Menil Collection, Houston. Photo: Hickey & Robertson, Houston.

nys": "The 'Skinnys' breathe. They are air sculptures with mythological subjects. You can see the sky or a plant through them.... Air has come into my life. These sculptures reflect that change."[44] A brightly colored and gilded thirty-foot *Sun God* (1983) at the University of California, San Diego, has become the campus mascot; students hold yearly spring rites in front of it.

In 1980 the sculptor received a major retrospective at the Centre Pompidou, which traveled to museums in Germany, Sweden, and Austria. Now she is working on the largest project of her career, *The Garden of the Tarot*—an outdoor environment in Tuscany, Italy, containing houses and sculptures in the form of fantastic figures and animals, taken from the symbols on tarot cards. Encrusted with mirrors and tile, it is the realization of her dream of creating a Gaudi-like environment.

Saint Phalle dared to be herself, to express herself in ways that were shockingly "female," long before the women's movement. "Her art is accessible to every one.... Her works not only assert life, but also delight in its processes. Her forms and shapes are related to growing things and not to the geometric shapes man has devised to control nature or to help define his identity.... Perhaps the nightmares of our century have taught us the value of affirmation, of joy, and have shown us the dangers of being too categorical or constrictive."[45]

Dorothea Tanning (1912–), an American surrealist painter who married Max Ernst and lived in France with him after World War II, created a series of surrealist sculptures between 1969 and 1973.

One melancholy evening in Paris, she was listening to electronic composer Karlheinz Stockhausen conducting his piece *Hymnen,* when suddenly "spinning among the unearthly sounds" she had a vision of "earthy even organic shapes that I would make, had to make, out of cloth and wool; I saw them so clearly, living materials becoming living sculptures, their life-span something like ours.... "[46]

During the next five years she sewed and stuffed strikingly original metamorphic soft sculptures—writhing figures in tweeds and rose-colored fabrics that turn into tables, couches. In *De Quel Amor* a twisted paroxysm of form is chained to a phallic-looking metal post. In *Open Sesame,* a group of writhing forms are smashing through the glass upper section of a closed door to the unknown. As in her canvases, these works hint at the creative transformative power of the subconscious and the struggle with unknown forces, with death. At her 1974 retrospective at the Pompidou Centre, Paris, these were arranged in a shabby hotel room environment called *L'Hôtel du Pavot, Room 202,* creating an atmosphere of terror and mystery.

Tanning resumed painting and, after the death of her husband, returned to New York, where she wrote her revealing autobiography, *Birthday.*

Since the 1960s **Marjorie Strider (1934–)** has been creating sculptures that emerge from windows, walls, brooms, fruits, and teapots, pushing into the viewer's space. In an early (1964) pop art show at the Pace Gallery, her standing cutout figures of cartoon pinup girls had bosoms and buttocks that bulged out of the flat boards. A populist who took her work out into the streets, she began to use polyurethane foam to create sculptures that spilled out of windows in downtown New York. She participated in conceptual streetworks and performances—in fact, critic John Perrault credits her with coining the term *performance art.* She placed empty window frames around the city that suddenly created compositions out of random scenes.

Marjorie Strider, WINDOW WORK II (1971), Venetian blinds and urethane foam, 6' x 10'. Collection of Sydney and Frances Lewis, Richmond, Va.

Always working in contradictory ways between two and three dimensions, her painted pictures of fruits and vegetables broke open and bulged forward into richly painted three-dimensional forms that invaded the viewer's real space. In the 1970s her images of brooms and common household objects bursting into ooze, and her painted bronze spirals of fruit peels, were interpreted as feminist statements of political and sexual liberation.

Marie Johnson-Calloway (1920–) uses assemblages and environments to express aspects of the black experience in America. Born in Balti-

more, daughter of a minister and a seamstress-artist, she grew up amidst the ferment of the Harlem Renaissance, attended Morgan State College, Baltimore (1952), and San Jose State College (MA, 1968), took graduate studies on a fellowship at Stanford University, and taught art at San Francisco State University from 1974 until her recent retirement.

The artist cuts out plywood silhouettes of characteristic black personalities, paints and clothes them with three-dimensional materials, sometimes building up the faces in relief, and gives them an expressive twist that somehow conveys the feel of the character. They may be exhibited alone or in an environmental setting.

Marie Johnson Calloway, MT. PILGRIM BAPTIST CHURCH (exterior), mixed media, 80″ x 196″, installed at Mills College, Oakland, Calif., 13 February 1989. Courtesy of the artist. Photo: Joe Samburg.

Johnson's aim is nothing less than to produce a "portrait of a people." Whether she shows a woman leaning out of a dilapidated tenement window; a Black Panther of the sixties, with dark glasses, beads, and African shirt; or a southern preacher (*Papa, the Reverend*, 1968), Johnson manages to capture the character of the people and the texture of their lives.

Johnson-Calloway has been active in the community—her life and art have been a seamless web. In the sixties she marched in Selma and was jailed. In San Jose, where she lived for many years, she was head of the NAACP and active in other civic groups. During the sixties and seventies she made hard-hitting political statements in her art. Reviewing Johnson's work in a joint 1977 exhibition with Betye Saar at the San Francisco Museum of Modern Art, Allan M. Gordon wrote: "In *The Cell* the head of a grim, bitter Black man glowers from behind the white bars ... a

subtle and powerful comment."[47]

That exhibition included an installation called *The Vanity*. A beautiful black woman in a white lace dress stands before the mirror of a real vanity table, covered with commonplace evocative elements—an overflowing jewel box, jars of makeup, a photo of her mother. A patterned bath curtain and tub stand beside her. It is an image of upward mobile black aspiration. In *Hope Street,* an installation at the Oakland Museum in 1987, a real street sign saying "Hope Street" was included with other elements.

The artist no longer feels that she must use explicitly political themes in her art: "I decided that just to *be* a Black person in America is political. I don't have to be overtly political. To come out with dignity in our society is a statement in itself. I want to show the ordinary people; depict their life style and struggle for survival."[48]

When **Otellie Loloma (1922–)** was included as one of 150 leading American craftspersons in the 1970 book *Objects U.S.A.,* she was described as "one of the first American Indians to break away from traditional designs and create forms in clay that remain personal without denying the richness of her heritage."

Born on the Hopi Second Mesa in Arizona, Loloma remembers that even as a child she made small dolls out of clay while her grandmother picked fruit. Her talent was recognized at Phoenix Indian High School. In 1945 she won a scholarship to study ceramics at Alfred University, which she attended with her then-husband, Charles Loloma, who was there on the G.I. bill. When they returned to Shungopavi she taught at the Day School, but encountered resistance from traditional potters when she tried to introduce new techniques, such as working on the wheel.

After setting up a studio in Scottsdale, Arizona, Loloma made ceramics, jewelry, and paintings (1958–62), ran a pottery shop with her husband, and taught sculpture during summer sessions at Arizona State University in Sedona. In 1960 she began to enter competitions, immediately winning a first prize in ceramic sculpture at the Arizona State Fair, the first of many honors. In 1962 when the Institute of American Indian Arts was founded, she was the only woman appointed to the original staff, eventually becoming chairperson of the ceramics sculpture department.

Loloma mixes wheel-thrown and hand-built forms, combining contemporary and Indian approaches. She still bases much of her work on legends that she heard from her father and neighbors as a child: "Through our legends, it is said that animals and birds talked. That is why we are taught to respect anything that breathes. We are encouraged to see the beauty and have

Otellie Loloma (Hopi), SPIRIT OF THE RAM (1978), ceramic, partially glaze painted, embellished with turquoise, coral, shell, height 14⅝". Collection Indian Arts and Crafts Board, W-79.8. Photo: U.S. Department of the Interior, Indian Arts and Crafts Board.

Gloria Lopez Cordova, FLIGHT INTO EGYPT (1982), carved aspen, 8″ x 21″ x 15½″. Millicent Rogers Museum, Taos, N.M.

an understanding of nature. This gives me the ability to have the inner feeling and to use this essence of our heritage to create and express."[49]

Bird Woman (1962, stoneware, Institute of American Indian Arts, Santa Fe), with a small bird on her head, looks up as if listening to the sounds of nature. She "represents all the living birds. There is a secret about her beliefs and how she teaches her children to learn about life." *Spirit of the Ram* (1978) is embellished with turquoise, coral, and shell. The artist has also worked in bronze and other media.

Often overlooked are the splendid traditional carvers, such as **Gloria Lopez Cordova (1942–)** of Cordova, New Mexico, who continues the family tradition of carving aspen or cedar wood saints (*santos*) to carry in processions and for other traditional purposes. Her grandfather, Jose Lopez, a noted Mexican-American craftsman, taught Gloria's mother, Precide Lopez, who in turn passed the skills on to her. Her work shows the tense abstract form and technical skill that comes from a centuries-old refinement of symbols integral to the community for which they are created.

Joyce Wahl Treiman (1922–) of Los Angeles is another painter who took an important detour into sculpture. A maverick expressionist and realist, she says, "Everyone's doing bronzes now, but no one was doing them then. I deliberately decided to work in opposition to the trend. Artists were trashing Rodin at that time, and I felt that Rodin was great, so I decided to make my own *Gates of Hell*."

Working freely in wax, Treiman modeled about fifty works in the next fifteen years. Her wry, witty *Couples,* clowns and jokers, capture the ambivalence of human relationships.

WOVEN FORMS

Like the "three fates," Lenore Tawney, Claire Zeisler, and Sheila Hicks have woven their way into modern American art. Inheritors of an age-old female tradition, they have changed the craft of weaving to woven forms—really sculpture. By thus raising a previously denigrated female "craft" into a "high art" form, these women were precursors of some of the major breakthroughs of feminist artists in the 1970s.

Lenore Tawney (1925–), regarded as a pioneer of woven forms, developed new techniques that shaped weavings into three-dimensional monumental forms. A meditative, inner-oriented person, Tawney brings a quality of Zen-like serenity to her work.

Born in Lorain, Ohio, and raised as a Catholic, Tawney as a child felt confined by the joyless attitude of the nuns at convent school who objected when she embroidered flowers on her blue serge school uniform. During a period of rebellion and turmoil at the University of Illinois (1943–45), her faith was swept away when she read Schopenhauer and when she lost her young husband. Grieving and searching for an outlet, Tawney enrolled in 1946 at the New Bauhaus—the Chicago Institute of Design—organized by Moholy-Nagy and other refugees who were introducing Bauhaus concepts to the United States. Arts and crafts were regarded as equally important—the same concepts applied to both. Tawney studied drawing with Moholy-Nagy and weaving with Marli Ehrmann, but the greatest influence on her was Archipenko, who stressed the importance of open spaces in the form and applied collage methods to sculpture in constructions of wood, metal, glass, and stone.

During a summer workshop at Archipenko's Woodstock studio, Tawney found herself so thor-

oughly immersed in the work that after return-ing to Chicago, the young woman quailed at the commitment—she knew that if she wanted to do sculpture at all, she would have to sacrifice her-self totally to it, abandoning any social life. So, during a wild jazz party at her house, she threw sculpture, clay, and tools down a shaft and later bought a small loom, figuring that she could fit weaving into her life and maintain a balance. Her very first weavings, black and white place-mats, were accepted in a "good design" show at the Museum of Modern Art.

On her way back from travels in France and North Africa, Tawney stopped off at Penland, North Carolina, to study for six weeks with the distinguished Finnish tapestry weaver, Marta Taipale. Soon after, the artist fell ill and nearly died. Her subsequent recovery was like a rebirth. As she worked on a design called *Family Tree* (1955), suddenly feeling a new freedom to work as she wished, she began to weave only the parts where there was a shape, while leaving the warp threads around them open and untouched. Taw-ney had wandered into "open-warp tapestry" (*Bound Man,* 1956, American Craft Museum, New York).

Other weavers thought her nontraditional methods were poor craftsmanship and rejected the works she submitted for craft shows, but art-ists responded to them immediately. She began to hang her weavings away from the wall be-cause light flowing through the transparent forms was an integral part of them.

In 1957 Tawney moved to New York and be-came part of the coterie of artists who lived in Coenties Slip, a neighborhood of lofts and ware-houses on the waterfront. There she became friends with Robert Indiana, Ellsworth Kelly, Jack Youngerman, and her next-door neighbor, Agnes Martin, who were all pioneering a new sensibility. Rebelling against the excessive emo-tionalism of action painting, they were moving into minimalism and systemic art.

Between 1960 and 1961, during a period of constant exchange with Martin, who shared her love of American Indian art, Tawney created rich-hued works incorporating feathers, bones, and beads. In this, as in the open-warp tapes-tries, she was an innovator.

After traveling in the Far East and Egypt, Tawney joined the Zen Studies Society, and med-itation became a part of her daily life. On the eve of her first major solo show at the Staten Island Museum (1962), the artist experienced a kind of artistic enlightenment. Responding to a growing spiritual inwardness, and also, no doubt, to the strong spare forms being produced by her col-leagues, she suddenly decided "to strip herself bare of infatuations with color, yarn surfaces and subject matter. She cleared her studio of all the hoarded yarns that had filled baskets, racks, and bowls."[50] Instead, she ordered a special linen yarn in neutral colors—black, white, tan.

Tawney had moved to a sailmaker's loft on South Street, containing a three-story-high cen-tral shaft, complete with tackles and pulley. In-spired by the great scale now available to her (and filled with images from her recent trip to Egypt), she saw in her mind's eye a series of enormously tall woven "personages"—totemic figures in thread and yarn (*The Queen, The King, The Bride*). But in order to carry out these visions it was necessary to *shape* the forms in-stead of leaving them flat. She devised a special reed with an open top so that she could move the outer edges of the forms in and out as she wove, inserting horizontal dowels to hold them in place at various widths. The artist was convinced that no gallery would show such enormous works. One was twenty-seven feet high "with knots huge as ship's bumpers. Archipenko would have liked them! They . . . showed his influence."[51]

The Staten Island show was hailed by her artist friends: "It was this exhibition that announced to artists working in the fiber medium that a revolution was beginning.... Function was no longer the only reason for working with fiber.... This was the first time that weaving was deliberately designed to be hung in space and viewed with the same sensibility as sculpture."[52] Tawney called them woven forms, a designation adopted by New York's Museum of Contemporary Crafts (now the American Craft Museum) the following year for a landmark exhibition that included her work, as well as pieces by Claire Zeisler, Sheila Hicks, Alice Adams and Dorian Zachai.

Tawney continues her search for spiritual enlightenment. A series of large cruciform weavings (*The Path,* 1962) was followed by circles within a square (*Red Sea,* 1974). These austere works are so monochromatic that the forms are barely discernible except for long narrow vertical slits permitting glimmers of light that hint at the shapes. Richard Howard described them as "Agnes Martin in flax.... The weaving she does now is such a departure ... one can scarcely compass the renunciations, the enormous repudiations of sensual expression which have obliged her thus ... without chromatics, almost without texture ... here are none of the old extravagances, the feathers, the looping yarns, the eccentric spacing ..."[53]

Feminist scholar Gloria Orenstein called Tawney's work "craft of the spirit."[54] Orenstein also points out that the power in Tawney's work is connected with a strong sense of herself as a woman.

In a lecture, Tawney once explained that woman, in a larger sense, weaves life and destiny. The great goddesses, she said, are weavers in Egypt, Greece, and other early cultures; and woman weaves the tissue of life in her womb.[55]

Lenore Tawney working on WATERS ABOVE THE FIRMAMENT II (1974). Photographed by Clayton J. Price for the catalog *Lenore Tawney: An Exhibition of Weaving, Collage, Assemblage,* Art Gallery, California State University, Fullerton, 1975.

Tawney also makes Cornell-like boxes incorporating bits of old texts, sheet music, feathers, stones, eggs, bones. In *The Mother Goddess* one peers through a small pelvic girdle bone to see one's self in the mirror—thus "we are all reflections of the Mother Goddess when we participate in the life of the spirit."[56]

Water has been a recurrent theme (*The River*, 1961). In her recent Cloud series, painted linen strands fall like a rain shower from a canvas ceiling. The spiritual significance of water was revealed in the artist's statement describing her feelings after hanging one of these in the lobby of the Federal Building, Santa Rosa, California:

> We climb a high mountain . . .
> We are at the top, lying in a waterfall.
> We are at the source.[57]

Claire Zeisler (1903–) was nearly sixty years old when she had her first solo show. With great good humor she calls herself the "grandmother of the fiber movement. . . . I would say I was a slightly late bloomer."[58] Yet in a few short years she became an international leader, the first to create free-standing sculptures entirely out of fiber.

Born Claire Bloch in Cincinnati, Ohio, she studied drawing and painting there and design at Columbia University. She settled in Chicago and has lived there ever since. Around 1930 she met curator-author Katherine Kuh and became interested in modern art. In the 1940s she studied at the American Bauhaus (the Institute of Design of the Illinois Institute of Technology) with Archipenko, Moholy-Nagy, and weaver Bea Swartchild. Zeisler describes herself as having been "arty" and "dilettantish" at the time, although she was already an avid collector of baskets and primitive artifacts.

The death of her husband caused a profound change. Too lonely to sit at home weaving, the artist set herself up in a studio and threw herself into her craft with a total commitment. After teaching herself traditional techniques (she spent years making yardage), Zeisler, feeling stifled by the confines of the loom, started to weave pockets into her work, painted the warp threads, added crocheting, built up layers. *Black Ritual* (1961) looks like a fringed African mask or shield, with gauze woven strips above and on either side ending in crocheted balls. Her first solo show was at the Chicago Public Library in 1962, the same year as Tawney's breakthrough at the Staten Island Museum. The following year she was included in the landmark Woven Fibers exhibit at New York's Museum of Contemporary Crafts.

The conservative European crafts community was startled in 1964 by a three-person exhibition at the Zurich Craft Museum which included Zeisler, Tawney, and Sheila Hicks. When she and other fiber artists got together in the early sixties they all felt they wanted to escape from the traditional tapestry syndrome: "So all of us did everything but wall hangings. We made it freehanging. Or freestanding, which I began to do. That's when I got the reputation that I carried the material a little further."

The big breakthrough came in the mid-sixties during a period of study in New York City with famed weaver Lilie Blumenau, whose Haitian assistant introduced Zeisler to knotting techniques. Freed at last from the loom, she obsessively explored the possibilities of square knots and found that she could build them into solid, self-supporting structures, entirely of fiber, requiring no armature. In the following years Zeisler produced a series of monumental totems in which the knotted inner core acts as a support for great cascades of fiber that fall to the floor like waterfalls or swirling skirts. Unorthodox

Claire Zeisler, MADAGASCAR V (1977), natural raffia and natural jute, 72″ x 88″ x 30″. Collection: Chicago Public Library Cultural Center, Chicago. Photo: Courtesy Rhona Hoffman Gallery.

natural fibers—jute, hemp, raffia—reflected her continuing love for primitive art.

Zeisler maintained a studio between 1967 and 1973 and taught at the Art Institute of Chicago. Since then she has worked in a studio in her apartment, which has a sweeping view of Lake Shore Drive and its high-rise architecture—at night a vista of lights, water, and darkness.

Zeisler loves to work in red. "I adore red. It says structure. It says vibrancy, life. I think I must dream in red." *Red Preview* (1969, Art Institute of Chicago) is an eight-foot totem whose erotic curves suggest a seated goddess with great tresses cascading to the floor. Strands pouring down the central open womblike form suggest fertility—the life-giving source. Indeed there is something shockingly raw and direct about this and other works. In some, hairy masses falling from tightly knotted walls have a dense, muscular, visceral quality (*Black Madagascar*, 1972; *Red Madagascar*, 1972).

Zeisler continues to experiment. *Floor Slinky* (1971) consists of thirty-two coiled forms made by stretching slinky toys to almost twelve feet in height, holding them in suspension, and wrapping them in red cotton and polyester threads. In the 1970s the artist folded, stitched, cut, and stretched leather into massed and suspended forms.

Zeisler had a major retrospective in 1979 at the Art Institute of Chicago and solo shows at California State University, Fullerton; St. Louis Art Museum; the Whitney Museum (1985); and elsewhere. Fiber artist Sheila Hicks, who traveled widely with her, collecting artifacts and studying ancient cultures, reports: "Her curiosity ... seems to increase with each excursion into a foreign culture. I have the impression that she has made an inventory of every bazaar on earth and knows three quarters of the junk dealers and *antiquaires* by their first name."[59]

An artist who started her career in her late fifties and hit her stride in her seventies, Claire Zeisler is an inspiring example of the open-ended potential of human creativity at any age.

Sheila Hicks (1934–)

Weaving ... is a rudimentary form of expression enabling the greatest access to my own dream world.
—Sheila Hicks[60]

Perhaps the most daring of the revolutionary new fiber artists, Sheila Hicks developed in her early years what she calls a "helicopter view" of life.[61] She lives and works in many countries, drawing inspiration from many cultures. Refusing to remain within the traditional confines of weaving, she creates without a loom great wrapped and tasseled forms, or huge environments made of "tons and masses" of hospital linens, nurses' blouses, and other unconventional materials.

Hicks developed this freedom at a young age. Because her parents, caught in the depression, moved from state to state with their children in search of jobs, Sheila learned to be independent of any local community or social class and to rely on herself. One thread of continuity was her annual summer vacation in Nebraska with three cultured maiden aunts who gave her a lot of attention and taught her to draw.

At the Yale School of Art and Architecture, her Bauhaus-oriented professor, Josef Albers, demanded clarity, logic, and discipline within the abstract mode, while her other painting professor, Rico Lebrun, stressed the humanistic and expressive. To this day she attempts to unify these polarities in her work.

Inspired by Albers's weaver-wife, Anni Albers, Hicks experimented with weaving on a backstrap loom. After deciding to do her master's dissertation on pre-Incan textiles, she took off for

Chile on a Fulbright scholarship, and began an intensive study of that rich vocabulary of textile structures. She was exposed to the wrapping, knotting, gauze weaving, and taseling that she later used so effectively in her work.

After completing the M.A. in 1959, Hicks married an apiculturist, had a daughter, and for five years made small weavings on a handmade loom in her home in Mexico. Although her husband referred to them as "potholders,"[62] Hicks, with customary independence, flew to New York and showed them to Alfred Barr at the Museum of Modern Art. He immediately bought them and urged her to make more, but on a larger scale. These early works were a kind of exquisite "white writing"—mysterious hieroglyphics of white woven on white.

Hicks was included in the 1963 landmark exhibition Woven Forms at the New York Museum of Contemporary Crafts and with Lenore Tawney and Claire Zeisler at the Arts and Crafts Museum in Zurich. As a result she met her pioneering colleagues and has remained friends with them.

An important outcome of the Zurich show was a commission from the rug company, Arterior GmbH, to produce designs for them in Wuppertal, Germany. There the artist learned to use the electric pistol in order to attach wrapped tasseled forms to a background of uncut wool pile—she feels as free to use modern technology as ancient craft techniques. In *Red Prayer Rug* (1964) and other works, great gushes of tasseled forms spring from the walls. One of these, displayed on a granite wall in New York's CBS building, attracted architectural commissions. For New York's Ford Foundation Building, she covered two large walls with embroidered honey-colored silk medallions (1967) and then created three rooms as fiber environments for the Georg Jensen Center for Advanced Design.

Sheila Hicks, THE PRINCIPAL WIFE GOES ON (1969), linen, silk, wool, and synthetic fiber, eleven elements, each 180″ long. National Museum of American Art, Smithsonian Institution. Gift of S. C. Johnson & Son, Inc.

Hicks remarried and in 1965 moved to Paris. In her thriving Atelier des Grands Augustins she has carried out commissions for the French National Assembly, the Fiat Tower, the Paris Bank of Rothschild, and the Rochester Institute of Technology and has produced silk tapestries for nineteen Air France jumbo jets. Her experimental works have been shown repeatedly at leading museums—for example, a great looped, wrapped, and tasseled form entitled *The Principal Wife* at New York's MOMA in 1969.

At the same time Hicks continues to keep one foot in the third world. Invited to Calicut in southern India to help develop the local textile industry, she used native looms and materials to create weaves and fabrics that the local artisans have been expanding upon ever since. In 1968 she returned to Chile to help found a cooperative workshop in a remote mountain shepherd village, where she taught native craftspeople to produce rugs and hangings of alpaca and wet-spun linen.

In 1970, invited to Morocco to infuse modern approaches into the conservative rug industry, she created a second series of "prayer rugs"— dense, rich wool wall pieces with arched tops that echo the doorways and arcades of Moslem architecture. These works, in diptyches and triptyches, glowed like Mark Rothko paintings when they were shown at the Galerie Bab Rouah in Rabat in 1971.

Hicks received a gold medal from the American Institute of Architects and a retrospective at the Stedelijk Museum in Amsterdam. She spent a year traveling around Israel, organizing an exhibition of textile artists entitled Free Fall: Sheila. An art adviser to Saudi Arabia's Ministry of Education, the artist carried out thirty-two tapestries for King Saud University (1982–85).

From time to time Hicks creates huge temporary installations in different places around the world, improvised from masses of sheets, pillow cases, hospital gowns, and other materials obtained from local hospitals and other sources. She suspends, stacks, and knots these materials, creating whole walls and varying the forms to fit the available space. For the exhibition Fiber R/Evolution, the artist made a *World Peace Khaki Quilt* using shapes cut from military garments of opposing worldwide armies, pieced together, to make a statement about the possibility of "peaceful coexistence."

Irene Waller describes her work: "She underlines the beauty of threads when used in the mass as no other artist does, with both a reverence and an exuberance, so that one is aware of nothing but the magnificence of the material and her handling of it. The resulting works are poems of thread."[63]

Other artists have carried the fiber revolution forward into new dimensions. **Kay Sekimachi (1926–),** raised in the Japanese tradition in San Francisco, studied with weaver Trude Guermonprez and at the California College of Arts and Crafts (1946–49) and then with Jack Lenor Larsen at Haystack Mountain School, Maine (1956).

Inspired by the wire weavings of Ruth Asawa, Sekimachi developed a very personal technique, using multilayered nylon monofilament and other fibers. The layers interchange, and when taken off the loom, curve and bend, creating symmetrical, transparent interwoven webs of great clarity and fluidity.

Barbara Shawcroft integrates fiber sculpture with architecture in huge works for BART train stations and the Embarcadero Center in San Francisco. **Francoise Grossen, Ferne Jacobs, Lia Cook, Cynthia Schira, Sherri Smith, Dorian Zachai,** and others have helped develop the fiber arts into major contemporary art expressions.

Kay Sekimachi, NAGARE VII, monofilament woven
plastic, 80″ x 9″ x 9″. National Museum of American Art,
Smithsonian Institution. Museum purchase.

CERAMICS

Ruth Windmuller Duckworth (1919–) once
said that she wants "her life to be a spit against
the wind." An innovator who helped break down
the boundaries between ceramics and abstract
sculpture, she was a maverick from the start.

She was born in Germany into a Jewish family,
"complete with nannies and a higher regard for
the males of the family. . . . The other four [chil-
dren] were brighter in school, so that I was
called 'stupid little Ruth' at home. Some of my
drive I think is due to the effect of living this
down."[64]

The only subjects she liked were art and
sports; her joy in being active outdoors in nature
still influences her work.

In 1936, when Jews were refused entry into
art schools, she left Hamburg, joined her sister
in Liverpool, England, and enrolled for four
years at the Liverpool School of Art. In her last
year she dropped out before getting a degree be-
cause she was so poor she sometimes went
hungry.

After supporting herself by putting on puppet
shows (she carved the heads) and bicycling
around Manchester and the Lake District with a
portable theater, she went to work in a munitions
factory to help Britain in the struggle against
fascism. It was dreadful—after two years she
had a breakdown.

Kind friends in London took her into their
home, where she began to carve in wood and
stone and entered a long psychoanalysis that
changed her life. ("I fight my night," she wrote
in her remarkable diaries.) Meanwhile she sup-
ported herself by carving tombstones at Fulham
Cemetery, but quit when she "noticed that my
own carvings were developing curly edges like
roses and ivy leaves."

In 1949 the artist married sculptor Aidron
Duckworth, had her first solo exhibition of

Barbara Shawcroft, YELLOW LEGS (1977), sisal rope materials 36′ x 20′ x 20′. Three Embarcadero Center, San Francisco, Calif. Photo: William Hocker, courtesy of the artist.

paintings and sculpture at London's Apollinaire Gallery in 1953, and worked with her husband on a commission for a church in New Malden. Her stone and wood sculptures show the influence of Henry Moore, Giacometti, and primitive art.

Duckworth became a potter by accident. She wanted to glaze a clay sculpture, so at the suggestion of her friend ceramist Lucie Rie, she took a course at the Hammersmith School of Art, discovered that she loved ceramics, and studied there with Bernard Leach and others.

The maverick Duckworth soon found the teaching too doctrinaire, however. Rejecting the idea that "a pot must have a foot—a middle—and a lip," she switched to the Central School of Arts and Crafts, became a teacher there, and set up her own studio. Bringing the fresh vision of a sculptor to ceramics, Duckworth was soon recognized as one of the most original potters in England, challenging traditional ways of creating form, whether in functional tea sets and bowls or in more innovative individual pieces. Even her salt shakers had a simple but remarkable shape—they looked like the forms of little breasts.

Duckworth won prizes at the 1962 International Handcrafts exhibition in Stuttgart and elsewhere and in 1964 was invited to join the art faculty at the University of Chicago. It was unsettling to leave her family, but she took the job for a year because she had always wanted to see the United States and Mexico, and was curious about "why people made those ugly pots that I so often saw in *Craft Horizons.*" This was the period when Peter Voulkos and others had created an abstract expressionist revolution in ceramics. Divorced in 1966, she stayed on, excited by the opportunities that were coming her way.

In 1968 the University of Chicago ordered a four-hundred-square-foot mural on the theme of *Earth, Water and Sky* for the entry of the Hinds Laboratory of Geophysical Sciences. Duckworth created a stoneware universe, covering the walls and ceiling with low relief abstract forms that convey the feeling of galaxies, pocked craters, rippling waves. The theme was sympathetic because Duckworth has always found her principal sources in nature. Even at her lowest moment, when she was working in the munitions plant, she had an epiphanal experience sitting in the factory yard during a meal break on the night shift, looking up at the stars: "Suddenly I saw them not only beside each other but before and behind one another; truly three-dimensional. It almost pushed me into the ground, I became so small. But it was magnificent and awe-inspiring—the distances were staggering. My fascination and love of skies has since surfaced in some of my murals."

In contrast with the large stoneware pieces, Duckworth's porcelains, as thin as seashells, are often small, seductive, and sensuous, with secretive openings that hint at the inner sexual core. She sometimes works in thin sheets reminiscent of filo pastry or the stacked layers on the underside of a mushroom cap: "What originally fascinated me about porcelain was its fragility in the unfired state: a sort of testing of my ability to be caring and nurturing enough to make a piece that would survive my handling it. How fragile can I make it and have it survive?"

Recognized internationally, Duckworth continues to do stoneware murals, such as *Clouds over Lake Michigan,* a kind of aerial weather view of Chicago's clouds, lake, and city (1976, Dresdner Bank, Chicago Board of Trade Building), as well as functional objects, stoneware sculptures, and heart-stoppingly refined small porcelains. The organic abstract forms in all her work suggest everything from buds to mushrooms, bones, vulvas, penises, and metamorphic

Ruth Duckworth, CLOUDS OVER LAKE MICHIGAN (1976), ceramic mural, 9'7" x 24'. Dresdner Bank, Chicago, Ill. Photo: Hedrich-Blessing, Chicago, courtesy of the artist.

figures. One group of works suggests a split brain or a mushroom that has been partly cut open.

She has had solo shows in Tokyo, Israel, England, and Hamburg, the city she left as a refugee. Her work is in collections as far apart as Windsor Castle, England; the National Museum of Modern Art, Kyoto; the Stedelijk Museum, Amsterdam; and the Philadelphia Museum of Art.

HAPPENINGS, PERFORMANCE, AND CONCEPTUAL ART

In the 1960s, a period of turmoil and social change, when the civil rights movement, the assassinations of President Kennedy and Martin Luther King, and growing resentment against the Vietnam war led to a general questioning of accepted social premises, American artists were also pushing at the peripheries.

It was a time of wild experimentation. Blurring the boundaries between art and life, artists created events in real time and space that became known as "happenings." In the proliferating events in artists' lofts and storefront theaters, women played important roles. Dancers Ann Halprin, Yvonne Rainer, Simone Forti, Trisha Brown, and others collaborated with artists and revolutionized dance by introducing improvisational actions from daily life. Meredith Monk staged "operas" that combined lights, music, extraordinary wordless sounds, and dance. In *Juice* she incorporated the audience and dancers into the form of the spiraling ramp at New York's Guggenheim Museum. At the Judson Church on Washington Square, Carolee Schneemann organized *Meat Joy,* an orgiastic celebration of the flesh with participants who were nearly nude and props that included raw chick-

ens and mackerels. A protofeminist asserting woman's right to express her own sexuality, she was one of the earliest to use the goddess theme, doing so in a 1963 performance, *Eye Body.* Entire books have been written about this subject, which is barely touched on here.

Yoko Ono (1933–), a conceptual artist, was born to a Tokyo banking family that moved to New York after World War II. She was one of the earliest members of the avant-garde Fluxus group, who believed that art should be lived— should generate a new way of thinking and seeing rather than produce commodities to be bought and sold. In 1960–61 her bare loft in lower Manhattan, furnished with orange crates, became the center for far-out concerts and events that attracted John Cage, Marcel and Teeny Duchamp, and other avant-garde artists and poets.

Her first exhibition, in 1961, included an irregular piece of canvas laid on the floor, entitled *Painting to Be Stepped On.* Typical of her work was the crystal ball she displayed in 1964 with the caption, "This sphere will be a sharp point when it gets to the far side of the room in your mind" (*Pointedness*). One of her films contains images of more than three-hundred buttocks, and her book *Grapefruit* consists of a set of instructions for musical and artistic pieces.

Once she published a sales list of the prices of her work as a piece of art, and another time sold shares in herself. Created at a very early date, these works remind us of the art of the 1980s that critiques "commodification." As critic David Bourdon pointed out in the *New York Times,* she was not taken seriously, yet her work anticipated the concept art of Joseph Kosuth and Lawrence Weiner, "who came in and did virtually the same things as Yoko, but made them respectable and

collectible."[65] After she married Beatle John Lennon, their performances together, such as their "bed piece" to "celebrate love not war," became world events.

In 1989 the artist was accorded a show of her films and "sculptures" at New York's Whitney Museum. For this occasion the artist cast some of her ephemeral mind-objects in bronze, to symbolize her feeling that the 1980s, in contrast with the freedom of art in the 1960s, was an era in which art and life were frozen and commodified.

Shigeko Kubota (1937–) studied sculpture at Tokyo University and was inspired by a John Cage performance in Japan to come to New York in 1964. She became a leader in the prolific Fluxus Group, which staged happenings and conceptual events and distributed printed materials. Since the 1970s she has become well known for her video sculptures constructed out of many television sets broadcasting simultaneous video programs that deal primarily with themes relating to nature.

Alison Knowles, Marta Minujin of Argentina, and **Yayoi Kusama** of Japan were also part of the New York experimental scene in the 1960s.

Kusama created unforgettable sculptures, consisting of boats, chairs, shoes, and other objects that sprouted innumerable phallus-like stuffed-canvas protruberances painted all over with thousands of dots. Sometimes these were installed in mirrored rooms that echoed the dotted forms. This hallucinatory imagery has obsessed the artist since her childhood in war-torn Japan.

Referred to as "the polka dot girl," she sometimes appeared covered with nothing but polka dots in numerous antiwar and antiestablishment performances and events on the steps of the Wall Street stock exchange, at the Statue of Liberty, and elsewhere. Returning to Japan in 1973, Kusama has in recent years been voluntarily working in the shelter of a hospital. She continues to pursue her art with great devotion and has also written an autobiography and other works. Now a leading Japanese artist, she had an impressive 1989 exhibition at New York's Center for International Art.

henge-like structures, created forms out of sticks, stones, earth, woven branches, expressing in a variety of ways their identity with Mother Nature, Mother Earth, and ancient cultures.

Climbing Parnassus: The 1970s

In the 1970s there was a flowering of work by women sculptors, embodying new visions and attitudes, sometimes on a scale never achieved by them before. It grew out of the encouraging atmosphere created by the feminist movement and by a general change in society that had begun in the late 1960s.

The 1970s saw the breakup of the hard-line modernist ideology. In a period of social ferment, artists began to reject the rigid formalism of the 1960s. There was a revival of realism, expressionism, narrative, and other kinds of content. Political and social themes reentered art for the first time since the 1930s. Many sculptors reached out to the public in performance art, rituals, site works, land art.

In her book *Overlay,* critic Lucy Lippard documented the return to the primitive, the prehistoric, and the primordial. Horrified by the alienation of modern life and the threat of global destruction, artists dug forms into the earth, portrayed ancient earth goddesses, erected Stone-

THE WOMEN'S MOVEMENT IN ART

In the late 1960s many American women awoke from a long slumber, looked around and saw that they had made little progress since the founding mothers had won the right to vote fifty years before. A new consciousness developed, influenced by such important writers as Simone de Beauvoir in France and Betty Friedan, whose book *The Feminine Mystique* rallied a generation of women.

Like their sisters in other professions, women artists began to analyze their situation and were angered to discover that there had been almost no solo shows by women in major museums in the previous decade; there were almost no works by women on display in the permanent collections of museums; and the leading galleries in New York carried only a few token women. A statistical study conducted by the Tamarind Lithography Workshop showed that critics often failed to review the work of even those women lucky enough to exhibit.

Indeed, the situation was worse than it had been in the 1920s, when magazines and newspapers had repeatedly carried articles declaring that women sculptors were now the equal of men. At that time roughly 20 percent of the work in major juried exhibitions was by women. In contrast, the 1969 Whitney Annual Exhibition included 143 men and 8 women.

Women artists organized, picketed, descended on museum directors and curators, and even engaged in guerrilla tactics, such as leaving eggs on the shiny floors of the Whitney Museum and

staging a sit-down strike at one of its openings. Deciding to circumvent the established galleries, they set up their own cooperative spaces—AIR and Soho 20 in New York City, WARM in Minneapolis, Artemisia in Chicago, and others. Under the leadership of Judy Chicago, Arlene Raven, and Sheila de Bretteville, the Woman's Building, the first center of feminist culture, opened in Los Angeles. The Women's Interart Center and later the Feminist Art Institute opened in New York City.

Not only museums and galleries, but even college textbooks were closed to women. Janson's *History of Art* and Gardner's *Art through the Ages* did not include a single woman. The claim was that none was worth including. In 1971 Linda Nochlin opened a national debate with her article in *Art News,* "Why Have There Been No Great Women Artists?" in which she analyzed some of the social forces that have militated against women artists through the centuries. The following year the Women's Caucus for Art was formed under the leadership of its first president, Ann Sutherland Harris, to conduct seminars and campaign vigorously for equal opportunity for women artists and art professors.

Beginning with Eleanor Tufts's *Our Hidden Heritage* in 1973, a torrent of books and articles flowed forth, revealing the buried history of women artists and dealing with various aspects of women in the arts. Mounting pressure resulted in a historic 1976 exhibition, Women Artists: 1550–1950, curated by Harris and Nochlin at the Los Angeles County Museum of Art, which brought before the public the splendid work of such artists as Artemisia Gentileschi, Anne Vallayer-Coster, and many others who had been largely written out of art history. This was followed by other important exhibitions of women's art, past and present.

The barrage of feminist scholarship has had an effect. Janson, Gardner, and other textbooks were finally revised in the 1980s to include some women artists, although a proper balance has by no means been achieved.

Among the critics, Lucy Lippard played an interesting role. Already famous for her books on pop art and other topics, Lippard had an established position and could have remained comfortably ensconced in the halls of high art, but instead, her newfound feminist consciousness forced her to recognize that "there were many women artists whose work was as good or better than that currently being shown, but who, because of the prevailingly discriminatory policies of most galleries and museums, can rarely get anyone to visit their studios or take them as seriously as their male counterparts."[1]

In 1971, Lippard curated Twenty-Six Contemporary Women Artists at the Aldrich Museum in Connecticut, selecting artists who had never had a solo show in New York City. History has demonstrated the validity of her thesis: among the twenty-six were such now-famous artists as Alice Aycock, Mary Miss, Jackie Winsor, and others, who were at that time receiving little attention. In the following years other feminist critics set about breaking down prejudice in the art establishment not only against women but against artists of color. They also helped to open up such taboo areas as social and political art. They developed critical tools for recognizing the special perceptions and forms that women were contributing—new points of view arising from a different experience in society.

Feminist art history and criticism have done far more than revive the forgotten women artists of the past. They have turned a searchlight on the ways in which art and images of all kinds have been used to perpetuate sexism and distort our perceptions to suit the needs of the power structure.

FEMINISM: A NEW VISION

For the first time in Western art, women are leading, not following. And far from displacing men, female leadership has opened up new freedom for everyone.
—Kay Larson[2]

Such [feminist] mixing of categories and genres became the style of 1970's Post-Modernism in all the arts.
—Charles Jencks[3]

Instead of advancing the avant-garde, many feminists in the 1970s challenged the notion of the avant-garde altogether; in fact, they challenged the idea of "style" or "form" as the primary issue. "Art about art" was viewed as an empty expression of elitism. They sought instead ways to communicate to an audience—to "raise consciousness, invite dialogue and transform culture."[4]

Working in a wide range of styles, some feminist artists turned to traditional history painting and realism; others infused abstract art with a new content. They mixed genres and media, pioneered in performance and video art, used their art in the streets, in rituals, in public events, as well as in the gallery. Above all, they brought to art a new interpretation of life.

Female Eroticism and Personal Expression

Women have been consistently portrayed in art and the media as the *object* of the male gaze and male desire, the muse or inspiration, rather than the active creator of meaning. They have been shown as virgins, whores, or witches, but seldom as real people. In the 1970s women began to assert their right to express their own identities and their own erotic feelings.

In the early 1960s Hannah Wilkie was already creating large oval fiberglass mesh genital forms, but at that time was afraid to show them.

In the seventies she could openly create a variety of latex, clay, and lint foldings as vulva icons, symbols of female desire and sensuality, and express her outrage against the treatment of women with her body art performances (her "starification" series).

Judy Chicago, a California artist also angered by the chauvinism she found in the art world, set up the first feminist art program at California State University in Fresno in 1969. A new vision emerged from these classes, and several of the women in it, such as Suzanne Lacy, have gone on to achieve national reputations.

Seeking an alternative to the old tradition of phallic imagery (the obelisk, the Washington Monument, the skyscraper), Chicago, when studying the work of women artists of the past—the flowers of Georgia O'Keeffe, the open centers in sculpture by Barbara Hepworth and Lee Bontecou, the mysterious recessive boxes in Louise Nevelson's walls—concluded that a recurring theme in women's art is central core imagery.

Chicago took the formerly hidden and unmentionable private parts of a woman's body and celebrated them in a five-year project called *The Dinner Party.* Working with a large group of assistants, she created thirty-nine place settings—each representing a great woman in history—set out on a huge triangular table. The painted porcelain dinner plate that served as the centerpiece of each setting was sculptured into a flowerlike vaginal image symbolizing that woman. *The Dinner Party,* which traveled from the San Francisco Museum of Modern Art to the Brooklyn Museum and elsewhere, became one of the most controversial works of modern times, evoking warm emotional response from some critics and disgust from others. As Linda Nochlin put it, the placid iris had been transformed "into a fighting symbol."[5] Today *The Dinner Party* is reproduced in many books and has become a classic icon of the period.

© Judy Chicago 1979, THE DINNER PARTY (1974–79), painted porcelain and needlework, 48′ x 48′ x 48′. Photo: Michael Alexander.

Miriam Schapiro in collaboration with Sherry Brody, THE DOLL HOUSE (1972), mixed media, 48″ x 41½″ x 8″. Collection of Miriam Schapiro. Courtesy Bernice Steinbaum Gallery, New York: Photo: Frank J. Thomas. Created for the collaborative exhibition *Womanhouse,* this subversive "sculpture" challenged conventional notions of art. Each room represents an aspect of women's fantasies and fears.

Such imagery became common in the 1970s. New York artist **Colette,** for example, converted her New York studio into a womblike lair of draped fabric. Few Angelenos will forget the exhibition of erotic art at Womanspace (a women's art center in Los Angeles whose successor is today's Woman's Building); hairy pubic forms and other images greeted a shocked public.

But this was only one of many ways in which women expressed their point of view. Some portrayed men through *their* eyes, as erotic objects or as vulnerable, frail, or menacing. Another group portrayed loving, sometimes lesbian, relationships between women, and others depicted women as strong, active, intellectual.

"The Personal Is Political" Turning to their own life experiences, women artists drew on domestic imagery—houses, clothing, food, dishes, cups, kitchen curtains, brooms.

When Judy Chicago teamed up with Miriam Schapiro in a full-scale feminist art program at the innovative California School of the Arts in Southern California, one of their projects was *Womanhouse.* With their students they remodeled an old Los Angeles house scheduled for demolition, converting each room into a fantasy expressing the despair, fear, or frustration of women. Sandra Orgel's *Linen Closet* expressed the claustrophobic feeling of women trapped in mindless household drudgery. In a pink *Nurturant Kitchen,* plastic fried eggs on the ceiling turned into breasts. In a bedroom a woman sat gazing into a mirror, painting her face with makeup all day long. Although *Womanhouse* existed for only a few months, it drew huge crowds, was televised, and had an impact on the public.

Feminists brought out of the closet a whole range of hitherto taboo subjects, such as menstruation, violence against women, rape, incest,

Sandra Orgel, LINEN CLOSET from Womanhouse Project (1972), mixed media (destroyed). Photo: Sandra Orgel.

child molestation, fear of aging. The world has changed so much that it is hard to remember how daring it was at that time to discuss such topics, let alone use them as themes for art. The public art programs of Suzanne Lacy and others have played a significant role in raising the consciousness of the public and changing the attitudes of police departments toward the victims of such crimes as rape and child abuse.

"High Art" and "Low Crafts": Pattern and Decoration Women artists and art historians now honored the thousands of years of anonymous art created by women in the form of crafts. In most cultures women have been basket makers, potters, weavers, embroiderers; it was they who sewed the clothing, decorated the home, and created useful and beautiful objects for it. This art had been denigrated as "mere decoration".

In the 1970s women artists embraced their age-old heritage. Feminist critics pointed out that there was little difference between the design on a Navajo blanket and a nonobjective painting by Josef Albers; that a beaded leather baby carrier sometimes had a form as beautiful as a minimalist sculpture. Miriam Schapiro, Joyce Kozloff, and others deliberately incorporated these forms into their work; some males also became practitioners of pattern painting.

Sculptor Harmony Hammond plaited and painted a traditional rag rug into an abstract spiral design, laid it on the floor, and called it *Sculpture*—a two-edged reference. First, it expressed identification with the women who made hooked and braided rag rugs; second, it was a send-up on the minimalism of sculptors such as Carl Andre who was placing metal squares on the floor instead of on a pedestal. After all,

Harmony Hammond, FLOOR PIECE II (1973), cloth and acrylic paint, diameter c. 4½′. Collection of the artist. Photo: Harmony Hammond.

women had placed their "democratic" art on the floor for centuries, hadn't they?

Although pattern and decoration as a separate movement largely faded in the 1980s, its pervasive influence can still be felt. In general, the increasing use of color, pattern, and rich complexity in sculpture and other media by both men and women—in what could be called a "maximalist" trend of the 1980s—was in part inspired by this woman-led movement of the 1970s. For the minimalist dictum "less is more," women artists substituted "more is not enough."

Public, Political, and Collective Art: Ritual and Performance Turning away from the individualism and commercialism of the contemporary art world, women artists sought forms that were more collaborative and more in touch with the community. *Womanhouse, The Dinner Party,* and Chicago's later *Birth Project* were experiments in collaboration.

Women played a major role in performance art—a collaborative, multimedia hybrid of theater, music, art, film, and dance. They also worked on a variety of public projects. Betye Saar's and Joyce Kozloff's installations for train stations, Nancy Holt's pocket park in Arlington, Virginia, and Mary Miss's *South Cove* in Battery Park are examples. Barbara Kruger and Jenny Holzer use the poster, the moving electric sign, and other mass media to reach a large public.

The Great Goddess: A New Spiritualism Breaking from religious expressions in which the male principle acts as a form of oppressive domination, a number of women artists such as Ana Mendieta, Carolee Schneemann, Donna Henes, Donna Byars, Betye Saar, Mary Beth Edelson, Betsy Damon, Kyra, and others turned for inspiration to goddess imagery and ancient female deities. In sculpture, painting, and ritual, they revived the image of woman as shaman, deity, powerful creator and generator of life.

Scholar Gloria Orenstein (who identified such themes in the work of women surrealists and contemporary artists) points out that the use of goddess imagery has been a means of symbolizing the creative potential of women—a way of connecting them with a long, ancient female history.[6]

ABSTRACT SCULPTURE

Abstract sculpture, since 1970, in contrast with the minimalism of the 1960s, opened up a wide range of maximal and expressive forms, incorporating rich color, pattern, and decorative elements. The boundaries between painting and sculpture are melting. Artists like Dorothea Rockburne, Cynthia Carlson, Ree Morton, and Elizabeth Murray hover between them, and the painterliness of Nancy Graves's multicolored bronzes makes them hybrids.

References to figures and other subject matter have reentered the work. This is very different from the pure "objectness" of the 1960s. In the case of Nancy Graves, for example, although she is classified in this book as an abstract sculptor, her work is constantly derived from forms in nature and makes reference to science, archaeology, and many other themes.

There has been a widespread return to the use of bronze, which had been largely abandoned in favor of welded steel and other modern materials. New casting methods now permit bronze to be used in very free ways, enhanced with colors and patinas never before associated with it.

Nancy Graves (1940–) is best known for her multicolored bronze assemblages, made by casting and welding together all kinds of unlikely natural and industrial forms—real leaves, pods, delicate tendrils, crayfish, seaweed, lobster claws,

C clamps, bamboo fans. Their open extravagant configurations suggest science fiction or ancient primeval life. Walking into a room of her looping, sprouting sculptures is like entering an undersea garden.

Graves first burst on the art world in 1969 at the Whitney Museum with a room filled with three life-sized, fur-covered *Camels*. These were followed by forms that include fossils, bones, and fetishistic pieces, before she arrived at her current bronze assemblages. Diverse as they seem, the works are bound together by a consistent theme. Since her childhood in Pittsfield, Massachusetts, where she spent much time at the Berkshire Museum of Natural History (her father worked there), Graves has been fascinated by natural history, anthropology, and archaeology. Her work is a constant exploration of the interface between the life sciences and art.

At the same time, Graves builds upon an awareness of the formal contributions of Picasso, Pollock, and David Smith and hopes to "challenge all who came before me, and do something that hasn't been done before."

Graves studied literature at Vassar (B.A., 1961), and then took the rigorous M.F.A. program in painting at Yale (1964), where her classmates included Brice Marden, Chuck Close, and Richard Serra (her husband between 1965 and 1970). In 1966 she and Serra lived in Florence, Italy, where a pivotal experience pointed her in the direction of her subsequent work. At the Florence Museum of Natural History, she saw the magnificent wax models of human and animal anatomy made by an eighteenth-century anatomist, Clemente Susini, which transcended mere scientific accuracy. Their beauty gave her the idea that she might be able to combine her love of natural history with art—extend sculpture into areas never considered before. Graves devoted the next three years to an intensive study

of bactrian camels, leading to the sculptures at the Whitney Museum in 1969.

These camels confounded and puzzled the critics. Totally realistic, they looked at first sight like taxidermy, yet were entirely made by the artist. Built up out of polyurethane, latex, burlap and painted animal skins on wooden armatures, they were more real than any real camel could be, at the same time evoking the abstract beauty of the forms. Coming at a time when minimalism and conceptual art dominated the art world, these works were truly subversive.

The extraordinary presence felt in *Camels* is partly due to Graves's passion for her subject. For years she studied the animal's anatomy, went to slaughterhouses, destroyed many of her early versions, even made several films later on at camel markets in North Africa. John Yau suggests that the camel may be a metaphor for the difficulties faced by a woman artist in a male-dominated art world. Like the camel, she must survive a long trek through difficult terrains, drawing on her own stored-up reserves for sustenance.[7]

Deciding that the internal structure was as interesting as the outside, Graves then created installations based on the forms of rhythmically grouped camel bones (*Variability of Similar Forms*, 1970), floor pieces strewn with simulated fossils (*Fossils*, 1970), others in which bones hang inside the casings of skin around them, and fetishistic installations that suggest masses of hides, feathers, totems, and ceremonial robes—poignant references to the passing of primitive cultures. In these works inspired by paleontology and prehistory the artist was as interested in formal problems—"the relationship between the inside and the outside of forms"—as in the subject.

Between 1970 and 1972 Graves had solo shows in Aachen, Germany, Vassar College, Cleveland's

Nancy Graves, INSIDE-OUTSIDE (1970), steel, wax, marbledust, acrylic, fiberglass, animal skin, oil paint, 4′ x 10′ x 10′. Private collection. Courtesy of M. Knoedler & Co., Inc., N.Y. Photo: Peter Moore.

New Gallery, and the University of Pennsylvania. Many assistants were required to carry out her ambitious program. During an entire summer, in ninety-degree heat, she worked on *Shaman* in her Greenwich Village studio, surrounded by gallons of latex, her throat sore from breathing the ammonia in the liquid. After these extraordinary exertions Graves took a sabbatical—a four-year detour into abstract paintings made of colored dots and gestural marks, based on motifs drawn from undersea and moon maps, weather charts, and other scientific material (1972–76).

Graves was introduced to bronze for the first time when German art patron Peter Ludwig commissioned her to make a bronze variation of a complex earlier fossil piece for the new Ludwig Museum of modern art in Cologne. This brought her to the Tallix Foundry in Peekskill, New York, where she has continued to work.

At first Graves modeled in wax for the conventional casting process until a mundane event spurred a new direction in her work. When one of her cats urinated on a favorite household plant and killed it, she asked the foundry to cast it and thus preserve the object. The foundry used an ancient, but little used, method of casting the fragile plant by encasing it in a thin ceramic shell, burning it out in a kiln, and then filling the hollow shell with molten metal.

Suddenly the artist realized that with this method she could cast almost any burnable form in nature, no matter how delicate or ephemeral, and incorporate it into a sculpture. Graves brought canvas bags to Peekskill crammed with a variety of objects to be cast—fish maws, lotus blossoms, palm fans, even potato chips. She piled up an inventory of bronze forms; then, working at the foundry with a crane to lift heavy pieces and a welder-assistant, she freely combined forms, looking for unexpected arrange-

ments that subverted the rational notion of how these objects would normally relate to one another. Sometimes she incorporated found objects, such as a wheel or a chain.

One idea led to another. Thin, limp ropes became self-supporting in metal. A string of cast sardines became hair; a group of bean pods and lotus heads, topped by a mandala of leaves, turned into *Agni,* the Indian goddess of fire. An s-curve of steel, cast palm leaves, and C clamps, set on real movable wheels, became *Wheelabout* (1985, Fort Worth Art Museum), a great movable toy. Other works turned into trees (*Trace,* Los Angeles County Museum of Art), dancing figures, unbelievable animals or insects, often poised on a point or extending out in a teetering balance that seems to defy gravity.

Graves's intuitive method of making sculpture is an extension of abstract expressionism. It has led to complex intertwining forms that push the medium of bronze beyond anything done before—the very opposite of the massive bronzes of earlier times. The artist freely acknowledges the influence of Picasso and especially David Smith, who welded found objects and painted them in colors in the early forties. The title of her sculpture *Zaga* pays homage to Smith's *Zig* series.

Trained as a painter, Graves has extended the use of color on bronze. She heats parts with a blowtorch and paints them with luscious chemical patinas or dabs on polyurethane paint, using color not only to transform the identity of the objects but to make forms appear to come forward or recede. Sometimes she adds jewel-like sections of enamel fused on metal.

The protean artist continues to move in new directions—for example, combining paintings with three-dimensional forms that project in space. A major traveling retrospective opened at the Hirshhorn Museum in 1987.

Nancy Graves, ZAGA (1983), cast bronze with polychrome patination, 72″ x 49″ x 32″. The Nelson-Atkins Museum of Art, Kansas City, Mo. Gift of the Friends of Art. Photo: Jon Abbott, courtesy M. Knoedler & Co., Inc., N.Y.

Jackie Winsor (1941–)

Basically, you make things out of the structure of
who *you* are.
—Jackie Winsor[8]

Jackie Winsor's roughly coiled ropes, bound trees, wrapped grids, or burned wood-and-cement cubes emit a muscular energy that evokes the spirit of her ancestors—pioneering ship captains and farmers on the bleak coast of Newfoundland, Canada. Although her sculpture is based primarily on minimalist forms—the cube, the sphere, the grid—her use of organic materials and her slow, patient, almost ritualistic wrapping, nailing, building layer on layer, give them a personal, autobiographical character.

Winsor's father was a factory foreman who designed his own house, but her mother did much of the construction, plumbing, and carpentering while he was at work. When Winsor was asked how she could haul heavy cement and wood pieces and engage in the brute labor required by her kind of art, she replied vehemently: "Look, what I got when I was very young was that women worked very hard. The idea that men are stronger than women is a matter of what your culturation is about.... I've had women assistants who came in being very limp-wristed ... But once they began working with me, they soon were as strong as I am. It has to do with a willingness to use one's abilities at full capacity."[9]

When the family moved to Boston it was a tremendous jolt. Winsor's adolescence was suffused with longing for Newfoundland until in late high school she developed a way out through a passionate involvement in art. Encouraged by her teachers, she took courses at the Boston Museum School before graduation. The first member of her working-class family to go to college, Winsor supported herself at the Massachusetts College of Art, won a summer scholarship to the Yale-Norfolk Summer School (where she was exposed for the first time to intellectual debates among practicing artists), and then took a master's degree at Douglass College, Rutgers, to be near the New York scene.

Winsor rented a loft on Canal Street in New York's Bowery district—a neighborhood filled with industrial materials, twine, cord, and heavy nautical ropes for ocean freighters. After discovering the toxicity of the plastics she was working with, she began to use these materials, so evocative of her seacoast childhood. An important early work, *Double Circle* (1970, University of Colorado, Boulder), is a massive double coil of thick rope, formed and wound by hand into a solid circle as large as a giant truck tire. The soft, pliable rope is transformed into a dense, weighty substance. In *Rope Trick* a massive coiled rope stands on end, like an Indian fakir's snake.

Winsor introduced logs, twigs, and trees into her sculpture. In *Four Corners* notched logs are wrapped at the four corners with raffialike unraveled strands of rope until the resulting four fat balls of twine almost completely cover the wood. Six months of labor, separating thick ropes into separate fibers and painstakingly wrapping and braiding them over the wood, culminated in a fifteen-hundred-pound sculpture that looks like some aboriginal artifact. On a rural site in Nova Scotia, the artist wrapped thirty slender trees around a living tree and bound the whole bundle with twine (*30 to 1 Bound Trees*, 1971). The work looks like the fasces of ancient Rome, transformed into a primeval symbol of unity.

Winsor crafts only a few pieces a year; each one involves a total investment of energy and feeling, and each one moves forward to a new idea. Leaving the ropes and twigs behind, Winsor created a huge cement ball that sits immov-

Jackie Winsor, DOUBLE CIRCLE (1970), rope, height 21″ x diameter 54″. From the Colorado Collection, University of Colorado Art Galleries, Boulder, Colo. Photo: eeva-inkeri, courtesy Paula Cooper Gallery, N.Y.

ably on the floor, a cement dome embedded with circles of brick, and other brick structures. She was trying to create a sense of density, mass, presence. When a selection of these early works was shown in 1976 at the Contemporary Arts Center, Cincinnati, they were described as having a "brute presence."

In *Nail Piece* (private collection) the artist, over a period of months, nailed nine boards together, one on top of the other, using fifty pounds of nails. Only the top layer of nails showed in the finished piece; nevertheless the work took on a heaviness, a mysterious presence that came from this obsessive pounding and layering of materials (the fifty pounds of nails equaled the fifty pounds of lumber). *Nail Piece* expresses a kind of boundless energy, an irrepressible force held within controllable bounds by a strong geometric form.

This angry strength also seemed to characterize Winsor's personality in the early decades of her career when she was struggling for recognition in the inhospitable art world. When critic Robert Pincus-Witten interviewed her, she was indignant at any mention of her liaison with a sculptor, since male sculptors' wives are never mentioned.

In recent years the artist has dealt increasingly with variations on the cube. Each of her carefully crafted boxes embodies a state of being and an aspect of the artist's psyche. In *Sheet Rock Piece* (1976), she layered ordinary build-

er's sheet rock, an "unaesthetic" material, into a three-foot cube that looks on the outside like an ordinary box. Each side has a small windowlike opening. The viewer, peering inside, can see the twenty layers required to make up the cube. Said a critic, "An object of great opacity and mass is visually penetrable and has at its core an empty 'seed' of light. It tantalizes us with an unreachably pure space at the center of its 'being'—a space that physically keeps us out; a space that can only be reached in our mind."[10]

Winsor has practiced violence on the cube—used fire and explosives on them—but builds them in such a way that they maintain themselves, albeit with some damage. In *Burnt Paper Piece* (1981–82, private collection), the artist set fire to reams of paper in the center of a wooden box covered with a fireproof cement. Through small openings in the sides, the viewer can see the burned interior. Black smoke left soot around the openings, but the hydrostone exterior maintained itself. The work is a metaphor for the human psyche, devastated by traumas, but somehow holding up, maintaining a façade. In *Exploded Piece* (1980–82, private collection), Winsor actually blew up a lovingly crafted box and then, leaving the residue, reconstructed the surface. These works hint at human survival after inner devastation.

Winsor was one of very few women accorded a solo show at the Museum of Modern Art and included among the shapers of post–World War II sculpture in the 1986 exhibition "Transformations," at the Guggenheim Museum.

Her recent mirrored boxes show an urbane polish in place of the "brute presence" of the early work, perhaps reflecting the change in her own mode of life (*Pink and Blue Piece,* 1985). Continuing to explore the frontiers of form and metaphor, the artist states her credo, "Making art is one of the most pioneering things one can do."

Lynda Benglis (1941–), known for her twisted metallic knots, has since the late 1960s been pouring, squeezing, and twisting materials into forms described as "frozen gestures." Through all its permutations, her work seems to flow from her early exposure to abstract expressionism.

Born in Lake Charles, Louisiana, Benglis attended Newcomb College in New Orleans where she was influenced by her art professor, Ida Kohlmeyer, a prominent abstract expressionist painter. They remain friends and have exhibited together. A 1962 Franz Kline retrospective at New Orleans's Delgado Museum also powerfully affected her vision.

After attending the Yale-Norfolk Summer School, Benglis moved to New York in 1963, enrolled in Reuben Tam's painting class at the Brooklyn Museum Art School, and was soon exposed to the New York art scene. Barnett Newman and his wife, Analee, she recalls, were particularly helpful and open to young artists coming to New York. She was also married to an artist and divorced. She still remembers that as his wife she was invisible as an artist.

Although Benglis understood the work of the then-dominant minimalists, such as Donald Judd and her good friend Carl André, she was searching for more visceral, organic experiences related to the body and its feelings. In a basement studio she dripped layers of wax encaustic paint onto tall, narrow, lozenge-shaped Masonite pieces. Abandoning the support altogether, she poured pigmented latex rubber onto the floor and peeled it off, producing irregularly shaped paintings of flowing color skeins (*Bounce,* 1969). Soon she was pouring semiflexible polyurethane foam into room corners—works whose oozing, plopping forms are almost scatalogical.

In huge polyurethane room installations shown around the country, the works sometimes looked like dripping wings or melting arms, reaching out from the walls (Massachusetts Institute of

Technology, Cambridge; the Walker Art Center, Minneapolis; Milwaukee Art Center, 1971). Benglis could afford to cast only a few of these large "ooze" pieces (most were destroyed to avoid storage costs). *Eat Meat,* cast in aluminum, suggests carcasses as well as less palatable substances.

While covering aluminum screening with plaster to create skinny tubular *Totems,* Benglis discovered that by twisting the tubing into knots she could create a range of expressive shapes that suggest various emotions and bodily movements. This led to a series of twisted forms that dance and move across the walls in calligraphic shapes. Later the artist metallized these forms in gold, silver, and copper.

In 1974, invited to lecture at the California School of the Arts, Benglis found herself in the midst of the feminist movement being sparked there by Miriam Schapiro, Judy Chicago, and others. Empowered to express herself freely, Benglis used outrageously gaudy "female" materials—sparkles, phosporescent day-glo colors, fan shapes, even net tutus—on her work. The *Knot* series developed into pleated, twisted, metallized, fanlike forms, and then into more restrained gilded forms with the aura of ancient Greek goddess-bodies.

That year, Benglis achieved a true *succès de scandale* when she advertised her exhibition at the Paula Cooper Gallery with a nude photo of herself holding a dildo as if it were her own anatomical part. The advertisement in *Artforum* caused a furor; she was accused of using pornography to sell her work. But what Benglis really had in mind was a satire of the macho stance commonly used to promote the persona, and therefore the work, of leading male artists. Shortly before, Robert Morris had used his nude body in a work, which also served to advertise his exhibition, but no one had objected. Ironi-

Lynda Benglis, ELNATH (1984), bronze wire, zinc, nickel. Private collection, courtesy Paula Cooper Gallery, N.Y. Photo: Geoffrey Clements.

cally, the controversy had the effect of making her name a household word.

Benglis's work is in major museums and collections. She explores her twist shapes in a variety of materials, including carved sandstone (*Falang,* 1980–81) and ceramic pieces covered with marvelous glazes (*Platinum Lustre,* 1981). A 1984 fellowship at New York's Glass Workshop inspired sand-cast glass pieces, fused with ceramic shards and jewel-like stones. Melinda Wortz says of these works: "Decorative this sculpture may be, but Benglis is never interested in decorative effects alone.... these sculptural forms look as if they might have erupted from the earth's core. Coiling and writhing, the pieces ... suggest ritual structures or Medusa-like swarms

of snakes.... One wonders where her protean talents will next lead her."[11]

The quirky abstract sculptures of **Rosemarie Castoro (1939–)** range from dancing, spidery or ladder-like groups to steel forms that seem derived from the angular creases of stiff crushed paper. Early in her career, after graduating as a painter from Pratt Art Institute in 1963, Castoro created three-dimensional forms that grew from a combination of minimalism and gestural painting. The artist covered masonite boards with thickly textured gesso surfaces that showed the sweeping marks of brush, broom, or mop, and then rubbed graphite into them to emphasize the texture. Soon she was bringing these large textured boards down off the walls and standing them on the floor, bending or arranging them in three-dimensional configurations, as in *Rotating Corners,* which resembles a revolving door, and *Break in the Middle* (1970), which depicts great curved walls covered with graphite-textured gesso surfaces in a changing rhythm of strokes.

These were followed by gangling epoxy and fiberglass forms that look like roots or tentacles, growing down through the ceiling or up from the ground. By 1975 the fiberglass forms were scuttling across the floor like weird dancing roots or vegetation (*Symphony; Two-Play Tunnel*). An anthromorphic quality informs these works (Castoro studied choreography and danced occasionally with Yvonne Rainer). *Hexatryst,* commissioned for the federal building in Topeka, Kansas, expresses a similar mobile quality.

In the 1980s Castoro made large crumpled forms by crushing and bending thin sheets of steel until they took on the gestures and attitudes of figures. *Flashers,* a group of ghostly steel forms, suggests that people can furtively hide or reveal their inner selves, while *Kings* and *Queens* have a regal, totemic quality.

Barbara Chase-Riboud (1936–) won renown in the 1970s for her imposing supernatural "personages," in which bronze abstract forms are combined with flowing silk and wool fibers. In the 1980s her work became more architectural and neoclassical.

Barbara Chase, an only child, was born into Philadelphia's black middle class. At seven she was sent for daily lessons to the Fletcher Art School and to the Philadelphia Museum's Saturday classes. At eight she won her first art prize.

While still in high school she won a *Seventeen* magazine art prize and sold her first prints to the Museum of Modern Art. Receiving several scholarships, she chose Tyler College of Art at Temple University (B.A., 1957), and then won a John Hay Whitney Award to study sculpture in Rome.

On a dare Chase left a Christmas Eve party in Rome and boarded a boat to Egypt with people she hardly knew. The artist later told Susan McHenry, "It makes my hair stand on end now.... I didn't even pause to wire my folks."[12] After they landed in Alexandria she found herself stranded in a strange land. Through sheer luck she ended up in the home of the American cultural attaché in Cairo, and while living with his family for three months, she was for the first time introduced to non-Western art. Almost blown away by the power and elegance of Egyptian art, she began to see Western culture as narrow and insular. "After that, Greek and Roman art looked like pastry to me."[13]

Chase went to Yale for a master's degree. There she and Sheila Hicks, who was deeply involved with Peruvian weaving techniques, found each other and began a mutually supportive friendship that continued later in Paris.

After completing an aluminum fountain for Wheaton Plaza in Washington, D.C., and gradu-

ating in 1960, Chase returned to Europe. For five years she traveled widely with her then-husband a noted photojournalist. By 1967, when she went back to work, several things had changed her: the civil rights movement, her travels in Asia and Africa, and a pan-African festival in Algeria. She now produced work that was different from the semiabstract sculptures she had done before. Bronze organic masklike forms now joined thickly braided, coiled, and knotted silk and wool fibers (*Confessions for Myself*, 1972; *Zanzibar*, 1972).

One influence in these pieces is African and Oceanic art, in which wooden masks adorned with raffia and other soft fibers cover the face of the wearer, while the fibers hanging down conceal the body, creating the magic supernatural personages of tribal ceremonies. In Paris, Sheila Hicks advised her on some of the technical problems connected with making the thick coils of fibers work.

These works have many-layered meanings. The hard bronze takes on soft, flowing forms, while the coiled and wrapped soft fiber skirts take on a hard form and appear to support the bronze; the traditional male medium of bronze is joined with the female craft tradition. The sculptures can be viewed as universal symbols of mutual interdependence and the need to reconcile seemingly opposing forces: male/female, negative/positive, black/white.

One of the first Western women to travel in China after the revolution, the sculptor, inspired by a magnificent burial robe of linked jade pieces found in the grave of a Chinese empress, created a sculpture made of linked pieces of multicolored bronze, sewn together with flexible wires. The hollow form has a powerful shamanistic female presence (*Cape*, 1973).

Chase-Riboud's design and technique earned her solo shows at the Betty Parsons Gallery, New

Barbara Chase-Riboud, STUDY OF A NUDE WOMAN AS CLEOPATRA (1983), wood, copper, multicolored bronze, 250 cm x 150 cm x 50 cm. Collection of the artist.

York; the University Art Gallery in Berkeley, California; the Massachusetts Institute of Technology; and at museums in France and Germany, where she is as well known as in the United States.

The gifted artist also published several books of poetry and three successful novels (*Sally Hemings, Valide,* and *Echo of Lions*), which have won international recognition.

In the 1980s Chase-Riboud's sculpture became imbued with an architectural and neoclassical feeling, perhaps influenced by the fact that her atelier is now in the fifteenth-century Palazzo Ricci, formerly the studio of Benvenuto Cellini, in Rome. In *Cleopatra's Door* (1983, also called *Nude Woman as Cleopatra*) the upright oak beams gradually metamorphose into hard metal links, which then take on a paradoxical "soft" draped quality across the top. Hard turns into soft, angle into curve, rough wood into gleaming many-colored metal. The glorious queen invites us through her doorway, but at the same time the image is androgynous.

Chase-Riboud now uses richly grained marble with bronze and fiber in works inspired by architectural elements: columns, doors, windows, arches. She has come full circle, accepting the great tradition of classicism as part of her aesthetic heritage, but continues to deal metaphorically with the mutual interdependence of contradictory elements—male and female, negative and positive, black and white, and, in a broader sense, the logical and the magical, the rational and the intuitive, the sensual and the spiritual.

Dorothea Rockburne (1934–)

The pleasures to which she aspires are those of an ideal platonic order, a perfect purity.
—Robert Storr[14]

The degree to which abstract art can be a metaphor for the transcendent is expressed perfectly in the work of Dorothea Rockburne. Her austere geometric abstractions made of creased and folded acetate, vellum, or canvas are based on mathematical systems such as the "golden section." But these systems are merely the underpinnings for an intuitive search for a state of metaphysical harmony.

The artist believes that she was born with this feeling for intense, but quiet harmony. As a frail child growing up in the town of Verdun on the St. Lawrence River near Montreal, Canada, she comforted herself during long sieges of pneumonia by listening to classical music on the radio: "At age five or six I'd be lying there listening to late Beethoven quartets. I liked the abstract quality of that music."[15]

Rockburne took art classes at age twelve and was still in her teens when she left for the Black Mountain School in North Carolina, an exciting experimental center where students and faculty were on the cutting edge, prepared to take risks. Her teachers were Philip Guston, Jack Tworkov, and Esteban Vicente; her friends included Cy Twombly, Robert Rauschenberg, and Franz Kline. Critically important were the dance classes she took with Merce Cunningham. Dance later turned out to be a catalyst in her development as an artist.

Rockburne married and had a daughter while still in school, but the marriage disolved. After settling in New York City in the 1950s, she worked as a waitress and at other low-paying jobs to support herself and her child, while struggling for two decades to find her own expression. In the 1960s, after reaching a dead end with abstract expressionist paintings, Rockburne took a detour into dance and participated in happenings with Robert Morris, Steve Paxton, Robert Rauschenberg, Claes Oldenburg, and others at the Judson Church and elsewhere. Dan-

cers like Yvonne Rainer and Trisha Brown inspired her: "I did that for three years, and from that I found out what to do in my work.... It freed my energy in some way that I can't describe ... and dancing taught me the way the body folds ... how the arms fold ... how folding produces emotion ... and that went into my art."[16]

Abandoning conventional painting, Rockburne made severe minimalist structures by spraying areas of tan wrinkle paint on large rectangles of dark iron (*Tropical Tan,* 1967–68). It was while spraying these works that she made one of those serendipitous discoveries sometimes experienced by creative people. The spray booth was covered with ordinary cheap brown wrapping paper. One day Rockburne stared at the brown paper and saw possibilities in it.

In her own body she began to identify with the way that paper could hang down on the wall, fold back into itself, or roll out. Instead of restricting herself to a single image, she used several panels of white paper on a wall side by side. Some rolled out on the floor, others were rolled up in a way that implied that they *could* unroll. Pieces of brown kraft paper and board covered with polished graphite were placed at intervals on the white rolls in such a way that they suggested a changing movement in the three-part composition (*A, C and D from Group/And,* 1970, Museum of Modern Art). These and the works that followed are also inspired by mathematics and philosophy: set theory, Boolean algebra, topology, the ideas of Pascal, Husserl, Wittgenstein.

During a trip to Italy on a Guggenheim fellowship, Rockburne became fascinated by the concept of the golden section—a system for arriving at ideal proportions that Renaissance artists took from the Greeks. Using this mathematical method as a structural framework, she invented a self-generating and self-complicating system for making drawings.

The idea of folding took possession of the artist in a series of golden section paintings. Rockburne gessoed canvas squares and rectangles on one side and varnished them on the back, and then slit and folded them into compositions of overlapping squares, triangles, rectangles, and resulting polygonal shapes. When the canvas dried, the stiff material supported itself without the aid of a stretcher, becoming a shaped canvas. She painted them in rich, sonorous colors derived from the Sienese and early Florentine masters who had inspired her in Italy (*Noli Me Tangere,* 1976; *The Discourse,* 1976).

Egyptian art inspired Rockburne's Egyptian series—all-white or all-black compositions made up of forms created by folding back squares or golden section rectangles of gessoed canvas. The results look like "sails" or triangular "pillows" of canvas, attached to the wall, with lines extending from them drawn on the wall itself. There is something serene and fresh about these works. The soft shadows at the edges of the forms, the dark incisive slits between the shapes, the interplay between the flat wall and the slightly raised forms, made critics think of sailboats on the Nile (*Stele,* 1980; *Seti,* 1980; *Scarab,* 1980). They are paintings, but they hover between two and three dimensions.

Rockburne still starts with the golden section but now paints her compositions with dragged brushwork and brilliant sensuous color and gold—pinks, oranges, magentas, inspired by such mannerist painters as Pontormo. She folds one shape over another and then paints in such a way that the top shape appears to belong to the one below it or to slip and slide over and under it in baffling eye-teasing ways. Like the mannerists, she plays with spatial ambiguities. Is the shape in front or in back? Is it on top or on the

Dorothea Rockburne, EGYPTIAN PAINTING, SETI (1980), conte pencil, oil paint on gessoed linen, glue, 95″ x 51¼″. Collection of Agnes Gund. Photo: Rick Gardner.

lower level? *Narcissus,* (1982–85) and *Two Angels,* (1984–85) are examples.

Although she began with spare, meager materials and is now reveling in sensual color and dragged brushwork, all her art has been informed by the same sense of metaphysical harmony that she felt as a child listening to Bach.

Jackie Ferrara stacks and layers planks of wood into forms that suggest temples, mastabas, staircases, and other architectural configurations. Although these works look as though they could be taken apart like children's building blocks, they are actually nailed, glued, and doweled with precise artistry. The models look at home in Ferrara's Soho loft, designed and built with fine cabinetry by her own hands. Ferrara is astonished at the way her career developed, since, as she put it, "I liked to work with my hands. Insidiously I became an artist; my hobby became my life."[17]

Born in Detroit, the sculptor first experienced the joy of making things in children's classes at the Detroit Institute of the Arts. After a brush with college at Michigan State University, she left for New York City. Living on the lower East Side and married to a jazz musician, Ferrara worked at low-paying jobs and spent nights listening to jazz in nightclubs. She began to take classes at settlement houses, making ceramics and primitive little figures, purely as a hobby.

When she took an office job at the Henry Street Playhouse, Ferrara made friends with actors and artists. Soon sculpture began to take over her life. In the late 1960s she created fetishistic objects of rope and feathers hanging from chains. She has always loved to work with cheap, readily available materials; a big cache of stuffed ten-cent birds supplied the impetus for these feathery frightening objects.

Jackie Ferrara, DUNE SEAT (1983), stained pine and poplar, 19½″ x 32½″ x 22″. Private collection. Courtesy Michael Klein, Inc. Photo: Roy M. Elkind.

A turning point in her work came when, after a divorce, she moved into a Prince Street loft and for a year and a half devoted herself to remodeling the studio, supporting herself by doing cabinetry for other artists. She loved the precision and order of this work. Because one-by-two-inch lathe was cheaper than regular lumber, Ferrara created beautiful doors and tables out of this material. When she went back to sculpture, she found that she could no longer create the expressionist fetishes. Rather, she quite naturally began to lay the lathe in clean clear configura-

tions—stairs, pyramids, and other simple but beautiful forms.

At first Ferrara covered the surfaces with a mixture of cotton batting and white glue to give a furry texture. She also picked up big pieces of cardboard found in the street and stacked them into forms. "I could make a huge structure for two dollars," she said.

Soon Ferrara realized that she didn't need the coating—she could leave the wood exposed. The artist, who enjoys doing puzzles and games, became fascinated by plotting out more and more

intricate and subtle forms on graph paper, sometimes using mathematical progressions. She said, "I have to know exactly where every piece will go ahead of time so that I can order the exact amount of wood."

In the early 1970s, while the sculptor was still working on her fetishistic images, a curator had come to her studio and invited her to show in a Whitney Annual. Although she has never been very political, Ferrara recognizes that the women's movement was a great help. "At that time they were looking for women" because of pressure from feminist groups. After she began to construct her wood pieces, critics recognized that she was creating a new kind of form.

Parquetry-like patterns of dark and light or stained colors enrich the work. Some models look like plazas; some like exotic Arabic interiors. The observer could theoretically walk into them and find places to sit, surrounded by walls and floors embellished with wood patterns stained in subtle colors. Other works look like chimneys or towers punctuated by slits. The artist says that in these "something happens with space perception. . . . these pieces are about exotic isolation ... tantalizing spaces that are sometimes visible through viewing holes, but are inaccessible and mysterious."

It was a natural progression from the wood forms to outdoor installations. One was for Laumeier Sculpture Park, St. Louis, and *Norwalk Platform* was funded by the General Services Administration for a park in Norwalk, Ohio. The seventy-foot platform, used for community events, is designed with several interesting staircases so that performers have a variety of exits and entrances. In the 1980s she completed a stone court for General Mills in Minneapolis; a concrete and slate lobby area for the Seattle convention center; a terrace of gravel, concrete, slate, and trees for the Stuart collection, University of California, San Diego; and a landscaped courtyard with water and trees for a government building in Atlanta.

Barbara Zucker (1940–) does things that aren't supposed to be done, like growing a fan on the end of a bent pipe or covering a steel sculpture with kitschy "flocking"—the fuzzy velvety stuff used on baroque wallpaper. These quirky juxtapositions awaken viewers to a new awareness.

The feminist movement was an important catalyst for the artist. A co-organizer for AIR, the first feminist cooperative gallery in New York City, she chose the fan, historically associated with feminine flirtatiousness, as a metaphor or leitmotif. For example, in *The Bride* the female principle, or fan, seems to be pinioned to the wall by an aggressive bent pipe. The artist did something unthinkable in these minimalist works— she covered the steel forms with flocking, thus softening it with a sensual, tactile surface, and even used organdy and rhinestones in others. The paradoxical images seemed to say that the feminine can be combined with strength, or that the female principle is entering the male bastion of steel sculpture. In *Plume II* (1980) the fan became a stately vertical six-and-a-half foot blue metallic enamel form standing poised and proud on a silver galvanized steel base.

After becoming a professor at the University of Vermont in Burlington, Zucker began to use latticework motifs, influenced by the Victorian architecture of the region, in the *Morristown Red Series* (1983), shown at the Pam Adler Gallery, New York.

Trained as a designer at the University of Michigan, with a 1977 M.A. in sculpture from Hunter College, New York, Zucker conveys im-

portant ideas within the restraints of taut and concentrated abstract forms.

Linda Howard (1934–) builds shimmering constructivist forms out of square aluminum rods, which she offsets to create luminescent curved surfaces. The shadows in these louvered constructions create a counterpoint of banded patterns that move slowly across the sculpture and the ground as the sun passes overhead.

Howard, who is interested in the notion of physical reality versus our idea of reality, feels that her work is related to Eastern philosophies and their counterparts in modern physics. Her structures, she says, are a means of "probing beyond physical reality to investigate various levels of consciousness and/or meditative states ... of finding *connections* between apparent opposites...."

The artist attempts to transform the solid matter of her sculpture into "spiritual energy" through the use of paradoxes and oppositions. For example, although the aluminum in her works has weight and density, she grinds it to a reflective luster, so that in the sunlight it appears to dematerialize. Paradoxically, shadows sometimes fall on the work to produce an illusion of solidity. Another paradox is that Howard's sculptures contain many curved planes, yet are made entirely of straight, square tubes. The curves result from the staggering and fanning out of the rods in regular sequences of spacing. Howard perceives the archways and gateways formed by the aluminum rods as "transitional spaces moving step by step to a larger scale and then on to the expanded universal cosmic space beyond."

Born in Evanston, Illinois, she earned an M.A. in sculpture from Hunter College, New York (1971); studied at the School of Architecture, City College, Bronx, New York; taught at New York Universitsy and Hunter College; and now lives near Tampa, Florida. She has received numerous grants and commissions, including *Sunyatta* (1979, Virlane Foundation Collection, New Orleans), *Samsara* (1981, Busch Corporation Center, Columbus, Ohio), and *Cathedral #6* (1986, University of Alaska, Fairbanks).

Dorothy Gillespie (1920–) creates polycolored spirals of mylar, aluminum, and steel that spring off walls and unfurl down staircases, creating a festival atmosphere.

A child prodigy from Roanoke, Virginia, she earned a degree at the Maryland Institute of Art and then studied in New York at the Art Students League (1943), the Clay Club, and Stanley Hayter's Atelier 17 print workshop. She exhibited her paintings at the Cherry Lane Theater.

After marrying an engineer in 1946, Gillespie lived in many countries because of his job and was busy with her growing family, but she managed to continue painting. As her situation became more settled, she began to experiment with combinations of abstract painting and sculpture by hanging paintings back to back or fastening them together in boxes or cubes. In the mid 1960s she was one of the first to use the strong but flexible space-age material, mylar, to create paintings, collages, and sculpture glittering with stars and ribbons.

Gillespie became a leader in the women's art movement, acting as coordinator of the Women's Interart Center from 1973 to 1977. In this period her work became increasingly three dimensional, and she felt empowered to try increasingly ambitious projects. In 1974, in Washington and New York, she exhibited room-sized environments of unfurling rolls of white paper, embellished with brilliantly colored designs—red, purple, blue, green. Since then Gillespie has completed metal murals and large installations

Linda Howard, CATHEDRAL SERIES: ELYSIAN (1986), white steel, 18½′ x 33′ x 27′. University of Alaska, Fairbanks. Photo: Courtesy of the artist.

of painted mylar, aluminum, and canvas on steel. Works of brilliantly painted metallic ribbons were completed for the Birmingham Museum of Art, Alabama, the Fort Lauderdale Museum, Florida, and elsewhere.

An artist who combines two- and three-dimensional art, Gillespie has said, "I started as a painter, and color is the beginning of my work."[18]

The swaddled, wrapped ladders of **Harmony Hammond (1944–)**, leaning against one another with awkward affection, are abstract forms but at the same time seem to be female presences.

Born in Hometown, Illinois, Hammond took Saturday classes at the Art Institute of Chicago while still in high school. She viewed the art world as an escape into freedom from her middle-class background, but while earning a degree at the University of Minnesota (1967) and supporting her young art student husband (soon divorced) by working at low-paying jobs, she realized

> that the art world wasn't an alternative to the middleclass society of Hometown, but that women were equally oppressed in the world of culture. . . . Like the early work of many women my age, mine was personal. But we learned to hide this aspect for fear that the work would be ignored or ridiculed. Underneath were feelings of not having the right to work in the first place, and the fear that our work would be taken away from us. So we hid our sources and disguised the meaning of our imagery in formal concerns."[19]

Hammond was painting "acceptable" hard-edged shaped canvases until she came to New York in 1969, and the next year joined a women artists' consciousness-raising group that helped her get in touch with the true sources of her art. In her first show in 1973 at AIR (the New York

women's collective) she exhibited fetishistic *Bags* and *Presences*—paint-spattered strips of clothing collected from women friends that hung on hooks and hangers like the nameless, ignored women of the past, now charged with a new totemic energy.

In a 1974 group exhibition with the women in her CR group at the Nancy Hoffman Gallery, New York, Hammond exhibited "floor pieces" that were actually circular hooked rag rugs, painted in brilliant colors in certain areas. These "sculptures" are wry comments on male-dominated minimal art and simultaneously pay homage to the warm, *useful* "abstract" forms created by women for centuries. Their spiral form is an ancient symbol for the female principle.

By 1977, objecting to the stereotyping of female imagery that some feminist artists were employing (flowers, vaginas, fruits, and so on), Hammond sought new forms. Using scrap ends of fabric dumped on the New York streets by the garment industry, she wrapped and bound them on cast-off pieces of wood and metal armatures. The resulting ladderlike forms covered with a skin of gesso, latex, acrylic paint, and rhoplex, have a bulky, fleshy, female look; the sensuously painted surface, to which Hammond sometimes adds glitter or pearls, blends with the colors of the rags themselves, bleeding through from underneath.

These are grouped to form metaphors for the female experience and the love of women for one another. *Hug* is a tall bulky ladder against which a smaller one leans, like a mother and daughter (Hammond has a daughter, Tanya). In *Hunkertime* (1979–80), nine rag-wrapped ladder forms lean against a wall like a group of women "hanging out together." In *Radiant Affection* (Metropolitan Museum of Art), two pink wrapped ovals interlaced with red represent "a female presence in the world."[20] The artist admits her debt to Eva

Hesse, whose wrapped, bound, visceral images felt, she says, as if they came out of her own gut.

Chicago's **Margaret Wharton (1943–)** has been wryly called a "chairperson." The chair, redolent with psychological associations, has been a vehicle for artists as varied as Marcel Duchamp, Lucas Samaras, and Scott Burton. What Wharton does, however, is to make sculptures *out* of old chairs. They hang by the hundreds from her studio roof waiting to be cut up, sliced, painted, deconstructed, and recombined into new totems that are variously metaphorical, satirical, or mystical, but are always somehow *people.* Many have autobiographical and feminist overtones.

In *Martyr* (1975) a chair has been deconstructed and recombined into a limp form that hangs on a wall with nails stuck into it. *Wallflower,* a poignantly shy totem, sits against the wall, her rhinestone eyes suggesting tears, while her headdress appears ready to sprout into new flowering. The wood has been cut into small segments and recombined into a patterned image that looks as if it were made out of braided stalks of wheat, something like a primitive corn dolly. In *Mockingbird* (1981), a narrow chair sprouts great wings of interlocking dowels suggesting that Wharton not only flies in newfound freedom but also takes a mocking look at the world around her.

Wharton earned an M.F.A. at the Art Institute of Chicago (1975), became involved in the women's movement, and was a founder of Artemisia, the Chicago women's cooperative gallery. A 1981 traveling retrospective was organized by the Museum of Contemporary Art, Chicago.

Ann Weaver Norton (1905–82) studied in her youth at the Art Students League and National Academy of Design and did semiabstract expressionist sculpture until the 1970s. Then, at an advanced age, she began to build extraordinary twenty-foot abstract "gates" and "arches" of cemented brick that now fill the Ann Norton Sculpture Garden, a nature preserve and museum in West Palm Beach, Florida.

In her last years she won wide recognition in avant-garde circles for the compelling power of these brickworks and her rough-hewn cedar "gateways." Her work is at the Detroit Institute of Arts, Storm King Art Center, and one archway is included in Boston's "art-on-the-line" program of subway art.

Ann Takayoshi Page (1940–) and **Neda Alhilali (1938–)** are two Los Angeles artists who have expanded the medium of paper into monumental abstract forms.

Alhilali, born in Czechoslovakia and trained in London, Munich, and Iraq, drew on international visions of ancient cultures after finally settling in southern California and obtaining an M.A. (1968) at the University of California, Los Angeles. Beginning with woven fiber forms, such as the macramé *Black Passage* (1971–73), a winged totem suspended from the ceiling, Alhilali soon became a pioneer in the large-scale use of sheets of paper in her outdoor installations on the sand known as *Beach Pieces.* Paper, she discovered, could be wet, stretched, formed, mashed, plaited, and painted. In *Beach Occurrence of Tongues* (1975), a procession of large tongue-shaped forms that also look like rocks or figures, winds back and forth across the beach in a kind of moving Stonehenge.

After this she plaited, pressed, and painted paper into reliefs enriched with painted overall patterns that clearly relate her to the pattern and decoration movement of the 1970s. In the *Cassiopeia* series of the 1980s, Alhilali wet and draped, like cloth, long sheets of paper painted in decorative patterns. These twisting forms

move from roofs to walls and across floors in innovative compositions. She also makes dense reliefs of layered, painted scrap aluminum. Transcending traditional boundaries, her work is simultaneously fiber, sculpture, and painting.

Seattle-born Ann Page earned a B.F.A. from John Herron Art Institute, Indiana University, and since coming to Los Angeles has exhibited kitelike paper and bamboo sculptures at the Space Gallery.

Los Angeles critic Suzanne Muchnic said of her ten-year retrospective at the Los Angeles Municipal Art Gallery in 1985:

> She soars on wings of crumpled paper . . . merges her Japanese heritage with Western influence and makes abstract art that's loaded with metaphoric associations. . . . Suggestions of birds and kites in her ruffled, translucent paper abstractions allude to flight, weightlessness and freedom.
>
> Skeletal bamboo structures and references to cocoons or shed skins—in hollow, rolled pieces such as "Casing" and "Ancestor"—recall stages of life and layers of anatomy. Her work can whisper as silently as a drifting flower petal or ring the gong of death, as in ominous dark pieces, pinned to walls like hides or flayed animals. *Antares,* an enormous abstraction filling a whole wall, is a red, roughly faceted, circular construction that can be seen as everything from an emblem of female sexuality to a tent or kite, wrecked by a storm and now impaled as a relic.[21]

Other artists who have worked with nontraditional materials—veils and sails and layers of fabric—are **Anne Healy** and **Rosemary Mayer.**

EARTHWORKS, SITE WORKS, AND MOMUMENTAL AND PUBLIC ART

One of the most impressive aspects of women's sculpture in the 1970s has been its increasingly ambitious scope and scale and its public nature. Moving out into the land or onto public spaces, women are creating earthworks, plazas, even paths and land forms that extend for miles.

Maya Lin's *Vietnam Veterans Memorial* in Washington, D.C., which the nation has responded to in an unprecedented way, is perhaps the quintessential example of the new role of woman in the most hallowed arenas of public art. Her contribution does not consist of a bigger and more assertive monument; on the contrary, her work brings to the time-honored theme of the war memorial a new sensibility—the compassionate attitude of a woman toward the tragedy of war. So revolutionary was her concept that the twenty-year-old artist found herself under attack. Her struggle to maintain the integrity of her work is described at the end of this book. Not only are women entering the field of public monuments and environmental art in large numbers; they are self-consciously bringing to it a new humanistic content.

Nancy Holt (1938–)

> I've always been a public artist. I want people to use the space.
> —Nancy Holt

Nancy Holt builds tunnels, cages, mounds, with openings in them through which viewers can look at the stars, the landscape, the world, in a new way, at the same time becoming conscious of how their individual perceptions are influencing what they see. She has said, "Some people think about my work as being about light or about the sun. But first and foremost, in the

beginning and continuing right through, my work is about perception and space. Light is something I got into because I was thinking about sight."[22]

Born in Worcester, Massachusetts, and educated as a biologist at Tufts University, Holt came to New York City and became part of the group of minimalist and conceptual artists—such as Carl André, Richard Serra, and Robert Morris—who gathered around Virginia Dwan, owner of the Dwan Gallery. There Holt met and in 1963 married Robert Smithson, a pioneer of the earthworks movement. Holt's interest in biology had a strong influence on him. They collaborated on videos and films (*Swamp*) that expressed revolutionary ideas about the artist's need to take art out of the galleries and into the land—to make humanity aware, in an apocalyptic age, of its oneness with nature. Holt was also creating her own works. In 1972 she placed a pipe through a sand dune at Narragansett, Rhode Island, so that people could look through it at a framed view of the ocean.

In 1973, the thirty-five-year-old Smithson was tragically killed in a plane crash while working on his earthwork *Amarillo Ramp.* Holt and friends Richard Serra and Tony Shafrazi completed it.

The following year, she purchased a piece of desert land in northwest Utah and placed four concrete tunnels on it in a cross-configuration in such a way that the viewer sitting inside of them could see the sun rising at the various solstices and equinoxes (*Sun Tunnels,* 1973–76). The artist drilled holes through the tunnel walls so that the sun, and the stars and moon at night, cast changing patterns on the dark walls. From a disorienting position, viewers became conscious of themselves in relation to the universe.

In 1977–79, on the wooded grounds of Western Washington University at Bellingham, Holt built *Rock Rings,* two concentric stone and mortar walls pierced by arched openings that are aligned with the North Star. She said: "I would like people to think about what they're seeing. . . . You look through a set of holes in thick stone walls. That does something to the landscape you're seeing. It's about making structures to focus our perception. . . . The structures exist to turn experience inside out. To bring perception into consciousness."[23] Holt was surprised to discover later that the ancient Indians of Chaco Canyon had also constructed buildings in alignment with the North Star. She feels a strong sympathy with the peoples of prehistory.

In *Star-Crossed* (1979–81), on the grounds of the art museum of Miami University in Oxford, Ohio, two intersecting concrete tunnels penetrate a grassy mound, overlooking an oval pool. Viewers walk into the tunnel at ground level and reach a point where the second tunnel intersects at a tilted angle, like a kind of telescope. Spectators see trees and sky one way; in the other direction, they see the light coming through the tunnel reflected in the pool. This work has male-female qualities, and also refers to the prehistoric earth mounds of the surrounding Ohio region.

For the roof garden of a federal building at Saginaw, Michigan, Holt constructed *Annual Ring,* a domed black steel cage with a circular opening in the top. Inside, a metal ring on the grass outlines a pool of light cast into it at the time of the summer solstice. People eat lunch inside the thirty-foot diameter and feel that they are part of the universe.

Time-Span (1981), on the grounds of the Laguna Gloria Art Museum, Austin, Texas, echoes the forms of old Texas stucco buildings, but also contains movable metal openings through which the site can be viewed. It is linked by a heavy chain to a stake in the river, suggesting the connection between the city of Austin and its source

of life in nature. In the 1980s the artist created a number of "waterworks" using plumbing pipes that actually carried hot water to heat the gallery.

Holt's works have increased in size and scope. *Dark Star Park* (1979–84) at the entrance to the town of Rosslyn, Virginia, contains large concrete balls with openings in them on landscaped park spaces. Drivers on the freeway and spectators who walk through the space encounter optical surprises and changing vistas. The artist thinks of the large balls as "stars that fell to the earth." One ball is aligned so that it casts a shadow to match a painted shadow on the ground on the precise day of the year when a Mr. Rosslyn originally founded the town, thus combining historical and cyclical time.

The artist is engrossed in a monumental project—the redevelopment of a miasmal landfill dump that stretches for miles along the New Jersey freeway. The challenge is to take a wasteland created by society and transform it into meaningful public art. About 125 million people a year will see it from planes passing overhead and from the freeway. The plan calls for a series of peaks to provide viewpoints of the equinoxes; a pool that will be a rain collector; and a methane flare lit from the methane gas seeping from the dump.

At *Sun Tunnels,* out in the vast Utah desert, a yearly festival celebrates the summer solstice at the time that the setting sun appears directly in line with the tunnel opening.

Athena Tacha (1936–), creator of rippling staircase sculptures that freeze like crystals or flow like lava, harmonizes art with the landscape, the people. Born in Larissa, Thessaly, she felt keenly the harshness of the American urban environment—the lack of pleasant public spaces where people can stroll, sit, and gather, as in the

Nancy Holt, STAR-CROSSED (1979–81), earth, concrete, water, grass. Mound—height 14′, diameter 40′, pool—length 18′10″, width 7′3″. Miami University Art Museum, Oxford, Ohio. Photo: Nancy Holt, courtesy John Weber Gallery, N.Y.

plazas and parks of Europe. Her outdoor forms carry echoes of the terraced hillside houses and ancient amphitheaters of her native Greece.

Tacha's father named her Athena to inspire her; he expected her to be both son and daughter to him. Not surprisingly she became a multifaceted intellectual, earning an M.A. in sculpture at Athens's National Academy of Fine Arts (1959), an M.A. in art history at Oberlin College, Ohio (1961), and a Ph.D. in aesthetics at the Sorbonne in Paris (1963).

As Athena Spear (she married art historian Richard Spear) she became curator of modern art at Oberlin's Allen Art Museum, organizing shows and writing catalogs on Rodin, Brancusi, and others. Continuing her own sculpture at the same time, she had by 1970 developed the concept of ramps and steps to involve the spectator. In 1973 she resumed the name Athena Tacha, and returned to her career as a sculptor and professor of sculpture at Oberlin.

During a 1974 fellowship at MIT's Center for Advanced Visual Studies in Cambridge, Massachusetts, Tacha was invited by director Gyorgy Kepes to propose a project for the bank of the Charles River. She began to see how step-sculptures might fit into the environment. "As I was walking along the river in the bitter cold," she wrote, "I became conscious of the inhuman character of American river banks; there is no pleasant place to sit, or to get a hot drink, and no way to walk down to the water . . . just an endless stream of fast traffic."[24] Noticing the pieces of ice floating on the river, the artist decided to use the dual nature of water in her model—flowing staircase forms on one side and angular crystal-like forms on the other. The project was never funded, but it was the seedbed for later commissions.

Streams (1975–76) in Ivy Street Park, Oberlin, Ohio, is a sandstone staircase that flows down a hill, punctuated by pink pumice boulders and lake pebbles. The concept was arrived at after a month of contemplation in a small village amidst the mountains and rushing streams of her native Thessaly (on a grant from the National Endowment for the Arts).

Tide Park (1976–77), a pocket park in Smithtown, Long Island, is an adobelike environment that invites viewers to climb and sit on curving steps, where they can enjoy the plantings, the small waterfall that spills into a pool below, and the design on the adjacent wall. It is made of inexpensive gunite—a thick skin of concrete sprayed over metal mesh and hand-finished. *Ripples* (1979) is a jagged staircase in front of a federal building in Norfolk, Virginia.

Tacha's step sculptures involve the viewer bodily in the work. She wants to "transform the body-rhythms of walking into a receiver of artistic expression, a sensor of a new kind of form . . . by varying the height, depth, width, inclination. . . . I aim to create a rich variety of temporal patterns, a different feeling of space, and a new awareness of gravity."[25]

The sculptor derives her forms from the flow of water and lava, the spiral of galaxies, the movements of subatomic particles: "I wish to express . . . the various forms of *fluidity* which appear to be the constant state of matter. . . . I wanted *rhythms* . . . growing naturally like ivy in the woods, fluctuating like a swarm of insects . . . overlapping or crossing . . . rhythmic systems of different frequencies, transformation of one set of forms into another."[26]

Tacha has made films, photo murals, conceptual works, books about forms in motion. She has created arcades by splitting strips of steel, bending the ends, and mounting them in cement below ground so that they are held in tension (*Tension Arches*, Cleveland, 1975–76; *Perspective Arcade*, Civic Center Mall, Toledo, 1980).

Athena Tacha, BLAIR FOUNTAIN (1982–83), concrete and rocks, c. 16′ x 60′ x 80′ (plus water jets). Riverfront Park, Tulsa, Okla. Photo: Athena Tacha.

Impressed by the relationship of great ancient monuments to the landscape, such as the pyramids in Egypt which seem to modify the whole horizon, Tacha exhibited models for such monuments at New York's Zabriskie and Max Hutchinson Galleries (1979–84). They remind one of Macchu Picchu or sets for a tragedy by Euripides (*33 Rhythms: Homage to the Cyclades,* 1978).

One of Tacha's largest commissions is the huge *Blair Fountain* (1982–83), part of a lake and dam project on the Arkansas River in Tulsa, Oklahoma. The artist took advantage of the hydraulic pressure of a waterfall to feed into round pools set in concentric concrete rings of varying diameters. Water spills over the tops, and jets of water spray up from the centers and from eight locations in the surrounding basin. The fountain and jets may be viewed from a promenade on the east bank or from the lake or from a bridge overlooking the dam.

An artist of conscience, Tacha exhibited proposals for memorials to victims of the Nazi Holocaust and the conflicts in Central America. In these she incorporates photographs sandblasted right into the wall, so that viewers traversing a pathway up a mound confront images of victims. She says: "Given the present state of the world, it is morally untenable to pursue an art career unless one makes art available to everybody (not only the financially or educationally privileged). One way of achieving this aim is to bring art into the urban environment."[27]

Mary Miss (1944–)

Haven't you noticed that much of the most important
sculpture today is being done by women? When I
went to school in the sixties there were almost no
women sculptors. Monuments? We are *anti-
monumental*; we want our work to be part of the
land, to grow into it and enhance it—not
to "stick up" or dominate it.
—Mary Miss[28]

Born in New York, Miss moved frequently be-
cause her father was a military officer. During
cross-country trips and years stationed abroad,
she saw forts, Indian sites, abandoned mines,
medieval towns, and castle ruins, all of which
left an indelible impression.

Miss studied at the University of California,
Santa Barbara (B.A., 1966), and the Rinehart
School of Sculpture, Maryland Art Institute
(M.F.A., 1978). In a basement studio in New York
City, she began to build room-sized structures
that reflected her outdoor western experience.
She first showed at the 1970 Whitney Annual
and then at the cooperative gallery, 55 Mercer
Street. She also became involved in meeting and
exhibiting with other women artists.

On a landfill area near the Battery, Miss con-
structed a temporary outdoor project that
launched her career—a series of wooden baffles,
one behind the other at fifty-foot intervals, with
circular holes cut in them at different heights in
such a way that the viewer, looking through the
openings, experienced a vast telescopic sense of
space and distance.

This was followed by *Perimeters/Pavilions/
Decoys* (1978), a temporary work extending
over acres on the grounds of the Nassau County
Museum of Fine Arts, Roslyn, Long Island.
Changing vistas were created for the viewer who
would climb up to a square wooden tower, then
down across open land, to a sunken pit entered

by a ladder, and ultimately to mystifying under-
ground rooms. The surprising vista changes
evoked memories of Egyptian tombs, Islamic
gardens, and English pergolas. In *Staged Gates*
(Hills and Dales Park, Dayton, Ohio), the viewer
is led up a wooded hillside through a succession
of openings that frame the landscape.

Miss enjoys dramatizing sites by setting up
screened lookout platforms through which the
viewer sees veiled vistas framed by posts, arch-
ways, or fences, as in *Veiled Landscape* (1980),
constructed for the winter Olympics at Lake
Placid, New York. *Field Rotation* (1981), on the
grounds of Governor State University, has a pat-
tern that makes the sitework appear to spin.
Rows of wooden posts radiate out from a central
pit into the adjacent field, creating the optical il-
lusion. Miss also built a platform work at Lau-
meier Sculpture Park, St. Louis, Missouri (1982).

In 1988, the sculptor completed one of the most
prestigious commissions in the country—*South
Cove* for Battery Park City, a posh real estate de-
velopment at the southern tip of Manhattan, not
far from Wall Street. Eager to bring her ecologi-
cal and social concerns to the project, Miss felt
that the general population should be given ac-
cess to the waterfront and the view, so often
blocked by industrial structures. She therefore
designed, in collaboration with architect Stanton
Eckstut and landscape architect Susan Child, a
walkway that curves out into the water. A small
island section just off the end of the pier and pil-
ings in the water that descend in height drama-
tize the connection between land and water. An
amusing metaphor is created by the shape of a
pergolalike lookout tower echoing the crown of
the Statue of Liberty visible across the water.

The artist expressed her visionary outlook at
a 1986 symposium in connection with the exhi-
bition *Sitings* at California's La Jolla Museum of
Art:

Mary Miss, BATTERY PARK CITY ESPLANADE III MODEL (1985). Proposal for 2½-acre South Cove Project, Battery Park City, N.Y.C. Photo courtesy of the artist.

I love working in these public situations because I want to change the nature of urban life. I went to school in the 1960s, and I'm still influenced by the idealism of that period. I have to spend a lot of time in committees, but it's exciting to talk to engineers and architects, people like Dominic Zorralla, who built the whole platform for Battery Park. Sometimes I have to fight with them, convince them to see my viewpoint, but I enjoy being shaken up by the give and take, the challenge of new points of view.

Patricia Johanson (1940–) says that she would like to turn the whole world into a sculpture garden—one so large that viewers would only gradually comprehend its grand plan. For several decades she has been creating environments that relate humans to nature.

Johanson's multidisciplinary approach, combining science and art, is rooted in her early family life. Her father designed celestial navigation instruments for the space program, while her mother exposed her to ballet, music, art lessons. Some of Johanson's feeling for the design of outdoor spaces comes from her family's habit of strolling and picnicking in the parks around New York City. Patricia was always pleased to come upon statues, nooks, and grottos.

At Bennington College, she not only enjoyed splendid art instruction but also met leading people in the art world. After exhibiting Barnett Newman–type paintings (single strips on immensely wide horizontal canvases), Johanson created a 1968 outdoor piece, a strip of three colors that ran for 1600 feet along a discarded railway line through wooded land in Buskirk, New York. Sculptor Tony Smith, an inspiring teacher and friend, encouraged her large vision of art as something infinitely extendable.

This was an early example of many works conceived as a line moving through space. A 1970 Guggenheim fellowship enabled her to investigate ancient architectural forms in Mexico. In 1970–71 she worked on *Cyrus Field,* a poetic path of marble, redwood, and cement blocks, winding with changing rhythms through three miles of wooded land. Johanson also earned two degrees over a period of years—one in American art history and the other in civil engineering and architecture so that she could carry out projects the engineers said couldn't be done.

Among several projects in the following period is a 1972 site work in the form of paths, terraces, stairs, and an overlook for the Con Edison Indian Point Visitors' Center, an eighty-acre park in New York state. When seen from the air, this work is in the shape of a snake. Later she designed a park in the form of a mask for Cleveland, Ohio.

Johanson married art historian Eugene Goossen and settled permanently in Buskirk. Feeling a harmony between child-rearing and the act of creating forms in nature, the sculptor sometimes carried her infant son Alvar on her back as she worked on projects. In 1975 she built *Nostoc II,* a landscape sculpture, for the Storm King Art Center.

In 1978, Johanson exhibited models and drawings at the Rosa Esman Gallery, New York, of landscape structures in the form of plants and flowers. She was later able to carry out some of these ideas in an ambitious project for the lagoon at Fair Park, Dallas, Texas, completed in 1986.

Created in the 1930s for an exposition, Fair Park includes two museums and a lagoon that had become eroded. Johanson transformed the lake into a nature habitat criss-crossed by earth-colored cement structures shaped like two native Texas plants, which project out from either end

of the lagoon. Children love to run all over them, and people can sit on terraced steps formed into the leaf shapes. In the watery interstices, Johanson planted water lilies and other native plants to create a natural, self-regulating habitat for fish and other creatures. The Dallas Museum of Natural History uses the lagoon for botanical and zoological school tours. Fair Park lagoon has been designated as a national historic site.

Like her sister site workers, Johanson regards her works as more than parks—they are symbols of the attempt to bring urban humanity into harmonious relationship with the earth.

Jody Pinto (1942–) combines the visceral and the monumental in site works derived from parts of the body. Born in New York City, she studied at the Pennsylvania Academy and the Philadelphia College of Art (B.F.A., 1973). In early works she dug deep wells and, in a manner reminiscent of ancient burial rituals, placed in them corpselike wrapped bundles containing red earth and pigment that bled in the rain. The artist hinted that her work had sources in painful early experiences, as well as content from her Catholic background—"bleeding hearts, sacred hearts and martyrs."[29] She drew strength from the women's movement and in 1972 founded Women Organized Against Rape, a Philadelphia organization.

The artist exorcised her fears in her works and made them the basis for a psychological rebirth. Inspired by the prehistoric Ohio Indian serpent mound, *Serpentine Corridor* (1979–80) at Wooster College, Ohio, was a wavy tunnel with an earthen roof, which was meant to be reseeded each year in order to grow new grass as a symbol of regeneration.

Several works derive from huge enlargement of body parts. "The body is the source of information" says Pinto. In *Heart Chamber for H. C.* (1978), a temporary installation at the Art Institute of Chicago, a cheesecloth bundle filled with red pigment was placed in a cinder-block chamber. Rain spilling into the chamber caused red fluid to flow into a gutter, or "artery," that spilled down into an earthen pit. This was her metaphor for a painful love affair.

Split-Tongue Pier (1980), on the grounds of Swarthmore College, Pennsylvania, is a tongue-shaped wooden pier that stretches over a creek and gradually splits apart, ending abruptly three-quarters of the way across the stream. The viewer is left standing with legs apart, looking at, but unable to reach, a heavy rock on the opposite shore, which has been split by a slender tree—a well-known local landmark. Thus the viewer is forced to identify bodily with the split rock.

Fingerspan (1987), Pinto's most monumental body-part sculpture, is an eighteen-thousand-pound covered bridge in the form of a gigantic steel finger which stretches across a rocky gorge in Philadelphia's Fairmount Park, enabling hikers to traverse a formerly impassable gorge. It had to be lowered onto the site by helicopter. Hikers passing through the steel mesh enclosure of the bridge become the "muscle and blood" of the finger. The pointing "finger" directs these "corpuscles" to the following part of their journey. Continuing to combine the visceral and the monumental, Pinto shows at the Hal Bromm Gallery, New York, and elsewhere.

Born in Philadelphia, **Elyn Zimmerman (1945–)** grew up in California, where, she says, the High Sierras with their granite outcroppings made a permanent impression on her. Today, in her site works, she brings the mountains into harmony with architecture and humans, planting boulders and streams amidst the arid concrete spaces around new office buildings.

At the University of California, Los Angeles, Zimmerman earned an M.F.A. degree in 1972. That year she showed the direction her work

Jody Pinto, FINGERSPAN (1987), site-specific installation of a 59′ pedestrian bridge of weathering steel in Fairmount Park, Philadelphia. Courtesy of the Fairmount Park Art Association. Photo: © Wayne Cozzolino, 1987.

would take in a proposal, *Mirror Wall,* calling for the insertion of a 30-by-20-foot polished granite wall into a natural rock outcropping.

Zimmerman's first permanent sitework, *Shunyatta* (1980), is a poetic integration of mounds, paths, stairways, and running water on the grounds of an Illinois estate. In a 200-foot circular wooded area behind a curved residence, the artist constructed a path that curves backward in both directions. On one side, the path goes to a seated meditation area. On the other, it curves past a mound and stone walls of changing heights that hide or open up the view, leading to stone steps cantilevered over a waterfall that spills into a sunken pool. As the viewer descends a narrow corridor along a rough carved wall, the sound of running water creates a nature mood. The artist plays with perceptual awareness, making the viewer sensitive to the surroundings through changing vistas and framing of spaces.

Zimmerman carried out a major public site work, *Marabar* (1984), in the open courtyard of the National Geographic Building in Washington, D.C. Giant boulders are set into the plaza along the edges of a long, narrow pool filled with moving water. Zimmerman has created the illusion that a rushing mountain stream located under the plaza has been opened up to public view, and the irregular granite boulders seem to be growing up through the paving from under the

© Elyn Zimmerman 1984, MARABAR, natural cleft and polished granite, pool—60′ x 6′ x 18″, boulders—
height 3½′-10½′. National Geographic Building, Washington, D.C. Photo: Elyn Zimmerman.

earth. One of the boulders is split into two parts, and the polished inner faces reflect against one another across the pool, sending reflections into nearby windows. The artist chose plum-colored granite rocks to harmonize with the surrounding pink stone building.

Marabar perhaps owes something to the influence of a year as an exchange sculptor in Japan, and to the work of the Japanese-American-sculptor, Isamu Noguchi. The task of locating and carving the many-tonned boulders was daunting. The sculptor traveled to Dakota quarries, had the giant rocks cubed and sent to a Minnesota stone-carving factory, where she shaped them into natural looking forms, splitting one and polishing its inner faces with sandblasting disks. When asked why she didn't use natural found rocks, she replied, "Found rocks look like potatoes." Hers have the crisp, rugged surfaces that catch the sunlight, like the High Sierras of her childhood.

Like many women site workers, Zimmerman is sensitive to the needs and feelings of the people in the area. Howard Paine, art director of the

National Geographic Society says: "We have about 1,000 employees in these buildings, coming and going here all the time. They love it; people sit out here at noon and eat sandwiches and play frisbee. It's become a park."[30]

Since the completion of *Marabar,* Zimmerman has designed a one-acre oval plaza, incorporating streams, trees, and granite boulders, for a new hotel and office complex next to O'Hare Airport, Chicago. "It is really a series of stylized landscapes [that] represent the kinds of glacial formations typical of the Great Lakes area," she says. For the Art in Public Places Program in Miami, she is building a "rock island" of cleft and honed limestones in a lagoon to be reached by a walkway from the Dade County Courthouse. In 1987 she completed a plaza with fountain, waterfall, amphitheater, and related garden for One Bethesda Center, Bethesda, Maryland.

Alice Aycock (1946–)

Mock on, mock on, Voltaire, Rousseau;
Mock on, mock on, 'tis all in vain.
You throw the sand against the wind
And the wind blows it back again.
—William Blake

Alice Aycock creates "psycho-architecture"—phantasmagoric structures that variously look like dream buildings, machine contraptions, or ominous amusement parks of the mind. They suggest the inadequacy of science and technology to make sense of or control the world. The artist has indicated a bewildering variety of sources for her work, including tantric imagery, Mycenean graves, eighteenth-century scientific texts, childhood fears, and the writings of schizophrenics.

In the fifteen years following graduation from art school, Aycock constructed more than sixty large installations in different parts of the world, culminating in a 1983–84 retrospective that traveled to five cities in West Germany, Holland, and Switzerland. By the age of thirty-nine she was a major international sculptor.

Growing up in Harrisburg, Pennsylvania, Aycock watched her father at work in his construction business, and at a young age began to draw houses and make them out of sticks, grass, and cardboard boxes. Another influence was her remarkable grandmother, a math teacher and artist, who told her long tales that she later realized were simplified versions of great works of literature. Not surprisingly, she likes to write and accompanies her installations with fantastical texts that refer to history, archaeology, psychology, and so on. There is, in fact, a large literary element in her work. Aycock also remembers being possessed by fears of death as a child because of a recurrent illness in the family. Her baffling, threatening early works sometimes seem like an attempt to exorcise these fears by externalizing them. They draw the spectator into potentially hazardous situations that threaten entombment, suffocation, dizzying entrapment on high places, or being sliced to pieces by machine blades.

Aycock majored in sculpture at Douglass College, New Jersey, and earned a master's degree at Hunter College, New York (1971), where she was influenced by her teacher, Robert Morris, a pioneer of site works. Her first important work, *Maze* (1972), consisted of six-foot-high concentric rings of wood, with three openings in the outer wall. Spectators entering the sculpture came up against dead ends and had to retrace their steps many times to find the exit. To the artist, this was, on one level, a metaphor for the individual's path in life.

Inspired by a trip to Greece, where she was moved by the *tholos* tombs of Mycenae, Aycock built *Low Building with a Dirt Roof for Mary* (1973) on a Pennsylvania farm site. It appeared to be a house half sunk into the ground until the

Alice Aycock, THE MACHINE THAT MAKES THE WORLD (1979), installation at the John Weber Gallery, N.Y., wood, steel. Courtesy of the artist. Photo: John Ferrari.

viewer crawled inside. There the person discovered a claustrophobic cramped space, with tons of dirt pressing on the sod roof overhead, inducing thoughts of death, suffocation, and at the same time, peaceful union with the earth. *Project for a Simple Network of Underground Wells and Tunnels* led the viewer down ladders into claustrophobic underground passageways.

For the 1977 Documenta show at Kassel, Germany, Aycock created *The Beginnings of a Complex,* five medieval-looking wooden towers and structures that could be reached only by first going into underground passageways. Disturbed by the sight of thousands of people swarming over her work, Aycock's next series avoided actual audience participation; rather they became "stage sets" which could not be entered but gave the viewer the *sensation* of being trapped in dangerous situations. *Studies for a Town,* a medieval-looking elliptical wood structure commissioned for the Projects Room of the Museum of Modern Art, could not be entered but led the viewer optically up staircases to baffling viewpoints.

In the late 1970s Aycock created "metaphors of human psychic expansion." In *Flights of Fancy* (1979, San Francisco Art Institute) stairs were turned upside down, things floated in the air, and other forms rejected "earthbound logic in favor of a transrational state of consciousness." In these works the artist expressed the desire to go beyond the limits of ordinary experience—flying, levitating, walking through walls. She even used the writings of "N. N.," a schizophrenic who described such sensations, as her accompanying text.

These works led up to *The Machine that Makes the World* (1979, John Weber Gallery, New York) which one critic thought of as a "symbol for the power of bureaucracy and other social institutions to limit human freedom."[31] Entering a wooden-walled walkway, the viewer passed under guillotinelike forms that threatened decapitation on the way to a circular chamber that could be penetrated only by moving bafflingly heavy circular walls.

Another installation at the John Weber Gallery proved to be a pivotal work that crossed the boundaries between science and magic. The artist, who had previously constructed her pieces mainly of wood, now incorporated metal, glass, and machine parts, opening up a whole new range of forms. In a theatrically lit installation, *How to Catch and Manufacture Ghosts,* pseudoscientific rotating cylinders, pulleys, wires, and a live pigeon inside a glass bell jar conjured up the atmosphere of early experiments with electricity. Science, Aycock felt, was at that time beginning to substitute these forces for religion.

A major work in this series is *Ghost Stories from the Workhouse* (1980), a permanent installation on the grounds of the University of South Florida, Tampa. This Rube Goldberg industrial complex of metal, glass, wood, plastics, and moving parts starts with a central square metal structure based on an electrical circuitry diagram. Two metal balloons attached to thin rods allude to early devices that captured electrical charges from the atmosphere. Cranks and rods lead to a section containing six churning metal cannisters, presumably containing "ghosts." In this fantasy, Aycock seems to be hinting that the nineteenth-century thought process, which substituted electricity for spirits and cause-and-effect logic for religion, is limited in its power to comprehend the limitless forces of the universe. At the same time, the sculptor loves the sight of oil refineries and other industrial forms, and some of her works are a kind of "homage to industrial architecture."[32]

In the early 1980s, Aycock made frightening machine structures, such as *Savage Sparkler*

(1981), a whirling drum with a rack of hot coils and loudly slamming metal sheets. She incorporated metal scimitar blades that rotated and threatened to slice the viewer in *A Theory of Universal Causality* (1982), *The Glance of Eternity* (1983), and *The Solar Wind* (1983). The artist relates these blademachines to a period of turmoil leading up to a divorce from Dennis Oppenheim, a sculptor who also probes the outer limits. Although this was a creatively and intellectually dynamic period in her life, it was, she says, "emotionally charged."[33]

It is impossible to deal here with the large number of Aycock's works. Recurrent motifs are the ferris wheel and the carousel, symbols of a "turning world."

In general, Aycock seems to imply that in a world where science has brought both benefits and potential disaster, humanity needs to arrive at a new and freer state of consciousness—one that goes beyond outworn mysticism, as well as the limitations of scientific thought, to a new awareness. There is a visionary futuristic quality to her work.

Too large to store, many of the sculptor's baroque works had to be destroyed, and in 1986 she was feeling some degree of burnout. For this reason her delicately precise drawings on mylar, which resemble architectural plans, are very important to her—they are the repository of her visions.

At thirty-nine Aycock bore a son and experienced a sense of rejuvenation: "A child is something I very much wanted. It's like going back to the earth."[34] In recent years many of her works have entered permanent collections. Her plans for the future are not modest—they include designing entire cities.

The "sculptures" of **Helen and Newton Harrison** involve whole cities, statewide water systems, even the oceans themselves. Their projects have been described by Kim Levin as "visionary earthworks on an epic scale with moral overtones." The Harrisons call their art "postconceptual" because they not only dream up vast ecological reclamation projects, expressed in the form of maps, models, photomurals, texts, and live performances, but go further, enlisting community support in an effort to implement their ideas in the real world.

Professors in the art department at the University of California, San Diego, they developed their unique collaboration gradually. In the early 1970s, Newton (a Yale-trained minimalist painter and "light and space" sculptor), concerned about issues facing the planet, began to create "survival pieces," such as a portable catfish farm installed in the Hayward Gallery, London. He raised fish and caused a public uproar by electrocuting, frying, and serving them to an invited audience of five hundred people. Helen organized the feast and was soon drawn into all aspects of subsequent projects, her background in sociology, anthropology, and art adding another dimension.

Meditations on the Condition of the Sacramento River, etc. was a study of the destruction wrought by irrigation systems and dams not only on the ecology of California but on the future of the very farming it was supposed to help. Blown-up maps and diagrammed aerial photographs were orchestrated into "art works" shown at the San Francisco Art Institute. There were events and performances, billboards were plastered with the word WATER, graffiti messages were chalked on streets, and so on.

The Harrisons then began to work with entire cities. Invited by the Maryland Institute of Art, they plotted a walking path from the Baltimore harbor to the city center, proposing ways of enriching the streets along the way. Three hundred people took the "walk" with them in a holiday

event. Afterward, aerial maps and photographs were arranged in a carefully designed gallery installation that gave startling new insights into the configuration of the city. In San Jose, discovering a neglected river that ran through it, they proposed to turn this wasteland into a natural habitat of trees and birds (particularly the blue heron, which was disappearing from the area)—a retreat where people could get away from the noise of the city. As a result, the city is redeveloping the area. They also proposed a new use for a debris-laden arroyo in Pasadena, California, and for offshore islands near Sarasota, Florida.

The Harrisons received international recognition in 1987, when they were invited to create a proposal for Kassel, Germany, at the prestigious Documenta international exhibition. In Kassel they found the same problems that confront all of humanity today. Acid rain was killing 80 percent of the trees; the German stork, famous in song and story, was practically extinct; the inner city, rebuilt after the fire bombings of World War II, was a dreary commercial center with little street life after dark; and the river—the reason for the original settlement of Kassel—was blocked off by new buildings, so that the public had little access.

The Harrisons planned a revitalized center, a walking path to the river, a bridge across it, and on the other side, a new *Garden of Extreme Measures*—a marshy park that the public could enjoy, which would also serve as a nesting place for the stork and encourage other life forms. They proposed to reclaim, for a variety of uses, half-buried ruins of ancient towers and churches. Kassel had turned its back on nature, the river, and its own history. The Harrisons reconnected it with all three in an exhibition that included a stuffed stork, a real nest, and diagrammed photographs, maps, and texts.

How does all this differ from the role of a landscape architect or city planner? The Harrisons embody their thinking in mixed media pre-sentations—visual artifacts, poetry, books, performances, events of every sort—and deal with the philosophical implications of their creations. Theirs is the widest possible interpretation of what the word *art* might mean.

The Lagoon Cycle, a documentary extending through several rooms, incorporates photographs, images, and a running dialogue on change and its implications. It has been made available to the public in a book. A current project is an immense ecological water program in Israel.

With an ever-expanding collaborative life (which includes four children), the Harrisons feel so strongly about the equality of their contributions that they take turns putting their names first on their works.

Joyce Kozloff (1942–), one of the prime movers of the pattern and decoration movement of the 1970s, creates sumptuous tiled interiors for train stations, airports and other public spaces. She deliberately set out to create a democratic art—to transform the environment of everyday people into something extraordinary.

Born in Somerville, New Jersey, Kozloff trained as a painter at Carnegie Tech and Columbia University. At a time when minimal art dominated the art world, she was doing hard-edge paintings. In 1971, in Los Angeles, she was drawn into the burgeoning feminist art movement and began to question the attitudes of the male-dominated mainstream.

During a summer in Mexico, noting that the beautiful patterns in rugs, belts, and other everyday objects resemble those on ancient monuments, she began to wonder about "who influences whom." Concluding that "we denigrate the 'low' arts because those are the things that women have done traditionally, like pottery and weaving," she returned to New York determined to incorporate patterns from Navajo blankets, Islamic tiles, and other sources into her paintings,

with no attempt to disguise their origins. She, along with painter Miriam Schapiro, was one of the organizers of a group of artists who were coming to similar conclusions.

Soon Kozloff was designing tile plaques and collaborating with ceramist Betty Woodman on decorated pitchers. *An Interior Decorated* (1979–81), a total room environment with silk hangings, tile plaques on the walls, and a patterned tile floor, was shown at the Everson Museum, Syracuse, and the Smithsonian's Renwick Museum, Washington, D.C.

When Kozloff won a competition to decorate a curved wall alongside a ramp in Harvard Square subway station, she entered a new phase of her career. Eager for her art to be enjoyed by the throngs who use the station, she incorporated mosaic tile motifs from New England folk arts—gravestone designs, weather vanes, ship orna-ments, quilts, wall stencils: "I hoped that people would recognize things from their own city, from their childhood.... This is a female aesthetic: I think the women involved with public art are more open-ended, making pieces that encourage viewer participation and require time to experience."[35] The color shifts in zones from cool to warm and back again, so that the spectator can enjoy a changing visual voyage while walking up or down the ramp. A sophisticated abstract artist, she created an interplay between the flat and three-dimensional aspects of her motifs.

Kozloff's vestibule for the Amtrak station in Wilmington, Delaware, is a vibrant homage to the "spiky" ornament of Frank Furness, the famous arts and crafts architect who designed the station in 1908. Art historian Thalia Gouma-Peterson compared it to the opulence and splendor of Byzantine interiors. Other works are

Joyce Kozloff, VESTIBULE, WILMINGTON DELAWARE TRAIN STATION (1984), hand-painted glazed ceramic tiles, 30′ x 20′ x 15′. Courtesy of the artist. Photo: eeva-inkeri.

medallions for San Francisco Airport, a wall alongside an escalator at the Humboldt-Hospital subway stop, Buffalo, New York, and a tile installation for Detroit's "people mover" in the financial district. The populist designer incorporates motifs from the community, such as Seneca Indian jewelry motifs in Buffalo or Bay Area Victorian patterns in San Francisco. Boston University's art gallery organized a 1986 exhibition that traveled to four other cities. In the catalog, Gouma-Peterson points out that Kozloff, like many contemporary feminist artists, is challenging rigid mainstream categories: "It is hard to know where to place Kozloff's work—is it crafts, mural decoration, or 3D installation—it is a mixture of all these."[36]

The artist herself compares her work to a quilt—it injects a warm female component into the cold "masculine" world of architecture.

Aleksandra Kasuba (1923–)

Aleksandra Kasuba (1923–), an environmental artist, studied sculpture in her native Lithuania before coming to the United States after World War II. Her abstract sculptural walls and façades of brick and marble are totally integrated with architecture.

Among these are four brick walls for the Rochester Institute of Technology (1969); a brick exterior for Lincoln Hospital, Bronx, New York; marble walls for Portland's Bank of California and Chicago's Container Corporation headquarters; and a seven-thousand-square-foot brick and granite plaza in front of the Old Post Office, Washington, D.C. Kasuba has also won architectural awards for organically shaped interiors made of stretched fabric.

Dora de Larios (1933–)

A properly designed and decorated public building ... a real "people space" can almost make you feel like you're in the Piazza San Marco in Venice.... It should exude a warm, pulsating aura—tactile, sensuous.... It enriches people, gives them hope and expands their vision.
—Dora de Larios[37]

Dora de Larios, an architectural sculptor-ceramist whose abstract wall murals range from the City Hall in Camarillo, California, to Central Park in Nagoya, Japan, is a crusader against the barrenness of modern architecture. The artist, she says, should be consulted from the beginning as part of the whole architectural design process instead of being brought in as an afterthought.

Although she has not been part of the Chicana art movement, she is proud of her Mexican heritage. She was awakened to art at the age of eight when her artistic parents, who worked as cosmeticians for Max Factor in Hollywood, California, took her to Mexico City to visit relatives. At the National Museum of Anthropology she was overwhelmed by the sight of the massive carved Aztec calendar stone: "The sheer scale of it—the beauty—hit me like a physical blow. I suddenly realized where I came from. This fabulous thing was a part of what I was. I began to hope that I could do something as big and beautiful as that one day."

After earning a B.F.A. in 1957 from the University of Southern California, the artist opened a pottery studio and was soon exhibiting widely and teaching at her alma mater and at University of California, Los Angeles. In 1963 she was one of ten artists selected to design tiles for Interspace (a manufacturer of ceramic tile). The company let her rent their industrial-sized facilities for her own commissions, enabling her for the first time, "to work on very large murals ... on the scale I had been dreaming of."

Aleksandra Kasuba, BRICK RELIEF (1981), 125′ x 14′. 560 Lexington Avenue,
N.Y.C. Architect: The Eggers Group, P.C. Photo: Harry Hartman, courtesy of the
artist.

De Larios's wall reliefs are greatly influenced by both Mexican and Japanese architectural art, and their forms have become more abstract. "Mexican museums and hotels are sheer drama," she says. "Japanese architecture is stark in comparison, but it still carries heavy drama." The influence of the bold pre-Columbian relief forms can still be felt in her work.

Her first architectural commission in 1971 for the Kona Surf Hotel, Hawaii, included a twenty-four-foot ceramic mural and three wall plaques for each room—a total of eighteen hundred pieces, glazed in colorful birds, flowers, and tropical motifs. For the Contemporary Hotel, Disney World, Orlando, Florida, she was the lead designer, heading a group of twenty artists who completed six ceramic murals (a total of eighteen thousand square feet). Other works are for libraries, hotels, hospitals, and corporations in Tahiti, Long Beach, Beverly Hills, and elsewhere.

In 1979 the city of Los Angeles presented her cast cement wall, *Friendship Patterns,* to its sister city, Nagoya, Japan. She supervised the installation in Nagoya's new Central Park, and was honored in ceremonies. In 1985, a forty-foot porcelain mural for the Anaheim Hilton Hotel (1985) required four and a half tons of clay to make.

Married at one time to an architect, de Larios has raised a daughter. In her Culver City studio she has completed a series of seven-foot, freestanding multimedia goddesses in stoneware, wood, and gold leaf. Her output ranges from immense walls to small functional ceramic ware, including a set of blue and white porcelain designed for the White House. Her work has been exhibited at the Smithsonian's Renwick Gallery,

Dora de Larios, FRIENDSHIP PATTERNS (1979), Portland cement, 6′ x 26′. Nagoya, Japan. Photo: Dora de Larios.

the Everson Museum, Syracuse, the Contemporary Crafts Museum, New York, and elsewhere.

Patsy Norvell (1943–), who trained at Bennington and Hunter College (M.A., 1970) and apprenticed with David Smith, creates poetic etched-glass installations, decorated with palm leaves and other motifs. *Glass Jungle* (1987) is in the lobby of the Oxford Building, Bethesda, Maryland.

INSTALLATIONS AND ASSEMBLAGES

Some artists create multimedia installations or total environments in galleries. Others, rejecting the notion of art as a commodity or a permanent object made to be bought and sold, create ephemeral or temporary forms, which are dismantled or disintegrate, remaining only in documentation or in the mind of the viewer. A few examples must serve as paradigms for the immense variety of such works being created by women today.

Judy Pfaff (1946–) creates wildly exuberant installations combining sculpture, painting, and process art. Thickets of string, colored wires, contact paper, wood, perforated metal, spring from walls, ceiling, and floor like confetti thrown in a New Year's Eve celebration. John Ashbery has called her work "an exhilarating mess,"[38] and *Art News* described it as "blissful havoc."[39]

Born in East London, Pfaff as a child seemed destined for reform school rather than a loft in Soho. Her father abandoned the family after her birth, and her mother left for America to try to make a life for herself. Judy was kicked out of schools and essentially grew up on the streets. At thirteen she rejoined her mother in Detroit, and there, in an unlikely ghetto junior high school, where she was doing poorly in academic classes, a young black teacher recognized her talent and got her admitted into Cass Technical High School—Detroit's version of New York's High School of Music and Art.

After an early marriage to "a very nice man" in the air force, they separated in Sweetwater, Texas, and she headed off in the van he gave her, to study art, ultimately earning a B.F.A. from Washington University, St. Louis. Talented enough to win a scholarship to Yale University, she found a mentor in her painting instructor, Al Held, who encouraged her to experiment.

Although she admired the minimal and process art of Robert Morris, Richard Serra, Bruce Nauman, and Barry Le Va, she has said that "increasingly I had a hard time with the idea that things were so right, so secure. . . . I tackled . . . opening up the language for myself as far and as wide as I could in terms of materials . . . colors and references; I tried to include all the things that were permissible for painting, but absent in sculpture. . . . I can't be bound by how they 'should' relate to one another."[40]

From the beginning Pfaff tried to create a whole cosmos in each work. In *Prototypes* (1978) at the Neuberger Museum, State University of New York at Purchase, she created a "crowd" of multicolored constructivist stick-figures projecting from floor, ceiling, and walls, which parodied different personality types. Already the viewer was surrounded by vertiginous jazzy images coming from all directions. One of Pfaff's intentions is to create forms that impinge on peripheral vision as well as frontally.

Inspired by underwater landscapes while snorkeling off the Yucatan coast of Mexico, Pfaff created *Deepwater* (1980), a blue, green, and lavender underwater environment of wire tangles, spirals, and curving tree branches at the Holly Solomon Gallery. The sight of racing cars at Daytona Beach impelled her to express the terror of maximum speed in *Formula Atlantic* at the Hirshhorn Museum, Washington, D.C. She

Judy Pfaff, partial view of DEEPWATER (1980), installation at the Holly Solomon Gallery, N.Y. Photo: Courtesy Holly Solomon Gallery. Photographer: Julius Kozlowski.

described these aggressive forms set amidst overpowering waves of color: "I am pursuing a deeper and a denser space, an intensified feeling of vertigo, and something of the terror of that sense of placelessness. . . . I want to push the parameters of dislocation and immersion as far as I can."[41]

Dragon, at the 1981 Whitney Biennial, was a metaphor for fire. The viewer walked through brilliantly colored pyrotechnics of wires, pipes, and string, hanging in thickets or springing off painted abstract expressionist walls. The sculptor's set for choreographer Nina Weiner's avant-garde *Wind Devils* at the 1983 Brooklyn Academy of Music's New Wave Festival was an uncanny collaboration.

The sculptor sometimes lives in the gallery for weeks, working day and night, surrounded by mountains of material that suggest richer and richer orchestrations of form. Most of her installations are too labyrinthine to move or preserve except in photographs.

Pfaff created a permanent installation for Japan's Wacoal Corporation (1985) and is now making permanent wall pieces, which still assault the viewer with their wild combinations of wood, metal, fiber, and such hardware objects as woks (*Apples and Oranges,* 1986; *Supermercado,* 1986, Whitney Museum).

Exemplifying postmodern maximalism in her assaultive art, she combines seemingly disparate modernist styles:

> Judy Pfaff's work is like an opera in which everyone gets to sing an aria. Instead of sticking to the hierarchical picture plane, her installations and reliefs stretch it, bend it, twist it. . . . Cubism, Futurism, Surrealism, and Abstract Expressionism slide into each other's universe in a way that opens up a new phantasmagoric space for us to enter. . . . the

viewer must surrender attachments to terms such as abstraction and figuration, hard-edged and atmospheric, dissonance and rhythm, found and invented. Here, sculpture and painting, separated for so long, see and touch each other in an accumulation of brushstrokes and planes, where two and three dimensions, color and air, burst through one another.[42]

The artist herself says, "What's happening now in sculpture seems really wide open and generous. . . . taking all sorts of permission and running with it, full out."[43]

Connie Zehr (1938–) sifts sand into sculptural mounds that mold the light. Marked with tracks, or combined with rocks, glass, and other materials, their meditative quietude is reminiscent of Japanese sand gardens.

Born in Evanston, Illinois, and trained at Ohio State University, she came to Los Angeles and was influenced by the forms and materials of the Southwest. She brought back bags of sand from trips to Death Valley and New Mexico that provided the impetus for her early works. *Eggs* (1972, Pasadena Art Museum), a floor covered with equidistant mounds of white sand, each cradling a brown egg, seemed a metaphor for regeneration or creativity, its infinitely extendible forms hinting of breasts, ova, nests, hills.

Different in mood was *Night Letter,* a tribute to the assassinated Martin Luther King (1976, Los Angeles Municipal Art Gallery). On black sand, Zehr randomly placed one hundred rocks blackened by a forest fire, with edges painted silver—a metaphor for destruction and survival. Several of these temporary installations were recreated for a retrospective, *Flashback* (1985), at the Los Angeles Municipal Art Gallery. The artist says "My philosophy has been that art is the idea and the viewer's experience of it—not the object

itself. Ideas and experiences cannot be possessed but are processed and integrated into one's life. Underneath there is a moral position against the material values of our culture, but more important, there is the belief that art can support meaning and connectedness to life."[44]

Gradually expanding her range of expression to include graphics painted on walls, tables, and mirrors, and most recently polystyrene figures and animals, each installation embodies a philosophical theme. In *Here/There* (1983, University of California, Irvine) the room was split into counterparts that presented two sides of reality—nature versus human spirit, or perhaps the material versus the metaphysical. For example a steel ball on the left table was echoed by a crystal ball on the right. *Threshold* (1986, California State University, Fullerton) contained a polystyrene man, a carved waterfall, and a dolphin. The dolphin, with its sonar communication, is a symbol of communication with the spiritual world; sleeping humanity is perhaps on the threshold of awakening, through nature, to a new and saving awareness.

Alexis Smith (1949–) grew up near Hollywood, California, and as a teenager changed her name from Patricia to Alexis because she liked the idea of taking a movie star's name. It is not too suprising, therefore, to discover that her work takes on some of the narrative qualities of film. Indeed, she often begins with a "treatment," such as a group of phrases taken from a favorite book, and then develops a "storyboard" of still frames around it—collages and assemblages arranged in a series. Incorporating movie posters, pop images, words, and kitsch objects from the 1930s and 1940s, these nostalgic images somehow capture the bittersweet ironies of modern American life.

At the avant-garde art department of the Uni-

versity of California at Irvine, Smith studied with Robert Irwin, Vija Celmins, and Bruce Nauman. Certain authors have triggered her imagination—Raymond Chandler for his urbane cynicism, Jorge Luis Borges for his use of dialogue among characters from many different historical periods at once, and John Dos Passos for his use of collage in literature. Her series *American Way* is based on lines from Dos Passos's book *U.S.A.* Five collages contain images of pop products, such as Coca-Cola bottles printed on old plates of offset newspaper printing, and so have the feeling of "yesterday's news." Real objects are affixed to them—a baseball card, a house number.

In her recent series *On the Road,* she uses phrases from Jack Kerouac's book in collages that evoke the speed, the restlessness, the freedom, and also the frenetic alienated character of America's love affair with the automobile. "I'm a joyful cynic," she said. "I try to show the coexistence of good and evil."[45]

Smith often converts an art gallery into an environment in which her collages are merely one element. At the Los Angeles County Museum of Art she surrounded viewers with a collage mural called *Cathay in L.A.,* containing a huge Chinese tiger and other oriental images. On it she superimposed "still-frame" collages made from kitsch objects, gewgaws from Chinese import stores, and snippets of words and images. A real parasol extended into the viewer's space.

Her most ambitious project, located in Grand Rapids, Michigan, has received little publicity. Setting out to give the undecorated, bare lobby of the DeVos Performing Art Center "a festive quality that a theater deserves," she transformed the staircase into a metaphor of the Grand Rapids that gave the city its name. A gigantic zizag Art Deco painted river spills down to the second level and then into stylized waterfalls and trees

Alexis Smith, installation view, The Museum of Contemporary Art, Los Angeles, 10 December 1986–10 January 1988. Courtesy of Margo Leavin Gallery, Los Angeles. Photo: Douglas M. Parker Studio, Los Angeles.

on the ground floor. The second level is designed as a grand piano, with a top hat on one side and a dancing shoe on the other. An immense fake art deco marquee adorns the inside door entrances to the theater. The decor in rich rust, blue, and purple combines motifs from Hollywood's heyday and motifs relating to Grand Rapids, past and present.

With a growing reputation as a major postmodern artist, Smith was one of few women included in the 1984 international show that celebrated the reopening of the Museum of Modern Art and was included in the exhibition Individuals that marked the opening of the new Museum of Contemporary Art in Los Angeles.

Betye Saar's (1926–) collages and boxes of the late 1960s and early 1970s suggest Joseph Cornell, but hers are filled with symbols of the black experience, the occult, and nostalgia. Today she works on public commissions with broad human-

istic themes in places as far apart as Los Angeles, Newark, and Miami.

Born in Pasadena, California, Saar was enormously impressed during childhood visits to her grandmother, who lived in Watts, by the sight of the Italian immigrant Simon Rodia building his folk art towers out of broken glass and shards of crockery set into cement. The character of her work was permanently affected by this collage vision.

Her mother, a believer in the occult, was sure that her superimaginative child had mysterious powers. After her father's death these powers suddenly ceased; nevertheless, she retained an interest in the mystical and the occult.

Saar showed early talent, but did not become an artist until she was thirty-four. At Pasadena City College in the 1940s, blacks were not encouraged to be art majors; they were pushed toward a trade. Her designs for floats for the Tournament of Roses won several times—until the

judges found out the artist was black, after which she was dismissed with an honorable mention. The anger which she kept locked inside, she says, ultimately fueled her drive to make it in the art world.

Saar studied design at the University of California, Los Angeles (1949), married, had three daughters, and in 1956 went to Long Beach State University to earn a teaching credential. After winning prizes for prints, her printmaking professor encouraged her to become an artist. Up to that time she had never dared to think of herself that way.

Since childhood Saar had been collecting and assembling small objects, and even before seeing Joseph Cornell's work, she had been putting her prints into deep boxlike frames and behind windows. Inspired by an exhibition of Cornell's boxes in Pasadena, she began to make assemblages.

Her early assemblages deal with the occult, incorporating tarot and zodiac symbols (*House of Tarot,* 1966). Later she incorporated African and Oceanic material in works like *Nine Mojo Secrets* (1971), an assemblage of fiber, beads, and seeds, with the eye of the universe at the top and a picture of an African ceremony in the center.

In the late 1960s, stirred by Martin Luther King's death and the black liberation movement, Saar began to collect derogatory images of blacks with the idea of exposing the racism inherent in them and turning them instead into images of empowerment. She collected the emblems of such products as Darkee toothpaste, Black Crow licorice, and Old Black Joe butter beans. In *The Liberation of Aunt Jemima* (1972, Art Gallery, University of California, Berkeley), Aunt Jemima carries a rifle and pistol against a background of pancake flour boxes with the usual "happy darky mammy" cliché on them.

Inspired by a cache of materials inherited from

a beloved aunt, Saar produced nostalgic assemblages that call up the beauty and sweetness of the black past, evoking the 1920s and 1930s with old photos, letters, bits of lace, gloves, and dried flowers (*Gone Are the Days,* 1970; *Grandma's Garden,* 1972). Even some of these nostalgia pieces contain social criticism, however. *Shield of Quality* (1974) shows well-to-do, light-skinned African-American women surrounded by symbols of elegance—a feather boa, a silver spoon. These are mounted in a yellow box, symbolizing the "high yellow" skin color that in black society is sometimes considered necessary for getting ahead. The piece criticizes the idea that only white is beautiful.

The artist's fame was growing; she was one of the rare African Americans ever accorded a solo show at the Whitney Museum (1975). Yet she was plagued by a certain melancholy: "Is that all there is? I didn't want to end up like that, or for my daughters to feel like that. I could see that the burdens that my mother and great-grandmother had passed along to me, I was passing along to my daughters. I decided to change, become a free, creative person."[46]

During a class in journal-keeping at UCLA, when the teacher asked the students to close their eyes and free-associate, such sad images of herself welled up that she sought help from a psychic, who helped her to see that the death of her father when she was a small child was a recurrent motif in her life and art. As early as *Black Girl's Window* (1969) she had shown a girl's face pressed against a window, combined with a skeleton, symbol of death. She began to push through the past, focus on the present: "I made up my mind not to do anything I didn't want to do—to live freely."[47]

At flea markets Saar searched for items that heal or bring a blessing—that give off a certain aura or energy, derived from their previous own-

ers—and incorporated them into "altars" or shrines. *Spirit Catcher,* made of baskets, feathers, raffia, and other objects is a votive object in her home—it repels bad feelings and attracts good ones. In 1984 Saar was given a two-part exhibition at the Museum of Contemporary Art, Los Angeles.

Since leaving her position as chairperson of the design department at Otis Parsons Art Institute, the artist has focused primarily on works in public places. For a train station in Newark, New Jersey, she converted a discarded ticket booth into an art work called *Fast Trax.* In 1987 she completed *On Our Way* for the Martin Luther King Metrorail Station, Miami, Florida.

In this work she involved the community by inviting the public to a party where she asked local citizens to pose for her and drew around the shadows they cast. She then cut out steel figures from these silhouettes and coated them with colored baked enamel patterns in black, green, and pink. The forms were bolted to the cement walls of the station, running alongside the stairs and escalator, and forming a group of waiting figures on a wall where people wait for trains. *On Our Way* thus became an integral part of the neighborhood. Saar objects to what she calls the "turd in the plaza" syndrome—an artwork commissioned by an elite group and foisted on the people.

Today Saar travels around the world doing installations and is the recipient of many grants and awards. A deep source of satisfaction is her continuing involvement with her daughters. In 1990 she and daughter **Alison Saar**, a prominent young sculptor, opened a two-person traveling exhibition at the University of California, Los Angeles, that revealed their strikingly distinct styles, but also included a collaborative installation.

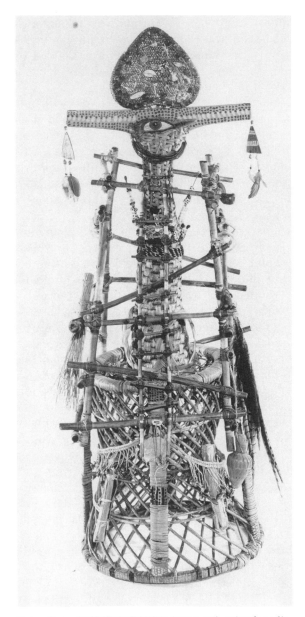

Betye Saar, SPIRIT CATCHER (1976–77), mixed media assemblage, 3′9″ x 18″ x 18″. Collection of the artist. Photo: Lezley Saar.

Michelle Stuart's (1940–) feeling for geology, archaeology, and remote natural places began as a child traveling with her father, a water rights engineer, around the southern California desert. After studying at Chouinard Institute in Los Angeles and working as a mapmaker and topological draughtswoman for the Army Corps of Engineers (this influenced her later use of maps and grids), she began to travel to prehistoric and primitive sites, documenting experiences that range from the Mayan ruins to the Nazca grid lines of Peru and the cliff dwellings of Mesa Verde.

Stuart created innovative works by crushing and pounding earth and rock from places she visited into long sheets of muslin-backed paper until their beaten earth-toned surfaces, pocked with dents and variations of texture, took on a sheen and sensual texture, almost like human skin. She hung these scrolls in folds and flaps that sometimes rolled out onto the floor. In 1975 she rolled a 460-foot scroll (*Niagara River Gorge Path Relocated*) down the entire face of a cliff at Artpark, Lewiston, New York, documenting the geology by rubbing the long panel with material from the changing layers of earth and rocks.

In a succession of hard-to-define art forms Stuart crossed the boundaries between sculpture, painting, photography, and printmaking. For example, she has surrounded a horizontal line of photographs of shorelines, birds, mountains, or prehistoric ruins with a grid of earth-rubbed squares from related regions (*Islas Encantadas Series: Celestial Sphere Equator*, 1981). She created a huge checkerboard by alternating color photographs of prehistoric sites with rubbings of ancient tools from those regions (*Stone Tool Morphology*, 1977–79). She also creates unreadable "books" made of layers of heavy earth-impregnated papers or fabrics, tied with frayed string and feathers (*Owl Bundle Book*, 1980). These "sculptures" evoke the mystery of the ancient hidden past.

In *Correspondences* (1981, Joslyn Museum), Stuart conjured up ancient Central America—the interplay between the Spanish conquerors and the Mayans. She surrounded a photograph of a Mayan carved snake deity, and another of two Christian crosses, with a wall of paper tiles rubbed with the warm tint of earth from Mayan locations; placed palms and jungle flora around the room; and played a sound track of her voice reading excerpts from conquistador diaries and Mayan shamanistic medical texts, interspersed with jungle and bird noises.

On the vast Rowena Plateau overlooking the Columbia River Gorge in Oregon, Stuart built a site work sponsored by the Portland Center for the Visual Arts (*Stone Alignments/Solstice Cairns*, 1979)—a one hundred-foot circle of boulders with a hub in the middle pointing in north-south alignments to read the summer solstice, marked at key points with cairns (cones of boulders). In contrast, the artist recently completed four traditional sculptures—sensitive bronze relief panels of leaves and flowers marking *The Four Seasons* (1987, College of Wooster, Ohio).

Is Stuart a site sculptor, painter, assemblagist? According to curator Judy Collischan Van Wagner, Stuart continues the American romantic tradition of painters like Albert Pinkham Ryder and Barnett Newman, and author Herman Melville, who shared with her an "introspective feeling for nature, awakening apprehensions of grand scale, unending space and eternal affairs inherent in ambiguous, mysterious and unconscious regions ... intimating an elevated beauty and grandeur."[48] But technically her method is often one of directly kneading, spreading, and pushing

pigment or layers of earth and other materials into a surface with her hands, in a manner reminiscent of women grinding corn or shamans engaging in sacred rituals of ancient tribes. Thus the artist relates herself at one and the same time to modern art, the romantic American tradition of "the sublime," the world of women's immemorial daily tasks, and the shaman's incantatory world.

Lita Albuquerque (1946–)

> We are lost from the starry dynamo of night.
> —William Blake

Lita Albuquerque, a Los Angeles–based metaphysical artist, sees herself as a shaman who restores our sense of connection with the cosmos. Haunted by concern that industrial civilization may lead to destruction of the planet, she says: "We are now at a critical stage. . . . We need to bring back the memory of how other civilizations connected to the earth and how the earth connected to the cosmos."[49]

Using meditation and automatic writing to get in touch with subconscious recollections of ancient civilizations and a primordial world, she often uses dreams as the source of artistic vision. For example, a dream of a red pyramid casting a giant shadow in the earth's interior led to one of her largest earthworks. During the International Sculpture Conference of 1980 in Washington, D.C., she obtained permission to dig a V-shaped trench and fill it with red pigment in front of the Washington Monument. The trench was aligned in such a way that the shadow of the monument fell upon it at a designated time. For her, the color red symbolizes the energy source of the earth.

Born in Santa Monica, California, but raised in Tunisia, Albuquerque was affected by that country's architecture, intense blue sky, and overlay of three religions. From her convent window she could see the bay where Dido, mythical queen of Carthage, saw the ships of Aeneas enter the harbor. Boats remain a symbol of transformation in her art.

Since she earned a degree at University of California, Los Angeles (1968), her work has flowed into many media—mystical paintings on silk, installations, performances. In remote desert areas she created petroglyphlike figures in the sand and covered them with powdered pigment. She placed pigmented rocks in gallery settings (one was in the Directions exhibition at the Hirshhorn Museum in 1981) and created spiral sculptures of copper. In all of these, the theme has been the attunement of organic life to the cosmos.

A 1983 site sculpture on the grounds of Orange Coast College in Costa Mesa, California, is a cement and grass pathway that spirals down to a meditation center. In a plaza near Las Vegas, she is building a forty-foot concrete and copper obelisk, designed to cast a shadow on the surrounding seventy-foot circle at the time of the winter solstice. The paved circle will be enriched with copper images of constellations. The idea, she says, "is to bring the heavens down to earth," to make viewers aware of their place in the universe.[50]

The installations of found objects, constructions, drawings, and photographs by **Kim Abeles (1952–)** "transform philosophic issues into visual dialogue." A gallery of her work is always an unexpected mélange that may include anything from a camera to X rays to a ticking metronome, often arranged in shrinelike forms.

A graduate of the University of California at Irvine's avant-garde program, she began with an early *Kimono* series—altarlike constructions based on the kimono. These were so well re-

ceived that she could easily have remained stuck in this trademark mode, but chose to move into new forms. Installations have been triggered by such themes as the discovery of the *Dead Sea Scrolls*, meditations on the career of Leon Trotsky (*Trotsky's Last Home*), the life of Saint-Bernadette, or a year-long meditation on Los Angeles's smog (*Mountain Wedge*, 1987).

An example of her method can be seen in *Calamity Jane and Questions of Truth* (1984–85). The mythical career of the consort of Wild Bill Hickok is a jumping-off point for a meditation on the myths we fabricate about people, or perhaps the impossibility of really knowing another person. Hanging in a symmetrical altar form are the fringed clothes and boots of the western heroine, but they are not real. Rather, they are cut out of transparent plastic with lines drawn on them, implying the unreality of our idea of her. On one side hang bottles containing sticks inscribed with all kinds of contradictory encyclopedia statements about Calamity Jane. On the other side, two photographs, clearly taken on the same day in the same studio, look entirely different. Above the altar an open suitcase contains photos of lie detector test results.

Abeles's traveling exhibition *Unknown Secrets* opened at Cornell University in 1988 and went to four other cities.

Amalia Mesa-Bains (1943–), a Chicana artist and psychologist, has transformed the traditional altar for the Day of the Dead into sophisticated contemporary art. Such altars, adorned with colorful cut-paper decorations, sacred icons, and baked goods, are created annually in Mexico to honor deceased relatives. Mexican women have also traditionally created a sacred spot in their homes where they place icons of a sacred figure amidst a bricolage of flowers, jewels, family photos, and other memorabilia. These private shrines are places of personal communication between the women and the transcendental world.

Mesa-Bains adds a feminist and social component to her reinterpretations of the altar form: "I've usually made altars for women—Frida Kahlo, Sor Juana Inez de la Cruz, Dolores del Rio. They were strong, intellectually curious, compassionate, nurturing and independent. They broke all boundaries. As a Chicana they were aspects of my culture and simultaneously they could be seen as models for all women."[51]

Born in Santa Clara, California, Mesa-Bains attended San Jose State College, earned an M.A. in interdisciplinary studies at San Francisco State College, and holds a Ph.D. in psychology from the Wright Institute, Berkeley. She thinks of altar making as a record of her development: "I first began making them at home. Around 1974 or '75 I began to do them in community settings. At that point I regarded them as cultural statements. They soon began to take on an aesthetic dimension. Recently, they began to be an expression of my own development as a person."[52] *Tribute to Frida Kahlo*, was in The Fifth Sun, a 1977 exhibition of Chicano-Latino art at the University Art Museum, Berkeley. Pictures of Kahlo were surrounded by all kinds of traditional objects and foods.

In *An Ofrenda for Dolores del Rio* (1984), dedicated to the Mexican-American movie star of the 1930s, a glamorous photo of del Rio is surrounded by a fan (forming a halo), draped satin, swags of cut-paper decorations, memorabilia, lace, glittery jewels, and flowers—all extremely sensual, female textures. The cross-shaped altar is strewn with confetti, as though the audience had just finished throwing it. Pointing out that the movies have usually created racist myths of female beauty, Mesa-Bains writes: "With a career in both the American and Mexican cinema,

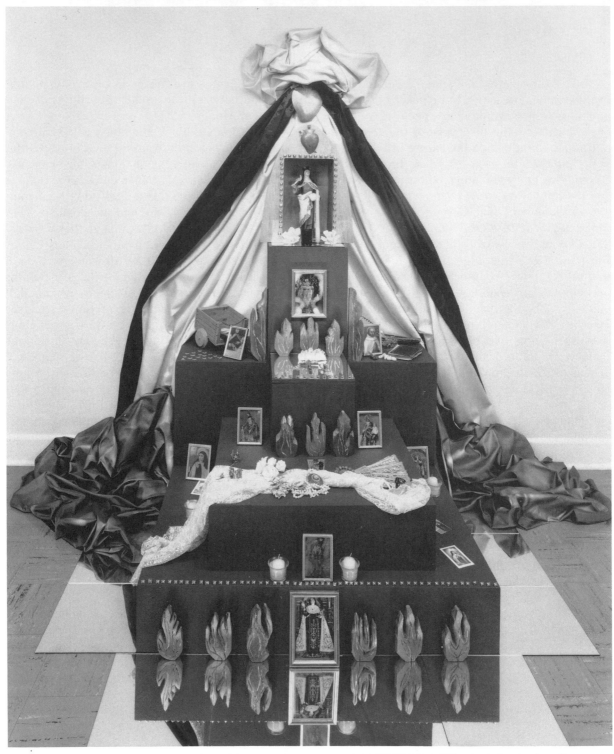

Amalia Mesa-Bains, RENUNCIATION AND DENIAL: ALTAR FOR SANTA TERESA DE AVILA (1984), mixed media installation. Courtesy of the artist. Photo: Wolfgang Dietze.

Dolores symbolized a universal yet particularly Mexican beauty to a generation of Chicanos. In her position as an accepted beauty in both cultures, Dolores gave meaning and power to a generation of Chicanos suffering rejection because of the accepted Anglo standard of beauty."[53]

In *Phoenix,* four vertical altars decorated with stylized images of flames and a feathered phoenix goddess lead up to a small sculptured deity surrounded by flame-shaped hands. A woman's deathmask, a bird pierced through the heart, and a lit candle are on a low table in front of it. Mesa-Bains explains: "Whether it be the passionate love of another person or of an idea, there are moments when that passion or fire is lost. Women, as keepers of the flame, are always part of the cycle, and it is from all our ashes that we beget the next fire. The *Phoenix* was a metaphor for the continuation of life and civilization. Whether she is a mother, lover, the goddess or a priestess, woman's passion really sustains life."

In 1988, Mesa-Bains had a three-altar show at the Intar Gallery, New York.

Linda Vallejo (1951–) of Los Angeles draws on her Mexican-American heritage in archetypal figures and masklike heads of handmade paper pulp, natural tree branches, and palm fronds.

A lithographer who studied in Madrid and earned an M.A. from California State University at Long Beach, Vallejo made surreal prints of mythological imagery from ancient cultures and directed the Self-Help Graphics Workshop in the Los Angeles barrio for a number of years.

It was a natural step from using handmade paper pulp in printmaking to forming it into three-dimensional sculptures. The artist uses tree branches and other natural forms whose shapes suggest images that she builds around them with a mixture of paper pulp and glue. They look like carvings of mystical woodland spirits or the Mexican masks worn at festivals.

Patricia Rodriguez (1944–), long a figure in the Bay Area Chicana art movement, creates intimate box constructions that evoke the spirit of her heritage. Born to Mexican-American farm workers who settled in California, Rodriguez learned to love art from her grandmother, who was always crocheting and making quilts and kept her supplied with cast-off paper and cardboard.

When Rodriguez won a scholarship to the San Francisco Art Institute, she defied her husband and family (Chicana women were not encouraged to get a higher education) by leaving for the Bay Area. "It was my ticket to freedom" she says.[54] But the art values on campus seemed strange and alien. Becoming active politically, she and three other Chicana women formed the *Mujeres Muralistas,* the first Latina women's group to initiate wall murals in the Bay Area. Rodriguez earned a master's degree at Sacramento State University and taught art in the Chicano studies program at the University of California, Berkeley (1975–80), the only Chicana teacher in the University of California system at the time. She put together a groundbreaking text on the history of Chicano/a artists.

After the university canceled the program, Rodriguez began to make the Cornell-like constructions infused with symbols relating to her people. After years of doing large public murals, she now wanted to create more intimate art that dealt with her personal feelings and her role as a Chicana artist. For example, in *Contemplation* she symbolized the conflict she faced "between having a child and being a career woman. Both together are very difficult to achieve if you're a starving artist. There are fetuses, there is a heart, and there is a pomegranate which is a very beautiful natural thing that shrivels up and yet holds it shape, and it has nails driven through it. To the side are gears which show energy, movement, and bravery. The whole refers

to being brave enough to dive into something and complete it by yourself as a Chicana."[55]

CONCEPTUAL AND PERCEPTUAL ART

Cecile Abish

Minimalism has not led to artistic nihilism. Rather, it has provided a cleared piece of ground in which she slowly . . . builds up an art of clarity and reason.
—Jeffrey Keeffe[56]

Cecile Abish's earthworks and gallery installations of common materials—particle board, sticks, and multicolored marbles—are laid out on the ground in configurations that have a kind of crystalline inner logic. They are theorems or puzzles which the viewer figures out.

Temporary works made to fit a particular space, they often incorporate the surface of the floor into the design. The fact that they fit an architectural or landscape space is not fortuitous. After earning a degree in sculpture at Brooklyn College, Abish worked as an architect and urban planner for several years, primarily in Israel, returning to New York in the 1960s when minimal and modular art held sway.

The breakthrough into her present mode came in several land artworks in the early seventies. In *Four into Three* (1974), she dug a line of four five-foot shallow squares into the sod, piling up the removed earth into three pyramids between them. Thus the four forms metamorphosed into three larger forms. The relationship between the cut-out space and the solid earth piles, between raw earth and grassy sod, triggered ideas for indoor works.

In Abish's poetic marble works, a series of installations at New York's Alessandra Gallery, a field of random multicolored marbles, dispersed as with a billiard cue, was interrupted by rec-

tangles or squares of particle board and cleared spaces that revealed echoing shapes of the floor boards themselves. The viewer gradually figured out that the forms were arrived at by first placing the particle boards on the ground before dispersing the marbles and then flipping them up against the wall or placing them on top of the marbles. These configurations inspired meditations on order versus entropy; matter versus antimatter, and so on. A 1978 marble installation at Wright State University, Dayton, Ohio, incorporated an upper viewing gallery into the composition.

As a visiting artist at the University of Massachusetts, Abish created a conceptual "exposé" of museums (1982). She took photographs of rooms at the Fogg Art Museum and then mounted them on an arrangement of boxlike structures that filled a gallery. The viewer was forced to view the museum *rooms* as spaces in which art itself gets lost and emptied of meaning. She is part of that group—including Carl André, Barry Le Va, and others—which took sculpture off the pedestals, onto the floors, into temporary installations, and permanently into the minds of viewers. A 1982 retrospective was held at New York State University, Stony Brook.

Maria Nordman (1943–), an international artist who divides her time between southern California and Europe, is a conceptual and perceptual artist who constructs natural light pieces that push perception to the limit. For Count Panza, one of the leading patrons of perceptual art, she spent months at his Italian villa, constructing two rooms that appear dark when you first walk in, but gradually move into cloudy mists and then into the dark again.

The object is not merely to explore how our eyes create an illusion—lines and forms alternately appear and disappear, background and

Cecile Abish, UNTITLED (1978), particle board, marbles, 1½″ x 34′ x 42′. Installation at Wright State University Art Gallery, Dayton, Ohio. Photo courtesy of the artist.

foreground merge—the experience produces a merger of the self with the oneness of the universe. As Melinda Wortz has noted, such attitudes have historical precedents in works like Malevich's white-on-white abstractions, intended to raise consciousness to higher spiritual realms.[57]

Born in Goerlitz, Silesia, in East Germany, Nordman came to the United States as a child, did research on light models at the Max Planck Institute in Stuttgart, and worked with architect Richard Neutra. Her first light explorations were shown at the Dickson Art Gallery, University of California, Los Angeles, in 1967. Since then she has carried out projects at the University of California, Irvine (1973), the Newport Harbor Art Museum, the Fogg Art Museum (1981), the 1976 Venice Biennale, the 1977 Documenta international exhibition in Kassel, and elsewhere.

For a 1979 installation at the University Art Museum in Berkeley (a brutally modern building with gray concrete walls and floors), Nordman covered the floors of two huge galleries with a matte white surface, and the door openings with red, blue, and green acetate. Visitors entered a completely empty gallery in the dark before dawn on 21 June, the day of the summer solstice. With the lights turned off, the viewer was invited to become aware of the changes in the natural light as dawn arrived; to hear the sounds of the awakening city; notice the walls beginning to glow; and observe the patterns that people made, moving through the large white space. The galleries remained open until nightfall, with the architecture of the building emerging out of the darkness and sinking back into it. The attitude in this piece resembles John Cage's music, in which the intervals of silence make the listener aware of accidental sounds in the environment.

Increasingly well known in Europe, Nordman in 1982 piloted an old canal freight ship to eight river stops in Western Europe (Rotterdam, Amsterdam, Düsseldorf, and so on). At each port of call, people were invited to enter the hull, slowly experience the effect of controlled light filtering into the cabin, and become aware of ambient sounds coming in from outside. This project, called *Ein Schip: Tjoba,* was organized by De Appel in Amsterdam.

Nordman's 1985 installation at the La Jolla Museum of Art in California included an enclosed wooden walkway with eight canvas doors that permitted the viewer to look out and experience differently the ocean and the nature sounds at the back of the seaside museum.

Nordman creates gardens, too. *Open Scheldt Garden* (1987), for the new Museum of Contemporary Art in Antwerp, Belgium, consists of an octagonal pit in the ground and a pattern of oak, beech, and other trees on the banks of the Scheldt River. The curator said "Maria spent days and days here just thinking about it ... the connection with the trees on the other bank and the octagonal tower in Van Eyck's painting of Saint Barbara in the Fine Arts Museum."[58]

The artist is not interested in art as a commodity. Her object is to heighten people's awareness of themselves in relation to the world, to arrive at a moment "when the viewer and the viewed are one."[59]

Agnes Denes is another conceptual artist who has staged events and created amazing drawings of forms derived from complex mathematical and philosophical systems, such as probability theory. After many years of theoretical exploration, she is now receiving funding to actually construct some of them.

PERFORMANCE ART

In the book, *The Amazing Decade,* art historian Moira Roth documents the extraordinary accomplishments of women in performance art—a me-

dium incorporating theater, dance, music, film, video, and the visual arts.[60]

Performance dates back to the happenings of the 1950s and 1960s, when artists (including many women) began to move out of the gallery with events that took place in time and space, on the streets, in the land, in the home, theater, and elsewhere. They wanted to break down the barriers between life and art—to involve the spectator in a more immediate way. In the 1970s, performance proved to be a flexible instrument for women to use in their effort to break out of old forms of bondage and shape a more humanistic world.

Roth traces three trends in women's performances in the 1970s: autobiographical expressions of personal feelings, mythic or spiritual rituals, and political-activist performance. At first some women used performance to vent rage and pain—sometimes in shocking ways. Who can ever forget Carolee Schneemann's *Interior Scroll* (1975), an event in which the artist unrolled and read from a long narrow scroll that had been inserted in her vagina. The text described how she, a filmmaker, was often told by leading male filmmakers that she was "charming, we are fond of you," but "don't ask us to look at your films. . . . we cannot look at the personal clutter, the persistence of feelings . . . the diaristic indulgence . . . the primitive techniques."[61] Now women insisted on their "personal clutter, the persistence of feelings."

In 1970, Judy Chicago used performance as a tool in her feminist art program at Fresno State University. As she explored ways to help her students find their expressive powers, she saw that although they were often inhibited in traditional painting and sculpture, they released themselves freely in this medium. At the time of *Womanhouse*, her student Faith Wilding sat rocking in a rocking chair while she intoned *Waiting*—a recital of woman's traditional passive role from infancy to the grave. Another performance was of women giving birth to themselves between the legs of their sister artists.

Some artists created new personae to embody various aspects of themselves. For example, Lynn Hershman of San Francisco assumed the role of the imaginary "Roberta Breitmore" and actually lived out her life for several years, exposing in the process the loneliness and alienation of women in our society. Eleanor Antin assumed the roles of king, nurse, ballerina—to express various aspects of herself and of society.

Adrian Piper and Faith Ringgold used performance to illuminate issues of racism and "otherness." Martha Rosler, Jacki Apple, Linda Montano, Mierle Laderman Ukeles, and others have dealt with a variety of social issues. Cheri Gaulke has been a leader in activist performance groups, such as the Waitresses and Sisters of Survival, which came out of the Los Angeles Woman's Building. They raise such issues as harassment of women in the workplace and the threat of nuclear war.

A closer look at a few performance artists reveals the variety and creativity developed in this genre.

Suzanne Lacy (1945–)

> I'm interested in changing the way people see themselves. Success is measured in the amount of involvement and transformation of people's lives.
> —Suzanne Lacy[62]

Suzanne Lacy is one of the primary exponents of performance art as a vehicle for social change. Her productions often take place over a period of months, involve large numbers of people, and require organizing talents and an ability to deal with bureaucracies. Her career began when, as a psychology student at California State University, Fresno, she enrolled in Judy Chicago's feminist art workshop. This proved to be the catalyst

that fused all of her interests—politics, psychology, and art.

After finishing a degree in psychology, Lacy transferred to Cal Arts, where she earned an M.F.A. working in the feminist program there and with Alan Kaprow, a pioneer of happenings in the 1950s. She was also influenced by the socially conscious environmental sculptures of Ed Kienholz.

Lacy collaborated with Chicago, Sandra Orgel, and Aviva Rahmani on *Ablutions* (1972), a performance focusing on rape, in which women bathed in tubs of blood and clay, raw meat and eggs, and were wrapped in bandages to the sound of audio tapes of victims recounting details of actual sexual assaults. Rape was seen as a political act of hatred against women, not a sexual act.

After joining the Woman's Building in Los Angeles, Lacy produced programs directed against various forms of violence against women. The first work to receive wide media coverage was *Three Weeks in May* (1977). The artist put up twenty-five-foot maps of Los Angeles in a shopping mall, and each day marked the spot where a new rape had taken place and a place where a victim could get help. Daily performances captured the attention of the media and made the public aware of the frequency of rapes in the city. Lacy organized a consciousness-raising group for victims and a gallery installation where the public, entering in small groups, looked up at four blood-covered nude victims cowering on a ledge and a suspended carcass of a winged lamb, and down at a poem crudely scrawled on the floor, describing a sexual assault.

Lacy collaborated with Leslie Labowitz, just returned from study in Germany with Joseph Beuys (an artist who believed in breaking down the boundaries between life and art). Their 1977 production, *In Mourning and in Rage,* was a landmark in the history of feminist performance. It was a response to the "Hillside Strangler" rape-murders. Lacy and Labowitz dramatized the larger significance of what was happening in a visually compelling event on the steps of the Los Angeles City Hall. Seven-foot-tall mourners, dressed and veiled in black, and a red-garbed chorus holding banners chanted "in memory of our sisters: women fight back." Specifically designed for news reporters, the event was televised nationally.

The artist had created a public ritual in which a visual tableau was combined with speech and music, one in which community groups and the news media played an integral part. Lacy and Labowitz founded Ariadne, A Social Art Network. For several years they developed activities to combat incest, child molestation, and other forms of violence against women, subjects that people were afraid to discuss in public. These efforts took an immense emotional toll on the two artists, but they helped change the attitudes of the public.

Lacy left the subject of violence for more celebratory themes. In 1979 she organized an International Dinner Party, in which two thousand women participated simultaneously in dinner parties around the world to celebrate the opening of Judy Chicago's installation. Other works focused on sisterhood among women of different races and backgrounds.

In recent years Lacy has dramatized the problem of discrimination against aging women. Pointing out that by the year 2020 almost one quarter of our population will be over sixty-five and consist principally of women, she has worked to counteract the negative stereotype of older women as "frail, passive and needy; to increase the visibility of older women's skills, talents and continuing contributions." In 1987, as artist-in-residence at the Minneapolis College of

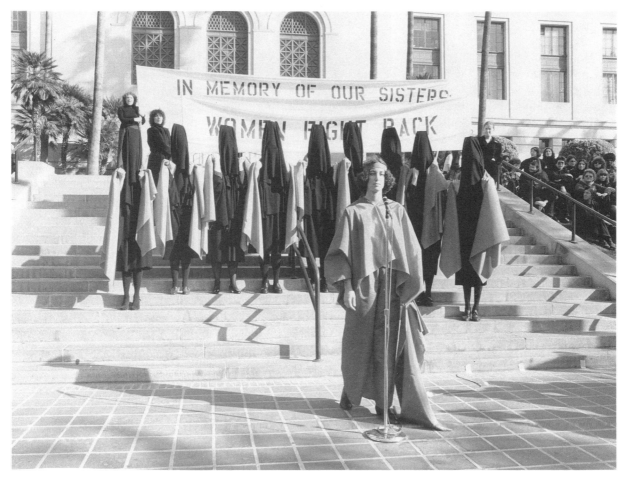

Suzanne Lacy and Leslie Labowitz, IN MOURNING AND IN RAGE (1977), performance, Los Angeles. Photo: Susan R. Mogul, courtesy of Suzanne Lacy.

Art and Design, Lacy organized The Crystal Quilt, whose mission was to develop leadership in older Minnesota women. With support from the Hubert H. Humphrey Institute of Public Affairs and other groups, Lacy formed a network of older women from all ethnic and economic backgrounds. They were to meet during the year to discuss their potential roles in society, exchange ideas on public policy with public leaders, and carry on other activities—for example, a dance performance.

The climax was a tableau vivant in which six hundred women between the ages of sixty-five and ninety sat at 150 tables positioned on a floor pattern of a black, yellow, and red patchwork quilt, designed by painter Miriam Schapiro. Over a loudspeaker came a collage of women's voices, recorded during the year. The audience completed the "quilt" by filing down among the participants to present them with colored scarves and interact with them. Although the project is over, it continues to exist via a book, video, slides, articles, and a permanent organization of older Minnesota women who have vowed to organize similar programs in other states.

Lacy's public work is the diametric opposite of

the esoteric performance art of the avant-garde. The preparatory phase of her productions, in which people meet and interact over a period of months, is to her as important—perhaps more important—than the culminating event. She wants to transform people, and she hopes that her projects will serve as models for artists wishing to reach out to the world.

Stylistically Lacy's events are sculptural—the forms are frozen in space in a visual tableau—in contrast with those of Rachel Rosenthal whose performances grow out of theater and depend more on movement and dialogue.

Rachel Rosenthal (1926–), with her shaved head, jutting jaw, and demonic superhuman gestures, has transformed herself into the very spirit of Gaia—the goddess-conscience of the earth, calling on all people to prevent the destruction of the planet. For years she went around with a pet rat on her shoulder—a symbol of her love for all living creatures.

Now in her sixties, she has become a major international figure in the last few years and was invited to perform at the 1987 Documenta international exposition and elsewhere. Her dramatic monologues, fusing theater, film, music, lighting, owe their ferocious energy and scale to a forty-year apprenticeship as painter, sculptor, dancer, actress, and teacher who has studied and worked with many of the great people of our time.

Raised in a privileged environment in the elegant sixteenth-arrondisement of Paris, Rosenthal studied ballet from the age of six with prima ballerina Olga Preobrajenska. Each year on her birthday she danced before hundreds of guests in her parents' salon. Fifty teddy bears served as characters in plays given before an audience of household servants.

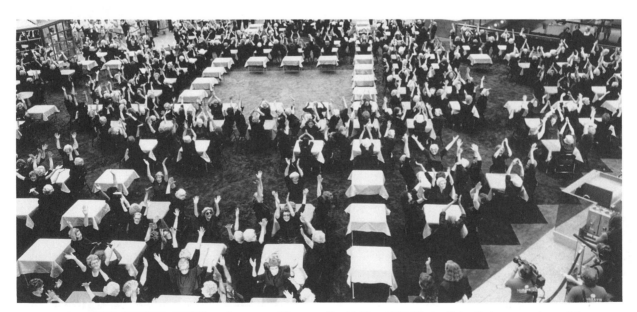

Suzanne Lacy, THE CRYSTAL QUILT, performance, Minneapolis, 10 May 1987. Photo: Peter Latner, courtesy of the artist.

This dream life ended when the Nazis invaded France and the Rosenthals fled to Brazil and then to New York, where she spent her teens. The artist studied painting with Hans Hofmann and drama with Erwin Piscator; she performed in Merce Cunningham's troupe (1950–51) and became friends with John Cage, Jasper Johns, Robert Rauschenberg and others. Artaud's book *The Theater and Its Double* inspired her with a new vision of what the stage might be. She came to Los Angeles in 1955 and set up "Instant Theater" workshops—a unique amalgam of improvisation, collective ritual, abstract art, poetry, and dance with roots in dada, Zen Buddhism and Artaud's theater of cruelty. Too advanced for the Los Angeles community at large, her performances in dingy storefronts nevertheless attracted a small, sophisticated cult audience that included artists like Ed Kienholz.

When she was struggling with her life after a divorce in the early 1970s, Rosenthal was lifted up by the wave of feminism; in particular she credits painter Miriam Schapiro and printmaker June Wayne with inspiring her to enter a new phase of her career. She shaved her head and created a sensational new persona. After a series of autobiographical performances in which she confronted, and threw off, the destructive influences of the past, she began to deal with the major issues of our time.

Rosenthal captured the imagination of the Los Angeles public with her 1984 performance *Kabba LAmobile,* created in connection with the Museum of Contemporary Art's inaugural exhibition, The Automobile and Culture. The artist communicated Los Angeles's mystic communion with the automobile. On a high steel scaffold before the splashing fountains of the Department of Water and Power building, waving her arms like a machine age demon, she chanted bits of the mystic kabala and excerpts from auto magazines, while choreographed stunt drivers careened around the piazza, sometimes tilted on two wheels. Rosenthal was carried off on the hood of a car while the music swelled and the fountains rose higher.

In *Gaia, Mon Amour,* perhaps her most famous work, the artist opened with a maddeningly rhythmic, hypnotic male voice-over, intoning about man's right to conquer nature, to rape and kill the earth, accompanied by slides of brightly packaged war toys alternating with images of tortured and dead animals, pollution, waste. During a climactic blackout, the sound of a nuclear explosion reverberated through the hall. As the lights came up, out of the debris of contemporary culture strewn on the stage, arose

> a phantom from the dawn of society. . . . Gaia . . . firmly planted on wide-spread legs, she moves only from the waist up. Her stare is fixed, nearly demonic in its intensity. Her hands and arms gesture . . . suggestive of free flowing . . . variations of tai chi; the extreme illumination—blue from the side and bright white overhead . . . produces an otherworldly disembodied effect. . . . I am the Matrix. You are in and of my Body. I am the Mother. I am the Daughter. I am the Lover. But scorned, I am also Lilith, the Maid of desolation. And I dance in the ruins of cities.[63]

A history of culture follows, tracing the development from early worship of Mother Earth to the triumph of the patriarchy through reason, logic, mathematics, and language, all used to subjugate the female principle. At the end the goddess drums and chants a sacred healing ceremony while slides of earth forms are projected behind her: "to love me, Gaia, is to love yourselves."

Responding to the nuclear disaster at Chernobyl, Rosenthal created *Was Black* (1986), a

Rachel Rosenthal, WAS BLACK (1986). Performance at John Anson Ford Theater, Hollywood, for Visions/Interarts. Photo: Jan Deen, courtesy of the artist.

black-and-white performance. A mourning on a global scale, it opened with the Russian lullaby her mother sang to her when she was an infant and reached a climax as the participants toasted one another by pouring salt into champagne glasses—a powerful image of the potential aridity of our future.

Laurie Anderson (1947–) has moved from performance artist to rock star, from rarified art aimed at a narrow elite to the use of mass media—without sacrificing meaning or complexity.

Spiky-haired, hollow-eyed, clad in baggy black androgynous costume, she is a kind of punk pixie who plays an electronic violin rigged with a tape deck and casts giant hand shadows on a huge illuminated screen behind her, while spooky electronic changes of voice convey the anxiety-ridden nature of a society made anonymous by corporate culture and threatened by fear of annihilation.

Growing up in a well-to-do, creative family outside of Chicago, Anderson was a virtuoso violinist at age sixteen, but suddenly decided to dump the endless practicing ("I was becoming a technocrat") in favor of far-ranging explorations of the new. She even hitchhiked to the North Pole one summer.

After studying art history at Barnard and receiving an M.F.A. in sculpture from Columbia University (1972), Anderson experimented with gallery art for a while, wrote reviews for *Artforum* and *Art News,* and was drawn into the world of performance artists (Vito Acconci, Chris Burden), avant-garde composers (Philip Glass), and pop musicians (Captain Beefheart). Her first performance piece, *Automotive* (1972), was an orchestration of car horns at the town green, Rochester, Vermont. Intrigued by street musicians, she played an electronic violin on street corners, while standing on ice skates embedded in chunks of ice. When the ice melted, the piece was over (*Duets on Ice*).

In *Handphone Table* (1978) at New York's Museum of Modern Art, seated viewers placed elbows in two depressions on a table and covered their ears with their hands. Strange undecipherable music from tape decks hidden in the table was conducted to the auditory center of their brain by bone conduction through their arms. The idea was to make viewers realize that they are programmed by an endless subliminal assault of information of which they are unaware.

Anderson first used the rock-concert format in *United States, Part 1,* at the Kitchen, a New York performance space. *United States, Part 2* debuted at the Orpheum, an old vaudeville theater. She crammed the stage with light and sound equipment and projected a huge U.S. map behind her, such as might be used by the North American Air Defense Command to monitor bombers and missiles. A film clip from the video game Space Invaders appeared on the screen at one point. Anderson uses popular catchphrases, advertising slogans, and a collage of voices and pictures to convey the ominous nature of our culture. In the segment called *O Superman,* her voice goes from a saccharine "Hello, this is your mother. Are you there? Are you coming home?" to the ominous "Well, you don't know me but I know you and I've got a message to give you. Here come the planes." At this point Anderson's hand casts a giant shadow on the screen, like a child imitating a plane, while the drone of aircraft squadrons fills the hall. Electronic audio devices transform her voice from one pitch to another, from a lone voice to a robotlike organ dirge or a massed chorus. She explains that she uses the anxiety-provoking electronic voice changes because

> I'm interested in a kind of corporate voice that might be compared to the writing in *Newsweek* or *Time,* in which someone starts an article and then it's edited and re-edited . . . and the article finally comes out in Timese or Newsweekese. . . .

Laurie Anderson performing in UNITED STATES, PART I. Photo © Paula Court 1980, courtesy Holly Solomon Gallery, N.Y.

One of the things I'm trying to get at through these filters is to look at those kinds of . . . particularly American—voices that try to convince you there's a person behind it and there isn't."[64]

Anderson attracts a broad audience ranging from New Wave aficionados to rock-and-roll devotees. An eight-minute independent record of her song *O Superman* was taken up by a BBC disc jockey in England and became such an underground hit that Warner Brothers signed a contract and sent 100,000 records to England; *O Superman* rose to number two on the British pop chart. Since that time Anderson has toured the world, breaking down the boundaries between popular culture and high art.

The tragic death of **Ana Mendieta (1948–85)** at the age of thirty-six placed a Cuban-American artist of tremendous spirit and imagination in the pantheon of creative female martyrs and saints.

Born in Havana to upper-class parents, she was hastily sent to the United States after the Castro takeover when she was twelve years old. Torn from parents and country, Ana grew up feeling deracinated in an Iowa orphan asylum. Later, her earthworks and "sod pieces" expressed her longing to return to her roots.

Growing up in foster homes in the Midwest and subjected to racial prejudice from other children in school, Mendieta became fiercely rebellious. She once told an audience that she would have been a juvenile delinquent if she hadn't found an outlet in art.

While she earned a graduate degree at the University of Iowa, she managed to outrage the faculty with unconventional art forms. In a performance inspired by an Afro-Cuban religious ceremony, she portrayed her transformation into the sacred sacrificial white cock by covering herself with blood and rolling in white feathers that clung to her body when she stood up. In 1973, disturbed by rapes on campus, she photo-documented a shocking performance in which the audience discovered her as the victim.

To express her longing for a piece of the earth that was native to her spirit, Mendieta began to create *siluetas* (silhouettes), or sod pieces, in which she pressed her body into the soil, leaving an impression or imprint, or built up the form in earth, clay, and sand. Sometimes the image was burned into the land with a mixture of gunpowder and sugar that crystallized the form; sometimes it was planted in fertilized soil. In one, her body seems to sprout a cloud of white flowers. These transient poetic works now exist in photographs, some of which were shown in 1980 at

Ana Mendieta, UNTITLED (1983–84), sand and binder on wood, 63″ x 39″ x 24′. Collection: Raquel Mendieta Harrington.

the AIR women's cooperative, New York, and at the Lerner-Heller Gallery. After moving to New York City in 1978, she had become part of the feminist-spirituality movement, believing in the healing power of the feminine principle, connected with nature and rooted in the ancient past.

Curious to see the land of her birth, Mendieta visited Cuba in 1980. She felt a great sense of identification with her heritage and carried out works on Cuban soil.

Mendieta won a Guggenheim fellowship (1980), three National Endowment for the Arts grants (1978, 1980, 1982), and the coveted American Academy in Rome Fellowship, enabling her to spend 1983–84 in Italy with her husband, sculptor Carl André. There she studied bronze casting and began to create permanent pieces—carved and burned-out tree trunks that seem like pri-

mordial female nature spirits. The artist was selected for the touring Awards in the Visual Arts show.

In 1985, her friend Adolpho Nodal, at that time director of the art gallery at Otis-Parsons Institute, Los Angeles, was in enthusiastic correspondence with her about a major public commission for MacArthur Park in that city. But to the shock of the entire art world, she fell to her death from the window of her thirty-fourth-floor Greenwich Village apartment. Her husband faced murder charges, but was acquitted.

Nodal, now manager of cultural affairs for Los Angeles, has written about his friend:

> Tropic-Ana, as she liked to be called, led a poetic life, a heroic life.... Totally intense ... tiny, dark-skinned, with long flowing black hair ... lovable, caring ... ambitious ... sharp ...

wild. She had a vision, she knew what she was doing and she was a highly accomplished artist. A scrappy fighter [who] clawed her way up as a kid, surpassing major cultural barriers in her new American home.... she was tenacious. She would have never let go; she was too busy.[65]

A very aware ... member of the artist planning team that helped develop [the MacArthur Park Public Art Program], she advocated the needs of the kids and of the transient Cuban and Black community in and around the park. Her project *La Jungla,* was a group of seven large tree trunks, carved and burned, representing the seven powers of life ("which rule the jungle") ... to be placed in a grove of pine trees on a slight incline. It would have been a "charged" space that would have provided just the right amount of other-worldliness to the park.... It would have given the Cuban and Black members of the neighborhood ... a sense of spirituality and hope that is severely lacking for them in this environment.[66]

Curator Howard Fox posthumously included one of Mendieta's "tree spirits" in his 1986 exhibition Avant-Garde of the Eighties at the Los Angeles County Museum of Art. In 1987 the New Museum, New York, mounted a full-scale memorial retrospective.

When **Betsy Damon (1940–)** appeared in 1977 amidst the rushing crowds on Wall Street— weighed down by 420 small sacks of colored flour, her face and hair painted white, her mouth a black gash—she aroused intense reactions. She was playing the role of the "7,000-year-old woman"—a symbol of centuries of oppression. Squatting in the center while an assistant drew a spiral design on the ground around her, Damon then began to slash the bags and spill the flour in a spiral design as she slowly moved out to the edge, symbolically unbinding herself from the past. Her object was to create for a moment a female space in the male-dominated urban streets; to connect women with a sense of their female ancestors.

Damon started her career with an M.F.A. from Columbia University, had two children, and was divorced. She attended the opening of *Woman-house* in Los Angeles and changed the direction of her life. Feeling that people need public rituals to bring them together and heighten their awareness, she created female myths and healing rituals with stones, knives, feathers, some at Soho 20, the New York women's collective gallery.

Damon has turned recently to ecological concerns. Recognizing that "our children will never have tasted fresh water," she set out to raise awareness that clean water is fast disappearing because of pollution. With a team of twelve people, she made *A Memory of Clean Water* (1987), a 250-foot casting in handmade paper of a dry creek bed near the once sacred Anasazi Indian site, Castle Rock, Utah. Embedded with bits of animal bones, feathers, and pebbles from the stream bed, the cast evoked the spirit of the once-rushing stream as it poured down the canyon. Damon involved each community where she showed it in a dialogue relating to local water conservation issues.

Mary Beth Edelson, through ritual, myth, and symbol, revived the concept of the Great Goddess. Edelson says she was not engaged in a retrogressive return to the past, but was tapping into ancient sources to inspire a sense of female empowerment in the present—attempting to restore the universal balance absent from masculinist views that have dominated the last five thousand years.

Edelson, with an M.F.A. from New York University, had been a painter for eighteen years when, deciding that traditional art was no longer related to her life experiences, she invited twenty-two critics, artists, and historians to suggest a work that he or she would like to see her attempt. The resulting exhibition and events launched her in the direction of installations, rituals, and other innovative approaches. "As I stopped painting. . . . I was flooded with a deluge of ideas. . . incorporating the collective unconscious into my creative process."[67]

In Woman Rising (1973–74) at the Henri Gallery, Washington, D.C., Edelson exhibited photographs, freely embellished with paint, of herself as the Goddess, taken during private rituals on the Outer Banks, North Carolina. The images show woman, powerful and wild, rising up and sending out lines of force to the sky or freeing herself from burial in the earth. She then took time-lapse photographs of self-transforming rituals amidst spectacular natural sites—caves, ruins, beaches—that echoed with ancient collective energies. The figure became a moving blur; lines of light wove calligraphies in the air.

Believing that the witch-hunts of the Christian era were an attempt to wipe out the spiritual and secular power held by women in earlier times, she conducted a Memorial to 9,000,000 Women Burned as Witches in the Christian Era (1977) at AIR, the New York women's collective. Participants gathered around a ladder lit with flames like those used to burn witches at the stake, read aloud names of the sacrificed, and then carried lit pumpkins on poles from the streets of Soho to the fountain in Washington Square Park—a reenactment of rituals in medieval times.

In Your 5,000 Years Are Up! (1977) at the art gallery of the University of California at La Jolla, black shrouded figures around a fire pit, mourned five thousand years of lost history and then emerged in a dance celebrating a new era. Edelson found ways of interacting with her audience; she collected stories in "story-gathering boxes," which became works of art as well as repositories of women's histories.

Edelson now identifies with groups such as the Elmwood Peers, which stress the need, in an age of chaos and violence, for partnership and cooperation between men and women. These groups, she says, have incorporated the message of feminist spirituality in their thinking. Edelson uses Jungian androgynous imagery in paintings, murals, and installations (Danforth Museum, Massachusetts; Musée de Quebec, Canada, 1987), and invites the spectator to leave symbolic elements at small bronze altars cast from mounds of hay. She says, "The real avant-garde is the territory of finding how we can come together."[68]

Faith Ringgold (1930–) combines embroidery, quilting, soft sculpture, painting, and performance art to express themes of black awareness and feminism. She says, "I emulate the nameless women . . . in every part of the world . . . who worked with . . . yarn and cloth and other soft and impermanent materials to create art, the formal qualities and design concepts of which have had an enormous influence on the male art of the last half century that our art institutions and collectors so highly prize today."[69]

Born Faith Jones in Harlem, she was an asthmatic child who spent long happy hours painting and cutting out dolls at home. Her mother, Willi Posey, a dressmaker, gave unstinting encouragement and later helped with the sewing on her sculptures and quilts.

The artist earned an M.A. in art at City University of New York, married a musician, had two children, was divorced, and taught art in New

York City schools. She painted conventional pictures—fishing boats, seascapes—and toured the museums of Europe. But all the while, although she appreciated Western art, she felt it had little to do with her own experience.

Under the influence of black writers like James Baldwin and Leroi Jones, her stylistic sources became African rather than European, with flattened space and geometric backgrounds. *The American People* series, shown at New York's Spectrum Gallery in 1967, was about social struggle in America (*The Flag Is Bleeding*).

The effort of dragging heavy paintings around congested streets and up narrow staircases led her to paint on fabrics which could be rolled up. Her interest in feminism also spurred her to use such "female" media as quilts and soft sculpture.

One of the first activists to challenge museum discrimination against women, in 1970 Ringgold joined Lucy Lippard, Poppy Johnson, and others in agitation against the Whitney Museum, and helped bring about the unprecedented inclusion of black artists Betye Saar and Barbara Chase-Riboud in the Whitney Sculpture Biennial. She helped form a black women artists' cooperative called Where We At.

The artist used black feminist themes in a *Slave Rape* series of fabric paintings showing wide-eyed black women in Africa about to be hunted down and carried off to slavery. In 1973 she made masks based on traditional African art—*Witch Masks* and *Weeping Women* with raffia hair and tears of beads strung together, followed by life-sized soft sculpture figures who became characters in performances. One series featured women with open mouths to show that "women should speak out"; others depicted famous people like Martin Luther King and Adam Clayton Powell or were portraits of people she knew in Harlem.

A major multimedia performance was *The Wake and Resurrection of the Bicentennial Negro* (1976) using masked performers, taped music, and life-sized soft sculpture characters. Buba, the hero, is dead from a drug overdose and his wife, Bena, has died of grief. The performance involves an African belief that ancestral deities are in limbo until "they are released through dance to return to the community in search of new lives." In the drama, Buba and Bena come back to life through the love of family and community.

Ringgold made narrative quilts about Harlem characters, and in 1981 she made sculptures to memorialize her grief at the senseless murders

Faith Ringgold, BUBA AND BENA #2, from THE WAKE AND RESURRECTION OF THE BICENTENNIAL NEGRO (1976), soft sculpture and mixed media. Courtesy Bernice Steinbaum Gallery, N.Y.C. Photo: Karen Bell.

of black children in Atlanta, Georgia. *Atlanta* shows twenty children in black satin standing on a checkerboard field, each wearing a tag with a photograph and name on it, while two parents scream helplessly in the background.

A resident of the once-fashionable (now being gentrified) Sugar Hill in Harlem, Ringgold spends part of each year as a professor at the University of California, San Diego. A twenty-year retrospective was held at the Studio Museum in Harlem (1984), and a solo show followed at Wooster College in Ohio (1985). In recognition of a lifetime of radical confrontative art she was awarded a Guggenheim fellowship in 1987.

THE REVIVAL OF FIGURATIVE SCULPTURE

After a long period in which abstraction was regarded as the only viable approach, realism and figurative content came flooding back into sculpture. Some sculptors, such as George Segal, actually cast their sculptures directly from life.

Some women are creating figurative sculpture today, but few use the direct-casting approach. Their work ranges from Marilyn Levine's super-realist ceramic objects (which are *not* cast from life) to Mary Frank's expressionist figures and Deborah Butterfield's near-abstract assemblages of horses.

Marilyn Levine (1935–) produces stoneware that mimics leather objects—sagging handbags, worn boots. One is tempted to open the handbag or pull on the boots until the cold, hard surface reveals their true nature.

Born in Medicine Hat, Alberta, Canada, Levine set out to be a chemist and earned an M.S. in 1959. When her chemist husband took a job at the University of Regina, Saskatchewan, nepotism rules prevented her from being hired along with him (a common problem for women in those days), so she enrolled in ceramics classes to pass the time. Levine became an outstanding potter. "Nobody had to teach me how to mix glazes," she says.

By 1967 she was selected for the Canadian Fine Crafts show at the National Gallery of Canada, Ottawa, and then won a Canada Council grant. A 1968 trip to San Francisco proved the turning point. The funk art movement was under way; she met many exciting ceramists who were crossing the border between craft and sculpture. Levine stumbled on her subject matter in a ceramics class given by Jim Melchert. He asked his students to make a pair of shoes in clay, and she discovered that she loved working on the details—grommets, laces, hobnails.

Levine took an M.F.A. in sculpture at the University of California, Berkeley (1971), taught in Utah, and then returned to the Bay Area because she enjoys "the openness, the freedom."

Levine's ceramic representations of leather purses, jackets, and suitcases are what Harold Rosenberg called "translations of objects into a different substance without altering the appearance." Even scratches, dust, and grease stains on the surface, are reproduced with uncanny accuracy; This kind of trompe l'oeil has a long tradition in ceramics going back to China and the eighteenth century in Europe.

Levine's sculptures seemed at first to be pop art, like Andy Warhol's Brillo boxes, or perhaps part of the hyperrealist movement that includes sculptors like Duane Hanson and John de Andrea. But unlike these artists she does not cast from real objects. Rather she constructs forms that, despite their seeming verisimilitude, belong to a class of objects and have a generalized aura.

Marilyn Levine, BROWN SATCHEL (1976), ceramic, 6″ x 9″ x 13½″. Collection: Alan Stillman, N.Y. Photo courtesy Fuller Gross Gallery, San Francisco.

Their worn surfaces make us think about the lives of the owners; the leather tends to take on the shape of its wearer. She enjoys certain contradictions and ironies:

> What's important to me is the dichotomy between hard and soft, the awareness that, although they seem to be made out of something pliable, these works are frozen forever. The actual permanence isn't important: it's the *awareness* of permanence.... It's the traces that are important in my work ... the unconscious leftovers, the scuffs and scrapes and grime on a pair of boots.... Of course everything that would be an unconscious mark on a real boot I've made consciously. My sculptures are also useful things made useless. I enjoy those polarities.[70]

Levine's sculpture was in the Sharp Focus show at New York's Sidney Janis Gallery. In 1981 she had a ten-year retrospective at Boston's Institute of Contemporary Art.

Nancy Grossman (1940–) creates tormented leather-bound heads that seem like imprisoned souls or metaphors for aggression, brutality, and pain. She revealed in a remarkably honest interview how these forms came out of her subconscious in the 1970s and frightened her with their sadomasochistic overtones.[71]

The sculptor, born in New York City, was a rebellious stormy child. She feared rejection by her father and felt the hostility of adults around her. She finally escaped into the world of art at Pratt Institute (B.A., 1962) and then won recognition for her disturbing, visceral drawings portraying

the failure of communication between men and women, shown at the Oscar Krasner Gallery, New York. Grossman won a 1966 Guggenheim fellowship and began to construct abstract assemblages of found objects—rusty cans, tubes, laces, leather—that have a ruptured, violated quality (*Bride*, 1966; *Slave*, 1967).

In the early 1970s some compulsion caused her to draw belted, closed-up heads, and then construct and carve them in wood. She had used leather frequently in her earlier collages, so it seemed natural to cover the tormented heads with this material—a kind of second skin.

In *Horn* (1974), the bound head sprouts a phallic-looking horn—a threatening aggressive image. In *Kazakh* (1971) a closed zipper covers the mouth, suggesting that the person's feelings are suppressed, but boiling. *Figure Sculpture* (1971), a powerful three-quarter figure, strapped, zippered, and laced in leather, with arms crossed above the head in a defensive gesture, is reminiscent of Michelangelo's *Bound Slave*. A drawing from this period shows a bound, sightless head with a gun protruding where the nose and mouth should be. Glass eyes stare out and gnashing teeth emerge in certain works. These expressive heads, which won a 1974 National Institute of Arts and Letters Award, arouse irrational feelings, reminding viewers of their own repressed rage and fear of bondage. They seem like totems of our time.

The spirits who inhabit Grossman's works have grown more serene in recent years. *Eldridge Ram* incorporates an actual pair of ram's horns that the artist was amazed to find on Eldridge St. in New York City not far from her studio. These forms stirred images in her mind of ancient rituals in which animals were sacrificed to bring blessings from the spirit world. The sculpture, with its flowing lines, seems like a metaphor for harmony between humans and the world of nature.

Nancy Grossman, ELDRIDGE RAM (1985), carved wood, ram's horns, leather, and nickel hardware, height 32″. Collection: William Nachman. Photo: Geoffrey Clements, courtesy of the artist.

Grossman's works are in the Whitney Museum, University Art Museum, Berkeley, and many other collections.

Isabel McIlvain (1943–) creates meticulously accurate nudes, yet they have a feeling of classicism or idealism, even when they include some object from mundane reality, such as a diving board.

McIlvain earned a B.A. in art at Smith College and an M.F.A. in sculpture at Pratt Institute (1972). She studied with Leonard Baskin, José de Creeft, and Robert Beverly Hale, the renowned teacher of anatomy, and is a sculpture professor at Boston University.

The artist aims for some ineffable quality that will "expand from its location to a much bigger sense of the beauty of all life."[72] In this she is different from her contemporaries, many of whom are involved with the literalness, irony, or alienation of modern life. Her small (sometimes only fifteen inches), serene-looking nudes in ghostly white hydrocal or bronze are refined and adjusted from direct observation and photographs (*Jet*, 1979).

McIlvain was in the 1981 exhibition Contemporary American Realism Since 1960 at the Pennsylvania Academy and had several shows at New York's George Schoelkopf Gallery. She won the competition for a portrait of John F. Kennedy for the statehouse in Boston.

Penelope Jencks (1936–), born in Baltimore, creates groups of life-sized bronze and terracotta figures that, like Etruscan and other ancient art, combines lively particularization and monumentality. Blair Birmelin compared them to the terra cotta army of the Emperor Chin.

Jencks was influenced by artist Edwin Dickinson, whom she knew from childhood, and by Hans Hofmann, who taught her "that art was the most important thing in the world." She had earned a B.F.A. in painting from Boston University when a sculpture class with Harold Tovish led her into sculpture. "He taught me to respect the integrity of that particular skull beneath that particular head and to avoid making any 'improvements.'"[73]

Interested in capturing the unconscious moment, she made sculptures of sleeping women and un-self-conscious children and then began to record the "awkwardness ... the uncomfortable look" that naturally comes over a model because she is being watched. Because it was more direct and less expensive than casting, Jencks developed a method of modeling life-sized hollowed-out clay figures, underglazed in colored slips. Jencks has the model sit or stand in an ordinary, ungraceful, flat-footed way, resulting in highly individualized, yet broadly simplified figures. In one exhibition, beach figures were posed on a sand-covered platform, creating the sense of a moment at the beach, frozen in time.

Jencks has created bronze monuments that have an unusual informality about them. Historian *Samuel Eliot Morison* sits perched in cap and boating clothes on a granite rock (1982, Commonwealth Avenue, commissioned by the city of Boston). Her *Family* group walking in Festival Park on the Toledo, Ohio, riverfront, is broken up, with the father and child on the piazza, and the mother lagging behind on a distant step. We come upon them like friends whom we have casually encountered on a family outing. At the same time, these democratized images evoke a broader sense of "family" or "great historian." Other commissions are at the Federal Courthouse, Danbury Connecticut, and in Chelsea Square, Chelsea, and Bunker Hill Pavilion, Charlestown, both in Massachusetts.

Isabel McIlvain, JET (1979), hydrocal, height 13″. Courtesy Robert Schoelkopf Gallery, N.Y. Photo: eeva-inkeri.

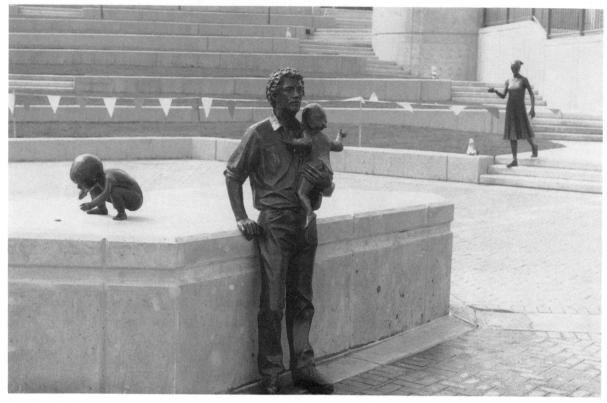

Penelope Jencks, detail of FAMILY (1984), bronze, lifesize. Festival Park. Collection of the City of Toledo, Ohio. Photo: Penelope Jencks.

Mary Frank (1933–) loves to tear and rip clay and dig her fingers into the soft material.[74] Her sculptures often look like fragments dug up at an archaeological site. Winged nymphs, intertwined lovers, and running horses are collages of clay pieces impetuously arranged in metamorphosing combinations. A figure turns into an animal, a house, or a tree, evoking memories of the Greek, Egyptian, or Babylonian mythic past. This combination of "filmic instantaneousness" and a sense of "timelessness" was noted in 1973 by the critic April Kingsley.[75]

Born in Switzerland, daughter of the American painter Eleonore Lockspeiser and British music critic Edward Lockspeiser, Mary emigrated with her mother from war-torn London to New York City in 1940. Always drawing, she loved to look at Persian and Indian miniatures in her mother's copies of *Verve,* the arts magazine.

Mary studied dance for four years with Martha

Graham, a "ferocious . . . overwhelming . . . presence."[76] The artist's passion for capturing figures in movement can be traced to her years with the great dancer.

At seventeen, a week after graduating from the Children's Professional School, she married photographer Robert Frank. In the following chaotic years she had two children, drove across America with him while he photo-documented the United States, and then traveled through many other countries. She remembers long waits with small children in hotels, relieved by occasional trips to the Louvre where she sat for hours, profoundly moved by Egyptian and Oriental art. She studied drawing briefly with Max Beckmann and Hans Hofmann in New York.

After finally settling in lower Manhattan, Frank carved monolithic wood forms, vaguely reminiscent of those of Raoul Hague (*Rainbow Figure*, walnut, 1965). Because she sought more movement and fluidity, she tried small plaster and wax environments of bathers and waves, inspired by summers at Cape Cod (*Daphne*, bronze, 1964; *Tidal Vision*, plaster, 1967).

Around 1966 Frank was influenced by a Museum of Modern Art exhibition of Reuben Nakian's plaster and ceramic mythic nudes, modeled spontaneously or scratched into clay with a pointed instrument. Experimenting, she gradually realized that she could work with great freedom and flexibility if she rolled out the clay into thin slabs and then bent and molded it into hollow forms. In 1970, critic Hilton Kramer described her stoneware sculptures at the Zabriskie Gallery, New York, as "marvels of poetic invention . . . the very process of the ceramic me-

Mary Frank, SWIMMER (1978), ceramic, 17″ x 94″ x 32″. Collection of Whitney Museum of American Art. Purchase, with funds from Mrs. Robert M. Benjamin, Mrs. Oscar Kolin, and Mrs. Nicholas Millhouse. Acq. #79.31. Photo: Jerry L. Thompson.

dium seems to have released the requisite spontaneity."[77]

Today Frank rolls out clay with a rolling pin and swiftly tears or cuts out shapes, incises them with lines or imprints them with leaves and ferns, bends and drapes them like fabric or leans them against one another, freely intermixing hollow forms, such as masks, with flat planes and solid figures. Hers is an art of rapid improvisation.

Frank's clay collages use

> scale disruptions, fragmentation, planar ambiguity, multifaceted meaning, contradictions of every sort.... [In her work they] seem so normal one hardly notices what is happening.... She catches our attention with a beautiful face which metamorphoses into the head of a ram as we move around it, only to disappear into the side of a mountain ...[78]

Frank's sculptures suggest the possibility of infinite extension and are always moving and becoming, as in *Swimmer* (1978, Whitney Museum of American Art), which art historian Roberta Tarbell has described as "a dynamic assemblage of vital fragments."[79] Her sculpture also expresses female erotic energy. Ecstatic figures sprout wings, embrace the earth, or swim through fish-filled seas—a pantheistic vision of woman at one with nature. Of *Persephone* (1985), a five-piece figure lying back on the ground, eyes closed, one arm flung out, the artist wrote: "She arches and turns and reaches back thru water and forth thru season. She survived many changes.... At first she is earth and water bound. Later she tumbles thru air. I'm not sure that she is mythological but I do know that at best working is."[80]

Viola Frey (1933–) a Bay Area ceramist, sometimes associated with the funk art movement, uses clay to make giant figure sculptures. They are icons of middle-class America. The nine-foot men, towering over the viewer, wear their blue suits and ties like armor, asserting their power, but their tense gestures hint at strain and uneasiness (*He-Man,* 1983; *Angry Man,* 1985). The women, in their patterned dresses and shoes, hold their hands in self-protective gestures. Massive but ordinary, the figures induce the onlooker to ask, "Is this what I turn into when I wear a suit?"[81]

There is something unsettling about such huge figures in clay. They have to be made in sections in order to fit into the kiln, and then fitted together. They are heavy and massive, but one is aware that they can shatter.

The funky figures suggest cheap bric-a-brac enlarged to a monstrous scale. Indeed, Frey is a collector of cast-off china and plastic kitsch. Such sources for her art go back to to her childhood on a grape farm in Lodi, California, when she and her brothers dug in trash dumps, looking for discarded "Made in Japan" items. They played with the colored glazed fragments that seemed precious amidst the drabness of farm life. There were no museums in Lodi—this was her first experience with "art"—and such images continue to evoke emotional associations.

Frey studied painting with Richard Diebenkorn and ceramics at Oakland's California College of Arts and Crafts. At that time she was influenced by the Japanese tradition in ceramics that swept through the Bay Area in the 1950s. Frey earned an M.F.A. in ceramics with Catherine Choy at Tulane University, and returned to San Francisco because the Bay Area revival of brushy figurative art by Richard Diebenkorn, David Park, and Joan Brown struck a sympathetic chord.

In 1960 Frey began to teach at the California College of Arts and Crafts. A 1964 Robert Arneson exhibition of such mundane objects as ce-

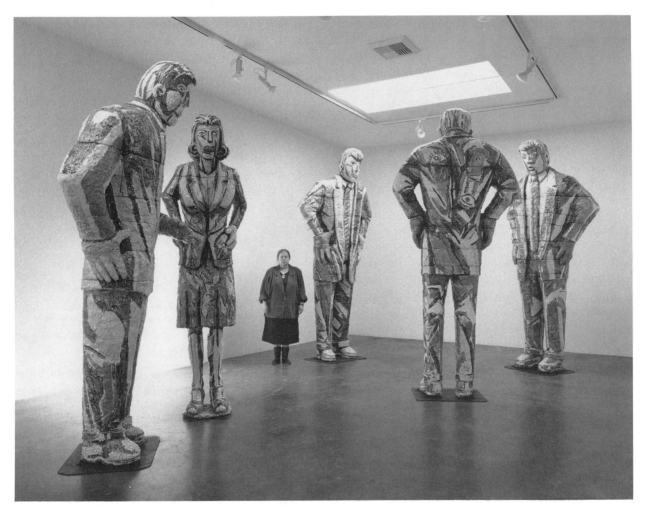

Viola Frey with installation, 15 March–12 April 1986, at the Asher/Faure Gallery, Los Angeles, ceramic. Photo: Susan Einstein, courtesy Asher/Faure Gallery, Los Angeles.

ramic toilets and trophies encouraged her to use everyday objects in her art. She haunted the Alameda flea market and other swap meets, becoming a collector of cheap china—figurines, dogs, cars—which she called "cultural artifacts" because she felt that they embodied social values. Soon she was incorporating them into her art, making plaster molds, then slip casting and joining them together in dense assemblages, and slathering them with colored overglazes and china paints. Frey put these nightmarish "still lifes" on ceramic tables and pedestals where they took on a classical air. (*Junkman, Bricoleur,* 1977, San Francisco Museum of Modern Art).

After moving to a large house and garden in Oakland, Frey was able for the first time to work on a very large scale, and she created towering figures. At first she made pairs of tough grandmothers wearing patterned dresses and flowered hats, with hands raised in fighting gesture, (she called them "battle-scarred powermongers"), and then pent-up "Type A" men in two-button suits and ties. Whereas the women had prominent mouths, she minimized the mouths on the men because they were culturally trained to focus on action and repress feelings. Tall figures, with white, blue, green, and mango-colored glazes flowing over their pitted surfaces, stood around her garden, ceramic animals cowered under the leaves, and freely painted plates hung on the fence.

Frey showed at the Wenger, Hank Baum, and Quay (1980, 1983) galleries in San Francisco. A traveling retrospective originated at the Crocker Art Museum in Sacramento (1981), and in 1982 her figures were shown at California State University, Fullerton, art gallery. Frey received national recognition in a 1984 solo show at the Whitney Museum, New York. Curator Patterson

Sims called her "a visual anthropologist of contemporary American culture ... a brilliant decoder of the ceremonies of self presentation and deportment, the ironies of dress and body language.... Frey's huge figures and assemblages reveal the average, kitsch and the stereotype as mirrors of American cultural values."[82] He pointed out that Frey is a close reader of Levi-Strauss and George Kubler, very much aware of the significance of signs and symbols in objects and clothing. Frey's figures assert themselves with a kind of brassy aggressiveness:

> That aggression is important to me. In some ways I am trying to achieve the opposite of Giacometti. His figures, with their use of linear elements attached to a generalized mass, give the feeling of receding from the viewer. No matter how close you get, the figure keeps retreating. The opposite is true in my figures. They intrude; they enter our personal space even from the other side of the room. I do this partly by distorting the proportions of the figure, by enlarging the head and hands.... I often.... [paint] in a section of strong color where one would not ordinarily expect it so that it jumps out and advances the figure.[83]

The artist wants us to think hard about ourselves when we look at her work. She says of her representations of ordinary people: "It is not going to be the President, but the average worker who is going to push the button."[84]

Patti Warashina (1940–) of Seattle, Washington, has also transformed ceramics into a medium for expressive figurative sculpture—in her case, surrealist fantasies of figures and objects engaged in improbable antics. She has said: "As a child I collected dolls, dreams, fantasies. As an 'adult' I still collect dolls, dreams, fantasies....

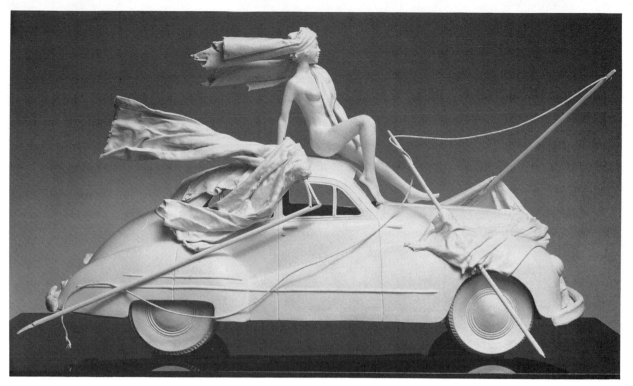

Patti Warashina, CLOTHESLINE ROBBERY (1979), low fire clay and mixed media, height 24″ x 36½″ x 17½″. Private collection. Photo: Roger Schreiber, courtesy of the artist.

my work involves translating these collective observations from my psyche into a tangible form, which I may or may not comprehend."[85]

Despite this denial of conscious intent, there are readable themes in her works. In the 1970s they often satirized male chauvinism, symbolized by objects in the mass culture (such as automobiles). Later she presented images of women breaking out of bondage.

Born in Spokane, Warashina earned an M.F.A. (1964) in ceramics at the University of Washington, where she now teaches. She studied with Robert Perry, Rudy Autio, and Shoji Hamada, and made Japanese-influenced functional wares. In the mid-sixties, she painted crowded, disoriented images in brilliant psychedelic colors on stacked pyramids—dogs, hands, fingers, bird

wings, soft ice cream. These works seem related to the turmoil of that decade.

In the 1970s Warashina mounted an assault on symbols of male supremacy. For example, a female figure lies buried in an open convertible (*Trojan Car,* 1977). Up to this point she had been underpainting and glazing her works in rich colors. Switching to ghostly white forms, she modeled women trapped in or breaking out of confined domestic roles—a figure hobbling along on crutches shaped like a knife and fork or plugged into a giant steam iron. Toward the end of the decade, a woman sits exultantly atop the hood of a car, grabbing octopus tentacles that squiggle out the windows—she is in control. In *Metamorphosis of an Angel,* seven female figures progress from mummy-bound forms to a

winged victory. This was the theme of a solo exhibition at the Tucson Museum of Art (*Freeing the Bird,* 1979; *Test Flight,* 1982;).

In 1986 the Seattle Arts Commission selected Warashina to carry out an eight-by-ten-foot porcelain sculpture for the foyer of the Seattle Opera House. Entitled *A Procession,* it includes seventy-two well-known contemporary Northwest visual artists parading across a bridge, while some swim in the water below. Constructed of hundreds of individually fired components, the figures run, jump, gesticulate, brandish their work, and ride in groups in cars.

Warashina says clay can "do anything, be anything." This urge to push the medium to virtuoso limits has resulted in unconventional, sometimes extremely fragile forms—flying draperies, thin sheets, pointed flames of clay. Individual forms are modeled, slip-cast in molds, and then finished, glazed, and joined in elaborate compositions.

Other members of the West Coast surrealist or funk ceramic movement are **Elaine Carhartt, Karen Lee Breschi**, who metamorphoses people into beasts and birds, and **Nancy Carman, Margaret Ford, Joyce Moty, Joanne Hayakawa**, and **Jacqueline Ione Rice**, all graduates of Seattle's University of Washington.

A ceramic sculptor of a different kind is Jerusalem-born **Bruria** who studied ceramics at Alfred University and now lives in Los Angeles. Influenced by the symbolism of the kabala, she created porcelain heads and figures that are also "inner landscapes." In *Peeling* (1977), layers seem to be peeling back from the face to the inner core of the self.

The semiabstract figure sculptures of **Camille Billops (1933–)** are sometimes inspired by Egyptian, Ethiopian, and other cultures. *The Mother* (1971) shows a seated woman with glaze-painted womb. She is shaped like a throne, suggesting a welcoming, all-giving source of life, her helmet-like head implying strength and power. This work was part of a trilogy in which Billops sought her own image of God and the mother of God—not necessarily the all-white image projected by society (*The Black Suffering Jesus Shows Us His Bleeding Heart*).

Recently the artist has turned to her own life experiences and family memories in a series of four-foot figurative images. *George and Phine* (1987), for example, inspired by an aunt and uncle who are thinking ambivalent thoughts about each other, is based on real people, but its wry humor seems to make a more general comment on the love-hate relationships that often exist between men and women. There is a kind of art deco jazz beat in the bold abstract design of these works, glaze painted in patterns of black, brown, blue, and mustard. An imaginative counterpoint is developed between the flat painted drawing and the three dimensional forms. Billops is equally well known as an artist and as cofounder of the renowned Hatch-Billops archive of African American art in New York City.

Some other excellent figure sculptors include **Arlene Love** and **Carole Feuerman**, who use cast resin. **Joan Danziger**'s metamorphic animal-humans express hidden aspects of the human personality; **Barbara Spring**'s lifesize wood carvings of people in interiors capture the absurd feel of everyday suburbia; **Stephanie Cooper**'s small-scale woodcarved spirits act out fairy tales that combine the magical and the everyday; **Patricia Renick**'s fiberglass figures merged with boat forms express the voyage of the spirit through life and death; **Genna Watson**'s decaying figures confront us with mortality; **Laurie Pincus**'s cutout figures capture the spirit of private dramas set amidst swimming pools and palm trees in Los Angeles.

Deborah Butterfield (1949–)

*I have this peculiar tunnel vision that allows me to
see horses everywhere. It's not very intellectual, it's
just that I see them there.*
—Deborah Butterfield[86]

Deborah Butterfield, who sculpts life-sized
horses in found materials—barbed wire, sticks,
crushed metal—promised herself in high school
that she'd never draw a horse again. She loved
riding and training horses, but she was embar-
rassed by them—her friends, she feared, would
see them as "stereotypical girl art." So she
fought against the subject that pressed itself
upon her. Today, critics find in them poetic met-
aphors for states of being.

She was born in San Diego, as she herself
notes, on 7 May 1949, the day of the seventy-fifth
running of the Kentucky Derby. As a child, her
favorite sports were horse training and dres-
sage, and approaching college, she seriously
considered a career in veterinary medicine, but
decided to major in art.

At San Diego State University and University
of California, San Diego and Davis, she studied
pottery. As she approached the end of her under-
graduate years she felt "I was not being fulfilled
by pots. . . ." It was not until the last two quarters
of graduate school at U.C., Davis, that Butter-
field found her way back to horses and sculp-
ture. She rented a farmhouse near the campus.
Part of the rent was to be in the form of a chore—
feeding twenty thoroughbred horses. So there
they were.

Butterfield started by making life-sized plas-
ter horses. Deeply concerned about the Vietnam
War, she rejected the traditional warlike stal-
lions of art history, choosing instead to portray
peaceful pregnant mares. "In my own quiet way
I was making art that was against war . . . about
procreation and nurturing rather than destruc-

tion."[87] The work began with a steel armature
and then was covered with a skin made of
chicken wire supporting burlap soaked in wet
plaster. The pieces were too heavy to move, and
she noticed that they looked better without the
plaster, but she was afraid to abandon traditional
methods.

The next year, 1976, while teaching in Madi-
son, Wisconsin, Butterfield was hectoring her
students to be gutsy and do the daring thing,
when she realized she herself was doing neither.
In a mood of disgust she told her sculptor hus-
band that she'd like to throw "shit all over the
horses,"[88] then realized that what she actually
wanted to do was smear mud on the armatures,
allowing the process, the act of working, to show
through in the final form. The artist had just ac-
quired a New Guinea grave sculpture made of
unfired clay that had stirred her deeply, and this
was probably the immediate trigger for the en-
suing breakthrough—her first mud and straw
horses.

It was not until the move to Bozeman, Mon-
tana, where the couple shared an academic ap-
pointment, that Butterfield, thinking no one
would be watching, felt free to do what she
wanted to do. The spring floods had left clotted
piles of mud and sticks in the river that reminded
her of reclining horses (her equivalent of reclin-
ing nudes); they also seemed like metaphors for
the psyche, surviving after a flood of experi-
ences. From then on, nothing could stop her. In
a series of mud horses on steel armatures, some
are pierced with spearlike branches, some seem
to be hiding in thickets or are stuck all over with
twigs like ancient fetishes. To make a memorial
to her dead father, she had to ski to the woods in
the Montana winter in order to cut tree branches
and hack frozen mud with a pick axe. From
wood and mud she went to metals—barbed wire
and other found materials.

Deborah Butterfield, HORSE (1985), steel, wire, and metal, 82½′ x 40′ x 117′. Hirshhorn Museum and Sculpture Garden, Smithsonian Institution. Museum purchase, 1985.

Between 1978 and 1984, Butterfield had twenty-two solo exhibitions in the United States, Europe, and the Middle East. She has an unusual power to convert industrial cast-off materials into deeply felt emotional experiences. Her *Jerusalem Horse* (1980), made in Israel of metal panels from wrecked war materials, lies on the ground, evoking thoughts of carnage and the Holocaust. Yet, while her works convey intense moods and capture with uncanny accuracy the gesture and movement of the animal, the forms also function as abstractions; the wrinkled or shiny materials, smeared with tar or splashed with color, twist around a skeletal core and inner hollows in powerful compositions.

Butterfield has at times thought of her horses as autobiography; as metaphors for herself.[89] As she herself has pointed out, images of the horse have in the past almost always been warlike and masculine. She brings to the ancient equestrian theme a new sensibility.

Anne Arnold (1925–) has been working for decades on "specific portraits of a dog, a skunk, a cat, a cow. She depicts every creature as different from even others of the same species—just as Charles Darwin found, upon examining finches, that every finch knows the differences among other finches and can identify them by looking at their 'faces.' Anyone who has lived with three or four animals of the same breed knows that each has a different 'personality.'"[90]

So sharply does Arnold perceive the uniqueness in, for example, the panting head of a bulldog (*Drummond,* stoneware, 1978) that a kind of wit results. At the same time her animals, formed with a strong sense of abstract design, are reduced to essential planes and rhythms.

Born in the seaside town of Melrose, Massachusetts, she has said that she "was fortunate, as a child, to be able to spend long summers in the woods, and on the sea—to have had time to watch plants grow and birds build nests and to have known and loved many animals. I learned much from those animals and grew to respect the specialized abilities of each and to understand the meaning of the web of life long before I had heard the word ecology."[91]

At Ohio State University she wrote her M.F.A. thesis on the animal sculpture of the Indian mound builders. Coming to New York in 1949, she studied sculpture with John Hovannes and William Zorach at the Art Students League, while supporting herself for six years as a frame maker. She became thoroughly familiar with woodworking and joinery.

Arnold carved rough-hewn life-sized animals out of hunks of wood found around the city. These heavy works were hard to store and transport, however, so she stretched canvas over cagelike armatures cut out of plywood, and later stretched nylon fabric, strengthened with painted polyester and epoxy resins. These works have a skinlike surface. In the four-foot head of a *Hippo* (1971), the pinkish-gray fleshy skin contrasts with the red interior of the open mouth and the tusklike ivory teeth. The bulging forms make a harmonious composition of curves.

When Arnold became ill from toxic resins, she began to work in clay. She developed methods for firing large hollow pieces by throwing sections on the wheel and then attaching textured slabs of clay to them, or firing sections and joining them. A teacher at Brooklyn College, Arnold won an Ingram Merrill grant in 1983. She says: "Animal forms ... always exhibit the exquisite logic of nature's engineering. I also felt deeply about the plight of the animal, bravely attempting to pursue its accustomed patterns in a world overpopulated and over-mechanized by man—and losing the battle."[92]

Anne Arnold, HIPPO HEAD (1971), canvas, height 46".
Courtesy Fischbach Gallery.

Whereas Anne Arnold creates individualized animal portraits, **Gwynne Murrill (1942–)** carves elegant wolves, dogs, cats, that are more generalized paradigms reduced to their essence. She may, for example, convey the idea of power, majesty, and readiness for action in the image of a wolf set atop a high totemic pole (*Wolf II*, 1976, teak).

Murrill began to carve animals while earning an M.F.A. at the University of California, Los Angeles. Noticing the beautiful joinery of pieces of wood in the floor of the U.C.L.A. art gallery, she was inspired to carve joined and laminated pieces of wood. She became highly skilled at cutting, shaping, gluing, and working with electrical grinders and sanders. Since childhood she had loved to draw animals, but it took courage to use them as her subjects at a time when the art faculty was promoting minimalism.

Murrill's skill brought her a 1978 New Talent Award from the Los Angeles County Museum and a 1979–80 Prix de Rome fellowship that permitted her to expand into bronze and sleek white marble. A 1986 Guggenheim fellowship followed.

Murrill brings a strong aesthetic content to her forms. She may emphasize the elegance of an animal's body by relating its curves to the curves in the wood's grain. In *Double Bronze Cats* (1982), the felines confront each other with instinctive aggressive gestures, but at the same time exhibit geometric forms that relate to the open spaces between their bodies and feet. The sculptor often sets up entire environments of animals that imply some metaphoric theme.

Donna Dennis (1942–) creates three-dimensional architectural constructions of old hotels, subway stations, and rooming houses. Reminiscent of Edward Hopper's imagery, they also resonate with a quality of intensely personal fan-

tasy. Most of them are about five feet, eight inches high—Dennis's own height—and she calls them "self-portraits" or "dream spaces." Although they give the illusion of verisimilitude, they do not actually duplicate existing structures; rather, they imaginatively recombine architectural elements and details to create forms charged with associations and emotions.

Born in Springfield, Ohio, Dennis attended Carleton College, Minnesota, and the Art Students League (1965–66). In the early 1970s her involvement with the feminist movement gave her the courage to break with conceptual and minimal art and to deal with personal experience. Her interest in "humble" subjects, such as broken-down tourist cabins or common weathered buildings covered with traces of past lives, parallels the new focus on the "humble" lives of women, previously overlooked and minimized. The message is "Look again, for there is far more to be seen than ever imagined before."

An experience that inspired her to work with architectural forms was a visit to the Metropolitan Museum of Art's reconstruction of an Egyptian mastaba tomb, whose narrow passageways lead to an inner chamber with a false door, where offerings were left for the deceased—a place that served as an interface between the real and metaphysical worlds. Dennis's "hotels" and "tourist cabins," with their alluring doors that cannot be entered, are also shrines—symbols of transience and journeying, metaphors for psychological transition and growth.

In 1973 Dennis exhibited false fronts of tacky resort hotels, complete with palm trees (*Hotel Pacifica, Egyptian Hotel*). They were like stage sets propped up in the back with scaffolding and sandbags. In a subsequent series of tourist cabins, the works became fully three dimensional. The viewer looks through screened porches and doorways to dimly lit interiors, which at first seem accessible but prove to be impenetrable. Some of the emotional resonance of these works comes from Dennis's childhood memories of cross-country travels with her family. They would be looking for a place to stop as it grew dark, and she remembers the combination of anxiety and adventure as they sought shelter.

As she became sensitive to architectural details around her studio in downtown New York City, several works were triggered by subway station entrances, which she rearranged as shrinelike gated temples (*Subway Station with Yellow and Blue*, 1947–48). *Tunnel Tower* (1979–80) was inspired by the entrance to the Holland Tunnel and White Tower hamburger stands. It has a turreted entrance, topped with a fragile scaffolding holding a partially lit neon sign saying TUNNEL. Excerpts from the artist's journal hint at her emotional investment in the work: "The word TUNNEL implies the surfacing of a whole huge underground network . . . the revealing of something powerful and submerged. . . . I want to make people feel the spaces they cannot see . . . and desire to enter them, and that represents for me, I realize, a desire to feel the presence of the spirit world, to feel its power."[93]

Two Stories with Porch (for Roger Cobuzio), (1977–79), inspired by a photograph of an ordinary clapboard New Jersey tourist house, took on new meaning when a close friend died while she was working on it. The building became a memorial, a metaphor for keeping the memory of her friend alive, represented by a light in the upstairs bedroom. The need to go on with her life is symbolized by a VACANCY sign in the darkened lower window—an invitation for new "guests" to enter her life.

One of Dennis's largest works, the twenty-five-foot *Deep Station* (1981–85), made viewers feel that the city subway had come right up into

Donna Dennis, DEEP STATION (1981–85), mixed media, 135″ x 240″ x 288″. Photo © 1987 Peter Mauss/Esto, courtesy of the artist.

the Brooklyn Museum lobby when it was exhibited there in 1987. It is a cutaway view of tracks curving back under dimly lit Piranesi-like arches. Dennis's works often refer to mysterious lower depths. They symbolize for her the vast, untapped power of women, and the tracks symbolize their dynamic journey into the future.

Dennis works at least a year on each construction duplicating peeling paint, faded draperies, broken neon signs, all the scars that show the past traces of life. A Guggenheim fellow, she was in the 1984 Venice Biennale, and has had solo shows at the Brooklyn Museum, State University of New York at Purchase, and elsewhere.

• 11 •

The 1980s and Beyond

The feminist ferment and euphoria of the 1970s were followed in the early 1980s by a sobering letdown. A tidal wave of neoexpressionist male painting swamped the art world and the myth of the heroic macho painter was revived.

Not that women sculptors hadn't made any headway at all. Jackie Winsor had a solo show at the Museum of Modern Art, and Louise Bourgeois, already in her seventies, received a long-overdue retrospective there. Nancy Graves became a leader in the movement to use colored bronze in free, expressive ways. A number of sculptors who had emerged in the favorable climate created by the women's movement became leading figures of the 1980s, and some who had started their careers in the alternative women's cooperatives were now showing in mainstream galleries.

But the fact that the situation, on the whole, was reverting to prefeminist levels was revealed when the Museum of Modern Art's blockbuster International Survey of Recent Painting and Sculpture opened in 1984 with 151 men and 14 women. As we approach the year 2000, it is obvious that patriarchal attitudes are deeply entrenched and eternal vigilance is required to maintain gains and move forward.

The Guerrilla Girls Women artists had fought too hard in the 1970s to let their gains slip away without a struggle. In 1985, in response to the chauvinistic imbalance of the Museum of Modern Art's international survey, a "hit-and-run" group called the Guerrilla Girls was organized in New York to become the "conscience of the art world." Using humor and show-business tactics, and hiding behind gorilla masks to remain anonymous, they papered Soho walls with charts and posters containing embarrassing statistics about the sexism of museums, critics, and galleries and revelations about self-serving art dealers who use their positions on museum boards to promote business. These tactics were so effective that other groups, such as the Mothers of Medusa in Los Angeles, sprang up around the country.

National Museum of Women in the Arts In 1987, under the leadership of prominent Washingtonian Wilhelmina Holladay, the first art museum devoted entirely to the work of women opened its doors in Washington, D.C. Amidst tremendous press coverage, praise, and vituperation, its opening exhibition "American Women Artists: 1830–1930," curated by art historian Eleanor Tufts, was revealed to the public.

A number of male critics and a few established women artists attacked the museum as unnecessary, claiming that any woman of talent had equal opportunity today and that the museum was merely "ghettoizing" women artists by putting them in a separate museum. Statistics disprove that thesis—for example, the new modern wing of the Metropolitan Museum of Art opened in the 1980s with 411 works by male artists and 28 by females (6.9 percent).

Some feminists, on the other hand, criticized

• 537 •

the museum for not going far enough. They wanted it to be a feminist center, where the strategies of chauvinistic art history could be exposed and the position of women artists, past and present, could be examined in the light of their historical situation.

The value of this museum will depend on how it develops—how much its leadership will permit a wide range of viewpoints in the exhibitions. Like the New Museum, the Studio Museum in Harlem, the Jewish Museum, and other specialized institutions, the National Museum of Women in the Arts can provide an alternative to mainstream stereotypes and combat the homogenization of our culture. For the first time in history, women have a permanent repository for their work and a center for exhibitions of women's art from all times and places.

POLITICAL ART

Political art, a dominant mode in the 1930s, died out when abstract art established hegemony after World War II. But in the 1970s, as antiwar, ecological, and feminist movements gathered momentum, artists once again began to work with social and political themes, often in unconventional alternative art forms such as performance and video art. By the 1980s, such overtly political work as Leon Golub's paintings depicting the sadistic torture of dissidents had received mainstream acceptance.

First-generation feminist art lost momentum during the early 1980s, however. Although certain European collectors saw feminist art as a historical movement and collected it, on the whole critics, dealers, and museums viewed the effort to explore female experience—pattern and decoration, vaginal imagery—as passé. But was the contribution of feminists really dead and gone? Critic Arlene Raven asserted that "forms

pioneered by feminists as early as the '60s are still alive and viable. Otherwise, why would artists not now associated with feminism explore decorative art, personal fantasy, biology (even male vaginal art!), environment, and ritual? A case can be made for attributing large segments of what has flowered in contemporary art to the forms and insights of the feminist art movement, *appropriated without acknowledgement*" (my italics).[1] The contribution of feminists has been coopted and at the same time denied by the male establishment.

Second-Wave Feminist Art A second generation of feminist artists arose in the 1980s. Rejecting the emphasis on female experience and female "form" which, they claim, merely reinforces the essentialist notion of woman as fundamentally and immutably different in nature from man, their position is that woman's "nature" is a myth constructed by society. Therefore they are deconstructing the ways in which the dominant male society uses language, media, imagery, to invent images of woman as "other" in order to maintain its ideological position. Some artists have appropriated patriarchal images and turned them upside down, using them as a form of self-exposure. For example, Cindy Sherman takes photographs of herself in a dozen different male-invented stereotyped roles. Barbara Kruger cuts up pictures from magazines and newspapers, and redesigns them, interrupting them with slogans that expose their nature or insist on change. Jenny Holzer commandeers the moving light signs on Broadway to flash her political messages to millions. Sherrie Levine ironically appropriates male "masterpieces" and parodies the idea of the heroic original male artist by copying and signing with her own name small reproductions of Matisse and others (thus implying that we experience art largely through reproductions today). She made a "found object"

out of Marcel Duchamp's work by lifting forms from his famous *Great Glass* and turning them into glass objects, displayed like elegant boutique commodities in museum vitrine display cases.

In contrast with the emotional and autobiographical character of earlier feminist art, these artists have adopted a cool, objective tone, a detached voice. Since most art reaches the public today through reproductions in magazines, books, and catalogs, they have downplayed the "touch of the hand" and are adopting the materials that are all-pervasive in their influence—photographs, printed language, posters, electronic signs, and other mass media.

This second generation has once again created a movement in which "women are leading, not following." These artists have been picked up by prestigious galleries, are featured in cover stories of art periodicals, and are selected for major international exhibitions. Of this group, the work of Holzer and Mary Kelly is included here because some of their imagery exists in three dimensions.

Jenny Holzer (1950–), a populist artist from Ohio who uses posters, electronic signs, television, and any other medium that will get her messages out to the largest possible audience, studied at Ohio State University and the Rhode Island School of Design. Then, feeling that painting was at a dead end, she tried unconventional art forms during a stint with the Whitney Museum's Independent Study Program in 1976–77. The challenging ideas presented there by visiting artists, the dense reading list, and the posters that she saw plastered all over Times Square stimulated her to "get up Jenny Holzer's *Reader's Digest* version of Western and Eastern thought. Once I had the 'Truisms,' which were my version of everything that could be right or wrong with the world expressed in the form of

people's pronouncements . . . I typed them up, offset the sheets and went around . . . wheat-pasting them . . . all over Manhattan."[2]

Holzer is a concerned person and a political artist who believes that "these are dangerous times and our survival is at stake. . . . I work on people's beliefs, people's attitudes, and sometimes I show concrete things that people might do. . . . I try to make work go to as many people as possible and to many different situations."[3]

Holzer has plastered statements on public phones, parking meters, T-shirts, and other places where people are surprised to come across them, and has even used her art on a truck in an election campaign. In 1982 she was delighted to secure the use of the computerized Spectacolor board on Times Square. Thousands of viewers were shocked to suddenly read such provocative statements as "Abuse of Power Comes as No Surprise" or "Private Property Created Crime" in a place where they usually saw ads. Since such signs are located at airports, banks, and in store windows, the potential is immense.

The artist has explored the aesthetics of this new art form, which can be slowed, stopped, moved up and down, incorporating colors, images, and a variety of typefaces. She says that she uses the kinetic medium "like music" to express the changing emphasis and meaning of her statements.

In contrast with these transient media, Holzer is engraving statements on ultrapermanent granite benches. The artist originally created them because she saw that people needed some place to sit down while they watched her moving light signs in art galleries. She soon realized that since people sit on a bench for a long time, they can read and absorb in a thoughtful way ideas engraved on them.

Holzer deals with militarism, power, poverty, freedom, and a wide range of political and phil-

osophical ideas, mostly in ambiguous, puzzling statements that make the viewer think and wonder. An example of a feminist message is the following evocative statement on the subject of rape, engraved on one of her benches:

Crack the pelvis so she lies right.
This is a mistake. When she dies
You cannot repeat the act. The
Bones will not grow together
Again and the personality will
not come back. She is going to sink
Deep into the moss to get white
and lighter. She is unresponsive
to begging and self-absorbed.

This is a deconstruction of the traditional representation of rape in art as a joyful, heroic image of power (as in Peter Paul Rubens's *Rape of the Daughters of Leucippus,* included in every art history survey text). Holzer injects the reality of the act, presented with distancing that causes the viewer to think about it. Holzer, who says she likes her work to be "useful," has also designed a series of sarcophagi engraved with her *Laments.* What could be more useful to a collector than an artwork in which to be buried!

Holzer gives due credit to the first generation of feminist artists as necessary and still viable. She admits that they paved the way and made it possible for younger artists like herself to move

Jenny Holzer, selection from THE SURVIVAL SERIES (1986). Times Square, New York, Spectacolor Board. Photo courtesy Barbara Gladstone Gallery, N.Y.

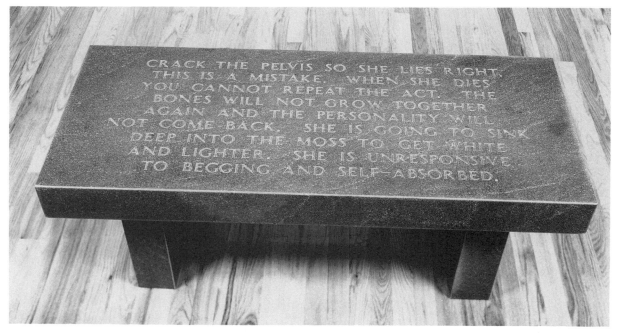

Jenny Holzer, "CRACK THE PELVIS . . . ," from UNDER A ROCK (1986), misty granite, 17¼″ x 48″ x 21″, ed. 3. Courtesy Barbara Gladstone Gallery. Photo: eeva-inkeri.

ahead, but she describes the difference between their work and her own:

> They would take things close at hand, like their bodies, or traditional women's work—repetition, domesticity, boredom—all the things that were women's lot. Now since the women's movement has been somewhat successful in the United States—there isn't always economic freedom but there is mental freedom—you have the permission and the confidence to go ahead and do what you want. World politics are a lot more interesting than patterns and repetition and boredom. . . . You also go to what's new. Realism or "real-world" concerns are newer to women than mysticism or poetics.[4]

Holzer has become a major international figure. When she was selected to represent the United States at the 1990 Venice Biennale—the first woman to receive this honor—the story made the first page of the *New York Times*.

Mary Kelly (1941–) An interesting aspect of feminism in recent years has been the international debate and exchange of ideas between American feminists and those in Britain and France. British feminist artists, critics, and art historians, such as Mary Kelly, Griselda Pollock, Rozsika Parker, Laura Mulvey, and Lisa Tickner—strongly influenced by revised Marxist, feminist, deconstructionist, and Lacanian psychoanalytic thought—are developing theoretical positions that

challenge the entire discipline of art history—the very way in which we look at art.

It is no longer sufficient, they say, to try to squeeze women artists into the established canons of male art, to simply add more women to the existing textbooks or museum walls. Those very canons have to be exposed for what they are—male constructs and instruments of power. Women's art of the past has to be examined anew in terms of women's historical position, and the art they create today should not only expose present-day realities but be an agent of change.

One of the most challenging artists to come out of the British school is Mary Kelly, an American who has spent much of her adult life studying, teaching, and working in England, and now works on both sides of the Atlantic.

Born in Minneapolis, she earned an M.A. at Pius XII Institute in Florence, Italy, and after moving to England, studied at St. Martin's School of Art in London (1968–70). In the early 1970s, Kelly's consciousness was raised in a study group in England that included such women as psychoanalyst Juliet Mitchell and filmmaker-critic Laura Mulvey. Kelly first collaborated on a multimedia exhibition, Women at Work, documenting the difference between the working conditions of women and men in a factory. A video and sound track accompanied the exhibition of photo images, objects, and text.

As a result of her investigations of language, Lacanian psychoanalysis, Marxism, and other disciplines, Kelly decided to use art to deconstruct and expose the ways in which society, through language and other means, creates female identity. Working directly from her own experience as a new mother, Kelly spent six years, between 1973 and 1979, charting in great detail the changes in herself and her young son from the time of his birth to the moment when, as an autonomous socialized "male," he entered

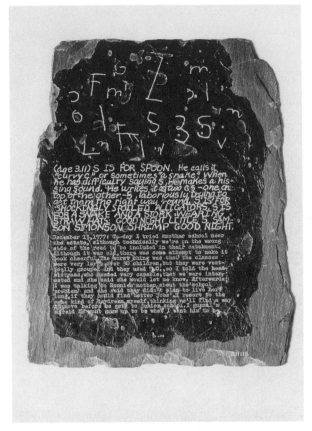

Mary Kelly, POSTPARTUM DOCUMENT, Pre-Writing Alphabet, Exerque and Diary, Document VI (1979), one of sixteen units, slate and resin, 35.6 x 27.9 cm. Collection of the Arts Council of Great Britain. Photo: Ray Barrie, courtesy of the artist.

school. Discarding conventional notions of what painting or sculpture ought to be, the artist incorporated a variety of media to create the *Post-Partum Document,* consisting of 135 units in six sections.

The work is in two parts: a series of framed collages (she calls them "fetishes") that include memorabilia from various stages, infant clothes, casts of the child's hands, diaper liners stained with feces (accompanied by tables analyzing the contents of the feces, documenting the gradual weaning and acceptance of solid food), and a series of slate "Rosetta stones" covered with the child's marks and letters, indicating his growing socialization through language. Below them are the mother's diary notations. The use of the ancient tablet format gives dignity and grandeur, albeit with some irony, to a fundamental human process which is overlooked and trivialized by a masculinized society.

The diaristic texts record the child's statements and actions and the mother's introspective thoughts at critical points in his development. Charted from day to day are the multitudinous ways in which the woman is socialized into the role of "mother," identifying bodily and psychically with the child at first, and then experiencing the loss brought on by his gradual separation into an independent male. Kelly deliberately omits her own image from the six-year project, because she believes that the representation of a woman's face or body in our society is inevitably false, a male construct. Rather, she helps us enter the mind of the woman protagonist by charting the ways in which various forces operate upon her.

As may be imagined, the *Post-Partum Document* was greeted with shouts of horror by mainstream British critics. It wasn't art at all, they said, but belonged in the lobby of a hospital obstetrical ward. There were endless jokes about

the presence of nappies in the art gallery. But in time sections were acquired by the Tate Gallery, London, the Australian National Gallery, Canberra, and other museums. The ultimate test of its validity is the way in which the *Post-Partum Document* gradually "gets under your skin," moving the viewer emotionally, despite the initial distancing effect of cool documentation. It is an in-depth excavation of the hidden world of woman's socialized experience and makes a telling contrast with Judy Chicago's collaborative *Birth Project,* which shows images of woman as creator-procreator.

The *Post-Partum Document* was rarely shown in its totality before being dispersed, but it has been made available to a wider audience through its transformation into a book in 1983.[5]

Kelly has embarked on another major opus, *Interim,* which charts the crisis of aging in women, combining a diaristic text derived from a hundred interviews with women and photographic images. Detail by detail, she builds up an overwhelming picture of the way in which women are programmed into a narcissistic preoccupation with their appearance and are made to suffer identity loss from the inevitable process of aging.

Once again it is interesting to compare the approach of two feminists to the same theme—aging. Suzanne Lacy organizes masses of older women in performance tableaux, calling on them to free themselves from the idea that they are ineffective by helping them to become active in society. Kelly deconstructs the ways in which society produces feelings of loss and ineffectiveness in older women.

The technique of using text and narrative, along with photographs, drawings, and real objects, in the gallery and then transmuting them into books, has been adopted by a number of socially oriented artists, as in the case of Helen and

Newton Harrison's *Lagoon Cycle* (discussed in the last chapter).

Other Political Artists Socially concerned artists are using a wide variety of expressions today. **Candace Hill-Montgomery** turned a Harlem street into a work of art by putting glittery mylar sheets over the gaping windows of tenements, thus dramatizing the decay of the area. **Christy Rupp** makes animal sculptures that are Aesop's fables for our time. **Martha Rosler**, a long-time activist artist, actually encouraged a group of the homeless to use the Dia Art Foundation gallery in New York as a headquarters where they could meet the public and organize support for their cause in a 1989 exhibition, "Homeless: The Street and Other Venues." On the walls were charts showing the widening gap between rich and poor, art works by the homeless, documentary photographs. This artist had the temerity to bring the destitute in direct physical contact with the middle-class art world. Lucy Lippard's running account of socially concerned art, *Get the Message: A Decade of Art for Social Change,* includes the work of many other women.[6]

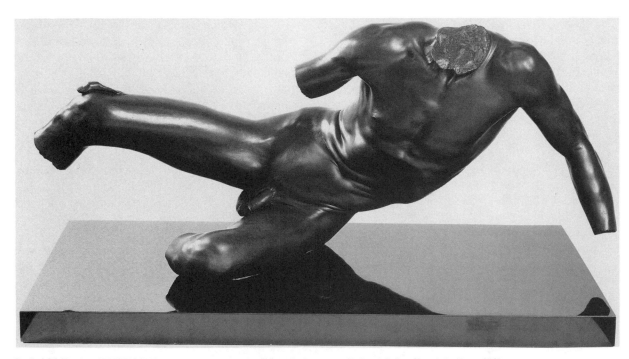

Isabel McIlvain, CEPHESSUS (1986), bronze, 12¼″ x 29″. Courtesy Robert Schoelkopf Gallery, N.Y.

POSTMODERN CLASSICISM
AND ECLECTICISM

Modernism had thrown out the art of the past, but as the modern movement seemed to exhaust itself in the 1970s, many artists began to look back nostalgically to early styles, such as classical and baroque. In the present age of agnosticism there is a great yearning for a time when art forms arose from commonly shared beliefs, and there is a desire to reestablish continuity with the past.

The whole idea of "originality" and "style"—of the artist as a heroic individual creator of new forms—was called into question. A painter like Pat Steir, for example, constructed a huge still life out of a grid of dozens of canvases, each painted in a different artist's style and each taken from a different historial era.

Postmodern architects in particular, reacting against the cold monotony and impersonality of the Bauhaus modern style that was turning every major city into a barren nightmare, began to "quote" from classical, Egyptian, medieval, and baroque motifs and reintroduced symbol, allegory, and metaphor in their work. These quotations, however, have a strangely poignant and mannerist quality because, despite the attempt to make them living expressions of the present, they seem to emphasize our longing for meaning in an age of disbelief.

The French couple Anne and Patrick Poirier are probably the most prominent examples, internationally, of sculptors who use the classical past and classical ruins as the basis for their art. In the United States several women sculptors are drawing on classical themes as the inspiration for new forms. Certain works by Isabel McIlvain, whom we have already discussed, can be viewed in that light.

Judith Shea (1948–) is not a neoclassicist, yet it is interesting to see how her work intersects with the revival of interest in classical forms. She uses clothing to form her sculpture. Cast in bronze, or modeled in felt and wax, the hollow shapes resonate with the human presence, becoming metaphors and at the same time remaining reductive abstract forms.

Born in Philadelphia and trained originally as a fashion designer at Parsons School of Design, Shea later returned for a degree in art (1975), but kept her obsessive interest in clothing. Although steel minimalism dominated sculpture, she says that the women's pattern and decoration movement of the 1970s gave her the courage to follow her natural bent of working with fabric.

Her first works were fabric garments hung flat against the wall to emphasize their archetypal abstract forms. Later, after teaching a course in medieval armor at the Metropolitan Museum, she began to cast volumetric metal works. In *Crusader*, segments of armor appear half sunk into the ground, as in the mire of the battlefield. In *He and She* (1984), a bronze oversized coat spread open on the ground, arm flung out in a confident gesture, encloses the tight-bound figure of a dress which "is unmistakably female, even stereotyped . . . like those little fetish figures. . . . The space represents two . . . opposites of form and personality."[7] She adds that she is concerned not only with gesture but also "with the use of open and closed space."

Indeed Shea—trained in the minimalist era—has always been as interested in abstract form as with figurative content and metaphor. She expressed this balance between classical figuration and modern abstraction in a series juxtaposing cast bronze clothing forms and pure geometric shapes—cubes, pyramids. In *The Bal-*

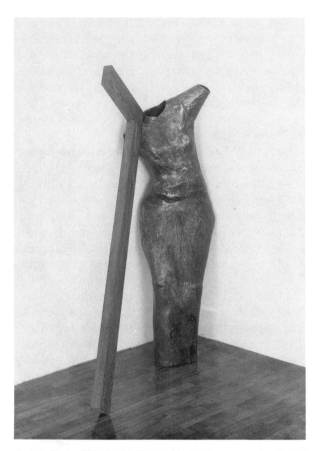

Judith Shea, CHE COSA DICE? (1986), bronze and oak, 62″ x 41″ x 48½″. Linda Hyman—Fine Arts. Photo: Zindman/ Fremont.

ance (1987), a bronze goddesslike figure seated on a plinth, reminiscent of one of the three fates on the Parthenon pediment, supports a wood cube on her lap. In *Che Cosa Dice?* a figure balances against a geometric support that resembles a crutch or a cross. These forms seem to express the eternal dichotomies of materialism versus idealism, Christianity versus paganism, the sensual versus the intellectual, etc.

Echoes of the Parthenon are not accidental: Shea was inspired by Greek architectural sculpture during a trip to that country and regards herself as an heir to that tradition, recast in modern form. Brancusi and Phidias merge in her work. A 1988 retrospective originated at the La Jolla Museum of Contemporary Art.

Muriel Castanis (1926–) creates ghostly "classical" figures by draping wet epoxy-soaked cloths on foam-and-metal mannikins and then waiting for them to harden into instant draped figures.

In the 1960s (inspired by Andy Warhol's Brillo boxes and pop art), Castanis began to drape resin-impregnated cloth on domestic objects such as bathtubs and chairs. In the 1970s, influenced by the feminist movement, she made hollow classicized figures to express the anonymity she felt as a woman. Gradually the figures became more celebratory—symbols of strength and dignity, of women moving ahead in the world. Castanis made use of the abstract rhythms created by the counterpoint between the hollow openings or voids and the closed forms of the garments. Since draping and tucking the wet folds into forms had to be done very quickly, before the glue set, an element of spontaneity and chance enlivened the work.

Architect Philip Johnson happened on a

Muriel Castanis, DAPHNE (1986), cloth and epoxy, 76″ x 41″ x 31″. Courtesy O. K. Harris Works of Art, N.Y. Photo: D. James Dee.

group of Castanis's sculptures displayed on the grounds of the Wave Hill Museum. Delighted, he phoned to offer her a commission for twelve sculptures to be located atop the new office building going up at 580 California Street in San Francisco. Johnson had already been exposed to the power and beauty of a woman's sculpture when Evelyn Beatrice Longman's gilded *Genius of Electricity* was placed in the lobby of the postmodern AT&T Building in New York City designed by Johnson and Burgee (see chapter 5).

Castanis's twelve-foot-high hooded figures with trailing sleeves make a rhythmical calligraphy against the dark mansard roof and are clearly visible from the ground, twenty-three stories below. The three figures, cast four times in fiberglass, crown each of twelve columns that soar from the ground all the way to the roof.

The sculpture group is very effective, a trailblazing return of figurative sculpture to an architectural ensemble. Such sculpture had disappeared from architecture during the modernist era after World War II. The ghostly figures, however, carry a meaning for some viewers that may have been unanticipated by the sculptor and architects. To Charles Jencks, one of the chief analysts of postmodern architecture, they seem to express the loss of belief in our time, "iconography without meaning or agnosticism in search of the nameless and formless hero.... 'the presence of the absence.'"[8]

To Jencks they seem like images of death, but there have been many other interpretations. Some even view the goddesses as emissaries of the future, bringing a humanizing message to a cold, technologized society. The building causes passersby to stop, wonder, and reflect on its meaning, while the rich variety of its forms provides a welcome relief from the hard, glassy adjacent towers.

Muriel Castanis, FIGURES (1985), top of 580 California Street, San Francisco, Johnson/Burgee, Architects.
Photo: William A. Porter.

Judith Brown (1931–) welds crushed automobile scrap metal into energetic moving torsos, horses, and flying draperies. Born in New York City, Brown learned to weld at Sarah Lawrence College (B.A., 1954), inspired by her teacher, Theodore Roszak, a pioneering abstract expressionist sculptor. A dancer as well as a sculptor, she was naturally drawn to images of the body in motion and its effect on the cloth surrounding it.

During trips to Greece and the British Museum (1980–81), she responded to the rhythm and motion, the hurtling energy, in groups of classical and Hellenistic figures. These experiences inspired such works as the three goddesses in *Aegean Trio* (private collection), *Caryatids* (1983–84, Pepsico Sculpture Garden, Purchase, New York), and *The Forum Trio* (1985, Virlane Foundation Collection, K & B Plaza, New Orleans).

Brown says that the texture of crushed automobile metal also expresses a kind of energy; she incorporates the wrinkles and creases into her compositions. In 1978 she won an award from the National Institute of Arts and Letters.

Sharron Quasius appropriates and deconstructs the compositions of classic paintings, such as Poussin's *Rape of the Sabine Women,* by translating them into very large, soft, stuffed canvas bas-reliefs. Bay Area painter **Joan Brown** has designed obelisks for Beverly Hills City Hall, the postmodern Horton Plaza Mall in San Diego, and elsewhere, all covered with brightly colored ceramics of cats and other symbols that grew out of her interest in Egyptian mythology and mysticism.

Audrey Flack, best known as a photorealist painter, is now creating neoclassical bronze goddesses. Four fourteen-foot gilded goddesses holding light rings have been commissioned to create a dramatic, welcoming entrance to the city of Rock Hill, South Carolina.

The bronze and terra-cotta figures of **Nancy Fried** show how feminism can lend an entirely new content to an established movement—in this case, postmodern classicism. Fried began her career with small, intricate painted reliefs of women lovers and scenes of female daily life, reminiscent of Persian miniatures, at the Los Angeles Woman's Building. She was in the New Museum's Extended Sensibilities show in New York City.

In 1988, at New York's Graham Modern Gallery, her group of tragic masks and headless torsos at first glance seemed like objects that we associate with classical fragments. On close examination the figures have one breast sliced off or show scar incisions on their bodies. A headless figure holds up a mirror to her deformity; in another, a mass of breasts spills out of the hollow opening in back of a head.

Slowly we realize that the images are of women who have experienced mastectomy or other female surgery. Although one out of ten women experience breast cancer in the United States, such images in art are taboo. Fried, who has experienced breast cancer herself, has managed to imbue the figures with a defiant nobility.

In so doing she subverts the time-honored value system of classicism, which has always depicted ideal beauty. The depiction of an exposed breast in a mythological Atalanta or Diana, for example, has always been a kind of tease, which implies the perfection and wholeness of the other one hidden under the draperies. In a society that makes a supreme fetish of breasts, Fried is saying that women can be splendid, can survive, even if they do not conform to a soul-crippling norm of physical perfection.

Postmodern Eclecticism Perhaps no artist expresses the postmodern eclectic attitude more clearly than **Jennifer Bartlett (1941–)**, whose works freely combine styles and media and

Nancy Fried, THE HAND MIRROR (1987), bronze, 9¾″ x 9¾″ x 8″. Courtesy of Graham Modern, N.Y. Photo: © Ellen Page Wilson 1988.

sometimes move through many-floored buildings and out onto the grounds.

Born in Long Beach, California, and trained as a painter at Mills College and Yale University, she moved to New York in 1968. Declaring that she wanted to make a painting that included everything in the world, Bartlett first aroused attention with the huge opus *Rhapsody* (1976). It consisted of nearly one thousand painted enameled metal units, each a twelve-inch square, arranged in a grid that wrapped all around the walls of the Paula Cooper Gallery, New York. The basic motifs of "house," "mountain," "tree," and "ocean" were taken through a series of permutations ranging from geometric abstraction to pointillist dots and brushy impressionist paint. *Rhapsody* was an overnight sensation, and critic John Russell declared in the *New York Times* that it was "the most ambitious single work" he had seen since arriving in New York.

Since then Bartlett has challenged herself in each succeeding work. For Philadelphia's Institute for Scientific Information she created a large lobby mural combining several interpretations of a garden theme (*In the Garden*, 1980) and divided a copy of it into fifty-four smaller units of different sizes, which she placed on walls throughout the building. This symbolized the way in which the company analyzed and reassembled information.

In the 1980s Bartlett began to combine three-dimensional forms with painted backgrounds. For the London home of famed art collectors Doris and Charles Saatchi, Bartlett interpreted the garden and pool visible just outside the door in a variety of works that move around the walls—collage closeups of leaves, distant views, pastels, paintings on mirrors, glass, and an Art Deco three-dimensional lacquered screen that stands on the floor (*The Garden*, 1981). This was followed by a commission completed in 1984 for the Volvo automobile company's executive headquarters on a wooded site overlooking a view of archipelagos in Göteberg, Sweden. Bartlett combined indoor paintings and three-dimensional forms with related outdoor works placed on the grounds. Thus, for example, she placed a yellow wooden table and chairs in the staff lounge. On the table is a portfolio of drawings of the scenery outside, a cigarette box in the form of a white house, and a small boat to serve as an ash tray. A screen behind the table shows a painted house, table, and chairs in a landscape. Through the windows or walking on the grounds viewers also come upon a granite version of the table and chairs, a group of full-sized rust-colored steel boats, and a wooden copper-roofed house containing a copper table and chairs, all placed strategically in the beautiful setting. The house, table, and boats are reduced to elemental forms, platonic and metaphoric, that induce thoughts of "shelter," "adventure," and so forth.

This approach was continued in a major retrospective that traveled to museums in Texas, New York, California and elsewhere. In front of groups of lyrical nature paintings the artist installed three-dimensional forms that stood in the viewer's real space. The Brooklyn Museum rotunda, for example, contained a variety of boats on the floor. In front of the painting *Sea Wall* stood real 3D objects seemingly removed from it and miraculously transmuted into real form and space.

Bartlett now lives in Paris and New York and is a major international artist. For the 1988 Paris performance of Leoš Jánaček's opera *From the House of the Dead* she carried out extraordinary sets. Enormously ambitious, she has written an autobiographical novel, *The History of the Universe,* and is developing a site work for Battery Park City consisting of plantings designed in garden styles derived from many periods and cultures.

Critics have found Bartlett's work strangely

Jennifer Bartlett, SMALL BOATS, HOUSES (1987). Painting: oil on canvas. Sculpture: painted wood, steel supports. Courtesy Paula Cooper Gallery. Photo: D. James Dee.

moving. Boats and swimmers suggest the risks and challenges of the adventurous spirit; the house (as in the work of many women artists) can be seen as a symbol of shelter and of the central self. Underneath the eclectic variations a brooding nostalgic quality emerges; she captures the spirit of our times in which, inundated by images, we are heirs to all ages, styles, and attitudes and believers in none.

ABSTRACT SCULPTURE IN THE 1980s

An odd new kind of eccentric abstraction, somewhere between animal, vegetable, mineral and geometric form, appeared. Much of this art, although abstract, has an implied organic and figurative quality, and some of it relates to ecological concerns—a feeling for nature and the erosion of the planet, expressed in the use of earthy materials and references to nature.

Mia Westerlund (Roosen) (1942–) is a pioneer of the new wave of abstract sculpture that combines quirky, organic, expressive qualities with almost minimal form. Although her work developed in the 1970s, it has influenced artists working in the 1980s. Totally abstract, but awkward and alive, her forms come, she says, "out of imagined figures. It's all about the tension between volume and surface, about the skin and the dense matter underneath."[9]

Born in New York City, the artist began sculpture around 1968. Influenced by artist friends Lynda Benglis and Alan Saret, she became involved in process art, flowing fiberglass onto such materials as hemp to create new forms that emerged from "letting the materials do eighty per cent of the work."

Roosen was already well recognized in Toronto, Canada, when she saw Eva Hesse's 1972 Guggenheim Museum retrospective and was astonished to find that she had been going in sim-

Mia Westerlund Roosen, UNTITLED (1983), bronze, concrete, and steel, 40″ x 36″ x 20″. Photo: Courtesy Leo Castelli Gallery, N.Y.

ilar directions. Struggling to separate her identity, she began to use concrete as her material. She first created slabs and wedges embedded with steel plates, reminiscent of paintings by Barnett Newman; then she cast irregularly shaped blocks, embedded with contrasting copper and steel notches that suggest vaginal incisions. These Brancusi-like simplified forms are called the *Minoan Series* (1978).

Searching for warmer, more expressive forms, Westerlund formed concrete into organic shapes that suggest body parts and odd indefinable creatures and covered them with a sensitively worked metallic or encaustic skin. *Heat* (1981), a precariously leaning form that looks like a tall cone gone limp, is made of concrete, covered with a luminescent hammered and patined surface. *Untitled* (1983) looks like a drooping worm, penis, or carapaced insect supported by thin steel stilts—a Kafka-like metamorphosis. *Pompadour* (1985) is an ambiguous form that can be read, among other things, as a pair of footless crossed legs or two kissing heads— forms that are alternately alluring, rejecting, and embracing.

Her work at the Leo Castelli Gallery in 1986 was described as

> monumental, idiosyncratic forms ... expressive and primitivistic.... While they are presentations of sculpture as volume, weight, and a stretched, precarious balance which at times seems to defy gravity ... they are ultimately not formalistic in intent. [They] ... are also fragments of sexuality ... at times ironic or humourous.... They address many of the issues which confront contemporary sculpture ... not the least of which is how to synthesize form and feeling with conviction and originality.[10]

Ursula von Rydingsvärd (1942–) laminates and carves cedar into stark, organic abstract forms that evoke saints and martyrs, chapel–like interiors or fences running along the land. She says that her rough-hewn earthy forms come from her Polish peasant background.

Some of the somber intensity of her work stems from her childhood. The artist's family, uprooted from a farm in Poland during World War II, spent seven years in German refugee camps after the war. Amidst this grim environment the only relief came from the rituals of the Catholic church. Although her work today is not ecclesiastical, it resonates with forms and metaphors drawn from these early experiences.

After coming to the United States, and obtaining an M.F.A. in painting from Columbia University in 1975, von Rydingsvärd received a gift of cedar lumber, a wood so soft that her fingernail leaves a mark in it. She has worked with cedar ever since.

Perhaps because she was a painter, the artist approaches sculpture in an unorthodox way. She combines lamination (gluing and clamping pieces together) and carving, which is ordinarily done on a single piece of wood. Out of rigid laminated sections grow knobby, visceral forms; the wood seems to twist, become fluid. Instead of polishing to reveal the grain, the artist uses a circular grinder that she calls her "paint brush" to make marks and textures on the surfaces. Lawrence Alloway has said that she works wood so that it takes on "a soft look ... a yielding and sensuous form, as if she released hamadryads."[11]

Early forms resembled opening buds (*For Weston 1978*, collection Mrs. Vera List). In 1979–80 she composed large site works by repeating elements spaced across the land. *Koszarawa* (State University of New York at Purchase), which suggests zigzagging low fences made of interlocking oar-shaped pieces of wood, was named after her mother's village.

In 1979 von Rydingsvärd created the haunting, apparitional *Song of a Saint,* a temporary

installation at Artpark in Lewiston, New York, that refers to Federico Garcia Lorca's poem about the martyrdom of Saint Eulalia (the artist herself is named after a martyred saint). In this work, 180 tall posts, bulging at varying heights with forms that suggest flayed flesh or cactus shapes, marched down a hillside and filled a gully. To critic Lawrence Alloway the site work seemed an ode to resistance in the face of mass torture. A permanent outdoor commission is *Tunnels on the Levee* (1983, Derveese Park, Dayton, Ohio), three rectangular wooden tunnels set into a grassy hillside, with huddled groups of carved wooden "figures" crowding into them (gas chambers? tombs?)

Stations for Santa Clara (1982) consisted of six lighted, white chapels, containing expressive groupings of wood forms. This work alluded to a saint who, to von Rydingsvärd, is the female equivalent of Saint Francis. The artist became involved with her personality while studying the works of Giotto at Assisi during a year in Italy.

After receiving a 1983–84 Guggenheim fellowship, von Rydingsvärd dedicated her 1984 exhibition at New York's Bette Stoler Gallery to the freedom of her birthplace, Poland. Laminated walls and fences, with hooked tops or nobby bulging centers, hinted at barbed wire, marching rows of figures, or rows of grain in her family's fields (*Lucretia's Field I* and *II,* 1984).

Although von Rydingsvärd has been influenced by both minimalism and abstract expressionism, the deep sources of her art are early memories. She remembers the refugee barracks of her childhood:

> If you can imagine men without jobs. What do they do with their lives? There were no laws, no police. Teenage children with no school to go to. They had no control over the future. The structure of these small camps was the church. . . . I enjoyed the structure and it is

Ursula von Rydingsvärd, detail of SONG OF A SAINT (ST. EULALIA) (1979), carved cedar, height 18′ x 330′ x 160′. Temporary installation at Artpark, Lewiston, N.Y. Photo courtesy of the artist.

something that I reach out to in my work. . . .
Also there were things in my life . . . that are
difficult to speak about. The menacing qualities
[in my work]—it's my secret way of stabbing,
quietly. . . . I still have to learn to probe in a way
that will allow things to come out that I still
haven't allowed to emerge.[12]

In *16 Hand Rests* (1984) she created a kind of
square wooden chapel with sixteen pews, where
the observer can fold hands for peaceful medi-
tation. *Urszulka* (1986) consists of five rough-
hewn stretchers for unknown victims. The artist
still goes through a ritual of washing the floor in
order to "become holy" before she begins to
work.

Ida Kohlmeyer (1912–) of New Orleans, an in-
ternationally recognized abstract painter, began,
late in her career, to transform the colorful pic-
tograms on her canvases into sculpture. Since
1983 she has been incorporating signs and sym-
bols, painted in brilliant hot pinks, oranges,
blues, and greens into surreal forms. Sometimes
she takes real chairs, mirrors, or coat trees and
makes them sprout hearts, arrows, lightning
bolts, clouds, birds, or lollipops (*Mythic Mirror*
and *Mythic Chair,* 1984).

In 1985, when she reached the age of seventy-
three, the mayor of New Orleans proclaimed
March to be Ida Kohlmeyer Month, and three ma-
jor exhibitions, including a traveling retrospec-
tive, were mounted simultaneously. A reviewer
in *Art News* declared that she is now "a New Or-
leans institution. Like Mardi Gras, the 73-year-
old artist is part of the fabric of life here. Her
nonobjective paintings and sculptures . . . are
joyful and celebratory, distilling the sensual, he-
donistic spirit of New Orleans. Indeed, [her] ex-
uberant art has become an almost ubiquitous

part of the local scene, appearing in stately Up-
town mansions and French Quarter garrets, in
corporate collections and in outdoor public
places."[13]

Throughout her career, Kohlmeyer has shown
admirable persistence in pursuing her goals de-
spite the obstacles inevitably encountered by a
well-to-do family woman, working in a commu-
nity that believed she belonged on the golf
course rather than in the studio. At thirty-seven,
driven by a restless, irrepressible urge to create,
Kohlmeyer took a graduate degree in painting at
Tulane, studied with Hans Hofmann, and in
1957, while teaching at Newcomb College, was
inspired by Mark Rothko, artist-in-residence.
Kohlmeyer developed a unique painterly state-
ment of brushy pictographs in fluorescent colors
held within a grid format.

All along, the artist experimented with three-
dimensional box constructions and in 1977 col-
laborated with her talented former student, Lynda
Benglis, on an installation, *Louisiana Prop Piece*
(constructed from Mardi Gras props), which filled
a hall in the New Orleans Museum of Art. But
Kohlmeyer did not really consider herself a
sculptor until 1983, when she won a competition
for a monumental outdoor sculpture outside an
office tower designed by Skidmore, Owings and
Merrill. The welded steel group, painted in bril-
liant polyurethane enamel colors, consists of five
pictographs that turn in the wind atop twenty-
foot metal poles. Its title, *Krewe of Poydras,* re-
fers to the fact that Kohlmeyer has created her
own Mardi Gras carnival club (called a "Krewe")
marching down Poydras Street.

Kohlmeyer's work shows the influence of
her lifelong passion for Mexican folk art and
Oceanic and African art, which crowds the walls
and floors of her home-studio in the Old Metairie
district. The lush hot pinks, oranges, and
mauves of the fabulous rose garden she tends

Ida Kohlmeyer, THE KREWE OF POYDRAS (1983), catalyzed polyurethane paint on steel, height 40–45′. Collection Westminster City Center Properties, 1515 Poydras Building, New Orleans, La. Photo: Bryan S. Berteaux.

are also reflected in her sculpture. An internationally recognized sculptor, her work is at the Metropolitan, Corcoran, and Brooklyn museums and in many corporate collections.

EMERGING SCULPTORS

It is impossible to include all the outstanding women sculptors working in the 1980s, or even to evaluate them without the perspective of time and historical distance. Many can be found in Virginia Watson-Jones's *Contemporary American Women Sculptors* (Oryx Press). Below are a few who exemplify different trends.

Some artists work with dirt, bones, twigs, and other natural materials, invoking their love of nature in an increasingly mechanized world. **Carol Hepper (1953–)** creates abstract forms out of willow branches, stretched hide, animal bones, and driftwood. Although not a Native American, she was influenced by the mythic ambience of the region around the Indian reservation in McLaughlin, South Dakota, where she grew up. Hepper was selected for the 1983 Guggenheim Museum exhibition New Perspectives in American Art.

Petah Coyne (1953–) takes giant clumps of black-brown earth (combined with hay, tar, wax, resin, chicken wire) and implants them with logs, branches, and roots that grow shaggily out of the surface. Her installation at New York's Sculpture Center was described as "part witches' sabbath, part hospital, part church.... Some of

Carol Hepper, SYNCHRONY (1983), mixed media 67″ x 57″ x 75″. Exxon Corporation Purchase Award, Solomon R. Guggenheim Museum, N.Y. Photo: Myles Aronowitz.

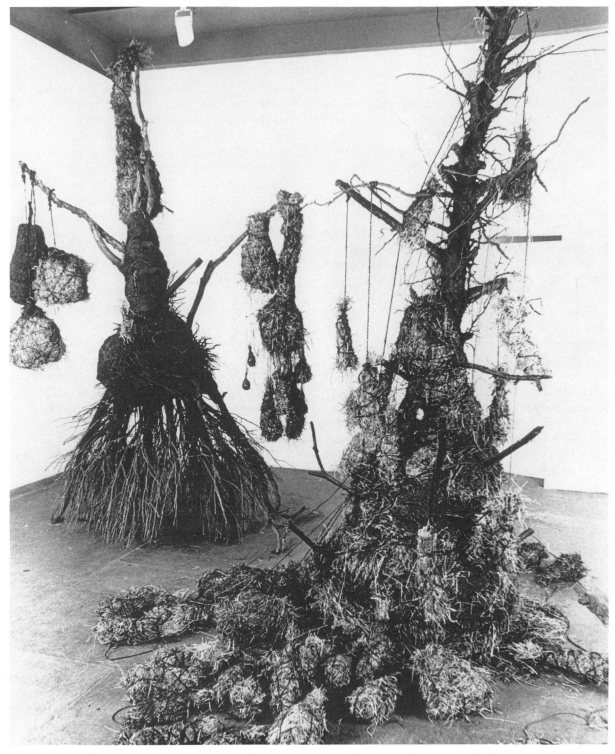

Petah Coyne, UNTITLED (1987), sticks, hay, mud, wire, rope, wax, and tar. Installation at the Sculpture Center, N.Y., September 1987. Photo: Petah Coyne.

these haunted creatures ... mov[e] across the floor like mud heads stumbling out of an ancient dream. There are big figures, too, rising almost to the ceiling on which tumors hang like bells or chimes.... There is a sense ... of malignancy tamed, transformed into something that can protect and heal."[14]

Meg Webster (1944–) creates living minimalist sculptures out of moss, plants, earth, and stones. The twisted wire constructions of **Maren Jenkins Hassinger (1947–)** dance along like a forest of bare-branched trees, expressing her fears about the destruction of nature and her hope for rebirth and renewal.

Heidi Fasnacht (1951–) cuts out plywood pieces, nails them together, and then resaws the multilayered wood into rough-hewn new forms that gyrate off the walls in gestures of aggressive power.

Gillian Jagger evokes the landscape in cast-cement works that spread out horizontally on the ground, derived from forms cast on the sides of hills, volcanos, and other sources. The wall-hung bronze forms of **Phoebe Adams (1953–)** express metamorphosis, growth, and transformation, carrying forward the biomorphic abstract tradition of artists like Jean Arp or Louise Bourgeois. Quirky and paradoxical, they droop, hang, or fly away from the wall in tenuous relationships of form. Sculptors like **Coleen Sterritt (1953–)** and **Sandra Shannonhouse (1947–)** create unclassifiable works that hover between the figurative and the abstract.

Video Art In the 1970s and 1980s **Shigeko Kubota, Rita Myers, Mary Lucier, Tomiyo Sasaki, Steina Vasulka, Barbara Buckner, Margia C. Kramer,** and others have become major figures in the important new field of video art—a genre in which the two-dimensional art of the screen is often combined with three-dimensional sculptural forms. Using multiple monitors and many other elements in their installations, and manipulating the images with advanced technology, these artists are addressing a wide range of social, aesthetic, and philosophical themes. A good discussion of their work can be found in *Making Their Mark: Women Artists Move into the Mainstream, 1970–85* (Abbeville Press, 1989).

TOWARD CULTURAL DIVERSITY

In recent decades an exciting new vision of a multicultural, multiethnic art world has arisen. Artists from diverse backgrounds—Native Americans, African Americans, Latinos, and Asian Americans—who in the past were largely excluded from the mainstream are beginning, in increasing numbers, to exhibit their work in major galleries and museums. They are emerging as a strong new force. The public is finally being privileged to share in the experiences of the many groups that make up the American cultural mosaic.

Women sculptors from these groups have been discussed throughout this book; the following few examples of younger artists working today suggest the rich variety and many visions they have to offer.

The work of contemporary Native American artists often expresses a "double vision"—an awareness of the interface between the long ancient heritage and the contemporary culture in which the artist functions simultaneously.[15] Thus, for example, Comanche ceramic sculptor **Karita Coffey (1947–)** sometimes reverently fashions traditional objects out of clay, such as masks or a pair of women's legging boots, but her stylistic approach is contemporary and nontraditional. Coffey has a graduate degree from the University of Oklahoma at Norman and is on the staff of the Institute of American Indian Arts in Santa Fe.

Karita Coffey, SOUTHERN PLAINS INDIAN WOMEN'S LEGGINGS (1981), white earthenware clay, 18″ x 9″ x 8½″. Private collection. Photo: Karita Coffey.

Imogene Goodshot creates wearable art objects—beaded tennis shoes and baseball hats—that are not only beautiful abstract forms but also allude wryly to the confrontation of cul-

tures. This gentle irony is characteristic of much Native American art. **Edna Jackson**, an Alaskan of Tinglit descent, makes poetic reliefs from handmade paper combined with woven bark and grasses that she gathers in the woods; **Lillian Pitt** of Portland, Oregon, freely reinterprets ancient Eskimo or Northwest Coast forms in raku-fired ceramic masks; **Gail E. Tremblay**, an intermedia artist of Iroquois and Micmac descent, combines weaving with metalwork, wood, feathers, and other materials in masks and forms influenced by Native American spirituality.

As we have already seen in the work of Elizabeth Catlett, Faith Ringgold, and Marie Johnson-Calloway, African American artists often deal with themes of racial oppression and, conversely, pride, or draw on their African heritage for inspiration. Others (such as Maren Hassinger) work in forms that are not readily distinguishable from mainstream art.

One of the most impressive younger artists, **Alison Saar (1956–)**, creates urban icons. She often combines wood carvings with cast-off materials, such as old decorative roof tin from destroyed houses, in images that pay homage to workers, the homeless, or an admired figure like singer Billie Holliday. For example, the nine-foot *Leroy "Phoenix" Lefeu,* a muscular street worker rising from a manhole on carved wooden steam, with a nimbus cloud behind his head and pants made of patterned roof tin, is transformed into a shaman filled with spiritual energy. A phoenix is inscribed on his chest; he holds a ghetto blaster in one hand and a cigarette with carved smoke in the other. In the half figure *Sapphire* the woman's breasts open up to reveal glass shards and other emblems of her psyche.

These works artfully combine the modernism of assemblage with the sacred feeling of ancient church *retablos,* or altarpieces. Saar has a master's degree from Otis-Parsons Institute in Los Angeles and is the daughter of artist Betye Saar.

Alison Saar, LEROY "PHOENIX" LEFEU (1987), wood and tin, height 103″. Collection: Joseph Austin, Los Angeles, Calif. Photo: Douglas M. Parker.

Winifred R. Owens-Hart (1949–) earned an M.F.A. from Howard University and has journeyed to the famed potter's village of Ipetumodu in Nigeria to work with the women who have made ceramics for generations in a tradition handed down from mother to daughter. She has documented this tradition and taught ceramics at Ife University. Her art has been deeply influenced by the techniques of Nigerian pottery, which she transforms to express her own experience.

In an ongoing *African American Women* series, Owens-Hart has explored the conflicts and hopes of black women in America, sometimes in painful imagery. *Divide and Conquer* shows a figure actually cracking apart. She writes that the helmet mask *Société Secrete*

> is a dream piece for me. I grew up in the original Museum of African Art (the former townhouse of Frederick Douglass) at a time when African art was not in vogue. Therefore I was able to touch these masks as a young girl. I always thought the idea of the passage from girlhood into womanhood was significant. In the Mende and Poro societies boys and girls experience the rites of passage ... a demarcation that our young people lack in their lives today. Unfortunately, their confusion comes born out of an imposed responsibility by society that they have not been *prepared* to meet. Hence the creation of this piece that I hope will remind those who know and evoke those who do not to ask about "the passage."[16]

The growing influence of the Latino community in the United States was reflected in blockbuster exhibitions in the 1980s, such as the traveling show Hispanic Art in the United States. Women were inadequately represented in this large exhibition; only three were included.

The Latina community includes artists from diverse cultures and nations. Artists from South

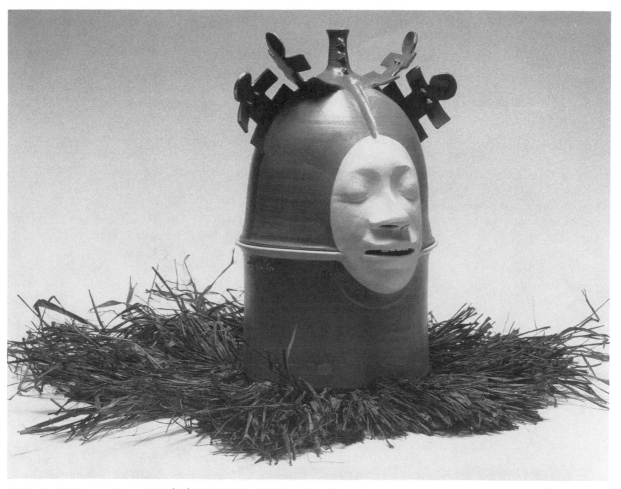

© Winifred R. Owens-Hart, SOCIÉTÉ SECRETE—HELMET MASK (1983), ceramic, height 15″. Collection of the artist. Photo: © Jarvis Grant 1984.

and Central America often come from middle-class backgrounds and are trained in ways that relate to international modern movements. This is true in the case of Marisol, Raquel Rabinovich, and **Joyce de Guatemala**, a Guatemalan now living in Pennsylvania, who draws on Mayan themes in abstract stainless steel and wood installations.

Chicanas (Mexican Americans) and Puerto Ricans living in the United States have been subjected to much exploitation and have had to struggle to enter universities and professional schools. Their work tends to be informed by a strong social conscience.

Inspired by the *La Raza* movement of the 1960s and 1970s, many Chicana artists began their careers by working on wall murals or posters and then developed more personal expressions. Now making a vigorous contribution to the art scene, they look back to their rich pre-Columbian, religious, and folk art heritage, which they transform into modern forms of expression that relate to issues today.

Amalia Mesa-Bains, Patricia Rodriguez, and Linda Vallejo were discussed in chapter 10. Mesa-Bains uses the traditional home altar form to pay homage to inspiring Chicana role models, Rodriguez creates intimate box constructions, and Vallejo works in a wide range of media. Other artists were included in the 1983–84 exhibition *Chicana Voices and Visions,* curated by Shifra Goldman at the Social and Political Action Resource Center (SPARC) in Venice, California. **Marina Guttiérez (1954–)**, an American-born artist of Puerto Rican heritage, makes strong statements about racism, war, and exploitation in her mixed-media works. In the box construction *Truth, Peace, and Purity,* for example, archetypal male figures of power, clutching money, can be turned by handles on the top of the box to reveal the powerless figures they control on the other side.

Cuban American Ana Mendieta was discussed in chapter 10 because her work was strongly connected with the feminist movement. Another Cuban-American, **Maria Brito (1947–)**, who studied with Duane Hanson and earned a 1979 M.F.A. at the University of Miami in Coral Gables, constructs mixed-media tableaux reminiscent of the "magic realism" and fantasy of artists like Marisol and authors like Gabriel Garcia Marquez. Certain works contain doors and windows that open in strange ways into other rooms and include electric lights, wall switches, and other found objects combined with ceramic sculptured masks and wings. These works sometimes express the subconscious terrors and yearnings of childhood memories. Thomas Messer, director of New York's Guggenheim Museum, selected her for a commission that was permanently installed in the Olympic Sculpture Park in Seoul, Korea. **Maria Lino,** a Cuban artist in Miami, uses forms derived from female body parts in sculptures that comment bitterly on sexism.

Los Angeles artist **Mineko Grimmer**, combining her Japanese heritage with an interest in the theories of John Cage, builds forms of Zen-like serenity. She constructs lattice structures of bamboo or wooden slats, sets them over pools, and suspends inverted pyramids of pebbles frozen in ice above them. As the ice melts, the pebbles drop one by one, ricochet against the forms, and plunk into the pool with a musical sound. The hypnotizing process produces a meditative incantatory effect, evoking thoughts about permanence and change.

Raised on the island of Honshu, Grimmer says that she was inspired by childhood memories of the ice freezing and then melting in the spring. Trained in Japan, she later earned a 1981 M.F.A. from Otis-Parsons Institute, Los Angeles, and has emerged as a leading southern California sculptor. Her work drew fascinated crowds when it was shown at the Equitable Building branch of the Whitney Museum of American Art, New York, in 1988.

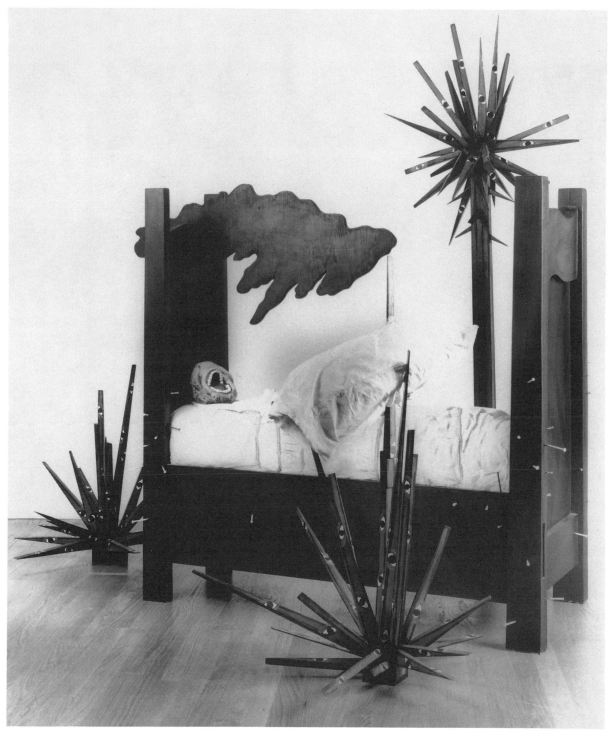

Maria Brito, THE GARDEN AND THE FRUIT (1987), mixed media, 70″ x 61¾″ x 64¾″. Courtesy of the artist. Photo: Ramon Guerrero.

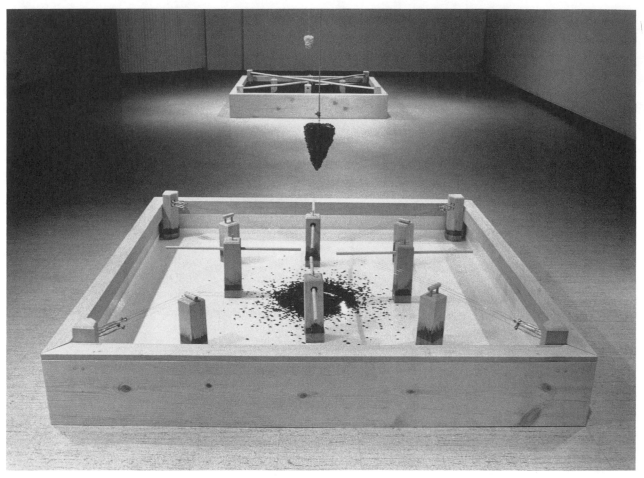

Mineko Grimmer, VARIATIONS (1985), ice, water, wood, and wires, 7′ x 7′ x 4′. Photo: Mineko Grimmer, courtesy of Koplin Gallery, Los Angeles.

CRAFTS TODAY

Since World War II crafts have been moving in the direction of fine arts; Toshiko Takaezu, for example, was, in the 1950s, one of the first to close the forms of her ceramic vessels, indicating that they were really sculptures (see chapter 8). She carried this idea to its logical conclusion by casting similar forms in bronze. In the 1970s feminists demanded a reevaluation of crafts, pointing out that they were put in a lower category than painting and sculpture primarily because women, for sociological reasons, had always been extremely active in this area.

In the 1980s the merger between art and craft became almost complete. With machinery turning out most objects for daily use, crafts are increasingly abandoning their earlier functional purposes and are crossing boundaries, merging with sculpture, painting, and assemblage in daringly original, frequently nonfunctional forms. Still, they continue to be distinguished by the skilled labor of loving hands, reverent technique, and integrity of feeling. In the exhibition catalog *The Eloquent Object,* crafts authority Rose Slivka pointed out that the craft movement has continued to grow despite the onslaught of mass production because it expresses human resistance against the depersonalizing forces of technological and corporate power. In the same book critic John Perrault had the audacity to declare that because of the commercialization, mechanization, and corruption of the art world, much of the best art today is found in crafts rather than in traditional painting and sculpture: "Crafts and fine art have switched places; it is paint-on-canvas art that is the middle-class mode, not pottery. It is 'fine art' that is kitsch."[17]

Indeed, many of the sculptures included in the last chapters of this book, (such as the ceramics of Mary Frank, Patti Warashina, Viola Frey,

Toshiko Takaezu, STONEWARE FORM (n.d.). Courtesy of the artist.

Winnie Owens-Hart, and Karita Coffey) might once have been called crafts. The weavings of Tawney, Zeisler, and Hicks, and the paper and aluminum works of Neda Alhilali can be viewed equally as sculpture or crafts.

Crafts have moved away from the reductionism of the previous decades toward a freer, more playful eclecticism, in which quotations from many different historical eras are pastiched together. The ceramics of **Betty Woodman (1930–)** exemplify this cultural pluralism. Liberated from traditional attitudes in the 1970s, when she began to collaborate with women in the Pattern and Decoration movement (Joyce Kozloff, Cynthia Carlson), Woodman feels free to attach a handle adapted from a Greek krater to a Medi-

terranean-influenced pillow pitcher and then slather the whole with mustard and green glazes appropriated from Tang dynasty ceramics. The loose slump of clay takes on eccentric shapes that remind some critics of the early maverick ceramist George Ohr. Uruguayan-born **Lidya Buzio (1948–)** paints fresco-like New York rooftop scenes on her burnished black pots. Like Woodman, she has spent time in Italy, and her work echoes the past while remaining distinctly modern.

Today, as always, women are leaders in the crafts movement. Many superb craftswomen were included in the 1986 traveling exhibition sponsored by the American Craft Museum, Craft Today: Poetry of the Physical.

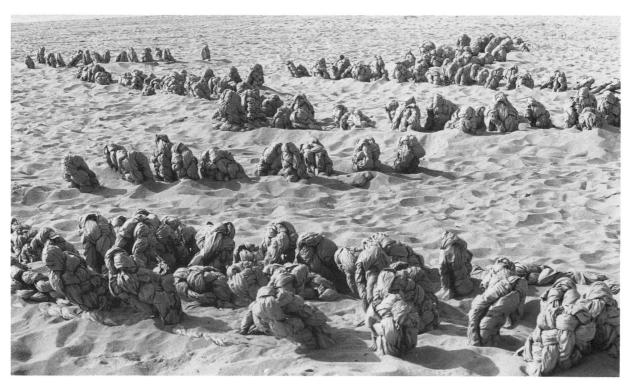

Neda Alhilali, BEACH OCCURRENCE OF TONGUES (1975), paper, 120′ x 120′. Photo: Neda Alhilali.

Betty Woodman, SPINACH
SOUP TUREEN AND STAND
(1985), glazed earthenware, 12″
x 20″ x 14″. Courtesy Max
Protetch Gallery, N.Y.

Lidya Buzio, DARK BLUE
ROOFSCAPE (1986),
earthenware, height 13¾″.
Collection: Betty Asher, Beverly
Hills, Calif. Photo courtesy
Garth Clark Gallery, Los
Angeles/New York.
Photographer: Anthony Cuñha

MAYA YING LIN AND THE
VIETNAM MEMORIAL

No sculpture or monument provides a more fitting conclusion to this book than Maya Lin's *Vietnam Veterans Memorial Wall* in Washington, D.C. Standing on the Mall between the Lincoln and Washington monuments, in the heart of the nation's most sacred historic site, its very form expresses what has been called "the new language" of women artists.

Drawing spectators down into the earth to commune with loved ones in a personal, intimate way, in almost ironic contrast to the upthrusting aggressiveness of the monuments that flank it, the wall symbolizes the humanizing contribution that women can make to the world as they increasingly enter avenues of national and international life. The courageous way in which the young artist confronted the forces arrayed against her as she sought to carry out her revolutionary design is a dramatic story.

Maya Ying Lin (1959–), born in Athens, Ohio, says that she "grew up in the woods," and her love of the land is profound. While in her senior year at Yale University she was taking a seminar in funerary architecture when a design competition for a memorial to the veterans of America's most controversial war was announced:

> We had already been questioning what a war memorial is, its purpose, its responsibility. Many earlier war memorials were propagandized statements about the victor, the issues, the politics, and not about the people who served and died. I felt a memorial should be honest about the reality of war and be for the people who gave their lives. For a strong and sobering feeling, it should carry their names.[18]

On her way back from a Thanksgiving visit to her family, she stopped off in Washington to look at the site. As she walked around the wide, pleasant, tree-encircled park where people were tossing frisbees in the sun, she decided that she "wanted to work with the land and not dominate it."[19]

> The problem was how to mourn death honestly. I decided to cut into the earth and polish the sides . . . open this wound or cut—one end pointing to the Washington Memorial and one to the Lincoln. . . . Grass would grow over it and heal the wound.[20]

> The grass would grow back, but the cut would remain, a pure, flat surface, like a geode when you cut into it and polish the edge. I didn't visualize heavy physical objects implanted in the earth; instead it was as if the black-brown earth were polished and made into an interface between the sunny world and the quiet, dark world beyond, that we can't enter.[21]

> I wanted the names arranged chronologically from the first death to the last. You don't die alphabetically. That way the memorial becomes a journey . . . it becomes a sequence in time. The veteran could see his friends at a moment in time . . . he could go to the wall and find the friends who were with him in battle.[22]

Back at Yale, Lin sketched out the idea and worked up a three-dimensional clay model. The monument consists of two polished black granite walls (each about 245 feet long), set against a cut in a hillside and converging at an obtuse angle. Spectators walk down a path parallel to the walls. As they do, they can read the names of those who died in the war.

"It seems almost too simple," Lin thought to herself. But then she realized that the 58,000 names of the fallen ones, inscribed on the black polished granite sides, *were* the memorial. "There was no need to embellish."[23]

The young artist never expected to win the competition; her professor thought the design

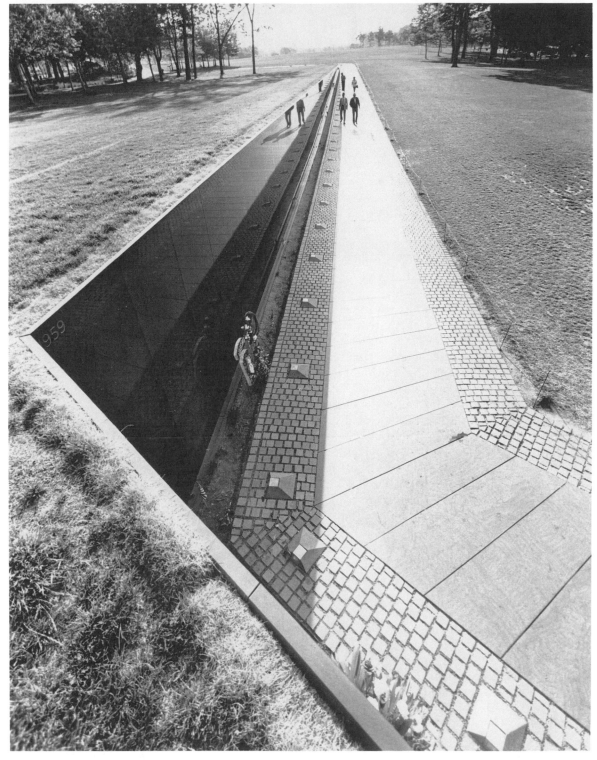

Maya Ying Lin, detail of VIETNAM VETERANS MEMORIAL WALL (1982), black polished granite. Washington, D.C.
National Park Service-NCR photo 12143(#31).

was too strong to be accepted, but encouraged her to submit it anyway (she got a B grade for the assignment). There were so many entries that the distinguished jury of architects and sculptors had to walk up and down aisles in a huge aircraft hangar to review them. From the beginning Lin's anonymous design haunted the jurors. After the selection had been narrowed, someone said, "He must have been very sure of himself" to submit such a naively rendered drawing.[24] In contrast with most of the other entries, which were tight architectural renderings, Lin's was a free artist's sketch. Her concept was chosen unanimously.

The choice was immediately controversial. There were objections to her youth, to her gender, to the fact that she is a Chinese American.[25] Although Lin and the selection jury had conceived of her design as neutral and apolitical, certain individuals and pressure groups interpreted the form and color as an attack on America's role in the Vietnam war. They called it "a black gash of shame," "a degrading ditch."[26] They wanted the monument to be above ground, they wanted it to incorporate a heroic figure of a soldier, they wanted it to be white, not black.

For some time Lin's education was interrupted and her life was taken up with defending the memorial. To prove to bureaucrats that her use of polished black granite was not unprecedented, Lin photographed every black granite monument in Washington, D.C. The artist saw the black granite as "a peaceful way of looking into infinity.... The spectators can see their faces reflected in it like a soft mirror."[27] One of the most stirring aspects of the monument is the way it reflects clouds, so that the names engraved on it appear to be written against the sky.

The battle over the color of the memorial ended in a dramatic confrontation. At a meeting called to discuss possible changes in the design,

after several people had repeatedly declared that black was "the color of shame and degradation," General George Price, one of America's highest-ranking black officers said "Black is not a color of shame.... Color meant nothing on the battlefields of Korea and Vietnam.... Color should mean nothing now." That ended any further discussion about the color of the monument.[28]

When pressures were exerted to incorporate a figurative "hero" in the work, several lawyers came forward and offered to represent her. Finally a compromise was worked out. Frederick Hart, a runner-up in the competition, was commissioned to create a figurative group, but it was not to be incorporated in Lin's design. Hart placed it some distance from the memorial, in such a way that the figures appear to be looking at the wall and contemplating its significance.

Maya Lin has decided not to be bitter. "If they had placed the figures inside of the memorial, it could have ruined it. They didn't. Essentially we won."[29]

Since its completion, Lin's work has won the hearts and minds of the Vietnam veterans it was designed to honor. It has acted as a healer, and even those opposed to the war feel humble in its presence. The memorial elicits profound human feelings of a depth far outside the range of any other monument in the capitol.

Maya Lin, in her struggle and triumph, can in many ways be seen to represent all American women sculptors, who in the past 150 years have often faced the obstacle of sexism—and, for women of color, racism. Vinnie Ream was vilified when awarded the commission for the statue of Lincoln in 1866, Harriet Hosmer had to threaten a libel suit to force magazines to retract claims that men were actually doing her work, Anne Whitney lost the Charles Sumner commission when the jurors learned that the artist was a woman. Nancy Prophet, May Howard Jackson,

Meta Vaux Warrick Fuller, and Augusta Savage faced a continual battle with racism.

It therefore seems especially appropriate that in 1989 Lin completed for the Southern Poverty Law Center in Montgomery, Alabama, a second important monument—the first memorial dedicated to the history of the civil rights movement. Her purpose was to create a tranquil, contemplative space in which people could thoughtfully consider "how far the country has come in its quest for equality and . . . how far it has to go."[30]

Spectators walk around a circular black granite table inscribed with the names and events of the civil rights era. Behind the table stands a curved black granite wall. Through a veil of water pouring gently down over it, viewers can read an inscription from the Bible that Martin Luther King, Jr., quoted in his speech, "I Have a Dream":

> We will not be satisfied until
> "justice rolls down like waters
> and righteousness like a mighty stream."

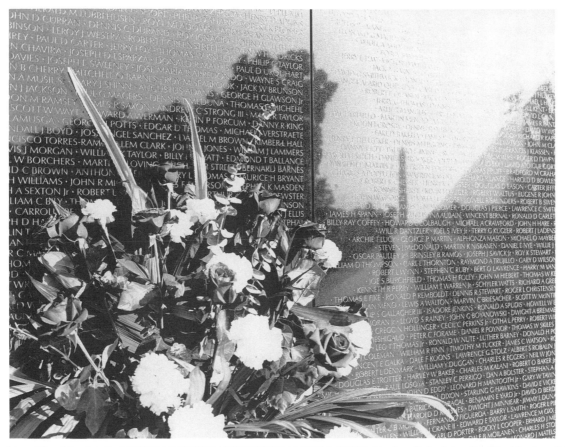

Maya Ying Lin, detail of VIETNAM VETERANS MEMORIAL WALL (1982), black polished granite. Washington, D.C. National Park Service-NCR photo 12143(#35).

NOTES

Introduction

1. In the last two decades a rich body of theory has been developed by feminist art historians. Thalia Gouma-Peterson and Patricia Mathews summarize it in "The Feminist Critique of Art History," *Art Bulletin,* September 1987 (see also the subsequent exchange with Norma Broude and Mary Garrard in the March 1989 *Art Bulletin*). Whitney Chadwick, building on the groundwork developed by earlier art historians, incorporates much of this material in an ambitious survey, *Women, Art and Society* (New York and London: Thames and Hudson, 1990), that challenges the premises of the traditional canon of patriarchal art history. Different viewpoints are being developed by critics like Arlene Raven, Joanna Frueh, Sandra Langer, and others.

But if theory is to continue to grow and develop properly, it has to be accompanied by an ever-expanding body of information. The phase of "excavation" of lost and hidden women's art and the search for the circumstances surrounding its production are far from over. Feminist critics and historians run the risk of developing theories based on the "anointed ones" who have been selected by the patriarchy unless research continues to go forward. There is an immense amount of sculpture by American women, much of it far from New York City and other major centers, which has yet to be uncovered and evaluated.

Chapter 1

1. John Sloan and Oliver LaFarge, *Introduction to American Indian Art* (New York: Exposition of Indian Tribal Arts, 1931). Although examples of work by Native American women are given in this chapter, it must be understood that gender roles were never completely uniform throughout the area that is now the United States; they varied from culture to culture, from community to community, and from period to period. Pottery was made primarily by women, but in some places sacred ceremonial vessels were made by men while women made the utilitarian ware. Among the pueblo groups, the men of San Ildefonso often decorated the pottery after the women formed it, whereas in the Zuni pueblo women made the pots and painted the designs. In rare cases we even hear of men making baskets. Among the Pomos, for example, although women made the finely woven gift baskets, men

made the coarser, more utilitarian baskets, such as fish traps and baby carriers. The situation varied greatly in the tremendously diverse Native American societies and was influenced so much by contact with the white community that it is often difficult to assess the facts about earlier times. Today traditional gender restrictions are disappearing; women carve in wood and stone, paint in abstract and representational styles, and make metal jewelry, while men often make ceramics. Mohave men are making effigy pottery today (they learned the technique from their female elders).

2. Marvin Cohodas, "Dat So La Lee's Basketry Design," *American Indian Art* 4 (Autumn 1976):22.

3. Thomas Harriot, *A Briefe and True Report of the New-Found Land of Virginia* (1590, De Brys Edition; New York/Dover Publications, 1972), 60.

4. Dumont de Montigny, *Mémoires Historiques sur la Louisiane* (Paris: C. J. B. Bauche, 1753), quoted in Charles C. Jones, Jr., *Antiquities of the Southern Indians, Particularly of the Georgia Tribes* (New York: D. Appleton & Co., 1873), 463.

Chapter 2

1. Joel Barlow, *The Columbiad, A Poem,* book 8 (London, printed for Richard Phillips, 1809), 267. Special collection, University of California, Irvine.

2. Philip Thicknesse, *Memoirs and Anecdotes of Philip Thicknesse* (London, 1788), as quoted in Charles Coleman Sellers, *Patience Wright: American Artist and Spy in George III's London* (Middletown, Conn.: Wesleyan University Press, 1970), 123.

3. Philip Thicknesse, *New Prose Bath Guide for the Year 1778* (printed for the author and sold in London and Bath, 1778), 50–53. Collection Houghton Library, Harvard University.

4. Ibid.

5. L. H. Butterfield, ed., *Adams Family Correspondence* (Cambridge: Harvard University Press, 1973), 2:235–36.

6. Quoted in Sellers, *Patience Wright,* 40.

7. Carl Van Doren, ed., *The Letters of Benjamin Franklin and Jane Mecom* (Princeton: Princeton University Press, 1950), 135–36.

8. Lesley Parker, "Patience Lovell Wright," *Art in America,* no. 24 (October 1936):148–57.

9. C. H. Hart, "Patience Wright, Modeller in Wax," *The Connoisseur,* September 1907, 19.

10. Charles Coleman Sellers has reconstructed a catalog *raisonné* of more than fifty portraits from articles in the *London Magazine* 44, *Gentleman's Magazine* 46, May 1776, 214–15, and other periodicals. See *Patience Wright,* 227–35, also 94–95. An engraving of Wright's bust of Dr. John Fothergill is in John Coakley Lettsom's *Memoirs of John Fothergill* (London, 1786), and a presumed plaster copy is in a private collection.

11. Elkanah Watson, *Men and Times of the Revolution* (New York: Dana & Co., 1857), 137–38.

12. Patience Wright to Benjamin Franklin, 14 March 1779 and March 1777, Franklin Papers, American Philosophical Society, quoted in Sellers, *Patience Wright,* 111, 160.

13. Ibid., 136.

14. Watson, *Men and Times of the Revolution,* 137–38.

15. Ibid., 140–41.

16. C. H. Hart, "Patience Wright, Modeller in Wax," 22.

17. William Dunlap, *History of the Rise and Progress of the Arts of Design in the United States,* vol. 1 (New York: G. P. Scott & Co., 1834), 155.

18. Rachel Wells to Benjamin Franklin, 16 December 1785, Franklin Papers. Courtesy American Philosophical Society.

19. *Letters of Mrs. Adams, the Wife of John Adams, with an Introductory Memoir by Her*

Grandson, Charles Francis Adams (Boston: Little & Brown, 1840; reprint, St. Clair Shores, Mich.: Scholarly Press, 1977), 229–30.

20. L. E. Tanner and J. L. Nevinson, "On Some Later Funeral Effigies in Westminster Abbey," *Archaeologia* 85 (1936): 196.

Chapter 3

1. William Gerdts, *American Neo-Classical Sculpture: The Marble Resurrection* (New York: Viking Press, 1973), 21.

2. Ibid.

3. Henry James, *William Wetmore Story and His Friends* (Boston: Houghton Mifflin, 1903; reprint, New York: Grove Press, 1957), 257.

4. John Rogers Papers, courtesy New York Historical Society, letter dated January 9, 1859.

5. James, *William Wetmore Story*, 257.

6. Newspaper clipping, Inventory of American Sculpture, National Museum of American Art.

7. William Dunlap, *History of the Rise and Progress of the Arts of Design in the United States* (Boston: C. E. Goodspeed & Co., 1918) 3:315; I. N. Phelps Stokes, *The Iconography of Manhattan Island 1498–1909* (New York: R. H. Dodd, 1915–28) 18:317.

8. Elizabeth Ellet, *Women Artists in All Ages and Countries* (New York: Harper & Brothers, 1859), 286–87.

9. Hannah Farnham Lee, *Familiar Sketches of Sculpture and Sculptors* (Boston: Crosby, Nichols and Co., 1854) 2:219.

10. Ibid.

11. Ibid., 220.

12. Ibid.

13. Ibid.

14. Phebe A. Hanaford, "Joanna Quiner," *Essex Institute Historical Collections,* 12:43.

15. Ibid., 41.

16. Ibid., 43–44.

17. Ibid., 41.

18. Ibid., 43.

19. Hannah Lee, *Familiar Sketches of Sculpture and Sculptors* (Boston: Crosby, Nichols & Co., 1854) 2:216.

20. Ibid., 217.

21. John Frankenstein, *American Art: It's Awful Altitude: A Satire,* 1864; reprint, ed. William Coyle (Bowling Green, Ohio: Bowling Green University Popular Press, 1972), 19–20. See footnote 30, p. 119. I am grateful to Franklin Riehlman for bringing this to my attention.

22. *New York Herald,* 4 January 1848; *Boston Evening Transcript,* 4 June 1849; *Philadelphia Public Ledger,* 24 November 1851. See George C. Groce and David H. Wallace, *The New York Historical Society's Dictionary of Artists in America: 1564–1860* (New Haven: Yale University Press, 1957).

23. Nathaniel Hawthorne, *The French and Italian Notebooks,* ed. Thomas Woodson, vol. 14, The Centenary Edition of the Works of Nathaniel Hawthorne (Columbus: Ohio State University Press, 1980), 158.

24. Ellet, *Women Artists in All Ages and Countries,* 354.

25. Ibid.

26. See Dolly Sherwood, "Harriet Hosmer's Sojourn in St. Louis," *Gateway Heritage,* Winter 1984–85, 42–48. Sherwood's biography of Hosmer is forthcoming.

27. Cornelia Carr, ed., *Harriet Hosmer: Letters and Memories* (New York: Moffat, Yard & Co., 1912), 15.

28. Ibid., 23.

29. Hawthorne, *The French and Italian Notebooks,* 159.

30. Carr, *Harriet Hosmer,* 24.

31. Ibid., 25.

32. Ibid., 35.

33. Robert L. Gale, *Thomas Crawford, American Sculptor* (Pittsburgh: University of Pittsburgh Press, 1964), 121.

34. James, *William Wetmore Story,* 257.

35. Frederick Kenyon, ed., *Letters of Elizabeth Barrett Browning* (New York: Macmillan Co., 1897), 2:166.

36. Carr, *Harriet Hosmer,* 79.

37. Ibid., 76.

38. Ibid., 84.

39. Barbara S. Groseclose, "Harriet Hosmer's Tomb to Judith Falconnet: Death and the Maiden," *American Art Journal,* Spring 1980, 78.

40. Hawthorne, *French and Italian Notebooks,* 509–10.

41. Ibid., 508–10.

42. Carr, *Harriet Hosmer,* 193.

43. Ibid., 363–65.

44. Gale, *Thomas Crawford,* 101. The quote from Hosmer's letter to Powers is in the Hiram Powers Papers, Archives of American Art, roll 1145.

45. *Atheneum,* 19 December 1873.

46. Kenyon, *Letters of Elizabeth Barrett Browning,* 392.

47. Eleanor Tufts, *American Women Artists: 1830–1930* (Washington, D.C.: International Exhibitions Foundation for National Museum of Women in the Arts, 1987), 104.

48. Phebe A. Hanaford, *Daughters of America* (Augusta, Maine: True & Co., 1883), 321–22.

49. Elizabeth Rogers Payne, "Anne Whitney: Sculptures: Art and Social Justice," *Massachusetts Review,* Spring 1971, 257.

50. Elizabeth Rogers Payne, "Anne Whitney, Sculptor," *Art Quarterly,* Autumn 1962, 244–61.

51. Wayne Craven, *Sculpture in America* (New York: Thomas Y. Crowell & Co., 1968), 228. Eleanor Tufts points out that painter William Trost Richards urged Whitney "in true Victorian tones" to portray Lady Godiva in costume, instead of nude, because she was "a virtuous woman." Tufts, *American Women Artists,* 111.

52. Ibid., 230.

53. Ibid., 231; Milton Brown, *American Art to 1900: Painting, Sculpture, Architecture* (New York: Harry N. Abrams, 1977), 565.

54. Henry Wreford, "A Negro Sculptress," *Athenaeum,* 3 March 1866, 2001.

55. Lydia Maria Child, "Edmonia Lewis," *Broken Fetter,* 3 March 1865, 25, quoted in Lynda Hartigan, *Sharing Traditions: Five Black Artists in Nineteenth-Century America* (Washington, D.C., published for the National Museum of American Art by the Smithsonian Institution Press, 1985), 88.

56. Wreford, "Negro Sculptress," 2001.

57. Child, "Edmonia Lewis."

58. Quoted in Sylvia Dannett, *Profiles of Negro Womanhood* (Yonkers, N.Y.: Educational Heritage [Negro Heritage Library], 1964) 1:122.

59. Ibid.

60. Ibid.

61. "Edmonia Lewis," *The Revolution* 7, no. 6, 20 April 1871.

62. Ibid., 8.

63. William J. Clark, Jr., *Great American Sculptures* (Philadelphia: Gebbie & Barrie, 1878), 141–42.

64. Ron Grossman, "Two Saviors Vie for Cleopatra," *Chicago Tribune*, 20 June 1988, sec. 5, p. 1. After Adams and his son's Boy Scout troop moved the statue to a safer spot, he spent years trying to interest the community. The Historical Society is restoring *Cleopatra* and is seeking a photograph or engraving that shows how it looked before it was damaged.

65. Charlotte Streifer Rubinstein, *American Women Artists: From Early Indian Times to the Present* (Boston: G. K. Hall, 1982).

66. Garrison's Diary, quoted in Marilyn Richardson, "Edmonia Lewis," *Harvard Magazine*, March-April 1986, 40. I wish to thank Ms. Richardson for clarifying many points about Lewis.

67. Grossman, "Two Saviors," 5.

68. *New York Evening Post*, Summer, 1864, quoted in *Harriet Hosmer: Letters and Memories*, 194.

69. Ellet, *Women Artists in All Ages and Countries*, p. 327.

70. I wish to thank Frederick A. Sharf for bringing this and other sources to my attention. Also see Frederick A. Sharf, "'A More Bracing Morning Atmosphere': Artistic Life in Salem, 1850–1859," Essex Institute Historical Collections 95 (April 1959): 160–63.

71. Hawthorne, *French and Italian Notebooks*, 77–78.

72. Ibid., 78.

73. Ibid. The 1858 Pocket Diary, 13 April 1858, 591.

74. Nathaniel Hawthorne, *The Marble Faun: or, the Romance of Monte Beni* (Boston: James R. Osgood & Co., 1873) 159. ". . . you sculptors are . . . the greatest plagiarists in the world."

75. Letters of Hawthorne to William D. Ticknor, 1851–1864 (Newark, N.J.: Carteret Book Club, 1910) 2:72, quoted in John L. Idol, Jr., and Sterling Eisiminger, "Hawthorne Sits for a Bust," *Essex Institute Historical Collections* 114, 1978:207–12.

76. Letters of John Rogers, Jr., courtesy the New York Historical Society, 14 December 1858. Art historian Wayne Craven must be credited with unearthing the fact that Lander was being harassed by scandal and gossip. He excerpted references to it from John Rogers's letters in *Sculpture in America* (New York: Thomas Crowell, 1968), 332–33. Idol and Eisiminger, in "Hawthorne Sits for a Bust," further documented the sequence of events surrounding Hawthorne's change of heart about Lander and her bust of him. Additional material from Rogers's letters, presented here, indicates the kind of gossip that was circulating. In a recently discovered typescript of a letter from Hawthorne to Lander and her sister, dated 13 November 1858, Hawthorne says that he cannot admit her to his house, "with its children," until she clears her name. See Nathaniel Hawthorne, *The Letters, 1857–1864*, ed. Thomas Woodson, James A. Rubino, L. Neal Smith, and Norman Holmes Pearson, vol. 28, The Centenary Edition of the Works of Nathaniel Hawthorne (Columbus: Ohio State University Press, 1987), 158–59. I wish to thank Dr. L. Neal Smith for bringing this letter to my attention.

77. Letters of John Rogers, Jr., courtesy the New York Historical Society, 14 December 1859 and 13 February 1959.

78. Julian Hawthorne, *Hawthorne and His Wife* (Boston: Houghton Mifflin & Co., Riverside Press, 1882), 2:183.

79. Hawthorne, *French and Italian Notebooks*, 741.

80. Ellet, *Women Artists in All Ages and Countries*, 332.

81. "A Salem Artiste in Rome," *Salem Register,* 1858; from the files of the James Duncan Phillips Library, Essex Institute, Salem, Mass.

82. *The National Statue, Virginia Dare,* exhibition catalog, Studio Building, Boston, ca. 1863? Frederick West Lander Papers, Special Collections, University of Nevada-Reno Library. Art historian Biruta Erdmann is working on a biography of Lander. She has given papers on the theme of Lander's statue as a symbol of the young American nation.

83. "A Salem Artiste in Rome."

84. *The National Statue, Virginia Dare.*

85. "A Salem Artiste in Rome."

86. Frederick Lander, clipping from the *Boston Advertiser,* Frederick Lander papers, Special Collections, University of Nevada-Reno Library.

87. Ellet, *Women Artists in All Ages and Countries,* 348.

88. Joseph Leach, *Bright Particular Star: The Life and Times of Charlotte Cushman* (New Haven: Yale University Press, 1970), 272.

89. Francis Power Cobbe, *Fraser's Magazine,* October 1865, 422.

90. James T. Fields, *Biographical Notes and Personal Sketches* (Boston: Houghton Mifflin & Co., 1881), 74.

91. Georg Brandes, *Reminiscences of My Childhood and Youth* (New York: Duffield, 1906), 323. The following account of Ream's early life is pieced together from various contradictory magazine articles and other sources, but no thorough biography of Ream has as yet been written.

92. Gordon Langley Hall, *Vinnie Ream: The Story of the Girl Who Sculptured Lincoln* (New York: Holt, Rinehart and Winston, 1963), 33. Almost identical material appears in a 1913 interview with Ream in the *Sunday Star,* Washington, 9 February 1913, quoted in Richard L. Hoxie, *Vinnie Ream* (privately printed, 1908/1915), 59–60.

A few scholars have suggested that Ream embroidered and exaggerated the facts or may never have had sittings from Lincoln. There are, however, many contemporary references to it. Ream told some of the same details to Charles Fairman, author of *Art and Artists of the Capitol* (Washington, D.C.: U.S. Government Printing Office, 1927), 235. One account states that she made sketches in the President's office over a period of five months, but the clay model of the bust was not finished at the time of Lincoln's assassination. For an accurate discussion, see Joan Lemp, "Vinnie Ream and Abraham Lincoln," *Woman's Art Journal,* Fall 1985, 24–29.

93. From an 1871 clipping, quoted in Joan Lemp, "Vinnie Ream and Abraham Lincoln," 25.

94. Gordon Langley Hall, *Vinnie Ream,* 45. See also Joan Lemp, "Vinnie Ream and Abraham Lincoln," 27, who quotes slightly different material from an unidentified article by Swisshelm: "Miss Vinnie Ream," 16 January 1867, in Box 8, Vinnie Ream Hoxie Papers, Library of Congress. Lemp discusses the political forces acting on Ream and describes how Harriet Hosmer and certain feminist groups came to her defense. See also Stephen W. Stathis and Lee Roderick, "Mallet, Chisel and Curls," *American Heritage,* February 1976.

95. This and following details are from "Vinnie Ream: The Lincoln Statue," *Weekly Star,* Washington, D.C., 13 January 1871. Clipping in the Vinnie Ream Hoxie Papers, Manuscript Division, Library of Congress.

96. *Il Buonarroti,* February 1870, quoted in Hoxie, *Vinnie Ream,* 8.

97. Brandes, *Reminiscences of My Childhood and Youth,* 318.

98. Ibid., 323.

99. Ibid., 320–21.

100. Hoxie, *Vinnie Ream,* 27.

101. Box 5, Papers of Vinnie Ream and Richard L. Hoxie, Library of Congress, Ms. Division. Most of

this material is in Ream's speech, "Lincoln and Farragut," reprinted in Mary K. O. Eagle, *The Congress of Women* (Chicago: International Publishing Co., 1894) 604–8.

102. "The Field of Sculpture for Women," an address before the International Council of Women, Toronto, Canada, 30 June 1909.

103. Hoxie, *Vinnie Ream,* 41.

104. Ibid.

105. O. B. Campbell, *The Story of Vinnie Ream* (Vinita, Okla.: Eastern Trails Historical Society, n.d.), 24. Contains details of Ream's early life and friendships with Native Americans, such as the Cherokee leader Elias C. Boudinot.

106. Moses Ezekiel, *Memoirs from the Baths of Diocletian* (Detroit: Wayne State University Press, 1975), 214.

107. "The Field of Sculpture for Women."

108. Lucy Larcom, *An Idyl of Work* (Boston: James R. Osgood, 1875), 177.

109. "American Studios in Rome and Florence," *Harper's New Monthly Magazine* 33 (June 1866):103.

110. Elsie B. Chatterton, "A Vermont Sculptor," *News and Notes, Vermont Historical Society,* 7, no. 2 (October 1955):11. This article describes Foley's early relationship with Tucker.

111. Quoted in Eleanor Tufts, "Margaret Foley's Metamorphosis: A Merrimac 'Female Operative' in Neo-Classical Rome," *Arts,* January 1982, 91. This is the principal scholarly source about Foley. See also Tufts's *American Women Artists: 1830–1930* (National Museum of Women in the Arts, 1987), 104–6.

112. Ibid., 92.

113. Unsigned letter, 1878, at Bixby Library, Vergennes, Vermont, quoted in Tufts, "Foley's Metamorphosis," 94.

114. *Mary Howitt: An Autobiography,* ed. Margaret Howitt (Boston and New York: Houghton Mifflin Co., 1889), 252.

115. Harriet Robinson, *Loom and Spindle,* 1898, quoted in Tufts, "Foley's Metamorphosis," 93.

116. Emily Cutrer, *The Art of the Woman: The Life and Work of Elisabet Ney* (Lincoln: University of Nebraska Press, 1988), the source of many details on Ney's life. Includes extensive bibliography and archival sources.

117. "Mistress of Her Art: Elisabet Ney of Texas, Long Famous as Sculptor," *Washington Post,* 22 May 1904, part 4, p. 1. Quoted in Cutrer, *The Art of the Woman,* 2.

118. Vernon Loggins called them this in *Two Romantics and Their Ideal Life* (New York: Odyssey Press, 1946).

119. Hermann Hüffer, "Mlle Elisabet Ney," Kölnischen *Zeitung,* 6 October 1862, n.p.

120. Elisabet Ney, "My Time with the General Garibaldi," unpublished memoir, Ney Montgomery Papers, the Texas Collection, Baylor University, Waco, Texas.

121. Ibid.

122. Edward Strahan, *The Masterpieces of the Centennial International Exhibition* (Philadelphia: Gebbie, Barrie, 1876; reprint, New York: Garland, 1977), 1:55.

123. Archives, Pennsylvania Historical Society.

124. Lorado Taft, *History of American Sculpture,* rev. ed. (New York: Macmillan, 1925), 213.

125. Files of the Architect of the Capitol.

126. "Lady-Artists in Rome," *Art Journal* (London), March 1866, 177.

127. Milton Brown et al., *American Art: Painting, Sculpture, Architecture, Decorative Arts, Photography* (New York: Harry N. Abrams, 1979), 326.

128. C. L. Willis, "An Art-Walk in Rome," *Art Journal* 1 (London, 1875):282.

129. Ibid.

130. See James Freeman, Appleton's *Cyclopaedia of American Biography,* vol. 2 (New York: D. Appleton, 1888), 540.

131. *The Revolution,* 11 May 1871, quoted in Clara Erskine Clement Waters and Laurence Hutton, *Artists of the Nineteenth Century and Their Works* (Houghton, Osgood & Co., 1879), 1:270.

132. "Lady Artists in Rome."

Chapter 4

1. Le Corbusier, *When the Cathedrals Were White* (New York: Reynal & Hitchcock, 1947), 60, quoted in *The American Renaissance: 1876–1917* (New York: Pantheon Books, 1979), 109.

2. I am grateful to Lois Fink at the National Museum of American Art, an authority on Americans in the French salon, for this information.

3. Janet Scudder, *Modeling My Life* (New York: Harcourt Brace & Co., 1925), 155, 165, 292–93.

4. Burke Wilkinson, *Uncommon Clay: The Life and Works of Augustus Saint-Gaudens* (San Diego: Harcourt Brace Jovanovich, 1985), 251.

5. Scudder, *Modeling My Life,* 58.

6. Lorado Taft, *The History of American Sculpture* (New York: Macmillan Co., 1924), 490.

7. Ibid., 579.

8. Henry Hudson and Theo Alice Ruggles Kitson Papers, Roll 3930, Archives of American Art/Smithsonian Institution.

9. Fay L. Hendrey, *Outdoor Sculpture in Grand Rapids* (Grand Rapids, Mich.: Iota Press, 1980). I wish to thank Samuel Hough, archivist of the Gorham Company papers, John Hay Library, Brown University, for informing me that casts of *The Hiker* were made for approximately forty-eight cities by the Gorham bronze foundry. See also Kathryn Greenthal's entry in *American Figurative Sculpture in the Museum of Fine Arts, Boston* (1986), 304–5. The Gorham bronze casting company paid the artist royalties. *The Hiker* stands on the Avenue of Heroes, approaching Arlington National Cemetery.

10. Landon Haynes, "To Julia Bracken Wendt," *Los Angeles Times*, 9 March 1924, magazine sec., 8.

11. Landon Haynes, "California Women of Distinction: Julia Bracken Wendt," *Los Angeles Times,* 9 March 1924, sec. 3, 8.

12. Reproduced in Everett C. Maxwell, "The Art of Julia Bracken Wendt, Noted Sculptures," *Fine Arts Journal,* November 1910, 278.

13. "Art and Artists," *Los Angeles Times,* 26 December 1909, sec. 3, 14.

14. Gretchen Sibley, "An Heroic Sculpture Hidden beneath the Minerals," *Terra* (Bulletin of Los Angeles County Museum of Natural History) 14, no. 1 (Summer 1975):12.

15. Ibid., 9.

16. Anthony Anderson, "Art and Artists," *Los Angeles Times,* 20 July 1913, sec. 3, 2.

17. Arthur Millier, "Our Artists in Person: Julia Bracken Wendt," *Los Angeles Times,* 26 November 1931, sec. 3, 16.

18. Maxwell, "The Art of Julie Bracken Wendt," 278. For a bibliography see Moure and Smith, *Dictionary of Art and Artists in Southern California before 1930.*

19. Taft, *The History of American Sculpture,* 528.

20. Bessie Potter Vonnoh, "Tears and Laughter Caught in Bronze: A Great Woman Sculptor Recalls Her Trials and Triumphs," *Delineator,* October 1925, 9.

21. Ibid., 8.

22. Janis Conner and Joel Rosenkranz, *Rediscov-*

eries in American Sculpture: Studio Works, 1893–1939 (Austin: University of Texas Press, 1989), 161, 163. See also Roslye B. Ultan, "Bessie Potter Vonnoh, American Sculptor (1872–1955)" (M.A. thesis, American University). Extensive bibliography and lists of works and exhibitions.

23. Vonnoh, "Tears and Laughter," 8.

24. Ibid.

25. Ibid., 9. This anecdote shows Potter's support of suffrage and her interest in dress reform.

26. Ibid.

27. May Brawley Hill, *The Woman Sculptor: Malvina Hoffman and Her Contemporaries* (New York: Berry Hill Galleries, 1984), 13.

28. Vonnoh, "Tears and Laughter," 9.

29. Ibid., 78.

30. Lorado Taft, "Women Sculptors of America," *Mentor,* 1 February 1919, 10.

31. Laura Hayes, Jean Loughborough, and Enid Yandell, *Three Girls in a Flat* (Chicago: Knight, Leonard & Co., 1892).

32. Ibid. See also the Caldwell catalog, listed in note 34.

33. Ibid., 109. Yandell's heroine describes seeing Hosmer's *Zenobia* (now lost) in Mrs. Palmer's home, indicating that turn-of-the-century women sculptors were well aware of their female predecessors.

34. Joseph May, "Miss Enid Yandell," *Paris World,* 6 September 1902, quoted in Désirée Caldwell, *Enid Yandell and the Branstock School* (Providence: Rhode Island School of Design, 1982), 6. Caldwell's catalog is the source of many details and contains a list of Yandell's works.

35. Richard Ladegast, "Enid Yandell, the Sculptor," *Outlook* 70 (4 January 1902):80–84.

36. Caldwell, *Enid Yandell and the Branstock School,* 7.

37. Taft, *History of American Sculpture,* 451.

38. Letter from Augustus Saint-Gaudens, 16 March 1900, Dartmouth College Archives, quoted in Susan Porter Green, *Helen Farnsworth Mears* (Oshkosh: Paine Art Center and Arboretum, 1972), 51.

39. Ladegast, "Enid Yandell."

40. "When a Kiss Is Not a Kiss," *Brooklyn Daily Eagle,* 14 July 1901, cited in Caldwell.

41. "Sculptress Comes to Chicago to Help Orphans of War," *Chicago-Tribune,* 11 November 1915, courtesy archives, Louisville Free Public Library.

42. "Get Married, Girls!" *Cincinnati Enquirer,* 6 December 1903, sec. 5, p. 5. See also Jean Coady, "Woman Sculptor's Career Lives on in Her Work," *Louisville Courier-Journal,* 20 December 1977. Obituary, *Art Digest,* August 1934, p. 23, mentions "nervous collapse."

43. Inez Hunt, *The Lady Who Lived on Ladders* (Palmer Lake, Colorado: Filter Press, 1970), 26.

44. Ibid., 2.

45. Quoted in Louise Noun, "Making Her Mark: Nellie Verne Walker, Sculptor," *The Palimpsest,* Winter 1987, 161. The source of many details.

46. Inez Hunt, *The Lady Who Lived on Ladders,* 10.

47. *Art and Progress,* April 1912, 550.

48. Florence Wilterding, "Jean Pond Miner Coburn," in *Famous Wisconsin Women* (Madison: State Historical Society of Wisconsin Women's Auxiliary, 1976), 6:4–9. Swedish-born Agnes Fromen also studied with Taft. She taught at Hull House and won many awards.

49. Quoted in Susan Faxon Olney et al., *A Circle of Friends: Art Colonies of Cornish and*

Dublin (Durham: Art Galleries, University of New Hampshire, 1985), 52.

50. *New York Sunday Tribune,* 11 August 1907, quoted in Olney, *A Circle of Friends.*

51. Frances Grimes, "Reminiscences," in ibid., 40.

52. Lucia Fairchild Fuller, "Frances Grimes: A Sculptor in Whose Work One Reads Delicacy and Intelligence," *Arts and Decoration* 14 (November 1920):34.

53. "Cornish Lady, Sister-in-Law of St. Gaudens, Notorious for Sculpturing," unidentified news clipping, Daniels Scrapbook, courtesy of Saint-Gaudens National Historic Site, Cornish, New Hampshire.

54. Ibid.

55. Ibid.

56. Quoted in Beatrice Gilman Proske, *Brookgreen Gardens Sculpture* (Murrells Inlet, South Carolina: Brookgreen Gardens, 1968), 13.

57. Wilkinson, *Uncommon Clay,* 248.

58. Ibid., 249.

59. Ibid., 250.

60. Proske, *Brookgreen Gardens,* 13.

61. Chris Petteys, *Dictionary of Women Artists: An International Dictionary of Women Artists Born before 1900* (Boston: G. K. Hall & Co., 1985), 702.

62. Wilkinson, *Uncommon Clay,* 251.

63. Susan Porter Green, *Helen Farnsworth Mears* (Oshkosh: Paine Art Center and Arboretum, 1972), 54.

64. Ibid., 119.

65. See Jeanne Madeline Weimann, *The Fair Women* (Chicago: Academy Chicago, 1981), 479–86.

66. Letter from Saint-Gaudens to Helen Mears, Paris, 28 January 1900, Dartmouth College Library. Art historian Diane Fischer informs me that Peddle and two male sculptors assisted Alexander Phimister Proctor on the quadriga that decorated the United States building.

67. Taft, *The History of American Sculpture,* 576.

68. Katherine Smith Chafee (Warren), "Women Artists in Colorado 1860–1960," in *Colorado Women in the Arts* (Boulder: Colorado Women in the Arts, 1979), 21.

69. Homer Saint-Gaudens, ed. *The Reminiscences of Augustus Saint-Gaudens* (New York: Century Co., 1913), 2:354–55. See also Proske, *Brookgreen Gardens,* 127–28.

70. Mary Eagle, *The Congress of Women at the World's Columbian Exposition* (Chicago: International Publishing Co., 1894), 430.

71. Edith Mayo, "Adelaide Johnson," in *Notable American Women: The Modern Period* (Cambridge: Harvard University Press, 1980), 380. The Johnson papers are at the Library of Congress and the Smithsonian Division of Political History.

72. Ibid.

73. Mary Annabale Fanton, "Clio Bracken: Woman Sculptor and Symbolist of the New Art," *Craftsman,* July 1905, 473.

74. Ibid. Many details of the Hunekers' life together are from Arnold Schwab, *James Gibbons Huneker, Critic of the Seven Arts* (Stanford, 1963). I am grateful to Mr. Schwab for sharing other clippings and sources with me.

75. Ibid.

76. Quoted in Proske, *Brookgreen Gardens Sculpture,* 45.

77. Grace Whitworth, "A Woman Sculptor of Genius," *Current Literature* 40 (January 1906):44.

78. "Mrs. Cadwalader Guild's Recent Sculptures," *International Studio*, December 1905, xliv.

79. Whitworth, "A Woman Sculptor of Genius," 43.

80. Walter Smith, *Industrial Art*, vol. 2 of *The Masterpieces of the Centennial International Exhibition* (Philadelphia 1877), 95–96, 280, quoted in Roger Stein's excellent essay "Artifact as Ideology" in *In Pursuit of Beauty: Americans and the Aesthetic Movement* (New York: Metropolitan Museum of Art and Rizzoli, 1986), 30.

81. Anthony R. Anderson, "Art and Artists," *Los Angeles Times*, 13 January 1907, sec. 6, 2.

Chapter 5

1. The women who participated in the exhibition mounted by the Plastic Club of Philadelphia in 1916 included Margaret Achelis, Louise Allen (war memorials, tablets, garden sculpture), Lillian Baer, Caroline Peddle Ball, Emily Clayton Bishop, Johanna Boericke, Effie Frances Braddock, Elizabeth Palmer Bradfield, Katherine Cohen, Nessa Cohen, Myra Musselman Carr, Mabel Conkling, Mary Elizabeth Cook (work in public buildings, Columbus, Ohio; medal in Paris salon for 600 life masks and 500 models for reconstruction of faces of World War I soldiers), Martha Jackson Cornwell, Marjory Curtis, Sally James Farnham, Beatrice Fenton, Laura Gardin Fraser, Harriet Frishmuth, Frances Grimes, Anna Glenny, Bridgett Guiness, Malvina Hoffman, Martha Hovenden (work in Washington Memorial Chapel, Valley Forge, Pa.), Edith Howland, Anna Vaughn Hyatt (later Huntington), Maude Jewett, Grace Mott Johnson, Isabel Moore Kimball (memorial tablets and *Wenonah* fountain in Winona, Minnesota), Anne Meredith Kitson, Jess M. Lawson (born Edinburgh, Scotland, won 1918 National Academy of Design Barnett prize and 1919 Pennsylvania Academy of Fine Art Widener medal), Florence Lucius (later Mrs. Jo Davidson, work in Whitney Museum of American Art), Anna Coleman Ladd, Mary Middleton Laessle, Roma Lewis, Evelyn Longman, Harriet Hyatt Mayor, Virginia McKee, Helen Mears, Geneva Mercer, Helen Morton, Olga Popoff Muller, Grace Purden Neal, Elizabeth Norton, Bashka Paeff, Edith Barretto Parsons, Dorothy Rice Pierce, Renee Prahar, Brenda Putnam, Lucy Currier Richards, Lucy Perkins Ripley, Mary M. Ryerson, Helen Sahler (medalist), Janet Scudder, Sylvia Shaw (later Judson), Eugenie Shonnard, Lindsey M. Sterling, Katherine Beecher Stetson, Annetta St. Gaudens, Helen Fox Trowbridge, Bessie Potter Vonnoh, Winifred D. Ward, Leila A. Wheelock, Laura Chanler White, Gertrude V. Whitney, Alice Morgan Wright. (I owe a debt of remembrance to the late Philadelphia librarian Hazel Gustow, who located this list for me.)

Lorado Taft noted in the 1924 edition of *The History of American Sculpture* that there were already more than one hundred professional women sculptors in New York City alone and that others were working around the country. Belle Kinney (Scholz) carried out monuments to southern leaders, including *Andrew Jackson* in the U.S. Capitol; Bay Area sculptor Gertrude Boyle Kanno did portraits of John Muir, Jack London, and others, as well as symbolist figures; British artist Marie Apel became a well-known New York City portrait sculptor; Nancy Cox-McCormack Cushman completed the *Carmack Memorial* for Nashville, Tennessee, and portraits of Mahatma Gandhi, Mussolini, and others; Nanna Mathews Bryant created flowing symbolist marble images; Mabel Landrum Torrey, whose *Wynken, Blinken and Nod* fountain is in Denver's Washington Park, collaborated on monuments with her husband; Philadelphian Louisa Eyre did memorial plaques and bronze children's portraits; Waldine Tauch made many public monuments for San Antonio and other Texas cities. (See Alice Hutson, *From Chalk to Bronze: A Biography of Waldine Tauch*, 1978.) American born Olga Popoff Muller studied in Russia, Germany, and Paris before finally settling in Bridgehampton, Long Island. Her romantic Rodinesque marbles were shown in Paris salons (1911, 1914) and at the Panama-Pacific International Exposition (*Centaur, Idyl, Primitive Man, Meditation* and *Head of Breton*), where she won a bronze medal. Eleanor M. Mellon carried out ecclesiastical statues.

2. Ada Rainey, "Fountains of Janet Scudder," *House Beautiful*, January 1914, 35:sup. 24.

3. Janet Scudder, *Modeling My Life* (New York: Harcourt, Brace & Co., 1925), 5.

4. Ibid., 46.

5. Ibid., 172.

6. "Janet Scudder Tells Why So Few Women Are Sculptors," *New York Times,* Sunday, 18 February 1912, part 4, p. 13.

7. Ibid., 13.

8. Ibid., 13.

9. Ibid., 13.

10. Loring Holmes Dodd, *The Golden Age of American Sculpture* (Boston: Chapman & Grimes, 1936), 53.

11. Letter from Frishmuth's companion-secretary, Ruth Talcott, 1986.

12. Ruth Talcott, ed., "Harriet Whitney Frishmuth, 1880–1980," *National Sculpture Review,* Summer 1980, 22. This may be the same Mrs. Hinton who was Clio Bracken's mother. See chapter 4. This article was adapted from an article in *Courier,* the Syracuse University library periodical. See note 14.

13. Ibid., 23.

14. "Harriet Whitney Frishmuth, American Sculptor," *Courier* (Syracuse University Library Associates) 9, no. 1 (October 1971):23. Consists of excerpts from Frishmuth's reminiscences, tape-recorded in 1964.

15. Charles N. Aronson, *Sculptured Hyacinths* (New York: Vantage Press, 1973), 130.

16. Ibid., 130.

17. Quoted in her obituary, *New York Times,* 1 January 1980.

18. Anne D'Harnoncourt, *Philadelphia: Three Centuries of American Art* (Philadelphia: Philadelphia Museum of Art, 1976), 522.

19. Anna Seaton-Schmidt, "Anna Coleman Ladd: Sculptor," *Art and Progress,* July 1911, 251. See also Paula Kozol's perceptive essay in *American Figurative Sculpture in the Museum of Fine Arts,* Boston (1986), the source of many details. An extensive vertical file of clippings and illustrations is in the National Museum of American Art library.

20. Rilla E. Jackman, *American Arts* (New York: Rand McNally, 1928), 447.

21. See A. Hyatt Mayor, *A Century of American Sculpture: Treasures from Brookgreen Gardens* (New York: Abbeville Press, 1987), 24. Huntington's nephew, A. Hyatt Mayor, who became a distinguished art historian and curator, wrote a delightful introductory essay about his aunt and her husband, Archer Huntington.

22. Ibid., 24–25.

23. *New York Times,* 31 December 1905, sec. 3, 6.

24. J. Walker McSpadden, *Famous Sculptors of America* (New York: Dodd, Mead & Co., 1925), 347.

25. Doris E. Cook, *Woman Sculptor: Anna Hyatt Huntington (1876–1973)* (Hartford, Conn.: Privately published, 1976), 9–10. Cook's book contains a good bibliography and lists exhibitions, awards, more than 200 of the prolific artist's works, and over 200 museums that own her work.

26. Ibid., 13.

27. Ibid., 13. The Institute of Arts and Letters.

28. Ibid., 13.

29. Mayor, *A Century of American Sculpture,* 25. For a good account of Huntington's career, see Janis Conner and Joel Rosenkranz, *Recent Discoveries in American Sculpture* (Austin: University of Texas Press, 1989), 71–77.

30. Lecture, 20 September 1972, Peabody Museum, partly quoted in Louise Todd Ambler, *Katherine Lane Weems: Sculpture and Drawings.* (Boston: Boston Athenaeum, 1987), 101.

31. Katherine Lane Weems, *Odds Were Against Me* (New York: Vantage Press, 1985).

32. Gertrude Lathrop, "Animals in Sculpture," *National Sculpture Review* 15, no. 3 (Fall 1966):8.

33. Michael Richman, *Daniel Chester French: An American Sculptor* (New York: Metropolitan Museum of Art, 1977), 195. See also Mrs. Daniel Chester French, *Memoirs of a Sculptor's Wife.*

34. *New York Times,* 22 January 1932, p. 14.

35. A.T.&T. news release, 27 September 1984.

36. Malvina Hoffman, *Yesterday Is Tomorrow, A Personal History* (New York: Crown Publishers, 1965), 33.

37. Ibid., 58.

38. Ibid., 72.

39. Ibid., 75.

40. Ibid., 115.

41. Linda Nochlin, "Malvina Hoffman: A Life in Sculpture," *Brearley Bulletin* 59, no. 2 (Spring 1984):8.

42. Hoffman, *Yesterday Is Tomorrow,* 108.

43. Diary entry, in Janis Conner, *A Dancer in Relief: Works by Malvina Hoffman,* Hudson River Museum, 1984, n.p. A penetrating study of the relationship between the dancer and the sculptor. Hoffman's papers are at the J. Paul Getty Center for the History of Art and Humanities.

44. Malvina Hoffman, *Heads and Tales* (New York: Charles Scribner's Sons, 1936), 145.

45. Ibid., 307.

46. Today anthropologists take a different, much more flexible view of "race." The Field Museum chooses not to reconstruct the full display, because in today's political climate it could prove offensive and might be viewed as a racist installation. See Pamela Hibbs Decoteau, "Malvina Hoffman and the 'Races of Man,'" *Woman's Art Journal* (Fall 1989/Winter 1990), 7–12.

47. Hoffman, *Yesterday Is Tomorrow,* 140–41.

48. B. H. Friedman, with the research collaboration of Flora Miller Irving, *Gertrude Vanderbilt Whitney* (Garden City, N.Y.: Doubleday & Co., 1978), 33, 62.

49. Ibid., 49.

50. Ibid., 96–97.

51. Ibid., 254.

52. Ibid., 179.

53. Hoffman, *Yesterday Is Tomorrow,* 73.

54. Gertrude Whitney, "The End of America's Apprenticeship," *Arts and Decoration* 13 (August 1920):150–51.

55. *New York Times,* 16 April 1915, 7:1, quoted in Friedman, 367.

56. "Poor Little Rich Girl and Her Art: Mrs. Harry Payne Whitney's Struggles to Be Taken Seriously as a Sculptor without Having Starved in a Garret," *New York Times,* 9 November 1919, magazine sec., 7.

57. Whitney Museum of American Art, Gertrude Vanderbilt Whitney Papers, gift of Flora Miller Biddle, Archives of American Art/Smithsonian Institution, Roll N/693, frame 0551.

58. Friedman, *Gertrude Vanderbilt Whitney,* 520. Whitney had a very high opinion of O'Connor's talent. Adviser/assistant on large projects and an intimate friend as well, O'Connor had a liaison with Whitney that was one of several discussed in Friedman's biography.

59. Emily Genauer, "Two Whitney Sculptures First-Rate. Romantic, Decorative Conception, However, Mars Many of Works Shown at Knoedler's," *World Telegram,* 19 or 21 March 1936.

60. Quoted in Dean Krakel, *End of the Trail* (Nor-

man: University of Oklahoma Press, 1973), 32. Contains a list of the artist's works.

61. Ibid., 34.

62. Ibid., 38.

63. Ibid., 52.

64. Ibid., 99. See also Dean Krakel, *Adventures in Western Art* (Kansas City: Lowell Press, 1977).

65. I am grateful to Calvin McCoy Hennig for permitting me to use these and other details from his "Outdoor Public Commemorative Monuments of Syracuse, New York" (Ph.D. diss., Syracuse University, 1983). This dissertation also contains some documentation about Theo Kitson's Spanish American War Memorial.

66. Ibid., 178.

67. Robert Freeman and Vivianne Lasky, *Hidden Treasure: Public Sculpture in Providence* (Providence: Rhode Island Bicentennial Foundation, 1980), 26.

68. Letter to the author, 1983.

69. Freeman Murray, *Emancipation and the Freed in American Sculpture: A Study in Interpretation* (Washington, D.C.: privately printed, 1916). Reprint, Black Folk in Art Series (Freeport: Books for Libraries Press, 1972), 56–57. Contains a picture of Fuller's *Emancipation Proclamation.*

70. David Driskell, *The Harlem Renaissance* (New York: Studio Museum in Harlem, 1987), 108.

71. Samella Lewis, *Art: African American* (New York: Harcourt Brace Jovanovich, 1978), 52.

72. Guy C. McElroy, *Black Women Visual Artists in Washington, D.C.* (Washington, D.C.: The Bethune Museum-Archives, Inc., 1987), 3.

73. Arna Bontemps and Jacqueline Fonvielle-Bontemps, *Forever Free: Art by African-American Women, 1862–1980* (Normal: Illinois State University, 1980), 21.

74. "Poetry and Sculpture," *The Crisis,* September 1927, 231.

75. W. E. B. Du Bois, "Postscript: May Howard Jackson," *The Crisis,* October 1931, 351. Guy McElroy states that Jackson often created "idealized images of mulattos." She was perhaps criticized for this by her African American friends; on the other hand, her work would not be accepted by white galleries either. Many African American writers and artists have probed the painful conflicts and problems faced by people of mixed heritage. Charles Waddell Chesnutt dealt with this theme in his turn-of-the-century novels. Contemporary artist Adrian Piper, who has worked with the subject of "otherness" in performance art and assemblages, wrote a powerful account of how it felt to grow up as a very light-skinned African American: "In reality I've been bullied by whites as well as blacks for the last three hundred years" ("Political Self-Portrait #2," *Heresies* 2, no. 4 [1979]: 38). Sculptor Barbara Chase-Riboud has written about miscegenation in her novels (*Sally Hemings* was about Thomas Jefferson and his slave mistress), and her abstract sculptures metaphorically show the "mixing" of opposing forces. She points out that America has always been a racially mixed country, although this remains a taboo subject. There is not even a proper American word to describe the person of mixed heritage; "mulatto" or "mulatta" comes from the word "mule," a mixture of a horse and donkey. Betye Saar and her daughter Alison Saar touch on the idea of the "gray experience" (as opposed to the "black experience") in *The House of Gris Gris* (1990), a magnificent collaborative installation.

76. See Rebecca Sisler, *The Girls* (Toronto: Clarke, Irwin & Co., 1972) and Christine Boyanoski, *Loring and Wyle: Sculptor's Legacy* (Art Gallery of Toronto, 1987).

Chapter 6

1. Mabel Dodge Luhan, *Movers and Shakers*, vol. 3 of *Intimate Memories* (New York: Harcourt Brace & Co., 1936), 83.

2. Christina Merriman, "New Bottles for New Wine:

The Work of Abastenia St. Leger Eberle," *The Survey,* 3 May 1913, 196.

3. "Which Is True Art?" *Washington Post,* 6 February 1916, 4.

4. Letter from Eberle to R. G. McIntyre, n.d., Macbeth Gallery records, Archives of American Art. Quoted in Louise R. Noun, *Abastenia St. Leger Eberle: Sculptor (1878–1942)* (Des Moines, Iowa: Des Moines Art Center, 1980). This catalog *raisonné* is the source of many details.

5. "Women Artists in a Naples Factory," *New York Sun,* 30 July 1911, 6. From the files of Kendall Young Library, Webster City, Iowa.

6. R. G. McIntyre, "The Broad Vision of Abastenia Eberle," *Arts and Decoration,* August 1913, 337.

7. *New York Times,* 1 March 1914, 11.

8. Noun, *Abastenia St. Leger Eberle,* 14.

9. Leslie Katz, *The Sculpture of Ethel Myers* (New York: Robert Schoelkopf Gallery, 1963).

10. Courtesy of Saul E. Zalesch, unpublished paper on Ethel Meyers, University of Delaware.

11. Ibid.

12. "At the Folsom Galleries," *Craftsman* 23 (October-March 1912–13):725–26.

13. Ibid., 726.

14. Betsy Fahlman, *Sculpture and Suffrage: The Art and Life of Alice Morgan Wright (1881–1975)* (Albany, N.Y.: Albany Institute of Art and History, 1978), 4. This excellent catalog *raisonné* is the source of many factual details and critical perceptions. See also Beatrice Proske, *Brookgreen Gardens.*

15. Douglas Hyland, "Adelheid Lange Roosevelt," *Avant-Garde Painting and Sculpture in America 1910–25,* ed. W. I. Homer (Wilmington, Del.: Delaware Art Museum, 1975), 122.

16. Douglas Hyland, "Adelheid Lange Roosevelt: American Cubist Sculptor," *Archives of American Art Journal* 4 (1981):11. The source of many details and critical perceptions.

17. Ibid., 13.

18. Douglas Hyland, "Adelaide Lange Roosevelt," in Homer, *Avant-Garde Painting,* 122.

19. Harvey Watts, *Philadelphia Public Ledger,* 10 April 1917, quoted in Francis Naumann, "The Big Show: The First Exhibition of the Society of Independent Artists," *Artforum,* April 1979, 34–39.

20. Robert Reiss, "Freytag-Loringhoven, Baroness-Elsa von," in Chris Petteys, *Dictionary of Women Artists* (Boston: G. K. Hall & Co., 1985), 263.

21. Robert Reiss, "My Baroness: Elsa von Freytag-Loringhoven," in *New York Dada,* ed. Rudolf E. Kuenzli (New York: Willis, Locker, & Owens, 1986), 81–101.

22. William C. Agee, *Morton Livingston Schamberg: The Machine Pastels* (New York: Salander-O'Reilly Galleries, 1987). Also Reiss, "My Baroness," 88.

23. Ibid.

24. Margaret Anderson, *My Thirty Years' War* (New York: Covici, Friede, 1930), 178.

25. Dickran Tashjian, *Skyscraper Primitives: Dada and the American Avant-Garde, 1910–1925* (Middletown, Conn.: Wesleyan University Press, 1975), 101. Describes the Williams-Loringhoven caper.

26. George Biddle, *An American Artist's Story* (Boston: Little, Brown & Co., 1939), 137.

27. Ibid.

28. Ibid., 140.

29. From *Poetry* magazine, quoted in Jane Heap, "Dada," *Little Review,* Spring 1922, 46.

30. Ibid.

31. Else[sic] von Freytag-Loringhoven, *The Little Review* 6, no. 9 (January 1920):29.

32. *Little Review* 12, no. 2 (May 1929):35.

33. Janet Flanner, *Paris Was Yesterday* (New York: Viking, 1967), 40.

34. Quoted in Don Stanley, "She Remembers Dada," *Los Angeles Times Magazine*, 5 October 1986, 20.

35. W. H. De B. Nelson, "Aesthetic Hysteria," *International Studio*, June 1917, cxxv.

36. Harvey Watts, "'Greatest Ever' in Art Shows," *Philadelphia Public Ledger*, 10 April 1917, p. 4, quoted in Francis Naumann, *Beatrice Wood and Friends: From Dada to Deco* (New York: Rosa Esman Gallery, 1978).

37. Beatrice Wood, *The Autobiography of Beatrice Wood: I Shock Myself* (Ojai, California: Dillingham Press, 1985), 31. Duchamp undoubtedly influenced the ideas in this essay, but Wood apparently did the actual writing. She is insufficiently recognized as one of the trio who created *The Blindman.*

38. Anaïs Nin, review of Wood's show at the California Palace of the Legion of Honor, *Artforum*, January 1965, 25.

39. Garth Clark, "Luster: The Art of Ceramic Light," in *Beatrice Wood Retrospective* (Fullerton: California State University, 1983), 34.

40. "Four Examples of the Work of Edith Woodman Burroughs," *Arts and Decoration* 5 (March 1915), 190.

41. "At the Berlin," *New York Times Magazine*, 7 February 1915, 23.

42. Guy Pène du Bois, "Mrs. Whitney's Journey in Art," *International Studio* 76 (January 1923):353, as quoted in May Brawley Hill, *The Woman Sculptor* (New York: Berry-Hill Galleries, 1984), 11. Hill's fine catalog is an excellent source of information about the women who were creating small bronzes during this period.

43. Hill, *The Woman Sculptor,* 24, n.16.

44. Van Deren Coke, *Andrew Dasburg* (Albuquerque: University of New Mexico Press, 1979), 15.

45. Rilla E. Jackman, *American Arts* (New York: Rand McNally, 1928), 407.

46. *New York Times,* 21 April 1935.

47. Phone interview with Mrs. Alfred Dasburg, November 1986. See the *Townsman,* Pleasantville, New York, 30 July 1936, archives of Pleasantville Public Library. In a letter to the editor she demands that the local swimming pool be opened to black people. Such discrimination is not only illegal and un-American, she says, but is keeping her from pursuing her art, because she is unable to sketch African-Americans at the pool for a mural that she is working on. Reproduced on p. 3 is a fine head of her friend Jacques Isler. In another *Townsman* article, Johnson complains that she has a studio filled with plaster models that she is unable to cast because of the expense.

48. *International Studio,* April 1917, 8.

49. *New York Times,* 21 March 1926, sec. 8, 14.

50. Roberta Tarbell et al., *Vanguard American Sculpture* (Newark, N.J.: Rutgers University, 1979), 47.

51. Blossom Kirschenbaum, "Nancy Elizabeth Prophet," *Sage* 4, no. 1 (Spring 1987):45–52.

52. Ibid.

53. Countee Cullen, "Elizabeth Prophet: Sculptress," *Opportunity* 8 (July 1930):204–5.

54. Jean Patezon, *Le rayonnement intellectuel,* March–April 1931, 61; from the files of the Rhode Island School of Design.

55. "Nancy Prophet Wins Success as Sculptress," unidentified news item from library, Rhode Island School of Design, 8 July 1932, 10.

"Proper Burial for Sculptress," *Providence Sunday Journal,* 18 December 1960, tells of her rescue from a pauper's grave.

56. Quoted in Paul Walter, "Eugenie Shonnard," *American Magazine of Art,* October 1928, 555.

57. Helen Ferris and Virginia Moore, *Girls Who Did: Stories of Real Girls and Their Careers* (New York: E. P. Dutton & Co., 1927), 235.

58. Quoted in "Sculptural Fantasies to Lift after War Gloom," *Literary Digest,* 18 February 1922, 28.

59. Ibid.

60. Lula Merrick, "Lucy Perkins Ripley: Sculptor," *International Studio* 75 (March 1922):17.

61. David Levering Lewis, *Harlem Renaissance: Art of Black America* (Harlem: Studio Museum, 1987), 62.

62. Ernest Watson, "Hildreth Meière: Mural Painter," *American Artist,* September 1941, 7.

63. William Zorach, *Art Is My Life: The Autobiography of William Zorach* (Cleveland, Ohio: World Publishing Co., 1967), 78.

Chapter 7

1. Joseph Solman, "The Easel Division of the W.P.A. Federal Art Project," in *New Deal Art Projects: An Anthology of Memoirs,* ed. Francis V. O'Connor (Washington, D.C.: Smithsonian Institution Press, 1972), 120.

2. Preamble, catalog of the first sculpture exhibition of the Sculptors Guild, 1938.

3. Transcript of taped interview, 1978, courtesy of George Gurney. Subsequent quotes by Margoulies are from this interview.

4. Letter from Margoulies to the author, 13 January 1983.

5. William H. Pierson and Martha Davidson, eds., *Arts of the United States: A Pictorial Survey* (New York: McGraw-Hill, 1960), 95.

6. Concetta Scaravaglione, "My Enjoyment in Sculpture," reprinted in *The Sculpture of Concetta Scaravaglione* (Richmond: Virginia Museum of Fine Arts, 1941), 6.

7. Frank Crotty, "Wife of George Biddle Is Famed Artist," *Worcester* (Mass.) *Telegram,* 29 April 1956. See also Sardeau Papers, Archives of American Art, and clipping file, Pennsylvania Academy of the Fine Arts.

8. Letter from the artist, 1983.

9. Marion Walton, "A Sculptor Looks Ahead," *Magazine of Art,* July 1940, 420–23.

10. Letter to the author.

11. Letter from the artist, April 1983. Subsequent quotes by Walton are from this letter. Attacks on public sculptors were very common. See Marlene Park and Gerold Markowitz, *Democratic Vistas: Post Offices and Public Art in the New Deal* (Philadelphia: Temple University Press, 1984).

12. Eugenie Gershoy, "Fantasy and Humor in Sculpture," in *Art for the Millions,* ed. Francis O'Connor (Boston: New York Graphic Society, 1972), 93.

13. Raymond J. Steiner, "Profile on: Eugene Gershoy," *Art Times,* November 1984, 8.

14. This and other quotations by Judson are from Sylvia Shaw Judson, *For Gardens and Other Places* (Chicago: Henry Regnery, 1967), n.p.

15. *Bulletin of the Chicago Art Institute,* 1938.

16. Romare Bearden and Harry Henderson, *Six Black Masters of American Art* (Garden City, N.Y.: Doubleday & Co., 1972), 78. This excellent account contains a few errors that are corrected in Deirdre L. Bibby, *Augusta Savage and the Art Schools of Harlem* (New York Public Library, Schomburg Center for Research in Black Culture, 1988).

17. Ibid., 81.

18. Ibid. See also Deirdre L. Bibby, *Augusta Savage and the Arts School of Harlem.*

19. Arna Alexander Bontemps and Jacqueline Fonvielle-Bontemps, *Forever Free: Art by African-American Women, 1862–1980* (Normal: Illinois State University, 1980), 28.

20. DeWitt S. Dykes, Jr., "Savage, Augusta Christine," *Notable American Women: The Modern Period, A Biographical Dictionary,* ed. Barbara Sherman et al. (Cambridge, Mass., and London: The Belknap Press of Harvard University Press, 1980), 629.

21. Sylvia Paine, "Evelyn Raymond," *Warm Journal* (published by the Women's Art Registry of Minneapolis), Autumn 1982, 4.

22. Harold Callender, *Fun Tomorrow: The Story of an Artist and of a Way of Life* (privately printed, 1953).

23. Suzanne Haik Terrell, *Angela Gregory: A Sculptor's Life,* Southeastern Architectural Archives, Newcomb College, 1981, n.p.

24. Sharon Litwin, "She Breathes Life into Stone," *Times-Picayune,* 21 March 1981, sec. 5.

25. Ibid.

26. I am indebted to Lewis Hoyer Rabbage for this information about Helen Turner.

27. "Angela Gregory: Her Sculpture Is Her Life," New Orleans *Clarion Herald,* 8 January 1981, 8–9.

28. Marjorie Roehl, "Sculpture, the Love of Her Life," New Orleans *States-Item,* 19 October 1978, sec. D.

29. Vernon Gay and Marilyn Evert, *Discovering Pittsburgh's Sculpture* (Pittsburgh: University of Pittsburgh Press, 1983), 100.

30. Quoted in Obituary, *Los Angeles Times,* 11 March 1983.

31. Letter to Balcomb Greene, 1926, in Linda Hyman, *Gertrude Greene: Constructions: Collages, Paintings* (New York: A.C.A. Galleries, 1981), n.p.

32. Hyman, *Gertrude Greene,* n.p.

33. Robert Beverly Hale, *Rhys Caparn* (Danbury, Conn.: Retrospective Press, 1972), n.p.

34. Rhys Caparn, photocopied account of her career.

35. Interview with the artist, Hallandale, Florida, 1986. Subsequent quotes by Slobodkina are from this interview.

36. Charles A. Beard, *A Century of Progress* (New York: Harper & Bros., 1933).

37. Eugen Neuhaus, *The Art of Treasure Island* (Berkeley: University of California Press, 1939), 59–60.

38. Ibid., 60.

Chapter 8

1. Laurie Wilson, *Louise Nevelson: Iconography and Sources* (New York: Garland, 1981), 64. I am indebted to this remarkable psychobiography for many factual details and insights into the origins of Nevelson's iconography (such as her desire to be a "queen" and an "empire builder"). Wilson shows that the facts sometimes differ from the image that Nevelson created about herself.

2. Louise Nevelson and Diana MacKown, *Dawns and Dusks* (New York: Charles Scribner's Sons, 1976), 88. Several other short quotes are from this remarkable series of interviews by MacKown, who was Nevelson's friend and assistant during the last twenty-five years of her life.

3. *New York World-Telegram,* 28 October 1944.

4. Nevelson and McKown, *Dawns and Dusks,* 102.

5. Interview with Sidney Geist, quoted in Wilson, *Louise Nevelson,* 84. Wilson believes that Nevelson's activity accelerated when her house was condemned by the city to make way for a housing project. In the period before she was actually forced to move out, she feverishly constructed an imaginary world in which to live, a sublimation for the imminent loss of her home.

6. Hilton Kramer, *Arts* 32, no. 9 (June 1958):58.

7. Robert Rosenbloom, "Louise Nevelson," *Arts Yearbook* 3 (1959):137.

8. Nevelson and McKown, *Dawns and Dusks,* 112.

9. Vicki Goldberg, "Louise Nevelson," *Saturday Review,* August 1980, 36.

10. Nevelson and McKown, *Dawns and Dusks,* 42.

11. Interview with the author, 1978. Subsequent quotes by Bourgeois are from this interview.

12. Robert Goldwater, *What Is Modern Sculpture?* (New York: Museum of Modern Art, 1969).

13. Eleanor Munro, *Originals: American Women Artists* (New York: Simon & Schuster, 1979), 156.

14. Deborah Wye, *Louise Bourgeois,* Museum of Modern Art, New York, 1983, 75.

15. This and the previous quote are from Lucy Lippard, "Louise Bourgeois: From the Inside Out," *Artforum* 13 (March 1975):32.

16. John Russell, *New York Times,* 24 July 1983, sec. 2, pp. 1–3.

17. Daniel Robbins, "Louise Bourgeois at the Museum of Modern Art," *Art Journal,* Winter 1983, 400–402.

18. Kingman Brewster, *Yale Alumni Magazine and Journal,* May 1977.

19. Mary Callery, "The Last Time I Saw Picasso," *Art News,* March 1942, 23.

20. Ibid.

21. Ibid., 36.

22. Peggy Guggenheim, "The New Gates of Paradise," 1961, archives of Claire Falkenstein. See also Peggy Guggenheim, *Out of This Century: Confessions of an Art Addict* (New York: Universe Books, 1979), 367.

23. Interview with the author, 1980. Subsequent quotes by Falkenstein are from this interview.

24. Siegfried Giedion, *Space, Time and Architecture: The Growth of a New Tradition* (Cambridge: Harvard University Press, 1942).

25. Falkenstein Lecture, Jack Rutberg Gallery, Los Angeles, 1987.

26. Ibid.

27. Alfred Frankenstein, *San Francisco Chronicle,* quoted in photocopied publicity brochure.

28. Rachael Griffin, "Portland and Its Environs," in *Art of the Pacific Northwest* (Washington, D.C.: Smithsonian Institution Press, 1974).

29. Ibid.

30. Eugen Neuhaus, *The Art of Treasure Island* (Berkeley: University of California Press, 1939), 60.

31. Jerayme MacAgy, Alice C. Kent, and Robert Howard, eds., *Autobiography from the Notebooks and Sculpture of Adaline Kent* (privately printed, 1958), 58.

32. *Art Digest* 28, no. 3 (1 November 1953):21.

33. MacAgy, *Autobiography,* 76.

34. Phone interview, 1982.

35. Joan Marter, *Dorothy Dehner and David Smith: Their Decades of Search and Fulfillment* (Rutgers: State University of New Jersey, Zimmerle Art Museum, 1984), the source of many details in this section.

36. Phone interview, 1985.

37. Marter, *Dorothy Dehner and David Smith*, and Joan Marter, "Dorothy Dehner," *Woman's Art Journal*, Fall 1980/Winter 1981, 48. See also Judd Tully, "Dorothy Dehner and Her Life on the Farm with David Smith," *American Artist*, October 1983, 58–61, 99–102.

38. Marter, *Dorothy Dehner and David Smith*, 15.

39. Marter, "Dorothy Dehner," 48.

40. Letter to author, 1983.

41. Irving Sandler, *The New York School: Painters and Sculptors of the Fifties* (New York: Harper & Row, 1978), 152.

42. Leo Steinberg, "Month in Review," *Arts*, April 1956, 45.

43. Virginia Watson Jones, *Contemporary American Women Sculptors* (Phoenix, Ariz.: Oryx Press, 1986), 195.

44. Wayne Andersen, *American Sculpture in Process: 1930–1970* (Boston: New York Graphic Society, 1975), 101.

45. Geri de Paoli, "Jane Teller's Sculpture and Drawings: Powerful Presences in the 'Big Rhythm,'" *Woman's Art Journal*, Spring-Summer 1987, 29.

46. Ibid., 30.

47. *Directions in Afro-American Art*, Herbert F. Johnson Museum, Cornell University, 1974, n.p.

48. James L. Riedy, *Chicago Sculpture* (Urbana: University of Illinois Press, 1981), 228.

49. John Bernard Myers, *Tracking the Marvelous: Life in the New York Art World* (New York: Random House, 1983).

50. Henry McBride, *New York Sun*, 1946, quoted in *Kimball* (Tulsa, Okla.: Philbrook Art Center, 1966), 2.

51. Peyton Boswell, "Debut at the Rehn Galleries," *Art Digest*, March 1946, 20:10.

52. Emily Genauer, *New York Herald Tribune*, 1952, quoted in *Kimball*, 2.

53. News release from Nova Gallery, Boston, 1961.

54. Edgard Driscoll, Jr., "Culinary Feats Join Visual on Cape, *Boston Sunday Globe*, 29 August 1965, 95.

55. Letter from Dr. Harvey Slatin to the author, 4 March 1987.

56. Ronald A. Kuchta, "Yeffe Kimball: 1914–1978," mimeographed memorial tribute, courtesy of Dr. Harvey Slatin and Ronald Kuchta.

57. Ruth Asawa, in Judith Anderson, "A Life Immersed in Art and Affection," *San Francisco Chronicle*, 8 February 1982, 16.

58. *Ruth Asawa Honor Award Show*, San Francisco Art Commission Gallery, 1976, 1.

59. Martica Sawin, "Fortnight in Review," *Art Digest*, 15 December 1954, 22.

60. Gerald Nordland, "Review," *Artforum*, June 1962, 8.

61. Gerald Nordland, *Ruth Asawa: A Retrospective View* (San Francisco: San Francisco Museum of Art, 1973).

62. Sally B. Woodbridge, *Ruth Asawa's San Francisco Fountain: Hyatt on Union Square* (privately printed, 1973), 5.

63. Letter to the author, 1978.

64. Ibid.

65. Marie Zoe Greene-Mercier, "The Role of Materials in My Geometric and Abstract Sculpture," *Leonardo* 15, no. 2 (1982):2.

66. Ibid., 5.

67. Michel Seuphor, *The Sculpture of This Century: Dictionary of Modern Sculpture* (New York: George Braziller, 1961).

68. Statement from the artist, 1983.

69. Andersen, *American Sculpture in Process,* 91–92.

70. Emery Grossman, "Interview with Luise Kaish, Sculptor," *Temple Israel Light* 13, no. 3 (November–December 1966):6.

71. Ibid.

72. Ibid.

73. Robert Dash, "Luise Kaish," *Arts,* April 1958, 63.

74. Quoted in Ark Dedication Statement issued by Temple B'rith Kodesh, Rochester, N.Y.

75. Jean Walrath, "New Art at the Temple, 18 Panel Sculpture," *Rochester Democrat and Chronicle,* 22 March 1964, 4.

76. Avram Kampf, *Contemporary Synagogue Art: Developments in the United States, 1945–65* (Philadelphia: Jewish Publication Society of America, 1966), 227.

77. Nathan Cabot Hale, *Welded Sculpture* (New York: Watson-Guptill, 1968), 178.

78. Jean C. Harris, *Barbara Lekberg: Sculpture: 1948–1978* (South Hadley, Mass.: Mt. Holyoke College Art Museum, 1978).

79. Ibid.

80. John I. H. Baur, *Four American Expressionists* (New York: Whitney Museum of American Art, 1959), 27.

81. Martin Bush, *Doris Caesar* (Utica: Syracuse University Press, 1970), 42.

82. Baur, *Four American Expressionists,* 34.

83. Ibid.

84. Dorothy Grafly, "Three Women Sculptors," *American Artist,* February 1952, 29.

85. Ibid.

86. Ibid.

87. Jones, *Contemporary American Women Sculptors,* 97.

88. Samella S. Lewis, *Art: African American* (New York: Harcourt Brace Jovanovich, 1978), 125.

89. Letter to the author, September 1983.

90. Elizabeth Catlett papers, *Amistad Log,* Amistad Research Center, New Orleans, Louisiana, March 1984, 6.

91. Ibid.

92. Samella Lewis, *The Art of Elizabeth Catlett* (Claremont, Calif.: Hancraft Studios, in collaboration with the Museum of African American Art, Los Angeles, 1984), 147. The principal source about Catlett. See also Thalia Gouma-Peterson's excellent essay, "Elizabeth Catlett: 'The Power of Human Feeling and of Art,'" *Woman's Art Journal,* Spring–Summer 1983, 48–56.

93. Diane Cochrane, "Laura Ziegler: Portraits in Terra Cotta," *American Artist,* June 1975, 32.

94. Ibid.

95. Letter to the author, 1983. Subsequent quotes by Pineda are from this letter.

96. I wish to thank Jeanne Hingston for sharing with me her unpublished essay "Simply Una," the source of many details in this entry.

97. Quoted in Elaine Levin, "Pioneers of Contemporary American Ceramics: Maija Grotell, Herbert Sanders," *Ceramics Monthly* (November 1976), 50. Also see Garth Clark and Margie Hughto, *A Century of Ceramics in the United States* (New York: E. P. Dutton, 1979), 115–16.

98. Quoted in *Marguerite: A Retrospective Exhibition of the Work of Master Potter Marguerite Wildenhain* (Ithica, N.Y.: Cornell University, Herbert F. Jonson Museum of Art, 1980), 16.

Chapter 9

1. According to Sam Hunter, Chryssa "was the first American artist to use emitted electric light and neon, rather than projected or screened light." See *American Art* (New York: Harry N. Abrams, 1979), 584. For a good recent discussion of her work, see Douglas C. Schultz, *Chryssa: Urban Icons* (Buffalo, N.Y.: Albright-Knox Art Gallery, 1983).

2. Pierre Restany, *Chryssa* (New York: Abrams, 1977), 45.

3. Ibid., 62–63. See also, Sam Hunter, *Chryssa* (New York: Harry N. Abrams, 1974).

4. Quoted in E. John Bullard, *The Kinetic Sculpture of Lin Emery* (New York: Max Hutchinson Gallery, 1982).

5. Roger Green, "The Kinetic Sculpture of Lin Emery," *Arts* 54, no. 4 (December 1979):107.

6. Ibid., 106.

7. Bill Golightly, "Tubular Bells," *Horizon*, April 1985.

8. Letter to the author, 1983.

9. Edward Lucie-Smith, *Sculpture since 1945* (New York: Universe Books, 1987), 75.

10. Letter to the author, 1983. For a discussion of Lijn's role (along with four other women) in the Hayward Gallery exhibition, see Rozsika Parker and Griselda Pollock, *Framing Feminism: Art and the Women's Movement 1970–1985* (London and New York: Pandora Press, 1987), 166.

11. Walter Hopps, *Anne Truitt: Sculpture and Drawings, 1961–1973* (Washington, D.C.: Corcoran Gallery of Art, 1974), 14.

12. Barbara Rose, "A Monumental Vision," *Vogue*, March 1987, 487.

13. Ibid., 535.

14. Ibid., 535.

15. Francis Martin, Jr., *Doris Leeper: Art in Public Places* (Orlando, Fla.: Loch Haven Art Center, 1979), 9.

16. Eleanor Munro, *Originals: American Women Artists* (New York: Simon & Schuster, 1979), 230.

17. Donald Kuspit, "Lila Katzen's 'Ruins and Reconstructions,'" in *Lila Katzen/Sculpture-Ruins and Reconstructions: A Cross-Cultural Dimension* (Huntsville, Ala.: Huntsville Museum of Art, 1985).

18. Irving Sandler, "Sylvia Stone's Egyptian Gardens," *Arts*, April 1977, 108.

19. Ibid.

20. Donald Judd, "Lee Bontecou," *Arts Magazine*, April 1965, 20.

21. Munro, *The Originals*, 386.

22. *Art News*, February 1959.

23. Dore Ashton, "Illusion and Fantasy: Lee," *Metro Young* 19 (1962):29.

24. Munro, *The Originals*, 384.

25. Donald Judd, "Lee Bontecou," 20.

26. Cindy Nemser, "An Interview with Eva Hesse," *Artforum*, May 1970, 62.

27. Diary, quoted in Lucy Lippard, *Eva Hesse* (New York: New York University Press, 1976), 13–14. Many details come from this book, the principal source of information about Hesse.

28. Ibid., 35.

29. Mel Bochner, *Arts Magazine*, November 1966, 57–58.

30. Cindy Nemser, *Art Talk: Conversations with 12 Women Artists* (New York: Charles Scribner's Sons, 1975), 208.

31. John Perrault, "The Materiality of Matter," *Village Voice*, 28 November 1968, 19.

32. Catalog statement in Elayne H. Varian, *Art in Process IV* (New York: Finch College Museum of Art, 1969), quoted in Lippard, *Eva Hesse*, 165.

33. H. H. Arnason, *History of Modern Art* (New York: Abrams, 1968), 571.

34. Ronald Watson, *Clyde Connell: Recent Paintings and Sculpture* (Fort Worth: Texas Christian University, 1982). A major source on Clyde Connell is Charlotte Moser, *Clyde Connell: The Art and Life of a Louisiana Woman* (Austin: University of Texas Press, 1988).

35. Jeff Goldberg, "Marisol in Her Own Words," *People*, 24 March 1975, 40. A searingly candid interview.

36. Nemser, *Art Talk*, 185.

37. See Roberta Bernstein, "Marisol's Self-Portraits: The Dream and the Dreamer," *Arts*, March 1985, 86. See also Paul Gardner, "Who Is Marisol?" *Art News*, May 1989, 147–51.

38. Ibid., 89.

39. Harvey Stein, *Artists Observed* (New York: Harry N. Abrams), 26.

40. Theodore Wolff, "Joy of Art: Art of Joy," *Christian Science Monitor*, 23 October 1979, 20.

41. Jerry Tallmer, "The Rebel in a White Leather Suit," *New York Post*, 21 April 1979, 16.

42. Ibid.

43. Ibid.

44. Niki de Saint Phalle, *My Skinnys* (New York: Gimpel & Weitzenhoffer Gallery, 1982), n.p.

45. Wolff, "Joy of Art: Art of Joy," 20.

46. Dorothea Tanning, *Birthday* (San Francisco, Lapis Press, 1976), 145.

47. Allan M. Gordon, *Artweek*, 14 May 1977, 3.

48. Phone interview, 2 June 1986.

49. Harmony Hammond, Jaune Quick-to-See-Smith, et al., *Women of Sweetgrass, Cedar and Sage: Contemporary Art by Native American Women* (New York: Gallery of the American Indian Community House, 1985), n.p. The following quotation also comes from this landmark catalog.

50. Mildred Constantine and Jack Lenor Larsen, *Beyond Craft: The Art Fabric* (New York: Van Nostrand Reinhold Co., 1972), 267.

51. Munro, *Originals*, 330. Many details come from this interview.

52. Jane Fassett Brite and Jean Samsta, *Fiber R/Evolution* (Milwaukee Art Museum, 1986), 9. This catalog includes a large number of contemporary women fiber artists creating innovative forms.

53. Richard Howard, "Tawney," *Craft Horizons*, February 1975, 71.

54. Gloria Orenstein, "Lenore Tawney: The Craft of the Spirit," *Feminist Art Journal*, Winter 1973–74, 11–13.

55. Lecture, "The Mythology of Weaving," California State University, Fullerton, 1975.

56. Orenstein, "Lenore Tawney," 13.

57. Jones, *Contemporary American Women Sculptors,* 573.

58. Janet Koplos, "Escaping the Wall: Claire Zeisler Retrospective," *New Art Examiner,* March 1979, 5. Subsequent quotes by Zeisler are from this article.

59. Sheila Hicks, *Claire Zeisler: A Retrospective* (Chicago: Art Institute of Chicago, 1979).

60. Sheila Hicks, Lausanne Biennale, 1975.

61. Munro, *Originals,* 366.

62. Ibid., 367.

63. Irene Waller, *Textile Sculptures* (New York: Taplinger Publishing Co., 1977), 79.

64. Alice Westphal, *Ruth Duckworth,* Exhibit A Gallery, Chicago, Illinois, 1977. Subsequent quotes by Duckworth are from this source.

65. Quoted in Paul Taylor, "Yoko Ono's New Bronze Age at the Whitney," *New York Times,* 5 February 1989. Arts and Leisure section.

Chapter 10

1. Lucy Lippard, *From the Center* (New York: E. P. Dutton, 1976), 38.

2. Kay Larson, "For the First Time Women Are Leading, Not Following," *Art News,* October 1980, 64–72.

3. Charles Jencks, *Post-Modernism: The New Classicism in Art and Architecture* (New York: Rizzoli, 1987), 22.

4. Arlene Raven, "The Circle," in *Crossing Over: Feminism and Art of Social Concern* (Ann Arbor: U.M.I. Research Press, 1988), 24. Also quoted in Lucy Lippard, *Get the Message* (New York: E. P. Dutton, 1984), 150.

5. Ann Sutherland Harris and Linda Nochlin, *Women Artists: 1550–1950* (New York: Knopf, 1976), 67.

6. See Gloria Feman Orenstein, "The Reemergence of the Archetype of the Great Goddess in Art by Contemporary Women," in *Feminist Art Criticism: An Anthology,* ed. Arlene Raven, Cassandra L. Langer, and Joanna Frueh (Ann Arbor/London: U.M.I. Research Press, 1988), 71–86. Marija Gimbutas has written controversial books documenting the image of the Great Goddess in ancient times.

7. John Yau, "Visionary Verisimilitude: The Sculpture of Nancy Graves," *Sculpture,* September–October 1987, 26–29, 63.

8. Quoted in John Gruen, "Jackie Winsor: Eloquence of a Yankee Pioneer," *Art News,* March 1979, 57.

9. Ibid., 59.

10. Howard J. Smagula, *Currents: Contemporary Directions in the Visual Arts* (Englewood Cliffs, N.J.: Prentice-Hall, 1983), 155–56.

11. Melinda Wortz, *Nation,* Summer 1985, 101.

12. Susan M. Henry, "'Sally Hemings': A Key to Our National Identity," *Ms.,* October 1980, 36.

13. Munro, *Originals,* 372.

14. Robert Storr, "Painterly Operations," *Art in America,* February 1986, 88.

15. John Gruen, "Dorothea Rockburne's Unanswered Questions," *Art News,* March 1986, 98.

16. Ibid., 100.

17. Interview with the author, February 1986. Subsequent quotes from Ferrara are from this interview.

18. Panel at National Sculpture Conference: Works by Women, University of Cincinnati, Ohio, 1987.

19. Lucy Lippard, "Harmony Hammond: Towards a Politics of Abstraction," in *Harmony Hammond: Ten Years, 1970–1980* (Minneapolis: Women's Art Registry of Minnesota, 1981), n.p.

20. Ibid.

21. Suzanne Muchnic, *Los Angeles Times*, 17 June 1985, pt. 5, p. 4.

22. Ted Castle, "Nancy Holt, Siteseer," *Art in America*, March 1982, 90.

23. Ibid.

24. Athena Tacha, "Rhythm as Form," *Landscape Architecture*, May 1978, 196–204.

25. Ibid., 197.

26. Ibid.

27. Watson-Jones, *Contemporary American Sculptors*, 569.

28. Interview with the author, San Diego, 1986.

29. Jody Pinto, *Excavations and Constructions: Notes for the Body/Land* (Philadelphia: Marian Locks Gallery, 1977).

30. Georgia Sargeant, "Marabar: National Geographic," *International Sculpture*, January–February 1987, 27.

31. Edward Fry, "The Poetic Machines of Alice Aycock," *Portfolio*, November 1981, 60–65.

32. Richard Poirier, "The Ghost in the Machine," *Art News*, October 1986, 82.

33. Ibid., 84.

34. Ibid., 85.

35. Hayden Herrera, "A Conversation with the Artist," in *Joyce Kozloff: Visionary Ornament* (Boston: Boston University Art Gallery, 1986), 29.

36. Thalia Gouma-Peterson, "Decorated Walls for Public Spaces: Joyce Kozloff's Architectural Installations," in *Joyce Kozloff: Visionary Ornament*, 56.

37. Roy J. Cousins, "Special People: Dora de Larios," *Westways*, July 1983, 56. Subsequent quotes by de Larios are from this article.

38. John Ashbery, "An Exhilarating Mess," *Newsweek*, 23 February 1981, 82.

39. Paul Gardner, "Blissful Havoc," *Art News*, Summer 1983, 68.

40. Wade Saunders, "Talking Objects: Interviews with Ten Younger Sculptors," *Art in America*, November 1985, 131.

41. Miranda McClintic, *Directions*, Hirshhorn Museum, 1981, 24.

42. John Yau, "Art on Location," *Artforum*, Summer 1986, 11.

43. Saunders, "Talking Objects," 131.

44. *Threshold* brochure, California State University, Fullerton, 1986.

45. Studio interview, 1987.

46. Phone interview, 1983.

47. Ibid.

48. Judy Collischan Van Wagner, *Michelle Stuart: Voyages* (Greenvale, N.Y.: Hillwood Gallery, Long Island University), 65.

49. Elenore Welles, "Lita Albuquerque: Beyond Time," *Visions*, Fall 1987, 26–28.

50. Ibid., 28.

51. Linda Kaun, *Offerings: The Altar Show* (Venice, Calif.: Social and Political Art Resources Center [SPARC], 1984), 8.

52. Ibid.

53. This and the following quotation are from the catalog *Ofrendas* (Sacramento: Galeria Posada, 1984).

54. Phone interview with the artist, 1987.

55. Shifra Goldman, "Portraying Ourselves: Contemporary Chicana Artists," in *Feminist Art Criticism: An Anthology.* Goldman mentions Celia Muñoz of Texas, who has recently become another important installation artist, and Camilla Trujillo of New Mexico, who creates ceramic figures that draw on her combined Chicana and Native American heritage. Goldman points out that Chicana women have had to struggle not only against economic exploitation and prejudice from white society but also against stereotypes within the Latin American culture of women as "submissive, docile, dependent and timid." The feminist movement helped Chicana artists rediscover their own vigorous history and develop a sense of themselves as strong and independent.

56. Jeffrey Keeffe, "Cecile Abish: Building from the Ground Up," *Artforum,* October 1978, p. 39.

57. Lecture by Melinda Wortz, Laguna Beach Museum of Art, April 1986.

58. Brigid Grauman, "Antwerp: Starting from Scratch," *Art News,* November 1987, 50.

59. Quoted from Nordman's book *Working Notes* (1980), in Ronald J. Onorato, *Maria Nordman: Trabajos en la Ciudad de Ondas* (La Jolla: La Jolla Museum of Contemporary Art, 1985).

60. Moira Roth, ed., with contributions by Mary Jane Jacob, Janet Burdick, and Alice Dubiel, *The Amazing Decade: Women and Performance Art in America, 1970–1980* (Los Angeles: Astro-Artz, 1983).

61. Ibid., 14.

62. Suzanne Muchnic, "The Artist as Activist for Feminist Events," *Los Angeles Times,* 3 September 1979, pt. 4, p. 10.

63. Fidel Danieli, "Gaia, Mon Amour," *Visual Art,* Summer 1984, 29–32.

64. "Interview with Laurie Anderson," *Impressions,* Spring 1981, 14–15, as quoted in Smagula, *Currents: Contemporary Directions in the Visual Arts,* 255.

65. Adolpho Nodal, "Ana Mendieta: 1948–1985," *High Performance,* no. 31 (1985):3.

66. Adolpho Nodal, unpublished eulogy, August 1985.

67. Mary Beth Edelson, *Seven Cycles: Public Rituals* (privately printed, 1980), 11.

68. Phone interview, 16 December 1987.

69. Colin Naylor and Genesis P-orridge, eds., *Contemporary Artists* (New York: St. Martin's Press, 1977), 809.

70. Christine Temin, "Leather? No, It's Clay," *Boston Sunday Globe,* 25 January 1981, sec. B., p. 9.

71. Cindy Nemser, *Art Talk: Conversations with 12 Women Artists* (New York: Charles Scribner's Sons, 1975), 330. See also Arlene Raven's profile of Grossman in Betty Brown and Arlene Raven, *Exposures: Women and Their Art* (New Sage Press, 1989).

72. Jones, *Contemporary American Women Sculptors,* 406.

73. Quoted in Marian Parry, "An Interview with Penelope Jencks," *American Artist,* August 1973, 36. See also Blair Birmelin, "Penelope Jencks: Sculpture," *Massachusetts Review* 24, no. 2 (Summer 1983):417–24.

74. Munro, *Originals,* 290.

75. April Kingsley, "Mary Frank: A Sense of Time-lessness," *Art News,* Summer 1973, 65.

76. Hayden Herrera, *Mary Frank: Sculpture/Drawings/Prints* (Purchase, N.Y.: Neuberger Museum, 1978).

77. Hilton Kramer, "The Sculpture of Mary Frank: Poetical, Metaphorical, Interior," *New York Times,* 22 February 1970.

78. Kingsley, "Mary Frank," 65.

79. Patricia Hills and Roberta Tarbell, *The Figurative Tradition and the Whitney Museum of Art* (New York: Whitney Museum of American Art, 1980), 169.

80. Mary Frank, *Mary Frank: Persephone Studies* (New York: Brooklyn Museum, 1987). See also Margaret Moorman, "In a Timeless World," *Art News,* May 1987, 90–98.

81. Edward J. Sozenski, "Art with a Bright, Funky West Coast Air," *Philadelphia Inquirer,* 13 November 1984, sec. F., p. 7.

82. Quoted in Elsa Longhauser, *It's All Part of the Clay: Viola Frey* (Philadelphia: Moore College of Art, 1984), 3.

83. Interview with Garth Clark in Longhauser, *It's All Part of the Clay,* 15. Clark is one of the major interpreters of Frey's work.

84. Quoted in Charles Miedzinski, "Images of Paradox," *Artweek,* 21 September 1985, 1.

85. *Overglaze Imagery: Cone 019-016* (Fullerton: California State University, Fullerton, Art Gallery, 1977), 203.

86. Interview with Deborah Butterfield, *Deborah Butterfield,* Museum of Art, Rhode Island School of Design, 1981, n.p.

87. Marcia Tucker, "Equestrian Mysteries," *Art in America,* June 1989, 156. Butterfield, who still trains and rides horses, reveals the emotional and political basis of her art in this interview.

88. *Deborah Butterfield.*

89. Douglas Schultz, *8 Sculptors,* Albright Knox Art Gallery, 1979.

90. John Bernard Myers, "The Other," *Artforum,* March 1983, 49.

91. Carter Ratcliff, "Anne Arnold," *Craft Horizons,* June 1971, 70.

92. Ibid.

93. Donna Dennis and Michael Newman, *Artists' Architecture* (London: Institute of Contemporary Art, 1983), 74–75.

Chapter 11

1. Arlene Raven, "The Last Essay on Feminist Criticism," *Feminist Art Criticism: An Anthology,* ed. Arlene Raven, Cassandra L. Langer, and Joanna Frueh (Ann Arbor: U.M.I. Research Press, 1988), 236. This quotation originally appeared in an article in the *Village Voice,* 6 October 1987, 9, replying to second-generation feminist deconstructionist critics, who assert that the emphasis on women's nature in earlier feminist art is "essentialist." Raven is a founding theoretician of first-generation feminist art criticism and is today a major interpreter of art for social change.

2. Quoted in Bruce Ferguson, "Wordsmith: An Interview with Jenny Holzer," *Art in America,* December 1986, 111.

3. Jeanne Siegel, "Jenny Holzer's Language Games," *Arts Magazine,* December 1985, 64.

4. Ferguson, "Wordsmith," 114.

5. Mary Kelly, *Post-Partum Document* (London: Routledge & Kegan Paul, 1983).

6. Lucy Lippard, *Get the Message: A Decade of Art for Social Change* (New York: E. P. Dutton, 1984). See also Arlene Raven, *Crossing Over: Feminism and Art of Social Concern* (Ann Arbor: U.M.I. Research Press, 1988). See also

Lippard's essay "Trojan Horses: Activist Art and Power," in *Art After Modernism: Rethinking Representation,* ed. Brian Wallis (New York: New Museum of Contemporary Art, 1984), 341–58. Many women artists have exhibited in large collaborative political art exhibitions organized by groups like PADD (Political Art Documentation/Distribution) and Group Material, which favor a collective approach and deemphasize the individualism of the "star system." These groups also get their work out to the general public on billboards, subway cards, etc.

An important public-political artist is Mierle Laderman Ukeles, who has devoted a decade to spotlighting the important role of New York City's Sanitation Department workers, those unsung heroes who clean up after the rest of us just as women clean up endlessly in the home. The idea (growing out of her feminist consciousness in the 1970s) is to honor those who do the world's insufficiently recognized "maintenance work." An early performance consisted of shaking the hands of thousands of sanitation workers around the city. Ukeles is currently creating *Flow City,* a multimedia installation for the new Department of Sanitation waterside facility, where trucks dump New York City's garbage onto disposal barges. The public, viewing the process through her Glass Bridge, is stimulated to think about the social and political implications of waste disposal. Ukeles is one of many women artists who have transformed the field of public art in radical new ways. (See Patricia Phillips, "Waste Not," *Art in America,* February 1989, 47–51.)

Some artists use "appropriation" or manipulate found objects or readymades to illuminate, deconstruct, or conceptualize social, economic, psychological, and political aspects of the culture. Barbara Bloom's *Age of Narcissism* is a room furnished with elegant traditional chairs, tables, mirrors, and other objects, each of which bears an image of the artist's face. Thus she comments on the 1980s, an era of greed and self-aggrandizement through acquisitions and, in the case of artists, through their work. Annette Lemieux would perhaps not regard herself as a "political artist," yet her subtly transformed objects, such as a beautiful spiral of books laid out on the floor, often comment on the loss of intellectual

and spiritual values in an age drowning in a deluge of mass media. Ann Hamilton is an important conceptual artist whose large installations provoke thoughts about society and the environment.

7. Wade Saunders, "Talking Objects: Interviews with Ten Sculptors," *Art in America,* November 1985, 135.

8. Charles Jencks, *Post-Modernism: The New Classicism in Art and Architecture* (New York: Rizzoli, 1987), 114.

9. Steven Henry Madoff, "Sculpture Unbound," *Art News,* November 1986, 106.

10. Castelli Gallery statement, 1986.

11. Lawrence Alloway, *Ursula von Rydingsvärd* (New York: Bette Stoler Gallery, 1984).

12. Interview with Judy Collischan Van Wagner in catalog *Judith Murray: Painting, Ursula von Rydingsvärd: Sculpture,* Hillwood Art Gallery, Long Island University, C.W. Post Campus, 1985, 44–45.

13. Roger Green, "Ida Kohlmeyer Month," *Art News,* Summer 1985, 104.

14. Michael Brenson, "Critics' Choices," *New York Times,* 13 September 1987.

15. See Harmony Hammond, Jaune Quick-to-See-Smith, Lucy Lippard, and Erin Younger, *Women of Sweetgrass, Cedar, and Sage: Contemporary Art by Native American Women* (New York: Gallery of the American Indian Community House, 1985). This landmark catalog illuminates the work of a large group of innovative artists and contains excellent theoretical discussions. The distinguished Native American painter and leader, Jaune Quick-to-See-Smith, points out that the work of Amerindian women is celebratory and spiritual, in spite of the hardships they face in their daily lives: "It doesn't speak of strife and turmoil (even though these things exist in abundance) ... It is made ... to uplift life, to uplift the spirit ... and often in a thankful way

to a greater being." Dream imagery is an important source of inspiration, she notes, and even though the artists are contemporary in their approach, their work maintains roots in the craft traditions.

The work of Native Americans today, as in the past, reflects a wide range of cultural backgrounds and attitudes. Indeed, the notion of the monolithic "Indian" is a chauvinistic myth. This is also true of Asian American, African American, and Latina artists. The waves of immigrants from China, Japan, Korea, Cambodia, Vietnam, and other Asian countries, as well as those from South and Central American countries, are made up of people from many distinctly different cultures who do not regard themselves as homogeneous. It is important to avoid stereotypes and to appreciate the subtle tensions created by the interplay of these varied backgrounds with the American experience. See Lucy R. Lippard's *Mixed Blessings: New Art in a Multicultural America* (New York: Pantheon, 1990).

16. Letter from Winnie Owens-Hart, 1989. Some other fine African American sculptors working today are Beverly Buchanan, Helen Ramsaran, Valerie Maynard, and Shirley Stark.

17. John Perrault, "Crafts is Art: Notes on Crafts, on Art, on Criticism," in *The Eloquent Object: The Evolution of American Art in Craft Media since 1945,* ed. Marcia and Tom Manhart (Tulsa, Oklahoma: Philbrook Museum of Art, 1987), 192.

18. Interview with Maya Lin, Joel Swerdlow, "To Heal a Nation," *National Geographic,* May 1985, 557.

19. Ibid.

20. Panel on war memorials at the "National Sculpture Conference: Works by Women," May 1987, Cincinnati, Ohio, hosted by the Art Department, University of Cincinnati. This historic conference brought together nearly one thousand professional women sculptors for seminars and exhibitions. The inadequate press coverage of this event indicates the continued bias of the New York art-journalistic establishment. The ex-

change that took place had an enormous effect on the participants and still exerts influence.

21. Swerdlow, "To Heal a Nation," 557.

22. Panel, "National Sculpture Conference: Works by Women."

23. Swerdlow, "To Heal a Nation," 557.

24. Phone conversation with Maya Lin, November 1989. The jurors assumed that her design was the work of a well-established male professional. See also Jan C. Scruggs and Joel L. Swerdlow, *To Heal a Nation: The Vietnam Veterans Memorial* (New York: Harper & Row, 1985), 63. Jurors said "He knows what he's doing, all right..."

25. See Elizabeth Hess, "A Tale of Two Memorials," *Art in America,* April 1983, 121–25, and Scruggs and Swerdlow, *To Heal a Nation: The Vietnam Veterans Memorial,* 127.

26. Scruggs and Swerdlow, *To Heal a Nation: The Vietnam Veterans Memorial,* 81–84. (Scruggs is the veteran who conceived of the monument and dedicated several years of his life to bringing it about. The book shows how the monument became a political football for various groups.) See also Hess, "A Tale of Two Memorials," 122, 123. Unconscious sexism and racism permeate these remarks; black was repeatedly called "the color of shame and degradation." One prominent military man demanded, "Build the memorial rising and white ... make it inspiring" (Scruggs and Swerdlow, *To Heal a Nation,* 84).

27. Panel, "National Sculpture Conference: Works by Women."

28. Scruggs and Swerdlow, *To Heal a Nation,* 100.

29. Panel, "National Sculpture Conference: Works by Women."

30. Jonathan Coleman, "First She Looks Inward," *Time,* 6 November 1989, 90–94.

Index

• B •

• D •

• F •

• G •

• I •

• J •

• M •

• Q •

• R •

• U •

• V •

Photo: Kim Petersen

A B O U T T H E A U T H O R

Charlotte Streifer Rubinstein is the author of the
critically acclaimed *American Women Artists: From
Early Indian Times to the Present* (G.K. Hall/Avon
Books, 1982), chosen by the Association of American
Publishers as Best Humanities Book of 1982 in the
Scholarly and Professional Category and by *Choice*
as one of the best academic books of 1983. Her
articles have appeared in *American Art Journal,
Artweek, Woman's Art Journal,* and *Women
Artists News.* An artist and a teacher, she lives in
Laguna Beach, California, with her husband and has
three children.